Tamás Hofer and Edit Fél

HUNGARIAN FOLK ART

Oxford University Press

Oxford/London/New York

1979

Title of the Hungarian original Magyar népművészet
Corvina Kiadó,
Budapest, 1975

© Tamás Hofer
and Edit Fél, 1975

Translated by Mária Kresz
and Bertha Gaster

Black-and-white photographs Tamás Kovács

Colour plates Károly Szelényi

Since photographs
taken from archives are
also included
in the book,
a complete list
of the photographers
is given on p. 64

Design István Faragó

This edition © Tamás Hofer
and Edit Fél, 1979

English translation © Mária Kresz
and Bertha Gaster 1979
ISBN 0 19 211448 4

First published
in England in 1979
by Oxford University
Press, in co-operation
with Corvina Kiadó,
Budapest

Printed in Hungary, 1979
Kossuth Printing House,
Budapest

Contents

Introduction

By the end of the nineteenth century and the beginning of the twentieth, factories were springing up all over Hungary, iron bridges spanned the Danube and a network of railways linked the different regions. Simultaneously, Budapest developed into a large city, and artists, painters and sculptors, drawing their original inspiration from Munich, Paris and Vienna, were creating a Hungarian national art in harmony with the prevailing artistic style of the period. The thousands living in Hungarian peasant villages at this time created a distinctive and local art world of their own, with decorative and functional objects. Some of those who witnessed this period of flowering in the history of peasant art are still alive, and many examples of it have survived. However, with the violent changes of recent years, the peasant world which both provided the framework for this type of art and gave it life has largely disappeared. At the same time, the present favours study of the subject since a century of research and collecting has given us the opportunity to see representative collections of folk art in museums, even though the intimacy with which earlier generations of ethnographers were able to observe the contemporary peasant world, whose presence seemed simple and natural to them, has vanished. Distance in time, however, allows for a better assessment of the significance of peasant art.

Peasant art is still relevant to Hungarians. In the middle of the last century, three-quarters of the Hungarian nation lived on the land and even a generation ago about half still did. In many respects modern Hungarian society has its roots in the peasant world. Modern Hungarian national culture (literature, music and art) is bound both directly and indirectly to the traditions of peasant culture. The search for national identity and character continually leads back to that world.

Peasant art and modern art use very different vehicles of expression. In the former they are not pictures or sculpture (or only very rarely) but many kinds of objects made to meet the demands of practical use. There is consequently no clear division between artist and craftsman, artisan and peasant both making objects for their own use. In a peasant community each functional object has, to some degree, aesthetic meaning. Experiments in modern art have helped to develop a sensitive understanding of folk art, especially within the range of the material environment of peasant culture. Fifty years ago folk art was considered a minor art, but today, as a consequence of the modern trends in art, strict boundaries are no longer drawn between representation and ornamentation. We are now interested in the processes by which a village community concentrates its aesthetic and human impulses into single objects.

The peasant way of life in which folk art flourished developed in basically identical ways over large areas and long periods of time. The shapes and techniques of folk art and the decorative motifs are not, for the most part, the exclusive expression of Hungarian or any other peasants, they were part of the social and cultural changes experienced by much of Europe. However, certain styles are restricted to certain regions and local communities, and those systems of interpersonal relations which gave rise to and nourished folk art can only be viewed from within the framework of a given village. Thus, the authors attempt to discuss, in some sections of the book, the Hungarian people as a whole; concurrently, 7

they have restricted themselves to particular examples and illustrations from individual villages.

In this book an attempt has been made to penetrate the life of certain peasant groups closely in order to show from what sphere of human life these beautiful or decorative objects came. Series of photographs illustrate the variety within one branch of art or one stylistic area; at the same time the authors try to show peasant art in its social and historical context.

The peasant villages which produced their local styles of folk art belonged to a complex, highly stratified national society. Within the same society, at the same period, other classes lived in different ways and produced other kinds of art. It is this situation and relationship which distinguishes peasant art from the art of a tribal society or the homogeneous art of the early empires—as well as from European "high" art. Peasant art does not exist alone; the "high" art of the same society coexists with it. There is a constant flow in both directions between urban and court art on the one hand, and peasant art on the other. It is important not simply to trace the record of certain motifs and structures but to bear constantly in mind that folk art was in continuous contact with the different forms of expression of the other strata of society which were familiar to the villagers themselves. If we find either a conscious endeavour to imitate, or a conscious striving for independence from these other forms of art, then we may have discovered expressions of the social consciousness of the peasant creators of peasant art.

In the last few centuries, the position and the role of the peasants within society as a whole, as well as the self-awareness of the peasantry have undergone definitive changes. Obviously it is these changes which can be detected in the transitions between the styles of different periods of folk art. Peasant generations whose situation and position have changed produced a folk art whose style has changed as well. (With this in mind, we may be better able to understand the reasons behind the sharp differences in the folk art of European societies.)

In the following text, the expressions "folk art" and "peasant art" are interchangeable. The growth and flowering of this art is related to the villages and to the peasants. Those social groups to which folk art is linked became differentiated in different ways in the variously structured societies of Europe. In Hungary, folk art is bound to those who lived on the land. The social position of all the peasants was by no means uniform. Some were free and some were serfs; they included villagers and citizens of market towns who enjoyed special rights but earned their living from the land, petty nobles, agricultural labourers without property, village craftsmen and herdsmen. However, despite such differences, their lives were based on peasant traditions and their thoughts were governed by peasant values. It was these people who constructed the world of objects we shall be dealing with here. The art of the peasantry will be discussed from the point of view of the "consumer"; the authors include all those objects of aesthetic value that were part of the material surroundings, regardless of whether the peasants made them themselves or bought them from an artisan, in a shop, or from a dealer who was a stranger to the community.

This social demarcation also serves to define the temporal framework. Many of the techniques and objects of "classical" folk art continue to live after the dissolution of the peasant way of life. Preserved deliberately and with care, they now serve consumers who are not peasants. However, we do not intend to pursue this development further, nor are the authors concerned with the "naïve" village artists, although they still exist today.

The majority of the objects illustrated date from the nineteenth century, but a significant number of earlier pieces have also been included (mostly from the eighteenth century, but a few from as early as the seventeenth) and a selection of more recent pieces from the beginning of the twentieth century has also been added. The allocation to each period reflects clearly the true differences in the volume of production at different times. Old photographs

have also been included showing villages and peasants in both their work-day and Sunday clothes to give an impression of the environment and the peasant way of life in which what are now museum pieces were created. These photographs are now historical documents; most of them were taken between forty and fifty years ago and do not represent the villages and the villagers of today.

It is not our intention to provide a "sociology of objects". Unattractive or badly made objects are not included, nor has any attempt been made to document the complete material equipment of peasants of differing social status. Priority is given to masters in preference to imitators, to the better works of art rather than those lacking quality and taste. Similarly, no attempt is made to give even an approximately complete cross-section of the variety of objects in existence, nor of all the regions in Hungary. The chief aim has been to give an idea of the distinctive quality of Hungarian folk art and its characteristics by choosing and illustrating certain groups of objects.

The first group consists of painted ceiling panels and church furnishings of the seventeenth, eighteenth and nineteenth centuries, illustrating the earlier artistic taste of the peasants. This group is followed by many examples of simple vessels and household utensils, objects formerly often neglected in favour of those more ornate and ceremonial. This group shows the simple, noble, serviceable forms and rural functional design of these objects, as well as the process of transformation whereby the functional object was elevated to a symbolic level and such great care was lavished on its making and design that it was no longer suitable for everyday use.

Only a few examples of pottery and furniture have been given, with the exception of pottery figures and open-work furniture decorated with figures, since both of these artefacts show pronounced skill in composition and an inventive and experimental spirit. For the same reason herdsmen's objects such as mirror-cases, salt-cellars and razor-cases, which constitute only a small group, are fully represented, since they were used for experiments in figural representation in the nineteenth century—the subjects most frequently depicted on the small carved objects are a pair of lovers, a herdsman, or a highwayman. It is worth noting that religious subjects play a very small role in representational folk art; most of the scenes are secular. When religious subjects do occur they are usually linked to late types of iconography.

Finally, embroidery is shown in detail, with series of variations grouped together. This medium gives an insight into the composition of designs: on the one hand, the severely geometric forms of ornamental composition in which even the abundance of floral ornament is arranged in systematic order, and on the other, the process of their dissolution, the growing relaxation in the design, foreshadowing the change of style to come.

The Peasant World
of Objects

The peasants with whose art this book is concerned lived in a material environment containing many highly differentiated man-made objects. In Átány, a village on the Hungarian Plain, a count made of the number of implements employed on a farm showed that, twenty years ago, between 200 and 1,200 different farming tools were in use, depending on the wealth and status of the farmer. In certain villages at the beginning of the century women possessed twenty to twenty-five complete sets of holiday attire and six to nine pillows were piled on the ornamental bed with about five to seven sets of pillow-cases for each. In certain regions, records show that this profusion of objects dates back to a considerably earlier period. In Kismarja, for instance, a peasant settlement the size of a small market town, an 1806 inventory of the household of a well-to-do old couple reveals that they owned 293 pieces of crockery (including ten jugs for wine and 108 bowls and dishes) and, in addition, 12 wooden platters, 4 pewter dishes and 9 pewter plates. At this time the majority of peasant objects were still hand-made, partly at home, partly by professional craftsmen, and on most of these objects the touch of the human hand that made them is quite evident.

All these various objects had to be beautiful as well; that is to say, there was an aesthetic standard for each type of object by which the well made could be distinguished from the ugly and badly made. Considerations such as aesthetic quality, proportion, beauty, workmanship and ornamentation seem, however, to have been of prime importance only in the case of certain objects.

Folk art is generally thought of as the art of the creation and decoration of useful objects. A more thorough examination of the material goods belonging to peasant families reveals that the relation between utility and artistry is not quite so simple. The majority of ordinary objects found in village homes are usually simple in shape and those to which especially meticulous care has been given are in fact those not used in daily life.

Decoration, or the creation of a beautiful shape, is an extra, giving the object an additional value. If the opportunity for choice is there, it is usually exercised in favour of the ornamental over the plain, the preference, even in functional objects, tending towards beauty as well as function wherever possible. But there is a point at which the aesthetic demand for decoration and the practical demands of use conflict. Rich, elaborate decoration, or a delicacy in the construction of the form of an object make it fragile, and consequently less suited to its function; in addition its daily employment would ruin the decoration and spoil its beauty. Certain carved wooden hoe-scrapers bear the marks of prolonged use; others are enriched with such an elaborate open-work decoration that they would break if employed for their proper function. An embroidered pillow-case would be spoiled by a single washing; it was therefore not made for daily use, for which a plain equivalent was more suitable. People rarely slept in the ornamental bed, stacked high with pillows. There were simpler, everyday beds in peasant houses for sleeping and the ornamental bed was reserved for laying out the dead. The grooved wooden boards used for making noodles for the wedding soup could be imitated by pottery boards, similar in form, which made pretty gifts, but which were quite useless for rolling noodles.

173–176

232–234

235

169–172, 467–470

10

The contradiction between decoration and practical use becomes clear when we consider that in most cases the decoration loses its immediacy when the object is in actual use, and is only in evidence when that object is displayed or exhibited. A bird or flower painted on a dish or plate disappears when food is put in it; but hung on the wall, it can be seen and admired.

It is important to make a distinction in the world of peasant objects between the comparatively few household items which were designed for daily use and the great profusion of objects which were only brought out on rare festive or ceremonial occasions, and which played a ritual role in those festivities. There was a difference between the more intimate objects for private use and the representative objects—to use the expression of Sigurd Erixon—intended for the eyes of others. Pillow-cases were a case in point: those on which the farmer actually rested his head were hidden under a counterpane; those which were never used had the place of honour in the room.

In reality there was no rigid barrier separating the two classes of objects. A decorated object for festive use was occasionally called into service for special occasions. A finely decorated, silver-mounted harness with intricately braided leather trappings could be used to **177–179** take the farmer to a fair, a wedding, or to church. Between everyday working clothes for the field and the "Sunday best", there was an intermediate range of clothing for less festive occasions, for the performance of various tasks, and for lighter work performed communally, such as spinning.

Various factors combined to raise an object from something in daily use to the rank of a ritual object for festive occasions; sometimes it was thanks to the object being made of some valuable material, sometimes not even that. It might simply be set aside, as new, untouched; for example, a shirt, no different from ordinary everyday shirts, would be reserved unworn and unwashed either to clothe the dead, or a bridegroom. Nevertheless, it appears that the most important reason for transforming an everyday object into a ceremonial, ritual or festive object was the aesthetic value of its form or decoration. Peasants usually give a good shape to all the useful objects they handle, but nonetheless it seems true that beautiful shapes and decorations elevated the objects out of their everyday use and transformed them into what might be described as symbols of themselves.

This differentiation is most marked when the two forms of the same object (the mundane and the festive) are seen together. A shepherd, for instance, who possessed a crook for hooking a sick sheep out of the flock by its leg and for leaning on while minding the sheep, also had another "Sunday" crook, functioning as the symbol of his calling, which he took **391–394** to church or to a fair or inn, or when visiting the authorities. The decoration on the crook often symbolized his calling; there might be the figure of the shepherd himself on it, or a **386** sheep's head, or a symbolical carving of the shepherd's place in the universe, as on the crook made by János Barna, with his portrait and a ram beneath it, and above it, Jesus pointing to **391** his heart, Mary, and other figures. These crooks were never used to hook sheep out of the flock (the fine and fragile carving made them quite unsuitable for that purpose), yet they express the essence and purpose of the shepherd's crook with greater concentration and purity than their plainer equivalents.

Where does this "duplication" of the objects of the material world come from, this refinement of form which goes far beyond practical function and use? The question should be regarded historically. Herbert Read, looking for the beginnings of aesthetic form and consciousness, took the stone axe as an example to demonstrate that already in the Mesolithic, or perhaps early in the Neolithic Age, developments producing the shape best calculated to be efficient had gone far beyond practical needs to a sort of formal perfection. Axes have been found made of beautiful and valuable material, which could have been of little or no use for practical purposes. This development was the result of the appearance of axes with symbolic, emblematic and ritual function (to serve as symbols of power or as votive offerings) 11

side by side with axes used for work. So form, having become divorced from function, was free to develop according to new principles or laws—those laws and principles which we now call "aesthetic". The shape of vessels similarly developed in new ways when their functional use changed to the non-functional; when, for instance, they were used to pour libations, or serve as urns for the ashes of the dead. With this development, instead of durability, the ceremonial aspects of form were emphasized.

To return to the Hungarian shepherd's crook, it is not known for certain when the divergence between the practical and the formal took place, for though the carving of the ceremonial crooks is perfectly compatible with the known shepherds' carvings of the nineteenth century, the ceremonial and ritual crook was known in Europe and in Hungary many centuries earlier—the bishop's crook is an example. There are, however, cases when the evolution of a certain object from its practical everyday function can be observed, and its transformation into a decorated, ritual object followed.

When a woman starts spinning, and the spindle is still empty, a weight in the form of a ring is placed on the spindle's end to help it twirl. This weight could be a slice of apple or potato, or a more durable ring made of stone, wood or metal. This simple gadget belongs to the class of objects connected with activities which favour their aesthetic elaboration—for spinning was a communal activity and all the objects connected with it would be seen and admired by others. The spinning-room was the recognized meeting place for young girls and young men, and all the material adjuncts of spinning, like other objects used by young **208–210** girls, the washing bats used for beating linen, for example, were suitable as decorative gifts in courtship. Spindle-rings made as presents, cast in lead in an ornamental shape or carved decoratively out of wood or stone, are known in many regions. In the region of Kalotaszeg, **192** the fashion of presenting bobbin rings became so general that by the time a girl was married, she might own more than a hundred such rings threaded on a string, which had been received on various occasions from different boys. Before her marriage she gave these away to her young male relations who were courting so that her husband would not be annoyed by the sight of them. These rings could, in fact, be put to practical use, but seldom were; they were the small change of acquaintance among young people, little gifts to encourage a closer friendship. These rings, and their change in use, demonstrate the point at which the form was freed from practical limitations to develop along purely aesthetic lines. In a few villages **193–194** boys made bobbin rings in groups of three, five or seven pieces, each in the shape of stars and flowers. This meant that the aesthetic possibilities of a single ring could be extended to include a more complex design: for instance, in the *hetesi* or "seven-part" composition, each multiple ring appears to be a flower, and in the star each individual ring is like a radiating source of light. Such a development meant that the ring had no practical use. These compositions of spindle-rings were never broken up, and the linked group was hung in the best room under the mirror. Their ritual role as a form of communication was, however, intensified. They expressed a deeper sentiment and intention than the single ring; hanging them in the main part of the room meant that the object had been presented publicly, and its public display bore this out.

The Meaning
and Function
of Beautiful Objects

One may ask why peasants spent so much time and energy in making and acquiring objects which were of no practical use in daily life. What did these carefully wrought objects, with their beautiful shapes, mean to them? To answer this question, let us consider the existence of some quasi-practical objects and their place in the lives of certain villages and families.

Such objects usually had a long life, they were carefully cherished and may well not only have outlived their makers but lasted for several further generations. Some, like spindle-rings, would be on view; others, like table-cloths, cloths to cover a coffin, and pillow-cases for special ceremonial occasions, might be stored in the bridal chest. These ceremonial occasions could be precisely defined: it was on such occasions that these objects assumed an active role, a public function in the formal activities, and it was then that they passed on their symbolic message.

In the contemporary terminology of ethnography and anthropology, such a ceremonial or festive usage is called a ritual. The word ritual is used here in a general sense, not restricted to religious-magical activities, but extended to mean every repetitive, highly formal, solemn festive action in which many performers are involved and in which the social relationships between certain persons and groups of people are expressed, established and fortified. It was characteristic of peasants that their social life was much more pervaded by ritual than life in contemporary industrial society. Single persons acquired a new status in life, formed and dissolved relationships by means of rituals, but the whole complex social system of village life, both uniting and dividing the inhabitants into larger or smaller groups, was also continually re-expressed in the actions of formal festivities and ceremonial occasions. And it was characteristic of peasant rituals that objects played a significant role and were as much a means of communication as words, gestures, movements or music. Thus, the whole range of beautiful objects which existed within a certain village can be considered as forming a kind of ritual language.

In terms of content and function, peasant rituals usually expressed relationships between people, the turning-points of human life, or situations of crisis: the choice of a mate, a wedding, a birth, a death. Though all these occasions have their religious aspects, the basic subject-matter is secular and human. One must not, however, ignore the fact that in these same villages, the Church possessed its own ceremonies, not locally generated, and complete with ready-made objects for communication with the transcendental powers.

What was the role of objects during such ceremonies? To take one example, the ornamental bed with its special bed-clothes and pillows was the most important ensemble in the peasant home in terms of value and size, but it was very rarely used in daily life, being regarded as a purely ceremonial furnishing. Its first public appearance was during the wedding ceremony, when the girl was married and her bedding, the product of many years' work by her mother and herself, was exhibited in her parents' house and then carried in a festive procession to the 491–492 house of the bridegroom, where it was again exhibited. It was then handed over to the bridegroom's family only after lengthy bargaining, half-serious, half-joking, in a formal dialogue. The procession of carrying the bedding *(ágyvitel)* was made up of young men and

women, walking in traditional order, dancing as they proceeded, and chanting out verses, some of them gaily ribald. The procession followed a long winding route so that it and the bedding could be seen by as many villagers as possible. As opposed to the church ceremony which bound the young couple together in the eyes of God, the *ágyvitel* symbolized the beginning of the couple's family life together on a secular level. Throughout the procession, the symbolic meaning of the bedding, though it would never be slept in, was unmistakable. When this same ornamental bedding was exhibited in the *parádés szoba* or best room of a house where there was a marriageable young girl, it indicated clearly that the family was prepared to allow the girl to marry. When it stood in the house of the bridegroom, it acted as a reminder of the splendid wedding rites and, as a basic contractual object, represented the solemnly sealed union of the young couple. On the other hand, within the bridegroom's house, the bed was more essentially the property of the young wife. If the new wife died young, or the marriage for some reason broke up, the wife or her family would reclaim its valuable bed furnishings. Thus, the ornamental bed, stacked high with pillows, can be considered as something like a security binding the couple until the birth and growth of children and the years spent together dissolved the possibility of the marriage breaking up.

Just as the villagers wore different clothes according to their work or the ceremony in which they were participating, so the ornamental bed itself was "dressed" with a different series of sheets, counterpanes, and pillow-cases, in keeping with the nature of the occasion. The bedding was changed according to the season, summer or winter, and the most precious pieces were only taken out for great holidays. The furnishings of the bed played various roles on the occasion of the major milestones of human life. After childbirth, until the mother had been churched, the bed was hidden behind an ornate curtain. In certain villages, the small pillow on top of the stack of pillows was taken off and put into the cradle under the head of the swaddled baby. Such occasions concerned only the most intimate circle of the family and the neighbours, but the bed was again seen by almost everybody in the village

583–585, 595, 603, 609, 620–621

when, after a death, the bed furnishings were used on the bier. The sides and the ends of the bier would be covered with perhaps five ornamentally woven or embroidered funeral sheets, on the top of which were draped kerchiefs otherwise used to decorate the wall or worn as

581

shawls. Pillows were then placed on it, either with a separate pillow-case pulled over each end of the pillow, or else with a pillow-case made originally for such a funereal purpose, with two ornamented borders, so that both sides of the bier lying in the middle of the room should be decorative. Then more counterpanes, coverlets and kerchiefs were placed over the dead body. After the funeral, when the pillows and counterpanes were replaced on the ornamental bed, mourning bed-clothes, which might be embroidered in black, dark blue, white or yellow dyed with saffron, were used for one year, or perhaps even for the rest of their lives, by the people living in the house. A case is known of a young woman who put mourning bed-clothes on her ornamental bed, for although none of her kindred had died, her house had burnt down with her belongings in it, including the bright coloured bedding she had received as her dowry, and so, though still young, she replaced these with mourning covers.

Thus, the ornamental bed was part of the furnishings of the best room, and with its changing bed-clothes, accompanied the life of the house. In the great, symbolic moments of its life, it represented on an abstract, ceremonial level the everyday bed in which a man and his wife slept, in which all people lay and took their rest.

These examples indicate the way to interpret the meaning of ornamental objects in the lives of the people using them. Ornamental objects were, however, only elements in the rituals. They were accompanied by ceremonial acts and gestures, by the reciting of formal texts, and by songs. In the jocular, but still ritual, dialogue between the bridegroom and best man, the bed and its furnishings were constantly referred to. Similarly, the counterpanes and the

pillow-cases would recall the songs sung as the bedding was carried through the village, and

the rhymes of the best man telling of the roots of marriage in the Garden of Eden, of the Tree of Knowledge and of the origins of Death, a subject not inappropriate, since the same bed would also serve as a bier.

This is why, as a general rule, the decoration of the objects themselves had less symbolic value; in the great moments of their use, speech and song spoke for them. Yet the theory that the greater the variety of channels and media employed to communicate a message, the more likely it is to reach its destination, remains true in folk art, in which the decoration on objects would, on occasion, impart a message and have a symbolic meaning. The Tree of Knowledge, mentioned by the best man during the wedding feast, may sometimes be seen embroidered on ornate sheets. On the mangling board or on the mirror frame made by the young man as a token of love before marriage, the figures of the girl and the boy might be seen dancing together, or the girl giving a flower to the young man of her choice. On rare occasions the bridal chest might also have painted on it the figures of a bride and her groom holding hands.

589
330, 334
339, 301

Another channel of communication was opened when an inscription was added to the object. On the washing bat to be seen in Illustration 209 the maker worked the letters of the inscription almost like a puzzle: "Ajandikba zsinálta Kis Marton" ("Made by Marton Kis as a Present"), and on the other side in tiny letters: "1838 Pintek Kati." (In Hungary the practice is to put the family name first, so the present was for a girl called Kati Pintek.) Other young men expressed their sentiments less laconically: "Kalára Birtalan, I give it to you", was written on the top of a stretcher for a loom made in 1831 by a young man in the Kalotaszeg region; on the back of the same stretcher the following text was hidden: "I am robbed of her who could make me merry; I see that which is good the reward of another." Half the surface of the brandy flasks used when men were making merry was sometimes covered with writing as the main decoration, the words being a friendly toast. Mihály Rajczy for instance, the fine potter of Mezőcsát, wrote such inscriptions on his flasks, one of which is illustrated here: "He who drinks out of this, let it be to his health, Blessing, Peace, Let us drink up, my friend, let this be emptied." That was the style of the 1840s. A few decades later an inscription on a bottle from Mezőcsát ran as follows: "Oh dear little vessel / container of my hopes / should my heart fill with sorrow, / let me drink from you." (Illustration 434.) The inscription occasionally gives terse expression to a feeling which can only be guessed at in a later period. For instance, perhaps the joy of a woman in her own hand-woven objects that decorated her home is revealed in the woven inscription of a cloth: "Julis Vég rejoices in her home."

209
441
434

When trying to discover what the objects of folk art meant for their original peasant users, the fact that they were only elements in ritual actions must be remembered. Sense and meaning were expressed by the distinctive order in which objects, gestures and words were united in a complex whole. The meaning must therefore be deduced from various media of expression, remembering that for the participants in the ritual action the whole context was familiar, and brief allusions sufficed for them. Nonetheless, there could be more than one meaning, and a single ritual, and the group of decorated objects connected with it, could express a number of things simultaneously. This semantic richness is especially characteristic of the decorated objects connected with the most important rituals where a number of people were involved: those used at a wedding, for example.

In the case of the dowry and the ornamental bed, the basic significance—the union of the bridegroom and the bride—carried a number of connotations. The symbolic bed suggested the physical union and the prospect of children, and the objects made reference, besides, to social dimensions and property rights and to the moral and religious aspects of marriage. This last meaning is expressed by the figures of Adam and Eve on a bedcover, by the patron saints on the headboard, or the stylized figures on the carved bridal chest which are interpreted as Love, Hope and Charity, or, alternatively, the representation of the figures of the Holy Family.

A wedding means many new relationships among persons other than the bride and groom and between families. All the relatives of both partners in the marriage will henceforth regard each other as interrelated. These new relationships are confirmed by drinking and dancing together and by the exchange of presents. In Tura, the bride used to embroider several dozen elaborate handkerchiefs for her new relatives before the wedding, as well as for those officiating at the wedding ceremonies who would be chosen from both families. On these handkerchiefs the embroidery indicated the type of relationship established through the marriage. On the handkerchief embroidered for the parents-in-law, for example, the colour of the yarn was restricted to blue; on the handkerchief given to the young men chosen as ushers a couple of gaily coloured birds would be embroidered. In certain villages articles of clothing were carried in a ceremonial procession between the houses of the bridegroom and the bride to be given to various members of both families, or even to close relatives who were no longer members of the immediate family. The gift was of greater or lesser value according to the closeness of the relationship. The connection of the bridegroom and bride to his or her own blood relatives was also strengthened by the wedding. In many Hungarian villages, if someone was asked whether he was related to someone else, he might answer by saying that they generally visited each other for a wedding or a funeral. While each of the generations of a family slipped further and further apart, such festive gatherings strengthened and united them, or, through absence, ended the active relationship based on a common progenitor. A wedding or funeral was an occasion for the re-examination and adjustment of the existing system of relationships, and also provided an opportunity to put an open and public end to minor or major quarrels, or to terminate a relationship in public.

These relationships, which in daily life were expressed only in casual meetings, the manner of saying good morning or addressing one another, were, on the occasion of a wedding, expressed in the sight of all within the whole system of inter-relationships in the house where the marriage took place. The seating order at the wedding table, for instance, classified the guests in order of rank, sometimes several hundred of them. All this had a financial and material aspect; nobody came to the wedding-house without a suitable gift, and everyone who brought a gift could certainly be sure of a reciprocal gift on a similar occasion.

Apart from the reinforcement of the relationships between single persons and families, the festivities denote a certain connection between all those present who had made merry and had eaten and drunk together. This connection was sometimes expressed by decorated objects. In some districts, for instance, every invited guest was given a woven handkerchief as a present, which both men and women tucked into their waistbands as signs of being participants in the wedding festivities. The "mourning handkerchief", presented by the bereaved's family at the funeral in the southern Danube region and worn by all members of the family had a similar significance in a very different context.

Behind all these gestures and the presentation of gifts to strengthen relationships was the assumption that all those taking part, including those who were not present but who were sent a package of wedding food, or who formed a group of sympathetic onlookers at the wedding procession, belonged together. They were all bound indissolubly by many kinds of ties over many generations. All of them shared the same values and had the same view of the world. At such a ceremonial level, they were all equal, all peasants together, all full of goodwill towards one another. This of course was an idealized state of affairs; rituals as a general rule express the ideal relationship between persons and groups and present a model which is often in contradiction to the realities of everyday life.

But ritual occasions—as well as the beautiful objects associated with them—have the power to express the contradictions and the conflicts of village life as well. There were, for instance, profound differences in wealth and consequently in the ways of life which sharply divided rural society in the vital period of folk art in the nineteenth century. Every young

girl, whether the daughter of a farm labourer or of a wealthy farmer, received an ornamental bed in her dowry, but the number of pillows she received (six, eight, nine, or eleven) and the number of pillow-cases for each of those pillows, was an exact expression of differences in rank and wealth. In the same way, the girls' costumes would in general follow the same design but they would be made out of cheaper or more expensive material, with only one row of gold lace or perhaps as many as four. Many bitter privations of the poor were hidden in desperate attempts to match the prodigality of the well-to-do. These differences grew to such a degree that as the extravagance of beautiful objects increased and the disparity between rich and poor became more and more obvious, a singular way of "avoiding the ritual" developed in precisely those regions in which folk art had flourished most. In the district of Kalotaszeg, for instance, where poor families with many daughters could not provide each with a suitable dowry, the "abduction" of the bride was arranged, after which the girl was married without her bed and bed-clothing having been carried through the village. The "abduction" of the bride, who was taken to the house of the bridegroom without a wedding feast and married quite simply, without a wreath on her head, naturally meant that the family lost face in the village, whereas a big wedding with the procession of the bride's trousseau and bedding, and the exhibition of the dowry meant an increase in prestige. Yet the very fact that this custom of "abduction" developed is a negative proof that the principles underlying the wedding ceremonies were valid.

The wife of a well-to-do farmer invited to be a godmother either by relatives with more or less the same social standing as herself, or by labourers or herdsmen dependent on her, would in each case give her goddaughter a dress as a present, but in the case of the relative the garment would be of cashmere, whereas in the case of the poor godchild it would be of cheap cotton. Even if the godmother could have afforded to buy the more expensive material for the poorer child, she would not have done so, for it would have offended her relatives. In such a situation, not only the donor's prestige and status were expressed in the gift, but also her social relationship to the recipient.

Here we arrive at a new level of the expressiveness of the objects of folk art. The form and quality of the gift expressed attitudes in a variety of ways, revealing either the depth or superficiality of the sentiments behind the formal gesture. For instance, the ankle-length ribbons with which the young men decorated their hats when they were recruited as soldiers were given to them by members of the family, close relations, godparents, and friends, and together revealed the whole array of relationships surrounding the new recruit. The colour of the ribbons could be freely chosen. If there had been a recent death in a young man's family, only black, purple, or dark blue ribbons were given to him. Where the obligation to buy a ribbon was accepted unwillingly, the colour was yellow. Hungarian peasants did not favour yellow; although the colour was not so offensive that it could not be worn, it was nonetheless a clear indication that the feelings of a young girl for a young man were no more than formal.

Many other examples could be cited to show how objects with a symbolic meaning provided various opportunities of expression for the peasants. One and the same object could play a different role in different situations: the same black veil covering the bonnet on the newly married young woman's head when she was churched could later become her shroud; the shirt a man wore on his wedding-day might later cover him in his coffin. The richly ornamental bedding also served as a bier, and its various furnishings, arranged differently, served respectively as decorations for different holidays and occasions. The possibilities of these various roles gave the objects a wealth of associative meanings. Such symbols were necessary in a society where the spoken and written word was employed as a means of expression far less than among modern town-dwellers. It was a society where no mourning-cards were printed, no letters of sympathy written, no telegrams of congratulation sent at

weddings, and where instead of a written contract, a formal shaking of hands and the mutual drinking of a toast bound people together.

Peasants used the expressive language of objects not only on great festive occasions, but also in the course of everyday life, as signs. Questions and answers were expressed through objects and through the particular way objects were arranged. At the time of courtship, for example, there were countless ways for the mutual discovery of intentions through the use of objects. Before the dancing at carnival time, girls sent a smaller or larger bunch of artificial flowers to the boys they favoured. A small bunch of flowers meant a willingness to dance with a boy, several bouquets on the boy's hat showed he had accepted the offers, and the sequence in which they were placed showed how he ranked his choices. However, a large bouquet of flowers placed by itself on the boy's hat meant a more serious attachment tending towards an engagement. Before proposing to the girl, the young man would try to find out by various acts whether the girl's parents would accept him. On making his evening visit he would leave his *cifraszűr* (embroidered frieze coat), as if by accident, at their house. If early the next morning he found the coat out on the porch, it meant he had been rejected. After the engagement, in some places the young man would wear in his waistcoat pocket a new handkerchief embroidered by his fiancée and he would receive a new one every week. Elsewhere he might wear the elaborately worked handkerchief stuck in his belt. In some districts he would use a decorative ribbon given by his fiancée to tie his apron, or to tie a bouquet on to his hat upside down. The girl, for her part, would reverse the bouquet of flowers which she had been wearing on her breast upside down, so that it was now the right way up. Traditionally a ring was worn only by a girl engaged to be married, though occasionally several rings were worn. An engaged young girl, *elgyűrűzött* or "with rings on her fingers", might have rings made of gold or silver for special occasions, but also cheap ones called *tehénkihajtó* suitable for "letting the cows out". (It was the duty of young girls to let the cows out to the cowherd early in the morning, and these simple rings told other girls of their engagement.)

Peasants were able to give subtle expression to their feelings through objects not only in situations for which they were, so to speak, designed, but in extraordinary and quite specific circumstances as well. A woman who had lost her husband and children wove a tablecloth for her own funeral, leaving out even the minimum of decoration. The tablecloth was simply in bands of white and saffron-dyed yellow. There was no other tablecloth as plain as this in the village, yet everyone present at the funeral understood that its unusual simplicity meant that the dead woman had mourned her lost family through the object meant for her own death. Another woman looking out of her window at dawn saw, tied to her single beloved rose-bush, the handkerchief of her husband, who worked in the city but found the unaccustomed labour hard to bear. This signal told her at once what words could not tell, that her husband had returned but for some grievous reason could not talk to her. Running outside, she found his body hanging in the stable where he had committed suicide.

What, then, was the significance for the peasant of ceremonial objects in situations removed from their original daily use? The production and maintenance of such a store of objects meant a great deal of hard work and sacrifice. The saying "gay dress, empty belly" was used in many villages where for the sake of these ceremonial objects everyday necessities were often sacrificed, and peasants even denied themselves food in order to possess objects which would increase their prestige. In this rivalry for objects accepted as beautiful by the community as a whole, few had anything to gain. But for those who could not compete in this rivalry, it meant bitterness and disgrace, the sense of being left behind.

Yet we can be sure that Julis Vég, like other women who dressed up their homes themselves, really rejoiced in her home decorated with her beautifully woven textiles. Old women of Mezőkövesd speak of the time when coloured pottery was in fashion and they loved their beautiful crockery: "It was like a passion, this love for beautiful plates. Going to the market we

felt we had to walk past the pottery sellers twice. If the pattern pleased us, we longed for it . . . we simply had to buy it, we could not leave it there." Little girls of five to eight years old minding the geese went to glean in the fields, and with the ears of wheat thus acquired ran to the potter in the market to trade them for patterned plates. The fact that peasant women are able to name the colour and the decoration of crockery they used forty or fifty years earlier but which has long since broken shows how important its beauty was for them.

The ritual festivals and ceremonies in which these ornamental objects came into their own also provided autoaesthetic satisfaction to those participating in them. Since these rituals provided a pattern and translated into ceremonial form the behavioural patterns suited to the more important events of life, they made the emotional, social and other burdens of such situations easier to bear. Traditional behaviour on festive occasions and the presence of ornamental objects gave reassurance to those socially involved.

The important role of objects in these peasant rituals had a stabilizing effect. Valuable, durable objects provided a visible and tangible structure, a form of permanence for the passing gestures, melodies and words, binding, conserving and passing them on to future generations. The system of beautifully shaped objects served as a reminder for each person, and for the entire community, of the proper way for country people to live. A beautifully furnished peasant house, with every object in its exact place, each having its appointed role in weddings or funerals or births, or in the hospitable entertainment of relatives at a pig-killing, together with the ornamental tools used in co-operative labour by members of the family at the various seasons of the year, all helped to regulate the activities of the people who lived among these objects, and to stabilize their view of the world and themselves. At religious services, all the inhabitants of the village appeared in church dressed in their Sunday best according to their age, sex, family circumstances, their rank and wealth, their position in the church or village community. What they wore and where they sat defined in meticulous detail everything of social concern, down to the fact that this or that young girl was being courted. It was like a great living chart showing the whole complicated inner structure and unity of rural society. Concurrently, it reinforced the order and unity of that society.

The significance of these rituals and of the beautifully shaped objects, became even clearer as the social structure began to disintegrate. Local costumes expressing the nature of occasions and distinct nuances of rank and role were discarded and replaced by simple clothing denoting the average "country person". This sometimes happened quite suddenly, when, in one of the larger villages where the previous Easter the majority of peasants were still dressed in the traditional summer costume, suddenly not a single girl or young woman appeared in such clothes. The process continued and the young girls who had formerly stood round the altar in their special costumes with ribbons in their hair, and the young married women who had stood in the aisles wearing their specially colourful garments, now mingled on the benches indistinguishable one from the other. Festive costumes demand a stiff, erect gait and controlled movements and these disappeared with the rejection of such costumes. In economic and sociological terms, the people remained the same; they continued to pay their taxes, they lived on the same land and carried their produce to market as before. Yet the change was like the end of a stage performance when the lights are switched off.

This raises an important question: how authentic was the performance in which the simple villagers were engaged with the stage props of their former folk art? What connection was there between the exalted level of ceremonial occasions, with their adjuncts of beautiful objects, and the reality of village life and rural conditions? Between a harmonious, balanced world, the unrivalled purity of folk-song, the serenity of popular art and the ceremonial assurance of ritual gesture on the one hand, and the record of disease and high infant mortality, the tragic fate of emigrants, and chronic poverty, on the other.

In the days when the peasant form of life was in a state of transition, villages where tradi- 19

tional costumes were still worn and traditional customs were still observed could be found side by side with villages where these customs had been entirely abandoned. From an economic and sociological point of view they were both peasant villages, but while the former still had a specific peasant culture, the latter did not. Can one say which is better? The force of economic and sociological pressures is historically significant in leading to the disintegration of the elaborate forms of rural life. Those who abandoned traditional costume had crossed a threshold which the people of the other villages would have to cross in their turn. They realized the consequences of the contradiction between the ceremonial world of beautiful objects and the growing realities of the new way of life.

In the earlier creative periods of folk art these contradictions had not yet resulted in stress and the peasant way of life seemed necessary and natural. The traditional customs and the costly ornamental objects, however, did not please everybody. From their position of moral superiority, the representatives of Church and State and rationalizing reformers filled with the best intentions, criticized wedding celebrations that lasted three or even five days when the participants were so poor and wretched. They could not understand why the peasants used to organize a great ceremonial meal in honour of their dead instead of buying modern tools and feeding and clothing their children. Sámuel Tessedik, who devoted his whole life to the improvement of rural conditions, wrote in 1784 that he felt like breaking up any wedding party that lasted longer than a day with armed bailiffs. He wanted a royal decree forbidding the ritual lamentation for the dead, and was angry that even the poorest peasants were capable of sacrificing the price of an ox for wedding gifts or for their daughter's dowry. The reformers of the period of the Enlightenment, full of goodwill towards the common people, were also troubled by the fact that the social conditions of the peasants and their folk art somehow did not harmonize. Today, however, we feel that these unselfish and noble-minded reformers, in their rather eager impatience, irritatingly lacked an understanding of the peasants as human beings. On the other hand, there were the romantic enthusiasts who also lacked this understanding; they saw village and country life through rose-coloured spectacles, from the outside, idyllically, and undoubtedly with a sense of superiority.

For the ethnographer attempting to gain an understanding of the peasant world from the inside, from the point of view of the peasants themselves, there was, however, no contradiction between the two aspects of peasant life, between the daily struggle and misery and the beauty of festive and ceremonial occasions. Holiday rites presented the world as it should be; the songs, gestures, customs and beautiful objects were like incantations designed to temper unrelenting reality. An awareness of the efforts made in order to acquire these beautiful objects will give a greater depth to the "message" of beauty and art if we relegate the hardships and monotony of everyday life to the background. It helps us to understand that folk art must not be regarded as the excess of a certain kind of well-being, nor as an aimless tendency to decorate, but as the determined effort of hard-working people to give a fine framework to their difficult life with elaborate gestures, texts and objects. Regarding the process as we do from a historical distance, when neither the activities of benevolent reformers, nor the Utopian plans of romantic enthusiasts for preserving old customs and objects are any longer relevant, we are in a better position to produce an unprejudiced opinion, based on the perception of the artefacts of folk art, about the elaborate ideas of the peasant on what it meant to lead a beautiful and harmonious existence.

The fine, ornamental objects were often still in existence when a peasant community was about to abandon its former customs and change its style of dress. The fate of these objects then became more than doubtful. The peasants were well aware of the fact that the objects represented the life and values they had just rejected. Their actions were quite logical; the old houses still in perfect condition, still good for generations, were destroyed, and new houses were built in the urban style, devoid of any local characteristics, but which gave them

prestige in the new scale of values. The old crockery was very often not only rejected, it was deliberately broken. A well-balanced transition was very rare; for example, in newly built two-level houses with large windows and with bathrooms, there was still a room arranged with painted peasant furniture and a bed stacked high with pillows as a reminder of former conditions.

The objects thus remaining were wrenched from their original context of ceremonial customs and rituals. The unity which formerly bound objects, songs, gestures, knowledge and moral principles disintegrated, and the various elements continued to exist only in isolation. With a little alteration, the pillow of the ornamental bed became a cushion on the sofa of the room arranged in the urban manner; yet this was strikingly different from its former role, when it was a definite part of the highly stacked bed, when the ceremonial wedding songs were sung in its presence and the jovial marriage rhymes referred to it again and again. It had its function on the bier, and it was decided beforehand who would inherit it. Under the new conditions, the objects of folk art became ornamental objects in the urban, middle-class sense. In this late period of their existence one could be forgiven for thinking that their function in earlier days had been the same, that they were simply peasant "arts and crafts", the tangible results of a peasant instinct for decoration, the pleasant fruits of winter leisure.

The Making
and Acquisition
of Objects
of Folk Art

Folk art was rediscovered by city dwellers who as members of an industrial society had become more and more consumers of mass-produced machine-made objects. For them the fact that the objects of folk art were hand-made, often by the same people who used them, acquired a romantic significance. The discoverers were enthusiastic amateurs, artists, connoisseurs, and only later scholars, influenced as they had been since the Renaissance by the aesthetic traditions of European "high art". Such traditions look, above all, for the expression of an artist's personality in his work. Folk-songs and beautiful rural objects, however, were not characterized by the desire for personal expression and did not conceal sad tales of harassed artists misunderstood by the world around them. The first discoverers of folk art thought of the creative communities which produced it as centres of idyllic harmony; and in the final analysis there emerged the idea that the copyright owners of the material objects of the peasantry were "the People", a word with a number of meanings interpreted differently at different periods in history. The Hungarian word for folk art—*népművészet*—is a compound of *nép* meaning people, in the sense of members of one nation, and *művészet* meaning art, but the word *nép* can be interpreted as the creators and makers of this art. Understandably, it was precisely around the problem of the creator and the creative processes that most of the confusion arose, and this formed an obstacle to an unbiased view of peasant art. At times, the nationalistic-moralistic-ideological conception of "the People" elevated the creations of folk art to a timeless, impersonal level. At other times the very same objects were judged by the aesthetic standards of "high art" and deemed, precisely on account of their anonymity and impersonality, to be the products of some inferior art which was no more than a small tributary of the stream of "high art".

However, scholarly investigations of peasant families and specific objects have demonstrated with certainty that the personality of individual peasants with varying degrees of ability and talent could be discerned in the creation and decoration of these objects. Nor was pride of authorship lacking. As many inscriptions prove, the peasants liked to mark an object with information about its maker and the date. Nor is there any lack of influential innovators

323, 330, 335, who gave new directions to whole genres of folk art. Zsiga Király, for instance, introduced
440–441, 459, 463 the art of creating figures with sealing-wax inlay, and Mihály Rajczy created new decorative motifs used ever since by the potters of Mezőcsát. The investigations also showed a highly differentiated division of labour in the production of objects for peasant use. Even if a peasant family was able to make most of its own simple articles for everyday use, the more ceremonial objects, made with great care, were the work of specialists from the village, craftsmen and artisans, and involved the use of manufactured objects. Factors such as the place where the objects of folk art were actually made, in what cottages, workshops, etc., and by whom, and the complex trade in these objects must therefore all be considered, for a brief survey of this network will reveal how folk art was integrated into the cultural and economic system of the country.

The question may also be approached from another angle. When and why does the demand
arise in certain peasant families for objects of no practical use in daily life, which are either

made at home or acquired through no small sacrifice? In other words: how and according to what conventions and schedule did the peasants construct their material environment, the majority, and the most costly of which were often the elaborate objects possessing a "ritual" function?

Everyday objects got broken, or wore out, or were thrown away, and new ones were continually being made, bought and used in their stead, while the things which wore out or became defective were relegated to subsidiary uses. In the case of decorative ceremonial objects, the mechanics of wear and tear and renewal did not function in the same way. Decoratively embroidered, elaborate bed-clothes and pillow-cases which were only used on special occasions did not of course deteriorate. There were certain things which by their nature were destined to be short-lived, such as the wedding cake cut into slices during the wedding ceremony, or honey-cake, or the flowers at the top of the maypoles which withered, **489–490** sprigs of rosemary, bunches of flowers. Other objects, after their role in the ceremony had been fulfilled, were kept as mementoes: the bridal wreath, for instance, was framed after the wedding, together with a photograph of the ceremony and the girl's long braid of hair, and hung on the wall among the family portraits.

There were certain decorative ceremonial objects which traditionally ended up in a different ceremonial role. In Mezőkövesd a man's shroud was made from the loose sleeves of **487** the shirt embroidered with white Madeira work that he had worn as a bridegroom. And if a girl or a woman died young, her best clothes, perhaps several sets of them, followed her into the grave. In the wealthy society of the villages of the Sárköz, where birth control has been practised for a long time, if the only daughter died young, a vault was built where dozens of her garments were hung beside her coffin. The embroidered sleeves of a woman's shift might be turned into a coverlet for the cradle of her child and the decorative textile inlay of the counterpane might also be used for a cradle cover or for the burial dress of a child. The history of such ceremonial objects, therefore, might end with some later significant turning-point in human life.

Their creation and acquisition was also bound up with some great or festive occasion in the life of an individual or his family. In the first place, there were the objects used for decorating the home: woven or embroidered bed-clothes, tablecloths, or wall hangings. These kinds of objects were all, or almost all, made within the family by the women of the house. The preparation of these ceremonial objects was therefore done according to a family division of labour, first the basic spinning and weaving, then the preparation of textiles for daily use, sacks and bags, bed-linen, bed-clothes, table-linen, and underclothes.

This activity of the women, which was their continuous occupation during the winter months, was interspersed with the preparation of the decorative pieces of the dowry when there was a marriageable girl in the house. The dowry, although also containing plain pieces, was primarily made up of decorative linen for festive and ceremonial occasions. The tablecloths were a case in point. In addition to those for everyday use, there was the Sunday tablecloth, another made especially for the wedding ceremony, and two for use exclusively at funerals to cover the table in front of the priest, a red one should the deceased be young, a black one if old. The dowry also included coverings for food presented on various ritual occasions, and above all, the decorative bed-clothes with the bed-covers and various pillow-cases. All in all, the dowry often consisted of two or three hundred pieces, excluding the girl's own clothes.

In regions where weaving and embroidery were highly developed, as in the villages of the Kalotaszeg region, mothers began to prepare the dowry when their daughters were about eight or ten years old. In southern Hungary, as soon as a girl was born, her grandmother began to embroider the sleeves of shifts in various patterns, devoting herself almost exclusively to this work, so that by the time the numerous shifts were completed, the embroidered **23**

sleeves were ready. In Kalotaszeg the preparation of the dowry took about ten years and began with the rough, ordinary clothes for household wear, gradually continuing with the more decorative kinds of linen.

Such a scheme involved at the same time the instruction of the girl in the art of sewing and embroidery, the work becoming more intricate as the years passed, the mother becoming increasingly deft in the art of weaving, and her daughter increasingly skilled in the art of sewing and embroidery. For the most important pieces, the assistance of woman relatives or of some especially skilled woman in the village might be sought. The bride-to-be worked for years on the shirts to be worn on special occasions by her prospective bridegroom, although these shirts were of course added to the prepared sleeves only when the engagement had taken place and the bridegroom's measurements were known. The weaving of the cloth which later hung on a rod along the two walls of the room where the young couple would live, might also be left until after the engagement, when the length of the walls in the bridegroom's house could be measured.

In the village as a whole, the homes with marriageable daughters would be occupied over many years with the preparation of decorative objects, with weaving and embroidering. In other homes in the same village, the shuttle was only used to prepare as much linen as was absolutely necessary for daily wear and household use. If a woman had only sons, she would not weave a single decorative tablecloth in her life, nor embroider a counterpane. Her husband, however, would drive himself for years to build a house for each of his sons, and to have land to give them when they became independent.

These facts indicate the different lines of descent of the decorative objects passing from generation to generation. The dowry, the textiles adorning the home and many of the women's garments, as well as certain pieces of furniture and pottery, were passed from mother to daughter, and this maternal line was not broken, since they also passed later to the granddaughters. Nor was this true only for the newly made or bought pieces of the dowry. In the Kalotaszeg villages, for instance, although fashions altered, the pieces of earlier times were not despised; on the contrary, it added to the rank and prestige of old families when the daughter occasionally put on a carefully preserved garment inherited from her grandmother or great-grandmother, which had been stored but never washed. From these villages, garments are known with the name of the owner embroidered on them, the oldest with a date from the eighteenth century. A dowry, therefore, might be made up of the handiwork of several generations. During the whole of her lifetime, a woman would be clothed in garments she received from her mother's house. If the mother was unable to give her daughter all the garments due to her, and if, for instance, a fur-lined coat or a sheepskin jacket was still missing, it could be added later, and the mother could also later help her daughter in providing clothes for her own children. As opposed to this inheritance through the female line, the house and all that belonged to it, the furniture and the farming implements, were inherited through the male line. Up to the last century, when new laws altered the legal customs of the peasants, the daughters inherited none of this property; their inheritance was their dowry. The basis of social prestige, the land, the farm, the stock of animals consequently belonged to the man, while the beautiful objects, the soft furnishing and the women's clothing, designed for display, belonged to the women, and the quality and quantity depended on the woman's diligence and the wealth of her family.

Following the history of elaborate objects from one family to the next, from one home to another, minor features characteristic of peasant society at large emerge. The connection, for instance, between godchildren and their godparents becomes clear. These were usually symmetrical relationships between two families, where each was godparent to the children of the other family. The gift of a beautiful object was made on every special occasion in the life of the godchild. It was the godmother who gave the child its best dress, called *korozsma*,

suitable new clothes for both boys and girls for their confirmation, and when a girl was married, her first "woman's" dress, into which she changed during the wedding festivities, after her wreath had been put aside for the night-long dancing. In many parts of the country, the wreath and the veil were also the gift of the godmother.

The custom of presenting gifts was less frequent in other types of relationships. In the Kalotaszeg villages girls of the same age-group went to the *sirató* ("wailing") or good-bye party of their girl-friend the evening before her wedding, when the bride bade farewell to her maidenhood, and on this occasion, every girl presented a couple of jugs, or a pair of cups or mugs. It was also customary in these villages for the blood-relatives of the bride to bring a present of food in a basket decorated with a tree of life called *termőág* ("yielding bough") in which a gift of clothing was also included. The collection of gifts in connection with the wedding was general, and relatives, neighbours and friends took part. The concept behind all this present-giving was that the foundation of a new family, even if the young couple remained in the household and farm of the parents, required the collection of new possessions, a whole set of new decorative objects.

Besides the collection of the textiles which formed the dowry of a young girl, her family also had to make sure that her bridal chest was ready well in advance of her marriage. As it was prepared, each piece of the dowry was folded and placed in the chest. The name of the bride is painted on the oldest bridal chests that have survived, dating from the eighteenth century, just as on the bridal chests in the houses of great nobles the name, the monogram or the coat of arms of the family used to adorn the chest. On some chests two names appear, that of mother and daughter, and two dates, showing that the chest was used by two generations. The bridal chest was also carried in the procession which took the ceremonial bedding from the house of the bride to the bridegroom's courtyard. In many villages the mirror was also carried in this procession, but other pieces of furniture were not so conspicuously connected with the wedding ceremony. The name of husband and wife, often with the wedding date, might also appear on other furniture, on painted corner benches, plate racks, shelves, wall cupboards, together with the year the furniture was made, which was usually placed not far from the wedding date.

263–265

On the open-work benches from northern Hungary, the decoration often included the figures of hussars. Many of these benches carry the date when a young man's military service ended, and perhaps an inscription: "A Wretched Hunter Has Been Given His Discharge Poor István Warga." These benches were also connected with marriage. The compulsory military service introduced in the second half of the last century was regarded in village custom as one of the milestones in a young man's life. Before his military service, the boy could behave as unmarried boys are expected to behave; after his return from service, he was obliged to prepare himself for marriage.

278–279
287–290

The acquisition of decorative pottery for great occasions was also part of the preparations for the wedding celebrations. Though the dowry of the bride contained decorative dishes to hang on the wall, in many regions of the country the main anxiety before the wedding concerned the provision of tableware with which to lay the table for the wedding feast, as the number of the guests and the ceremonial character of the occasion took precedence over all other considerations of hospitality. In Mezőkövesd, as soon as a child was born, the mother began collecting decorative plates and dishes, and by the time the child was about fourteen years old, she had already bought the great pots for cooking the wedding broth. If a woman had no child, then no crockery was bought: "Why buy for the street?" such a woman would say (i.e. in order to lend to others for their weddings). In the district of Magyarszombatfa, the family often ordered from the potter a whole kiln full of pottery for the wedding. This would comprise about a hundred plates, about thirty soup bowls, the same number of dishes for meat, five or six great cooking pots, twelve wine jugs, some small

bowls for horse-radish or sauces, salt-cellars, and pans for baking cakes or roasting meat. Special dishes were also made as wedding gifts, often with the name of husband and wife on them.

The two brandy flasks shown in Illustration 416 representing a peasant couple were made as a wedding present; the money-box in Illustration 420 in the shape of a bride with her wreath was used to collect money for the young couple during the "bride's dance" on the night of the wedding party.

The preparation of the dowry and other acquisitions connected with the wedding reveal how the peasant world of objects was renewed in each generation. The objects owned by the young people always represented new fashions and new tastes. If they were to live separately in their own home their youthful taste would be reflected in their new house. However, if the young people were to remain within the household of their parents, custom varied from one region of the country to another as to the extent to which their belongings were displayed in the common home. In regions where traditions were strict, where the "old master" exerted his authority and his wife "held the ladle in her hand" in the running of the household, the ceremonial bed of the mother-in-law stood in the best room, *her* plates and textiles hung on the wall, *her* tablecloth was spread on the table. The young wife could follow the tastes of her own generation and change the pots used for cooking and the table dishes and dinner plates only when she took over the household. Her husband could only consider acquiring a carriage and harness of his own choice or new kinds of farming equipment when he inherited the farm. In the villages of Kalotaszeg, however, directly after the marriage, if the young couple had no home of their own to go to, there would be changes in the house. The mirror belonging to the mother-in-law would be taken off the wall together with her decorative plates and other belongings, and those of the new wife hung in their stead. The decorative bed-clothes were changed, a new tablecloth was spread on the table, and the young wife's bridal chest was given pride of place in the main room. The new wife, however, did not put the newest, most up-to-date bed-clothes that had been made specifically for her on the bed for everyday use but used those which had belonged to her own mother and which reflected therefore the taste of a former generation. The newest pieces of her dowry were carefully preserved and only used on special occasions, and these in turn would be taken into daily use by her daughter a generation later.

The renewal of this world of objects in each generation was therefore due to customs which ensured the continuous replacement of the old-style objects by newer ones, and thus allowed for changes in taste.

The wedding and the display of the dowry also merit a few words. In contrast to other ceremonial occasions, when only those ornamental objects with a relevant significance were used, at the time of the wedding the complete collection of ceremonial and festive objects designed for a whole lifetime were displayed before the entire village community. The concept of the world of objects, and its reality in rural surroundings, could be seen on this occasion: it was not simply an accumulation of pleasing and valuable things; it also indicated the structure of a system of objects.

If we consider all the effort that went into preparing and acquiring these objects in the course of one human life, the amount of energy concentrated on organizing the grand display of the dowry becomes evident. In certain parts of the country, only a funeral could be compared to a wedding in this respect. A death once again opened the house to the whole community, and again a great accumulation of textiles were displayed, this time on the bier in the house clothed in mourning. Some of these pieces had formed part of the dowry, and others were made subsequently by the woman specifically for this occasion. Among the illustrations in this book are details of two funeral sheets embroidered in black. In the village in the centre of Transylvania where they originated, women worked on their embroidery secretly,

behind closed doors, so that when the time came for a bier to be set up in their own house, the coverings should be a surprise, even to close relatives and neighbours.

The planning and execution of these groups of objects taken as a whole meant great sacrifices both in work and money. In the very large dowries from Kalotaszentkirály (Sâncraiu, Rumania) the amount of material used for both rough and finer purposes, for decorative and plain clothes, amounted to some five hundred metres. Even if part of it had already been prepared by forebears and relatives, nonetheless the burden of growing the hemp and spinning and weaving it weighed heavily on the women. A report from the same region from the beginning of the century mentions that during harvest time, the young girls, despite their fatigue, made use of every minute of their work break to labour at their embroidery. Half of these hundreds of metres of material were partly or completely woven out of cotton, which had to be bought. Where no geese were raised, the eiderdown for the ceremonial bed had to be bought as well, and this would cost the equivalent of the price of a young bullock or a pig of four hundredweight. The wreaths made of beads, the special head-dress decorated with beads which was due to a girl after confirmation, and which was a compulsory part of the dowry of all marriageable girls, together with the sheepskin vest embroidered with silk, cost the price of a two-year-old calf. The peasants used to say in these villages that "with every girl the house burns down". All this applies to the period at the beginning of the century which saw the greatest extravagance and display of folk art. The very precise inventory and budget, however, which Le Play, the French sociologist, published in 1846 of the household of an average Hungarian peasant family from the Great Plain demonstrated that, although the housewife worked one hundred and thirteen days yearly on linen-work, she was only able to supply a quarter of the necessary clothing and had to buy the rest, which meant that 38 per cent of the family income was spent on clothing.

Who were the artisans who worked for peasant communities and in whose workshops the objects of folk art were made? The answer varies according to various periods of folk art, the different trades, and even more according to the different regions of the country. The joiners who painted the ceiling panels and furniture of rural churches in the seventeenth and eighteenth centuries were members of town guilds—panels painted by members of the guilds of Kolozsvár (Cluj-Napoca, Rumania) and Miskolc are illustrated here—and they often **38** signed their name in Latin and worked not only on rural commissions but also for the towns **30–37** and for the nobility. The documents of the Joiners' Guild of Győr dating from the Turkish occupation in the seventeenth century show that foreign journeymen came to the local workshops from as far afield as Copenhagen, Strasbourg and Basle, demonstrating how much these workshops were part of an international network. It was quite the contrary in the case of the tailors of the frieze coats or *szűr* of Debrecen, who in 1815 sent a petition to the king begging him to cancel the decree obliging their apprentices and journeymen to travel. They claimed that nothing useful could be learned in other regions, that nowhere were Debrecen style frieze coats made as well as in Debrecen.

In the finest period of Hungarian folk art, it was precisely such rural workshops, such artisans working in villages and country towns, potters, furriers, tailors of frieze coats, shoemakers, weavers, joiners making the tulip-painted chests, who were of special importance. Not only those who gave them their commissions and bought their products belonged to the social strata close to the peasants or were peasants themselves, but the artisans' way of life was also similar. This was evident in the way they dressed. The guilds were obliged to make regulations forbidding their journeymen to wear linen pantaloons like peasant boys and farm-hands, or to join the latter in the stables in the evenings. But even in Debrecen —and after all, Debrecen was one of the largest towns of the country at the time—there were guilds which required their members to wear cloth trousers at least on Sundays, as well as on holidays and at the funerals of members of the guild. In this same period the guilds of **27**

Lower Austria were perturbed that their journeymen and apprentices were dressing too luxuriously, following the newest bourgeois fashion, "like gentlemen".

Many Hungarian craftsmen had two jobs, working in their vineyard or on their plot of land as well, and their idea of wealth was the ownership of land. In 1828 only 1,228 of the artisans working in Veszprém County lived exclusively by their trade throughout the year; the other 2,385 worked at their trade for only part of the year, and were for the rest of the time busy on their farms. In many places journeymen and apprentices were given no contract for the summer, "since in any case during that season they leave their employment and go home to their families and relatives in the country, as they can earn more from work in the fields". These, however, were the masters and journeymen hired by them, who had already created their best work and who had become members of the guild. On the other hand, most potters continued to work in cottage industry, living essentially as peasants. Potters often peddled their wares from village to village, like others engaged in cottage industries, such as those who made wooden vessels or wooden household implements, and like them, the potters also bartered their goods directly for agricultural products. There was a certain standard which prescribed how many times each vessel had to be filled with barter grain, according to the size and the quality of the vessel. For instance, the potters of Sümeg, when bartering their wares for wheat, required them to be filled twice with rye, three times with barley, maize or beans, and four times with oats, which are comparatively light. Often, the grain received in exchange for the pottery did not go directly to the potter, for if he himself owned no horse or cart, he had to ask a carter to sell the pots for him. After bargaining over the average price, such a carter would take over one or two kilns of pottery, which he sold for his own profit. Potter villages sometimes had a neighbouring twin village of carters, who distributed their wares over several counties.

Peddlers on foot and vendors with carts often brought the products of distant workshops and factories to the villages. The "cambric Slovaks" brought the fine cambric produced in the German and Polish settlements along the Carpathians; peddlers from Bosnia and from Turkey brought framed mirrors, beads, necklaces and other fancy goods.

The biggest displays of wares made by craftsmen and sold by vendors to the peasants were to be seen at the fairs. Craftsmen from distant parts of the country brought the newest of their products to the country fair, vying with each other for originality of decoration and shape. It is therefore understandable that the authorities, waging a war on peasant luxury, forbade the selling of new and fancifully decorated articles at fairs. The *cifraszűr* (embroidered frieze coats) to be described in detail later, were also forbidden to be sold at fairs, though permission was reluctantly given for them to be made to order.

The majority of agricultural products, as well as cattle and stock from peasant farms, were assembled and sold to merchants at these same country fairs. At the end of the eighteenth and the beginning of the nineteenth century, about 10,000 cattle and 50,000 sheep would be on sale at a Debrecen country fair. The Debrecen fairs, attended by people from throughout the countryside, were of prime importance and were only rivalled by those of Pest. A great quantity of artisans' products and other commodities changed hands at this fair and found their way into the urban and rural households of more distant neighbourhoods. In Debrecen, alongside the great fenced area of the cattle-fair, the stalls built of bricks and timber were like a separate town. This market-place lay desolate for most of the year and only came to life with the country fair, held four times yearly, when between 1,000 and 1,800 merchants applied for licences to sell their wares. The Vienna merchants had two rows of tents to themselves, another row was allocated to the furriers from Pest, others for the indigo-dyers from Upper Hungary and the weavers and the cloth manufacturers from Transylvania. There were also the poor peddlers and those who occasionally set up temporary tents. The number of

people in the crowds surging in and out between the rows of vendors can only be guessed;

the honey-cake dealers, for instance, found it worth their while to set up as many as a hundred tents, although they only sold presents for children and young girls, and trifles for the visitor to take home to the family.

The distribution and sale of the goods made by artisans and workshops throws a new light on the process whereby the local world of peasant objects was transformed. It becomes clear why certain new products, like the *cifraszűr* (embroidered frieze coat) or factory-made goods like coloured cotton material for women's dresses achieved a nationwide popularity in a short space of time, and helps to explain why in some types of folk art one style of decoration is found spread over a large region, while in others, it varies even from village to village. The different kinds of regional differentiation in the style of the various types of objects can also be explained by the different methods of organizing production and distribution. Artisans living in large centres of production usually worked according to a certain common denominator of taste which extended over a considerable region. Dishes and brandy flasks from Hódmezővásárhely, for instance, can be found over almost the whole of the Great Plain. However, in those types of articles made in the peasant houses themselves, such as textiles, woven linen and embroidery produced by women and made for use in their own homes, characteristics peculiar to the particular village where they were produced can often be discerned.

Periods in the History
of Folk Art:
Early Styles

Were we to rearrange the illustrations in this volume—now divided according to genre and subject—in a chronological order, the majority of the material would fall into the period of the last century or the beginning of the present. There are certain types of articles which only began to appear at this time, herdsmen's carvings with coloured sealing-wax inlay, for instance, made their appearance only in the 1830s, embroidered frieze coats perhaps ten or twenty years earlier, open-work benches from the Balassagyarmat region from between 1870 and 1880. Most of the exhibits in Hungarian museums and collections date from this period, and the conclusions of the general public and ethnographers both in Hungary and abroad are based on these works. The description of folk art in Hungarian villages given in the preceding chapters also refers to this period.

Some examples, however, have survived from both earlier and later periods. Along with sporadic survivals from the seventeenth century, these pieces provide a picture of folk art of the last 300 to 350 years, and a fairly extensive selection of such examples of early folk art is accordingly provided in these pages.

Putting works of folk art in a chronological sequence reveals their development and shows that forms and ornamentation do change; it also reveals that certain elements of this art survive tenaciously, almost unchanged. Similarly, periods of great originality and activity in peasant art are seen in contrast to quieter and more passive periods.

A survey of the last three centuries reveals more than merely the history of Hungarian folk art and the chronology of its surviving examples. It is difficult to analyse the nature of peasant art as the art of a social stratum and how that art is related to the other cultural trends of the society to which it belongs at any given historical moment. During these three hundred years the structure of Hungarian society and the social situation of the peasants changed repeatedly, often with startling rapidity. It is this dynamic historical change that furnishes the background for our understanding of the changes within peasant art, the differences in style and the explosive brilliance of its blossoming, followed occasionally by certain periods of decline.

It is impossible to provide a single definition to cover the folk art of the eighteenth century. The various genres found side by side and the various styles of ornamentation can only **153** be described, as it were, polyphonically, like a musical score. Everyday vessels and household utensils were made with a certain elegance in the simplicity of their forms and orna- **212** mented—as, for instance, the mangling boards with motifs of geometric designs or rosettes deriving from much earlier centuries. These motifs persist, even if peripherally, in later folk art. If, however, we look for the main motif of the eighteenth century, it is surely to be found **580, 427–428, 615** in the floral designs, tulips, pomegranates, carnations, in the symmetrical, straight flower-cluster designs consisting of 3, 5, or 7 flowers, as well as in the scroll and garland designs which adorned embroidery, pottery and painted furniture alike. On either side of a floral **518, 603, 587, 584** design the figures of stags might be found, or two birds, often peacocks facing each other, while on some embroideries the Lamb of God appears or a pelican feeding its young with its **30** own blood.

The most significant rural monuments of the period are the village churches. The church was occasionally built in the same way as the village houses, with wattled walls plastered with mud. The belfries were made by rural carpenters. The interiors of village churches were enlivened with painted ceiling panels, pulpits and benches, and, in Calvinist churches, vessels and embroidered coverings for the Lord's table, all of which mirrored contemporary rural taste. In a later period the churches, along with their interiors and furnishings, reflected more urban taste; consequently, the arrangement of the "best room" of a peasant house and the interior of the House of God were executed in two basically different styles. In the seventeenth and eighteenth centuries, however, the rural churches still expressed the artistic aspirations of the peasants of the time, realizing on a large scale the same ideals that prevailed in their humble dwellings. If a peasant was in a position to order a painted bridal chest for his daughter, he would do so from the same joiner who had decorated the church with floral designs, and the same flowers were painted on the chest as on the panels of the church.

These churches were regarded by the peasants as their own, particularly as they were often built and endowed by the rural community which also ordered the painted decoration. This fact is recorded in inscriptions. The church at Fehérgyarmat, for instance, was in 1766 "built anew by the Noble Calvinist Congregation... from a Devout Donation by its Members." The inscription in the church of nearby Csenger expresses the gratitude of the small and needy peasant congregation that it was capable of such a work as the erection of the church: "Blessed be the Lord, whose feet tread here. He gave a Heart from Heaven to this miserable people... that this [house]... should be so beautiful." There are inscriptions naming the sources from which the rural community managed to provide the funds for building and decorating the church. In the village of Magyarvalkó (Vălcăul Unguresc, Rumania), for instance, the rent of the mountain pastures in 1778 went to pay for the painting of the church ceiling; in Mátyus in 1732 a new pulpit was erected from the proceeds of the timber from village forests; in Magyargyerőmonostor (Manaştarul Unguror, Rumania) in 1758 benches were set up and painted which were paid for out of the profit from the acreage of communally owned land legally devoted to church use. In some churches, individual peasants made donations, as, for instance, one Mihály Jobbágy (or "serf") in Bánhorváti, who had a stall painted "in his zealous devotion to the Glory of God for the use of the honourable teachers of the Souls... at his own expense..." The choir for the unmarried youths in the Calvinist church of Magyarvista (Viştea, Rumania) was painted in 1699 out of funds donated by the young men themselves "for the Adornment of the house of God... out of their Good Will towards God". Even the names of farm-hands are to be found among the donors, who, if unable to afford more, met the cost of painting a few panels of the pulpit stairs.

These facts reveal the manner in which the artistic production of the period was linked with community life, especially that part of it connected with the Church. It appears that in this period, when there were as yet no ceremonial "best rooms" in peasant houses, rooms which were not normally used and which were filled with purely decorative objects, it was the rural church which served as the "best room" for the whole village, where the most beautiful objects were collected, and where, no doubt, there existed a certain rivalry in the prestige and placing of these decorative objects. In Transylvania, as well as other regions, the villages kept their most precious possessions within the fortified walls of the churches; the great chests for grain and the painted chests packed with clothing stood on shelves along the wall, communally collected together for protection and display.

Village churches, especially the Calvinist churches, had noble patrons in addition to the members of the rural congregation. The ceiling of the Calvinist church of Noszvaj, for instance, painted with the stags, storks, pelicans, tulips and pomegranates typical of the period, was paid for by Krisztina Borsányi, the wife of a local landowner. In this period, it is impossible to distinguish whether the painted panels in rural churches were commissioned by

11–15
18–38
427–428, 457

268

25

26–29

31

noble patrons or by peasants. In both cases the same flowers and figures referring to stories or parables from the Bible appear in the design, and very often the same craftsman was commissioned to do the work. The name of the donor appeared on these panels with a similar degree of pride whether he was a noble landowner, peasant, village lad or farm-hand. There is even a church (Magyarbikal, Bicalat, Rumania, 1790) where the inscription records that half was "made to the order of His Honour Sigmond Bíró" while the other half, the ceiling and the stalls included, was made through the donation of the peasants, "the Calv. Congr. of Magyar Bikal at their own expense."

Neither the zeal to become a donor, nor the desire to record the fact of the donation in inscriptions should be taken for granted. During the medieval period the donor's coat of arms appeared at most on the keystone. In Transylvania, it was János Hunyadi, the Governor of the country, who, in 1448, was the first to have his name inscribed in the church of Tövis (Teiuş, Rumania). A few decades later the names of great and lesser nobles, town officials and village priests appeared in churches, and in the first years of the sixteenth century the name of a peasant was painted on the sacristy door which he had donated to his village church. At the same time the architectural forms and floral ornamentation of the Renaissance were increasingly adopted by more and more classes in society, and donorship became more general.

The designs of the ceiling panels and church furnishings show the full range of the floral motifs favoured both in the mansions of the rural nobility and the homes of the peasants of the time. Such church designs were undoubtedly a direct source of inspiration for other genres of decoration as well; the painting of furniture must have taken its flower designs from this source. The crewel embroidery of Hódmezővásárhely, with the design known locally as *templomcifrás* ("church fancy") might have taken its name either from ecclesiastical embroidery or from panel painting, but in either case, from ornamental forms originating in the church. **19, 39, 589, 584** Adam and Eve under the Tree of Knowledge, the pelican carved on the pulpit canopy or the panels of the choir are also to be found in peasant needlework.

The beasts depicted on church panels are usually derived from biblical parables or ecclesiastical symbols. Yet the dragon with its seven heads on the ceiling of the church in Kraszna (Crasna, Rumania) seems nearer to the realms of folk poetry and belief than the Bible, even if we take into account the visions in Revelations. Occasionally an old record indicates that these figures conveyed exact and very explicit messages to the contemporary peasants. The reason the peasants of Madocsa had the figure of a carp—which could be interpreted as a symbol of Christ—carved on the wall of their church was because the income of one of the fishponds was donated by "Master Pál Kratz, Citizen of Buda, the lessee of the fishponds of Madocsa" towards the building of the Calvinist church, despite the fact that he was a Catholic; the pond brought in such a profit that the construction could continue and all existing debts be repaid. "It was the desire of many members that the figure of a carp should be carved into stone and placed somewhere on the walls of the church to remind the descendants of the extraordinary grace of God."

If we examine the remains of folk art which have survived from peasant houses—needlework, painted furniture, glazed pottery, etc.—we can see a similarity in taste to the contemporary pieces found in the houses of the gentry. The art of the non-peasant, highly stratified Hungarian society of the time could not, of course, have been homogeneous. In addition to the baroque, rococo and neo-classical styles of architecture and decoration favoured by the aristocracy and higher clergy, and by towns with royal privileges, there existed a wealth of **109** earlier architectural forms and decoration originally inspired by the Renaissance but imbued with a provincial quality. The latter styles flourished in the country houses of the lesser nobility, the urban houses of citizens of the country towns, and in their public buildings, which **32** bore a strong resemblance to the peasant objects and constructions of the same period, for

instance, to peasant embroidery. It is usually easy to distinguish the domestic embroidery of "gentlemen's houses" from the rougher, cheaper homespun pieces, where instead of silk and gilt or silver thread, cotton and wool were used. Professional embroiderers all over the country used more or less similar stitches; peasant women, however, used many kinds of stitches and needlework techniques, while the motifs themselves and the designs were simpler, bolder and more compact. Yet both peasant embroidery and the domestic embroidery of noble households used the same motifs and designs, with the same pomegranates and stags.

This was probably equally true of peasant costumes. Authorities of the period were much concerned with the regulation of costume for the various ranks of the citizenry to avoid any confusion in the recognition of rank which was expressed in clothing. Peasants were forbidden to wear certain kinds of costly and distinctive materials and certain kinds of trimmings. At the beginning of the nineteenth century the costumes of the west Hungarian peasants living along the river Rába were described with disapproval as being hardly distinguishable from those of the women of the nobility on account of the expensive material the peasant women used. In short, the ideal style of clothing for people of various ranks was the same, but the quality of the material was essentially different. The difference in the quality of nineteenth-century peasant clothing clearly indicates a departure from this rule if we take as an example the extravagant peasant costumes of the end of the century as a comparison, e.g. that of the Sárköz or of the Matyó people of Mezőkövesd. The women of Sárköz used the most expensive **495, 487–488** French silken brocades and Jacquard ribbons; the people of Mezőkövesd, expensive cashmere materials, gold lace and silken shawls. Nevertheless, the more the peasants spent on their costumes, the more firmly peasant in character they appeared and they became even further divorced from the fashionable attire worn by the urban citizens, the wives of gentlemen and the high-born ladies of the period.

Periods in the History of Folk Art: Development of New Styles

How was the originally reasonably homogeneous aesthetic taste of the Hungarian people later divided according to social strata? How did the later, much more "peasant" style of folk art develop? One of the factors contributing to this process of change was the gentry's gradual shift away from that taste in art which formerly they had shared with the peasants. Writing of the Hungarians of Transylvania—a region less affected than others by the ravages of the Turkish wars, the campaigns to expel them and the migrations of the peasants—authors of eighteenth-century memoirs gave a vivid account of the way the aristocrats were the first to abandon their former simplicity of manners for "new fashions". Baron Péter Apor, in his memoirs, *Metamorphosis Transylvaniae* (1736), recalls with nostalgia the days of his youth, when even in the higher nobles' mansions the tables were laid with wooden platters and pewter plates, when wine was drunk out of earthenware beakers and young male guests took no offence if their bedding was straw strewn upon the ground. All this was already in the past at the time Baron Apor wrote his memoirs; in the 1730s, wine was drunk out of crystal goblets and even the young expected to drink herb tea or chocolate in the morning. However, country squires and the lesser country nobility were still living with the same simplicity even a hundred years later. For example, the poet Dániel Berzsenyi, one of the most distinguished personalities of the literary revival of the first half of the nineteenth century, and a landowner with an estate of 1,500 acres, lived in a thatched cottage with the earth floor typically found in peasant dwellings.

The increasingly differentiated demands of the peasants, the town-dwellers and the nobles gradually differentiated the artisans themselves. Formerly, members of a town guild worked for both the gentry and the peasants. In the graded price lists, the luxury articles intended for high society and the more useful objects meant for the common people were listed side by side; the fashionable ornamentations designed for urban circles were made by members of the same guild who also made artefacts for the peasants. Working for both circles meant that the patterns and other decorative elements employed in making an object for the town were handled by the same artisan who made things for the village. The joiner who painted **38** the panels for the church of Magyarókereke (Muerău, Rumania) was a member of the guild **267** of Kolozsvár, the same guild of joiners which made the beautiful chest covered with leather and decorated inside with a cut-paper design for the mayor of the town in 1776. Both works were prepared according to a similar taste and with similar craftsmanship.

The joiners who painted floral patterns on the ceiling of the churches of Noszvaj and Me-**26–37, 268** gyaszó were also members of the Joiners' Guild of Miskolc. The Miskolc Joiners' Guild had, however, already split into two by 1791: those whose work followed the new bourgeois taste and turned to urban patterns were called "German joiners", while those who followed the old traditions, painting their wares with flower designs, were known as "Hungarian joiners". This division resulted in some cabinet-makers specializing in furniture to suit urban taste, while others turned to the exclusive manufacture of painted bridal chests and painted peasant furniture to be sold at country fairs. Other guilds split similarly; beside the bootmakers and **34** Hungarian cobblers making moccasins in the traditional fashion, appeared the "German"

cobblers who made fine shoes; beside the "Hungarian" tailors, makers of traditional noble-man's clothes, the braided cloth suits, breeches, dolmans and pelisses, there appeared the "German" tailors, the makers of city trousers, jackets, coats and long overcoats.

Even when the guild did not split in this fashion, by the nineteenth century there were many artisans who worked exclusively for a peasant clientele and adopted a semi-peasant way of life. In town houses and among the gentry, china, faience and enamelled iron vessels were increasingly used and the potter's craft became a peasant profession. As early as the eighteenth century, a number of craftsmen moved out of the larger towns into small country towns, later even into villages. With the advent of more developed forms of industrial production the older guilds began to decay in the larger cities, but in villages and country towns, even up to the middle of the nineteenth century, new guilds were still being founded. At a time when the peasants were both inclined and able to buy more, when the demand for the number of beautifully made luxury objects increased in peasant homes, the craftsmen abandoned by their former city customers were ready to fulfil the demands of the new market. The relationship between customers and craftsmen became homogeneous: the craftsmen who worked for a peasant clientele became rural people themselves as they moved into the villages, and based on the old traditions of the crafts, a peasant art expressing peasant demands came into existence through their handiwork.

The peasant demand for ornamental objects emerging so abruptly at a time when in Hungary, as elsewhere, the old craftsmanship was rapidly and irrevocably disappearing and industry was developing, gave a new lease of life to certain crafts. To the potters, the furriers and the tailors of *szűr* (frieze coats) it meant a belated, anachronistic flowering of their trade. In Hód-mezővásárhely, the largest centre of pottery in the Great Plain, only 8 potters were registered in 1788; by about 1836 their number had risen to 50, in 1848 to 169 and it reached a peak by 1860–70 when, according to information provided by Lajos Kiss, 400–500 potters worked in the town. Although the number of guild members was reduced to 240 in 1880, there were 163 in 1903, and in 1912, 119 masters were still active although not as prosperous as formerly.

An excellent way of studying the evolution of the new wave of peasant art, its diffusion and development, is to follow the development of the *cifraszűr* (embroidered frieze coat). This is an archaic type of coat; the ancient way of tailoring was adapted to the width of the material which depended on the width of the loom on which it was woven, the tailoring always following straight lines. The material was a coarse waterproof woollen cloth, thickened by fulling. The *szűrköpönyeg* (plain frieze coat) served as the principal protection for herdsmen and peasants against the elements; it was used to lie on and also as a covering. At the beginning of the nineteenth century it was still made in large quantities and the members of the guild of frieze-coat tailors of Debrecen imported annually about 200,000 rolls of frieze-cloth from Transylvania, mostly from Saxon clothmakers. The material itself, "frieze" *(szűr)*, a rough woollen cloth, and the coat made out of the material, was the typical clothing of peasant serfs, herdsmen, drivers and drovers. As the lines of an old poem say, "Noble blood shows when clothed in roughest frieze, peasant nature cannot be hid though clothed in velvet gown".

In the first years of the nineteenth century, the plain garment symbolizing the subordinate social position of the peasant was decorated with appliqué work and embroidery. The decoration itself was highly original and definitely peasant in style; instead of the gentry's braiding, trimming and large silver buttons, the peasants used coloured appliqué and embroidery arranged along the seams of the garment in a manner unparalleled by anything in the fashion of the nobles or gentry.

There was no need for the authorities to worry that the herdsmen or peasants clothed in their decorated frieze coats could be mistaken for noblemen, yet the fashion had hardly come into existence before it was discouraged, perhaps because it marked the appearance of a new kind of peasant self-awareness. The embroidery of the frieze coat originated in western

Transdanubia and the authorities in that region had issued a series of orders as early as the 1810s "to hinder the Luxury that has slipped in among the poor and humble inhabitants, for the so-called smart young men have their *szűr* made with lewd extravagant fancywork", and "ambitious young people emulating one another make every effort to acquire a *cifra-szűr*", spending all their fortune on it, and even stooping as low as theft.

The ban was not merely on paper. It was recorded, for instance, that the Somogy authorities imposed a fine of 12 florins on a tailor for embroidering three frieze coats and even imprisoned him for a week. These same authorities tried to confiscate the embroidered coats, and if anyone dared to appear in public in such a garment, the appliqué was cut off it. But all this led to complications, and as early as 1816 Vas County was inquiring of the central authorities whether it was possible "to cut off the fancy stuff from the coat or the extravagantly broad brims from the hat of those Noblemen who wear fancy frieze coats, and are dressed like vagabonds, without offending against their noble privileges". This piece of evidence demonstrates that in spite of the difference between peasant costumes and gentlemen's fashion, many of the rural nobility dressed like the peasants.

Orders, punishments, confiscations produced no result; in 1833 the tailors of frieze coats pleaded with the Somogy County authorities for help: "Immorality has advanced so far among young scoundrels without any education that many of them are not afraid to have their coats smothered with red cloth, and some even have mirrors sewn on to the shoulders of their coats." The complaint of the frieze-coat tailors over this frenzy of decorative emulation continued: "And if we are unable to make them in that manner, our middle range of coats remain unsold, to our immense loss; nobody will buy them even if they are cheap, whilst they are willing to pay the price of a fancy frieze coat even if the money has to be stolen, in defiance of the criminal law." The tailors also asked for a committee to define the permitted type of decoration for frieze coats.

What kind of decoration was it against which authorities fought so persistently and so unsuccessfully? In addition to the traditional appliqué on the borders, elements of fashionable

525–536 designs appeared, the Biedermeier flower bouquets, roses with petals, rosebuds and garlands. The existence of such early antecedents, however, can only be proved by a comparative analysis of designs, or by evidence from the pattern books of certain frieze-coat tailors, which show the fashionable patterns that inspired their work. An embroiderer of frieze coats in the last century used the patterns quite differently from the embroiderers of the old-style linen-work a century earlier. On the older embroidery we can see an attempt to imitate an ideal, while on the frieze coats the decorative elements are freely handled in the service of originality. The thick yarn, the rough stiff cloth and the placing of the pattern made it necessary for the designs to be composed in a new way. The result was a composition of strong, contrasting colours, making vivid use of various shades; an elaborate design tending to concentrate the pattern in certain areas, leaving large empty spaces, the simple motifs integrated within the pattern, the result being a closely decorated surface with a rhythmic interplay of colour and form. These features are also characteristic of other genres of nineteenth-century folk art.

Within twenty or thirty years, the *cifraszűr*, invented in western Transdanubia, had conquered the whole country as far as the Transylvania mountains. In the 1840s in Debrecen the embroidered frieze coat was already so much in vogue that frieze-tailors from other towns went there to learn the new decoration. The new centres for the making of embroidered frieze coats established numerous local schools in the art of frieze needlework, in the composition of the design, the choice of motifs and colour schemes, with the result that the nationwide distribution of the embroidered frieze coat led to the appearance of various different local forms of decoration.

The high point in the career of the embroidered frieze coat was reached between 1870 and

1890, when master tailors employed between twelve and sixteen assistants, went to the fair in glass coaches, and acquired estates of several hundred acres from their profits. No less than 800–1,000 embroidered frieze coats were said to have been sold at a single national country fair in Székesfehérvár. The persistence of this form of decoration is shown by the fact that when the sewing machine began to be used in the towns of the Great Plain, in eastern centres such as Nagyvárad (Oradea, Rumania) and Nagyszalonta (Salonta, Rumania), the former embroidery designs were transposed into appliqué work and the bouquets and garlands which were machine-sewn were abstracted into almost geometrical motifs.

The Hungarians living in Transylvania for the most part knew only this type of appliqué frieze coat, becoming acquainted with it towards the end of the nineteenth and the beginning of the twentieth century. This is in general characteristic of the folk art of Hungarian groups in Transylvania; the currents of nineteenth-century peasant style arrived only after a considerable time lag and made less of an impression.

The embroidered frieze coat became an integral part of peasant customs. It became obligatory for the bridegroom to wear it at his wedding, and in many places young men had to go wooing in embroidered frieze coats. Differences in cut and decoration appeared and different kinds of frieze coats were worn by herdsmen and farmers; among herdsmen, for example, there were variations in the coats of the shepherds, the swineherds and the men who tended the horses.

The embroidered frieze coat is represented in the other genres of folk art which were coming into vogue during this period. In the carved objects with sealing-wax inlay made by herdsmen in Transdanubia during the first half of the nineteenth century, the figure of the hero rarely appears without a richly embroidered frieze coat. The first master of this herdsmen's art, Zsiga Király, always represented himself wearing a *cifraszűr* when addressing himself to his sweetheart. In his work, the highwayman who forces the gendarme to his knees also wears a fancy *szűr*. The artist found such pleasure in representing the still novel *szűr* that he would depict the coat spread out to show off its decoration to better advantage. The song about a highwayman called Simon sung by minstrel beggars declares that his shroud was his embroidered frieze coat and he was buried wrapped in it. A case is also known of a highwayman who died far away in prison and his family at home mourned over his fancy *szűr* and buried it in his stead.

What were the changes in the situation of the peasants which so profoundly altered their taste and their artistic aspirations? What alteration occurred to the material property of peasants and why did the number of decorative, non-functional objects increase? How did the aesthetic quality develop which resulted in the innumerable variations in the materials, colouring and patterns of women's clothes? What gave rise to the new consciousness of self, evident far beyond the field of aesthetics, which resulted in a definitely new appearance of peasant costumes and objects, often of an expressly rural character?

If we were to attempt to define the basic force behind this historical development, we might say that it was the Industrial Revolution taking place in western Europe which, through complicated transitions and delays, also set the current of modernization flowing in other parts of Europe. The agrarian and feudal regions of eastern Europe, including Hungary, were affected first and foremost in their agriculture, which had to meet the increasing food demands of the rapidly growing urban populations of western Europe. Many great estates had already been induced to modernize towards the end of the eighteenth and the beginning of the nineteenth century, when there was a boom in wheat and wool. In peasant farms close to the highways and markets, people began production for sale, as in the region of western Hungary close to Vienna, where the embroidered *szűr* made its first appearance, and where already at the beginning of the nineteenth century observers noted that farmers' wives dressed with an extravagance rivalling the luxurious clothing of the ladies of the nobility. The large

508

510

321, 332–333, 376

323

335

agrarian towns of the Great Plain where peasant society was most highly differentiated and mobile also profited early from the opportunities to sell and export their products.

To modernize agriculture, it was necessary to change the feudal organization of agricultural production. The decree issued by Empress Maria Theresa in 1767 was an attempt to protect the serfs' plots of land against the landlords; at the end of the eighteenth century, Joseph II gave full freedom of movement to the serfs, as well as the possibility to inherit, thus making the legal rights of serfs to their land more akin to the rights of citizens holding private property. The Hungarian reform movement of the opposition, with its nationalist fervour, strove for cultural propaganda in favour of the peasants and achieved further social reforms, while the Hungarian movement for reform and independence which exploded in 1848, when revolutions flared up all over Europe, resulted in the final abolition of feudalism and the emancipation of the serfs, who became owners of most of their former feudal tenures.

Hungarian agriculture progressed towards bourgeois, capitalist development in a divided manner: half the agricultural land belonged to large manorial estates, and the other half, broken up into tiny holdings, to the peasants. Half the rural population did not even own such a tiny holding, but were cotters or day-labourers working for wages, or farm-hands on large estates.

The economic changes of the decades which followed in Hungary took place under the Austro-Hungarian Monarchy. From 1850 onwards the swiftly developing industries of Austria and Bohemia led to speedy agricultural evolution in Hungary: acreages expanded, pasture land came under the plough, the regulation of the rivers produced new agricultural regions the size of a province, the quantity of agricultural produce multiplied, railways and canals were built and the food industry developed rapidly. In this period of extensive growth concentrated on increased wheat production, peasant farms were still able to keep abreast with the great estates and shared in the general prosperity. The agrarian crisis of the 1870s, however, due in part to the appearance of American and Russian wheat on the market pushing prices down, affected the peasant holdings far more than the large estates. At about this time specialized areas of production developed—dairy products, livestock, orchards and vegetable gardens—but this meant the dissolution of the self-sufficient mixed farming which was the basis of the traditional peasant way of life. Industrial centres sprang up all over the country, Budapest developed rapidly, and an increasing number of rural inhabitants set off from their villages towards the cities, thus abandoning for ever the peasant way of life. At the end of the century large groups of emigrants also left for America. Around the turn of the century the peasant holdings, broken up even more, could no longer compete either in their equipment or in their farming and marketing methods in the merciless world-wide race of production, and through the exploitation of their own labour and the reduction of their demands, their only aim became to hold the land they owned. Only a few regions specializing in certain products could be regarded as fortunate exceptions.

In any case, the peasants were faced with a tragic alternative. By the beginning of the nineteenth century land was already scarce, almost half the peasant population had none, and although later, after the emancipation of the serfs, the peasants were able to acquire parts of certain feudal estates, up to 1945 the large estates tightly surrounded the peasant holdings. Only in certain parts of the country were the peasants able to organize competitively profitable farms, and though industrialization and urbanization had made rapid strides by the end of the century, there were still too few cities and too little industry to absorb the surplus rural population. Peasant folk art and ceremonial and festive peasant customs, developing proudly and with self-awareness, sometimes almost despairingly, were in reality the expressions of hope in an already impossible peasant future which was to be proved an illusion.

Peasant art of the nineteenth century was the creation of the rural communities where human relations were organized on basically peasant lines and where thinking was based on

a system of peasant values. This was the last stage of a form of life evolved in the Middle Ages in Hungary. The flowering, enriched folk art was based on the ideology of this form of life. The "new" peasant style of folk art stressed the memorable moments of human life, human relationships and the enduring values, which were the gift of previous centuries, and celebrated them with the assistance of an abundance of new and colourful objects. The main genres and basic shapes of these objects were, however, also rooted in tradition.

A factor which gave a new direction to popular art in the 1800s (in some regions it occurred twenty or thirty years later) was a rise in the material well-being of the peasant attributable to the increasing demand for production for the market and agricultural prosperity. This enabled him to enrich his material world and to multiply the number of festive objects, giving them an increasing refinement in their ceremonial roles.

The growing trade in commodities meant that the peasant had wider and more varied sources at his disposal from which to accumulate objects. In addition to home products, the function and number of objects bought for money or exchanged for agricultural produce increased, and the role played by the products of rural craftsmen and artisans, as well as factory-made objects, grew correspondingly. In some cases, these products replaced those formerly made at home; homespun, home-woven linen, for instance, was replaced by finer cambric goods in the towns and the Great Plain, and already in the nineteenth century spinning and weaving are recorded as things of the past. In other regions, however, the growing desire for luxuries increased the demand for homespun linen to such a degree that it could hardly be met. In the villages of Kalotaszeg, for instance, women would work at their embroidery and at their spinning and weaving whenever they had a break in farm labour, but the yarn they used was largely ready-made, bought cotton.

The rapid diffusion of factory-made products increased the range of the materials used in folk art. A wider variety of colour was employed. In women's costumes, first the shawls and then the bodices were made of brighter materials. Pedlars bought remnants in Vienna and sold the pieces at fairs, or going from village to village. Some twenty or thirty years later the most expensive silks, brocades, velvets, gold lace tassels and Jacquard ribbons were part of the stock of materials used in peasant costumes. "Young women and girls are as fancy as the birds of God", wrote an observer of the change of fashion in 1842. "On the wives and daughters of common farmers... one can often see material worth hundreds", added another observer a few years later. At the same time, as far as the men were concerned there was a more general use of factory-made cloth side by side with the former homespun linen, the grey and white rough woollen cloth and frieze and sheepskin jackets and coats. During that period, the peasants were able and willing to buy, and their demand for luxuries resulted in long rows of stalls at fairs where the frieze-coat tailors, furriers, potters and other artisans sold their goods, increasingly "peasant" in taste, to their country customers.

Not only did the peasants' prosperity increase, but their mental attitudes and the consciousness of their social position also changed profoundly. In the background were the laws which, however dilatory in their development and restricted in their effectiveness, nonetheless guaranteed and protected their personal and political rights. The emancipation of the serfs ended the direct domination by the landlords and freed the peasants from the obligations of personal service. At the same time, there was the shattering experience of the War of Independence of 1848–9 which ended in defeat and which, though its aims were not always clear or consistently conceived, nonetheless called on the peasants to fight, mobilized them to a great degree, and implanted in their minds the image of a state where peasants would enjoy equal rights with others. Lajos Kossuth and Sándor Petőfi became the leaders in the social and political orientation of later peasant generations, and their lives came to stand for the fight for national independence and freedom for the peasant, two concepts interwoven and indivisible.

In the meantime, the effects of the cultural movement on the creation of a new national culture reached the peasants; it was a movement which in no small measure sought its roots among them. The movement for linguistic reform integrated words from rural dialects and peasant expressions into literary speech. The literary revival used folk forms of poetry and rhyme and folklore genres for the expression of new ideas. While folk poetry was discovered at a very early stage, the material world of the peasant or folk art was only discovered at a comparatively late date. Peasant costumes, however, were already an object of interest by the beginning of the nineteenth century and descriptions and prints of them began to be published in the hope that they would serve as the pattern for a truly Hungarian style of dress. The expressions "folk costumes" and "Hungarian costume" are often synonymous in the literature of that time. Peasant clothing took on a symbolically political meaning when, after the defeat of the War of Independence, gentlemen with political leanings wore embroidered frieze coats as a public expression of their nationalistic feelings.

Such cultural changes in the homes of the urban bourgeoisie and the mansions of the nobility meant that cultural elements of peasant origin were mingled in the general current of ideas flowing from urban dwellers and the gentry to peasant society. Examples of this feed-back can be found in the songs of poets like Petőfi, which were inspired by folklore, and which, in fact, managed to find their way back into the villages where they were sung as real folk-songs. The effect of such cultural interrelationships was reinforced by the new and effective channels of cultural communication which had opened up at this time. After the thorough-going radical school reforms of the 1860s there was a general increase in elementary schooling among the peasants, and by the end of the century illiteracy was progressively reduced. At this period, as well, peasant men tended to undertake terms of urban work, and also had to do their military service, which meant that generations of peasant men found themselves in urban surroundings for long stretches of time.

The collections of fairy-tales which appeared in book form played their part in the preservation and diffusion of folk tales, and it is often difficult to decide whether the text of an old tale was known through oral tradition or through favourite authors like László Arany or Elek Benedek, whose collections of folk tales ran into many editions. At the beginning of this century, tales collected from woodcutters telling stories around their fires in the mountains of Transylvania, or from the tobacco workers smoothing out the leaves in the tobacco-barns of the large estates on the Great Plain, included tales formerly unknown, which certainly can be attributed to the effect of the printed fairy-tales, first and foremost the stories of the Brothers Grimm.

In town theatres at this time folk comedies were extremely popular; they were plays about village life which put rural costumes and peasant customs onto the stage. The representation of the peasant in these comedies is today considered very superficial, yet the peasants of that time were delighted to learn the light songs in vogue in town, written by urban composers for the stage peasants. Zoltán Kodály wrote that when he was collecting folk-songs in about 1910, the young people in the villages preferred to sing these pseudo-folk-songs taken from the theatre. (This phenomenon must not be regarded as a radical and definitive change of taste, but rather as characteristic of a certain age-group. A similar phenomenon occurs with folk costume. The peasant girls who ordered fashionable dresses from a seamstress and the young men who wore a tie and trousers like a gentleman returned to the simpler, rural way of dressing as they grew older.)

With the exception of folk costumes, the discovery of other branches of folk art—pottery, textiles, embroidery, carving—and their integration into the movement for a national culture came comparatively late. The first big exhibition of handicrafts was organized in the 1870s, and a few decades later it was already fashionable to decorate urban homes with peasant objects. The collecting, buying and selling of peasant objects also began together with courses

organized for teaching traditional handicrafts, which, unfortunately, meant intervention from without. Apart from such direct intervention, the recognition of the national value of folk art, which affected the peasant as well, was also important, and had repercussions in the actual works of art themselves.

In 1855 the press carried the news that a tailor of frieze coats from Győr had made an embroidered coat for an exhibition abroad, with the Hungarian coat of arms embroidered on the collar. Numerous embroidered frieze coats are known from a later date, from both Transdanubia and the Great Plain, which also carried the Hungarian coat of arms, a symbol which, in contrast to the double-headed eagle of the Habsburg House, made clear reference to Kossuth and the 1848 War of Independence. On the later type of frieze coats favoured in the eastern part of the Great Plain, which had machine-stitched appliqué as decoration, several coats of arms appeared on a single frieze coat; in some cases there were as many as five coats of arms on a single collar. The Hungarian coat of arms can also be seen on the herdsmen's ointment-cases carved in horn, on mirror-cases decorated with sealing-wax inlay, on whetstone holders worn by young peasant boys, on the slipware dishes hanging on walls and, even more frequently, on the stoneware plates manufactured for peasant use. On the brandy flasks, where the main decoration was the inscription, in addition to such traditional texts as "my name is flask, I contain brandy, drink from me, friend, but don't topple over", patriotic inscriptions began to appear between 1880 and 1890: "God bless this country, every speck of dust in it..." Or, to quote the inscription from the wine jug of a guild, "there is no wine better than that in my sweet country, in my home country, beautiful Hungary". Furniture with open-work decoration shows similar tendencies. Soldiers appear on them, with a man carrying the national flag. Most of them parade peacefully, but a peasant of Litke from Nógrád County, who carved an open-work back to his bench, placed the war dead under the feet of attacking hussars. The bench is dated 1910—scarcely four years before the outbreak of the First World War, when hundreds of thousands of Hungarian peasants did indeed fall as soldiers in the terrible carnage.

The fact that the new flowering of a peasant style of folk art can be attributed not only to the change in material conditions, increasing well-being and a proliferation of available objects, but also to a profound alteration in the peasant mentality, is supported by observations of research workers on folk music. At about the same time as the new peasant styles in folk art appeared, folk music, which is not directly dependent on trade in material goods, changed radically. Béla Bartók, classifying Hungarian folk-songs according to their formal characteristics and structure, was the first to distinguish the stratum of the "new style", which, as he declared in 1934, had predominated "in the last ten to twelve decades", that is, in the same period when the embroidered frieze coat was in fashion. The diffusion of the new style of folk-song was so rapid and all-pervasive that Bartók described it as the "musical revolution in the Hungarian village". Earlier melodies, which were replaced by the new style or relegated to a peripheral position, consisted partly of archaic pentatonic tunes, and partly of melodies deriving from European historical styles or from songs sung by the gentry and the nobles two or three centuries earlier. In a pithy sentence, Bartók declared that the spreading stream of the new-style peasant folk music had halted the process of the "denationalization" of folk music.

Are there any features in this new kind of vital folk music which might be compared with the characteristics of the new folk art and its objects? The similarity in the sociological nature of the changes in the two branches of folk art is incontestable. In both cases, a new, peasant style of art superseded, along with the most archaic elements, those older features which derived from aristocratic and urban sources, e.g. *virágénekek* or "flower songs" (love songs), *históriás énekek* or historical narratives, and student songs on the one hand, and motifs such as the pomegranate and the carnation on the other. Nor do the new-style songs become less

534

367

445

287–290

41

"peasant" because, at the same time, songs in a similar style were in vogue in the cities and among the gentry, for these "urban folk-songs", to use Zoltán Kodály's phrase, took peasants and village customs as their subject-matter and stressed their rural character. Similarly, the embroidered frieze coat did not lose its "peasant" character even if it was occasionally worn by a gentleman.

The new-style folk-song was most suited to group singing, while the old style with its complicated ornaments was unsuited to that purpose. One might find a parallel in the fact that the objects of the new "peasant" style of folk art were appropriate for reproduction and were manufactured in greater quantities than the more unique pieces of the older folk art. Béla Bartók could distinguish more types of melodies among the new-style folk-songs than among the old; however, these, with a tighter construction in their phrasing and structure, their stricter, more uniform rhythms and simpler manner of performance, had a certain restricted character which contrasted with their diversity. The same is more or less true of the new-style visual folk art. Appearing with a great variety in its colour and form and in the arrangement of its ornamentation, it nonetheless developed within a more defined and restricted area.

Finally, the dynamics of the diffusion of the new-style folk art and the new-style folk music are also similar, though the styles of folk art are more immediately bound to the media, and thus spread less rapidly. Just as the fashion for embroidered frieze coats extended as far as the limits of the Hungarian-speaking people on the borders of Transylvania, so the new taste in music spread over the same region in roughly the same period. And just as the new decorative style reached the Transylvanian Hungarians with a delay of some one or two generations, and never reached certain groups at all, so the new style of music seemed to halt at the border of Transylvania. Although at about the time of the First World War some of the new-style songs were sung by isolated groups of Hungarians living in Moldavia and some of the Budapest theatre songs were also known, the majority of the Transylvanian Hungarians still sang in the old style, and have remained faithful ever since to the older instrumental music.

The same socio-economic change which brought relative prosperity to the peasant at the beginning of the nineteenth century, and induced a new kind of self-awareness and gave him furniture painted with flowers and brightly coloured textiles for his clothes, one or two generations later, necessarily and inexorably, progressed to the stage where the old order of peasant life began to crumble. The new peasant styles which burst to the surface with elemental force in folk art, folk music and folk costumes bear witness to the great rifts existing in nineteenth-century Hungarian society and the contradictions in its historical development. In richer and in more fortunate countries, the various social groups were able to advance towards modernization in a more homogeneous manner. In Hungary, a definitely peasant, rural culture was able to flourish in the shadow of rapidly expanding cities, the spread of industrial enterprise and the growth of the railway system, because the villagers remained outside the main stream of development. The strong pressures of necessity kept them peasants at a time when their way of life was daily becoming anachronistic. This historical process, full of contradictions, exacted a great price in terms of human conflict and suffering. On the one hand were increasing rural poverty, struggle for existence, and hard work: in the middle of the nineteenth century the landless labourers, the paupers, were already in the majority, and at the turn of the century the future was darkening for the landowning farmers as well. On the other hand there flourished an original and vigorous folk art and folk music, which in other parts of Europe, more fortunate in their development, could never have been born quite in this form.

With a proper appreciation of the changes that occurred in peasant society, we are in a position to separate the alterations in the peasant way of life and the surviving examples of the new peasant style of folk art into more exact periods. It is possible to distinguish two waves of this new folk art, each of which left differently conceived objects and artefacts to bear witness to its artistic intentions and style. There was also later a wave which rested on a different basis, but we shall not deal with this latter here.

The first wave belongs to the first half of the nineteenth century when the feudal system and serfdom were still in existence, and only certain regions and certain types of art were influenced by the new, vigorous "peasant" style. Western Transdanubia, well-situated for trade, and the wealthy agrarian towns of the Great Plain were such regions. This period is represented by the furniture from Hódmezővásárhely. Its ornamentation is clearly based on the panel painting of the joiners whose work appeared in churches, yet its colour and form are louder, heavier and stronger. Other examples are the pottery of Debrecen and Mezőcsát, and the older kind of frieze embroidery, especially that of Transdanubia, as well as the earlier furriers' embroideries.

The first wave of peasant art has a certain touch of "noble" influence in its style. This is due not only to a closer connection with the older form of folk art, but also to the fact that the prosperous lesser nobles were the most influential group both in the political movement for reform and the movement for a cultural renaissance. It was during this period that the porches of peasant homes were adorned with pillars in imitation of the nobles' country mansions built in the neo-classical style, though in a simplified form, and in accordance with traditional modes of architecture. And this was also the period when suits of cloth decorated with braiding came into fashion among peasant men, as described by the ethnographer István Györffy: "At the time the serfs were emancipated, peasant men dressed in clothes like the ones noblemen used to wear."

Sometimes the connection is direct. In Mezőcsát lived lesser nobles who farmed their land themselves, and the potters also belonged to the nobility. The "Miska" jug shown in Illustration 408 was made by "Noble Márton Horvát" in 1847 for "Noble János Abonyi", living in the same place. The "Toby" or "Miska" jugs of Mezőcsát (the earliest known bearing the date 1828) were given the type of clothes worn by noblemen: a richly braided dolman with large buttons, a bow around the neck, and a high shako on the head, while their faces shone with the self-assured ruddiness of wealthy farmers or country squires. The silver chain clasping a pelisse and other silver jewellery shown in Illustration 542 are also objects straddling the borderline between the life of the rural nobility and the peasants. Such jewellery was commissioned by both the nobles and the richer peasants from the same small-town silversmiths.

Though the folk art of this period can be distinguished from the earlier period precisely by its more "peasant" character, the customs and objects of the time were also linked to contemporary currents of cultural life and the contemporary historical background. It was during this period, for instance, that the "best room" used only on holidays came into fashion,

273
21
424–428
408–410, 459
525–526
106–108
504
408
542–544
43

and however peasant-like this room might seem with its bed stacked high with cushions and the brightly coloured plates hanging on the wall, yet its development cannot be completely divorced from the example set by the parlours in the mansions of country squires and wealthy citizens, however great the distance between ladies drinking tea and peasant merry-making at weddings and pig-killings may have been.

A very peasant and popular type of the folk art which evolved in the first half of the nineteenth century was the figural art of the herdsmen, i.e. the representation of human figures with sealing-wax inlay. The manner of representation and the treatment of the figures is in a truly original and vernacular vein and the figures themselves, their costumes, the objects in their hands and around them, convey the same symbolic meaning as in the real world of that time. The shepherd holds his crook, the swineherd his axe, the young man is shown with his girl, wearing his embroidered frieze coat, the young girls hold sprigs of rosemary, the symbol of maidenhood, in their hands, or, should their morals be dubious, they are given hats. Where couples are represented, they are either a girl and her suitor or a pair drinking or dancing together, almost never a married couple. In the case of one of the illustrations in the book, three figures are shown. Its maker no doubt intended to depict the rivalry between **362** two men. The girl in the centre of the composition shows an obvious preference for the young man dressed like a city gentleman to the lad with a moustache (presumably a highwayman) wearing wide linen trousers and carrying a gun, who approaches them with an angry look, thirsting for revenge. It is also worth noting that with the exception of herdsmen and highwaymen, and in rare cases the Madonna, almost the sole subject of the Transdanubian herdsmen's art is the pair of lovers. This would be difficult to imagine in another period, in a more severely feudal, traditional peasant world when the figures represented either patron saints or legendary heroes. However rural the manner of treating the figures, we are left with the impression that in some subtle way they have a kinship with the sentimental Biedermeier romantic literature of the period.

The effect of new bourgeois influences can also be detected in the composition of the pairs of lovers. In the early examples, the lovers stand side by side, or, as may be supposed from **329–331** the representation of musicians, are dancing arm in arm. From the 1860s and throughout the 1870s, they are shown sitting together at a table, drinking toasts to each other. This was strictly against the code of earlier peasant behaviour; not even a wife would sit down to table with her husband, and to sit at a table with one's sweetheart would have seemed a frivolous, sophisticated scene to villagers of the time.

The representation of the seated couple offered an unusual compositional task. On the earlier pieces, the figures were invariably standing and were shown either full-face or in profile. There were hardly any attempts to depict movement. One of the rare examples is the **334** mangling board, shown in Illustration 334, where the woman herself is represented full-face, but the dancing legs are shown in profile in order to give the impression of swift movement. Even when the arms are making gestures, when the figures are shown arm in arm or holding hands, they are always in a standing position. When the theme of two lovers drinking together at a table was first introduced, the man and the woman were still shown standing, and between them, apparently floating in mid-air, was the table with the wine jugs on it. It is **338** only at a later period, around 1880, that the figures are finally shown sitting at a table, e.g. on the mirror-case in Illustration 338. The unknown maker of the mirror-case is the same **336–337** artist who produced the picture of the highwayman Jóska Savanyú being taken prisoner when he fell asleep sitting on the edge of a forest.

It is worth considering the great popularity of mirror-cases among the herdsmen of the period on which these figural scenes appear. Travellers passing through Hungary spoke with admiration of the skill with which the swineherds of Transdanubia threw their axes **44** form a distance of some thirty to forty metres to kill wild boar or a pig intended for

roasting. One of the trials the herdsmen caused the authorities was through their clothes. Smelling of the rancid fat and smoky ashes used to make their garments waterproof, they were so rank that they could not be allowed into church in their working clothes. Yet it was these same herdsmen, living for months in the open air, combating wind, storm and wild beasts, whose rough hands produced such minute, intricate cases complete with inlay for their mirrors. Some of the late pieces are quite evidently made in imitation of gentlemen's metal pocket-cases. A special slit in the mirror-case served to hold moustache-wax, as these mirrors were used by the herdsmen when they dressed their moustaches. Were it not known that the material used to stiffen the twirled moustaches was indeed used by herdsmen, these mirror-cases could certainly be regarded as toilet accessories of a gentleman or a petit-bourgeois. The coloured sealing-wax which served as material for the inlay of the mirror-cases and for colouring the figures of highwaymen and herdsmen, and which was used by artists like Zsiga Király, actually came from the towns, since originally it was used to seal letters, sometimes even perfumed love letters.

The second wave of peasant-style folk art came between the 1860s and 1870s. It flourished in different regions from those of the preceding period, as different regions or production centres were involved in each stage of the development of folk art. The vogue for the coloured, painted furniture of Hódmezővásárhely, for instance, came to an end about 1850 and was replaced by plain urban brown or dark green furniture. At the same period, in the northern region of the Great Plain, in Eger, Salgótarján and a few adjoining centres, mass-produced peasant furniture began to appear with garlands and bouquets painted on a red marbled surface. **264** In Mezőcsát, a few potters still repeated patterns based on the earlier period, but the production of folk pottery at Debrecen nearly ceased and was continued at Tiszafüred, Hódmezővásárhely and Mezőtúr. These centres enjoyed a long tradition of pottery-making, and it was here that typical forms of pottery, made in much greater quantities than in the former period, were produced: glazed water jugs from Mezőtúr of coloured ochre and decorated with a flower design, brown, green and yellow brandy jugs from Hódmezővásárhely and small green or blue brandy flasks, plates from Tiszafüred, decorated with flowers, birds or stars **436, 442, 443** to brighten the dark corners of living rooms and kitchens.

The divergence between the tastes of town-dwellers and peasants increased. Ornamentation was more pronounced in colour and form and more unmistakably peasant-like. The pottery of the Great Plain provides a good example of this change in taste. The jug for the Communion wine made in Debrecen in 1793 for the Calvinist church of Báránd is decorated with **427–428** pomegranates and flower-clusters in a loose symmetrical design, similar to that on church panels. On a guild jug also made in Debrecen in 1847, the loose wavy scroll design and a **425** peacock looking backwards can be considered as an example of the first wave of peasant art, though executed in the more refined manner of that style, and the same can be seen in the design on the plate made by Mihály Rajczy in those years, also with a sensitively painted figure **459** of a bird looking backwards. But when the flasks with the painting of a cock on them, made **439** in Tiszafüred a generation later, strongly coloured and executed in a sweeping design, or the more robust, vigorously decorated brandy jugs of Hódmezővásárhely are compared with **436** them, the more "peasant" quality invariably found in the latter becomes quite clear.

"Toby" or "Miska" jugs came into existence in the first half of the nineteenth century. **406, 408–410** Though no two were alike, their shapes varied within a defined range. In the second half of the century, brandy flasks were also made in the shapes of men and women, and money-boxes, **412–417, 419–420** tobacco-holders or sugar-holders were made in the form of heads. These all gave a greater **402–405** scope for experimentation: for example brandy flasks representing peasant wives and fine ladies, peasant men in linen pantaloons or in great sheepskin cloaks, a uniformed county attendant smoking his pipe, various types of soldiers and hussars on horseback, musicians and different kinds of animals.

A characteristic of this second wave of the peasant style was the representation of human and animal figures which was formerly very rare and now appeared in new genres of peasant art. The majority of examples of the herdsmen's carved figures come from this period, especially those in low or high relief. The growing taste for human figures can be observed chronologically; at first only one, then two or three figures appear in a composition, and later **334, 353** whole gangs of highwaymen are shown together. There are scenes of merrymaking also, with bands of four or five musicians. Once skilled in the composition of whole scenes, certain herdsmen had enough self-confidence to undertake the illustration of well-known ballads and **336–338** romances, e.g. Illustrations 336–338 of the capture of the highwayman Jóska Savanyú.

In the northern part of Hungary it was also the herdsmen who made carvings on their shepherd's crooks of the animals they tended and on the handles of wooden mugs and matchboxes. Since it was a Catholic region, they also carved religious scenes. It is not difficult to find examples of the blending of the old forms of artistic expression with the practical de- **305** mands of contemporary life; the matchbox on which József Barna carved the figure of the Prophet Daniel in the lion's den in a terse style reminiscent of the Middle Ages, bears witness, for instance, to the fact that the earlier flint, steel and tinder-bag had been replaced by a box for matches in the herdsman's bag.

The herdsmen's traditional carving skill in this region produced a whole range of benches with open-work backs, and plate racks, chairs and other kind of furniture in a similar style. These open-work panels make no attempt to deal with one of the most insoluble problems of folk art: the expression of space. The figures, trees and flowers represented on a flat plane simply have their background removed. This very simple technique produced an interesting spatial effect: the benches with their open-work backs are placed in front of a whitewashed wall—or in the case of a table with open-work decoration, in front of the plain wooden boards which form part of the construction—and the light falling on the design creates shadows with interesting effects on the background, thus giving the figures a modelled aspect. This kind of furniture was never made in quantity, yet the fairly rare examples which remain are sufficient to show various kinds of artistic choice in subject-matter and treatment.

One maker of these benches József Pál, whose creations were found in the village of Litke **283–286, 287** in Nógrád County, went so far with these effects that he gave up any attempt at colouring or plasticity and left it to his carved figures to produce a silhouette effect, which he enhanced with a lattice-like pattern in the background. This approach, however, did not lead to abandoning every effort at representation nor to a simplification of the composition. He composed the broad backs of his benches, generally divided into ten panels, according to a carefully elaborated iconographical programme, dividing each panel into two parts and putting contrasting scenes on the upper and the lower panels. One bench gives a brief survey of Christian salvation, beginning with the birth of Christ and the journey of the Three Kings guided by **283, 284** angels, followed by scenes of the Child Jesus speaking to the scribes in the Temple, the treach- **285–286** ery of Judas and his suicide, the Crucifixion and the coming of the Holy Ghost. There is no indication of how the maker intended the scenes of everyday life on the lower panels to relate with those above them, yet it is quite clear that he intended the confrontation of the Child Jesus lying in a crib between the ox and the ass in the poor stable, and a carving of a large sophisticated baby-carriage and children sitting on high chairs round a table being served by their nurse, as social criticism.

Other makers of benches took full advantage of the opportunities provided by open-work to carve in a more plastic manner and colour their work. This is how János Csábrádi, **277–282** who made one of the finest benches still extant, dated 1889, worked. He constructed the whole bench in accordance with a single, integral idea, composing both the single panels and the whole back in a regular symmetrical pattern. The middle panel, broader than the others, **46** served as an axis, on which two stags stand facing each other under the branches of an oak-

tree. On the adjacent panels two hunters turn their backs on each other; on the next are small forest beasts; finally, the last two panels show a hussar on each side, facing towards the centre. The whole composition is symmetrical, but loosely so, since neither side is a rigid and exact reflection of the other. This can be taken as a general trend of the period—greater flexibility in composition rather than the former, more severe style.

Contrary to Csábrádi, János Bertók, another carver of benches, had a fine feeling for the narrative details of village scenes. The narrow panels of a single table show scenes of plough- 291–293 ing, sowing and villagers going off haymaking. Another master carver, Pál Lőrincz, made use of enlarged oak-trees to unite his composition and to order his panels into an organic whole. Under these trees are scenes taken from village and forest life: two young men quarrelling 294–296 over a nest in the wood while a third steals the eggs; a bagpipe player; a smith working in the wood, who, as Pál Lőrincz explained, was busy secretly manufacturing weapons for the guerillas of the 1848 War of Independence.

This is the period when the *cifraszűr* (embroidered frieze coat) reached the height of its popularity and took on those features which were also characteristic of the linen embroidery of the period: the simultaneous use of strong contrasting colours with attempts at shading, 525–535 and a tendency to overcrowd the composition. It is evident that the needlework executed by professional embroiderers such as the tailors of frieze coats or furriers had a direct influence on peasant embroidery. The same tendency can be seen in the furriers' work. Coloured silks had been used for a long time in the embroidery of sheepskin garments, but the silk embroidery 514 became even more colourful and variegated at about this time, whereas when crewel yarn 512–513 was used instead of silk, requiring less work and larger stitches, the embroidery became fuller and closer, like the embroidery on frieze, and the thick yarn produced a plastic effect.

Curiously enough, on these professionally made embroideries, which to some extent were precursors of peasant embroidery, there can be observed a tendency which is later apparent in other genres as well. After reaching a climax of luxuriant colouring, a certain economy in the use of colour began to make itself felt, ending in a reduction to a single colour. At the same time there was an extension of the embroidery to cover a large surface and an even closer, more congested design. The embroidery on the short fur pelisses worn by wom- 515 en in the surroundings of Debrecen, formerly full of colour, was limited to green with small dots of vivid red; in the Jászság region the white sheepskin jackets, vests and capes were embroidered in dark green, and in Borsod County, in black. The frieze coats with ma- chine-stitched decoration underwent a similar metamorphosis. The overall appliqué pattern 536 was in a single colour, and other colours were used only in the smaller insertions within the motifs. Later, even these few bright colours disappeared and only black cloth appliqué on the white frieze foundation was used. The fancy *szűr* finished its career in the eastern corner of the Great Plain and in Transylvania, in black and white.

After the gradual dissolution of the gentry, many of whom had taken up administrative positions, the taste which the peasant society came into contact with in the nineteenth cen- tury was that of the petit-bourgeois, a world of petit-bourgeois homes and costumes, their elaborate sideboards and crocheted covers, their kitchen wall-hangings pre-printed with sen- 63 timental scenes and ornate cushions, all reflecting the empty eclecticism of pseudo-historical styles. Though such sentimental and superficial dressing was strongly opposed to the robust vigour of peasant art, yet rural artisans and peasant artists were capable of making the most of this material. In the vine-growing villages along the northern coast of Lake Balaton, for instance, it became the fashion between 1860 and 1880 for a couple to set up a votive cross with the figures of their patron saints on the roadside or in front of their house, and to erect stone monuments, sometimes three or four metres high, in the churchyards. This sentimen- 70–71 tal, mass-produced ecclesiastical art with its plaster of Paris Madonnas and angels gave birth to the simplified, rustic, late style of village sculpture.

These crosses expressed both the trend towards more urban and bourgeois attitudes as well as peasant taste. The fact that the cemetery became the arena for rivalry among the villagers, each vying for superiority in size of monuments, and that these were worked in stone remaining as lasting memorials, betokens something essentially foreign to former peasant tradition. According to the old custom, a cross or a post carved of wood marked a grave and, even further back in time, a living tree or an unmarked natural rock. Yet these enormous stone crosses cannot be considered as imitations of urban models; the crosses in town cemeteries were not as large nor were the patron saints of the dead reproduced on urban monuments.

Two apparently contrary currents complement each other in the peasant life of this period. Technical modernization in agriculture and the reorganization of farming advanced rapidly: the old wooden plough and other home-made agricultural tools gave way to more practical, modern equipment and machine-made tools; new plants, crops and new kinds of livestock were introduced. All this meant changes in the organization of labour and marketing. At the same time the old pattern of peasant life was reflected in clothes, in the arrangement of the houses and in ceremonial and festive customs; all these economic developments appeared to invest new energy into the unfolding of peasant forms.

The contradictions of the period can be seen among groups of country people, farming in essentially the same way and on essentially the same technological level, some creating a colourful world of objects around themselves in the peasant style, others choosing a more neutral pseudo-urban way of life. One group might also prefer peasant forms of art in certain areas of their material culture while following tastes already regarded as bourgeois in other areas of life.

The contrast in the town of Kecskemét between the "peasant ladies" following the latest fashion and dressing in long silken gowns, with a parasol in their gloved hands, and their menfolk wearing boots, wide linen trousers and sheepskin cloaks, was noted in 1845. Between 1850 and 1860, painted furniture with floral design began to go out of fashion in Hódmező-vásárhely, while at the same time the production of pottery reached its height, and brandy bottles, flasks, plates and dishes in peasant style attained their greatest artistic achievement. Seamstresses made silk gowns for the young daughters and wives in country towns according to the latest style found in the Budapest fashion papers, but the sheepskin jackets and pelisses of these same women were embroidered by the local furriers with traditional peasant designs.

In the same country towns, the herdsmen's costumes and way of life followed a course of their own from the end of the century onwards. Even though farmers began to discard the embroidered frieze coat, it continued to exist as the typical costume of herdsmen. Other garments and accessories which were formerly in general use among the peasants were retained by the herdsmen as the distinctive signs of their more traditional social position.

397–401 Bagpipes, for instance, which were once the favourite musical instrument not only in small peasant villages but also at the court of the Prince of Transylvania, became restricted to herdsmen. The top of the bagpipe was made with skilled craftsmanship and was shaped like other objects made by herdsmen. Through their clinging to tradition, the herdsmen played a specific role in the country towns. In the church in the upper town of Szeged, for instance, the midnight mass on Christmas Eve, known as the "Herdsmen's Mass", was attended by herdsmen from the great pasture-lands belonging to the city, wrapped in their great sheepskin cloaks and carrying their bagpipes; it is still recalled that in the last century they used to perform a festive dance in church to the music of the bagpipes after mass. The herdsmen of Szeged

399, 401 were fond of bagpipes with a top in the shape of a young lady's head, representing town ladies with their special coiffure as imagined by herdsmen who lived far away from the town.

Already existing regional differences tended to increase during this period. The art of certain districts, or even villages, acquired specific characteristics. This is clearly seen in

48 embroidery as, for example, in two neighbouring regions in southern Transdanubia, the

villages of the Sárköz and those of the Drávaszög. The coifs for married women in both regions are embroidered with white yarn on a black background and the ornamental motifs stemmed from floral designs of the previous century. In the Sárköz, coifs were worn low over the forehead and their wide surface was decorated with motifs arranged side by side. In the Drávaszög, the coif was placed over the stiff, rounded knot of hair at the back of the head and its round surface was divided into two. In addition, the stitches and designs were also differently executed. In the Sárköz, the work was done in a fine bending chain-stitch and the tendency was to elaborate the design and use close, crowded patterns. In the Drávaszög, the embroidery was worked in mock satin-stitching and the tendency was just the contrary, to enlarge the pattern and give the impression of compact patches.

623–625
627–629

In actual fact, Hungarian peasant embroidery on linen was limited to relatively few basic forms of composition, but since it was worked according to differing local taste, on many different backgrounds, with numerous kinds of stitches, a great variety of forms was achieved. This can be clearly seen in comparing variations of the same composition. Photographs illustrating four variants of a symmetrical flower-cluster design from Transylvania, which can also be seen on Sárköz coifs and on an old *matyó* sheet border from Mezőkövesd, have been placed side by side for the purpose of comparison. The older Kalotaszeg embroidery is distinguished by the graceful linear design of the stems and flowers, worked in the square chain-stitch known as the *írásos* or pre-printed technique; at a later period the same type of work became simpler and more compact in its nature, according to the terminology of this book, more "peasant" in style. In nearby Torockó (Rimetea, Rumania) the flowers worked in a variant of long-armed cross-stitch became more rigid, aiming at patch effects. The latest of the examples shown is a mourning counterpane from the Mezőség (Cîmpia Ardealului) region in Transylvania where the execution of the work was less concerned with harmonious proportions and symmetry in the design; it seems to be improvised and less deft than the former pieces. The design is simplified, concentrating on the system of branches and achieving a rough sense of immediacy and vigour lacking in the more refined pieces.

625, 633
593–594

638

596

595

Another popular composition among the "old style" floral patterns is the curving scroll design where the flower motifs are set on alternate sides of a tendril. A variant from Torockó embroidered in the old manner is shown among the illustrations. It was originally a pillow-slip border and the pattern is an enlargement of one section of the undulating tendril. The tendril has lost its significance and seems to be a serpent; the pattern is locally called the serpent pattern. On a cross-stitched counterpane border from Torockó and on a counterpane border from Kalotaszeg, dated 1864, whole flower-clusters are set into the curves of the tendril, as in the serpent pattern pillow-slip borders. The difference in the type of work and perhaps the different intentions of the women who worked them produced two dissimilar effects. On the first, the curving tendril has stiffened into a geometrical curve and the pattern is looser, more linear, and well-proportioned; on the latter two, the curving lines of the square chain-stitch and the heavy motifs sewn with long-armed cross-stitch have developed into a closely knit pattern of patches. On a sheet from the Mezőség region, the flower designs have been replaced by huge single acorns, giving the pattern a strong vertical emphasis, while in the village of Mezőkeszü (Chesau, Rumania) in the same region, the design has been extended horizontally, with the flowers opened up and the design reduced to a geometric formula. Another piece of embroidery, a pillow-slip border from the same region, condenses the design into a crowded pattern, like thick foliage.

610

613–614

618

620

622

The pieces on which the composition becomes looser and on which the alterations in the design can be observed in the process of transition, are especially interesting. A design much in favour in old-style embroidery was the flower-cluster with a bird on each side. Embroideries of this type, illustrated in this volume, can be compared to those where the birds are not symmetrically placed among the scattered flowers. A funeral sheet from Pécs shows how the

601

embroiderer attempted to master her design, for the pattern has become enlarged and the elements from older variations are repeated, yet lifted from their original context; thus no fewer

603
than six peacocks and two pelicans are placed beside a single large flower-cluster. The figural
591
composition of Abraham's sacrifice, known from a variety of centuries old examples shown here as part of a ceremonial counterpane, may be seen in a transition stage on the end
592
border of a pillow-slip. As the biblical narrative has no role to play here the composition has been treated according to the laws of ornamental design. The earlier examples had already employed a mirror-like compositional design; here each of these scenes has become symmetrical with two Isaacs and two Angels appearing on either side of Abraham. Tiny flowers and birds fill in the gaps, and three or four small dogs walk along the patriarch's sword.

In the latter half of the nineteenth century the folk art of certain regions became increasingly differentiated in contrast to regions where folk costumes had been abandoned and where homes had lost their colourful peasant character; at the same time a few regions emerged which produced a folk art superior in nearly all genres to others. Public attention has been drawn to the art of these latter regions which have come to represent Hungarian folk art in general.

The forty or fifty Hungarian villages of the Kalotaszeg region west of Kolozsvár (Cluj-Napoca, Rumania) lying among the hills is a region where wood-carving, painted furniture and both men's and women's costumes were colourful and rich. Their homespuns and many kinds of embroidery attracted the attention of artists and art lovers relatively early. The "discovery" of Hungarian peasant art is said to have taken place here.

Another region of this kind was formed by five villages of the Sárköz region along the southern reaches of the Danube. After the regulation of rivers in the mid-nineteenth century these villages acquired new agricultural land and with it considerable prosperity. Both in the quality of the material used for women's clothes—silk, brocade, expensive trimmings and gold lace—and in the sophisticated use of colour and shape, together with the more distinctive effects achieved by the profusion of materials and garments, the people of the Sárköz region, it is fair to say, went furthest in the unfolding of the opportunities provided within the peasant style of dressing of the nineteenth century. In other genres as well, the people of the Sárköz made the most of the decorative possibilities offered. The whole surface of their
559
woven textiles was filled with patterns, the new embroideries on their coifs reorganized the
623–626
earlier design, at first in a thicker, closer design, and later in a more detailed one. The shin-
455
ing, brightly coloured dishes of the Sárköz kitchens, made expressly for them by the potters of Szekszárd and Baja, also achieved an unsurpassed level of decoration.

A third, particularly active centre for folk art was the country town of Mezőkövesd. With its urban background and large population, its artisan tradition, one might have thought it probable that it would have a greater chance to develop along bourgeois lines.

Until about 1860 the clothes of Mezőkövesd represented market town reserve and earlier rural simplicity. The embroideries of this period repeated the strictly composed designs of the preceding era, with symmetrical flower-clusters and loose wreath designs, although in a somewhat more vigorous manner, using only two colours, red and blue. The economic changes in the country, together with industrial development, forced a critical choice on the older type of country towns. In the 1870s, Mezőkövesd, which was regarded as a regional centre, switched over and became the leading inspiration of peasant taste and style for the neighbouring villages.

487
Costumes, in the vernacular manner, rioted with colour in Mezőkövesd. Even men's clothes shared in this luxuriance; the borders of the extraordinarily wide sleeves of their shirts were covered with embroidery. Furniture from Eger, painted red and with flower patterns, stood in the rooms of peasant homes. On the walls hung brilliantly decorated plates
50
made by the potters of Tiszafüred according to the demands of their Mezőkövesd customers,

and on the ceremonial bed the pillow-cases were made of brightly coloured cashmere, cotton or silk. The counterpanes were decorated with embroidery.

Mezőkövesd embroidery is a good example of the second wave of peasant art since it shows its distinctive features and the alteration in creative peasant attitudes. The change-over, it seems, began with the dissolution of the strict rules of composition practised earlier. The single motifs became independent, the composition now covered the entire surface. In some places the development of the designs stopped at this stage, scattering the enlarged but independent motifs all over the surface, as illustrated in a piece from Szentistván, a village near Mezőkövesd. In Mezőkövesd, however, new rules of composition soon organized these independent elements into a new integrated design: stems curving freely, in great variety, linked the single motifs. Compared with the alterations in composition, the colour scheme changed fairly late: green appears beside the red and the blue, then yellow and finally, the varying shades of these colours. Though it can be shown that certain motifs and techniques remained constant, a radically new style of embroidery came into existence. In place of the former design which was lucidly arranged since it was based on symmetry and repetition, and which stressed the individual motif, the new tendency was to cover the entire surface. The composition became free and flexible and made no attempt to stress any single element. Yet the totally embroidered surface had to be integrated and for this purpose rhythmical changes in colour were used.

The changes that took place did not occur in the taste of the peasant only (the Mezőkövesd embroideries were worked by peasant women), but also in the creative attitude of people as a whole. At most, the design of the pattern was entrusted to some peasant woman known for her skill in outlining the design on the linen. Before the changes in style, the attitude of the people of Mezőkövesd, also known as the Matyó, towards their own traditional *matyó* needle-work was impersonal and humble. It was this attitude which sustained their work, despite some of its local characteristics, within the framework of a style prevalent throughout the countryside. Though old Mezőkövesd embroidery differed in certain details, yet every known counterpane is embroidered in a familiar traditional design of symmetrical flower-clusters and wreaths. The switch to the new style meant the appearance of a new kind of initiative and a desire for the acclaim which came from the general taste for bright, lively, crowded, brilliantly coloured work, and for variations in design. The general public apparently favoured the new style of embroidery precisely because it was different from the work of other villages; it was more variegated and offered great opportunities for personal initiative. To take an example, when boys grew to be young men, they were given a shirt with wide embroidered sleeves. The women who designed the patterns introduced a new element into it every year, so that anybody well acquainted with the patterns could tell the age-group of a young man from his sleeve.

This inclination towards novelty and change is in marked contrast to the old descriptions of the peasant mentality which stress precisely the lack of desire for novelty, the aversion to innovation, the adherence to a strict traditionalism. The peasant communities creating the new style of folk art competed with one another and, through this continuous renewal in their work, were already part of a modernizing world, a world in which they had to adapt themselves to changes in economic and social structures, and a new, dynamic personality type, open to initiatives, was regarded as ideal.

The example of Mezőkövesd illustrates well the process set in motion when an area's surrounding society began to buy or commission locally-made ornamental objects, and when these objects began to circulate through town shops into bourgeois homes. The Matyó people of Mezőkövesd were discovered by the general public in the years preceding the First World War. In 1912, at the Opera Ball held in Budapest, the participants dressed in *matyó* costumes or garments embroidered with Mezőkövesd needlework. Soon, *matyó* embroidery

began to appear in urban homes on coverlets and cushion covers. At about the same time, new organizational forms of labour appeared; the large estates engaged seasonal workers for a lump sum (hence the labourers were called *summás* from the Latin *summa* or "sum") and young girls and women were also taken on in teams to go and work in distant parts of the country to tend the new plants and vegetables. The main region which provided seasonal labourers for distant estates was the overpopulated Mezőkövesd and its environs, since its inhabitants could not earn a living at home. The season lasted from three to eight months and earnings were supplemented by commercial embroidery at home, which gradually became a form of mass production. *Matyó* embroidery thus continued to exist on two different levels. For their own use the Matyó women continued to elaborate the decoration of their own costume, enriching the style which had evolved a few decades earlier. At the same time there was the embroidery made for sale, a mass-produced variant of the same style, but worked on cheap material, with large stitches and a muted colour scheme adapted to the bourgeois tastes of the early nineteenth century. So in addition to genuine folk art made by peasant women for peasants, a folk art arose which represented, imitated and interpreted it through the cheaper means of mass production according to the tastes of town-dwellers and non-locals.

The sale of these embroideries was not exclusively in the hands of merchants: the Mezőkövesd women themselves carried the pieces to town to sell, and among the customers were other peasants, living in the villages which were then passing through the transitional stage between old and new, who were beginning to abandon their former rituals and traditions, and who were still happy to buy *matyó* embroidery and *matyó* garments, partly in imitation of the fashions of the upper classes, partly through a nostalgia for the lost artistic forms of peasant life. This was the period when the villages all over the country, though depeasantized, tended to adopt new customs recalling their former peasant life, such as the wine harvest festival which became popular in regions where there were no vineyards, or the village dances, where instead of the old discarded peasant costumes a romantic generalized form of national dress was worn, the men's costumes imitating the wide linen trousers and voluminous sleeves of peasant dress, and the girls wearing red, white and green ribbons (the national colours) round the hem of their skirts, sleeveless jackets and head-dresses. The appearance of *matyó* embroidery and *matyó* dolls in peasant houses was a sign of the same sentimental feeling.

It must not be assumed that the production of a commercial folk art among the people of Mezőkövesd, now executed mostly by seasonal labourers working on distant estates, meant that the genuine kind of folk art had lost its old social and moral significance and validity. Proof of this can be seen in the deliberate change in the local costume introduced in 1924 by decision of the Elders of the community. For peasant fashions which changed every year resulted in a continual addition of decoration and women's costumes became overloaded with expensive gold and silver lace and fringes which were called "glitters". During Lent in 1924, the Elders of Mezőkövesd, the members of the church and the local magistracy, persuaded the priests of this very devout Catholic community to intervene. The priests ordained that from then on nobody could come to church in clothes decorated with golden tassels, trimmings, braid or "glitters", or several bands of Jacquard ribbons. As such highly decorated garments were only worn for church, their *raison d'être* ceased. That fact was instantly understood by the people of Mezőkövesd who listened to the sermon in which this proscription was announced and, as those who were present still remember, sobs were heard from the crowded rows of the young girls who most grieved for the glittering ornaments of their Sunday clothes. The following week the gilt trimming and glittering tassels cut off the garments were collected in a chapel, and the young girls themselves had to carry them in a procession to a bonfire lit in front of the parish church. From that moment gold lace disappeared from the costumes of Mezőkövesd.

The large Mezőkövesd society was able to alter its costume rapidly and uniformly, and to place this alteration in a broad context of social and divine order. The same society was equally capable of finding a general solution to compensate for the lost glitters. The Mezőkövesd women, who had developed a subtle aesthetic sense for the details of costume and embroidery, found the aprons without their trimmings scant and unsatisfactory, and, as a quick remedy, sewed on black silken tassels in their stead. In addition, within three or four weeks, throughout the population of 20,000, a new kind of decoration had sprung up, and the pattern of the gilt and silver lace was embroidered on the apron with artificial silk thread in yellow or white. By Easter the majority of the young girls and men went to church wearing aprons decorated in this manner.

This example shows very clearly the close relationship which existed between festive clothes and the Church service, and how variations in colour, ornament and form on the clothing of the participants marked the structure and local organization of the whole society. In Mezőkövesd it would never have occurred to anyone that the clothes decorated with gold lace might be worn on, say, Sunday afternoon, for parading on the street, or that simpler garments could be worn to church. With the ban on "glitters" for church, the reason for their existence had ceased.

In this late period of folk art, in certain regions where it continued to exist, festive and ceremonial objects were accumulated in unprecedented numbers. In the Sárköz villages where a strict system of birth control known as the "one-child" system resulted in a concentration of wealth and inherited legacies, sometimes not less than 200–300 woven table-cloths for festival occasions, and 60, 70 or even 100 large glazed earthenware dishes could be found in the households of the decreasing number of the original inhabitants. Parallel with this accumulation and multiplication of objects went forms of decoration often exaggerated to the extreme. All the earlier styles of folk art were distinguished by an unfailing sense of proportion, which set certain standards of taste. In this late period, however, the signs of decadence and distortion were already beginning to appear in the changes made in the style of decoration.

The tendency to overcrowd the design and fill in the whole surface led to the transformation of the well defined linear square chain-stitch work of Kalotaszeg into a closely filled **613** patch in which both composition and single motifs were lost. Another similar example from a region many hundreds of miles away is the white and black embroidery of the Sárköz coifs, worked with minute stitches, which became condensed in the same way, until the entire embroidery became a single strip.

The progress of the ornamentation also led to bigger designs and larger patterns. The result was sometimes quite successful, as in the border of a counterpane from the village of Szentistván, where flowers the size of sunflowers were arranged in a row. Often, however, **634** the enlargement of the ornamentation led to a deterioration in the quality of the work; late frieze coats, for instance, were worked in large, rough stitches. On some frieze coats the embroidery spread to cover the whole surface of the coat, thus losing the contrast which formerly existed between the large white or dark surface and the strong colours of the embroidery. It is difficult to get an impression of these somewhat distorted developments from the illustrations reproduced in this book, for in selecting them, naturally the best, most classical objects were chosen to represent each period of folk art. Nor are there any illustrations for the very last period of spontaneous folk art, which cannot correctly be inserted in the category of new peasant art (mostly from the nineteenth century), and might perhaps be described as the most recent folk art.

These new tendencies appeared at the beginning of the twentieth century in a surprisingly similar form in villages lying distant from one another and continued to develop along similar lines between the two wars. At a comparatively late date these villages were raised

above the average standard of their peasant neighbourhoods by an economic differentiation in production and they acquired greater wealth than the other villages through horticulture and market-gardening. Frequent trips to the market in the neighbouring town or city gave an increased mobility to their way of life, and their folk art developed along the lines of this increased contact.

The most characteristic manifestation of this very late folk art is the embroidery on clothes which began with the white embroidery or one-coloured pre-printed embroidering of printed patterns from the towns, and later evolved into multicoloured embroidery, with patterns of flowers in their natural colours. This embroidery was not for the valuable "Sunday best", but for the cheap washable linen garments worn on half-holidays and weekdays. It changed with the rapid changes in fashion and each generation had its favourite pattern for this kind of embroidery, which was designed by designer-women of each respective age-group.

In contrast to those older pieces of bed-clothing, and the later peasant-style ones made of fine materials and durable enough to last for generations, the clothes decorated with the newest style of embroidery were short-lived, but gay and fashionable. And it was tpyical of the seasonal labourers of Mezőkövesd, who kept their treasured costumes embroidered in the peasant manner at home, that when working on distant estates where these garments could not be taken, they wore the cheap washable clothes embroidered with the newest type of needlework.

The title chosen by Johann Gottfried Herder for his book, mostly a collection of folk poetry, was *Stimmen der Völker in Liedern*. The assumption that folk poetry represents the true and genuine character of a nation, that it is the voice of the people, has been an impelling force in folkloristics. In the process of discovering folk culture, attention was paid to decorative objects only at a late stage, and even then that study was closely connected with the aim of finding and defining national characteristics. Those who discovered folk art, and many who followed them, regarded rural art as a mirror which reflected ancestral tastes in art and the particular qualities which distinguish a nation. The differences between the folk art of the various European nations are, of course, obvious. Regions vary in their preference for certain genres and crafts, certain motifs and themes, and certain colour schemes. An aggregate of various objects differing in their material, function and form, which represent the folk art of various peoples, seems, even to the uninitiated outsider, to represent personalities and temperaments of different types. Such impressions are difficult to embody in scientific definitions. Works of folk art which are heterogeneous in material and shape may escape all well-defined categories of style.

The writers of this book are not primarily concerned here with a search for the artistic characteristics that may be common to Hungarian peasant art under discussion, but rather in continuing the train of thought begun in the earlier chapters. The point of interest is still the peasant world of objects. The size and composition of this world, with the beautiful objects which are included in it, was something clearly variable, and these alterations were connected with the changing conditions of peasant life, with the economic and social position and the aspirations of the peasants themselves. The historical circumstances which at any given time demarcated the relationships among the various social groups and social strata in a complex national society and determined the circulation of material belongings, ideals and fashions in the lives of a particular family, village or region, were reflected even in a single peasant house, and even more so, in individual villages and regions. Considered from this point of view, the authors hope they have been successful in explaining some of the differences between the art of the various smaller Hungarian regions and localities. Now we shall try to consider the art of these peasant groups in a wider context, embracing all the regions of Europe, in the hope of discovering what was unique in the social conditions which formed the background of Hungarian peasant art over a period of 300 years. The changing historical situation might provide a key to the understanding of the overall qualities of rural art in Hungary, despite all its variations in genre and local style.

It is true that even if we focus on the rather more prosaic material nature of folk art and on the social situation of the lower strata, we still must rely heavily on personal impressions when making such comparisons. What exactly does "peasant" mean? What is the significance of the word "folk"? To be more precise: what is considered "rural" or "popular", and what "urban" or "bourgeois" among peasants and other strata of society in the historical condition of any given time? To establish the social connotations of folk art one would have to make a precise reconstruction of these evaluations. But that rarely happens. The

waxed moustaches of the nineteenth-century Hungarian herdsmen, as well as the way they wore their kerchiefs, would be considered something very "peasant" today; yet in the eyes of their contemporaries, these characteristics pointed them out as country dandies following a city vogue and aping the gentry. The loose kerchief of a herdsman on the Hortobágy was described by an observer in 1845 as being "a black muslin twisted round his neck à la Byron". Even greater possibilities of error through subjective misinterpretation are likely if one attempts to compare the costumes and furniture of different peoples. The carved wardrobes, grandfather clocks, cast iron ovens and glazed earthenware tiles which fall within the category of folk art in the Rhine provinces and the Netherlands were considered by Hungarian peasants to be urban and even suitable for gentlemen's homes.

It would be valuable to have the judgement of scholars conversant with the folk art of other European peoples on what is considered by researchers as peculiar to Hungarian examples of folk art, and how these differ from others. Such evaluations, however, do not exist, and the writers of this book are consequently forced to offer their own opinions from a Hungarian standpoint. Therefore, an attempt has been made which is based on Hungarian folk art from within, as it were, to make a survey of the question: how does the folk art of the peoples surrounding Hungary differ from our own?

Hungary is not unsuitable as the base of such a European survey, for the country enjoys a position as a centre of transition on the historical, sociological and cultural maps of Europe. For centuries, Hungarian village life was regulated by feudal institutions on the pattern of those in central and western Europe. One by one, it was hit by the waves of European artistic, religious and intellectual currents, and often in its most Eastern versions. On the other hand, for hundreds of years the economy of Hungary followed mostly an eastern European pattern of development, and the life and culture of Hungarian villages possessed many characteristics in common with its eastern and southern neighbours. Hungarian peasant culture is bound both to the East and the West, but nevertheless in both directions there are definite distinctions to be noted.

If we consider the number of peasants in proportion to the population as a whole, the intermediate position of Hungary becomes clear. Between 1930 and 1940 the agrarian population of Hungary still constituted a majority, standing at 50.8 per cent. During the same period, the agricultural population of Great Britain was less than 6 per cent, Switzerland and Holland around 20 per cent, Germany, Austria and Denmark about 30 per cent, France around 34 per cent. In Poland and the Balkans, on the other hand, the agrarian population amounted to approximately 80 per cent of the whole. How far those living from working the soil are to be reckoned as peasants will not be discussed here. In any case, in Hungary the majority of them lived the life of peasants, and this was also particularly true of countries to the east and south of Hungary.

These rough percentages demonstrate the differences in historical development. At the time of the survey and even earlier, western European farms were larger and more productive and consequently more prosperous than Hungarian peasant farms, which in turn were richer than those in the countries to the east in terms of productivity and life standard. The rural population of western Europe was part of a society urbanized fairly early, and to a much greater degree than Hungary. It was supplied with commodities by craftsmen and merchants living in a close network of cities and towns, and finally, by a quickly developing manufacturing industry, while in Hungary urban development came to a halt at the end of the Middle Ages, cities remained alien to the peasants and only agrarian towns evolved in rural districts. About 1830 Hungarian statisticians noted with regret that in Hungary only one in every 78 inhabitants was an artisan (according to another reckoning one in every 51), while in Lombardy there was one to every 9 inhabitants and in Lower Austria one to every 15. But even this low percentage of artisans and the slow rate of the central European type of urban

development was in advance of those regions which were subjected to five centuries of Ottoman rule. The result was that from the eighteenth century onwards Hungarian industry and the modernization of Hungarian agriculture suffered a time-lag in comparison with her immediate western neighbours, although it was in advance of other eastern European countries by at least one generation.

These differences in the rate of modernization are reflected in the folk art of each nation. In Hungary, as early as the second half of the last century, and still more so in the period between the two wars, the disintegration of the former rural way of life can be observed, the abandoning of peasant costumes and a decadence in the newer examples of folk art. In Yugoslavia, Rumania and Bulgaria, it appears, the popular art of many regions has continued to thrive more vigorously and creatively up to the present day.

If we look at the West as presented either in books on folk art or in folk art exhibitions, the artefacts inherited seem to have their origins in a far more distant past. In Austria, the eighteenth and nineteenth centuries are of equal importance in terms of the production of works of folk art and there are even significant groups of objects dating from the seventeenth century. The peak of folk art was reached about two generations earlier than in Hungary, where the nineteenth century saw the flowering of folk art, both in quantity and range, and the peak periods of certain regions and genres extend beyond the turn of the century. Experts agree that in Germany the second half of the eighteenth century was the climactic period which lasted until the middle of the nineteenth and had its beginnings in the sixteenth century.

Similar differences in time can be seen in the diffusion and popularity of certain genres and types of objects. Painted or carved bridal chests, for instance, were replaced by wardrobes in certain regions of France between 1740 and 1780. In the same period in Hungary, painted chests made only a sporadic appearance replacing the more archaic carpenter-made wooden chests used as bridal chests, but in the nineteenth century the painted softwood chest with a floral design became general throughout the country. The wardrobe really only made its appearance when the interior of the house was no longer peasant in character. It was a piece of furniture expressing bourgeois aspirations and appeared so late in the nineteenth century that there are hardly any known examples of wardrobes painted with floral decoration from Hungarian villages. In the Balkan countries the painted chest appeared generations later than in Hungary, and in many regions it never became part of the traditional rural interior at all. The brightly coloured materials, the textiles which gave rise to variegated new types of costume and garments in Hungary in the 1820s and 1830s were quite general in Austria and Germany a generation earlier. The wealthy peasant women of southern Sweden met with the same reproaches for their extravagance in fashionable clothes at the beginning of the eighteenth century as were levelled against Hungarian peasant women for similar behaviour only a century later.

These differences in time resulted in the most distinctively creative periods of the folk art of the various countries developing under different historical and artistic climates.

Viewed side by side with Hungarian folk art, Austrian folk art is clearly imbued with elements deriving from the baroque, the rococo and the Louis XVI or *Zopf* styles, all of which make their appearance in Hungarian folk art as well, but without becoming dominant. One reason for this difference in emphasis may be that these styles produced a much greater number of works in Austria in the sphere of "high art", as well as the fact that the emerging rural pomp among the Austrian peasantry had already stamped many ornamental objects with the fashionable decoration of the day. But it must also be remembered that in Austria the production of ornamental objects was much more the province of professional artisans, who were well acquainted with the current artistic forms of the time.

It is interesting to observe which factors existed to influence the distance between the

artistic tendencies of the higher and lower strata of society, that is to say, in what manner the distance between the peasantry and the urban population was widened or narrowed. When agriculture prospered, when the lot of the peasants was improving, when money was plentiful, their costumes and material belongings seem to have approached the level of those of the bourgeoisie. In the period when the shapes and ornamentation of Western and Central European folk art came into being, the revolution in prices, beginning in 1550 and lasting for about a century, must have played a significant role, as the price of agricultural produce rose and the rural standard of living rose correspondingly. At the turn of the sixteenth and seventeenth centuries, Shakespeare puts the following words into Hamlet's mouth, expressing his astonishment at the fashionable joking of the grave-diggers: "By the Lord, Horatio, these three years I have taken note of it; the age is grown so picked that the toe of the peasant comes so near the heel of the courtier, he galls his kibe." English country folk, it appears, managed to come so close to the bourgeois standard of living that no art which might be termed folk art in the continental sense ever developed among them. It was in this period, the sixteenth to seventeenth centuries, that peasant festive and ceremonial customs were first consciously observed; in Germany and the Netherlands peasants appear in urban, bourgeois paintings which depict peasant weddings, fairs and inn-scenes. (The peasants are often grotesquely represented, a fact which has been interpreted by certain agricultural historians as signs of the envy felt by the townsfolk for the prosperity of the peasants.) This is the period when many new kinds of objects were introduced to the rural inhabitants of Western Europe: lead-glazed pottery and faience, painted furniture and furniture made by cabinet-makers, etc., which attained their specifically rural, peasant forms in the following centuries, after the period of prosperity ended. "That which we call folk art," wrote Arnold Hauser, perhaps somewhat too pointedly, "came into existence in the eighteenth century. Not only most of the folk-songs which are known and still sung date from that century, but practically the whole set of ornaments of the newer folk art as well. That was the time when most of the patterns of woven textiles, embroidery and lace came into existence, together with the decorations on jugs and plates, and the various types of furniture and domestic implements..."

In Hungary, as related in the previous chapters, folk art also evolved in conjunction with a sudden upswing in agriculture. It was the interplay of particular historical and sociological factors which led to a consciously peasant style in the development of folk art.

Peasant society at the beginning of this development was poorer and more isolated in Hungary than in the West, and far more dependent on itself for the production not only of the simple necessities of everyday life, but of elaborate, festive and ceremonial artefacts as well. The social orientation of such a peasantry was not so much towards the towns, which were few, and whose citizenry were mostly of foreign origin, but rather towards the lesser nobility, the country gentry, who were far more populous and much more closely connected with the village inhabitants than in the western parts of Europe. According to the historian Kálmán Benda, in the second half of the eighteenth century 4.4 per cent of the population of Hungary belonged to the nobility, while the bourgeoisie made up 1.5 to 2 per cent of the populace. (In the Austrian and Bohemian provinces, the bourgeoisie made up 4 to 5 per cent of the population and there were perhaps only half as many nobles as in Hungary. In contrast, in some of the provinces of Poland one in every ten people was a noble. In France the nobility numbered less than 1 per cent, whereas the bourgeoisie constituted about 10 to 12 per cent of the population.) When the villagers rose socially in order to free themselves from their feudal peasant status it was not the inhabitants of distant cities whom they chose to emulate but, in addition to the peasants living in country towns—men like themselves—it was first and foremost the lesser nobles who served as their models, and indeed the number of lesser nobles swelled considerably with the addition of the peasants who were elevated to

their ranks. Features characteristic of the world of the lesser nobility can be found in old ornamental styles and in village songs of the eighteenth century, and even the new wave in folk art of the nineteenth century did not at first discard the features which recalled its influence.

In addition to identical features as regards the form and style of objects, correlation in the behaviour, in the great importance attributed to the gestures appropriate to festive and ceremonial occasions, to social merry-making on holidays and to the display of beautiful objects—which meant sacrifices out of proportion to the dwarf holdings of peasants and their income—similarities may be noticed between the attitudes of the peasantry and the rural nobility, who, for the most part, were equally intent on maintaining the traditional festive and ceremonial forms of noble life on a small estate and a narrow income.

In the decades following the liberation of the serfs, when the production of ornamental objects for peasants was at its most prolific, and cities, developing into industrial centres, became even more alien to the peasants, peasant tradition in isolated villages became aware of a strong current of support from the populist nationalist movements of the age. Artisans who had previously worked for peasants, bourgeoisie and noblemen alike, now worked only for peasant customers and, due to the diminished connection with upper-class fashions, continued to elaborate the traditional wealth of patterns according to the taste of their peasant customers.

In considering peasant art from the material side alone, this late rural display in Hungary, it appears, did not lead to the accumulation of such great wealth in the peasant houses as it did in the earlier periods of a truly flowering folk art among the rich peasants of western Europe. Books on folk art naturally demonstrate first of all the peak points of that art, and do not usually show the average levels existing below them, or the stratification in the poorer layers of society. The peak levels, however, are also revealing. Hungarian peasant houses, for instance—even the largest and most beautiful—should not be compared to the high, many-storeyed houses with large halls of the Netherlands, or northern Germany, or the huge buildings of several storeys in the Alps housing not only the family but also a number of farm-hands. Such buildings often date from the sixteenth or seventeenth centuries, while in Hungary the oldest existing peasant houses were built in the eighteenth century.

The difference does not only lie in the distinct, clearly marked architectural periods in which peasant houses were built. Even in later times, Hungarian peasant houses were not planned to last several centuries. The method of house building in Hungary, even in the recent past, was by the joint work of relatives and neighbours, the walls of the house being constructed in a single day from traditional building materials, clay or mud bricks. The great buildings of the Netherlands and the Alps, on the other hand, were the work of professional artisans and the same is true for the wooden wall panelling and tiles and the cast iron or faience stoves. In Hungary, the house and its furnishing involved far less work by professional artisans and manufacturers; there were hardly any pewter and copper vessels, or faience dishes in the house, little hardwood furniture with turned or carved decoration, and very few textiles made by professional weavers, nor damask cloths with figural patterns.

If we consider, however, the 30 to 40 silk dresses of a young girl from one of the Sárköz villages, the 200 to 300 patterned, woven tablecloths, the sheepskin cloaks of the men, each one made from up to 20 sheepskins and taking many months to embroider, or the necklaces of the women, sometimes containing three rows of gold or silver coins, we will hardly underestimate the material investment and value which the art of Hungarian peasants represented. Much of this wealth, however, was concentrated on objects of an ephemeral, temporal nature, firmly rooted in the peasant background.

In term of artistic creation, this same condition produced distinctive opportunities for Hungarian peasants. They were, it is true, culturally left to themselves, but they were driven by the initiative and enterprise characteristic of the age of modernization and created an 59

impressive variety of distinctive forms within the multitude of local styles and genres. Many a composition and motif was given its most original, most "Hungarian" form in this late period, such as the floral designs which the artistic current of the sixteenth to seventeenth centuries had brought into vogue and introduced into the Hungarian countryside, as well as many of the elemental, archaic decorative designs common to a number of other European regions. It appears that the Hungarian peasants created their most specifically Hungarian works of art through the use of the legacy bequeathed to them by European historical styles and the heritage of rural life emerging in the Middle Ages, at a time when, due to the rapidly changing historical environment, the peoples whose cultures in earlier times had been closely interlinked now seemed to diverge more, and the line taken by the Hungarians moved away from both its western and eastern neighbours.

This, of course, is only a description and a historical sketch of circumstances which is designed to help give an understanding of folk art. Those who wish to hear the authentic "voice of the Hungarians" in folk poetry and in the design of decorative objects must listen to the songs and see the objects themselves. The rest of this volume is devoted to the presentation of such objects, which speak for themselves.

The task of the ethnographer or cultural anthropologist has been adequately defined as that of "translating", or making comprehensible, the phenomena of certain ways of life and of cultures for men living in other cultures. The text of this volume is a commentary on the folk art presented herein with this ethnographical attitude in mind. It is designed to speak to people, neither Hungarian nor peasant, of the significance and value of these objects, which were made for Hungarian peasants living far from the reader in time, space, and life-style.

As a result of this attitude, these objects have been described in the context of the peasant's life in his village, of weddings and funerals, of struggle, sacrifice and joy. Account has been taken of the vicissitudes of the peasantry's fortunes, and the fate of the Hungarian-speaking people during the last three centuries of transformation in Europe. It is part of the essence of the objects of folk art that they are capable of a many-sided and rich manifestation of these factors. In their existence as artefacts in everyday use or in their role as ritual or festive objects, they were not only witnesses to the progress of human life and to various societies, but direct participants. They were not only made to be beautiful, they were made to fit into the human hand, offering wine or cracking a nut, signalling unmistakably to the world that their owner was courting a girl, or mourning a loved one at the bier. They can only be fully understood in their entirety if the role they formerly played (even though present attitudes to art do not regard this as strictly "artistic") is also made plain. This sort of information supplied by an ethnographer helps in the interpretation of the illustrations; the reader can hear the "voice of the Hungarians" while looking at the photographs, the voice of peasants and country people living many generations ago.

If we place the objects in their historical, geographical and social environment we can better understand where this section or band of colour falls within the spectrum of human art. Perhaps then we can also understand that these objects reveal a blueprint, carefully elaborated over the centuries, for a way of life and for an orientation to the world and to society. Of course, they constitute only one of the numerous blueprints worked out during the changing directions man's history has taken, all of which have become our heritage, and the grasp of which enhances our understanding of our own existence.

The most important general works and detailed studies
on Hungarian folk art

BALOGH, ILONA: *Magyar fatornyok* [Hungarian Wooden Belfries].
Budapest, 1935
BALOGH, JOLÁN: "A népművészet és a történeti stílusok" [Folk Art
and the Historical Styles]. *Néprajzi Értesítő* XLIX (1967), 73–165
BÁTKY, ZSIGMOND: "Szarvasagancs lőportartóink ornamentikájához"
[On the Ornamentation of Horn Gunpowder Flasks in Hungary].
Néprajzi Értesítő XVIII (1926), 1–11
BÁTKY, ZSIGMOND: Pásztor ivópoharak–*Hirten Schöpfkellen*. Budapest, 1928
BÁTKY, ZSIGMOND–GYÖRFFY, ISTVÁN–VISKI, KÁROLY: *A magyar népművészet*
[Hungarian Folk Art]. Budapest, 1928
BÁTKY, SIGISMUND–GYÖRFFY, ETIENNE: *L'Art populaire hongrois*. Introduction
par Charles Viski. Budapest, 1928
K. CSILLÉRY, KLÁRA: "Le coffre de charpenterie." *Acta Ethnographica* I (1950),
237–330
K. CSILLÉRY, KLÁRA: "Az ácsolt láda" [The Hewn Chest]. *A Magyar
Tudományos Akadémia II. Oszt. Közleményei* I/2 (1951), 231–284
K. CSILLÉRY, KLÁRA: *Hungarian Peasant Furniture*. Budapest, 1972
DOMANOVSZKY, GYÖRGY: *Mezőcsáti kerámia* [Mezőcsát Pottery]. Budapest, 1953
DOMANOVSZKY, GYÖRGY: *Hungarian Pottery*. Budapest, 1968
FÉL, EDIT: *Ungarische Volksstickerei*. Budapest, 1961
FÉL, EDIT–HOFER, TAMÁS: *Saints, Soldiers, Shepherds: The Human Figure
in Hungarian Folk Art*. Budapest, 1966
FÉL, EDIT–HOFER, TAMÁS–K. CSILLÉRY, KLÁRA: *Hungarian Peasant Art*.
2nd ed. Budapest, 1969
FERENCZ, KORNÉLIA–PALOTAY, GERTRUD: *Hímzőmesterség. A magyarországi
népi hímzések öltéstechnikája* [Needlecraft. The Stitches Used in Popular
Hungarian Embroidery]. Budapest, 1940
GYÖRFFY, ISTVÁN: *Magyar népi ruhahímzések I. Cifraszűr* [Popular Hungarian
Embroidery in Wearing Apparel. I. The Embroidered Frieze Coat].
Budapest, 1930
GYÖRFFY, ISTVÁN: *Matyó népviselet* [Folk Costume of the Matyó]. Budapest, 1956
KÁROLYI, ANTAL–PERÉNYI, IMRE–TÓTH, KÁLMÁN–VARGHA, LÁSZLÓ:
A magyar falu építészete [The Architecture of Hungarian Villages]. Budapest,
1955
KÓS, KÁROLY: *Népélet és néphagyomány. Tíz tanulmány* [Folk Life and Folk
Tradition. Ten Studies]. Bucharest, 1972
KÓS, KÁROLY–SZENTIMREI, JUDIT–NAGY, JENŐ: *Kászoni székely népművészet*
[The Folk Art of the Székely People in the Kászon District]. Bucharest, 1972
KRESZ, MÁRIA: *Ungarische Bauerntrachten* 1810–1867. Berlin–Budapest, 1957
KRESZ, MÁRIA: "Fazekas, korsós, tálas" [Potter, Jugmaker, Dishmaker].
Ethnographia 71 (1960), 297–379
MADARASSY, LÁSZLÓ: *Dunántúli tükrösök* [Transdanubian Mirror Cases].
Budapest, 1932
MADARASSY, LÁSZLÓ: *Művészkedő magyar pásztorok* [Hungarian Herdsman
Artists]. Budapest, 1934
MALONYAY, DEZSŐ: *A magyar nép művészete* I–V [Hungarian Folk Art, vols.
I–V]. Budapest, 1907–1922
MANGA, JÁNOS: *Herdsmen's Art in Hungary*. Budapest, 1972
ORTUTAY, GYULA: *A magyar népművészet*. I–II [Hungarian Folk Art, vols.
I–II]. Budapest, 1941
PALOTAY, GERTRUD: *A szolnok-dobokai Szék magyar hímzései* [Hungarian
Embroidery from Szék in Szolnok-Doboka County]. Kolozsvár, 1944
TOMBOR, ILONA: *Old Hungarian Painted Woodwork, 15th–19th Centuries*.
Budapest, 1967
TOMBOR, ILONA: *Magyarországi festett famennyezetek és rokon emlékek
a XV–XIX. századból* [Painted Wooden Ceilings and Similar Historical
Monuments from the Fifteenth to Nineteenth Century in Hungary].
Budapest, 1968
VISKI, KÁROLY: *Székely szőnyegek* [Székely Carpets]. Budapest, 1928
VISKI, KÁROLY: "Díszítőművészet" [Decorative Art]. In: Bátky, Zsigmond–
Györffy, István–Viski, Károly: *A Magyarság Néprajza* II [The Ethnography
of the Hungarians, vol. II]. 2nd ed. Budapest, (1942), 274–395

Bibliography

Further works which have provided information and ideas:

APOR, PÉTER: *Metamorphosis Transylvaniae azaz Erdélynek változása*
[The Metamorphosis or Transformation of Transylvania]. (1736).
Budapest, 1972

BALOGH, JOLÁN: *Az erdélyi renaissance. I* [The Renaissance in Transylvania,
vol. I]. Kolozsvár, 1943

BARTÓK, BÉLA: "Die Volksmusik der Magyaren und der benachbarten Völker."
Ungarische Jahrbücher XV (Berlin, 1935), 194–258

BARTÓK, BÉLA: "Népzenénk és a szomszéd népek népzenéje" [Our Folk
Music and the Folk Music of Neighbouring Peoples]. In: *Bartók Béla
összegyűjtött írásai* [The Collected Writings of Béla Bartók]. Prepared
for publication by András Szőllősy. Budapest, 1966, 403–461

BATÁRI, FERENC: "Asztalos legények Győrött a XVII. században"
[Joiner Journeymen in Győr in the Seventeenth Century]. *Arrabona*
IX (1967), 93–126

BEREND, T. IVÁN–RÁNKI, GYÖRGY: *Közép-Kelet-Európa gazdasági fejlődése
a 19–20. században* [The Economic Development of Central Eastern Europe
in the Nineteenth and Twentieth Centuries]. Budapest, 1969

CUGH, DEZSŐ: "Magyarszombatfa és környéke fazekassága" [The Pottery
of Magyarszombatfa and the Neighbouring Region]. In: *Népünk hagyományaiból*
[The Traditions of Our People]. Budapest, 1955, 45–54

ERIXON, SIGURD: "Volkskunst und Kunstkultur." *Volkswerk, Jahrbuch
des Staatlichen Museums für Deutsche Volkskunde*. Berlin, 1941, 36–49

Europa et Hungaria. Congressus Ethnographicus in Hungaria 16–20 X (1963),
Budapest. Ed. by Gy. Ortutay and T. Bodrogi. Budapest, 1965

GÖNCZI, FERENC: "A cifraszűrök készítésének és viselésének eltiltása"
[The Ban on the Making and Wearing of Embroidered Frieze Coats].
Néprajzi Értesítő XXXIV (1942), 268–272

GYÍMESI, SÁNDOR: "A kapitalizmus és a parasztgazdaság" [Capitalism
and the Peasant Farm]. *Ethnographia* 79 (1968), 149–162

GYÖRFFY, ISTVÁN: "A nagykun viselet a XVIII. században" [The Costume
of the Great Cumanians in the Eighteenth Century]. *Ethnographia* 48 (1937),
114–139, 362–374

HAUSER, ARNOLD: "Kunstgeschichte nach Bildungsschichten: Volkskunst
und volkstümliche Kunst." *Philosophie der Kunstgeschichte*. München,
1958, 307–404

HUXLEY, SIR JULIAN (organizer): "A Discussion on Ritualization
of Behaviour in Animals and Man." *Philosophical Transactions of the Royal
Society of London*. Series B, No. 772. London, 1966

KEPES, GYÖRGY (editor): *The Man-Made Object*. New York, 1965

KISS, LAJOS: "Vásárhelyi tálasok" [The Dishmakers of Vásárhely].
Vásárhelyi Kistükör (1964), 289–389

KODÁLY, ZOLTÁN: *Visszatekintés* I–II. Ed. by Ferenc Bónis. Budapest,
1974. *Összegyűjtött írások, beszédek, nyilatkozatok*. II [Collected Writings,
Lectures, Statements, vol. II]. Budapest, 1964

MEYER-HEISIG, ERICH: *Deutsche Volkskunst*. München, 1954

MORVAY, JUDIT: "Cserépedények a mezőkövesdiek kultúrájában"
[Pottery in the Culture of the Mezőkövesd People]. *Néprajzi Értesítő*
XXXVI (1955), 31–63

NÉMETH, JÓZSEF: "A sümegi népi fazekasság" [The Folk Pottery of Sümeg].
Néprajzi Közlemények V/1 (1960), 186–235

PAPP, LÁSZLÓ: "A kecskeméti viselet múltja" [The History of the Costumes
Worn in Kecskemét]. *Néprajzi Értesítő* XXII (1930), 14–46

READ, HERBERT: *The Origins of Form in Art*. London, 1965

REDFIELD, ROBERT: *Peasant Society and Culture*. Chicago, 1956

SCHMIDT, LEOPOLD: *Volkskunst in Österreich*. Wien–Hannover, 1966

SLICHER VAN BARTH, B. H.: *The Agrarian History of Western Europe A.D.
500–1850*. London, 1963

SVENSSON, SIGFRID: *Skånes folkdräkter. En dräkthistorisk undersökning 1500–1900*.
Stockholm, 1935

SZABÓ, ISTVÁN (editor): *A parasztság Magyarországon a kapitalizmus
korában 1848–1914*. I–II. [The Hungarian Peasantry in the Period
of Capitalism, 1848–1914, vols. I–II]. Budapest, 1965

SZABOLCSI, BENCE: "A magyar zene stílusfordulója a XVIII. században.
Adatok az 'új népdal' történetéhez" [The Change of Style in Hungarian
Music in the Eighteenth Century. Data on the History of the "New
Folk-Song"]. In: *A magyar zene évszázadai. Tanulmányok*. II. [Centuries
of Hungarian Music. Studies, vol. II]. Budapest, 1961, 121–150

SZÁDECZKY, LAJOS: *Iparfejlődés és céhek története Magyarországon*
[The Development of Industry and the History of Guilds in Hungary].
Budapest, 1913

SZIMICS, MÁRIA: *A debreceni országos vásárok története* [The History
of National Country Fairs in Debrecen]. Budapest, 1938

TAKÁCS, LAJOS: "A cifraszűrök eltiltása Vas vármegyében (1816–1817)"
[The Ban of the Embroidered Frieze Coats in Vas County, 1816–1817].
Néprajzi Közlemények III/1–2 (1958), 326–328

TARDIEU, SUSANNE: *La Vie domestique dans le Mâçonnais rural préindustriel.*
Paris, 1964

THESCHEDIK, SÁMUEL: *A' Paraszt Ember Magyar Országban Mitsoda és mi
lehetne* [Peasant Man in Hungary: What He Is and What He Could Be].
Pécs, 1786

TURNER, VICTOR W: "Forms of Symbolic Action: Introduction." In: *Forms
of Symbolic Action.* Proceedings of the 1969 Annual Spring Meeting
of the American Ethnological Society. Seattle and London, 1969, 3–25

VARGA, GYULA: "Egy parasztporta leltára 1806-ban" [The Inventory
of a Peasant Household in 1806]. *Múzeumi Kurír* (1970/1), 8–17

VISKI, KÁROLY: "Népi és úri műveltség összefüggései a tárgyi néprajzban"
[The Interrelationship of Peasant and Upper Class Cultures in Material Culture].
In: *Úr és paraszt a magyar élet egységében* [Gentlemen and Peasants
in the Context of Hungarian Life]. Ed. by Sándor Eckhardt.
Budapest, 1941, 135–160

WARRINER, DOREEN: *Economics of Peasant Farming.* London–New York–
Toronto, 1939

ZOLTAI, LAJOS: "A debreceni viselet a XVI–XVIII. században"
[The Debrecen Costume in the Sixteenth to Eighteenth Century].
Ethnographia 49 (1938), 75–108, 287–315

Illustrations

The text of the captions is designed to provide the most important information
on the form, production technique, colour and function of the objects,
as well as a basic measurement, usually the height (when photographed
in detail, the height of the detail), of the objects reproduced. Inscriptions,
initials and dates on the objects are also given in the text.
The place names refer to the locality where the object, now in a museum
or a collection, was originally discovered, or where it may still be found.
In the case of pottery and other artefacts the place of manufacture
is also given.
The majority of the objects illustrated are in the collection of the Ethnographical
Museum of Budapest. Thus, reference to the Museum is made without
including the name of Hungary's capital. Many provincial museums,
ecclesiastical authorities and private collectors have given permission
for objects from their collections to be photographed for the present volume.
Thus it has been possible to reproduce objects in the possession of the Palóc
Museum, Balassagyarmat, the Déri Museum, Debrecen, the Dobó István
Museum, Eger, the Tornyai János Museum, Hódmezővásárhely,
the Rippl-Rónai Museum, Kaposvár, the Győrffy István Museum, Karcag,
the Balaton Museum, Keszthely, the Kiskun Museum, Kiskunfélegyháza,
the Herman Ottó Museum, Miskolc, the Palóc House, Parád,
belonging to the local museum authority of Heves County, the Janus Pannonius
Museum, Pécs, the Local History Museum, Ráckeve, the Liszt Ferenc
Museum, Sopron, the Móra Ferenc Museum, Szeged, the István Király
Museum, Székesfehérvár, the Damjanich János Museum, Szolnok,
the Savaria Museum, Szombathely, the Village Museum, Tiszavasvári,
the Regional Museum, Vásárosnamény, the Bakony Museum, Veszprém,
the Göcsej Village Museum, Zalaegerszeg, and the Scientific Collections
of the Calvinist Church in the district west of the Tisza, Sárospatak.
Permission to photograph other objects was kindly granted by several
private collectors.
The authors wish to pay homage to Mrs. Tibor Keresztes, whose fine
collection has in the meantime been bequeathed to the Ethnographical Museum.
Permission for reproduction has also been granted by János Bozsó
of Kecskemét, Sándor Bökönyi, János Lakos and Mrs. Lajos Pákay
of Budapest.
Several thousand photographs provided the selection of the 638 illustrations,
mostly of single objects, appearing in the present volume. This entailed
considerable effort most willingly given by the photographer Tamás Kovács,
and understanding shown on the part of the museums. The first selection
of photographs was made in 1969, and further photographs were taken
and added later. Special thanks are due to Miklós Lantos, who has made
a series of fine, lyric photographs of a great many monuments (buildings,
free-standing crosses, etc.) of folk art reproduced in the present volume.
We also wish to express our gratitude to the directors of the museums
and the curators of the collections for their co-operation in making
this collection of photographs possible.

In addition to the black-and-white photographs made by Tamás Kovács and the colour photographs by Károly Szelényi, the illustrations by the following photographers have also been included in this book:

Demeter Balla	73
Péter Korniss	57, 58, 59
Miklós Lantos	7, 8, 12, 13, 14, 18, 22, 23, 24, 40, 42, 50, 61, 80, 82, 97, 98, 101, 112, 115, 116, 120, 121, 124, 237, 238, 240, 241, 243, 244
Alfréd Schiller	194
Károly Szelényi	113, 114
László Szelényi	75
László Varga	60, 103

Photographs now in the photographic archives of the Ethnographical Museum were taken by the following:

Dezső Antal	15, 99, 100, 107, 108, 109, 110, 111
Károly Antal	493, 494
Rudolf Balogh (respectively Magyar Filmiroda)	5, 6, 9, 10, 11, 480, 484, 489, 491, 492, 495, 497, 499, 506, 510
Zsigmond Bátky	16, 498
Edit Fél	106
József Franciscy	303
Sándor Gönyei	1, 2, 3, 4, 54, 55, 117, 119, 231, 235, 482, 485, 490, 496, 501, 507, 508, 509, 511
Iván Hevesy	102, 104
Tamás Hofer	79, 105, 185, 233, 483
János Jankó	481
Emil Keglovich	486
István Kovács	234
János Manga	500

The following are works by provincial photographers whose identity is not known: 487, 488, 502, 503, 504, 505.

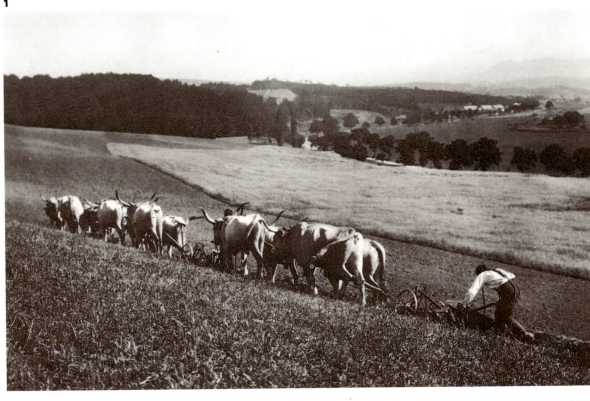

1 Ploughing with oxen. Zagyvapálfalva, Kökényes-puszta, Nógrád County

2 Gathering fodder. Maconka, Heves County

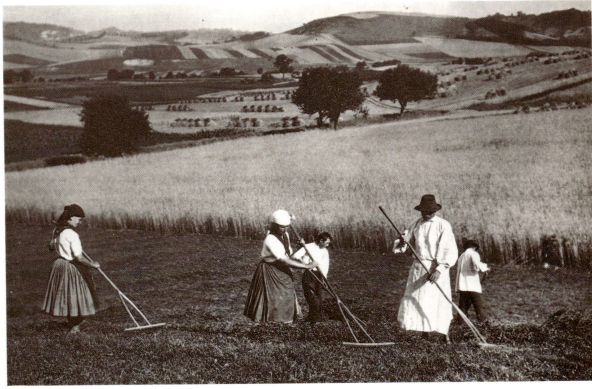

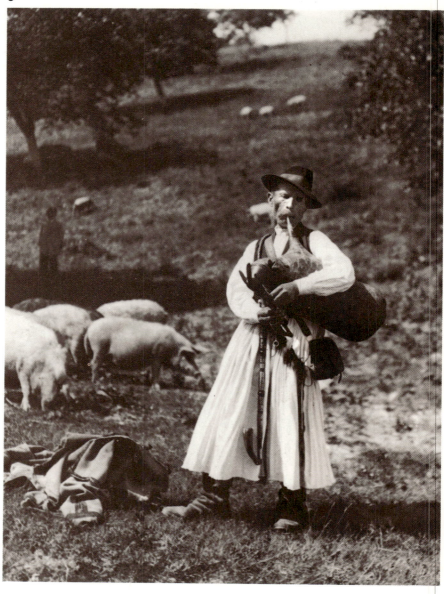

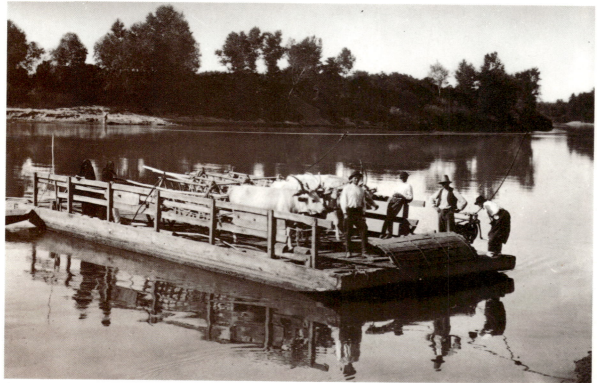

3 Shepherd, wearing a shirt and wide trousers, playing a goatskin bagpipe beside his flock. Buják, Nógrád County

4 The ferry at Kisar. Transportation of people and ox-drawn wagon on the Tisza river. Szabolcs-Szatmár County

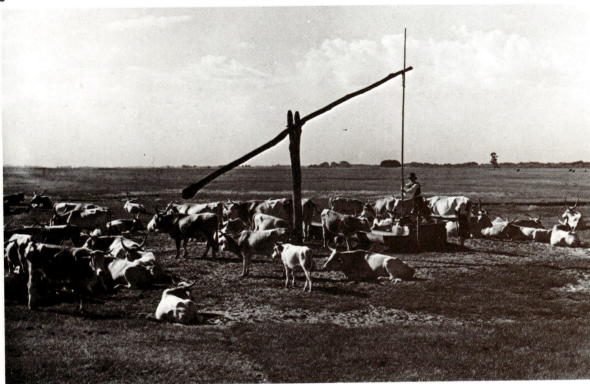

5 A herd of cattle at noon at a watering place.
Bugac, Bács-Kiskun County

6 A troop of mounted herdsmen wearing broad-brimmed hats with *cifraszűr* (embroidered frieze coats) slung over their shoulders and lassoes on the necks of their horses.
Hortobágy, Hajdú-Bihar County

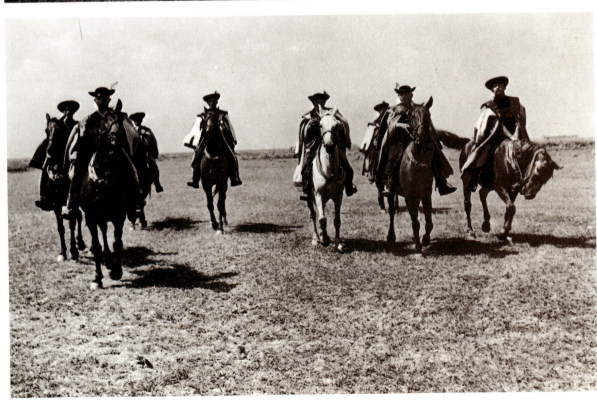

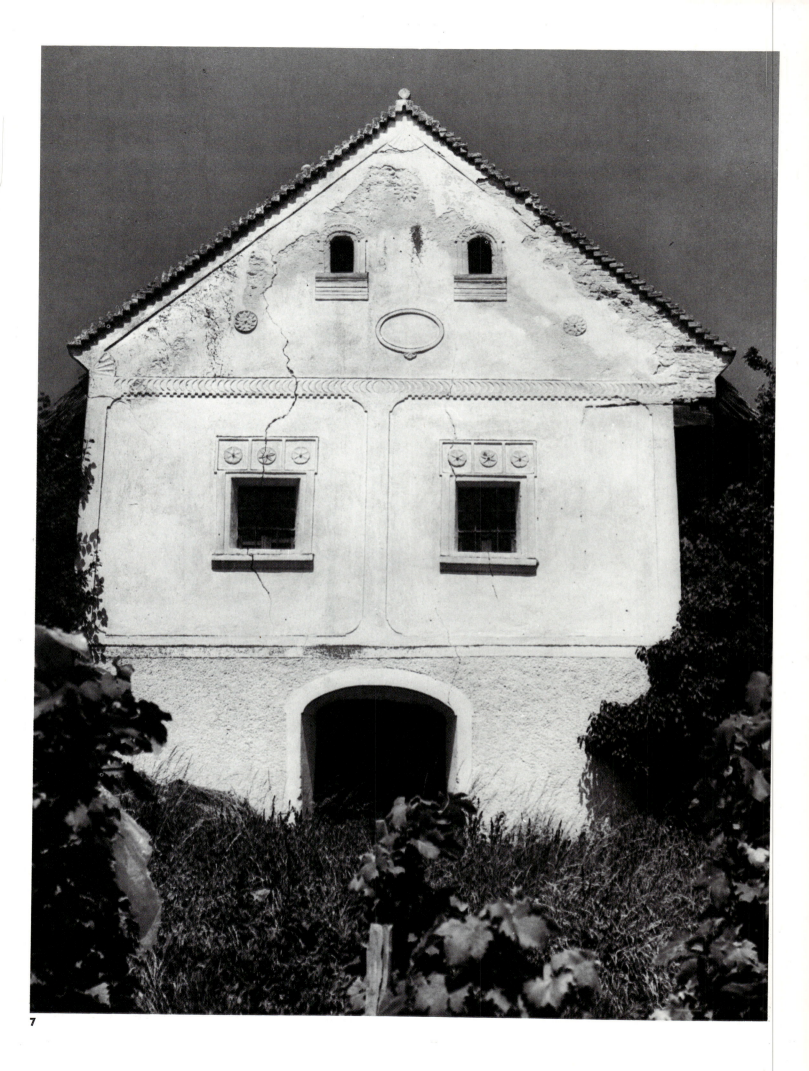

7

7 Wine-cellar
in a vineyard.
Balatonakali,
Veszprém County

8 Abandoned
and roofless log
wine-cellar.
Nagyberki,
Somogy County
(Open-air Ethnograph-
ical Museum, Szenna)

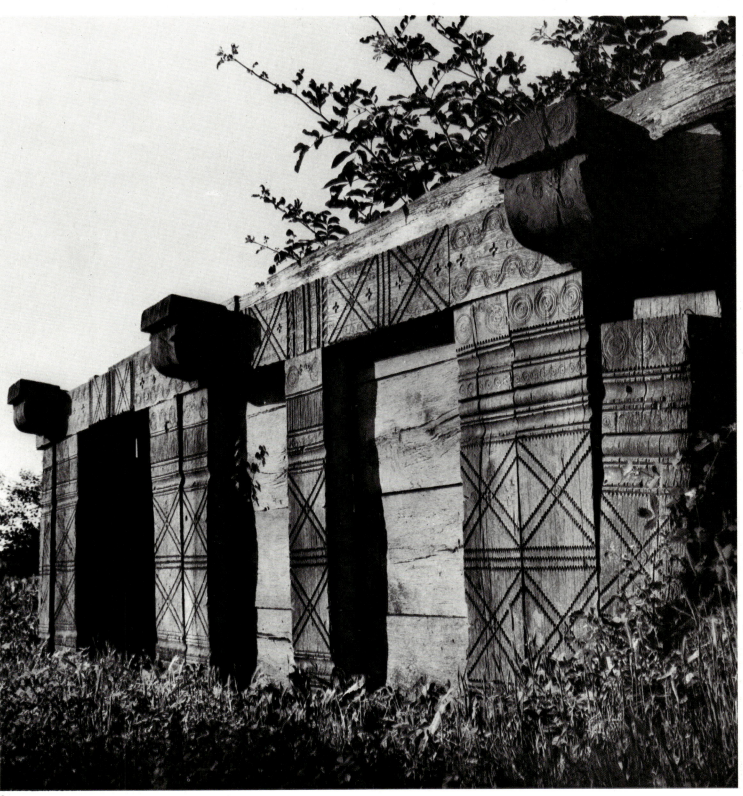

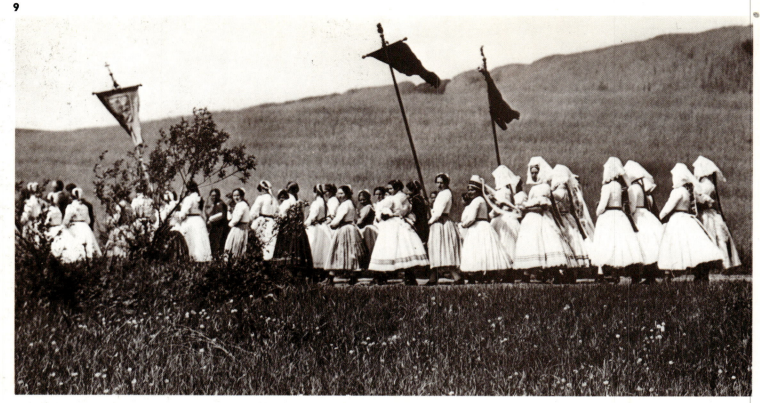

9 Procession
of the blessing
of the wheat.
Kazár,
Nógrád County

10 Villagers
in their Sunday
clothes in front
of the church.
Hollókő,
Nógrád County

11 Wooden belfry.
Vista (Viştea,
Rumania)

12 Wooden belfry
surmounted
by a star 1793.
Nemesnép,
Zala County

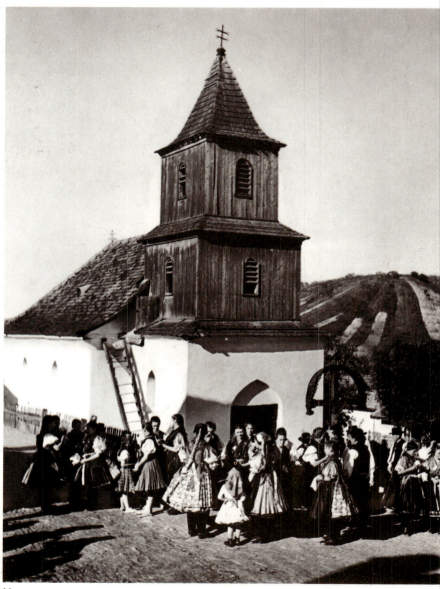

10

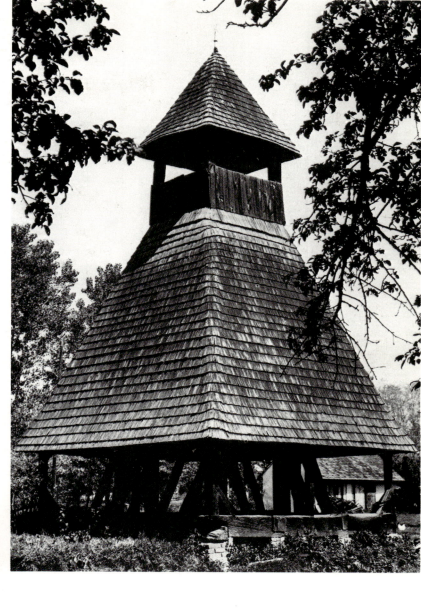

12

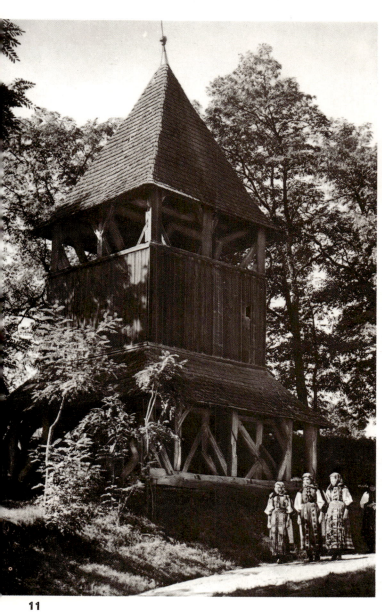

11

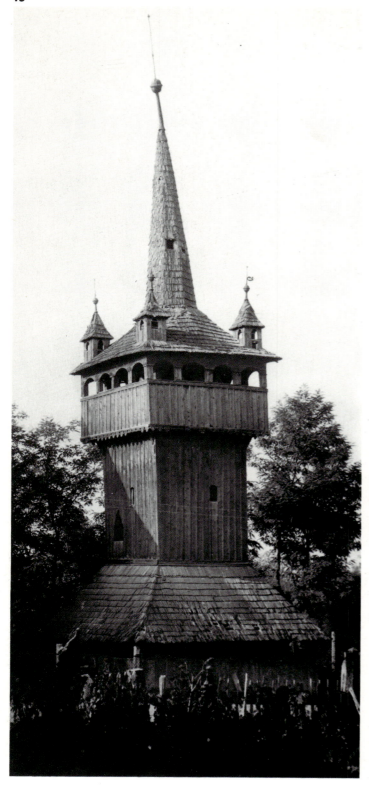

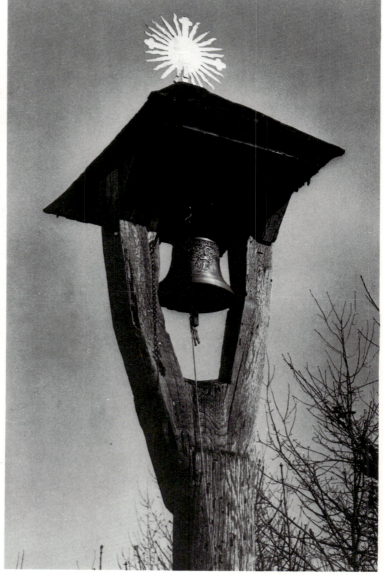

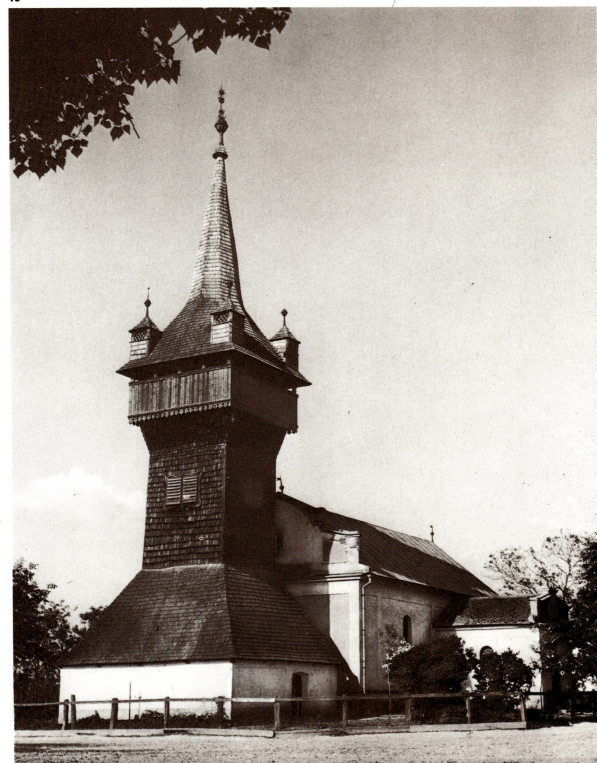

13 Wooden belfry
with four small
turrets, *c.* 1680.
Nemesborzova,
Szabolcs-Szatmár
County.
(Since 1973
in the open-air
Museum
of Ethnography
at Szentendre)

14 Belfry surmounted
by a cross surrounded
by rays.
Kakasd,
Tolna County

15 Belfry.
Zsurk, Szabolcs-
Szatmár County

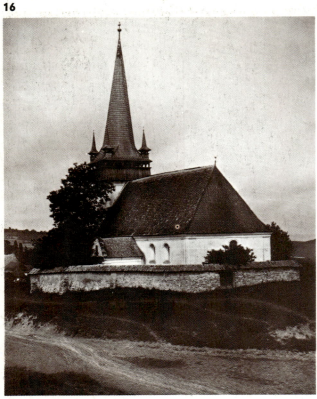

16

16 A church
with four turrets at
the base of the spire.
Körösfő (Izvorul
Crişului, Rumania).
The spire was built
in 1764

17 Gate in the wall
surrounding a church.
Inscription: "J(anuae)
E(cclesiae) VALVAE
HAE SUMPTU
PUBLICO ERECTAE
STANT AB AO R.S.
MDCCLXVI DIE 14-ta
Mar."
Sajókeresztúr,
Borsod-Abaúj-
Zemplén County

18 Interior
of the Calvinist
church at Kórós,
Baranya County.
Pinewood ceiling
and choir loft painted
in blue, green and
dark red tempera,
distinctively outlined,
on a blue, light red,
light grey and white
ground. The row
of panels above are
from that part
of the ceiling painted
in 1795; the other
panels date from
1834, when
the church was
enlarged. Inscription
at the back
of the choir:
"THIS CHOIR WAS
MADE in the Year
1836."

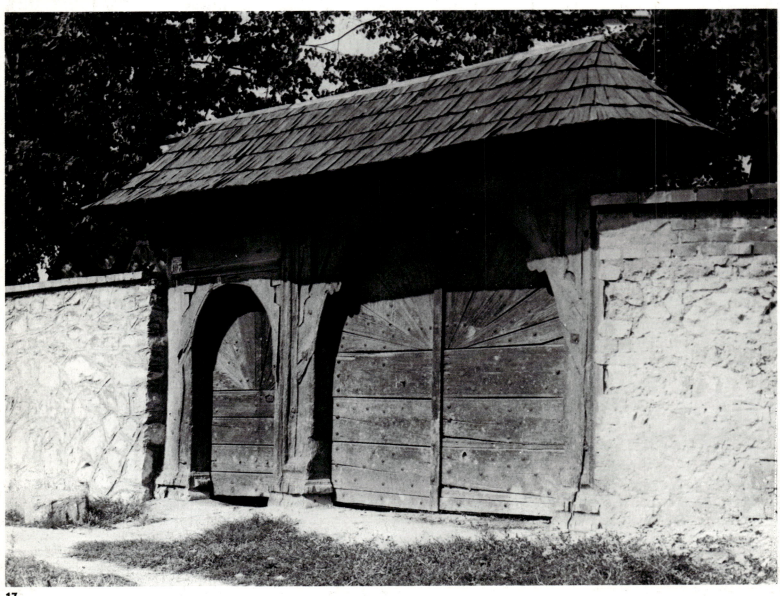

17

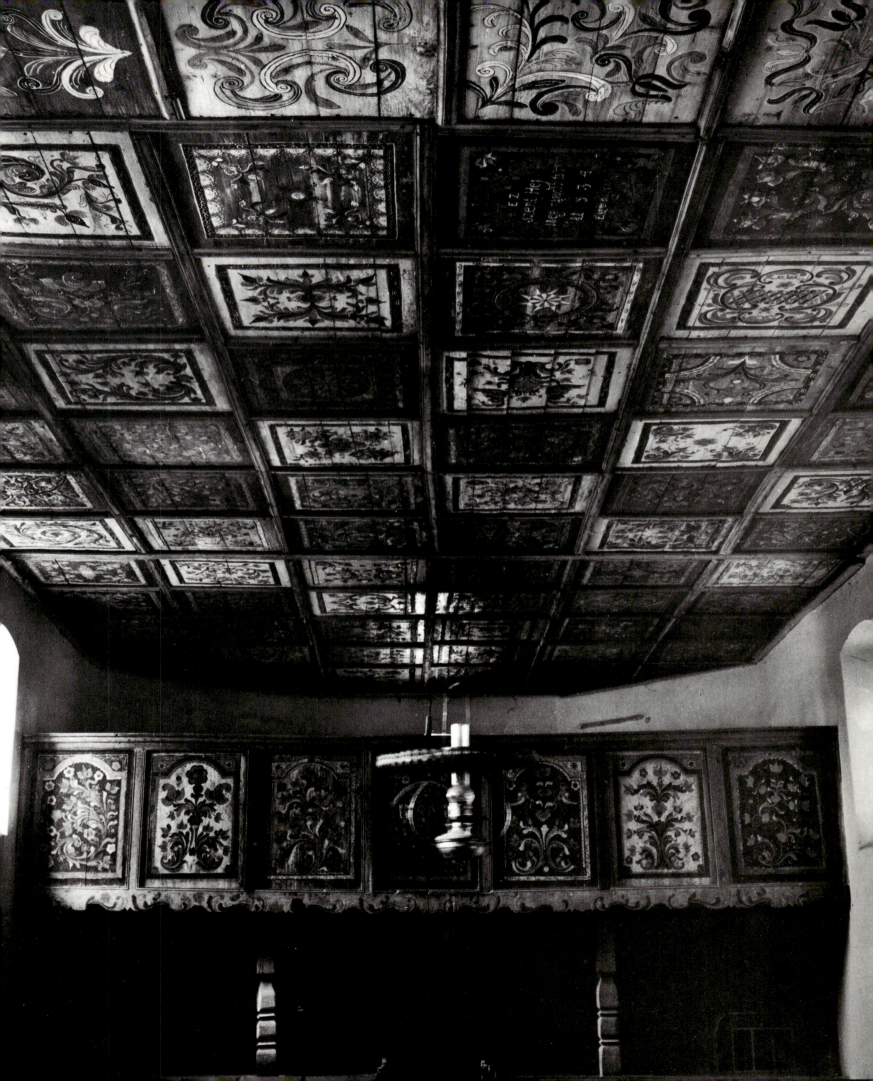

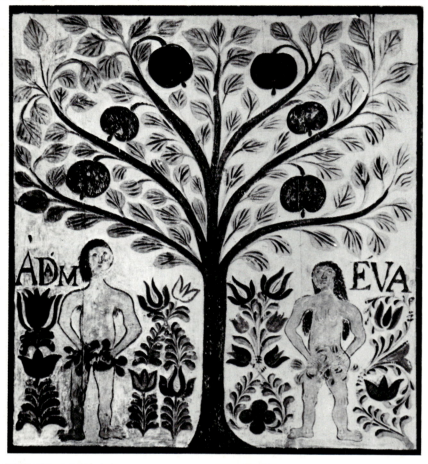

19 Adam and Eve beneath the apple tree in Eden. Detail from the choir of the Calvinist church at Mezőkeresztes, Borsod-Abaúj-Zemplén County. Painted on pine in red, grey and brown tempera, on a white ground. Inscription: "God is spirit and they who adore Him necessarily adore Him in spirit and truth. Ao Dni 1728." (Scientific Collections of the Calvinist Church District west of the Tisza river, Sárospatak)

20 A flower-cluster design with seven flowers from the choir of the Calvinist church at Mezőkeresztes. (See Ill. 19)

21 Detail
from the *papok széke*
("stool for priests")
of the former
Calvinist church
in Hódmezővásárhely
(Csongrád County),
now demolished.
Tempera
on pinewood.
The work
of the joiners Dániel
and Péter Asztalos
and Ferenc Adoni,
from the town
of Gyula, 1732.
(Tornyai János
Museum,
Hódmezővásárhely)

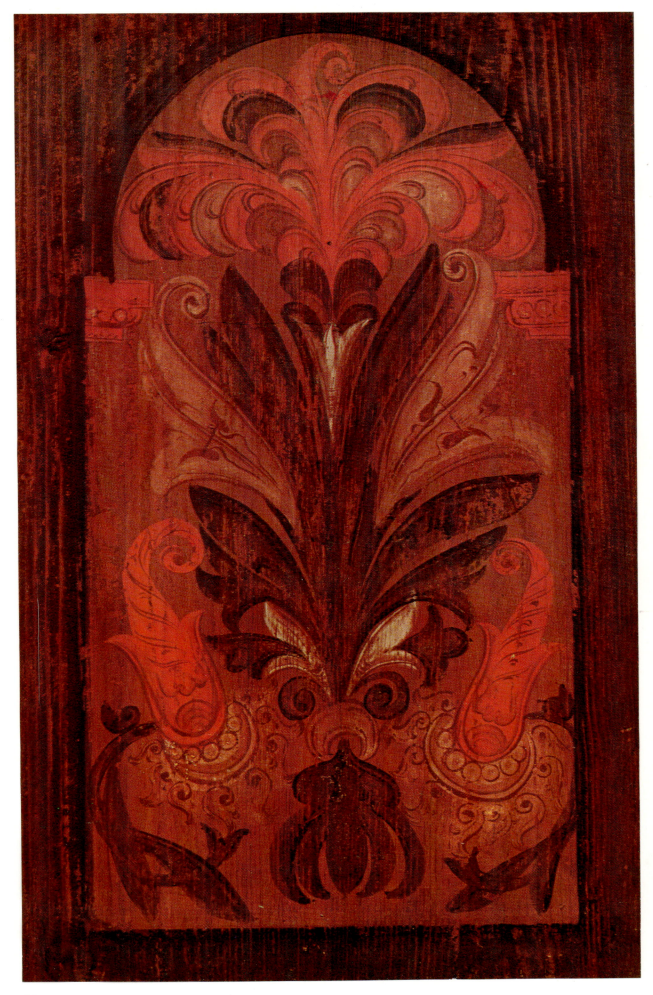

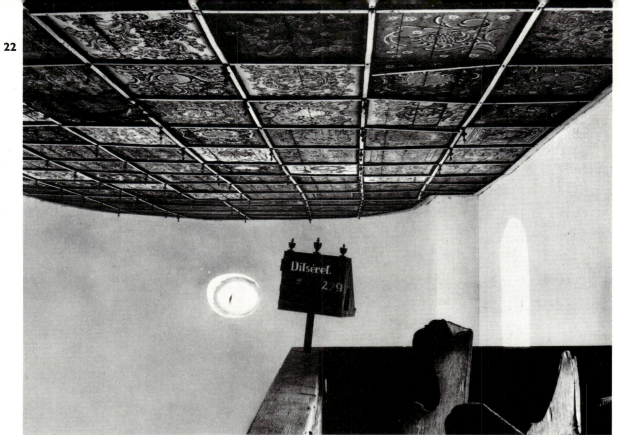

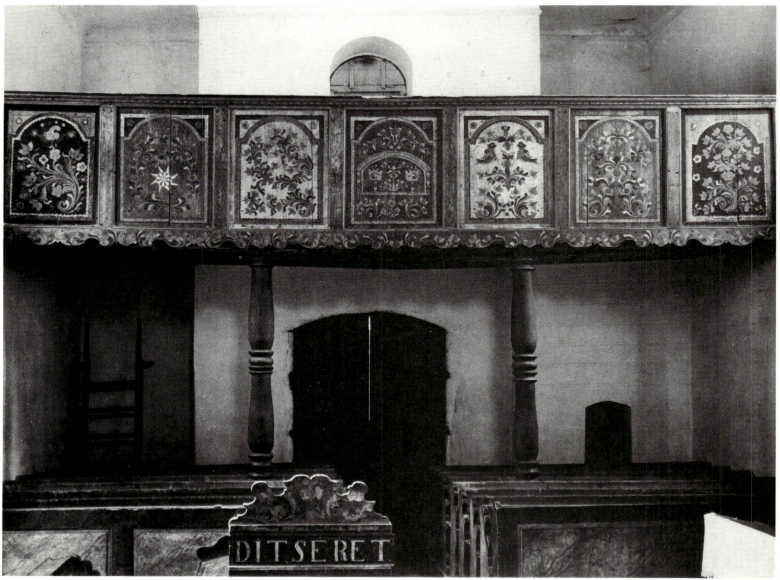

24

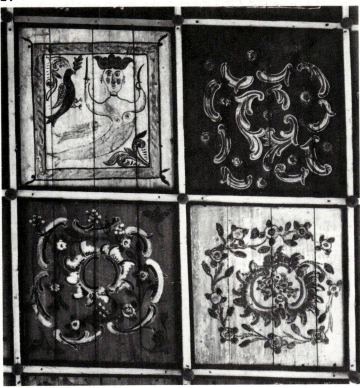

24 Detail with mermaid from the painted ceiling of the Calvinist church at Drávaiványi, Baranya County

25 Angel. Panel from the Calvinist church at Csenger, Szabolcs-Szatmár County. Painted by István Asztalos of Felsőbánya. Inscription: "The wood was bought with the money given by valiant Gábor Csontos: with the assistance of his dear son, Gábor Csontos and others, this Place was built, God be Blessed that it was finished...

Anno 1745 D. May 4. Blessed be the Lord Whose feet tread here, He gave a Heart from Heaven to this miserable people... that this [house]... should be so beautiful."

22 The interior of the Calvinist church at Drávaiványi, Baranya County, taken from the choir. The pine ceiling is painted in tempera. The ground colours of the panels are white, blue, yellow and reddish-brown, consecutively. Inscription: "the church of the Lord was built with the gracious permission of His Majesty Emperor Joseph II the King... with the goodwill of honourable Sigmond and János Petrovszki and at the cost and by the labour of the members of the Iványi congregation when the reverend... Bíró was preacher, in the year 1792."

23 The choir of the Calvinist church at Kovácshida, Baranya County. Tempera on pine. *c.* 1830.

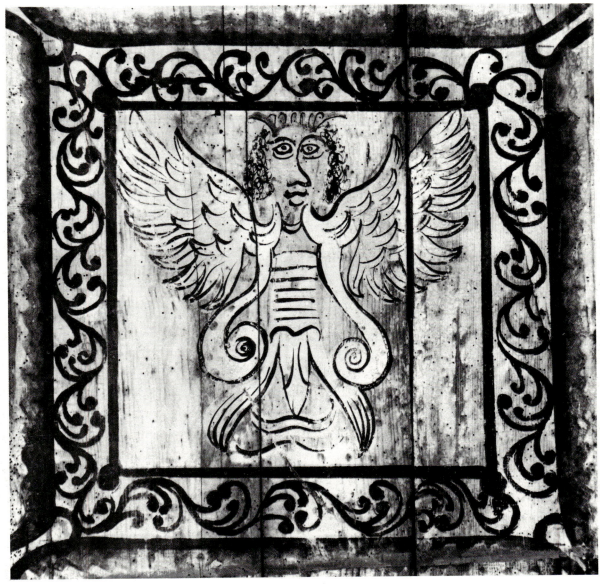

25

26 Painted storks on the ceiling panel of the Calvinist church at Noszvaj, Borsod-Abaúj-Zemplén County. Tempera on pine. Inscription: "This house is the shelter of the Lord. Its faithful Nurse is the Honourable and Noble Kristina Bossányi... MADE WITH THE HELP OF GOD BY IMRE ASZTALOS OF MISKOLC, 1734." (Dobó István Castle Museum, Eger)

27 Pelican feeding its young in a nest on a treetop. Ceiling panel of the Noszvaj church (See Ill. 26)

28 Eagle attacking a rabbit. Ceiling panel of the Noszvaj church. (See Ill. 26)

29 Deer and bird resting in a wood. Ceiling panel of the Noszvaj church. (See Ill. 26)

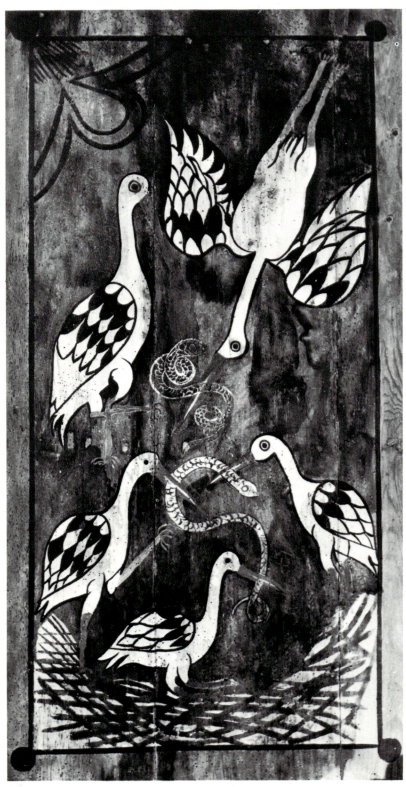

26

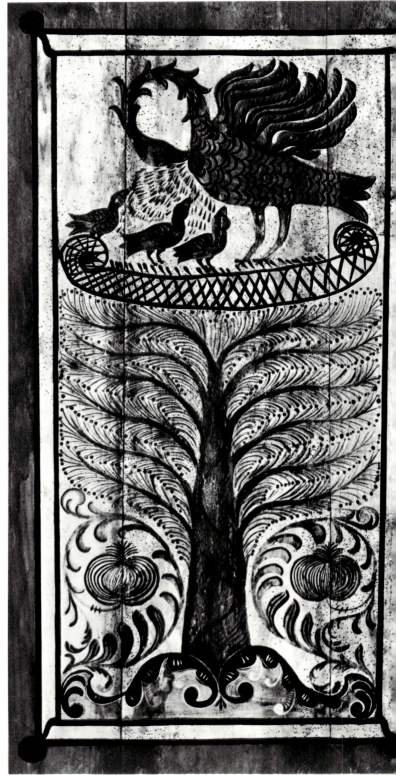

27

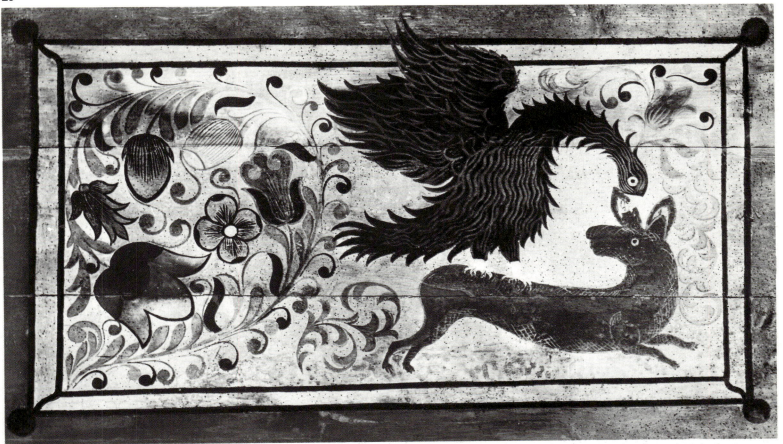

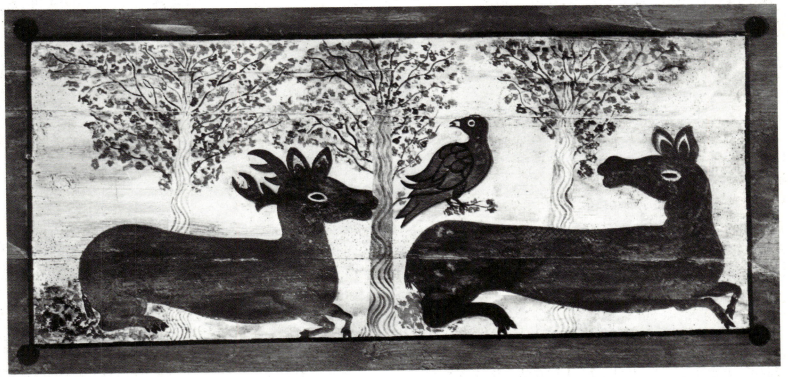

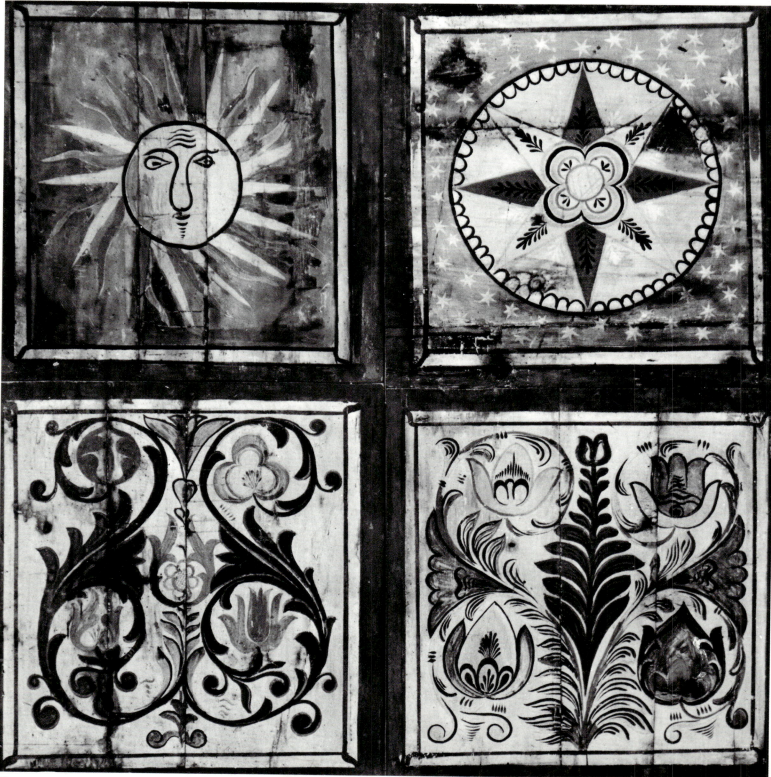

30 Four ceiling panels of the Calvinist church at Megyaszó, Borsod-Abaúj-Zemplén County. Tempera on pine. Red, blue, dark brown and black, also green and yellow on a white ground. (Herman Ottó Museum, Miskolc)

31 Ceiling panel with painted inscription from the Calvinist church at Megyaszó, Borsod-Abaúj-Zemplén County:
"Anno Doi 1735 Die 12 Februarii Through the Help of GOD the Labour of this Work was done by Imre Asztalos and István Asztalos masters from Miskoltz"

32 Four flower-cluster designs. Painted ceiling panel from the Calvinist church at Megyaszó, Borsod-Abaúj-Zemplén County. (See Ill. 31)

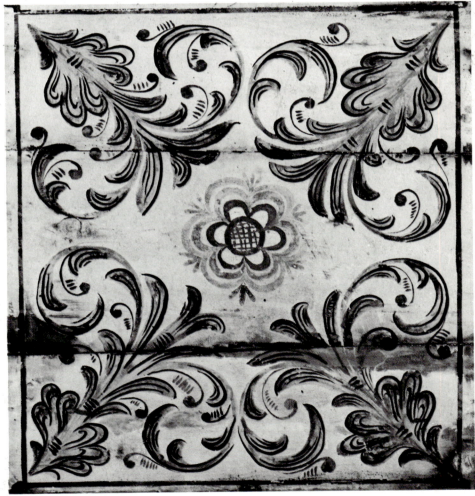

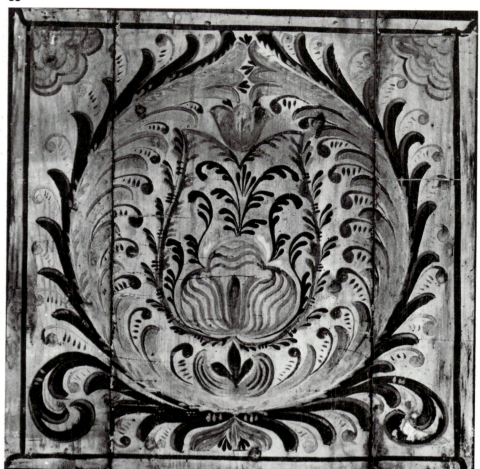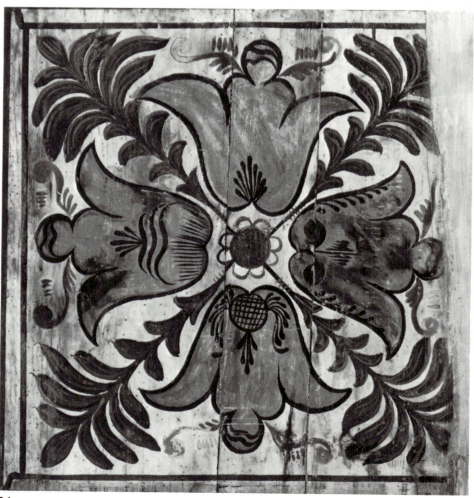

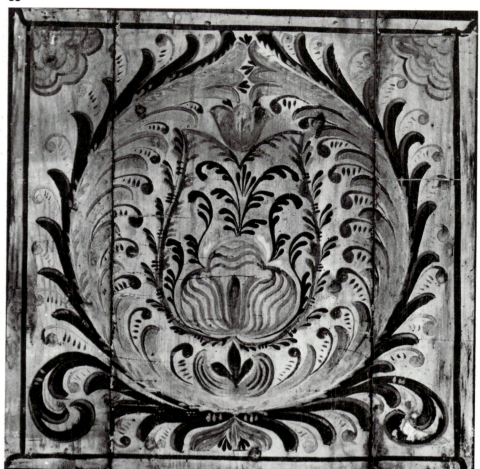

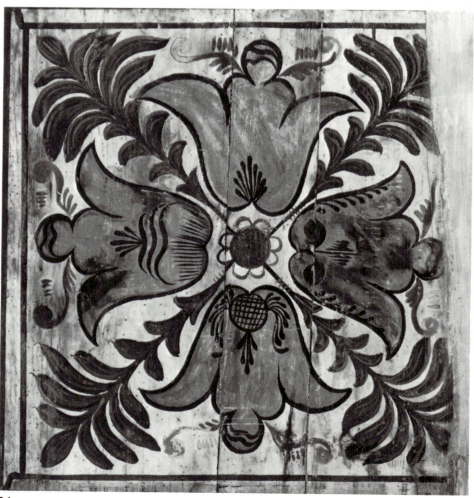

33 Pomegranate design with a small and large tulip. Painted ceiling panel from the Calvinist church at Megyaszó, Borsod-Abaúj-Zemplén County. (See Ill. 31)

34 Foliate design of four tulips with stems meeting at the centre. Painted ceiling panel from the Calvinist church at Megyaszó, Borsod-Abaúj-Zemplén County. (See Ill. 31)

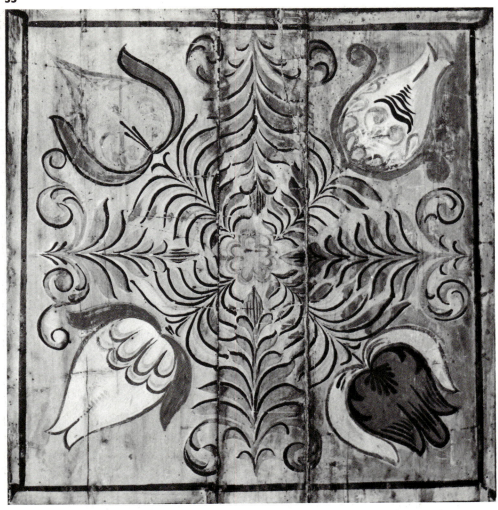

35 Foliate design of four different tulips with stems meeting at the centre. Painted ceiling panel of the Calvinist church at Megyaszó, Borsod-Abaúj-Zemplén County. (See Ill. 31)

36 Six-pointed star in the centre of a foliate design of tulips and tendrils. Painted ceiling panel from the Calvinist church at Megyaszó, Borsod-Abaúj-Zemplén County. (See Ill. 31)

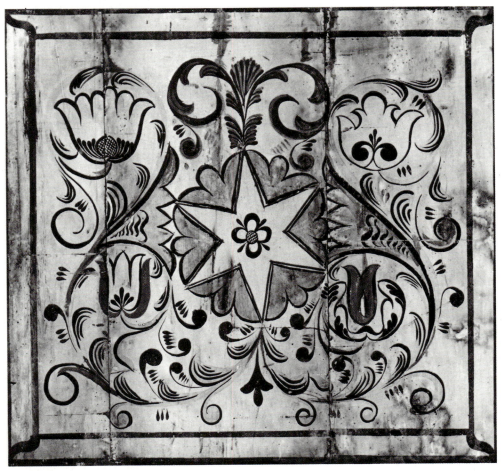

37 Four painted ceiling panels from the Calvinist church at Megyaszó (Borsod-Abaúj-Zemplén County), with a unicorn on one and tendrils, with foliage and tulips on the others. (See Ill. 31)

38 Painted ceiling panel with flower-cluster and pomegranate design from the Calvinist church at Magyarókereke (Muerău, Rumania), demolished in 1897.

Tempera on pine. The work of the master joiner Lőrinc Umling of Kolozsvár, 1746 (Ethnographical Museum)

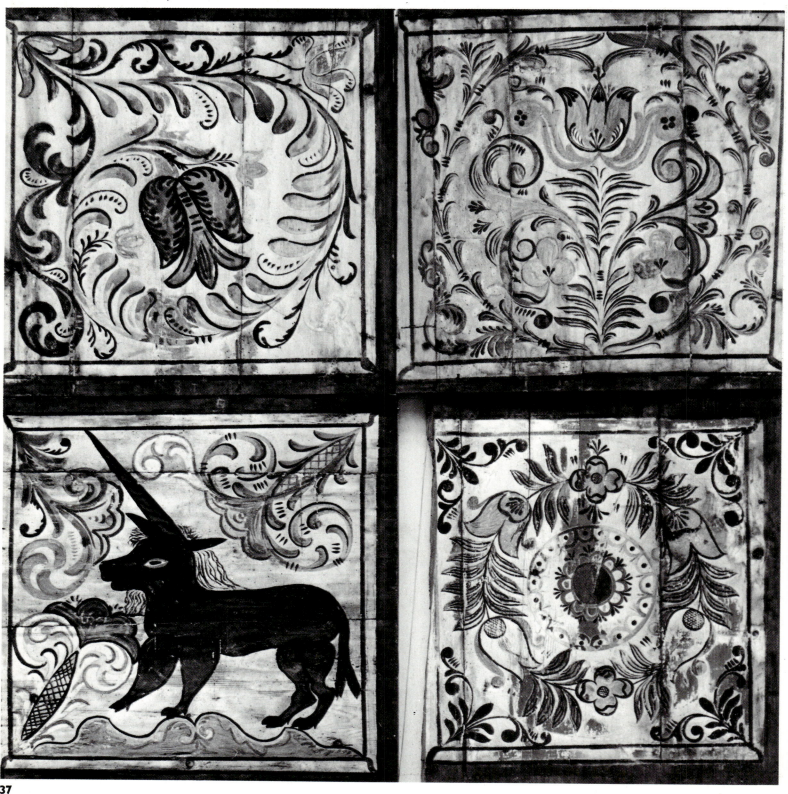

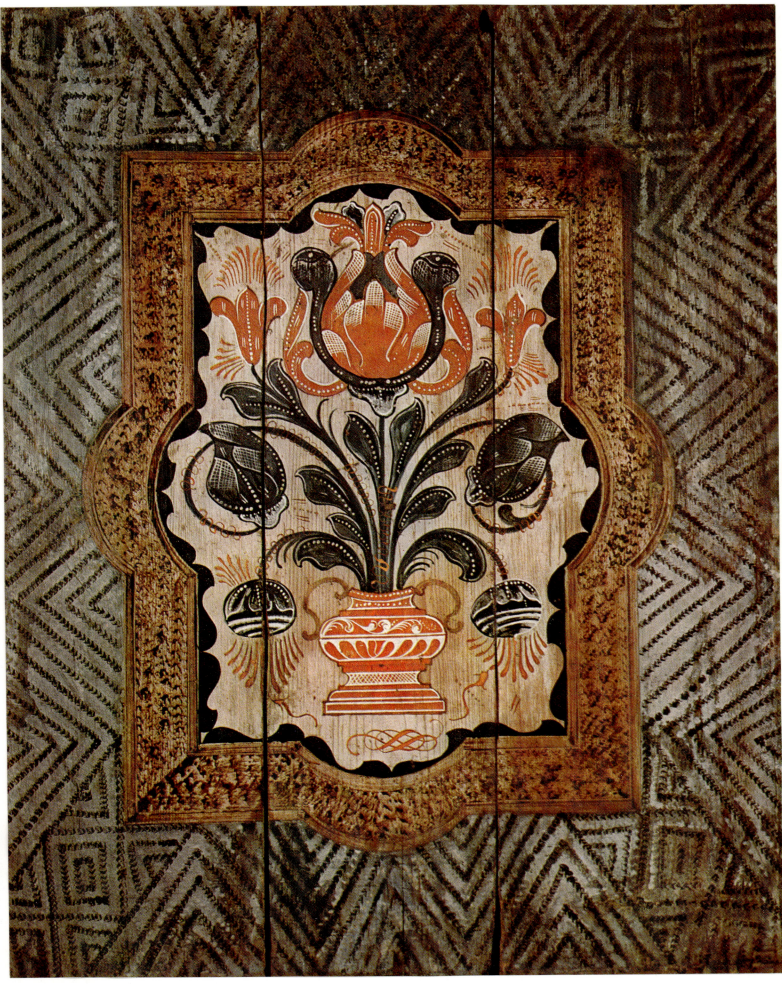

38

39 Carved canopy of the pulpit from the Calvinist church in Hódmezővásárhely (Csongrád County), with the figure of a pelican feeding its young with its own blood. Softwood, with traces of red and green paint. The work of the joiners Dániel Asztalos, Péter Asztalos and Ferenc Adoni, from Gyula, 1732. Height: *52 cm.* (Tornyai János Museum, Hódmezővásárhely)

40 Grave-posts in the Calvinist graveyard at Szatmárcseke, Szabolcs-Szatmár County

41 Carved grave-post in the Calvinist graveyard at Foktő, Bács-Kiskun County

42 Carved grave-post in the Calvinist graveyard at Nagybajom, Somogy County

43 Heart-shaped metal tablet with the monogram of the deceased from a cross on a grave in the Catholic graveyard in Kiskunfélegyháza, Bács-Kiskun County. (Kiskun Museum, Kiskunfélegyháza)

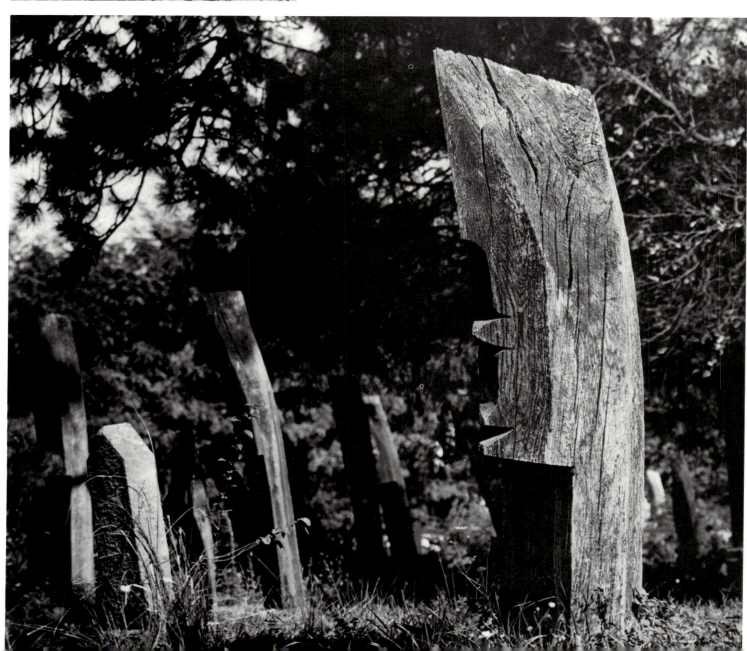

41

42

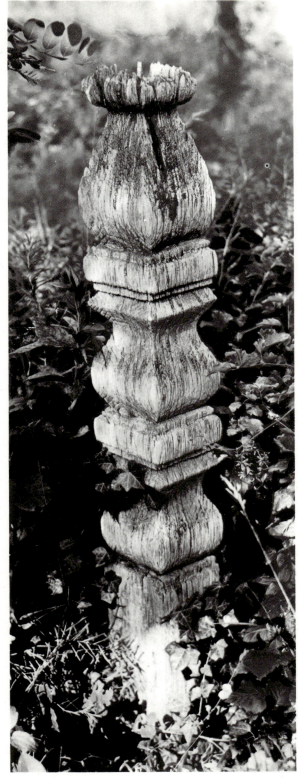

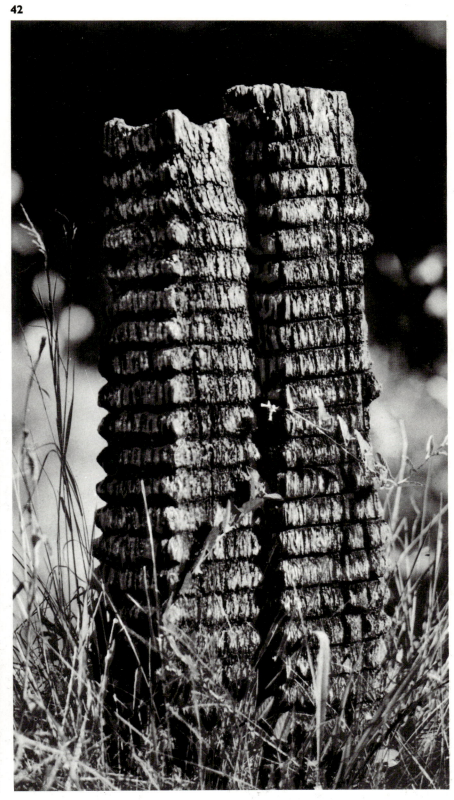

43

44 Grave-posts,
of different shapes,
of a man and wife,
in the Calvinist
graveyard at Verőce-
maros, Pest County

45 Elaborately carved
grave-posts of
children in the
Calvinist graveyard
at Verőcemaros,
Pest County

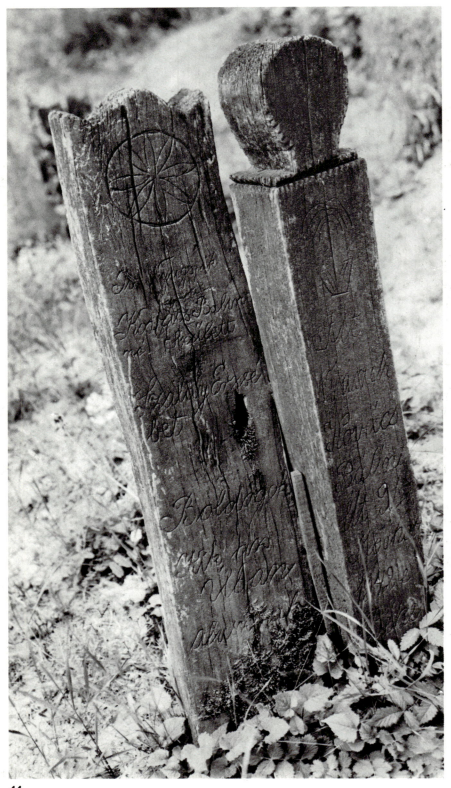

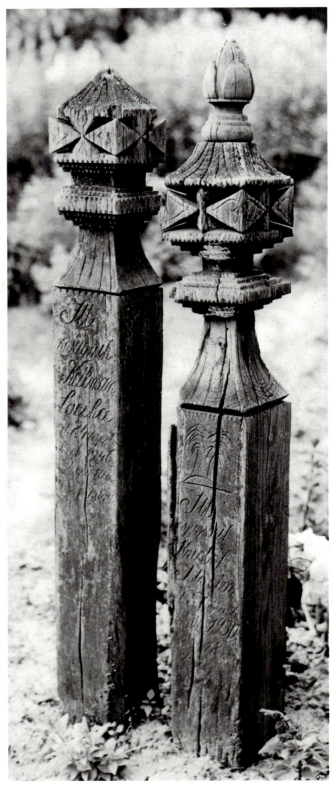

44

45

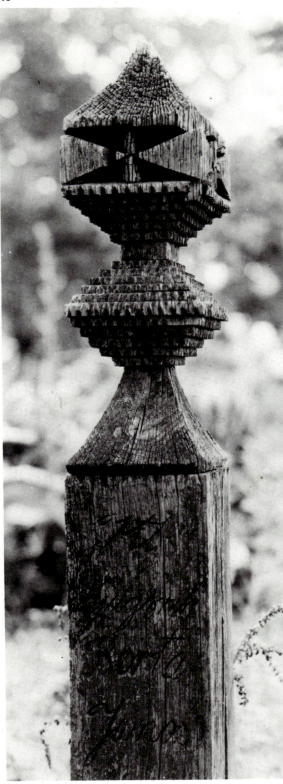

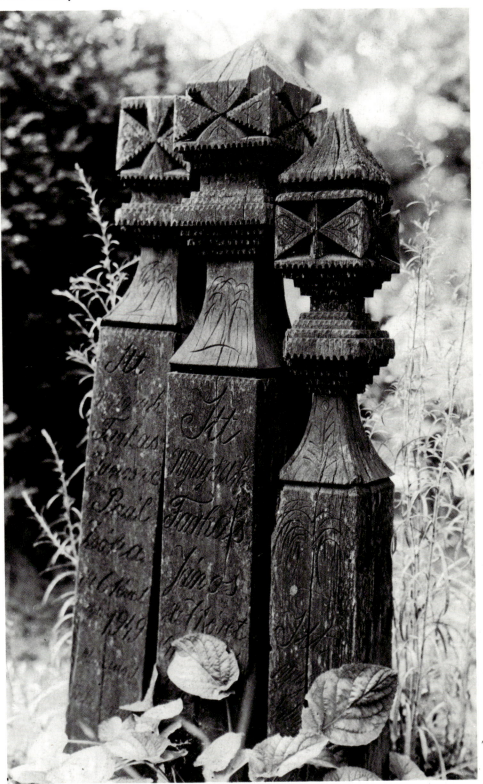

46 Elaborately carved grave-post in the Calvinist graveyard at Verőce-maros, Pest County

47 Elaborately carved grave-posts for man, wife, and child in the Calvinist graveyard at Verőcemaros, Pest County

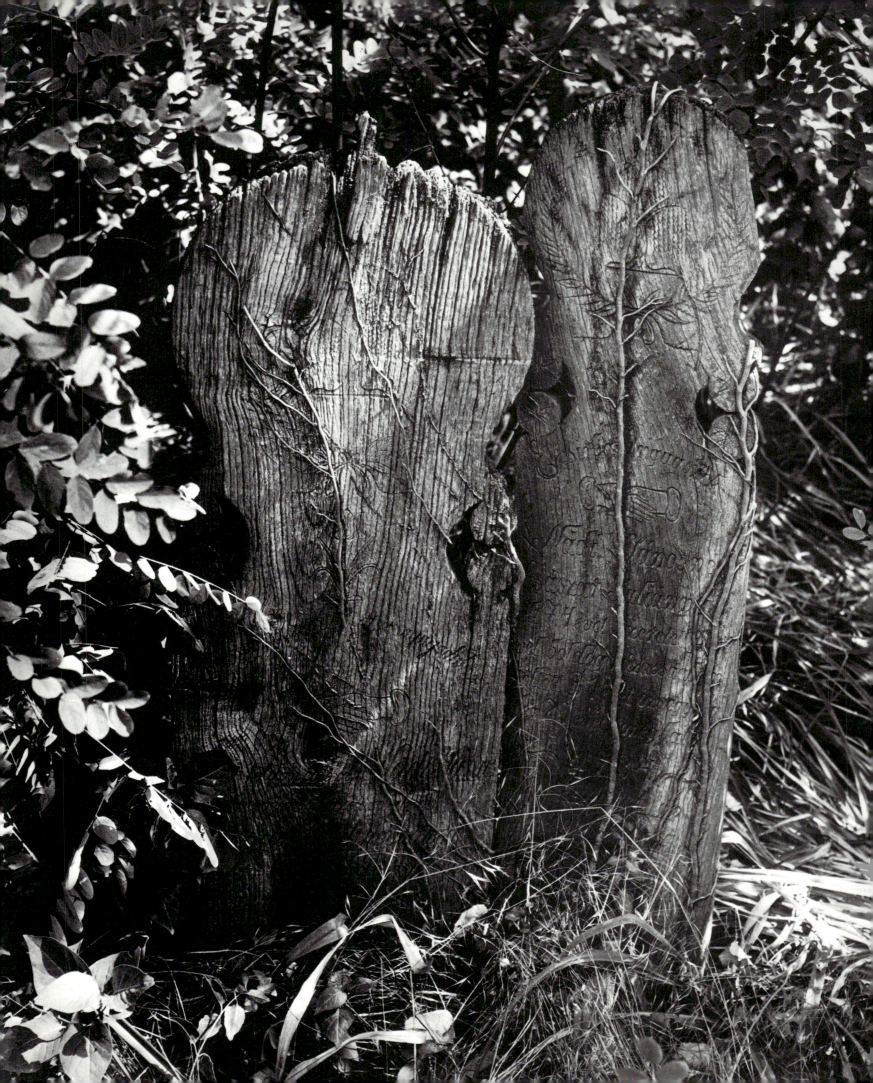

48 Carved grave-posts in the Calvinist graveyard at Dunapataj, Bács-Kiskun County

49 Grave-posts carved with a weeping willow encircled by a wreath in the Calvinist graveyard at Dunapataj, Bács-Kiskun County

50 Carved grave-posts of children in the Calvinist graveyard at Nagypeterd, Baranya County

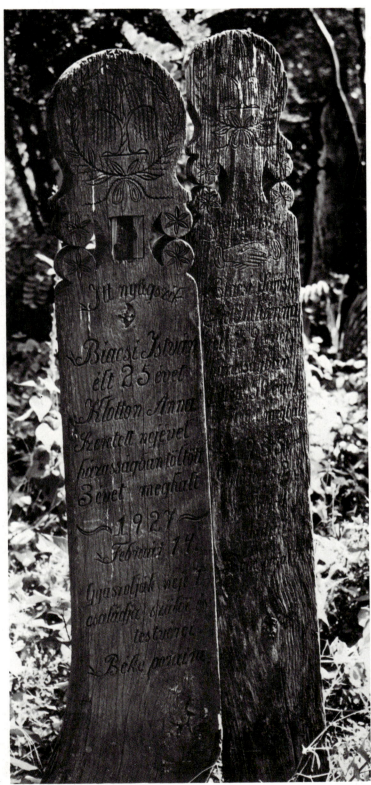

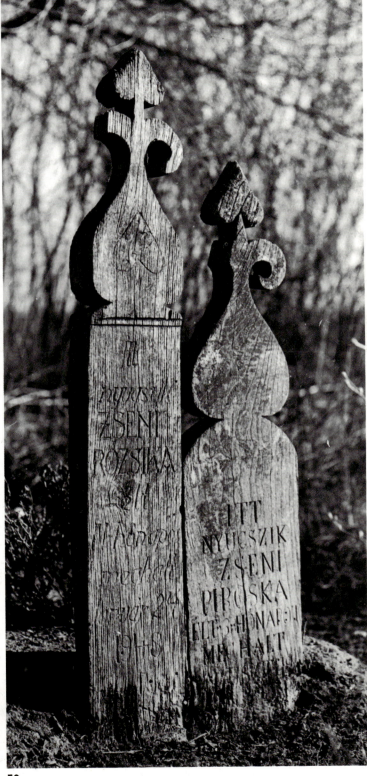

48 49

50

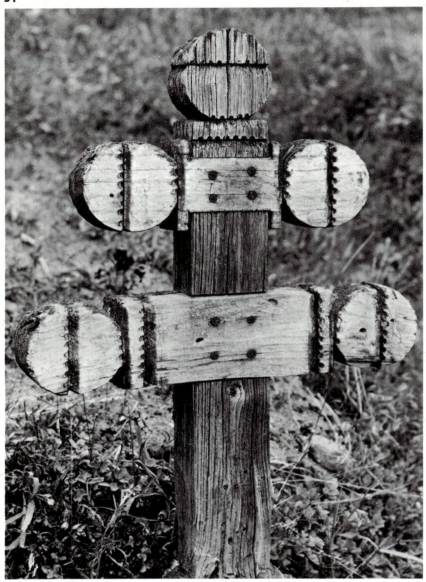

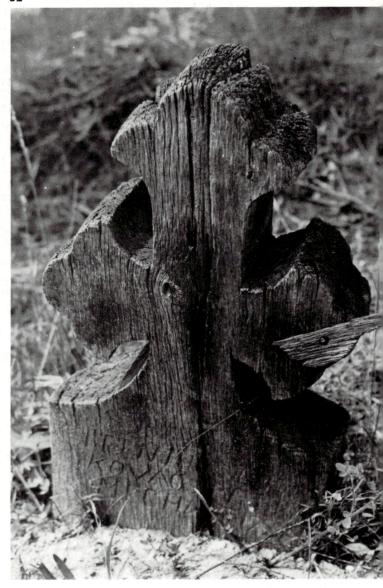

51 Carved wooden
cross in
the Catholic
graveyard
at Karancsberény,
Nógrád County

52 Carved wooden
cross in
the Catholic
graveyard
at Karancsberény,
Nógrád County

53 Carved wooden
cross in
the Catholic
graveyard at Foktő,
Bács-Kiskun County

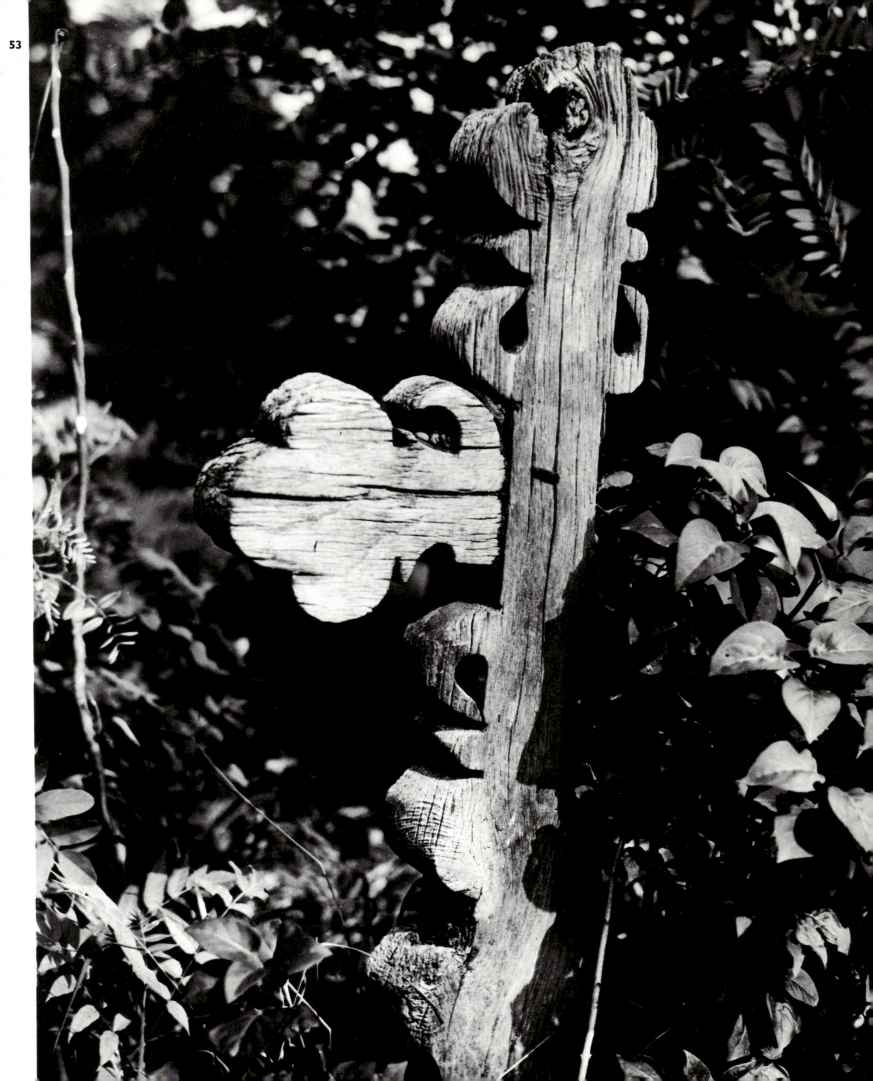

54 Carved wooden
cross in
the Catholic
graveyard
at Karancskeszi,
Nógrád County

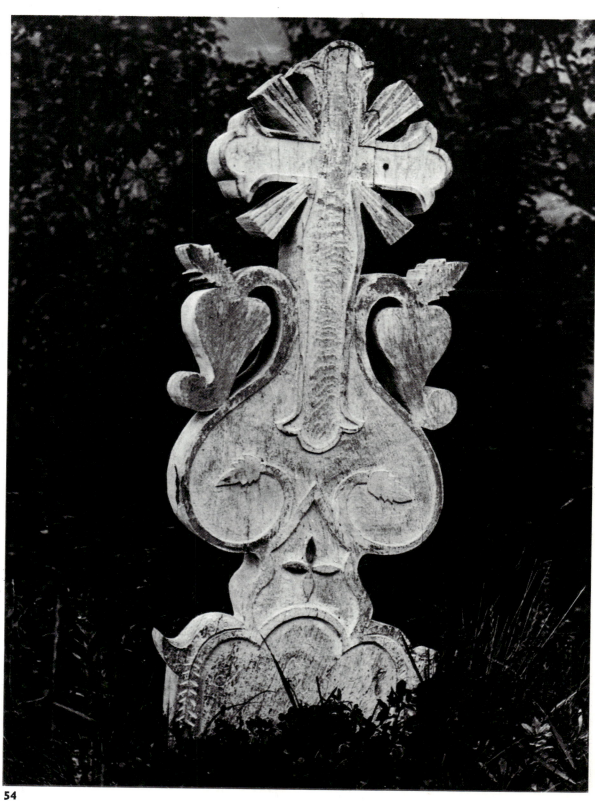

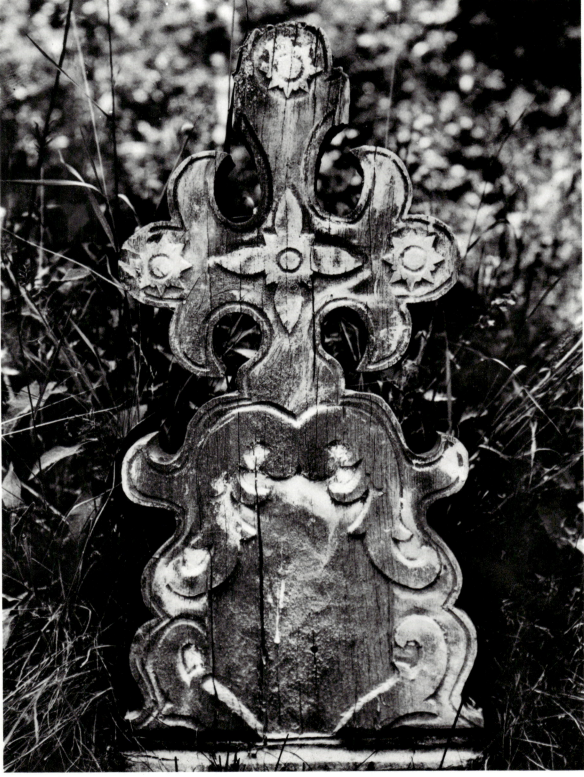

55 Carved wooden
cross in
the Catholic
graveyard
at Karancskeszi,
Nógrád County

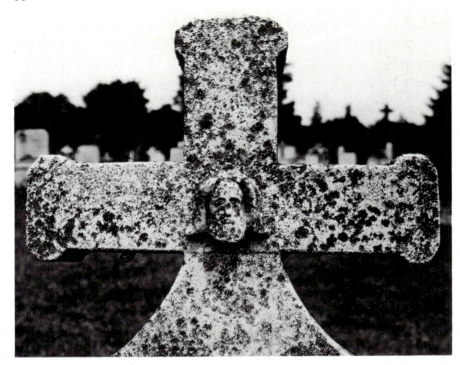

56 Carved stone cross with a representation of the head of Christ. From the Catholic cemetery at Rezi, Veszprém County

57 Carved stone cross with a figure of one of the Marys, in the graveyard at Csíkdelne (Delniţa, Rumania)

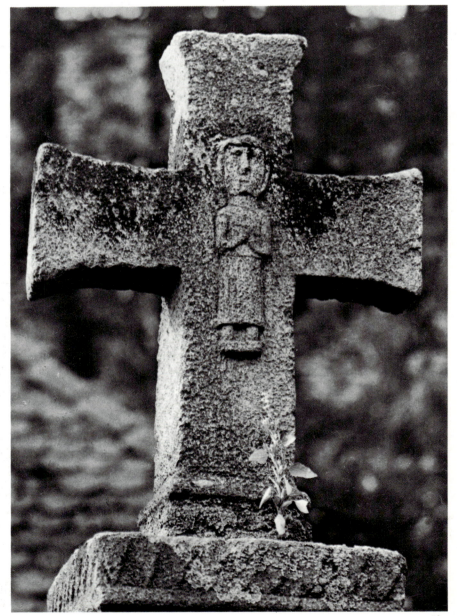

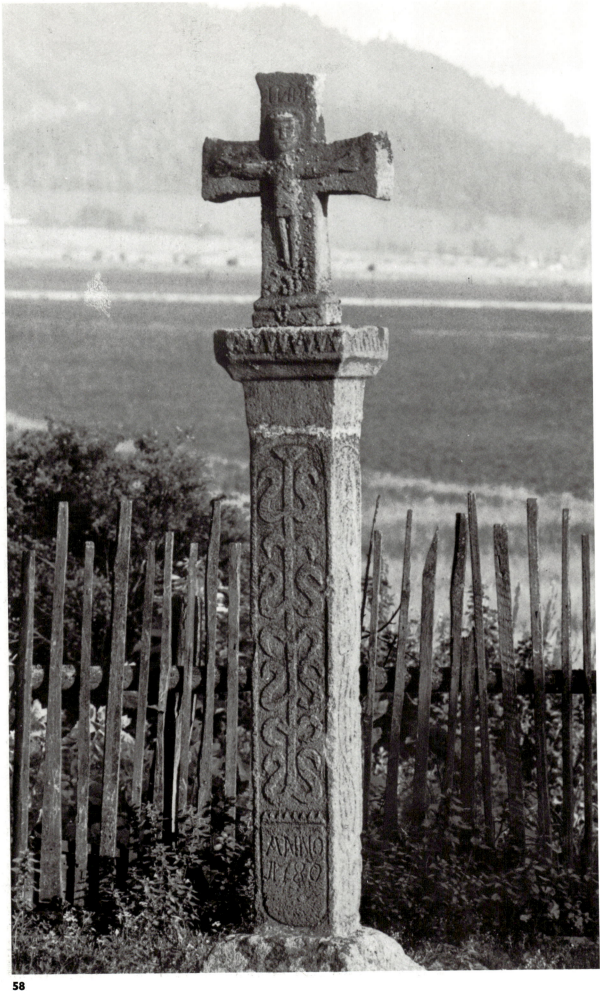

58 Memorial cross carved in stone depicting the body of Christ and tulips. 1780, Csíkdelne (Delniţa, Rumania)

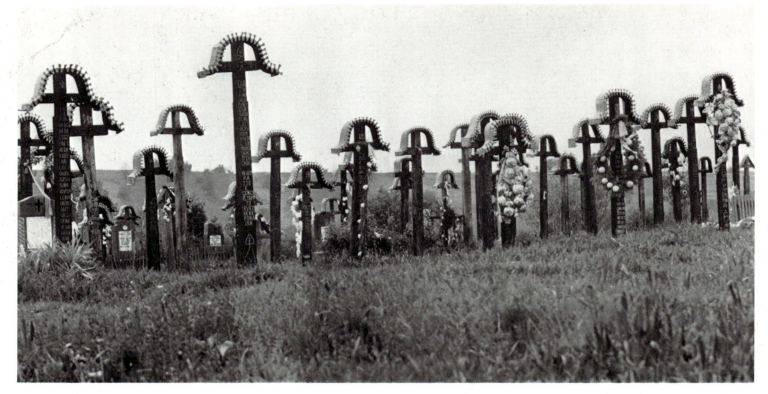

59 Wooden crosses
from the cemetery
at Szentegyházasfalu
(Vlăhiţa, Rumania)

60 A chapel and votive
stone crosses erected
in fulfilment
of vows.
Csíksomlyó
(Şumuleu, Rumania)

61 The stations
of the Cross.
Bóly, Baranya County

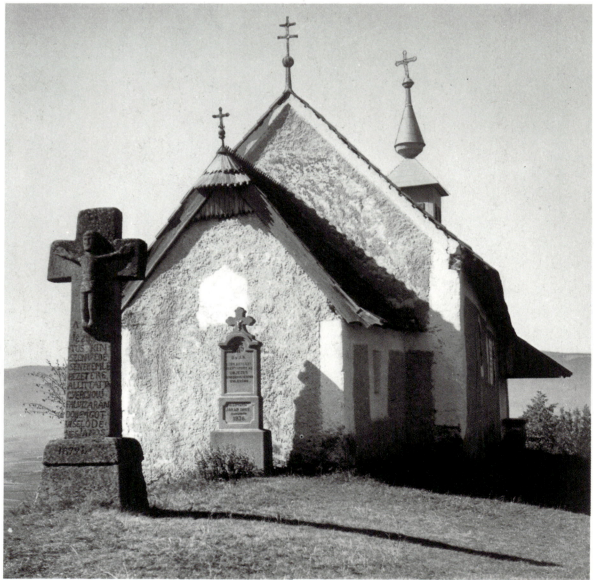

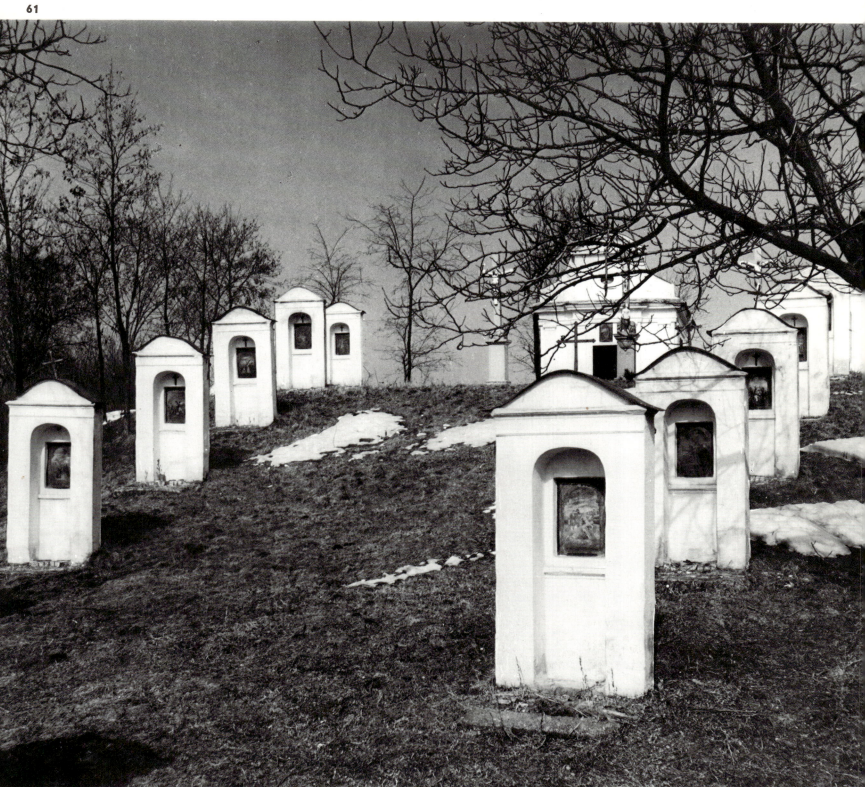

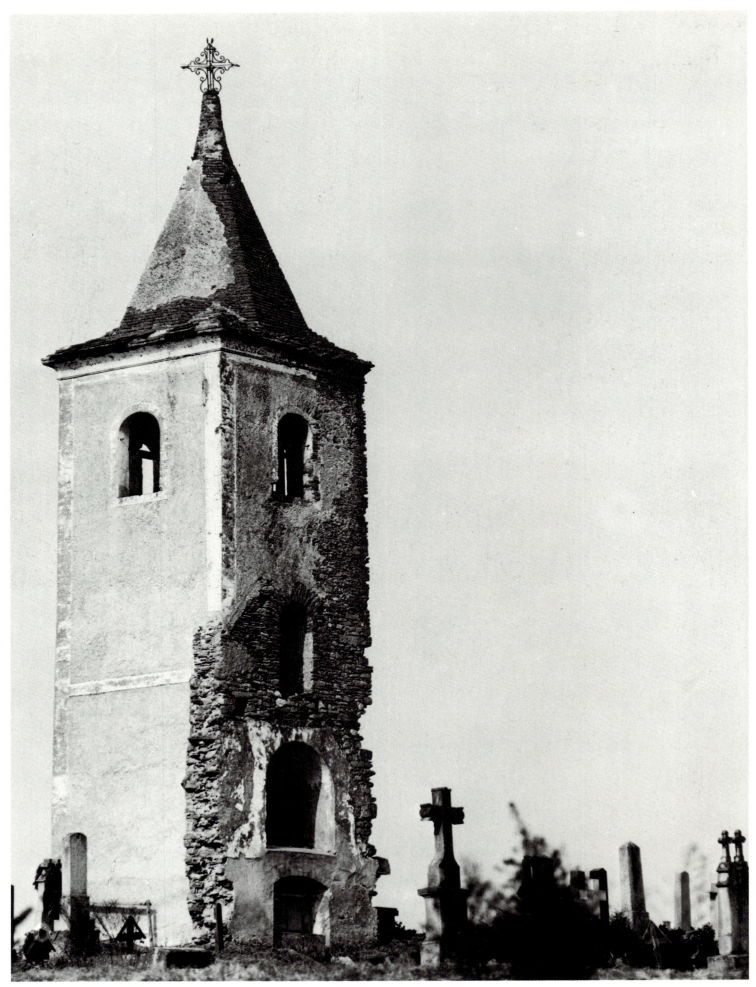

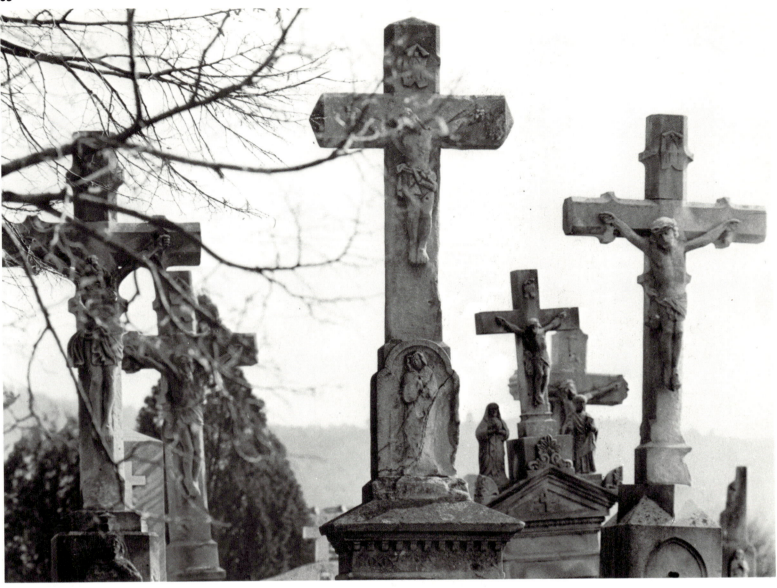

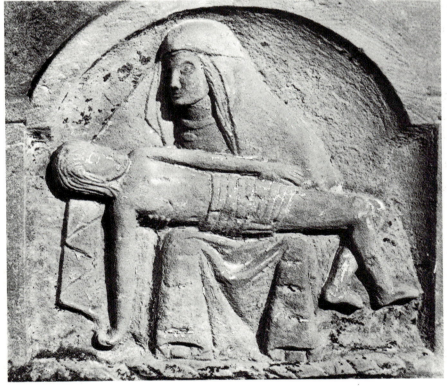

62 Graveyard with belfry and crosses on the graves.
Karmacs,
Veszprém County

63 Cemetery with carved stone crosses.
Vonyarcvashegy,
Veszprém County

64 Pietà on a carved gravestone from 1938. Detail.
Rezi,
Veszprém County

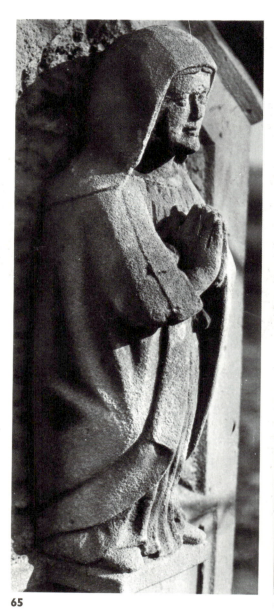

65

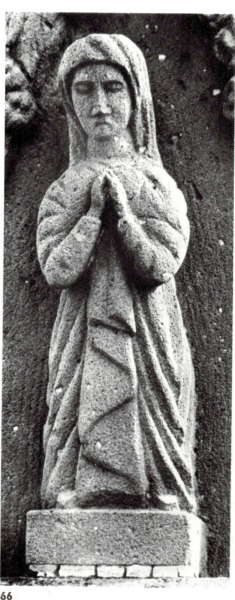

66

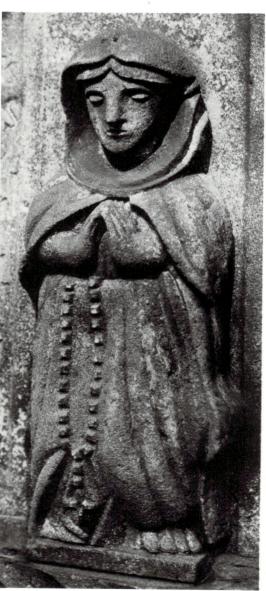

67

65 Our Lady
of Lourdes
on a carved
gravestone. Detail.
Rezi,
Veszprém County

66 Our Lady
of Sorrows
on a carved grave-
stone. Detail.
Vonyarcvashegy,
Veszprém County

67 Figure of a nun
on a carved
gravestone. Detail.
Vonyarcvashegy,
Veszprém County

68 Stone cross
marking a grave,
with a representation
of the body of Christ.
Detail.
Keszthely region,
Veszprém County

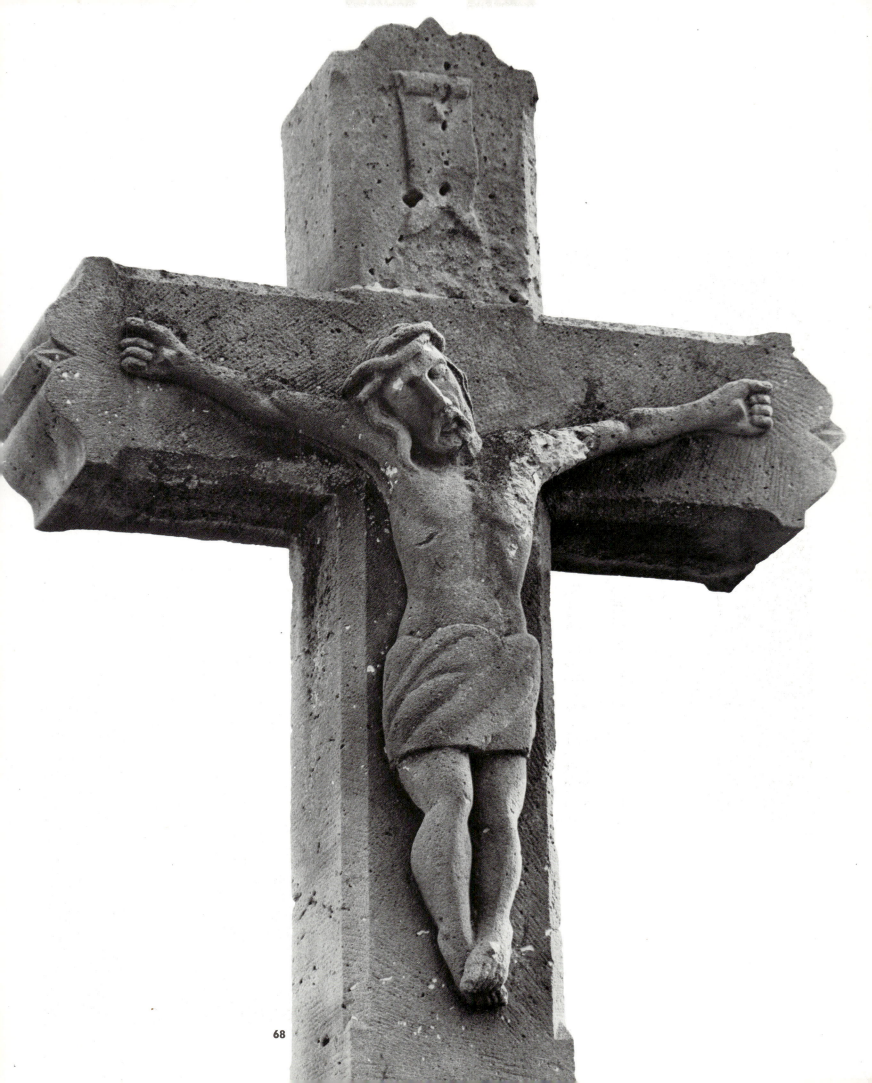

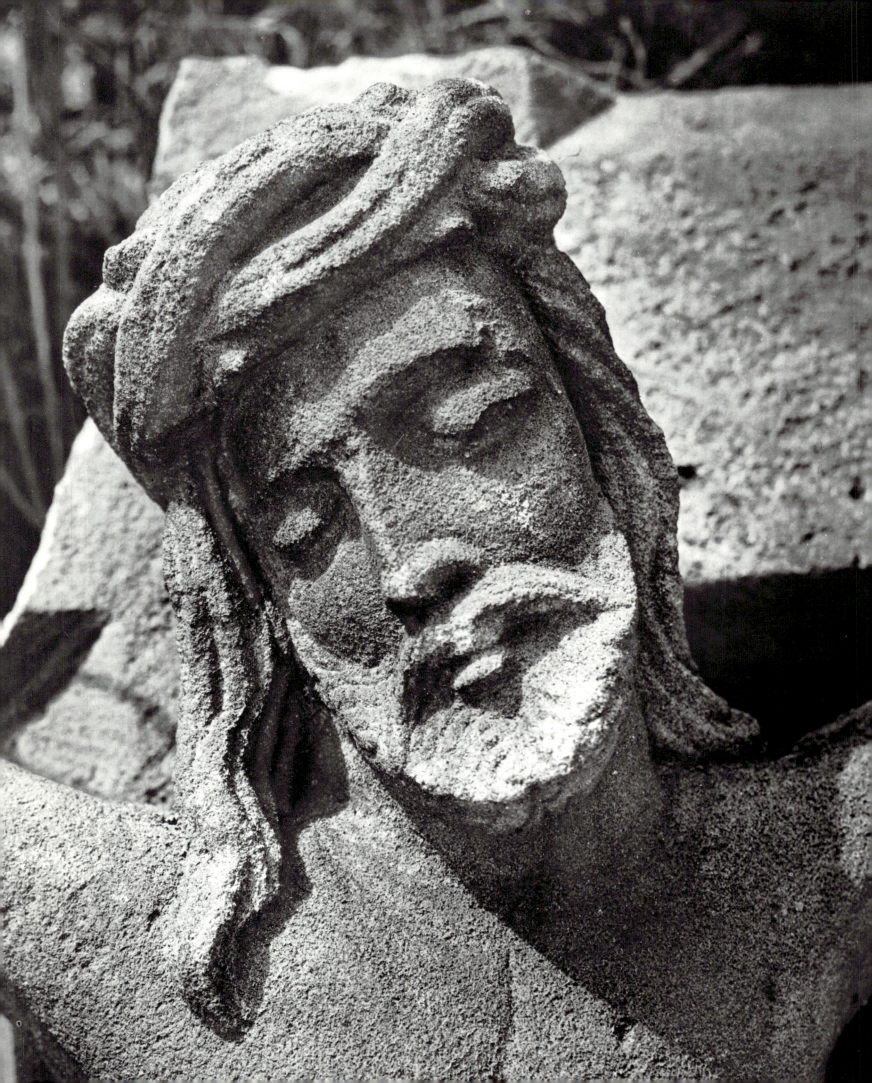

69 Head of Christ, from a stone cross marking a grave. Detail. Gyenesdiás, Veszprém County

70 St. Wendelin, from a stone cross marking a grave. Detail. *c.* 1870. It was customary to carve the figure of the patron saint of the husband and wife below the cross. In this case the man's name was Wendelin, the wife's Anna. Vonyarcvashegy, Veszprém County. (See Ill. 71)

71 St. Anne, from a stone cross marking a grave. Detail. Vonyarcvashegy, Veszprém County (See Ill. 70)

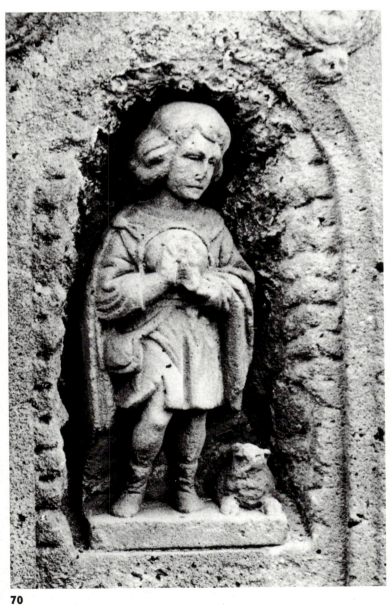

70

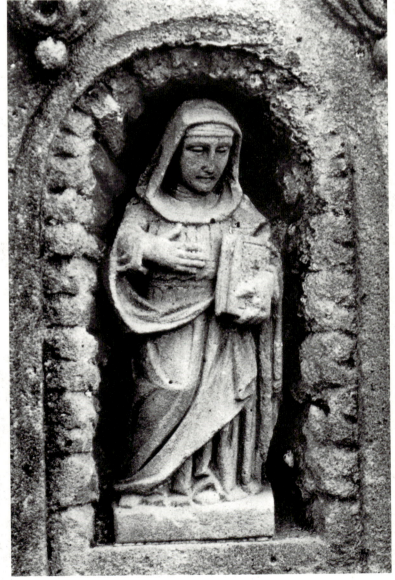

71

72 Carved stone
cross in the cemetery
at Parád, Heves
County. Inscription:
"Erected
for the Glory of God
by Sándor Kas
and his wife Borbála
Kives on May 1 in
the year 1896. May
the souls
of the faithful dead
rest in the Mercy
of God Amen."

73 Stone cross, much
eroded, at Lengyel-
tóti, Somogy County

74 Angel, carved
on a gravestone.
Karmacs,
Veszprém County

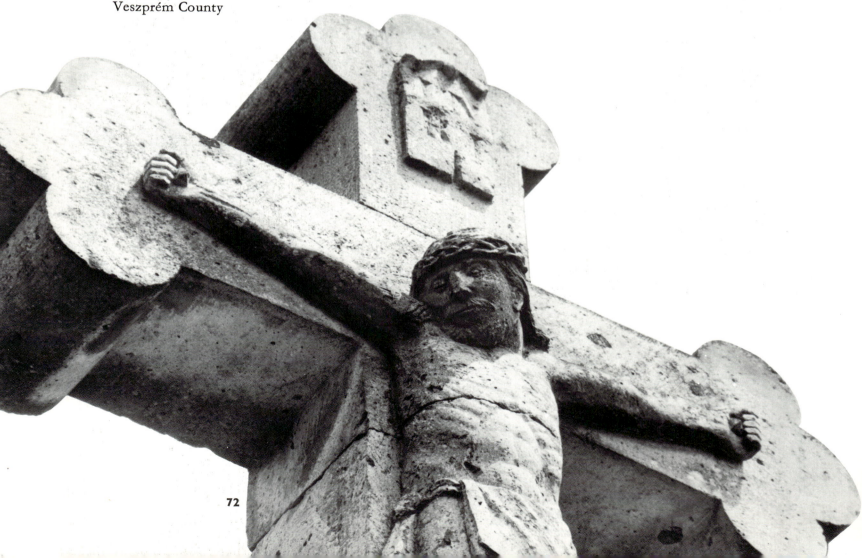

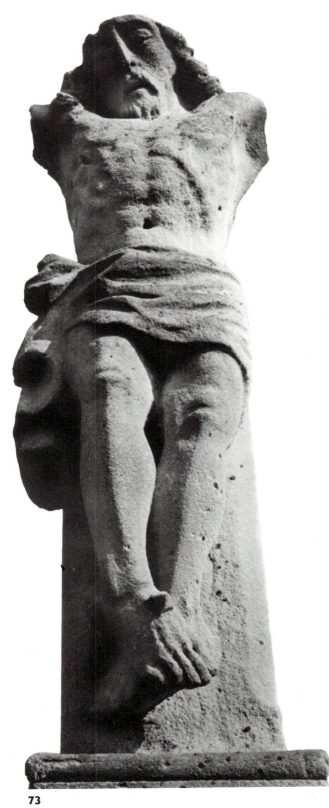

73

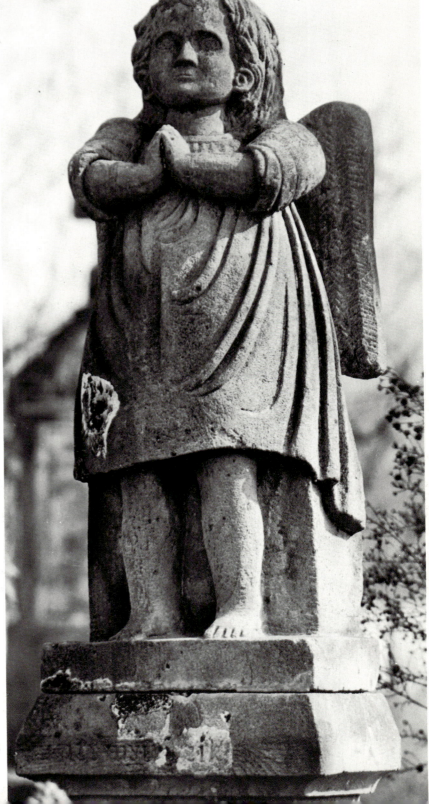

74

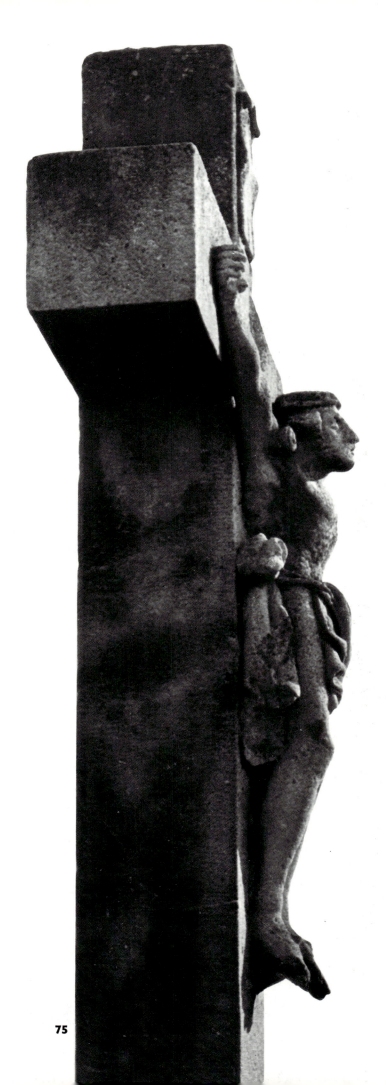

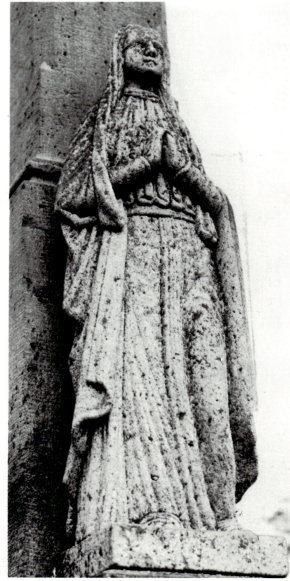

75

75 Memorial cross carved in stone. Pusztaszabolcs, Fejér County

76 Figure of one of the Marys at the foot of the Cross. Detail of a carved stone cross from the cemetery at Vöröstó, Veszprém County

77 Stone cross on a grave carved with the figure of Christ. Gyenesdiás, Veszprém County

76

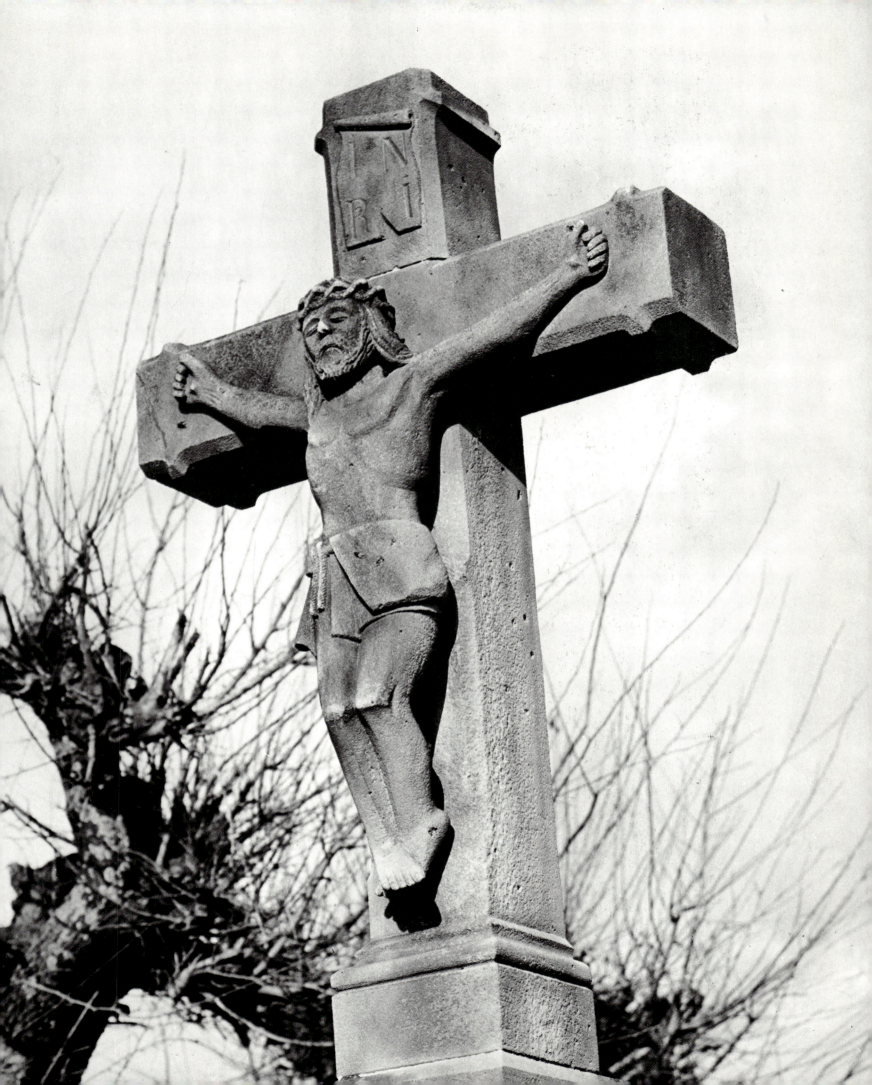

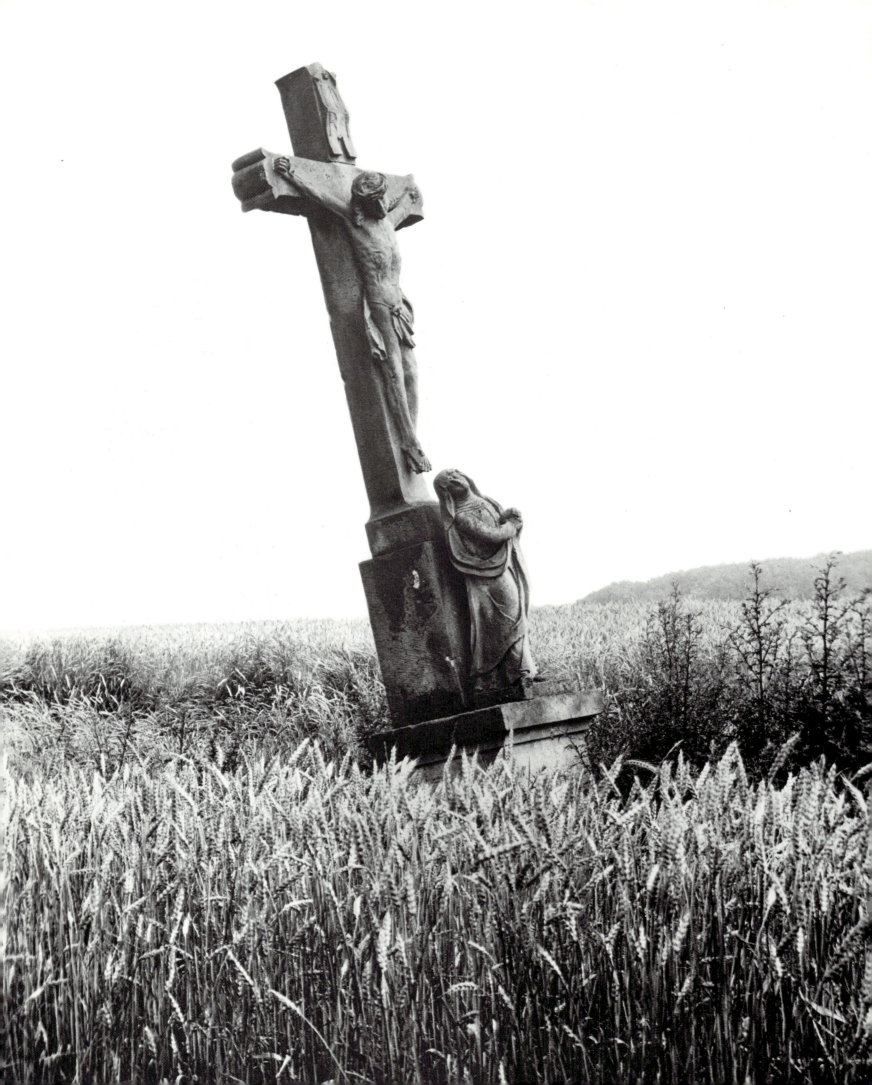

78 Wayside cross
carved in stone
with the figures
of Christ and Our
Lady of Sorrows.
Balaton uplands

79 Figures of Jesus
and Mary, both
pointing to their
heart, carved
on a gravestone.
Detail.
Keszthely region,
Veszprém County

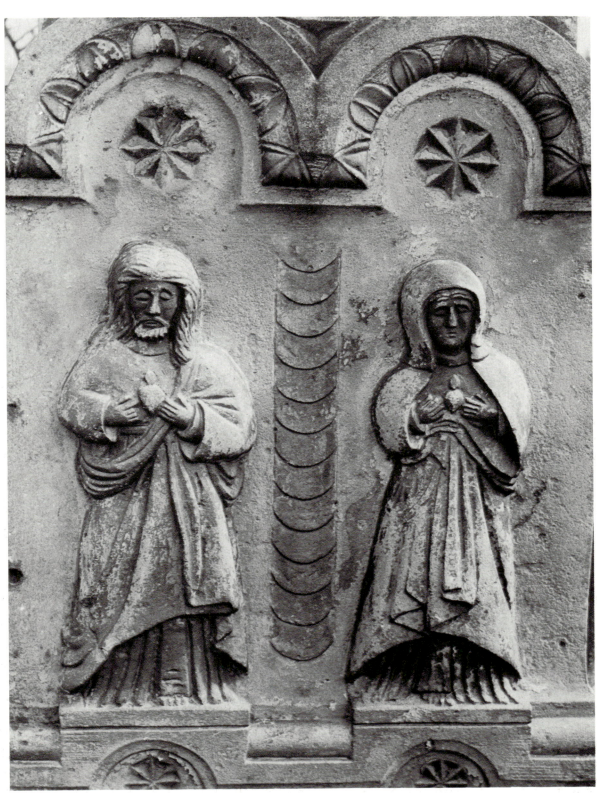

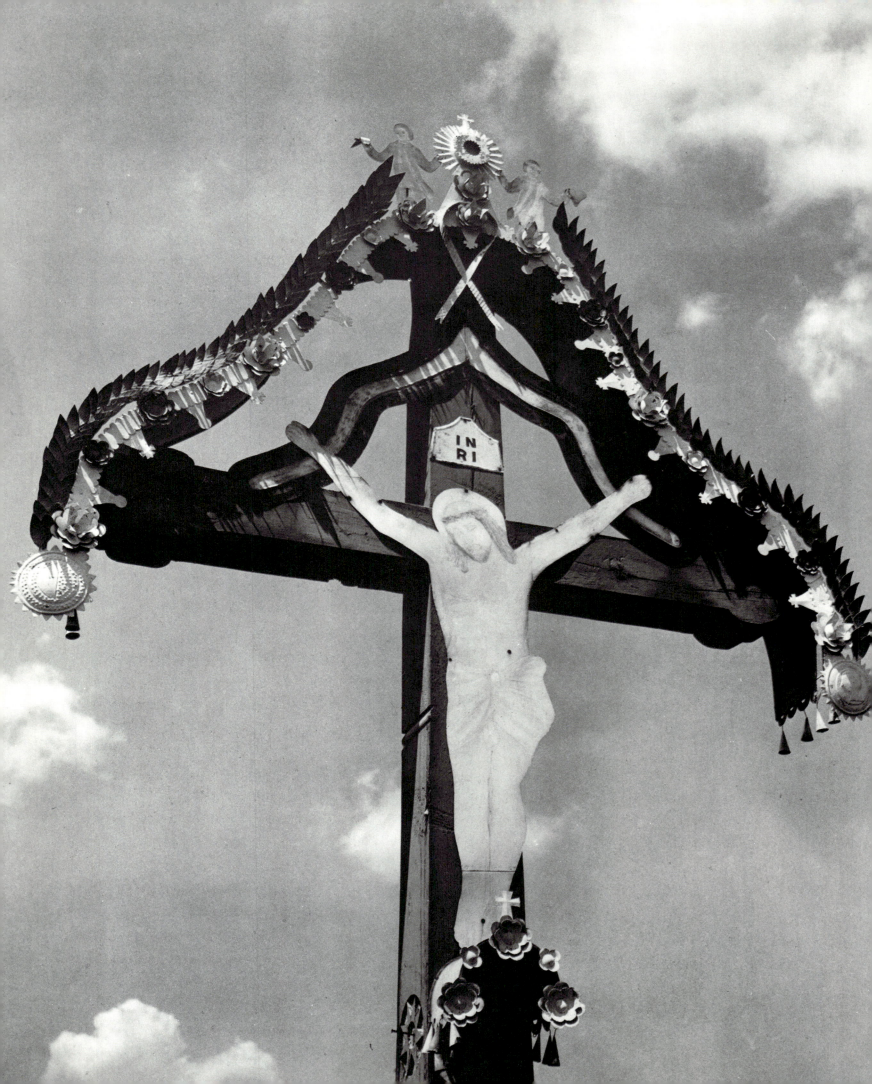

80 Wooden wayside cross with the figure of Christ. Pórszombat, Zala County

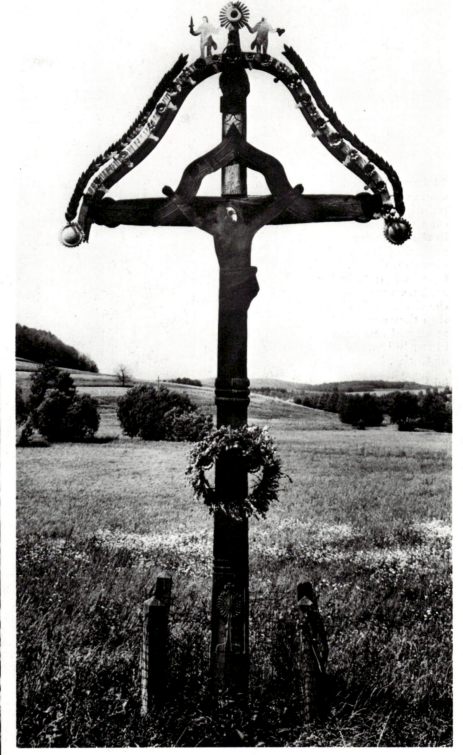

81 Our Lady of Sorrows, carved on a wooden wayside cross. Detail. Zebecke, Zala County (Göcsej Village Museum, Zalaegerszeg)

82 Wooden wayside cross with the figure of Christ. Szilvágy, Zala County

83 Large painted
stone statue of Jesus
pointing to his heart,
on a grave
in the cemetery
at Parád (Heves
County). Detail.
Inscription: "Sándor
Szakács 1931 Under
the shade of this holy
sign they are
at eternal rest
in the holy name
of Christ."

84 Franciscan monk.
Wood, carved
and painted, with
a brown robe. *2.2 cm*.
Dunaszekcső,
Baranya County
(János Bozsó's
collection, Kecskemét)

85 Mary Magdalene.
Wood, carved
and painted, with
a purple robe.
Detail. *2.5 cm*.
Dunaszekcső,
Baranya County
(János Bozsó's
collection,
Kecskemét)

86 Carved
and painted wooden
cross with the figure
of Christ. Detail.
Dunaszekcső,
Baranya County
(János Bozsó's
collection,
Kecskemét)

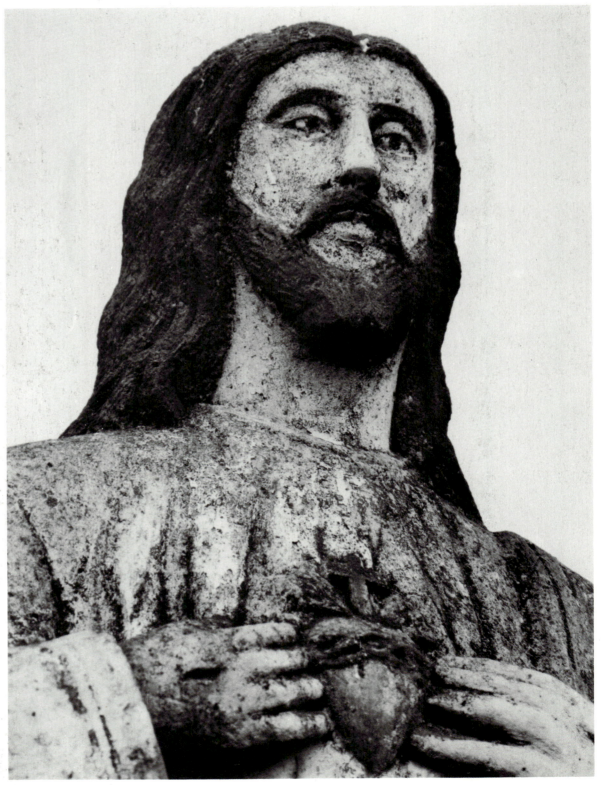

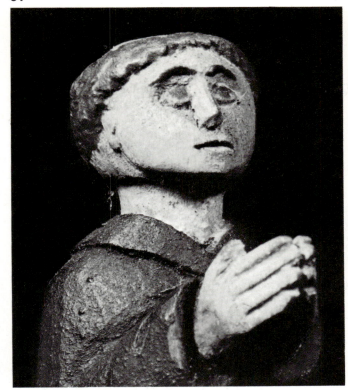

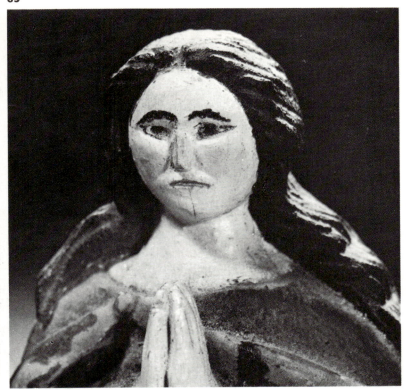

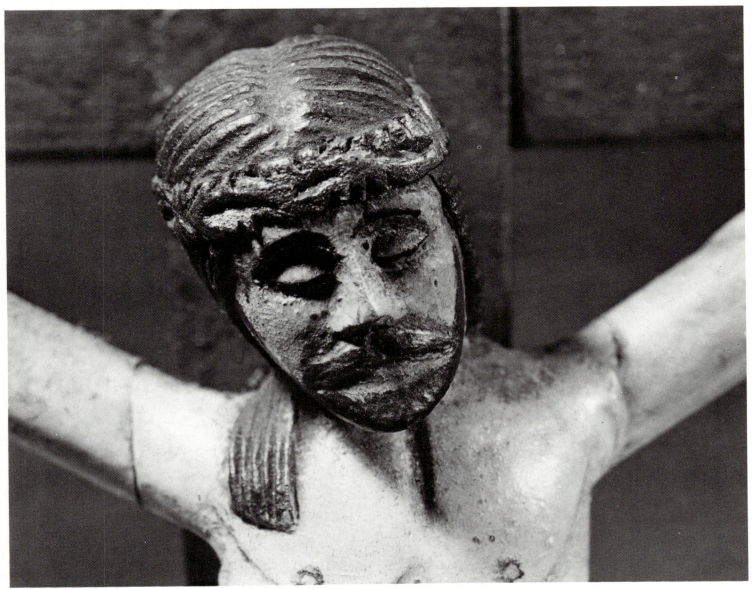

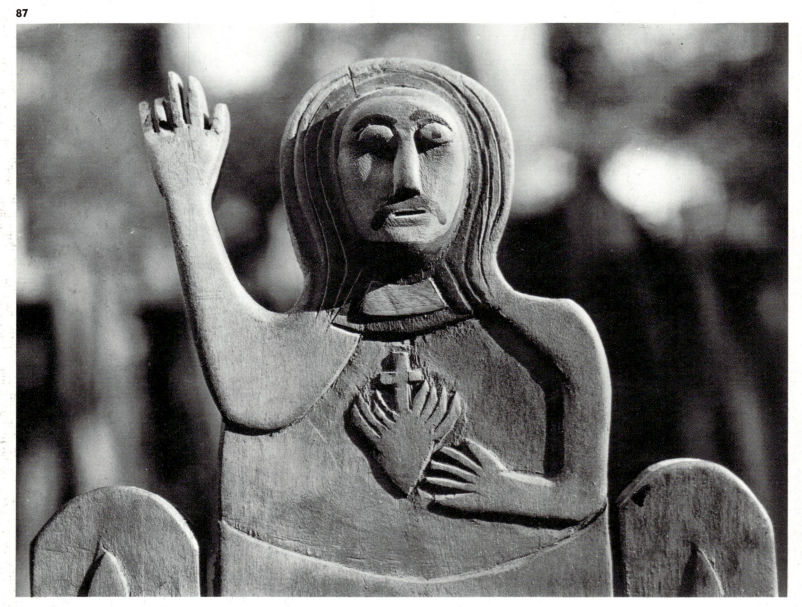

87 Figure of Jesus pointing to his heart. Detail from a candle-stick carved in wood, and painted. Made by Pál Gyurkó, 1939. Height of detail: *10.2 cm.* Hatvan, Heves County (Palóc Museum, Balassagyarmat)

88 Carved wooden crucifix. Height: *8.7 cm.* Nőtincs, Nógrád County (Palóc Museum, Balassagyarmat)

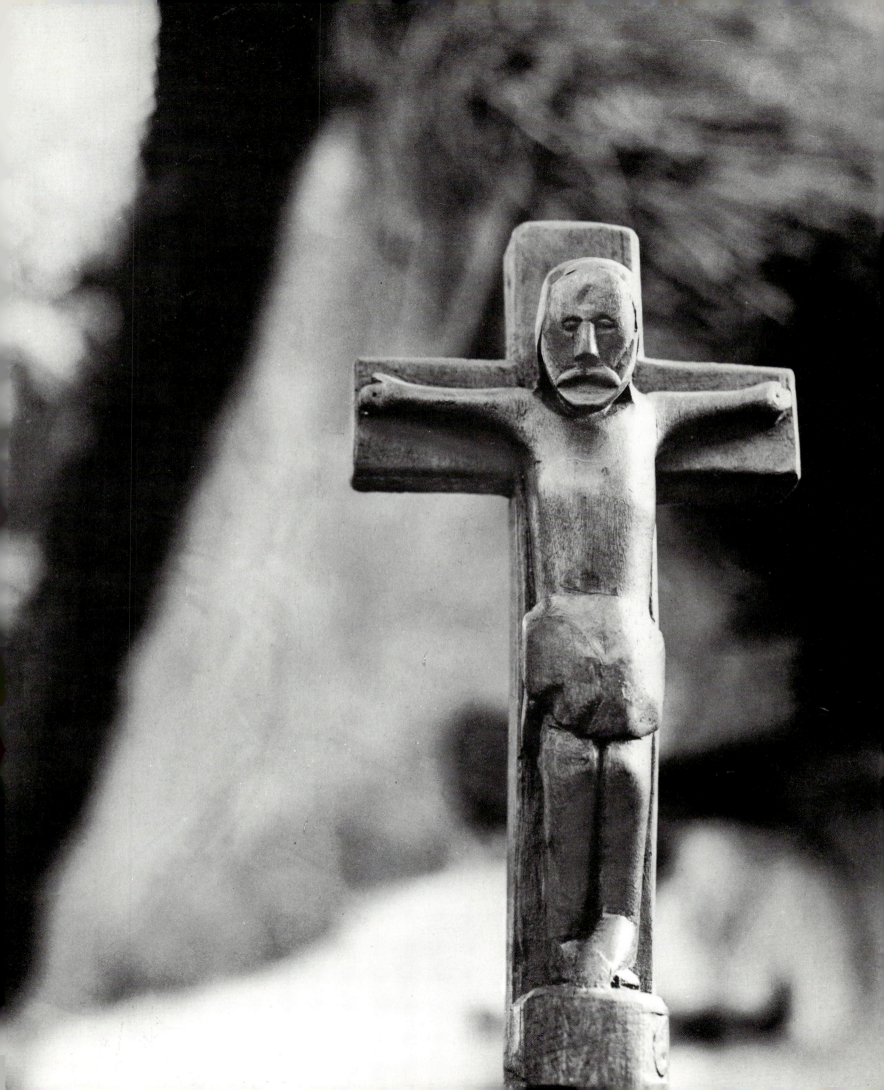

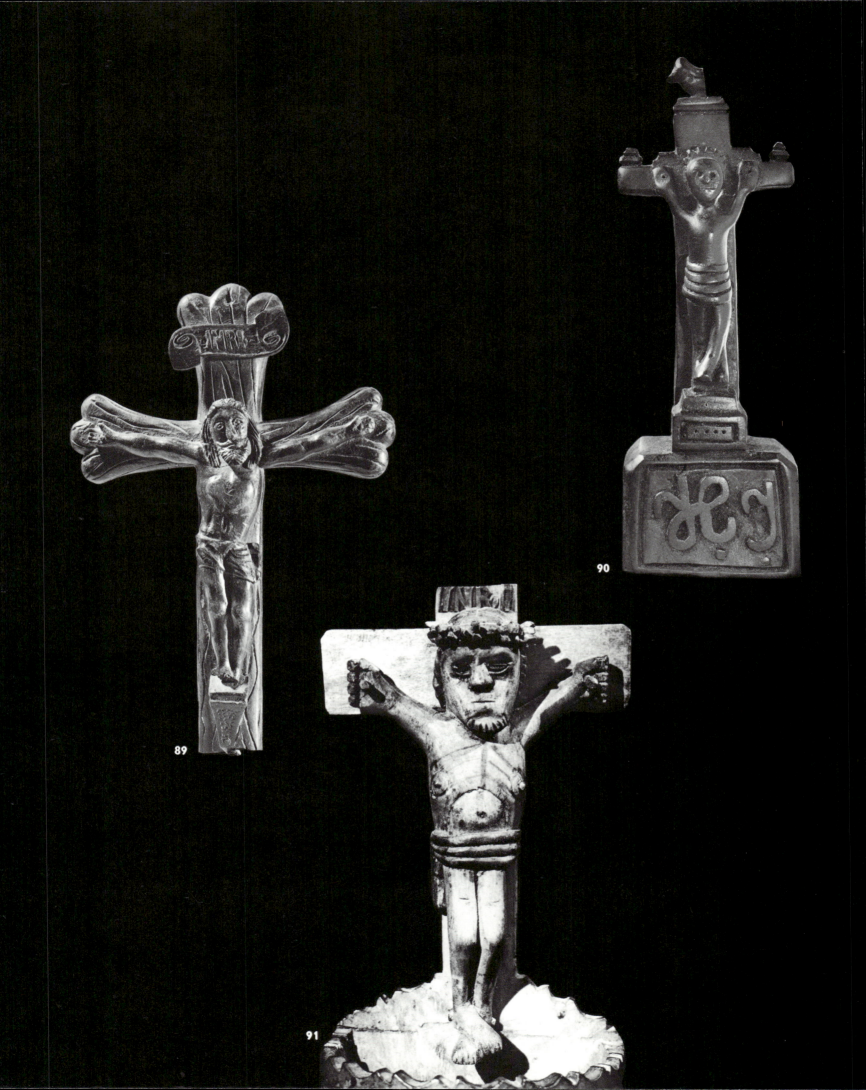

89

90

91

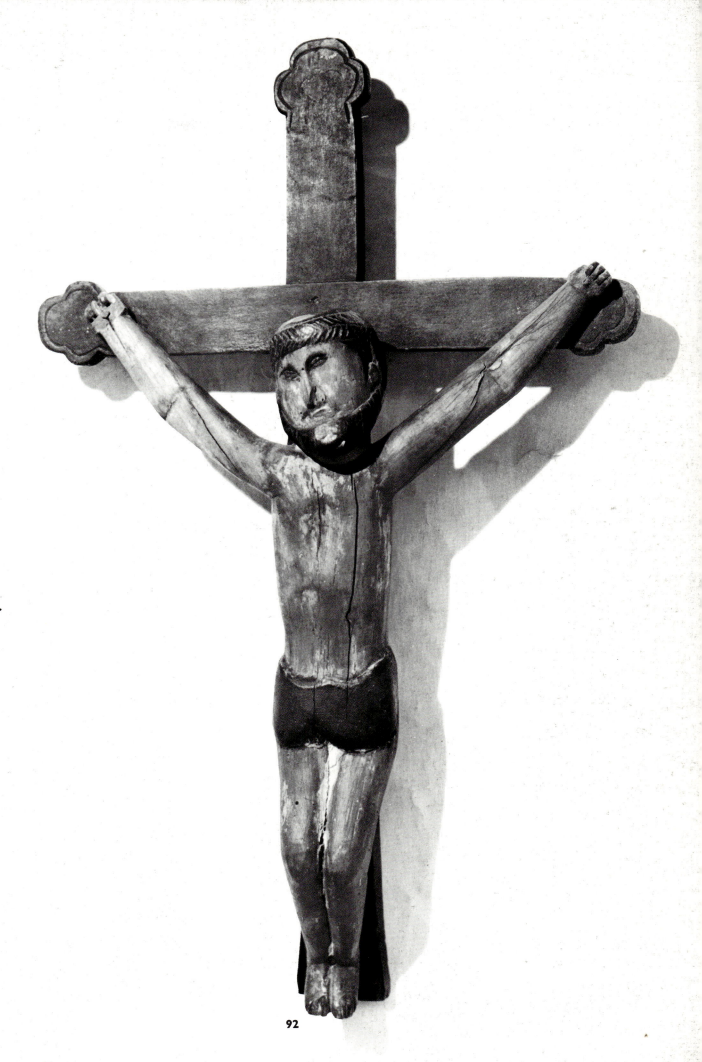

89 Wooden crucifix,
carved and varnished.
21.2 cm. Kecskemét
(János Bozsó's
collection,
Kecskemét)

90 Carved wooden
crucifix with
the initials H. J.
Made by János
Havrán. *16 cm.*
Kisterenye, Nógrád
County (Palóc
Museum,
Balassagyarmat)

91 Carved wooden
crucifix,
part of a stoup
for holy water.
13.5 cm.
Keszthely (Balaton
Museum, Keszthely)

92 Wooden crucifix
carved from a single
piece of wood
with three branches,
and painted. *46 cm.*
Bodony, Heves
County (Palóc
House, Parád)

92

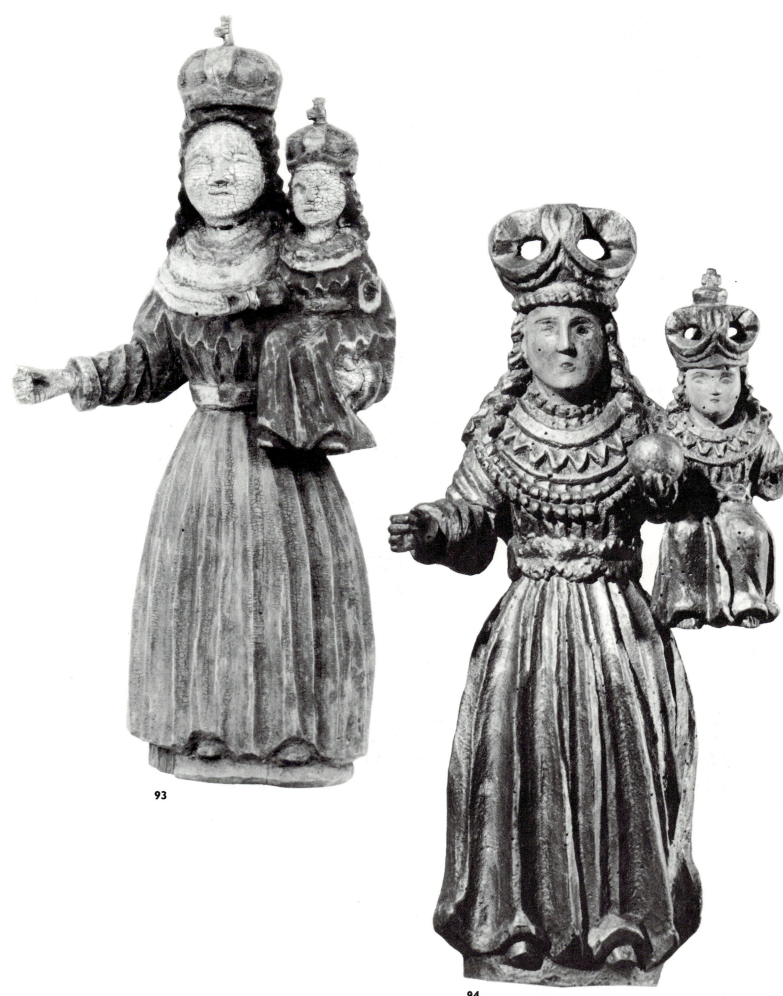

93

94

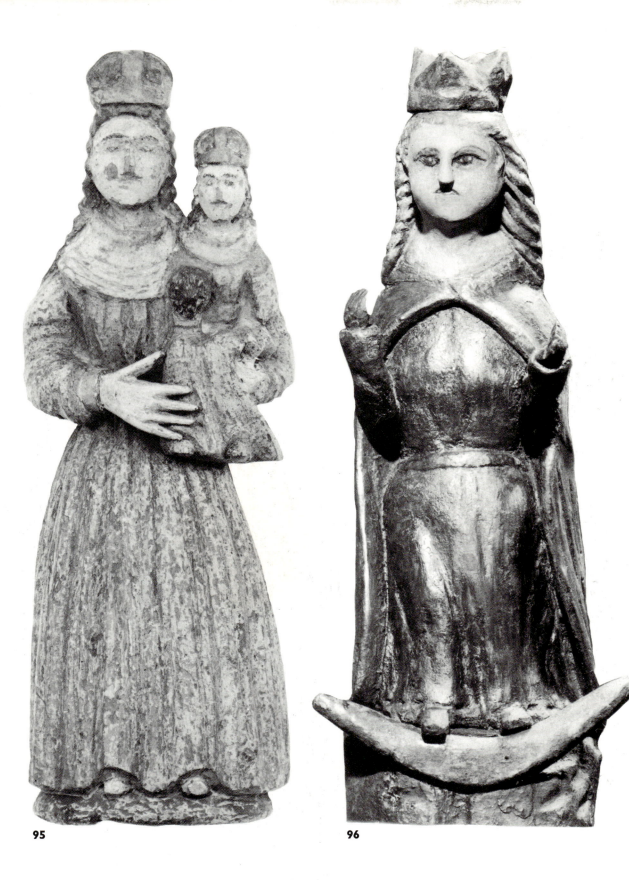

95

96

93 Carved figures
of Mary
and the Child Jesus
from the niche
on the gable
of a house. Painted
wood. The robes
of Mary and the Child
are light blue with
red, the faces are
white. *32 cm.*
Kiskunfélegyháza,
Bács-Kiskun County
(Kiskun Museum,
Kiskunfélegyháza)

94 Carved figures
of Mary
and the Child Jesus.
Painted wood.
The faces are
in natural colours,
the clothes
and crowns are gilded.
31 cm.
Kiskunfélegyháza,
Bács-Kiskun County
(Kiskun Museum,
Kiskunfélegyháza)

95 Carved figures
of Mary
and the Child Jesus.
Painted wood.
The robes of Mary
and the Child are
blue, with some red
and yellow. *34 cm.*
Kiskunfélegyháza,
Bács-Kiskun County
(Kiskun Museum,
Kiskunfélegyháza)

96 Carved Madonna
standing
on the crescent moon.
Painted wood.
The robe is dark
red, the cloak dark
blue, the crown is
gilded. *31 cm.*
Kiskunfélegyháza,
Bács-Kiskun County
(Kiskun Museum,
Kiskunfélegyháza)

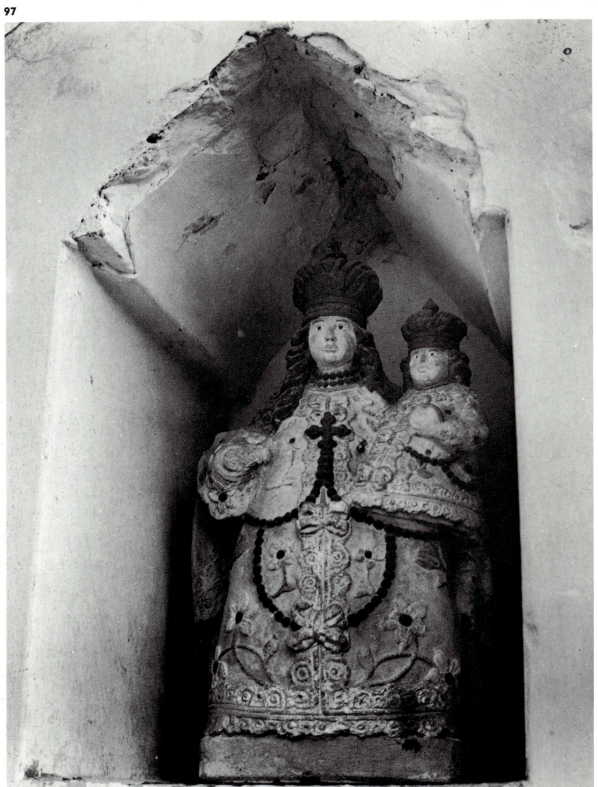

97 Statue of Mary
and the Child Jesus
from the niche
on the gable
of a house. Painted
stone.
Páka, Zala County

98 Window
with iron bars
and wooden
shutters.
Látrány,
Somogy County

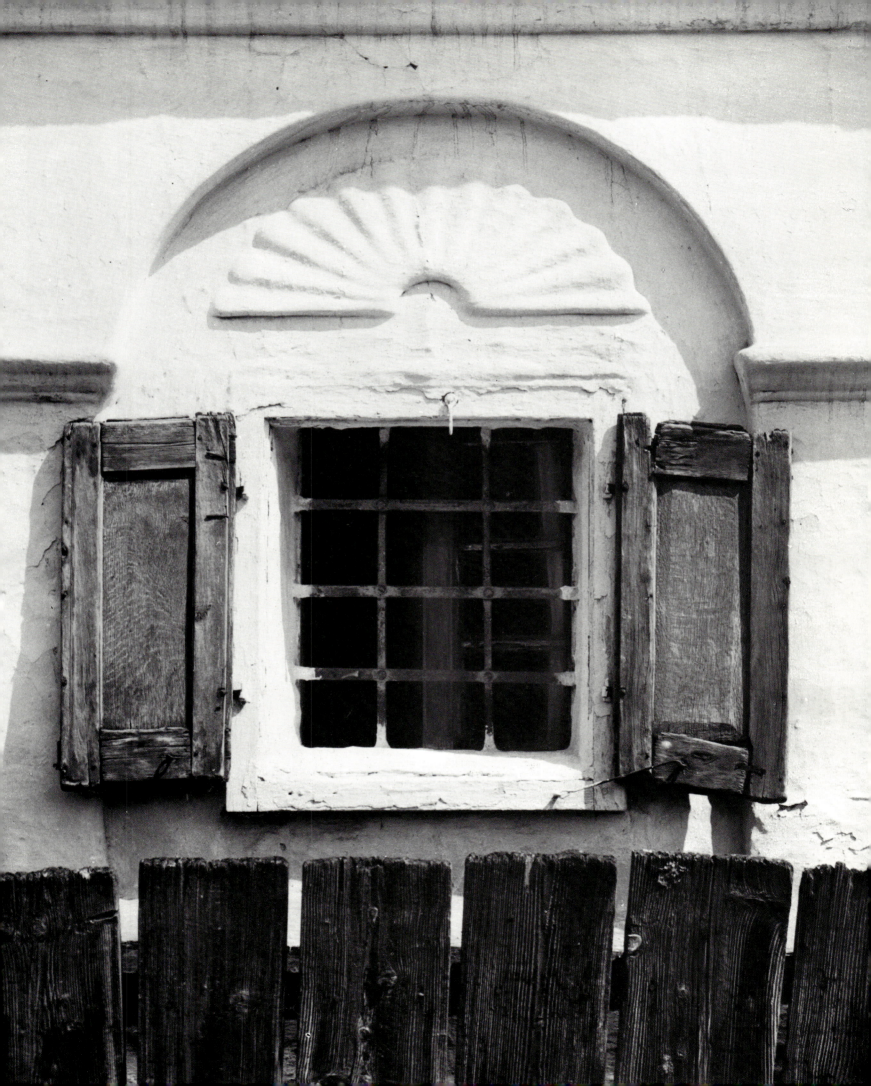

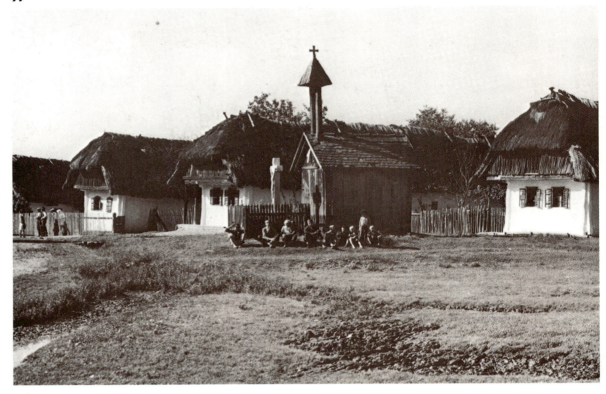

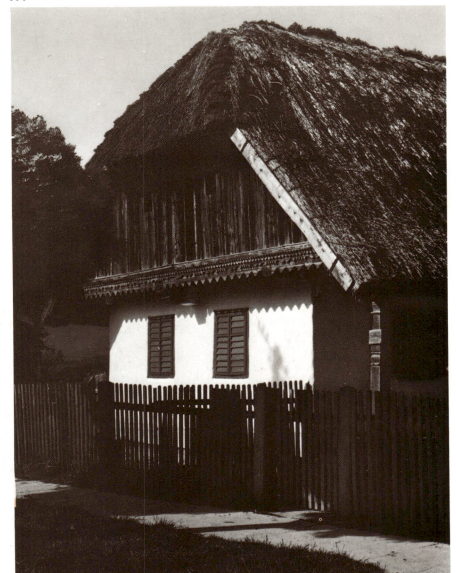

99 Street with timber-framed houses resting on wooden beams.
Mumor, Zala County

100 Row of houses built on plots with narrow frontage.
Bóly, Baranya County

101 Thatched cottage with carved gables.
Nagydobsza, Somogy County

102 Reed-thatched house with an arcaded porch.
Zamárdi, Somogy County

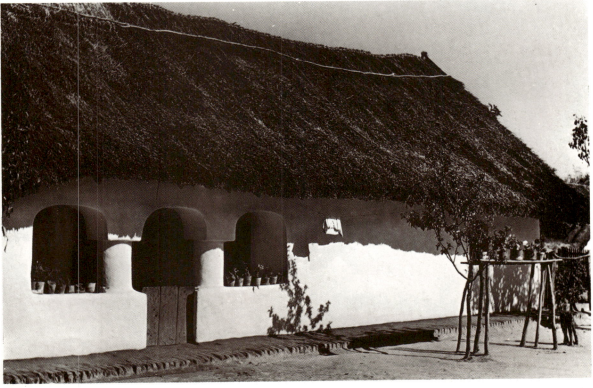

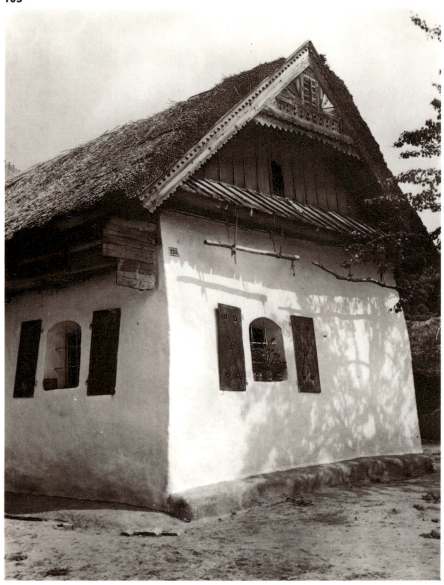

103 Reed-thatched house with a projecting gable of elaborately sawn boards, sloping planks for the rain to drain off, and iron window-shutters. Martos (Martovce, Czechoslovakia)

104 House with a pillared porch facing the courtyard. Zamárdi, Somogy County

105 Row of farm buildings (e.g. stables and sties) on the outskirts of the village. Átány, Heves County

106 Reed-thatched house with a pillared porch. Átány, Heves County

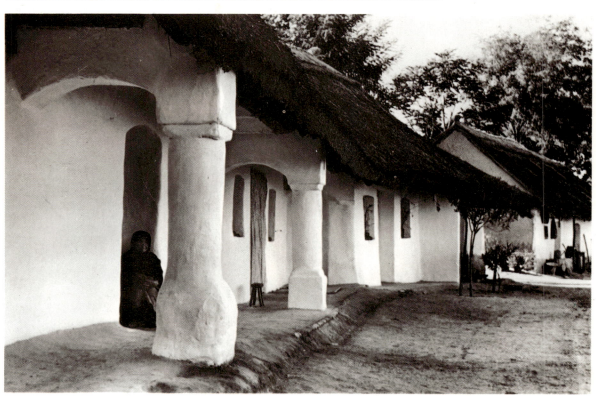

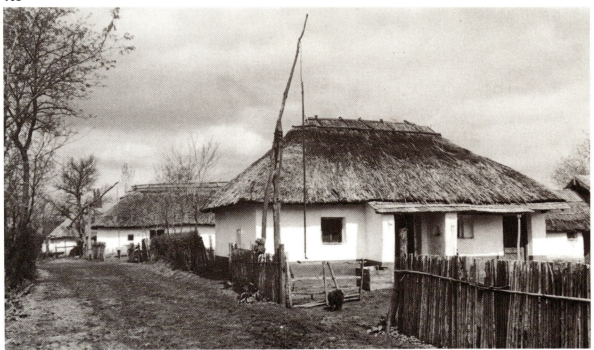

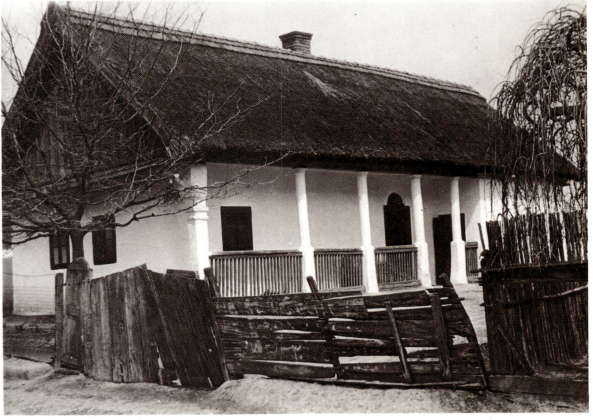

107

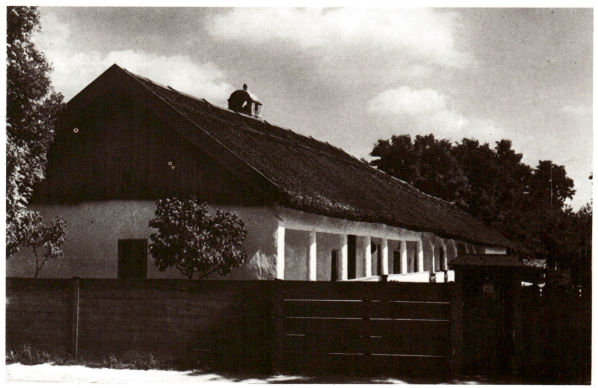

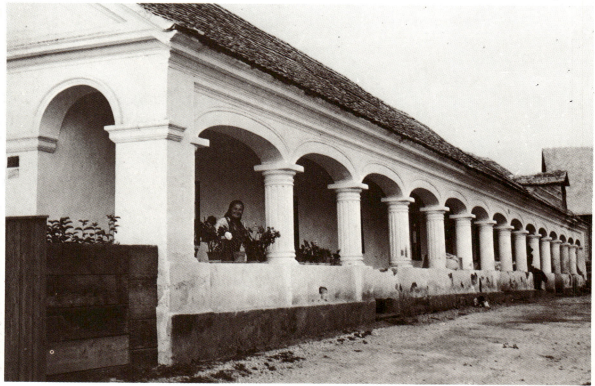

108

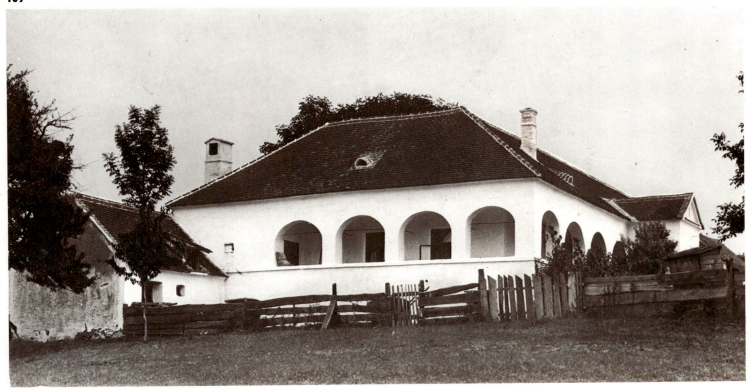

107 Reed-thatched house with a pillared porch and wooden fence. Komádi, Hajdú-Bihar County

108 Façade of a peasant house facing the yard, with arched, stone-pillared porch. Jászó, Borsod-Abaúj-Zemplén County

109 Mansion of a country nobleman with arcaded porch. Csatár, Veszprém County

110 Street with two-storey houses. The lower level is a wine-cellar. Hollókő, Nógrád County

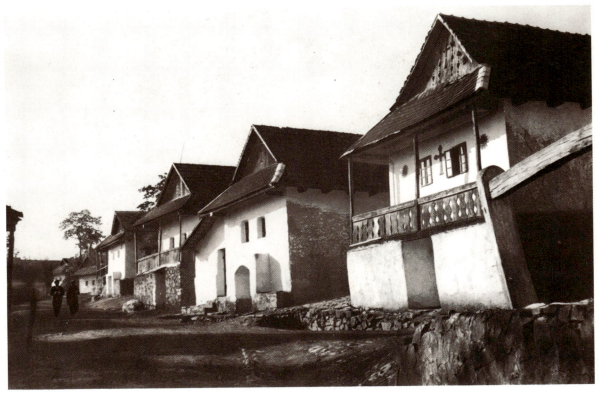

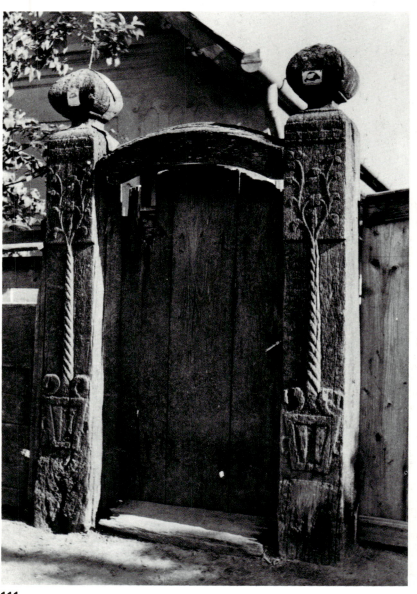

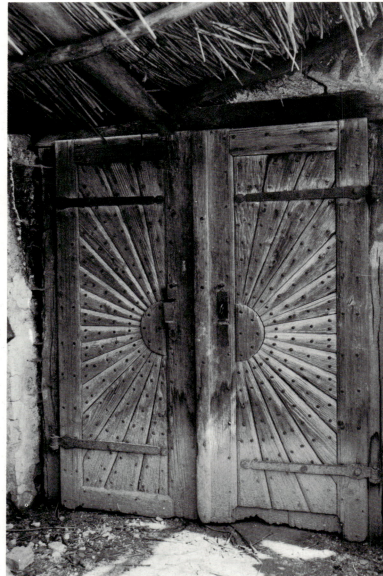

111

112

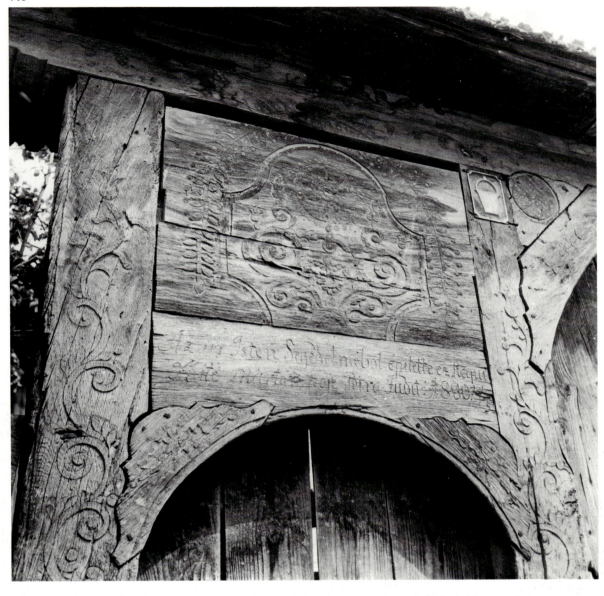

111 Small gate
to a house with
carved posts.
Záhony, Szabolcs-
Szatmár County

112 Shed door
"lined" with boards
arranged radially
and decorated
with wrought-iron
nails.
Aszófő,
Veszprém County

113 Front
of a Székely double
gate carved
in relief, 1880.
Szentegyházasfalu
(Vlăhiţa, Rumania)

114 Two-storey
houses with Székely
double gates.
Szentegyházasfalu
(Vlăhiţa, Rumania)

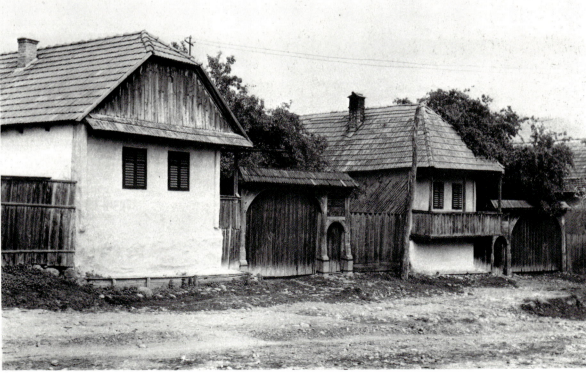

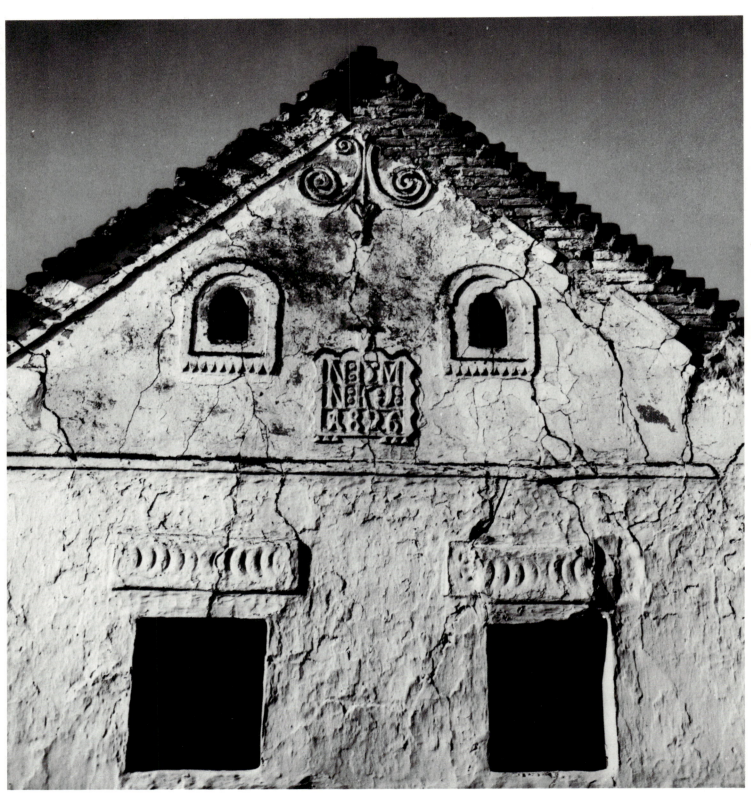

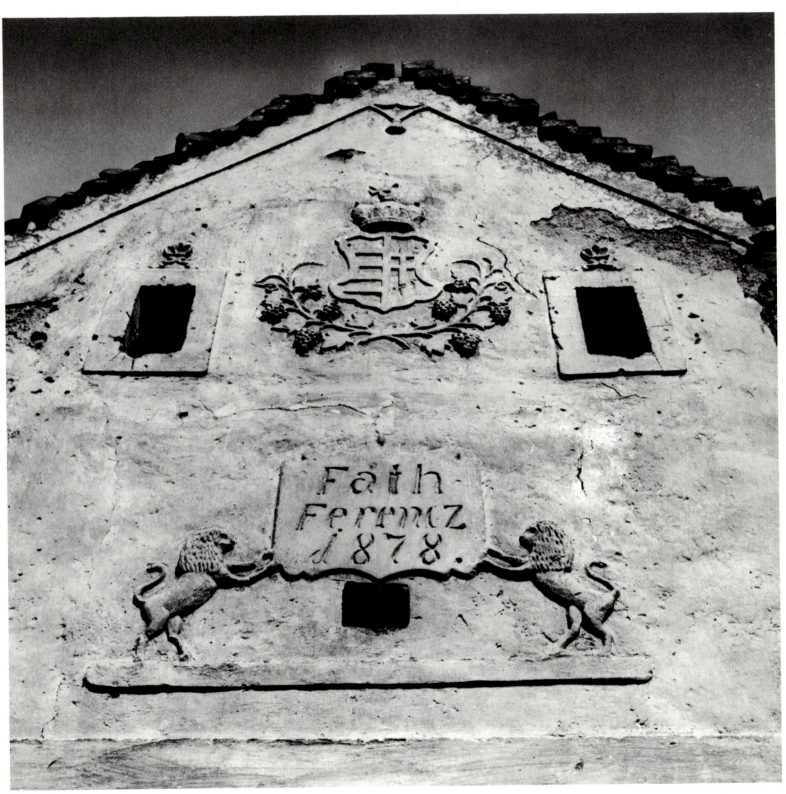

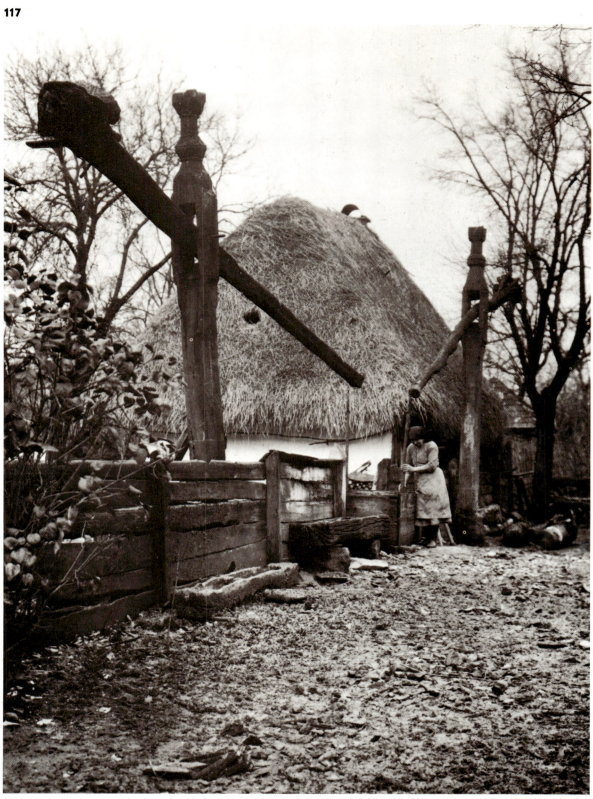

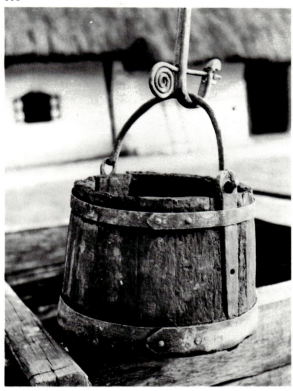

117 Well shared
by two
neighbouring houses,
with two sweep-
poles.
Tarpa, Szabolcs-
Szatmár County

118 Wooden bucket
on the end
of a sweep-pole.
Zala County (Göcsej
Village Museum,
Zalaegerszeg)

119 Kitchen with
earthenware dishes
and plates.
Börzsöny,
Pest County

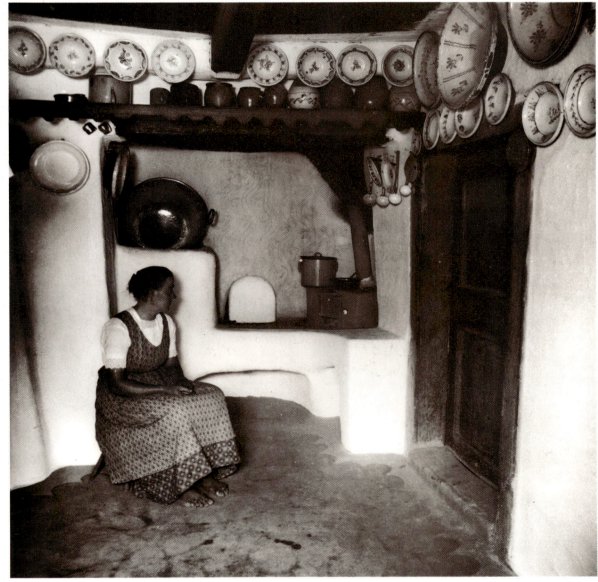

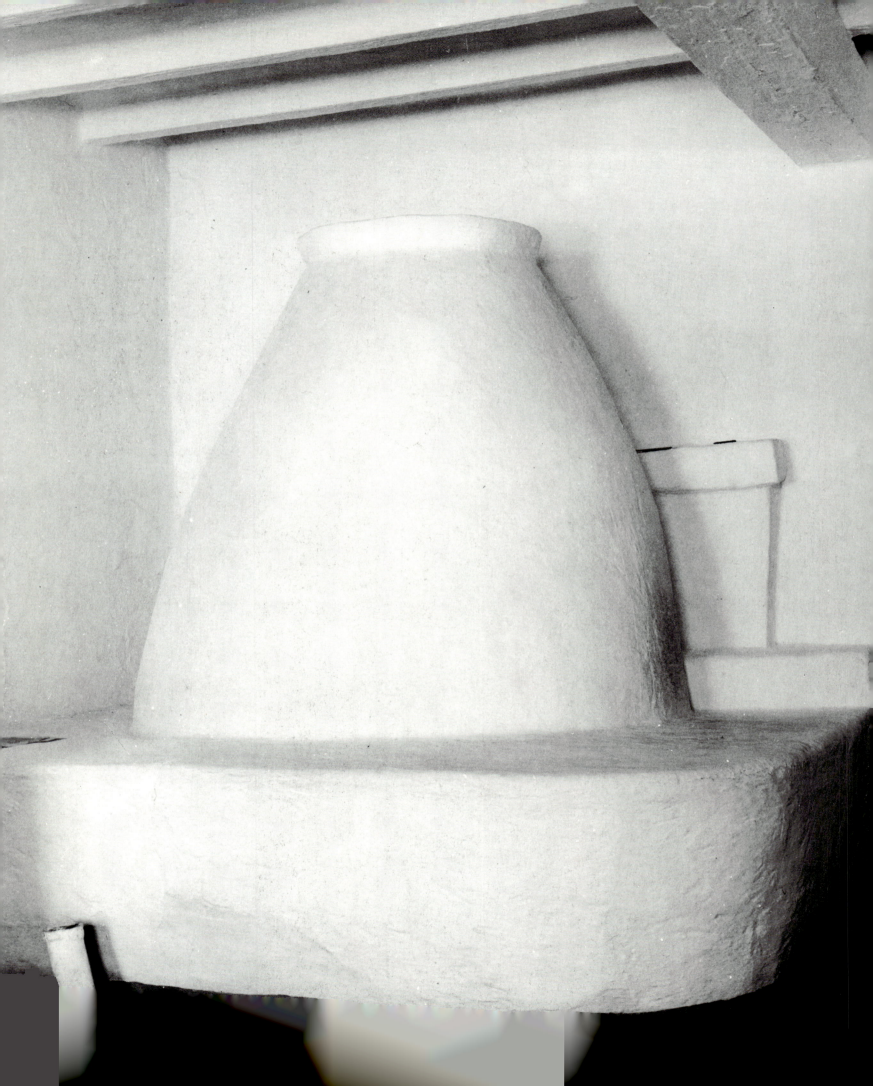

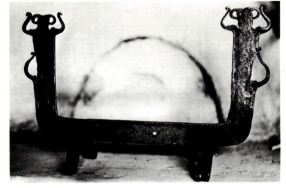

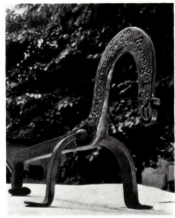

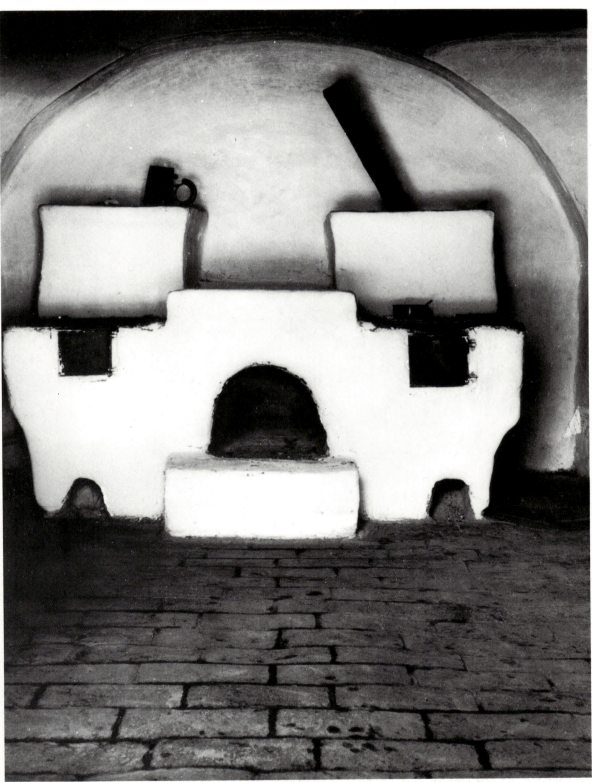

120 Beehive-shaped clay oven with low platform running round it for seating. Tápé, Csongrád County

121 Communal kitchen (shared by two families) with an oven and two fireplaces. Zamárdi, Somogy County

122 Andiron. Forged iron. *26 cm* The Great Plain (Ethnographical Museum)

123 Andiron in the shape of a beast. Forged iron with hammered decoration. *18.5 cm.* Torockó (Rimetea, Rumania) (Ethnographical Museum)

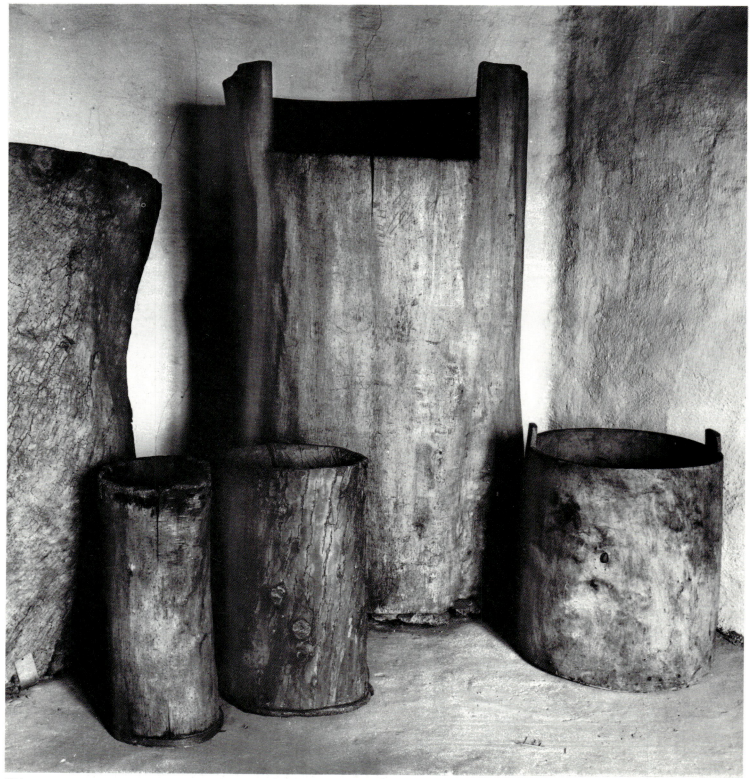

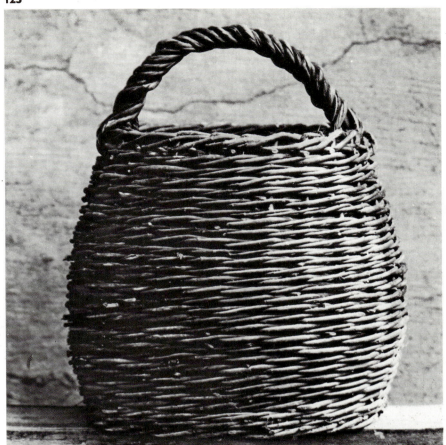

124 Pantry interior with containers for storing grain and flour, carved from a single block of wood.
Ormánság region, Baranya County (Janus Pannonius Museum, Pécs)

125 One-handled wicker-work basket. *33.4 cm.*
Mohács, Baranya County (Ethnographical Museum)

126 Basket with four divisions, made from laths, for peas, beans, etc. *33 cm.*
Átány, Heves County (Ethnographical Museum)

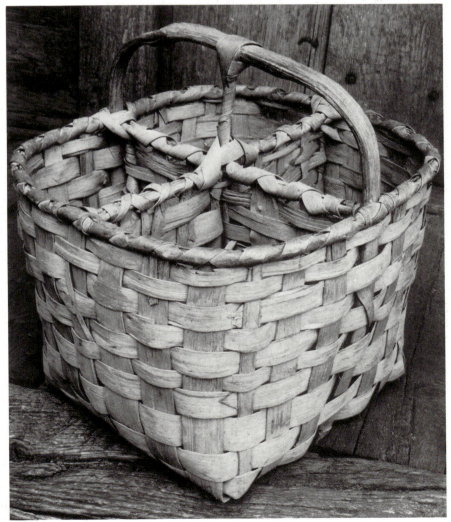

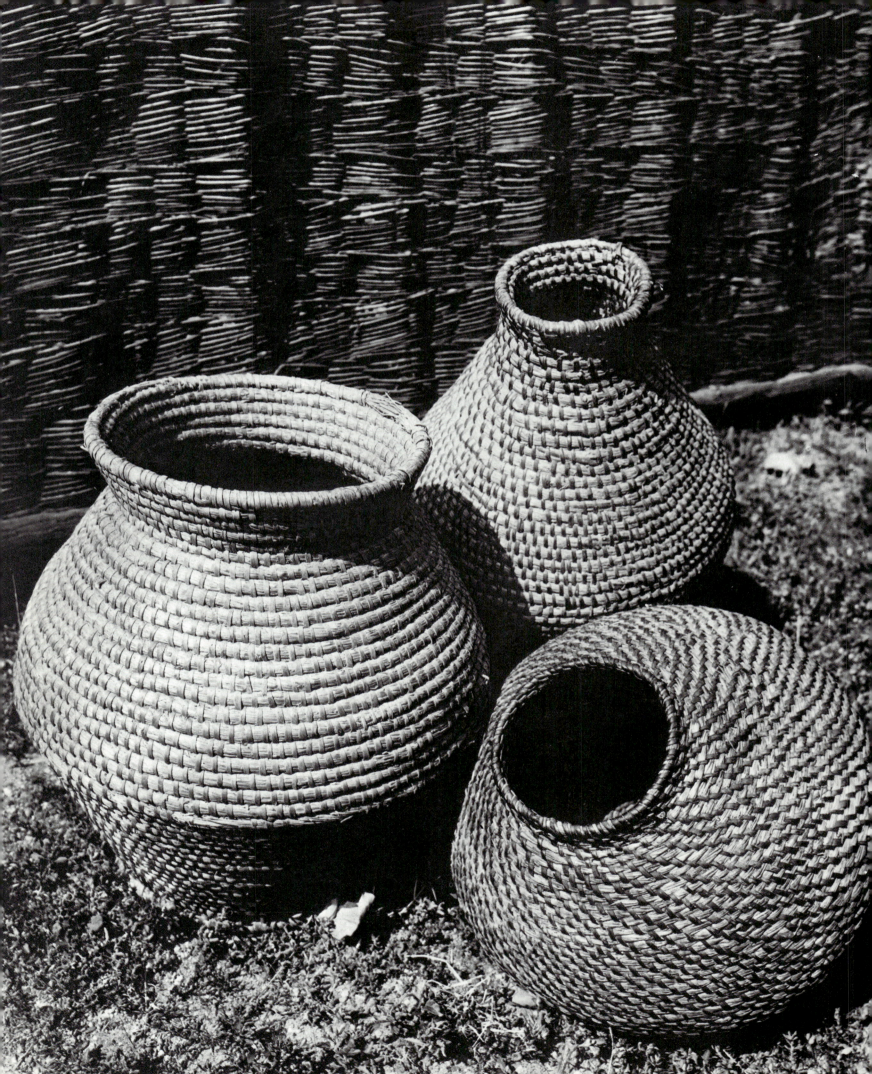

127 Coiled straw baskets for peas and beans.
60 cm, 70 cm and 35 cm.
Baglad, Zala County, Alsónyék, Tolna County, and Tarnabod, Heves County (Ethnographical Museum)

128 Coiled rush basket for fish.
52 cm.
Börvely, Szabolcs-Szatmár County (Ethnographical Museum)

129 Straw sewing basket with lid.
15.5 cm.
Nagysalló (Šarluhy, Czechoslovakia) (Ethnographical Museum)

130 Straw basket with lid, for eggs. *30 cm.*
Recsk, Heves County (Ethnographical Museum)

129

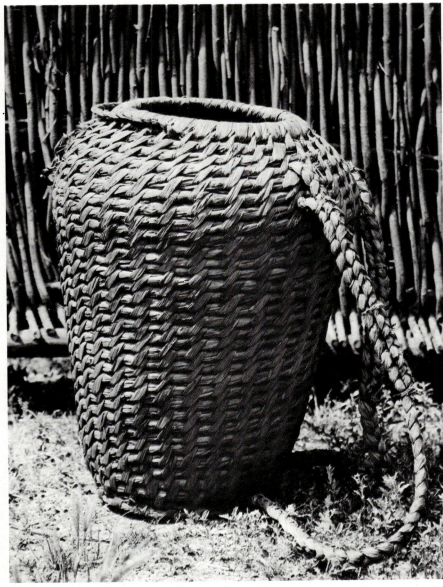

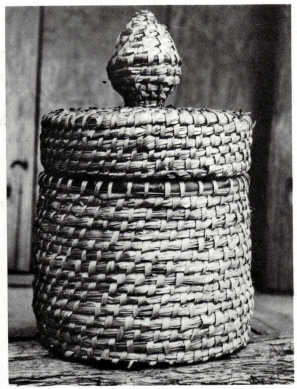

127 **128**

130

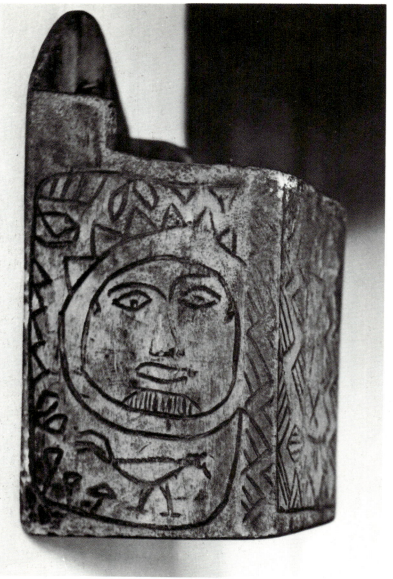

131 Hanging salt-cellar for kitchen wall. Softwood with engraved and poker-work decoration.
28.3 cm.
Domokos
(Dămăcuşeni,
Rumania) (Déri
Museum, Debrecen)

132 Hanging match-holder for wall. Softwood with engraved decoration.
21.5 cm.
Tiszaigar,
Heves County
(Ethnographical
Museum)

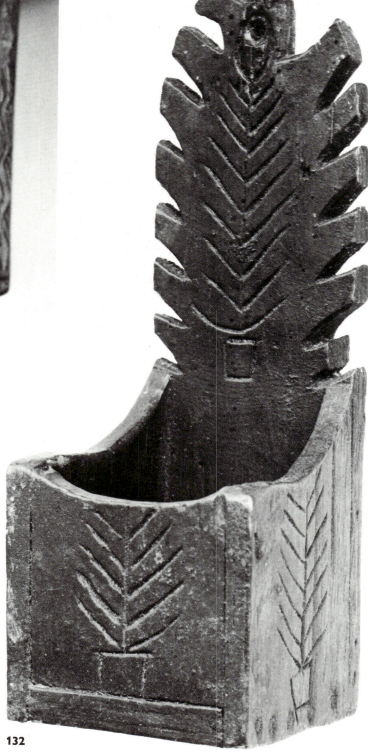

132

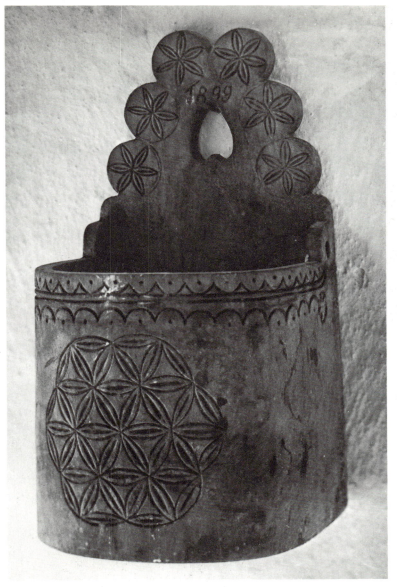

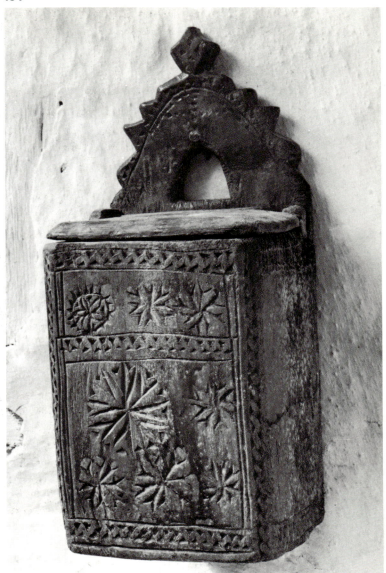

133 Hanging salt-cellar for kitchen wall, with notched back, engraved rosette, and the date: "1899." Softwood. *33.3 cm.* Nógrád County (Palóc Museum, Balassagyarmat)

134 Hanging salt-cellar for kitchen wall. Softwood with engraved decoration. *28.5 cm.* Domokos (Dămăcuşeni, Rumania) (Ethnographical Museum)

135 Mortar carved
from a single piece
of wood with
engraved decoration.
22.5 cm. Inscription:
"1857 BE."
Dömsöd,
Pest County
(Ethnographical
Museum)

136 Wooden platter
and fork with
wooden handle.
Diameter of platter:
22 cm.
Átány,
Heves County
(Ethnographical
Museum)

137 Wooden dish,
wooden spoon
and mug, with
engraved decoration
on the handle
of the spoon.
Softwood. Height
of dish: *10 cm;*
length of spoon:
26 cm; height
of mug: *6.5 cm*.
Kispalád, Szabolcs-
Szatmár County
(Ethnographical
Museum)

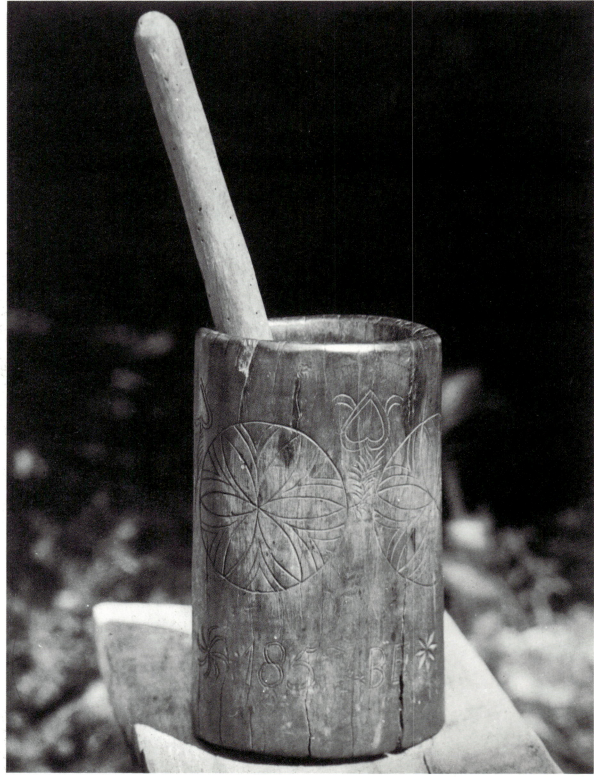

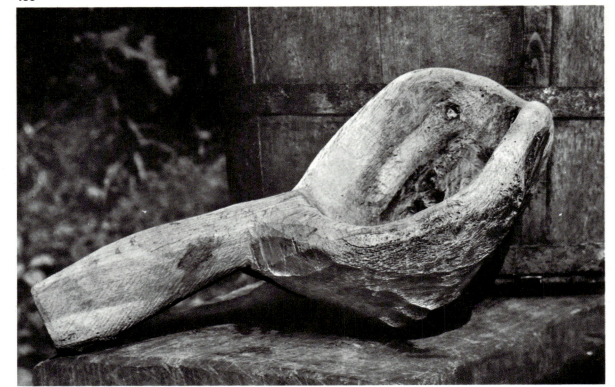

138 Water-dipper
scooped out
of hardwood root.
14.2 cm.
Tiszafüred,
Heves County
(Ethnographical
Museum)

139 Wooden dish
with double handles
carved from single
block of wood.
17 cm.
Mátraalmás,
Nógrád County
(Ethnographical
Museum)

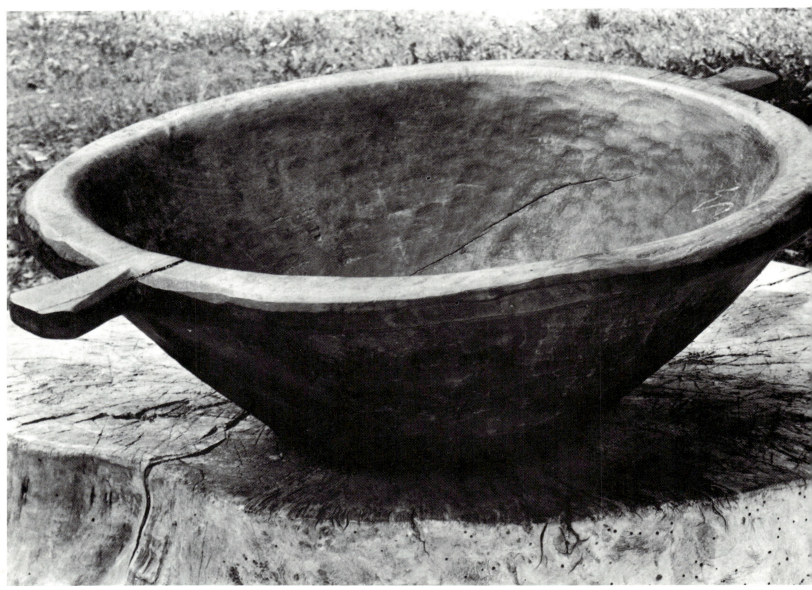

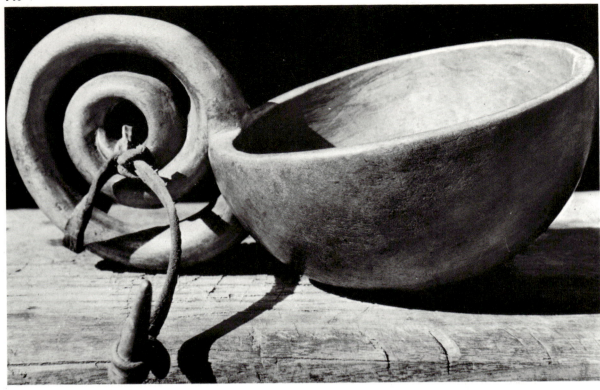

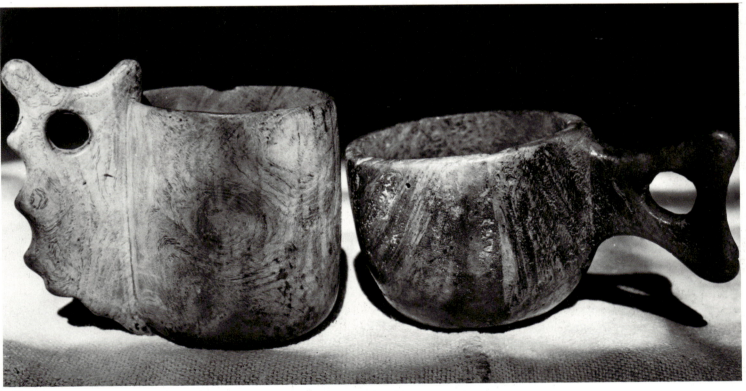

140 Water-dipper, with a spiral handle which has a strap and loop. *7.5 cm.* Ivád, Heves County (Ethnographical Museum)

141 Water-dippers carved from single blocks of wood. *9.5 cm* and *6.5 cm.* Pusztaberki, Nógrád County, and Nagy-oroszi, Nógrád County (Ethnographical Museum)

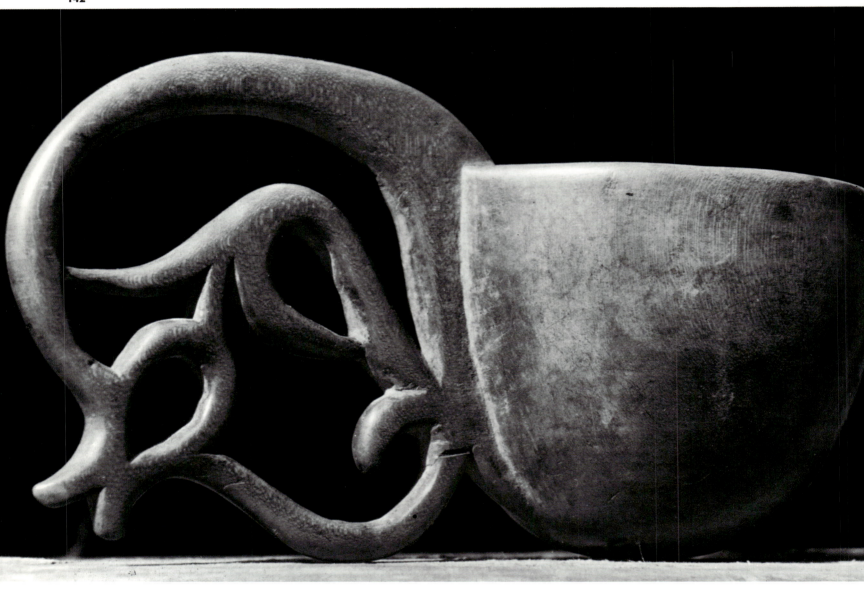

142 Water-dipper
with open-work
handle in the shape
of a flower. Wood
from a fruit tree.
9 cm.
Felsőtárkány,
Heves County
(Ethnographical
Museum)

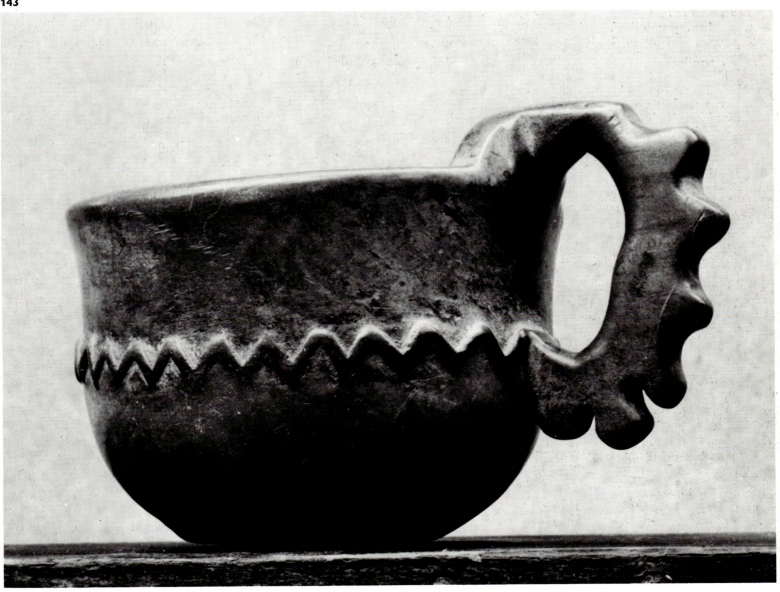

143 Water-dipper
with a notched
handle. Wood from
a fruit tree. *6.5 cm.*
Nádújfalu,
Nógrád County
(Ethnographical
Museum)

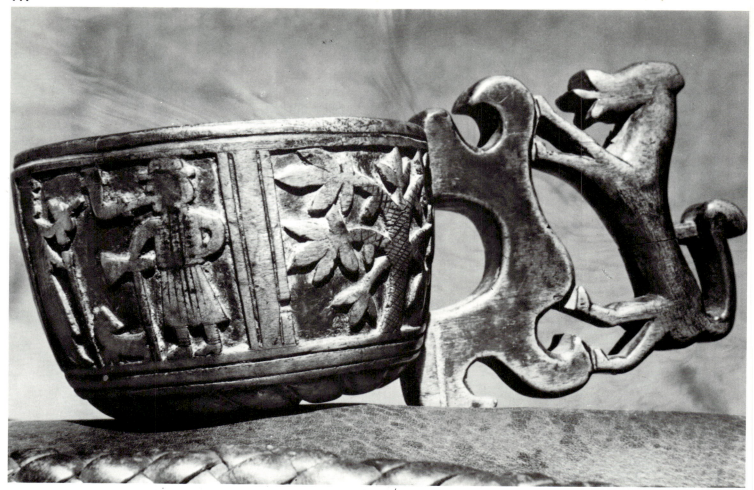

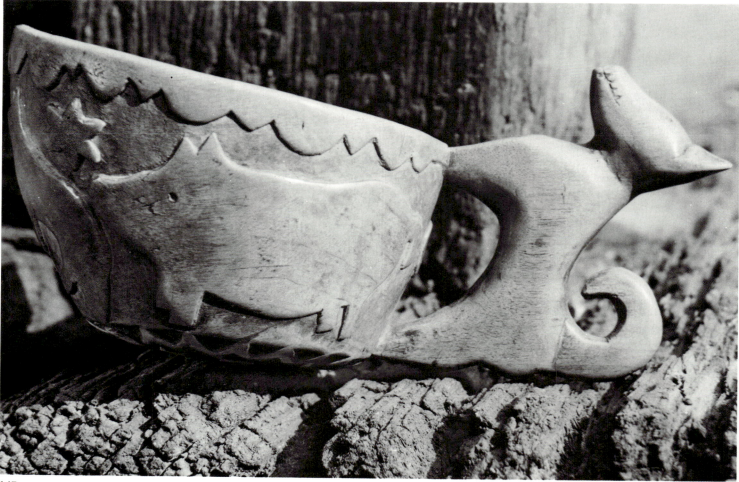

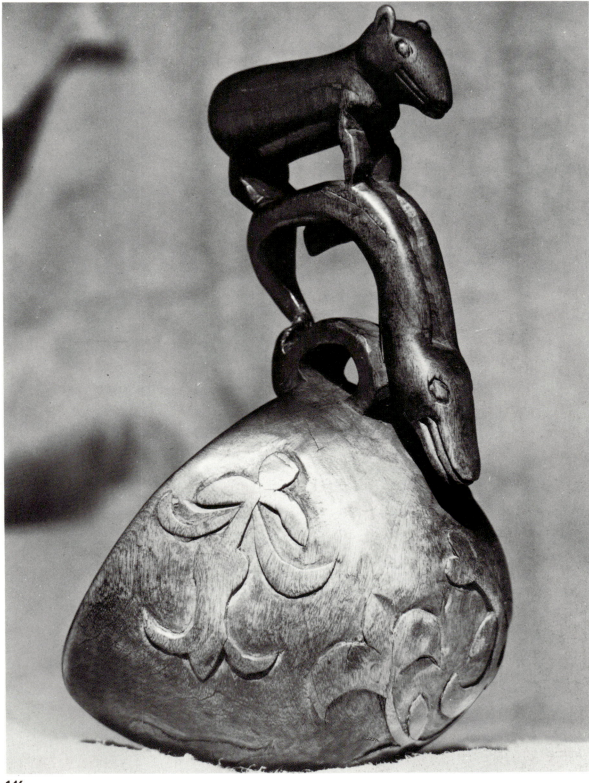

144 Water-dipper with hunting scenes carved in relief, and a handle in the shape of a dog. Wood from a fruit tree. *6.5 cm.*, with handle: *16 cm.* Made by Pál Gyurkó. Nógrád County (Ethnographical Museum)

145 Water-dipper with the figure of a pig carved in relief on the side. The handle is in the shape of a dog, the initials "V.F." are carved on the base. Wood from a fruit tree. *6 cm.* Mátra region (Ethnographical Museum)

146 Water-dipper with lilies carved in relief on the side. The handle is in the shape of a snake with a dog on its back. *16 cm.* Mátra region (Ethnographical Museum)

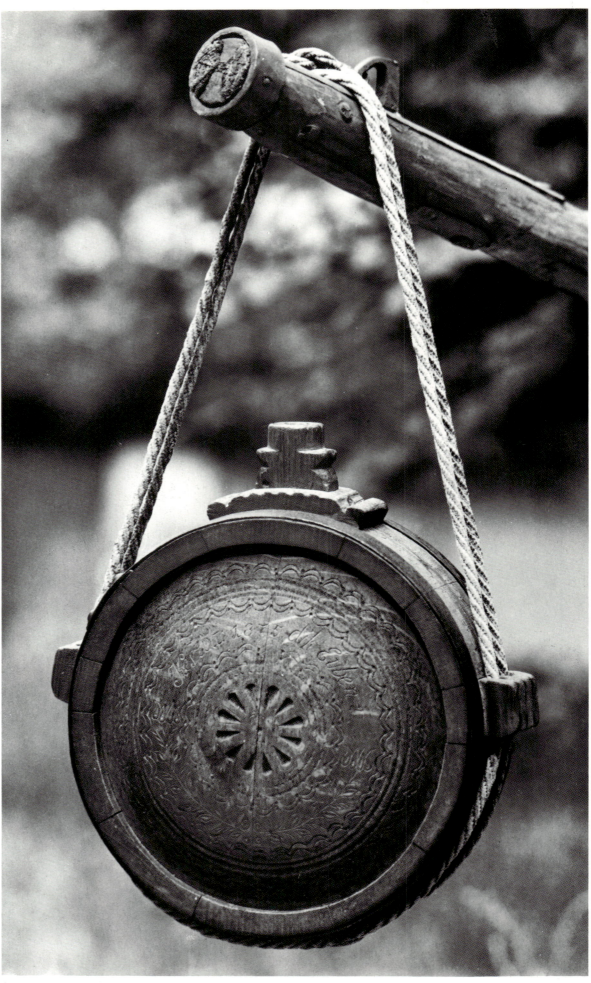

147 Flat water barrel with carved and engraved decoration used by field workers. Inscription: "Made in the Year 1875 by F.Ö. the noble Sándor Pál." *35.5 cm.* Átány, Heves County (Ethnographical Museum)

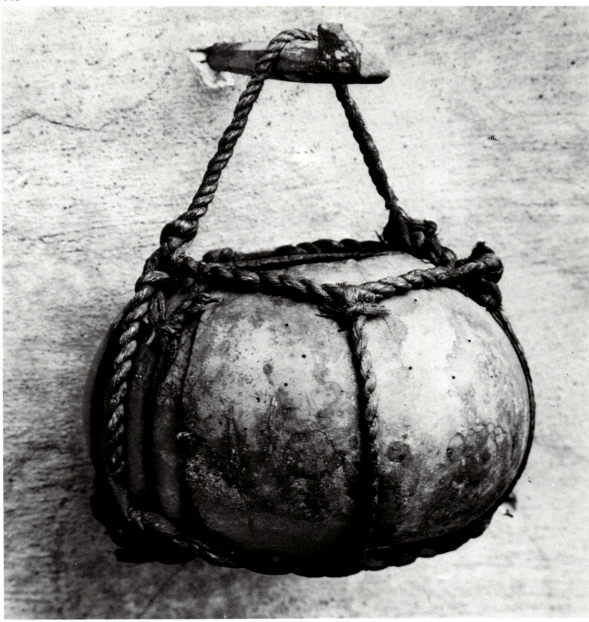

148 A gourd for salt hung in a plaited rush. *15 cm.* Haraszti (Charast, Yugoslavia) (Ethnographical Museum)

149 Gourds for water or wine, with engraved decoration. Left: pipe-smoking highwaymen on the upper half, floral design on the lower. Right: herdsmen exchanging gifts, surrounded by tendrils with rosettes and tulips, with the decoration repeated on the upper part. *18 cm* and *19 cm.* Csokonya, Somogy County (Ethnographical Museum)

150

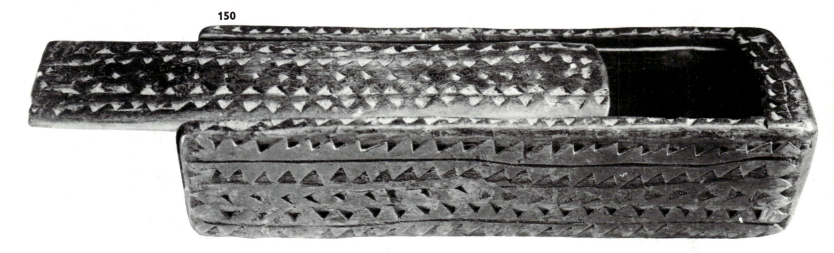

151

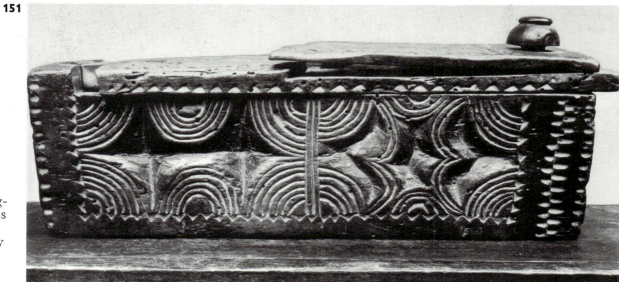

150 Razor-case, with a sliding lid and chip-carved decoration in a zig-zag design on sides and lid. *4.4 cm.* Hódmezővásárhely Csongrád County (Ethnographical Museum)

151 Razor-case with a double lid. Softwood. *4.2 cm.* Hódmezővásárhely, Csongrád County (Ethnographical Museum)

152 Razor-case with engraved and chip-carved decoration. Hardwood. Inscription: "1895 A J." *5.8 cm.* Kiskunfélegyháza, Bács-Kiskun County (Kiskun Museum, Kiskunfélegyháza)

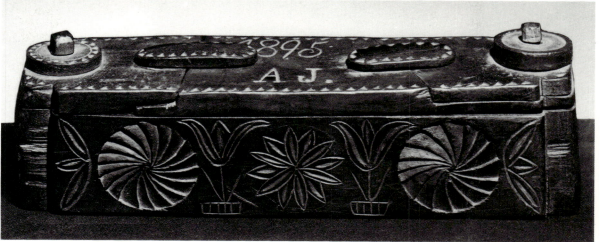

152

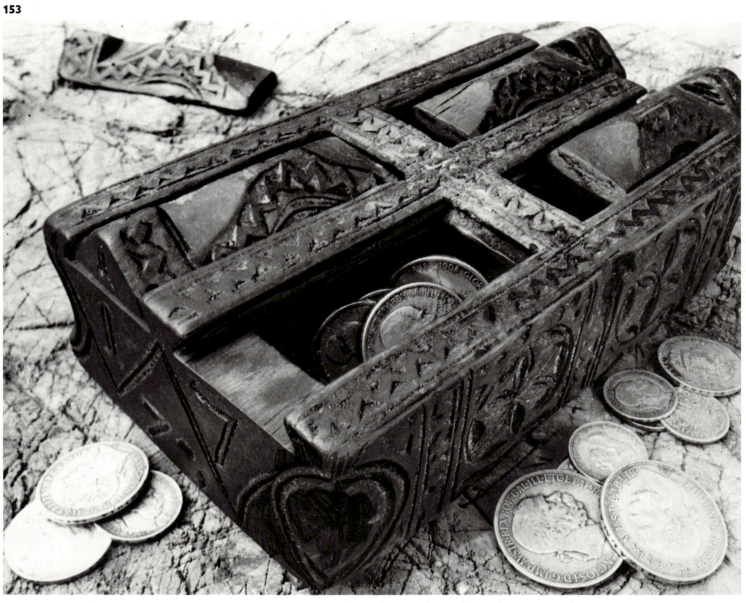

153 Money-box
with four compart-
ments and chip-
carved decoration.
Hardwood.
Inscription: "1773."
9 cm.
Érsekcsanád,
Bács-Kiskun County
(Ethnographical
Museum)

154

155

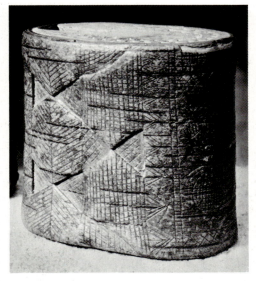

154 Salt-cellar with engraved decoration. Birch-bark. *6 cm.* Alsórákos (Racoşul-de-Jos, Rumania) (Ethnographical Museum)

155 Salt-cellar with engraved decoration. Flat side of the salt-cellar in Ill. 154. Birch-bark. *13 cm.* Alsórákos (Racoşul-de-Jos, Rumania) (Ethnographical Museum)

156 Salt-cellar with engraved decoration. Birch-bark. *6.2 cm.* Gyimesközéplok (Lunca-de-Jos, Rumania) (Ethnographical Museum)

157 Powder-flask with carved decoration. Birch-bark. *13 cm.* Gyimesközéplok (Lunca-de-Jos, Rumania) (Ethnographical Museum)

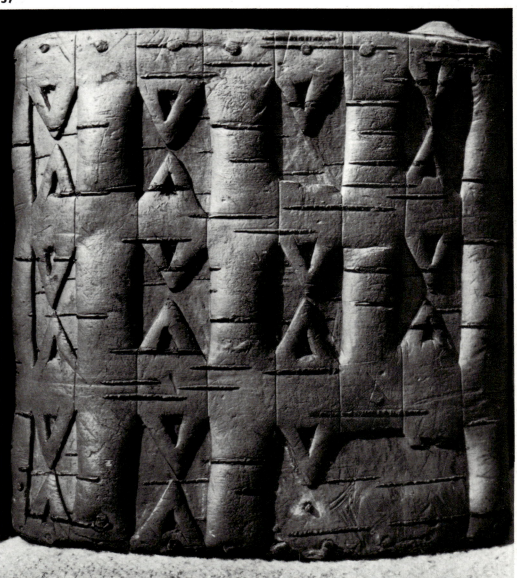

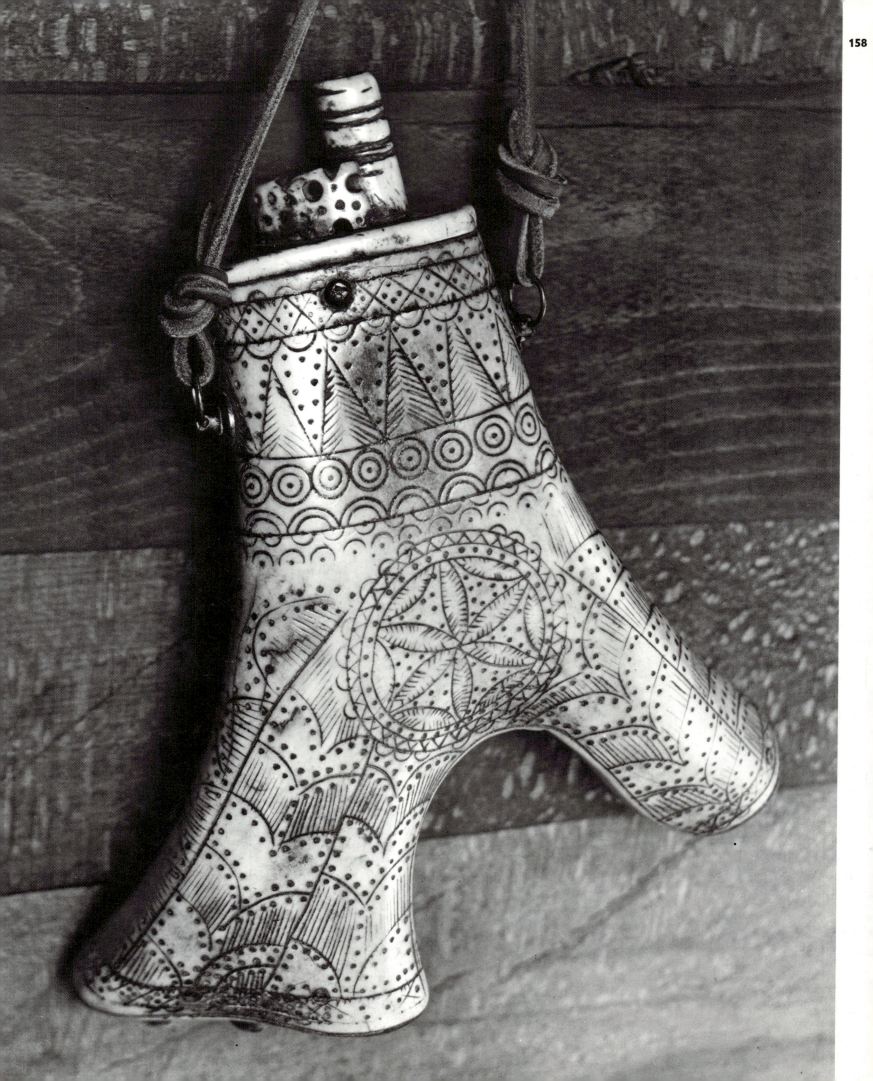

158 Powder-flask with engraved, geometrical decoration made from a stag's horn. Transylvania (Ethnographical Museum)

159 Powder-flask with engraved design, made from a stag's horn. Detail. *16 cm.* Inscription: "1719." Eastern Hungary (Ethnographical Museum)

159

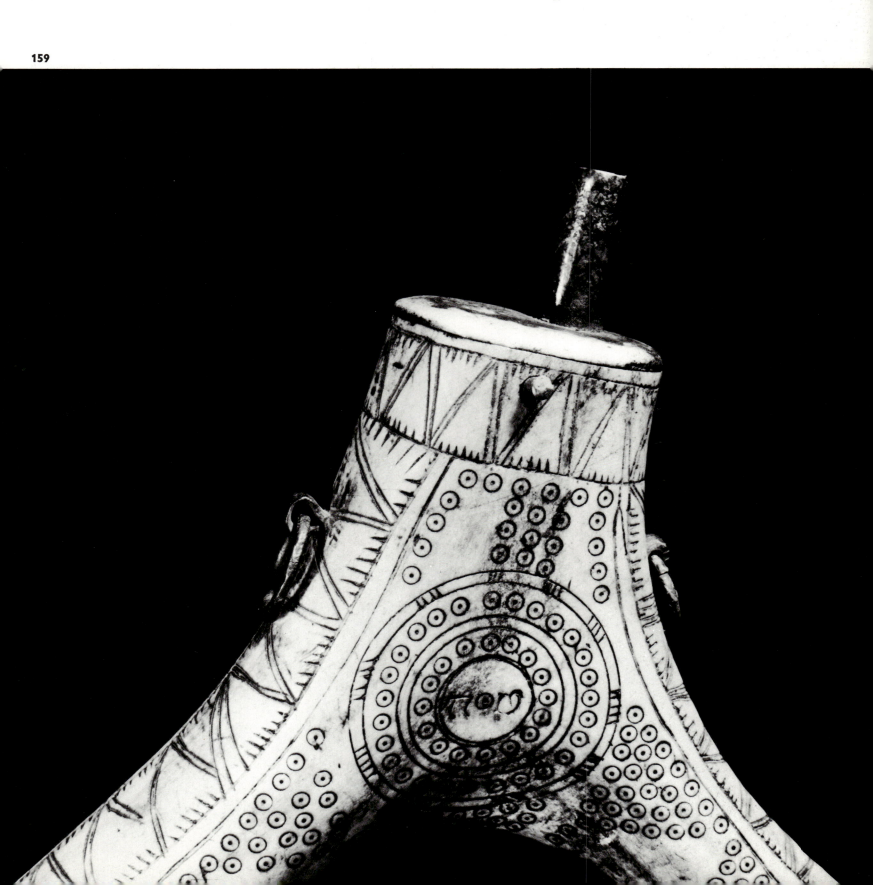

160 Powder-flask
with engraved
anthropomorphic
design, made from
a stag's horn. Detail.
6.5 cm.
Eastern Hungary
(Ethnographical
Museum)

161 Central rosette
on a powder-flask
made from a stag's
horn. Detail. *7.5 cm.*
Transylvania
(Ethnographical
Museum)

161

162 Central swastika
in the design
of a powder-flask.
Engraved decoration
on a stag's horn.
7 cm.
Hungary
(Ethnographical
Museum)

163

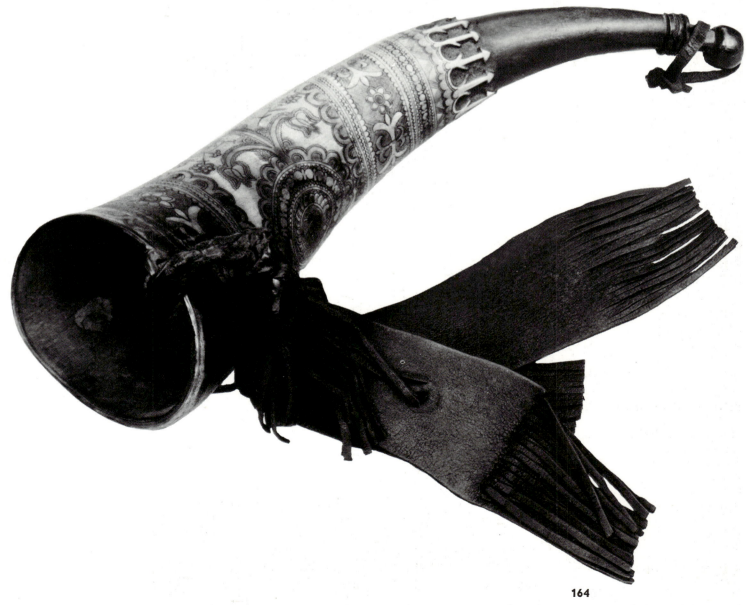

164

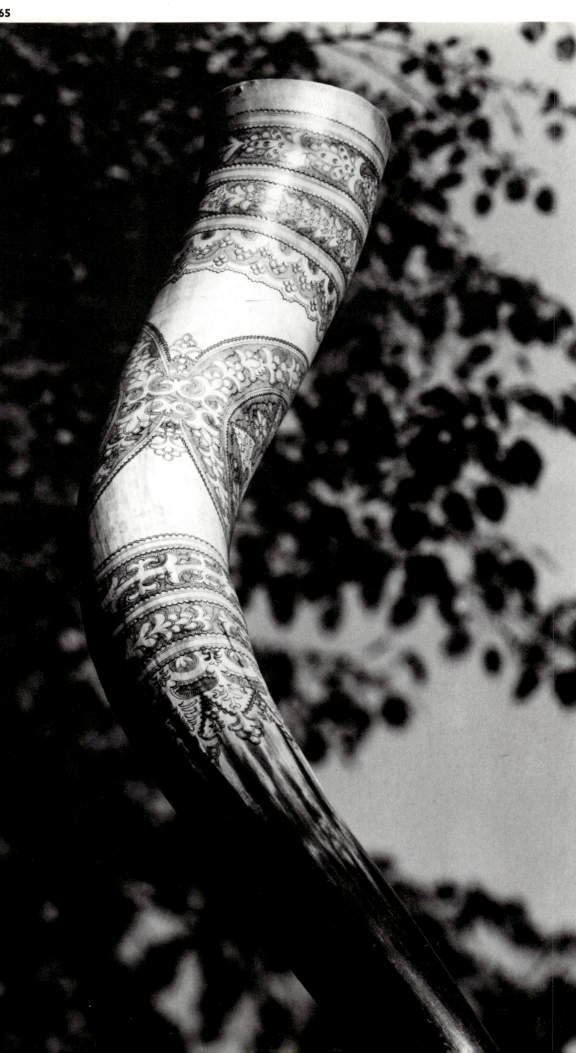

163 Central rosette in the design of a drinking horn, engraved and yellowed with nitric acid. *8 cm*. Inscription: "1892 Juhász János." Zemplén County. (See Ill. 164) (Ethnographical Museum)

164 Drinking horn with carved design yellowed with nitric acid, with leather tassels. *36 cm*. Zemplén County (Ethnographical Museum)

165 A horn with delicate engraving. *69 cm*. Upper Tisza region (Ethnographical Museum)

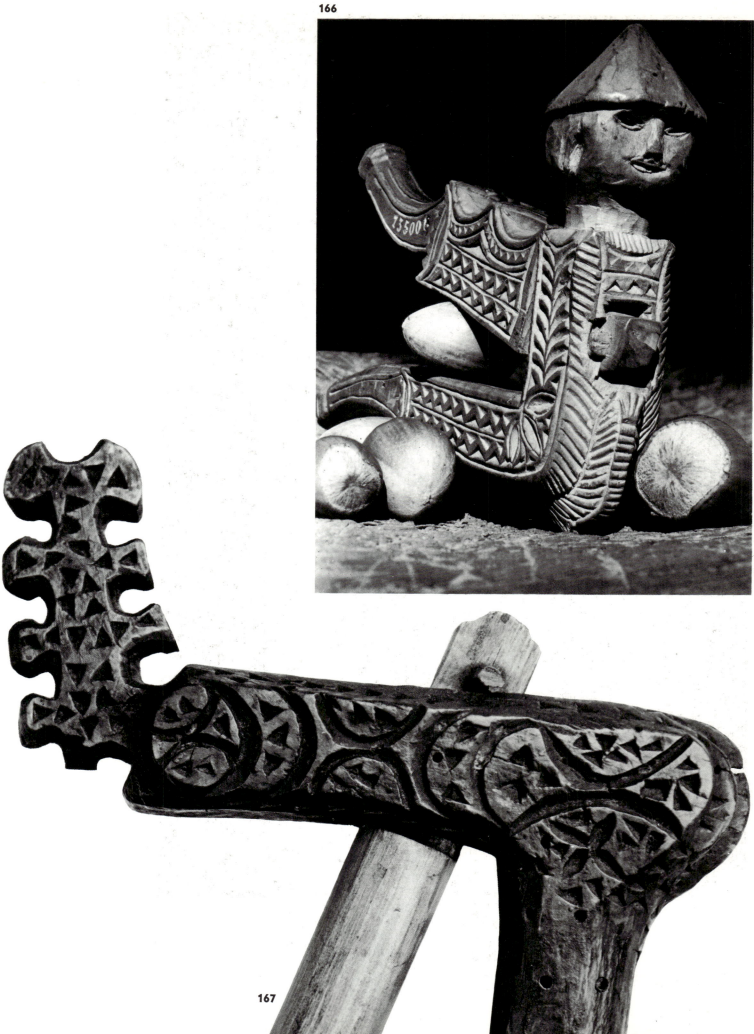

166 A nut-cracker decorated with chip-carving. The top of the nut-cracker is in the shape of a man's head. Wood from a fruit tree. *9.5 cm*. Kalotaszeg region (Rumania) (Ethnographical Museum)

167 A nut-cracker decorated with chip-carving. Wood from a fruit tree. Partly restored. Detail. *11.5 cm*. Magyarvalkó (Vălcăul Unguresc, Rumania) (Ethnographical Museum)

168 A nut-cracker decorated with chip-carving. Wood from a fruit tree. *20.5 cm*. Zemplén County (Ethnographical Museum)

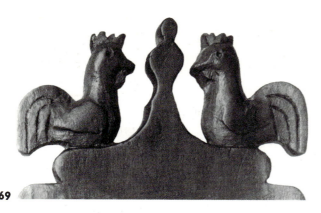

169

170

169 Grooved board
for making shell-
shaped noodles with
two cocks at the end.
Wood from a fruit
tree. Detail. *3.2 cm.*
Great Plain.
(Mrs. Tibor
Keresztes's collection)

170 Figure of a horse,
carved on the back
of a grooved board
for making shell-
shaped noodles.
3 cm. Inscription:
"1844 Sz.V.L."
Debrecen,
Hajdú-Bihar County
(Déri Museum,
Debrecen)

171 Grooved board
for making shell-
shaped noodles,
and stick used to roll
the spiral-shaped
pastry. Wood from
a fruit tree. *17.5 cm.*
Pápa,
Veszprém County
(Ethnographical
Museum)

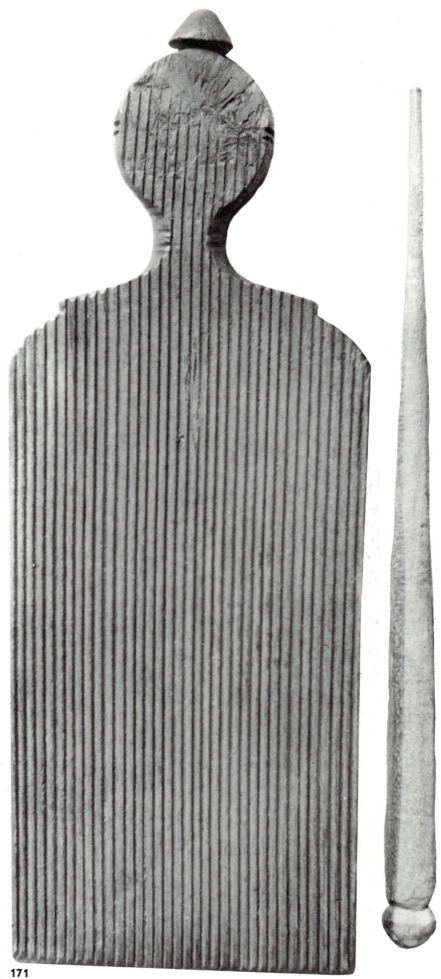

171

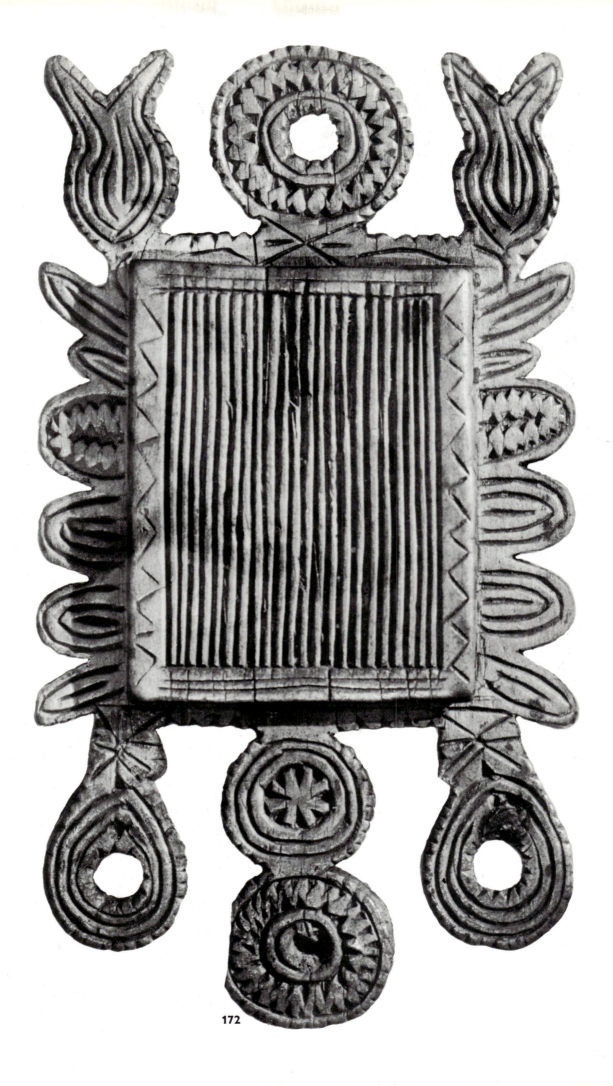

172 Grooved board for making shell-shaped noodles decorated with engraving and chip-carving. Wood from a fruit tree. *13 cm.* Debrecen, Hajdú-Bihar County (Déri Museum, Debrecen)

172

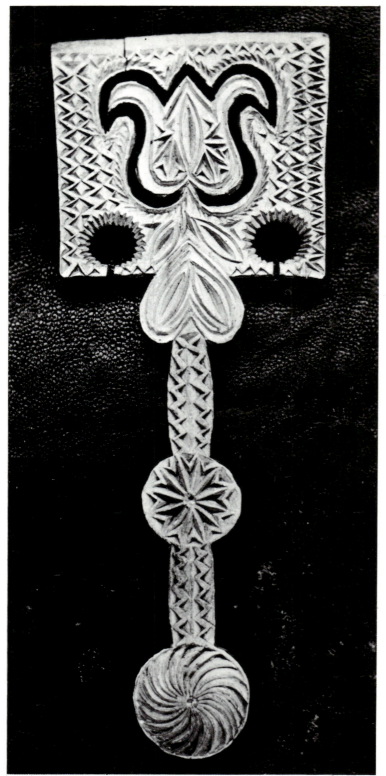

173

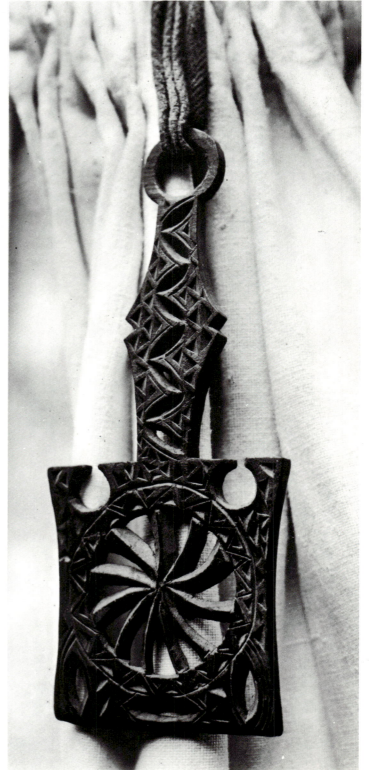

174

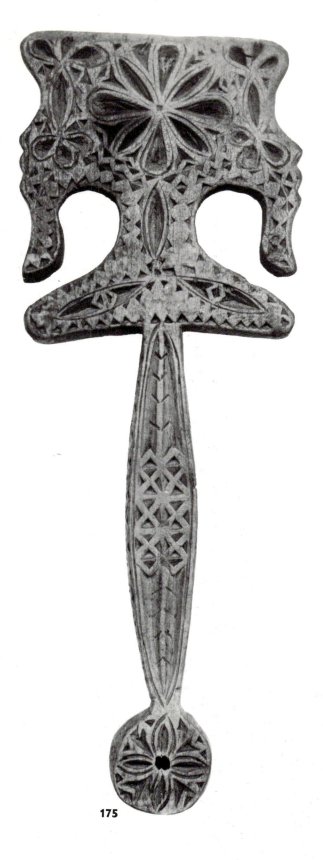

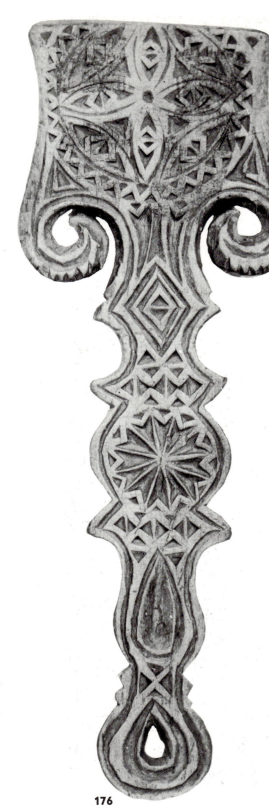

175

176

173 Hoe-scraper decorated with open-work and chip-carving in tulip design. Wood from a fruit tree. *13 cm.* Kalotaszeg region (Rumania)

174 Hoe-scraper decorated with open-work and chip-carving. Wood from a fruit tree. *13.5 cm.* Kalotaszeg region (Rumania) (Ethnographical Museum)

175 Hoe-scraper decorated with chip-carving. Wood from a fruit tree. *16 cm.* Bogártelke (Bagara, Rumania) (Ethnographical Museum)

176 Hoe-scraper decorated with chip-carving. Wood from a fruit tree. *15.8 cm.* Kalotaszeg region (Rumania) (Ethnographical Museum)

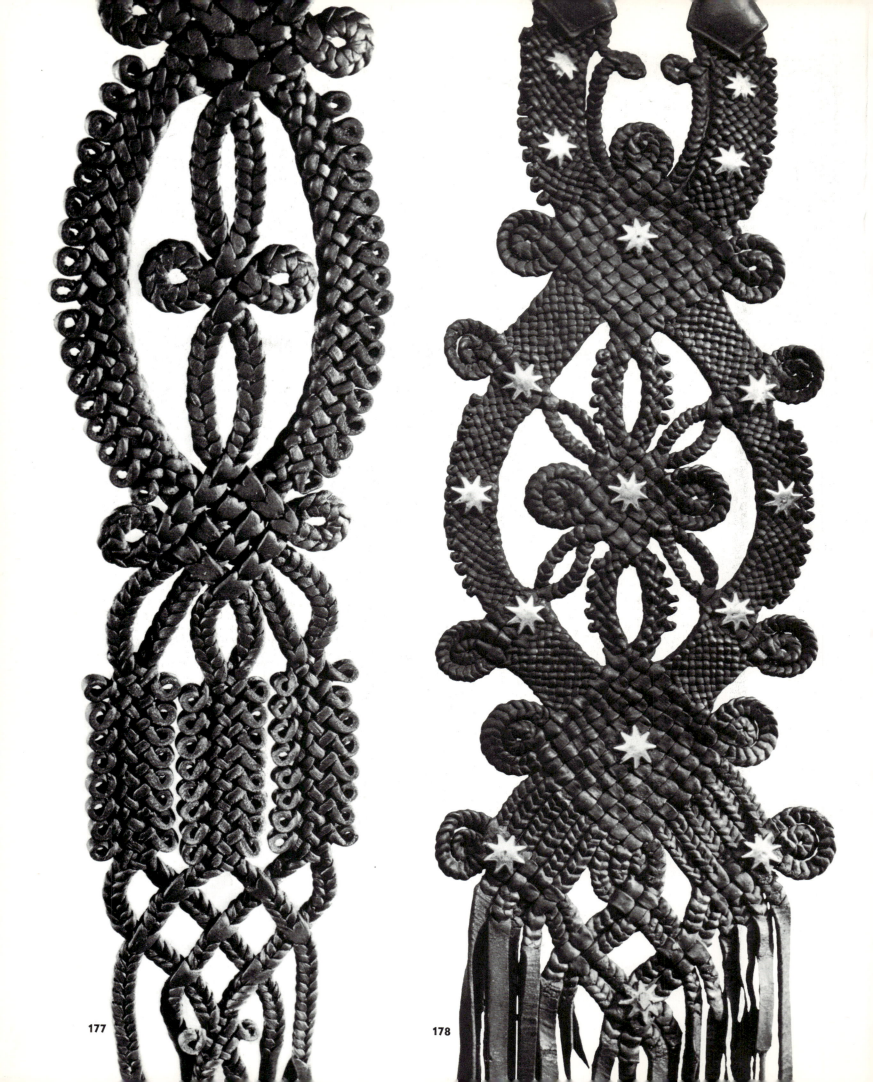

177 178

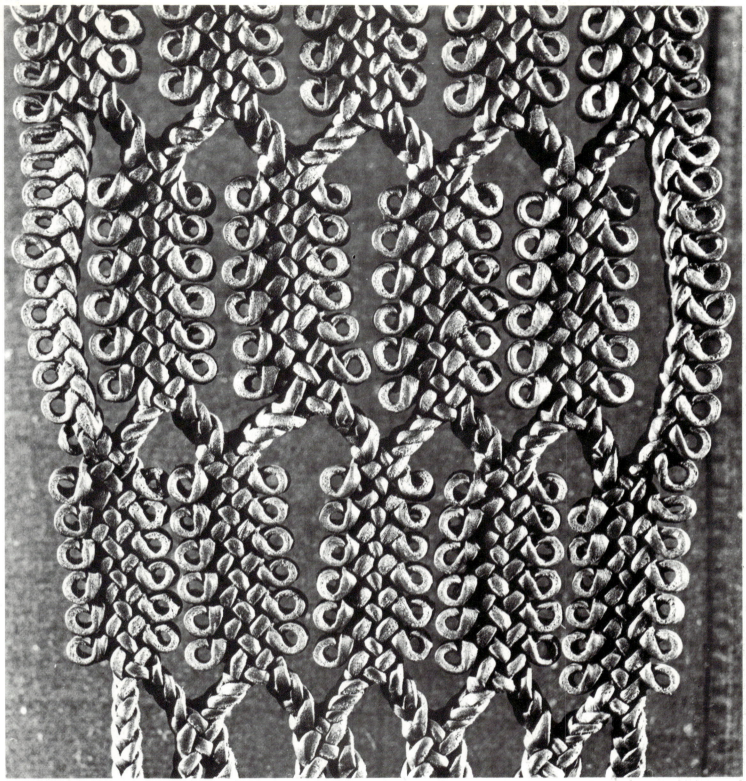

177 Braided thong
trappings from
an ornamental
harness. *42 cm.*
Great Plain
(Ethnographical
Museum)

178 Silver-studded
trappings
from an ornamental
harness. *51 cm.*
Great Plain
(Ethnographical
Museum)

179 Braided thong
trappings
from an ornamental
harness. *21 cm.*
Great Plain
(Ethnographical
Museum)

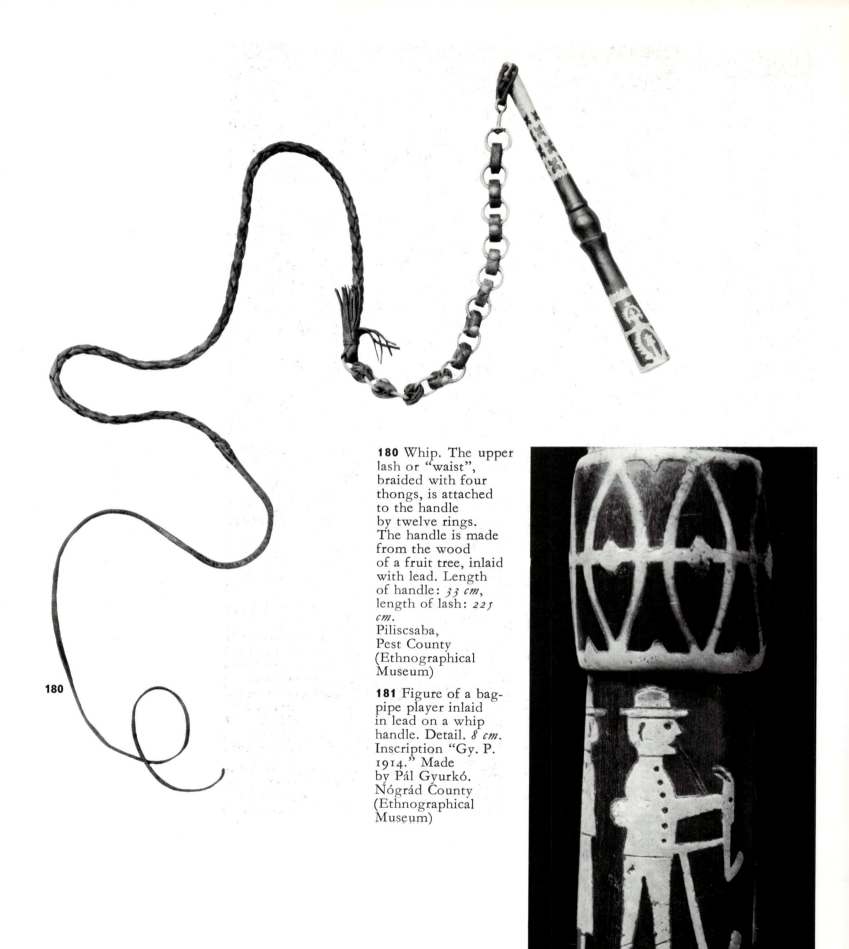

180 Whip. The upper lash or "waist", braided with four thongs, is attached to the handle by twelve rings. The handle is made from the wood of a fruit tree, inlaid with lead. Length of handle: *33 cm*, length of lash: *225 cm*.
Piliscsaba,
Pest County
(Ethnographical Museum)

181 Figure of a bagpipe player inlaid in lead on a whip handle. Detail. *8 cm*. Inscription "Gy. P. 1914." Made by Pál Gyurkó. Nógrád County (Ethnographical Museum)

180

181

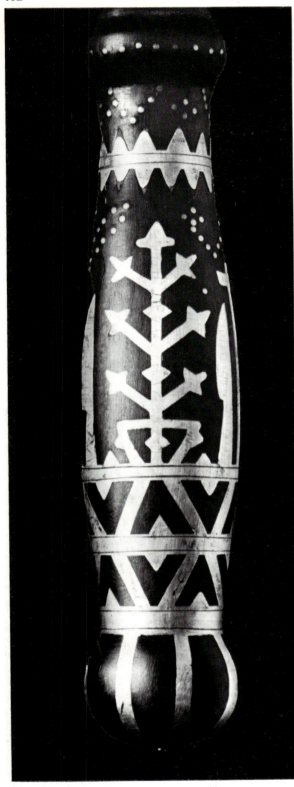
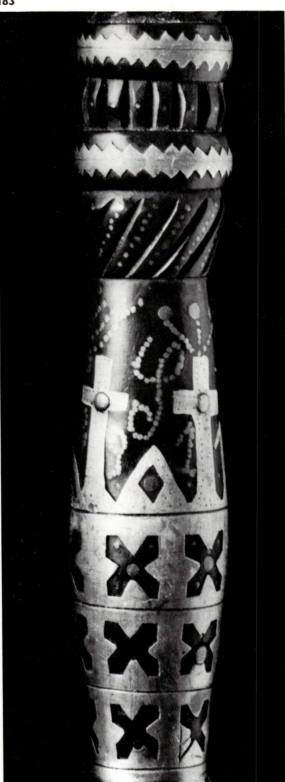

182 Flower-cluster inlaid in lead on a whip handle. Detail. *12.5 cm.* Nógrád County (Ethnographical Museum)

183 Lead inlay and studded decoration on a whip handle. Detail. *15.6 cm.* Inscription: "1891 S." Hont, Nógrád County (Ethnographical Museum)

184

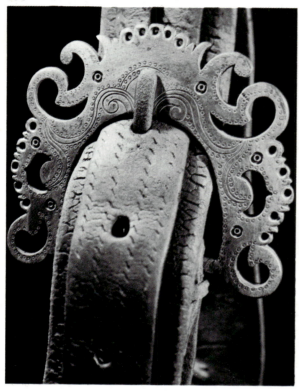

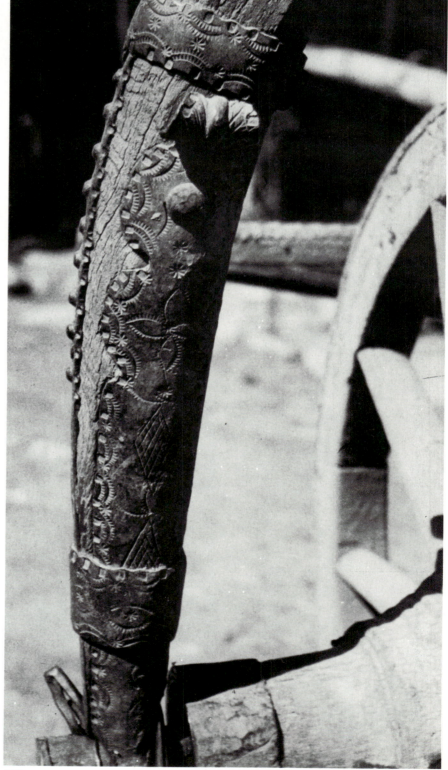

184 Cast copper buckle on the strap of a cow-bell with engraved and hammered decoration. *11.3 cm.* Kecskemét, Bács-Kiskun County (János Bozsó's collection, Kecskemét)

185 Side-support of a wagon. Elaborate iron-work on wood. Méra (Mera, Rumania)

186 Knob of stick decorated with chip-carving. Wood from a fruit tree. *25 cm.* Magyarvalkó (Vălcăul Unguresc, Rumania) (Ethnographical Museum)

187 Head of stick for tying sheaves together, decorated with chip-carving. Wood from a fruit tree. *15 cm.* Western Hungary (Ethnographical Museum)

188 Bonds carved from tree roots, used to bind down the contents of a cart. Diameter: *9* and *14 cm.* Jánd, Szabolcs-Szatmár County (Regional Museum, Vásárosnamény)

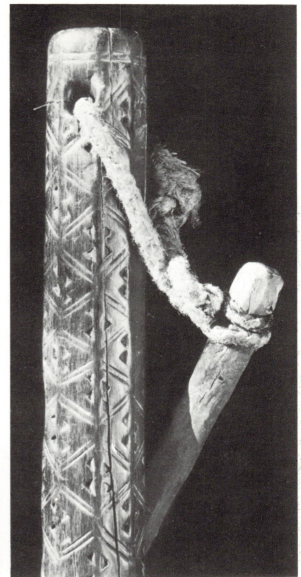

187

188

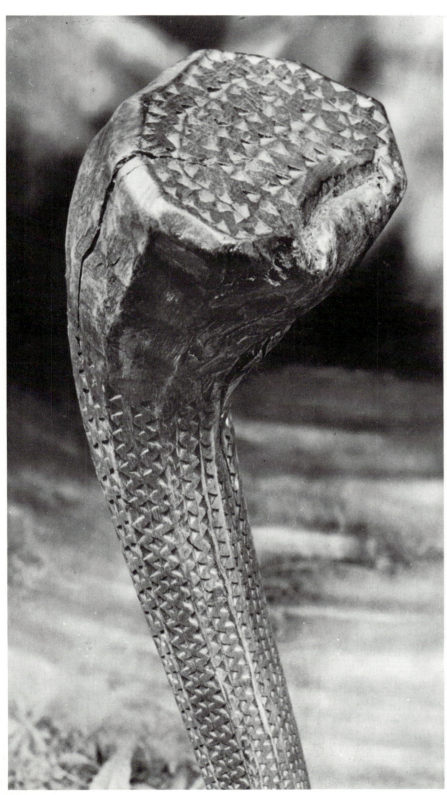

186

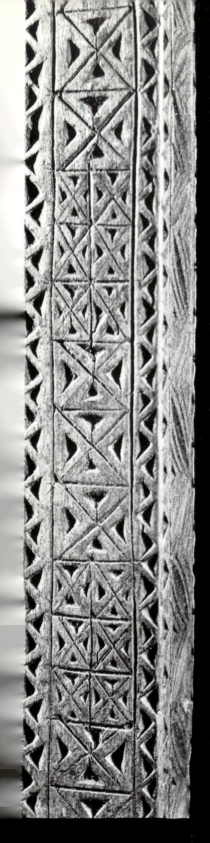

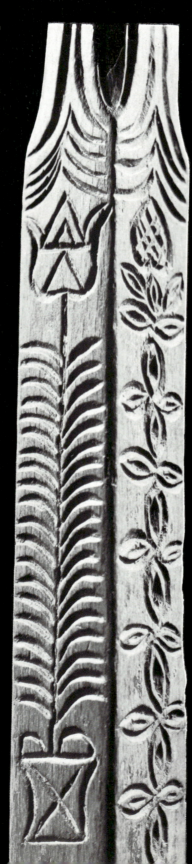

190

191

189 Distaff, decorated with chip-carving. Detail. Hardwood. *15 cm*. Inscription: "*1812*." Brassó (Braşov) region (Rumania) (Ethnographical Museum)

190 Distaff, decorated with chip-carving. Detail. Hardwood. *19 cm*. Little Plain, in north-west Hungary (Ethnographical Museum)

191 Distaff, decorated with chip-carving. Detail. Softwood. Another part of the distaff in Ill. 190. *17 cm*. Little Plain, in north-west Hungary (Ethnographical Museum)

192

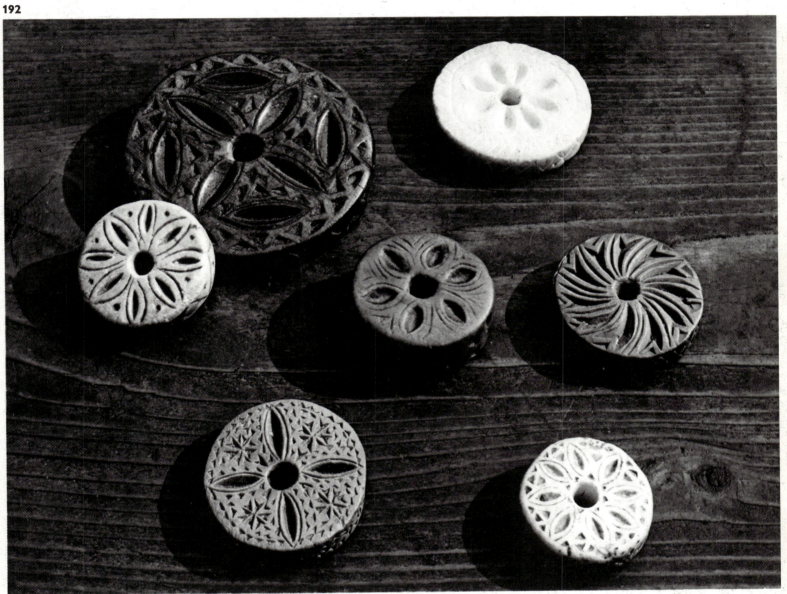

192 Bobbin rings (from left to right, downwards). Alabaster with engraved decoration, diameter: *3 cm*; carved wood with chip-carved decoration, diameter: *6 cm*; alabaster with engraved and carved decoration, diameter: *3.8 cm*; wood, engraved and carved, diameter: *2.9 cm*; wood, engraved and carved, diameter: *3.2 cm*; wood, engraved and carved, diameter: *3.3 cm*; stone, engraved and carved, diameter: *2.8 cm*. All from the Kalotaszeg region (Rumania) (Ethnographical Museum)

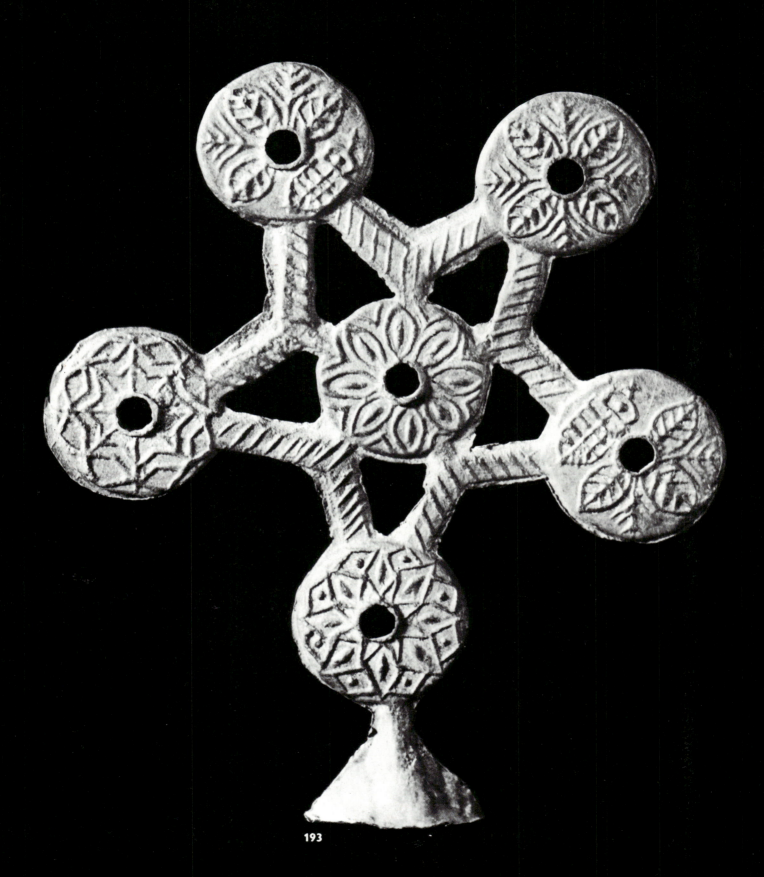

193

193 Six bobbin
rings, cast in lead
and arranged
in the form of a star.
12 cm.
Méra
(Mera, Rumania)
(Ethnographical
Museum)

194 Seven bobbin
rings cast in lead
and arranged
in the form
of a flower-cluster.
14 cm. Inscription:
"1953."
Méra
(Mera, Rumania)
(Ethnographical
Museum)

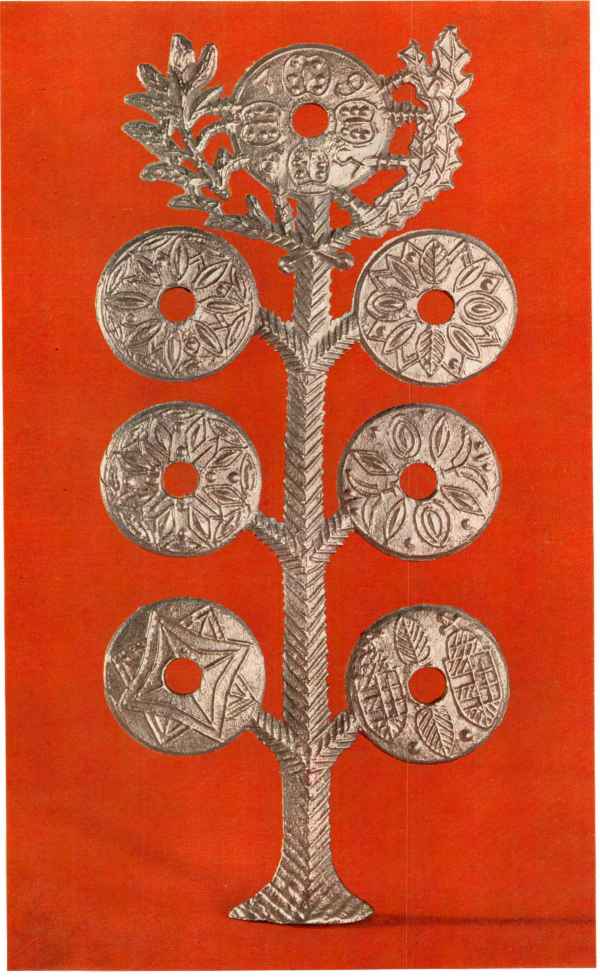

195 Foot of a distaff decorated with a design of tulips and rosettes, chip-carved and engraved. Hardwood. *36 cm.* Inscription with initials: "TODAY 1908 BUT. Long live the owner."

Désháza (Deja, Rumania) (Ethnographical Museum)

196 Foot of distaff, with tulip flower-cluster design growing out of a pot, carved and chip-carved. Wood from a fruit tree. *23.5 cm.* Little Plain in north-west Hungary (Ethnographical Museum)

197 Pin for fastening the hemp to the distaff, cast in the shape of a flower-cluster with seven branches. Lead. *11.5 cm.* Bogyiszló, Tolna County (Ethnographical Museum)

198 Pin for fastening the hemp to the distaff, cast in the shape of a flower-cluster with five branches. *11.5 cm.* Bogyiszló, Tolna County (Ethnographical Museum)

195

196

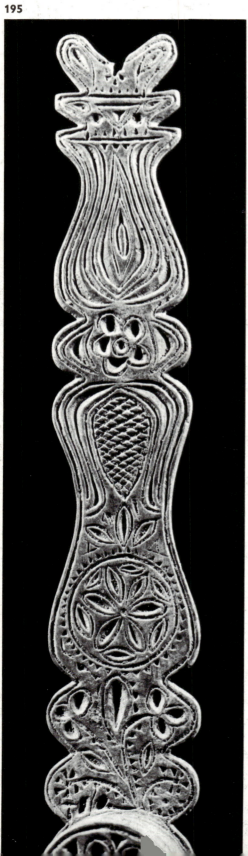

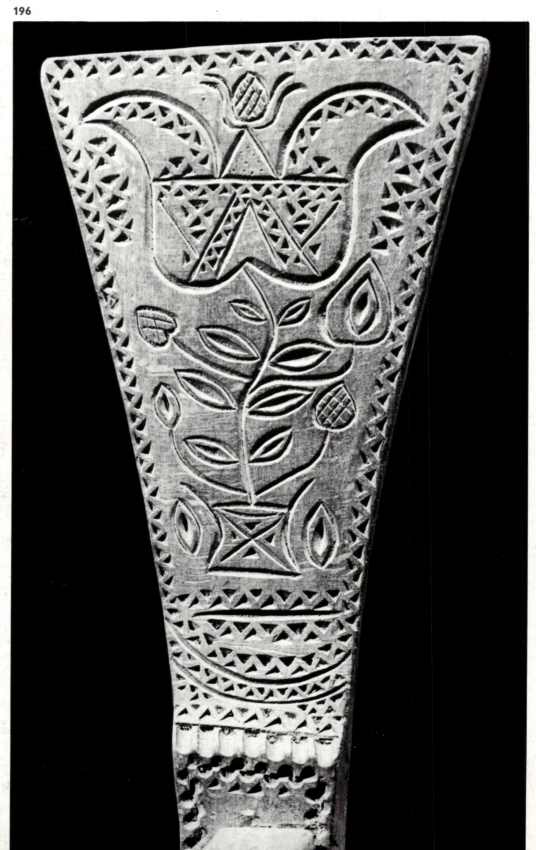

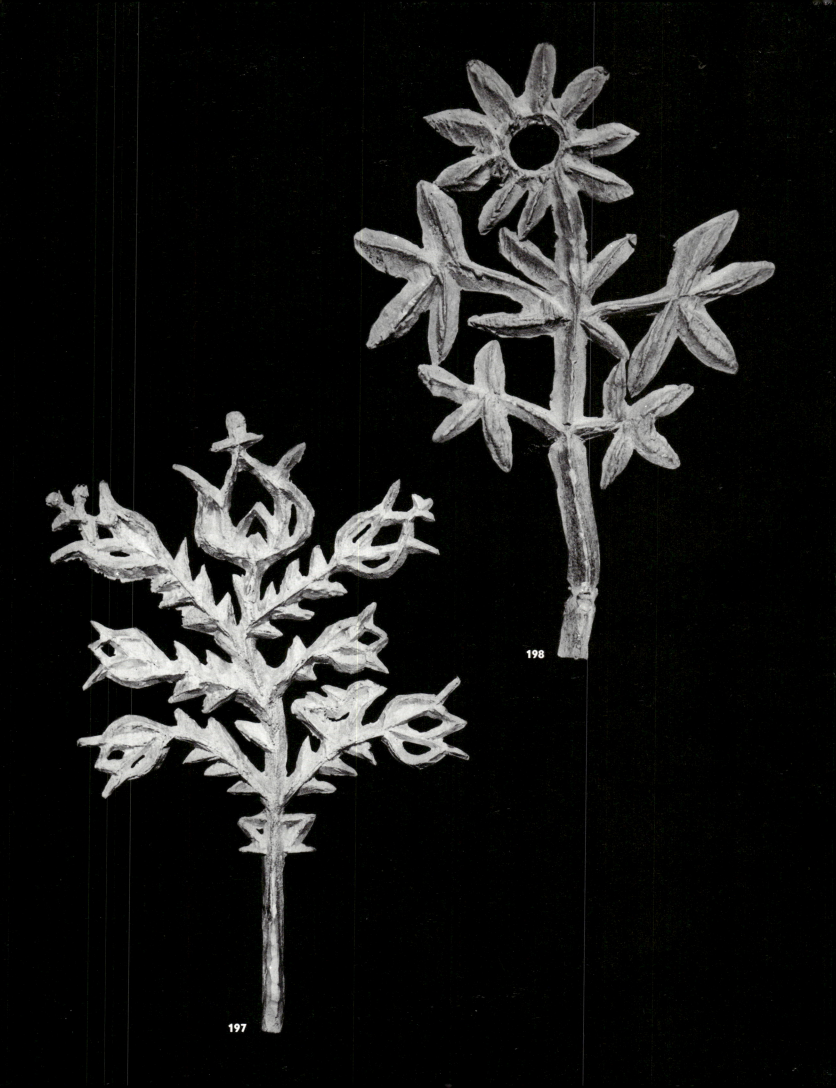

199 Pin for fastening
the hemp
to the distaff, cast
in the shape
of a rosette. Lead.
11 cm.
Bogyiszló,
Tolna County
(Ethnographical
Museum)

200 Pin for fastening
the hemp
to the distaff. Cast
in the shape
of a three-branched
flower-cluster set
within semicircles.
Lead. *11 cm.*
Bogyiszló,
Tolna County
(Ethnographical
Museum)

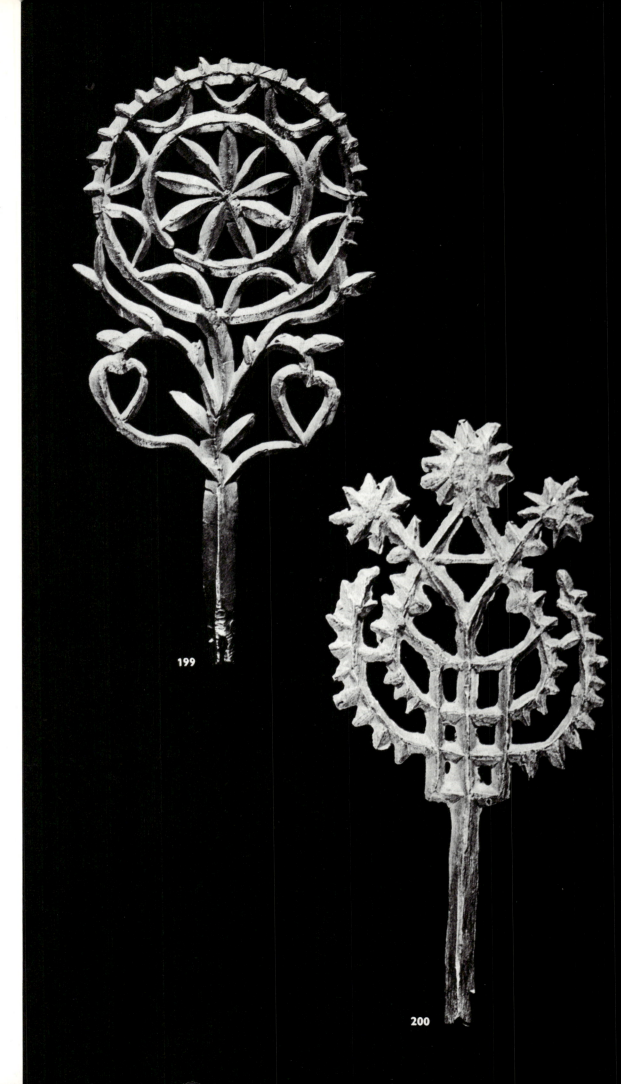

199

200

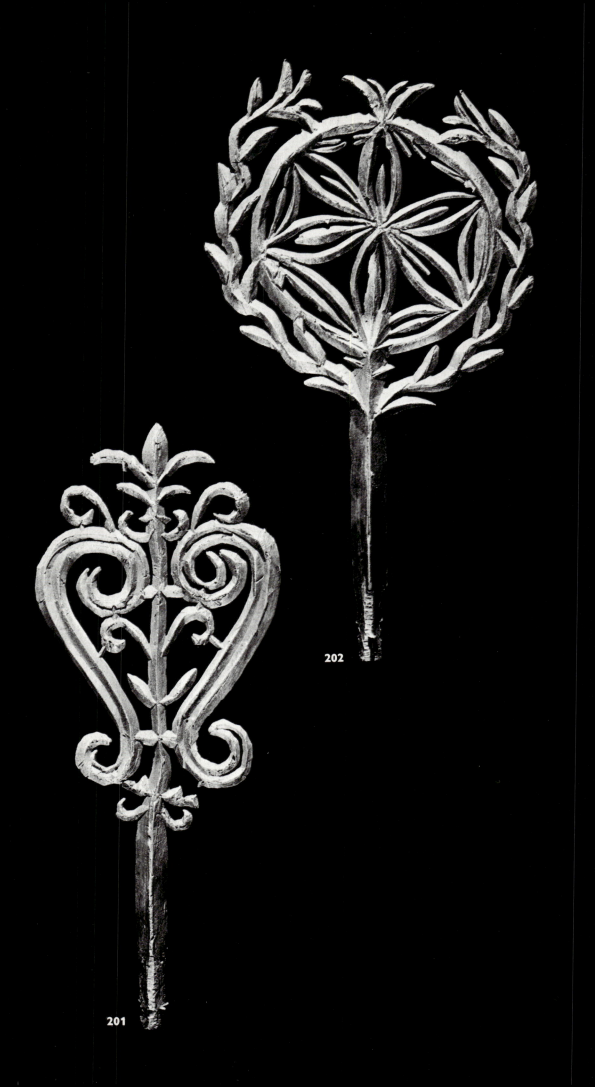

201 Pin for fastening
the hemp
to the distaff, cast
in the shape
of a tulip. Lead.
11 cm.
Bogyiszló,
Tolna County
(Ethnographical
Museum)

202 Pin for fastening
the hemp
to the distaff, cast
in the shape
of a rosette enclosed
in a wreath. Lead.
11 cm.
Bogyiszló,
Tolna County
(Ethnographical
Museum)

201

202

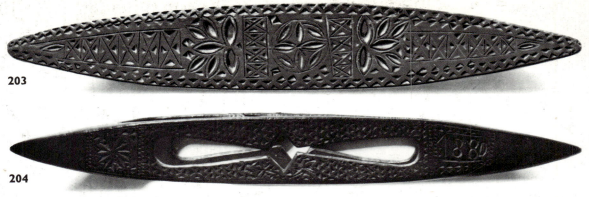

203 Shuttle decorated with chip-carving. Wood from a fruit tree. *4 cm.* Kalotaszeg region (Rumania) (Ethnographical Museum)

204 Shuttle decorated with open-work and chip-carving. Wood from a fruit tree. *3 cm.* Inscription: "1880." Kalotaszeg region (Rumania) (Ethnographical Museum)

205 Two washing bats, engraved and with carving in relief. One is decorated mainly with geometrical motifs interspersed with large and small rosettes. Inscription: "T I", presumably the name of a girl, and "V. B. Cs." The "V. B." are the young man's initials, the "Cs." is *csinálta* (made). *35 cm.* Kalotaszeg region (Rumania). The other bat is decorated with a tulip flower-cluster design growing out of a pot. Inscription: "B T." Both made from wood from a fruit tree. *37 cm.* Rimaszombat (Rimavská Sobota, Czechoslovakia) (Ethnographical Museum)

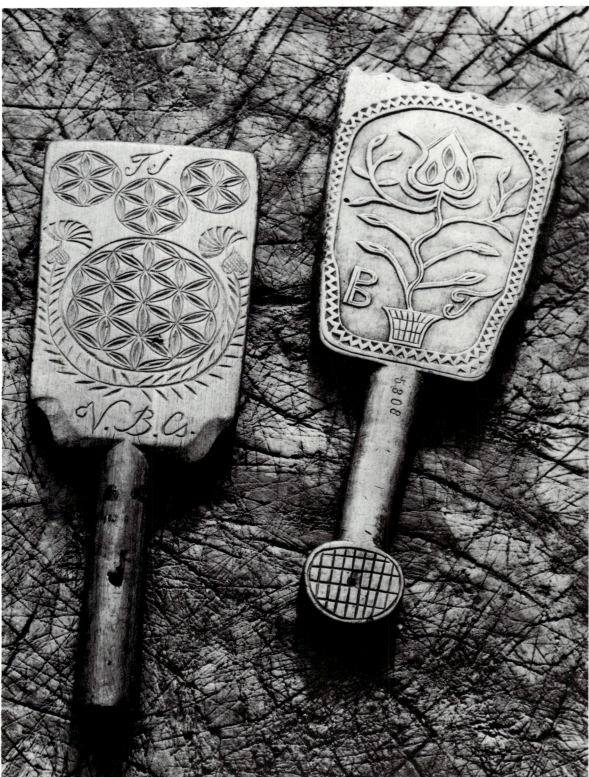

205

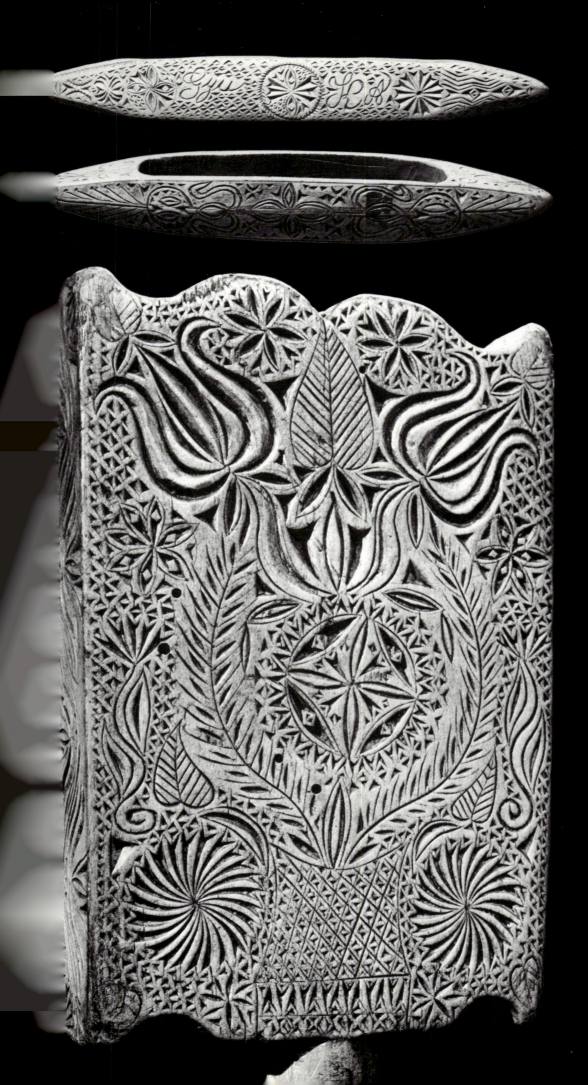

206 Shuttle, engraved and chip-carved. Wood from a fruit tree. *3.6 cm.* Inscription: "Gyu KA 1884." Kalotaszeg region (Rumania) (Ethnographical Museum)

207 Shuttle, engraved and chip-carved. Wood from a fruit tree. *3.8 cm.* Magyarvalkó (Vălcăul Unguresc, Rumania) (Ethnographical Museum)

208 Washing bat decorated with a pair of tulips, rosettes and foliage, with a wreath in the centre. Engraved and chip-carved. Wood from a fruit tree. *25 cm.* Inscription on the back: "János Zsiga February 27, 1895." Mákó (Macau, Rumania) (Ethnographical Museum)

209 Washing bat inlaid with rosettes in lead. Engraved and chip-carved walnut. *24 cm.* Inscription on the back: "1838 Kati Pintek"; on the front: MADE BY MÁRTON KIS AS A PRESENT. Kalotaszeg region (Rumania) (Ethnographical Museum)

210 Washing bat with two pairs of confronting birds. Engraved and chip-carved. Wood from a fruit tree. *25 cm.* Inscription on the side: "1867." Magyarvalkó (Vălcăul Unguresc, Rumania) (Ethnographical Museum)

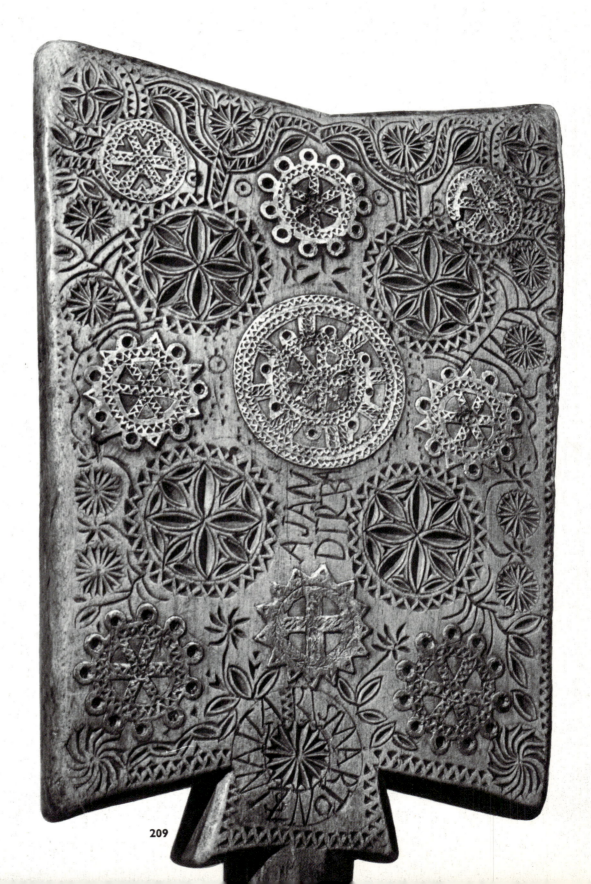

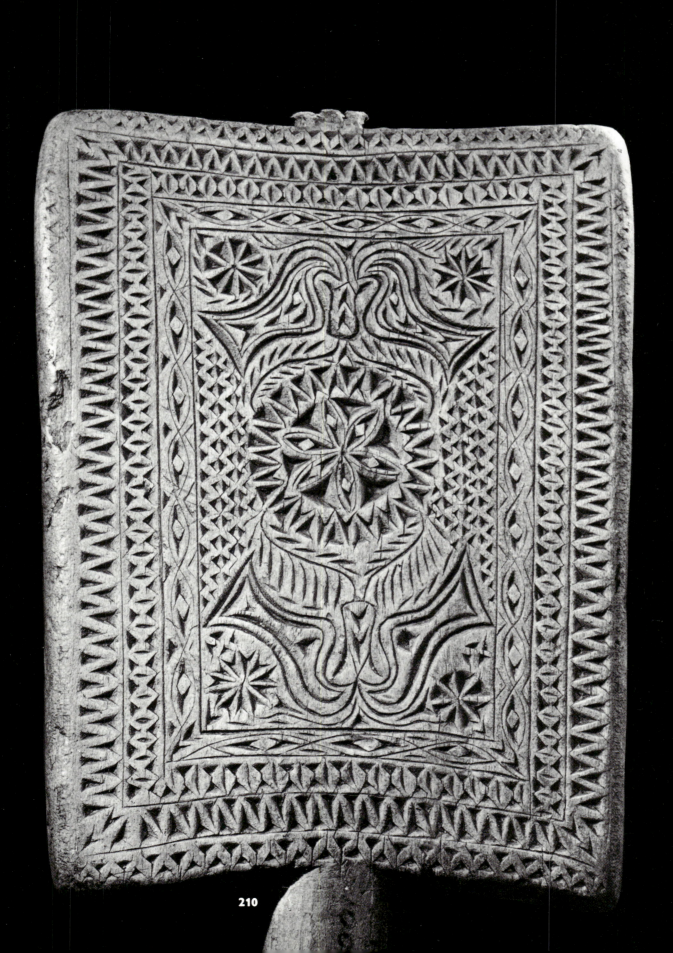

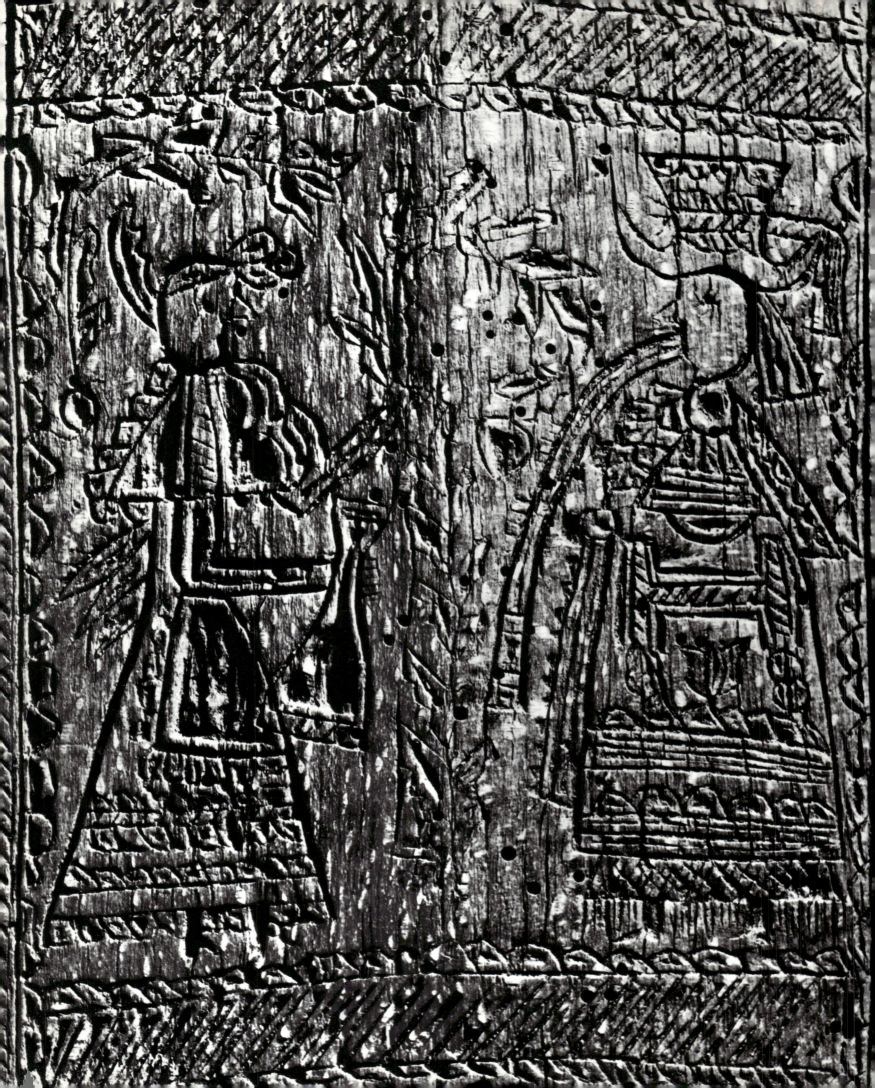

211 Figures
of a woman holding
a bottle of wine
and a flowering
branch and a man
in *szűr* (frieze coat)
playing a long flute.
The bottom part
of a mangling board,
engraved towards the
handle. Oak.
16.5 cm.
Zala County
(Göcsej Museum,
Zalaegerszeg)

212 Mangling board
engraved with
a large rosette.
Hardwood. *55 cm.*
Inscription: "1796."
Sobor, Győr-
Sopron County
(Ethnographical
Museum)

213 Mangling board,
engraved
and decorated with
a chip-carving
of a tulip flower-
cluster growing out
of a pot. Limewood.
62 cm. Inscription:
"M 1825 U."
Little Plain
in north-west
Hungary
(Ethnographical
Museum)

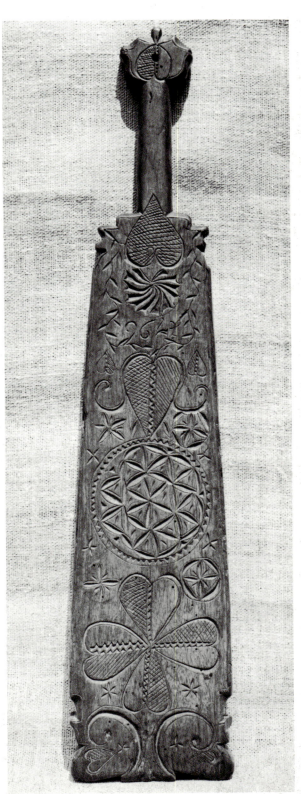

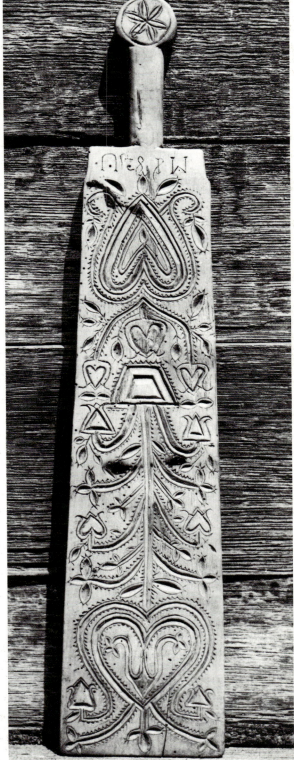

211 **212** **213**

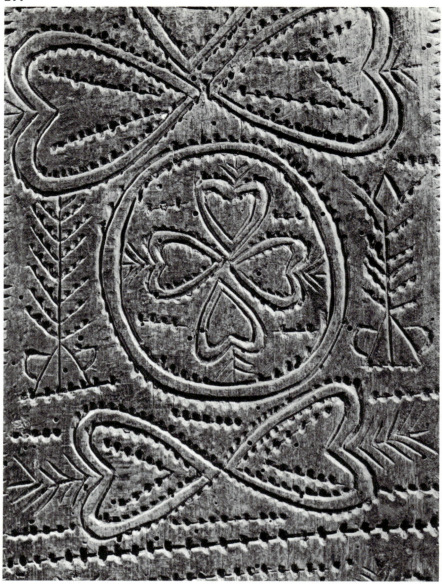

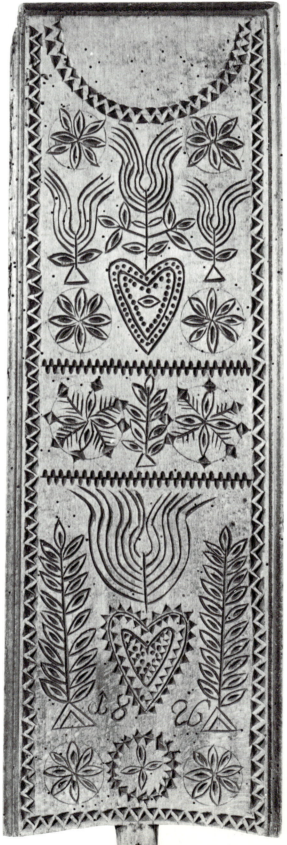

214 Upper side of a mangling board, with engraved decoration. Detail. *20 cm*. Inscription: "1802." Transdanubia (Ethnographical Museum)

215 Upper side of a mangling board decorated with a design of tulips, rosettes, stylized flower-clusters and hearts on three small fields on the surface. Engraved and chip-carved. *55.5 cm*. Inscription: "1826." Transdanubia (Ethnographical Museum)

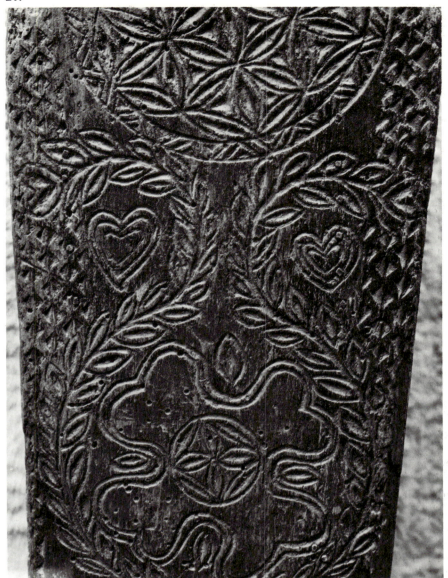

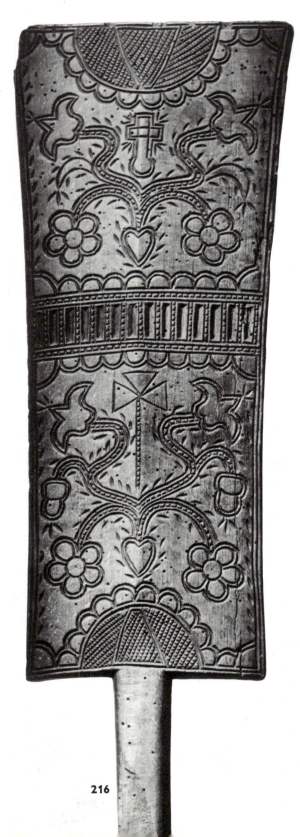

216 Mangling board. Upper side, divided into two fields, with an engraved design of tulips, rosettes and acorns on flower-clusters, and stylized crosses at the axis. There are traces of red and black paint in the engraved lines. Beech. *61.5 cm.* Vaspör, Zala County (Göcsej Museum, Zalaegerszeg)

217 Upper side of a mangling board, with engraved and chip-carved design of foliate scrolls, rosettes and hearts. *23 cm.* Detail. Győr-Sopron County (Ethnographical Museum)

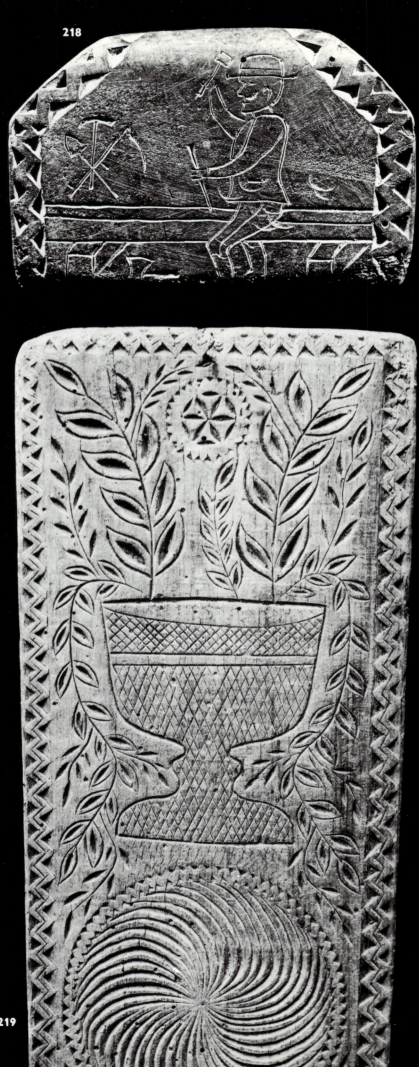

218 Figure
of carpenter working
on a beam with
spade, pickaxe and
scythe beside him,
and an axe at his feet.
Chip-carved and en-
graved. Detail
of a mangling board.
Hardwood. *11 cm.*
Inscription: "István
Halász born on XIV
of IX month 1890
made this."
Kecskemét,
Bács-Kiskun County
(János Bozsó's
collection,
Kecskemét)

219 Upper side
of a mangling board,
with goblet and large
rosette, chip-carved
and engraved. Detail.
Beech. *35 cm.*
Inscription: "18 MS
13."
Győr-Sopron County
(Ethnographical
Museum)

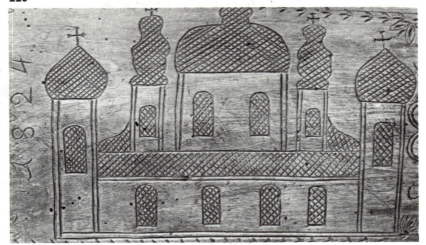

220 Upper side
of a mangling board,
engraved with
the design
of a church with
five spires. Detail.
Hardwood. *34 cm.*
Inscription: "1824."
Transdanubia
(Ethnographical
Museum)

221 Upper side
of a mangling board,
with engraved
and chip-carved
tulip flower-cluster
design. Detail.
Hardwood. *32 cm.*
Inscription: "1833."
Transdanubia
(Ethnographical
Museum)

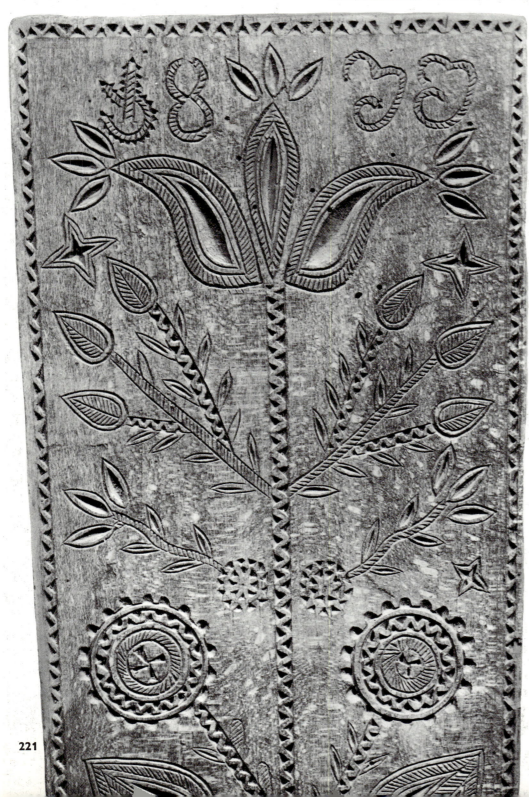

221

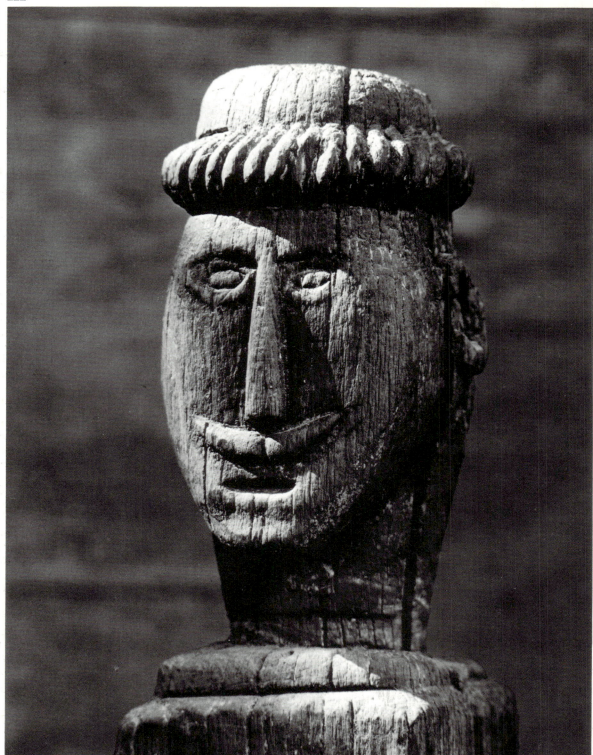

222 Man's head
on the post
of a water-mill.
Acacia-wood. *27 cm*.
Ráckeve, Pest County
(Local Museum,
Ráckeve)

223 Man's head
on a carpenter's
bench. Detail.
Acacia-wood.
Inscription: "1811."
Békés County
(Móra Ferenc
Museum, Szeged)

224 Inn-sign showing
the head of a man
with a bunch
of grapes in his
mouth. Hardwood
painted in colours.
37 cm.
Debrecen, Hajdú-
Bihar County (Déri
Museum, Debrecen)

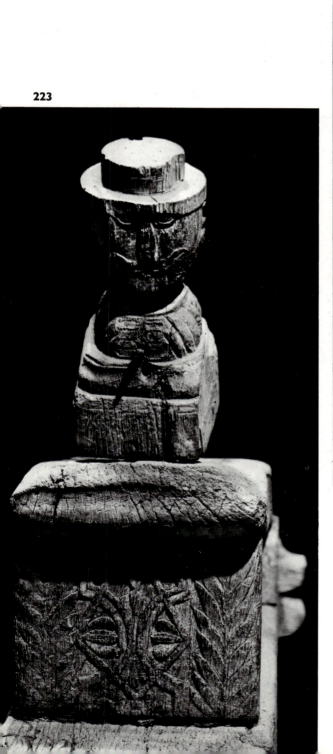

223

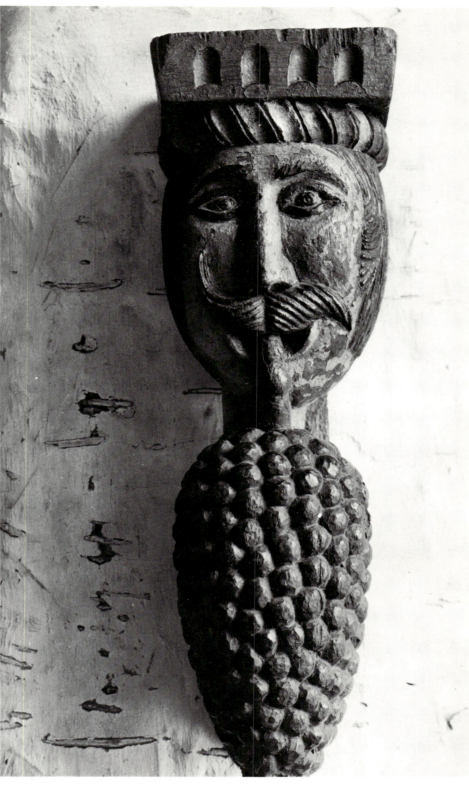

224

225 Windmill.
Kiskundorozsma,
Bács-Kiskun County

226 Flour-bench
of a windmill with
the monogram
of Jesus carved
among elaborate
foliage. Inscription:
"This windmill was
built by Lajos
Csányi for the sake
of the people living
along the road
to Mindszent August
18, in 1860."
Kiskunfélegyháza,
Bács-Kiskun County
(Kiskun Museum,
Kiskunfélegyháza)

227 Inner
construction
of a windmill,
the work
of carpenter-millers.
1860.
Kiskunfélegyháza,
Bács-Kiskun County
(Kiskun Museum,
Kiskunfélegyháza)

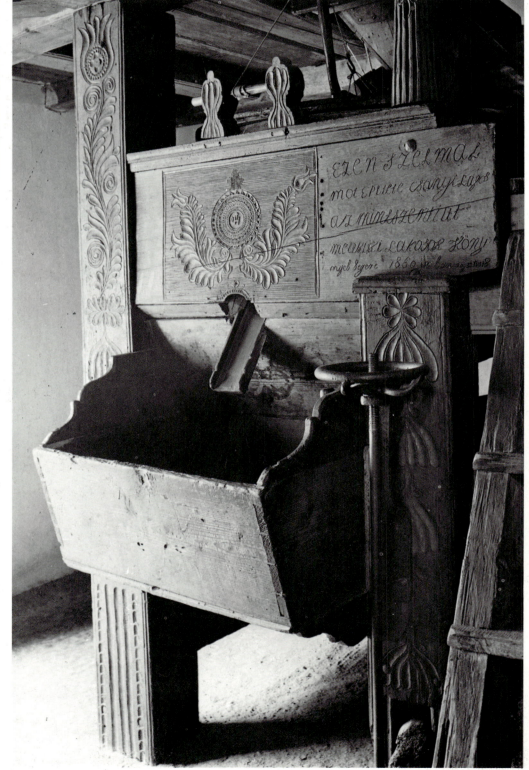

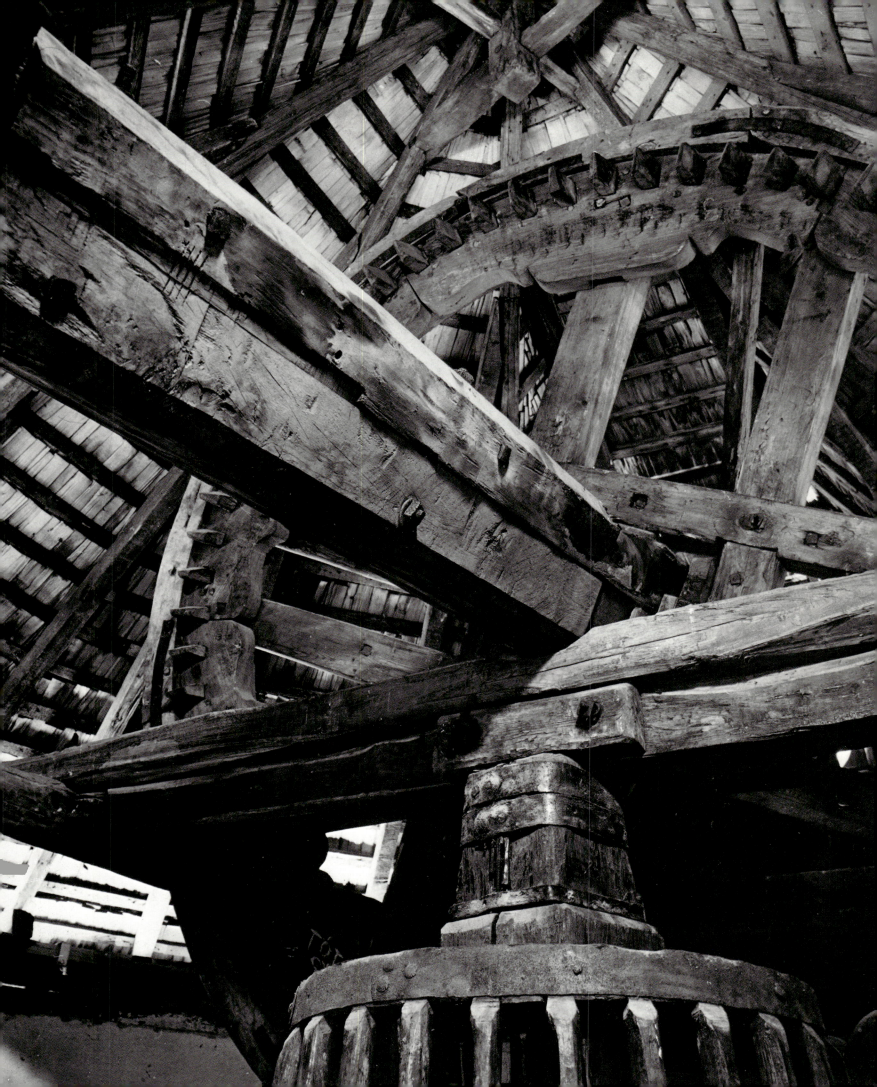

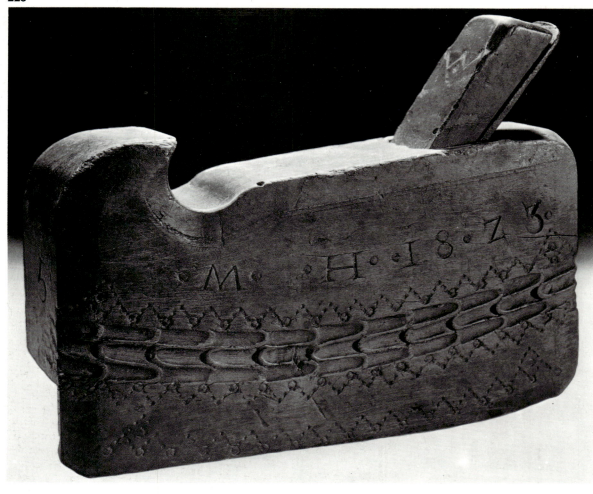

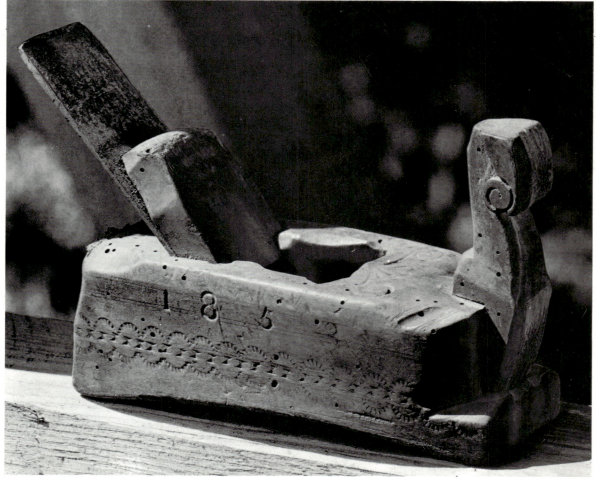

228 A rabbet plane with hammered and engraved decoration. *15 cm.* Inscription: "M H 1823." Zalaegerszeg, Zala County (Göcsej Museum, Zalaegerszeg)

229 A plane with hammered and chip-carved decoration. *13 cm.* Inscription: "1852." Zalaegerszeg, Zala County (Göcsej Museum, Zalaegerszeg)

230 Flour-bench of a windmill carved with a chalice and the host above, and two candlesticks. *33.3 cm.* Inscription: "The old year has passed away / A new year has come to stay, / let 1845 open its breast / in peaceful rest..... From my true heart do I sigh / blessings descended from heaven on high / upon the lord of this mill here / to blossom daily in the next year." Kiskunfélegyháza, Bács-Kiskun County (Kiskun Museum, Kiskunfélegyháza)

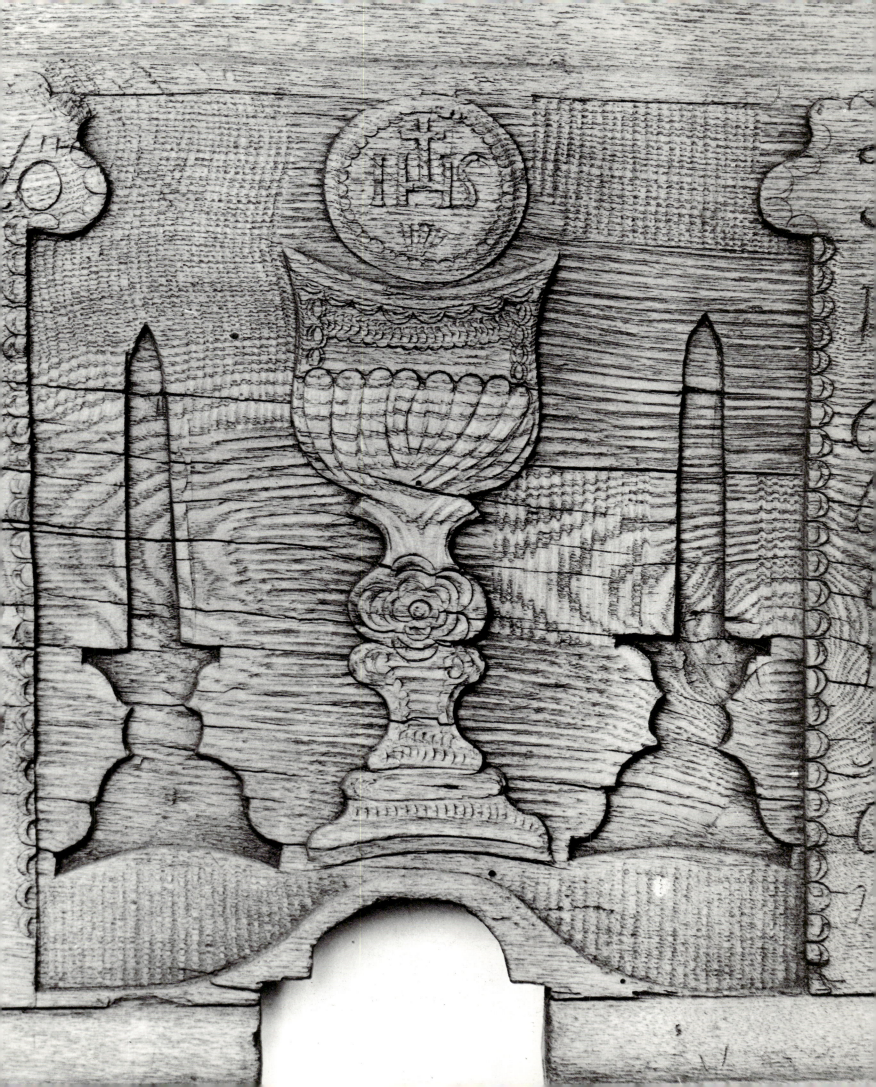

231

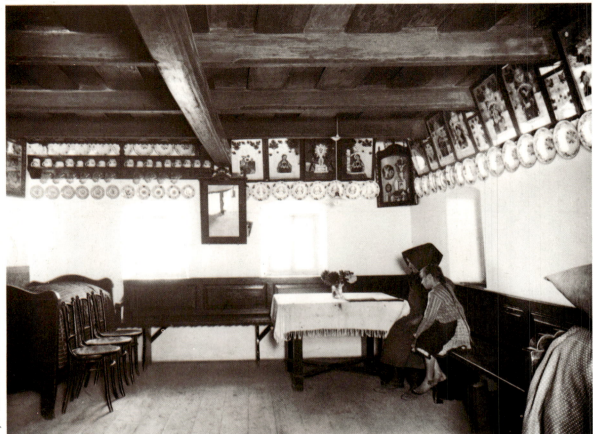

231 The *parádés szoba* ("best room") with devotional pictures, stoneware plates and mugs hanging on the wall. Tura, Pest County

232 Beds covered with hangings, and stacked with eiderdowns and pillows in elaborately woven slips. Rows of stoneware plates painted with roses surround the mirror. Martos (Martovce, Czechoslovakia)

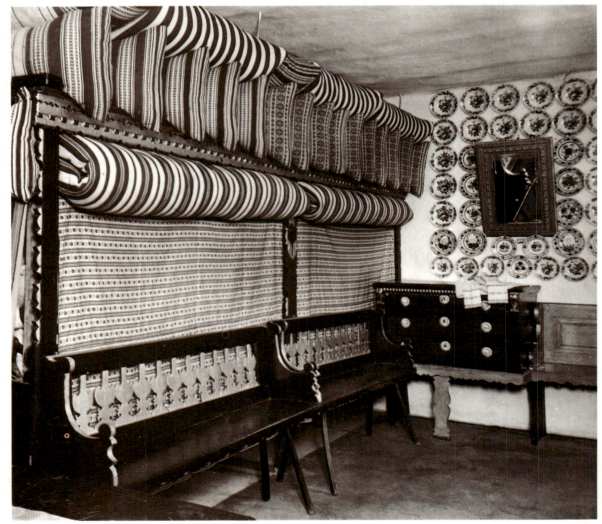

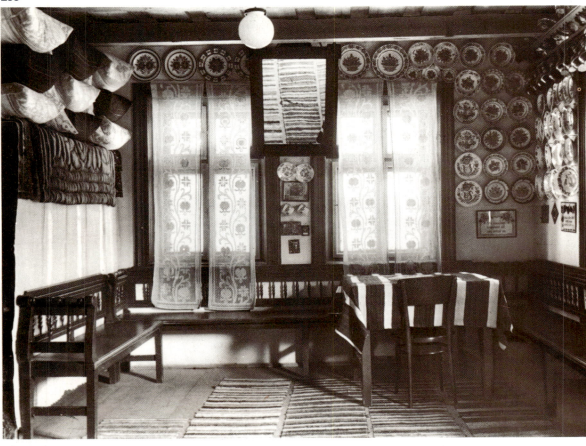

233 The *parádés szoba* ("best room") with bed stacked up to the ceiling with pillows. The wall around the corner table is adorned with fine stoneware plates and jugs on pegs. Kalotaszentkirály (Sâncraiu, Rumania)

234 Beds in the *parádés szoba* ("best room") stacked to the ceiling with eiderdowns and pillows. Detail. Mátisfalva (Matişcui, Rumania)

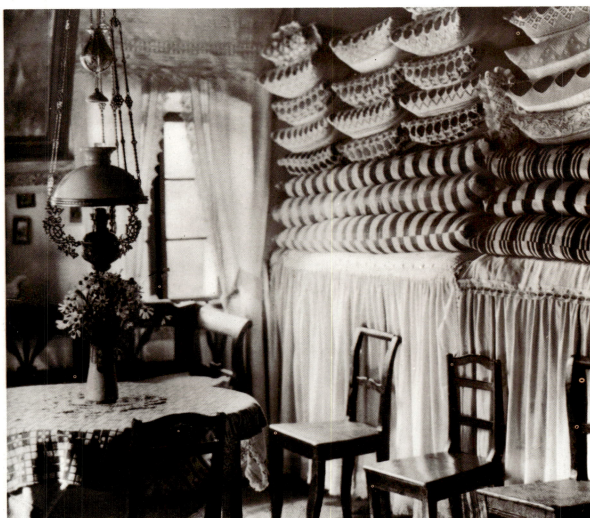

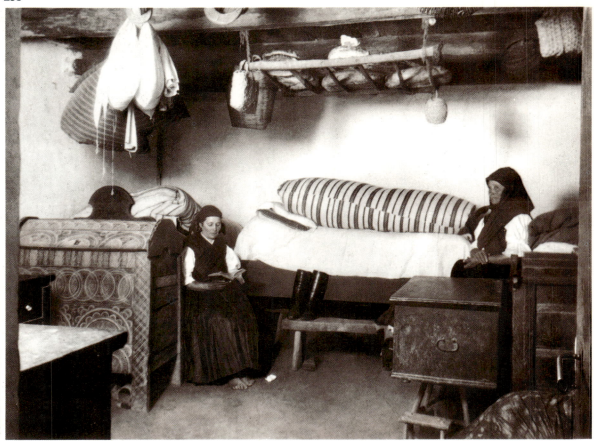

235 Room with beds for everyday use and a hewn chest and a painted chest. Maconka, Nógrád County

236 The corner of a sleeping room with hewn chests and boots, sheepskin jacket and bundles of hemp hanging on a rod. Kazár, Nógrád County

237 Tiled stove. Szenna, Somogy County

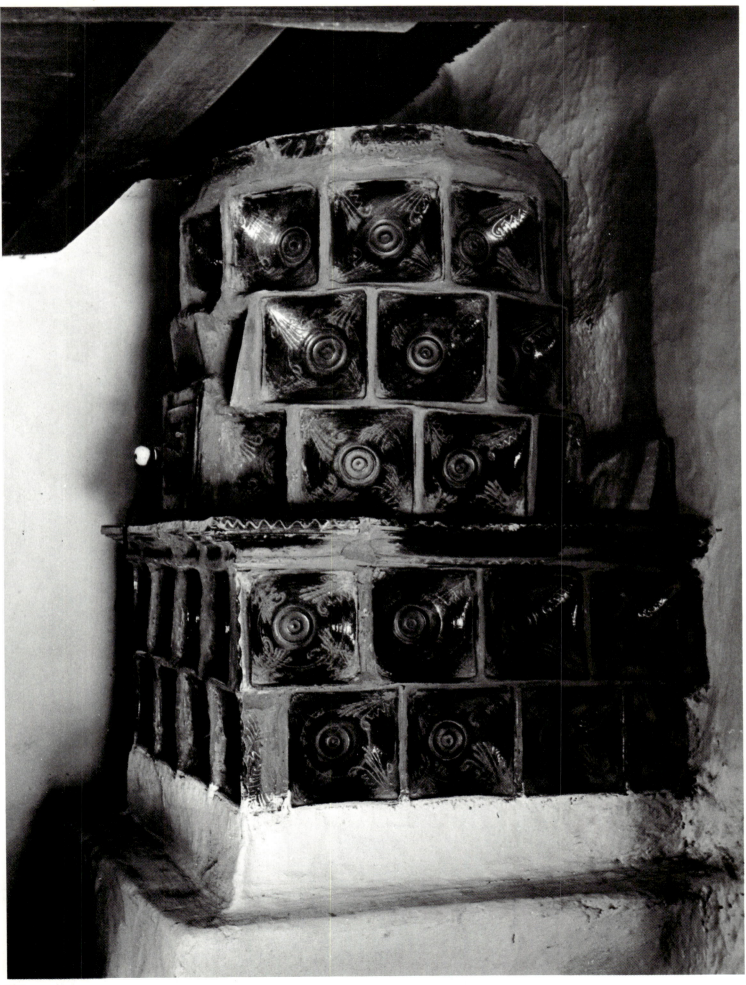

237

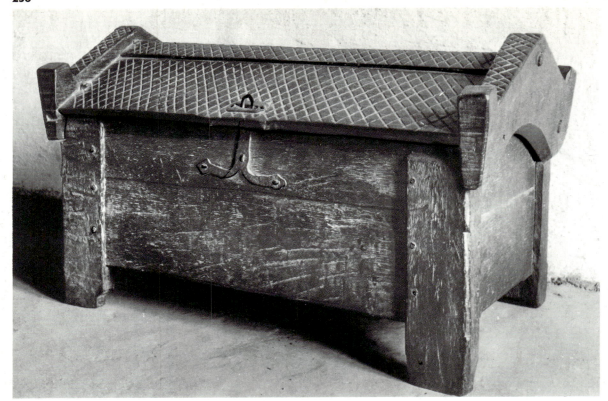

238 Plain hewn
chest. Hardwood,
with engraved
decoration. *60 cm.*
(Janus Pannonius
Museum, Pécs)

239 Rosette from
the front of a hewn
bridal chest with
engraved geometrical
pattern. Painted
brown and green.
Beech. *49.5 cm.*
Baranya County
(Ethnographical
Museum)

240 Hewn chest with
engraved and painted
decoration. Detail.
Baranya County
(Janus Pannonius
Museum, Pécs)

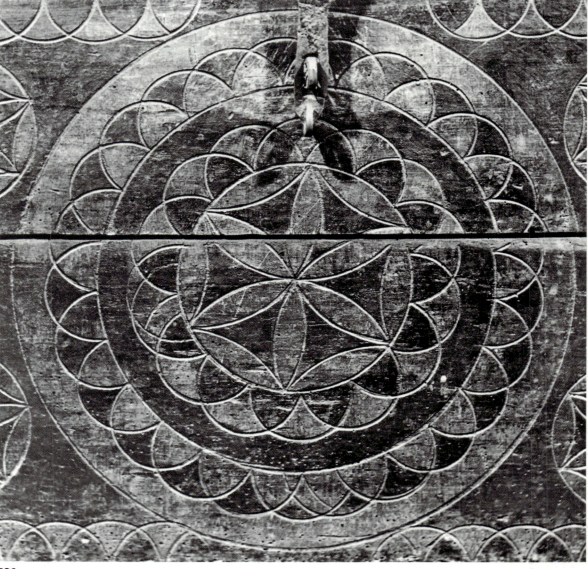

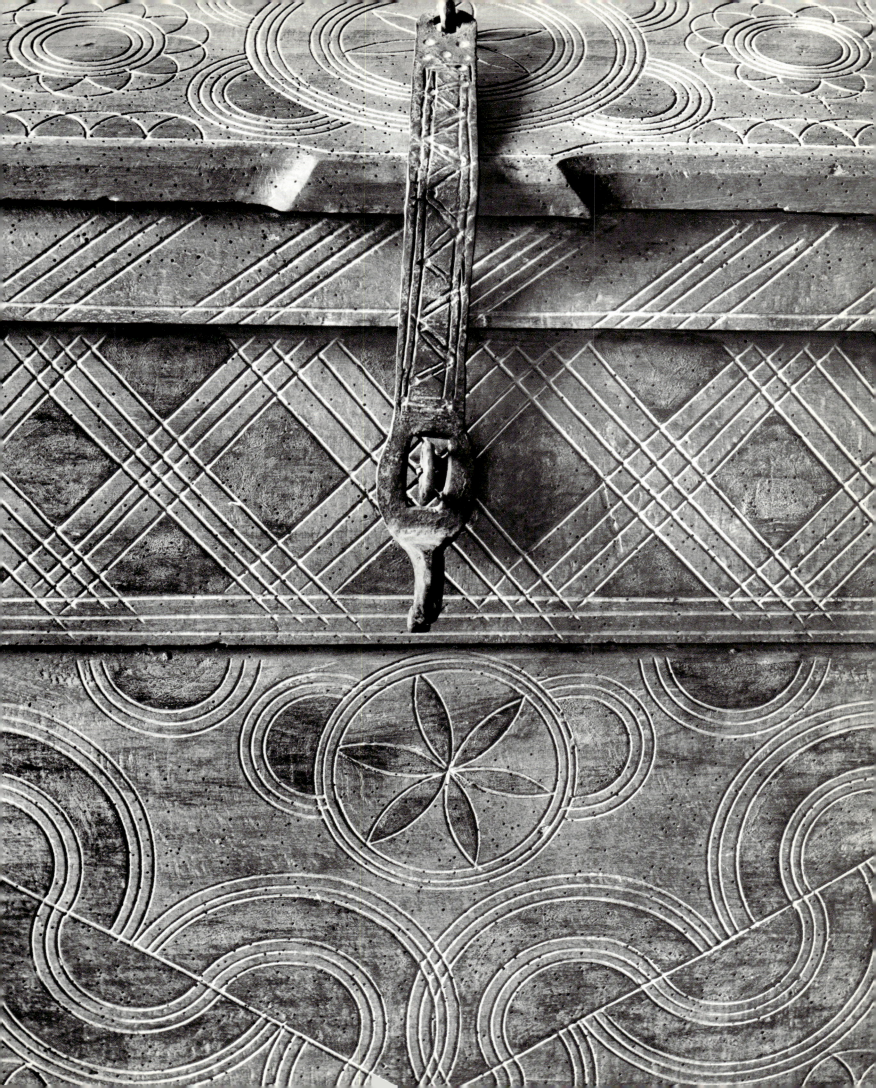

241

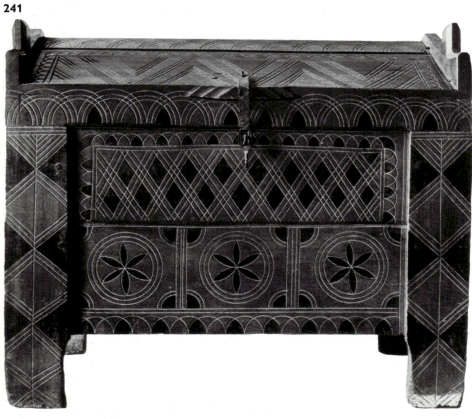

241

241 Hewn bridal
chest with painted
and engraved
geometrical pattern.
Baranya County
(Janus Pannonius
Museum, Pécs)

242 Top lid
of a hewn chest with
painted and engraved
decoration. (Detail
of Ill. 239.) *35 cm*.
Baranya County
(Ethnographical
Museum)

243 Front of a hewn
bridal chest with
engraved decoration.
(The front of the
chest in Ill. 244.)
Beech.
Nógrád County
(Janus Pannonius
Museum, Pécs)

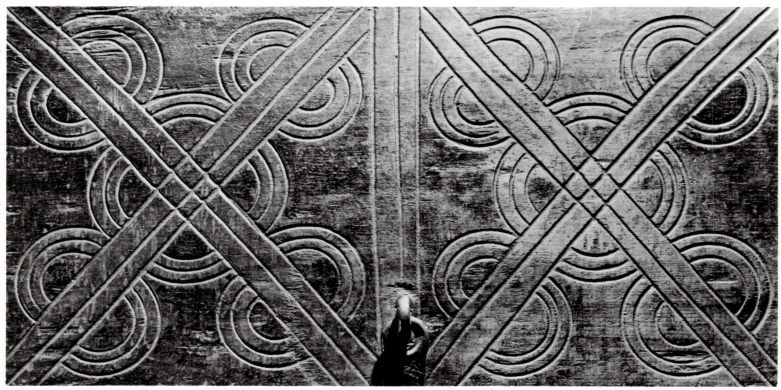

242

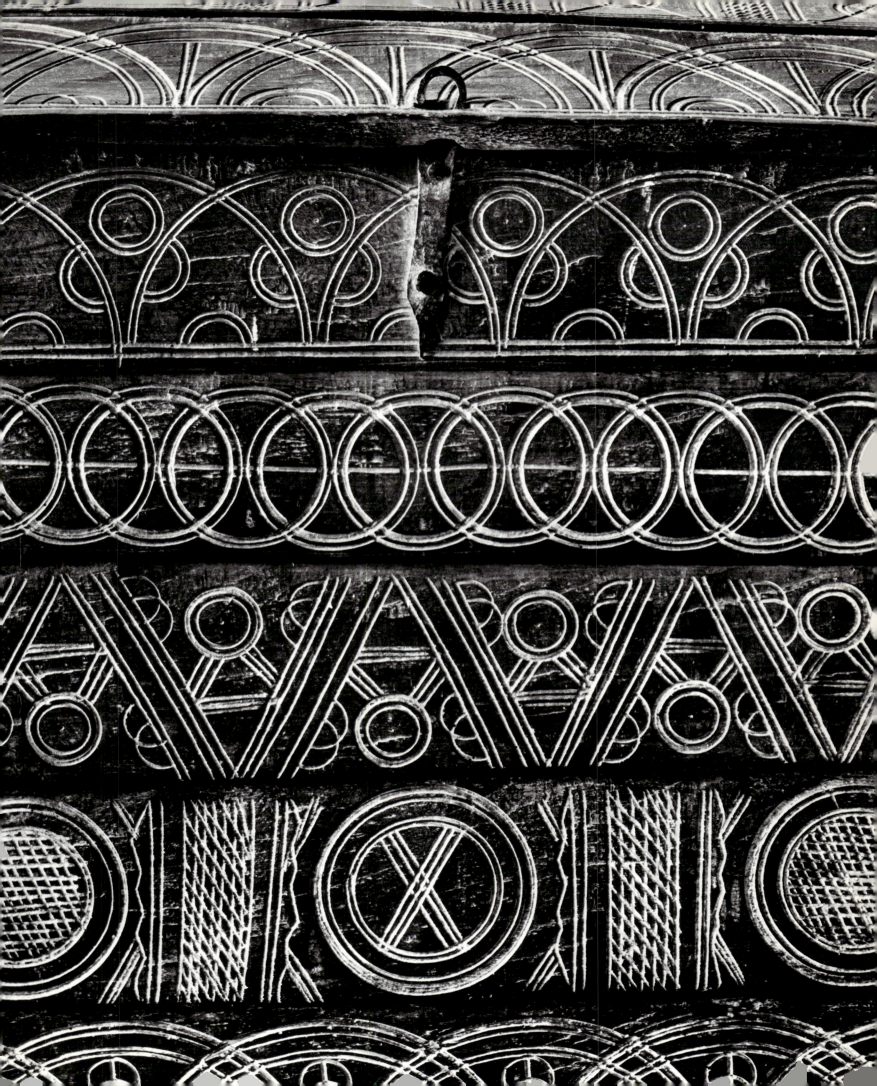

244 Hewn bridal chest with engraved decoration. Beech. Nógrád County (Janus Pannonius Museum, Pécs)

245 Front of a hewn bridal chest with engraved decoration. Detail. Beech. *22 cm*. Maconka, Nógrád County

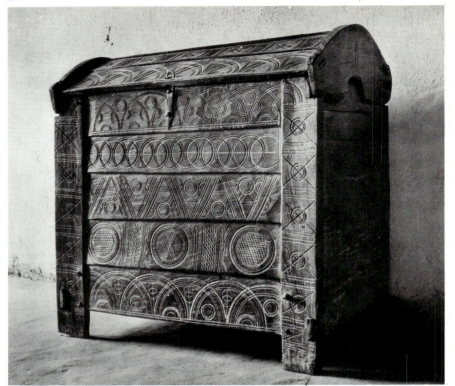

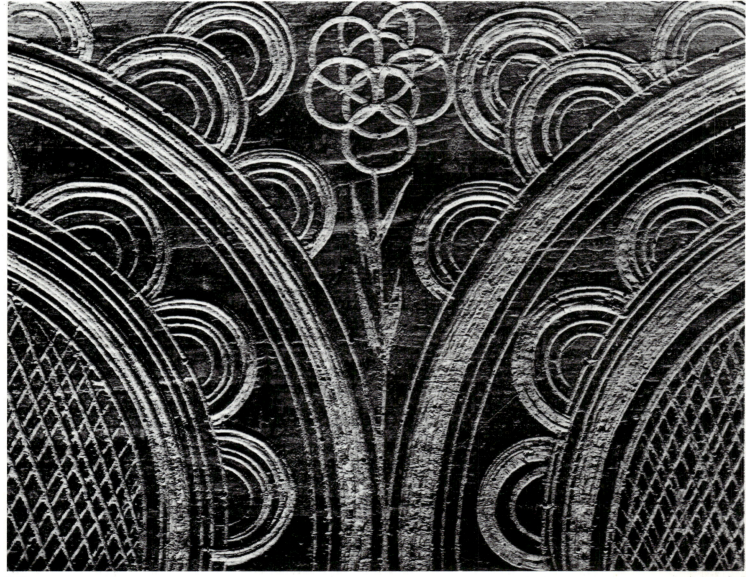

245

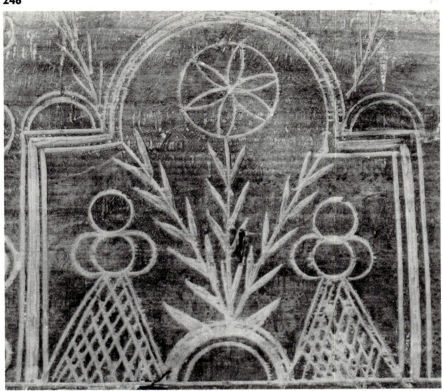

246 Front of a hewn bridal chest. Flower-cluster set in a niche with two stylized figures. Engraved decoration. Beech. *22 cm.* Inscription: "1889." Borsodnádasd, Borsod-Abaúj-Zemplén County (Ethnographical Museum)

247 The front of a hewn bridal chest with engraved decoration. On the top plank are the stylized figures of people, arms raised in prayer. Oak. *54.7 cm.* Southern Tisza region (Ethnographical Museum)

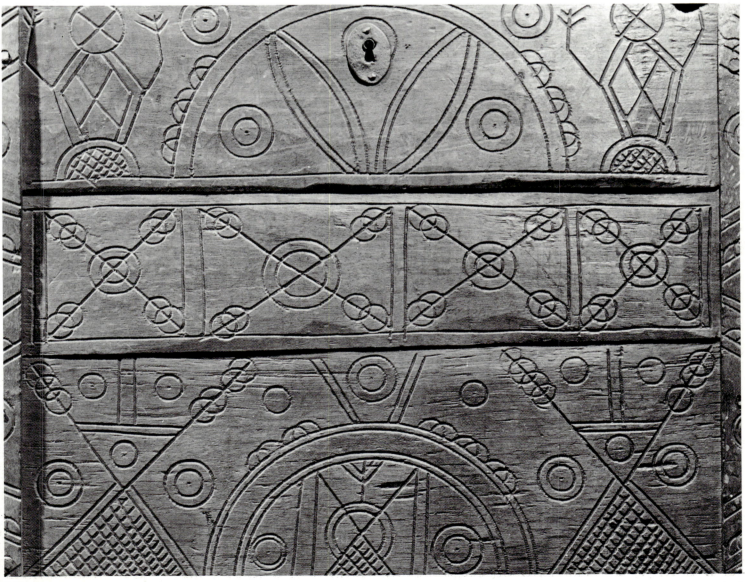

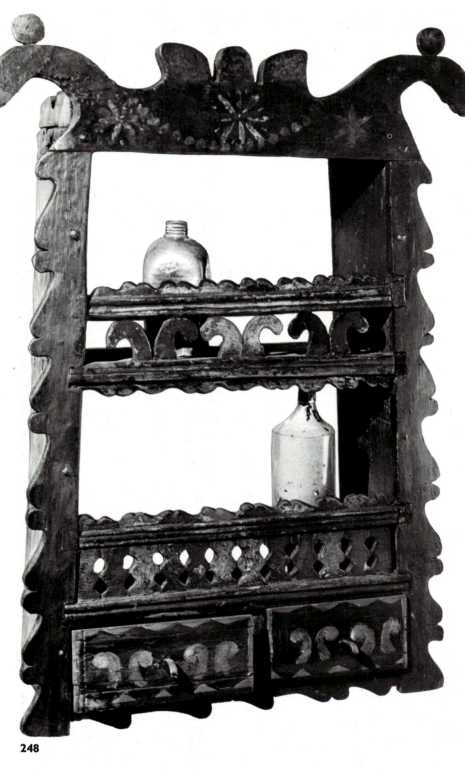

248

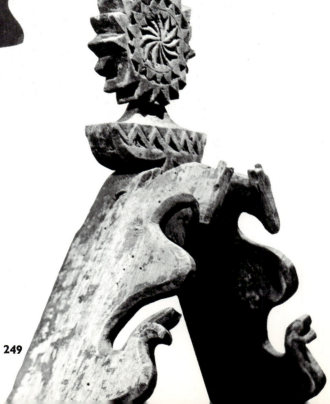

249

248 Wall rack with carved and painted decoration. Mainly red, with dark blue ground. Softwood. *95 cm.* Sárköz region, Tolna County (Ethnographical Museum)

249 Top of triangular wall rack with a star and heads of horses. Softwood. *25 cm.* Inscription: "1872." Kecskemét, Bács-Kiskun County (János Bozsó's collection, Kecskemét)

250 Wall rack with a carved front and the frame painted green. Softwood. *62 cm.* Átány, Heves County (Ethnographical Museum)

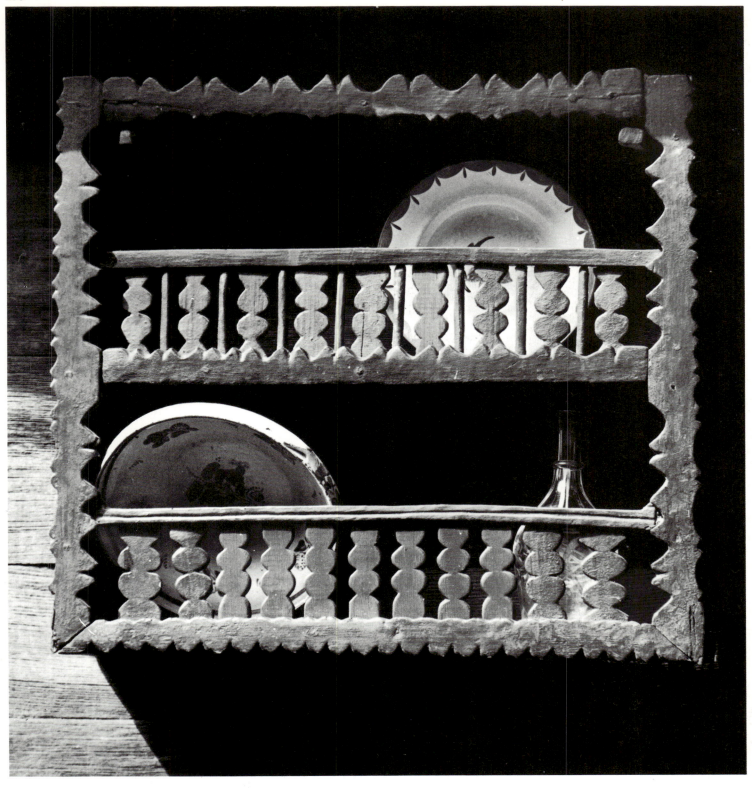

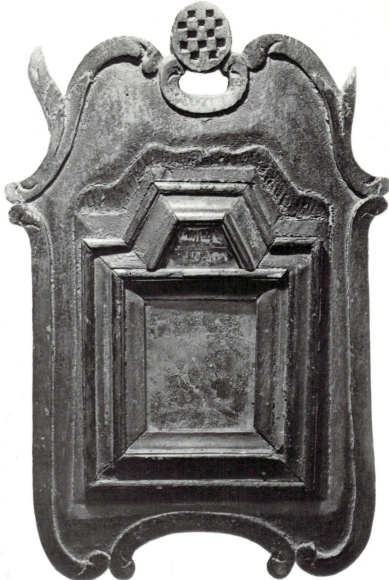

252

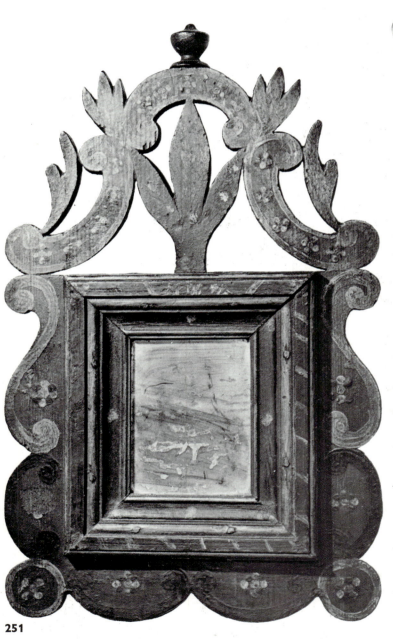

251

251 Wall mirror.
The small mirror,
purchased in an
angular frame, was
inserted into a carved
and painted open-
work outer frame.
Painted in red,
white and green
on a blue ground.
Softwood. *66 cm.*
Hódmezővásárhely,
Csongrád County
(Ethnographical
Museum)

252 Small wall
mirror with Turkish
inscription. The small
mirror, purchased
in an angular frame,
was inserted into
a larger frame with
a curved top.
Carved and painted
dark green with
traces of stripes
in lighter colours.
43.5 cm.
Kiskunhalas, Bács-
Kiskun County
(Ethnographical
Museum)

253 A pipe-holder
with six meerschaum
pipes. *44 cm.*
Kecskemét region,
Bács-Kiskun County
(János Bozsó's
collection,
Kecskemét)

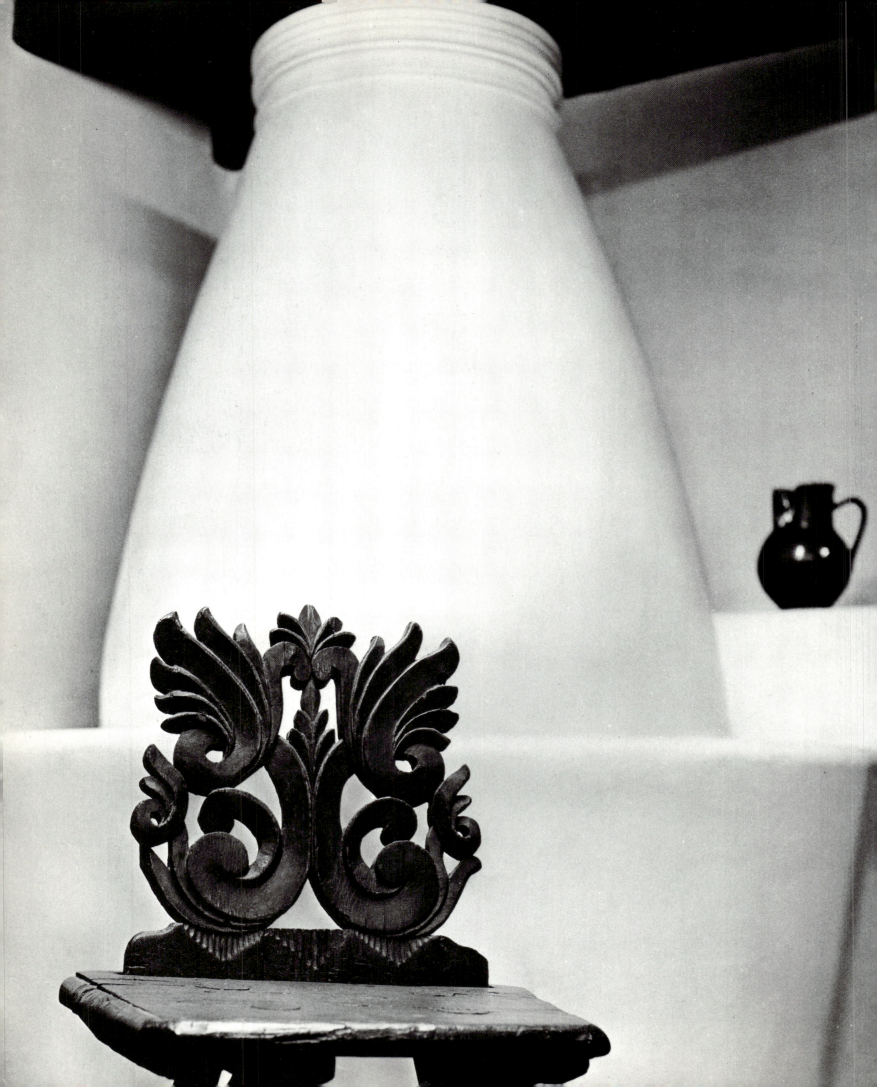

254 Chair with open-work back standing in front of an oven. Height of the back of the chair: *39.5 cm.* Debrecen, Hajdú-Bihar County (Déri Museum, Debrecen)

255 Low chair with the seat and back carved from a single block of wood. *45 cm.* Milota, Szabolcs-Szatmár County (Ethnographical Museum)

256 Chair. Each bar of the semicircular back is carved with two tulips with a rosette between them. Hardwood. *74.5 cm.* Veszprém County (Bakony Museum, Veszprém)

257 Back of carved chair. Between the two double curves of the back are open-work floral and foliate motifs. Hardwood. *41 cm.* Balaton uplands (Ethnographical Museum)

258 Chair-back carved in relief. The violin-shaped back is divided by a band with a heart-shaped opening above it; above and below the band is a carved design of flower-clusters on a ground with a beaten-in pattern. Walnut. *41.4 cm.* Inscription: "M M 1766." Nyúlhegy, Győr-Sopron County (Ethnographical Museum)

259 Chair-back carved in relief with open-work. Oak. *47 cm.* Inscription: "1781 PRO AN." Szentes, Csongrád County (Ethnographical Museum) *(See next page)*

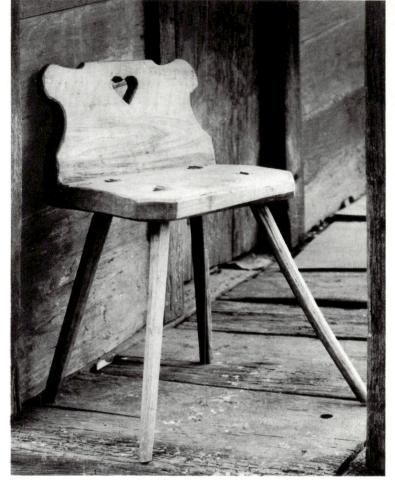

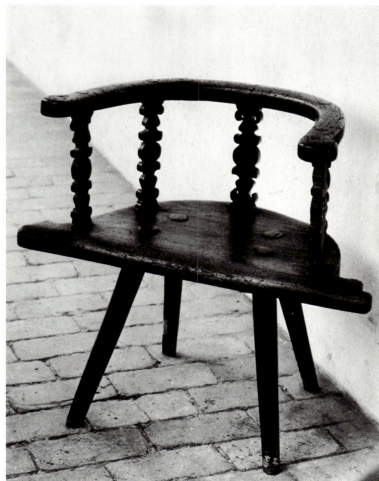

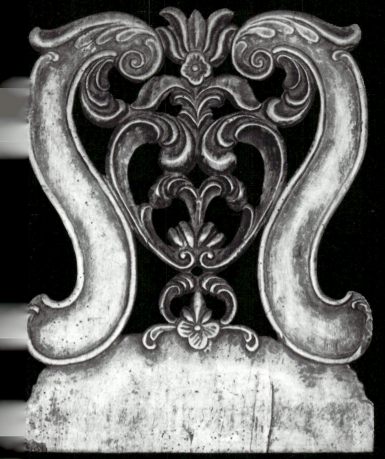

257

258

259

260 Open-work chair-back, painted black with simplified baroque and rococo motifs. Hardwood. *43 cm*. Egyek, Hajdú-Bihar County (Ethnographical Museum)

261 Chair-back ornamented with carving and a beaten-in pattern. There is an elaborately designed edge and a heart-shaped opening in the middle; the rosettes are carved in relief. Walnut. *44.5 cm*. Inscription: "1855." Csanak, Győr-Sopron County (Ethnographical Museum)

262 Chair-back carved in relief, violin-shaped with acorns in the curves. The heart-shaped opening in the centre is surrounded by floral motifs. Hardwood. *41.5 cm*. Veszprém County (Ethnographical Museum)

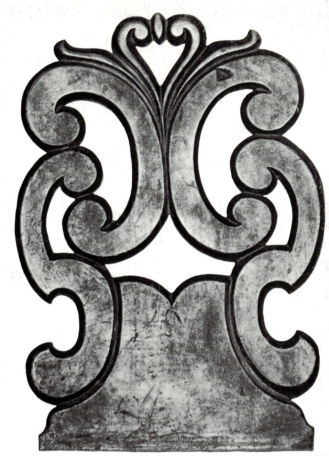

260

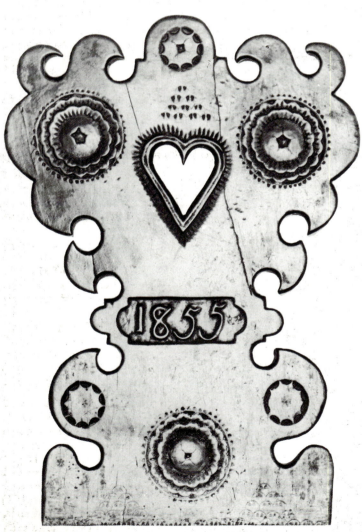

261

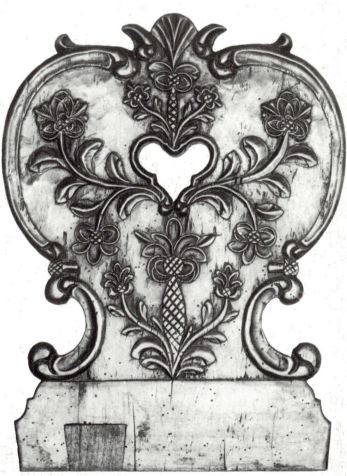

262

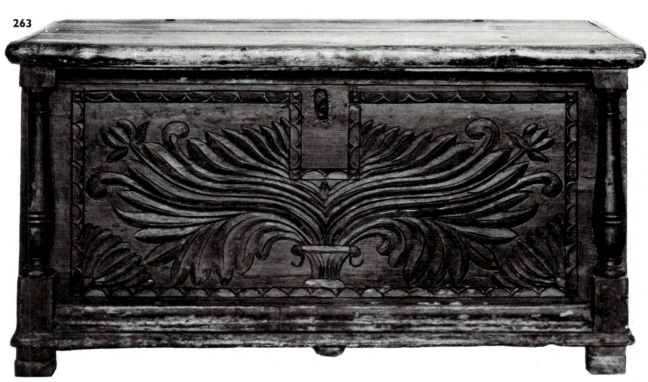

263

263 Bridal chest decorated with a single large flower-cluster in a vase. Carved and engraved design. Painted dark blue. Made by Zsigmond Mohai, shipbuilder from Komárom, for his daughter born in 1851. Pine wood. 56 cm. Komárom, Komárom County (Ethnographical Museum)

264 Front of a chest. Painted red with black marbling, the design is in white, blue, yellow and green. Pine wood. 40.5 cm. Inscription: "1852." Átány, Heves County (Ethnographical Museum)

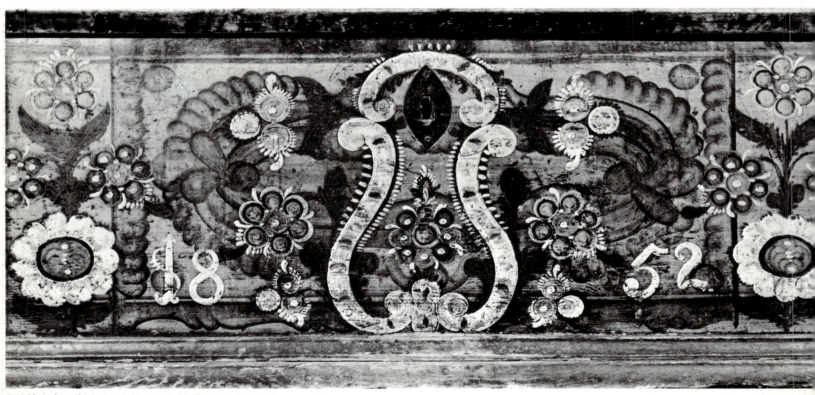

264

265 Carved chest from Komárom. Painted red, yellow, green and buff on a dark blue ground. Two carved shields with a rosette in each. Pine wood. *48 cm.* Inscription: "NOBLE ERSÉBET FEÉL... 1810." Komárom County (Ethnographical Museum)

266 Carved and painted chest with a design of birds. *49 cm.* The work of Komárom joiners. Szeremle, Bács-Kiskun County (Ethnographical Museum)

265

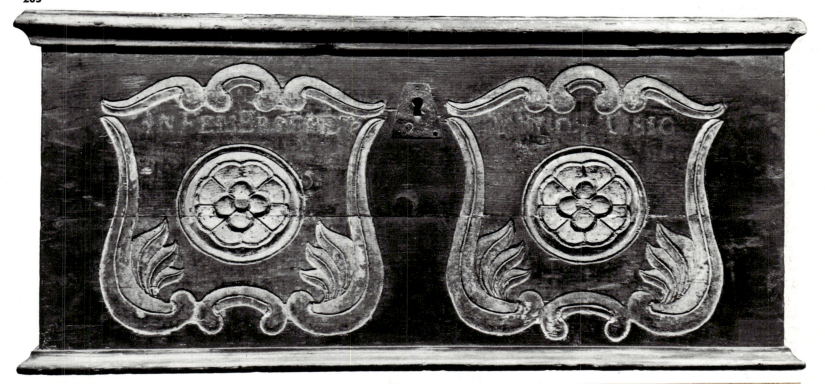

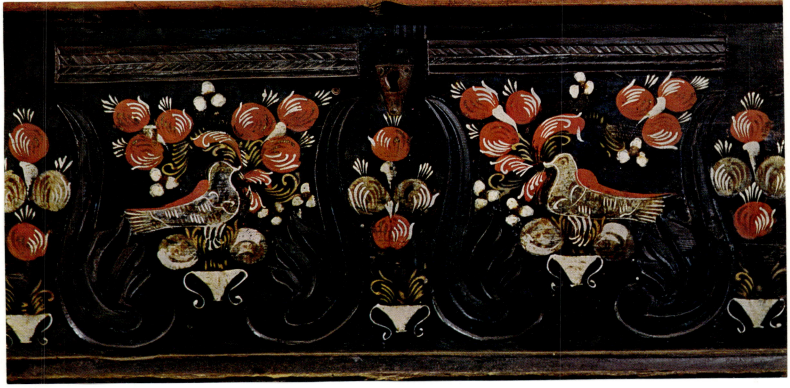

266

267

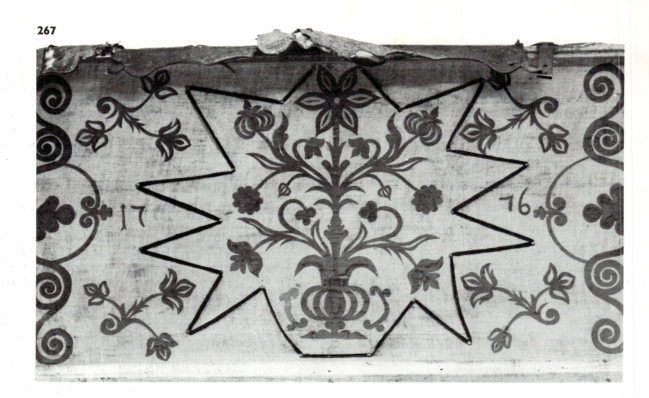

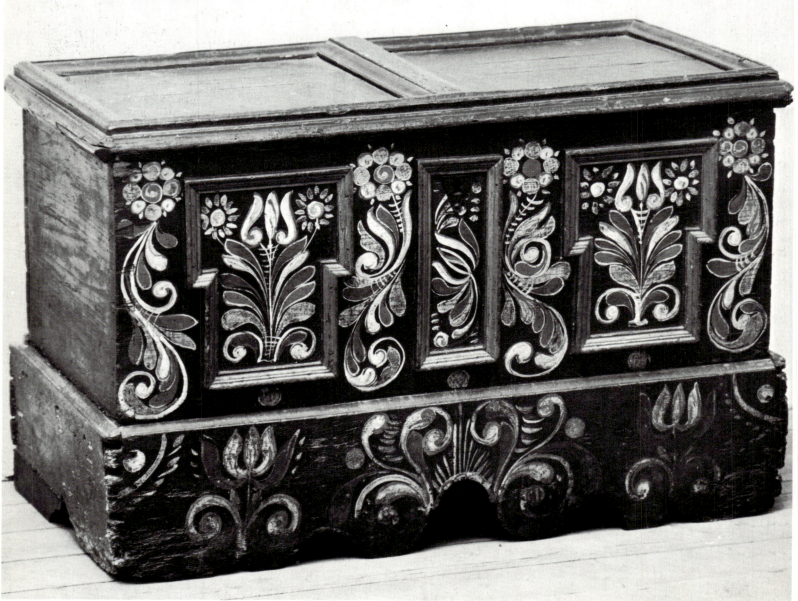

268

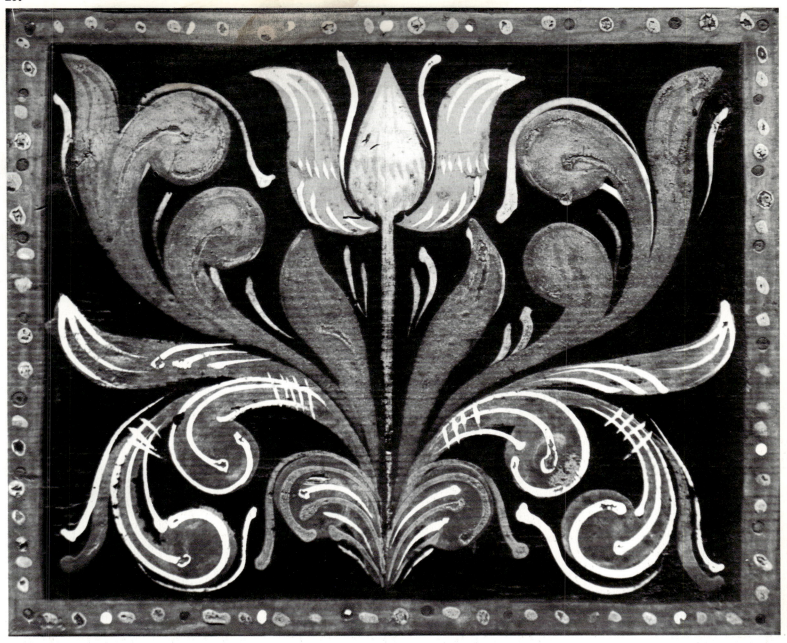

267 Inside of a chest
lid, lined with linen
and decorated with
paper cut-outs
in red and green,
and black linen
ribbon fastened with
nails. *59 cm.*
Inscription: "1776."
The work of joiners
from Kolozsvár.
(Cluj-Napoca,
Rumania) (Mrs. Lajos
Pákay's collection,
Budapest)

268 Carved chest
standing on a tall
base. Painted in
bright yellow and
green with red tulips
and foliage, and
rosettes on dark
brown ground.
Pine wood. *62 cm.*
Miskolc, Borsod-
Abaúj-Zemplén
County (Herman
Ottó Museum,
Miskolc)

269 Tulip design
from the front
of a painted chest.
Bright red, green
and white on a black
ground. Detail.
27.2 cm.
Szeremle,
Bács-Kiskun County
(Ethnographical
Museum)

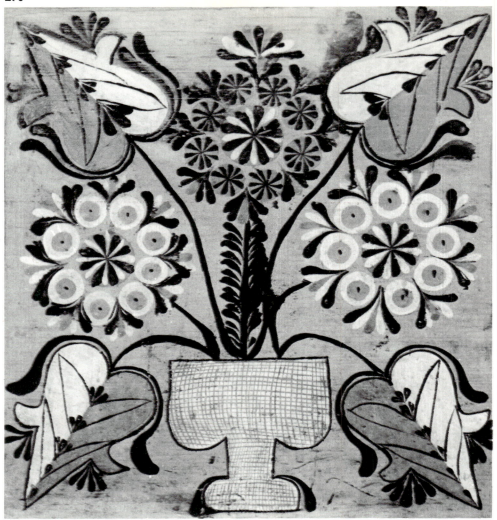

270 Tulips in a pot.
One yellow section
from the front
of a dark blue chest.
Painted red, yellow,
green and white
on a yellow ground.
38 cm. Inscription:
"1817."
Kalotaszeg region
(Rumania)
(Ethnographical
Museum)

271 Flower-cluster
in a pot, from the lid
of the chest shown
in Ill. 272. Detail.
37 cm.
Kalotaszeg region
(Rumania)
(Ethnographical
Museum)

272 Front
of a painted chest.
Detail. *42 cm*.
Inscription: "1825."
Kalotaszeg region
(Rumania)
(Ethnographical
Museum)

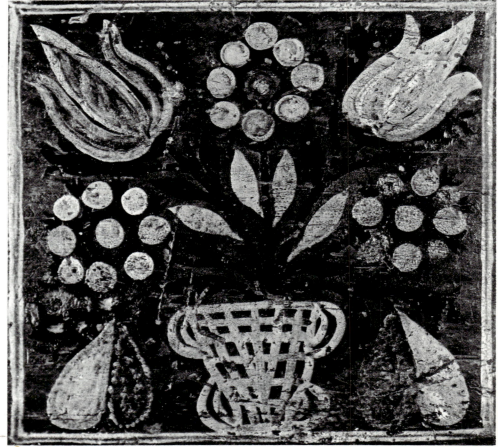

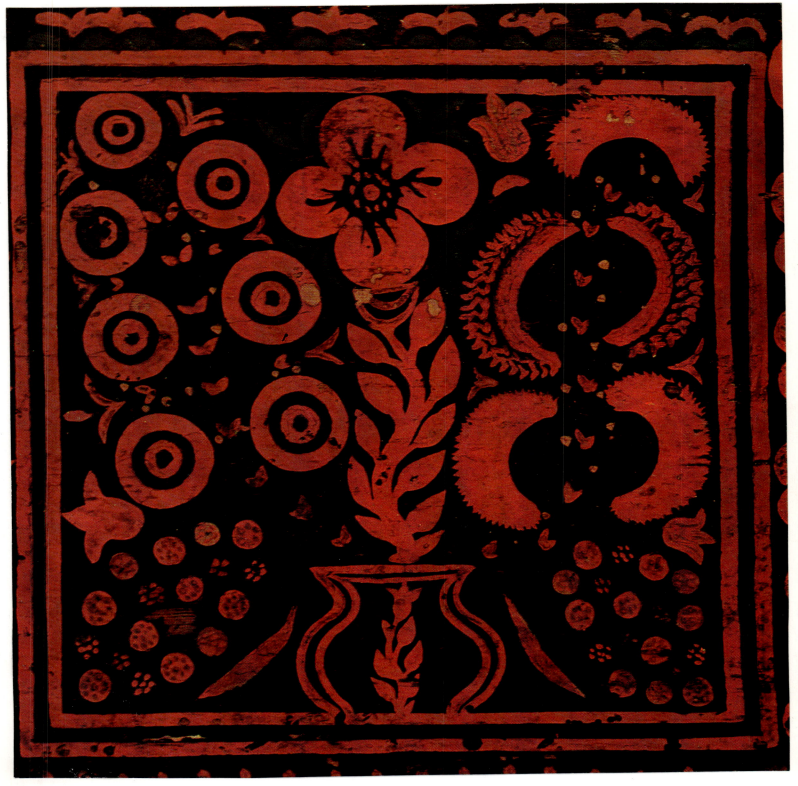

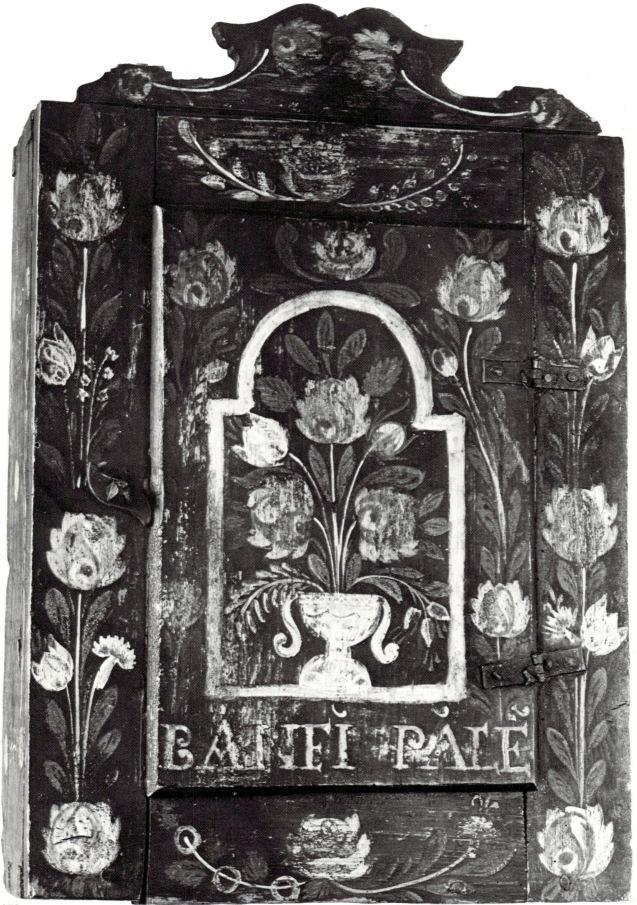

273 Wall cupboard, with a gable top, painted red and yellow on a dark blue ground. Softwood. *70.3 cm.* Inscription: "PÁL BÁNFI's." Hódmezővásárhely, Csongrád County (Ethnographical Museum)

274 Hanging saltcellar with lid and drawer. One of the small birds on the upper corner is missing. *27 cm.* Inscription: "FELVINCZI KATI." Kalotaszeg region (Rumania) (Ethnographical Museum)

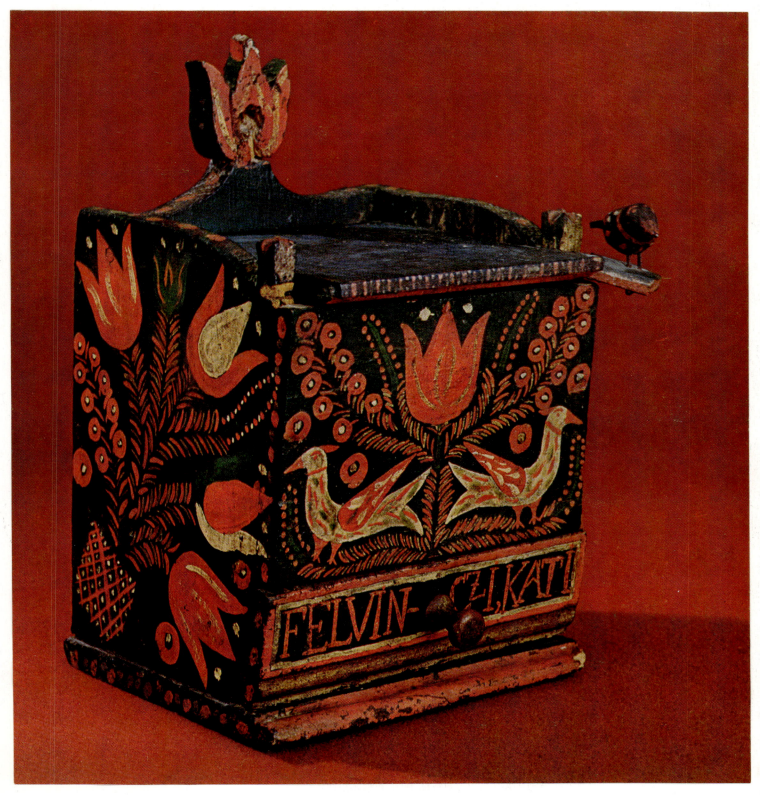

274

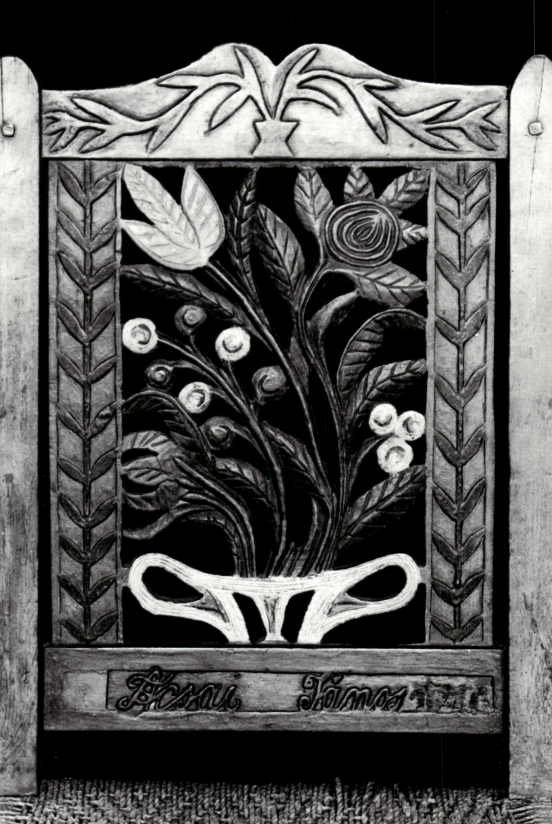

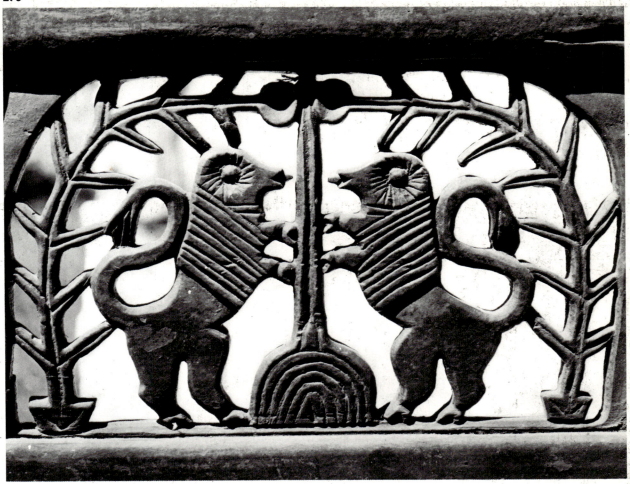

275 Chair-back.
The open-work
design of flowers in
a vase is painted red,
yellow, black
and white. The chair
is painted blue. *32 cm.*
Inscription: "Acsai
János."
Makó, Csongrád
County (Mrs. Tibor
Keresztes's collection)

276 Two lions carved
in the open-work
panel of a chair.
21.5 cm.
Nógrád County
(Palóc Museum,
Balassagyarmat)

277 Cattle from
the open-work
carving on the back of
the bench in
Ill. 280. *6 cm.*
Nógrád County
(Ethnographical
Museum)

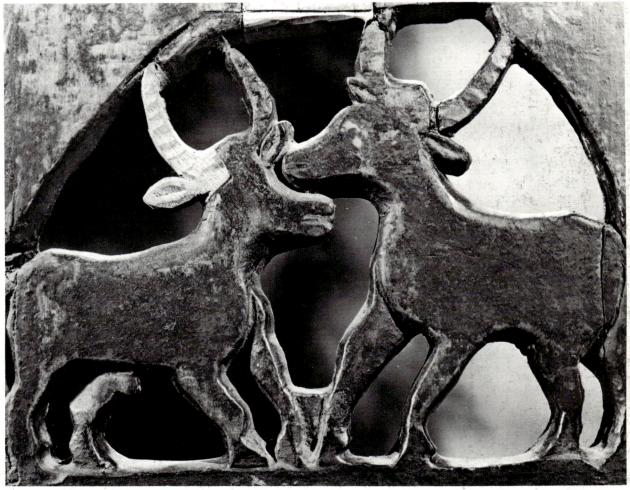

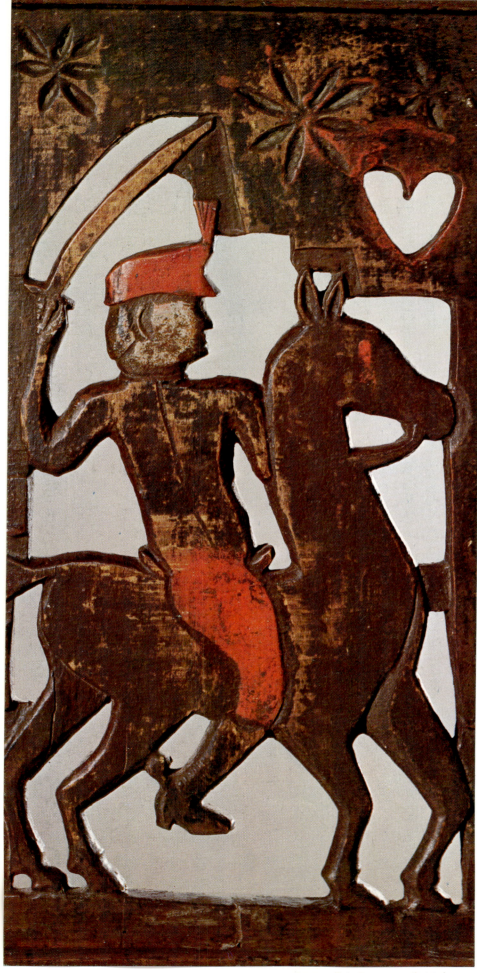

278 Charging hussar.
Open-work carving
on the panel of
the bench in
Ill. 280. Painted. *27 cm*.
Nógrád County
(Ethnographical
Museum)

279 Charging hussar. Open-work carving on the panel of the bench in Ill. 280. Painted. *27 cm.* Nógrád County (Ethnographical Museum)

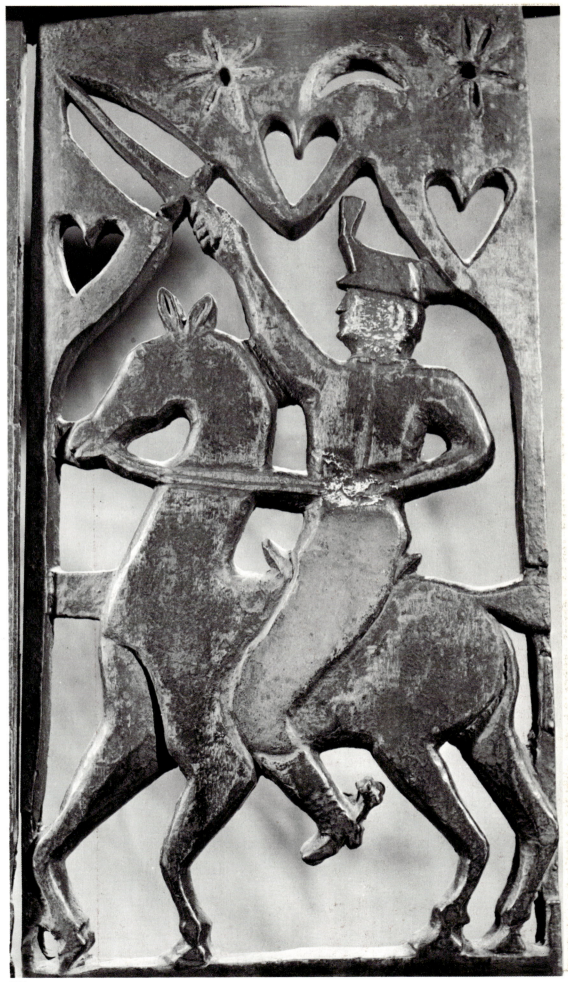

279

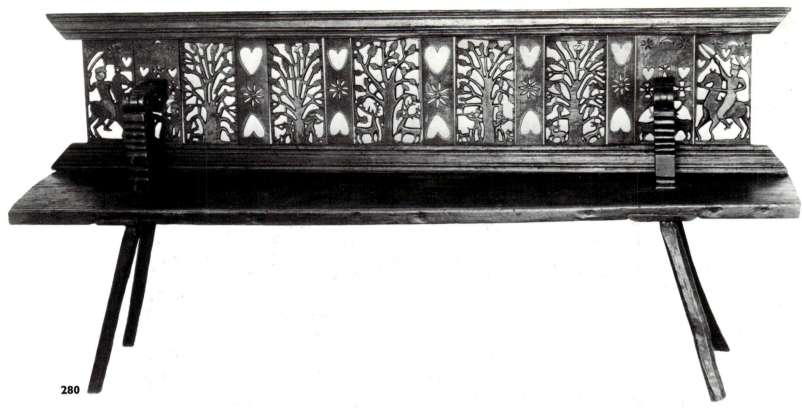

280

280 Bench with open-work carving. Painted brown with red and green. *94 cm.* Inscription: "Csábrádi János 1885." Nógrád County (Ethnographical Museum)

281 Hunter in the forest with a hare at his feet. Open-work carving, painted. Panel from the bench in Ill. 280. Detail. *27 cm.* Nógrád County (Ethnographical Museum)

282 Two deer facing each other under a tree. Open-work carving, painted. Panel from the bench in Ill. 280. Detail. *27 cm.* Nógrád County (Ethnographical Museum)

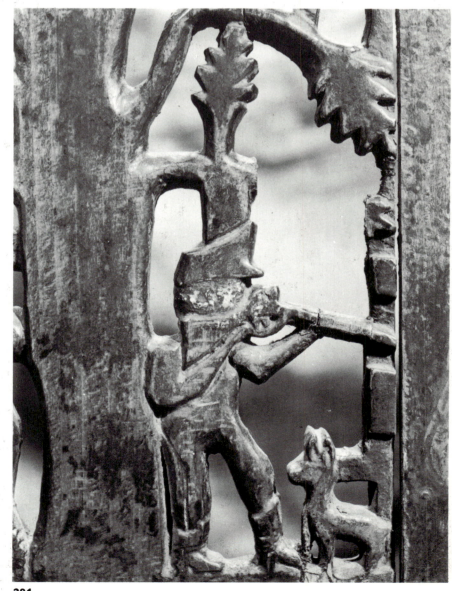

281

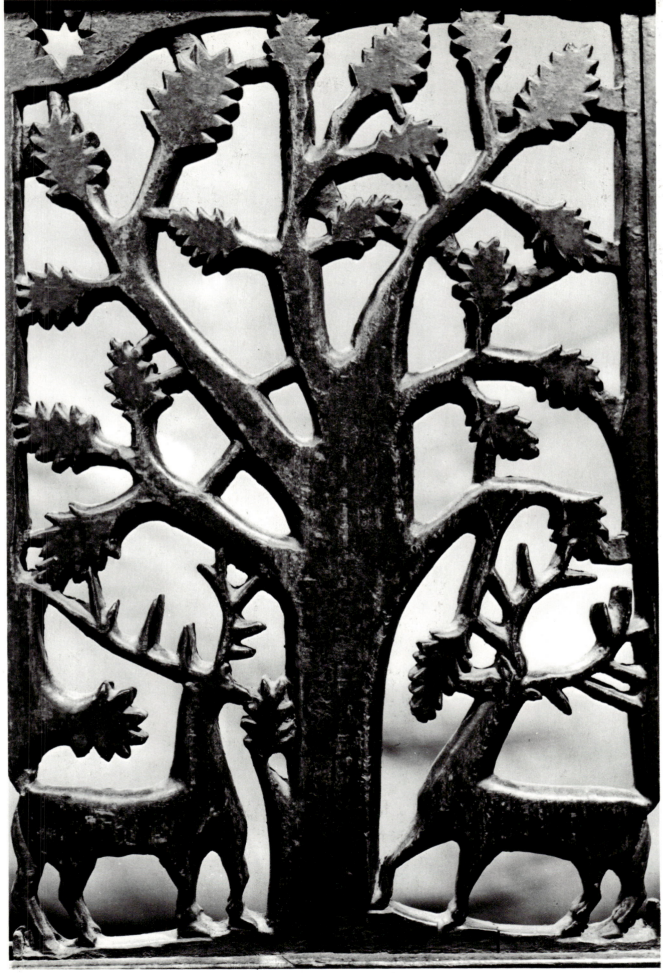

283 Open-work panel of a bench, the first of a series of panels illustrating the story of Christ. The panel is divided into two parts: above, scenes from the life of Christ, below, scenes of daily life (see Ills. 284–286). Above: one of the Three Kings is led by angels towards Bethlehem. Below: peasant ploughing his land. Hardwood. Made by József Pál. *27.8 cm.* Litke, Nógrád County (Palóc Museum, Balassagyarmat)

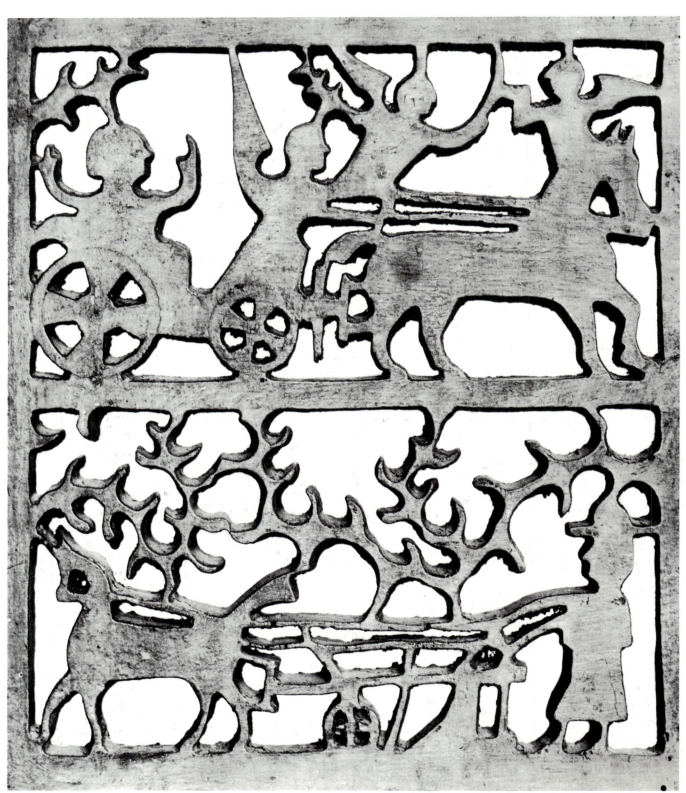

284 The birth of Christ, with the crib surrounded by animals. Below: a baby carriage, and children being fed by a woman at table. Detail of an open-work panel from the bench in Ill. 283. *27.8 cm.* Litke, Nógrád County

(Palóc Museum, Balassagyarmat)

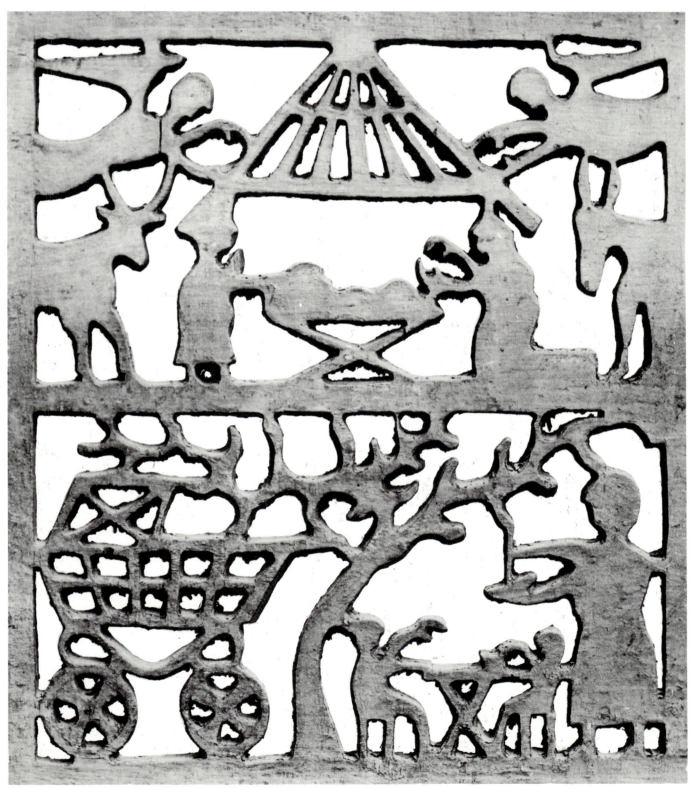

285 Open-work
panel from a bench.
Above: Christ
in the Garden
of Gethsemane
receiving the cup
of sorrows from
an angel. Below:
hunter with shot
deer. (See Ill. 283)
27.8 cm.
Litke,
Nógrád County

(Palóc Museum,
Balassagyarmat)

286 Open-work panel
from a bench. Above:
the Crucifixion.
Below: an auto-
mobile, with a man
running in front.
(See Ill. 283) *27.8 cm.*
Litke,
Nógrád County
(Palóc Museum,
Balassagyarmat)

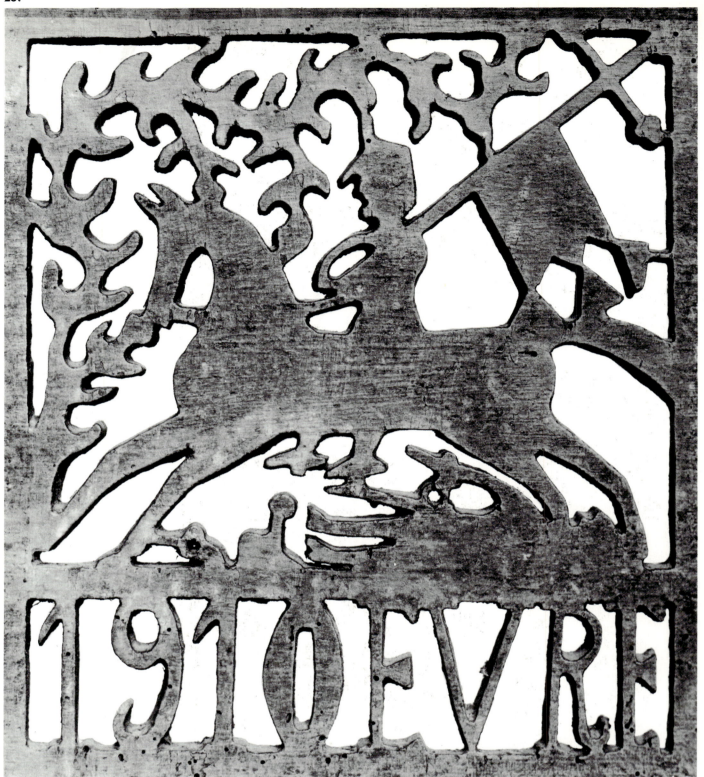

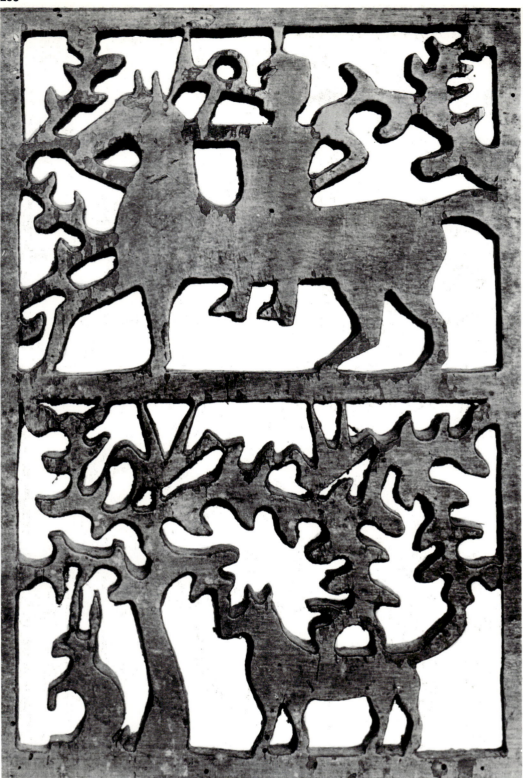

287 Open-work panel from a bench depicting a man on horseback carrying a flag. Softwood frame, with hardwood insert painted brown. Made by József Pál. *26 cm*. Inscription: "FOR THE YEAR 1910." Nógrád County (Palóc Museum, Balassagyarmat)

288 Open-work panel from a bench. Above: a hussar blowing a trumpet. Below: animals in a forest. Softwood frame, with hardwood insert painted brown. (See Ill. 287) *26 cm*. Nógrád County (Palóc Museum, Balassagyarmat)

289 Open-work panel from a bench. Above: hussar charging with drawn sword. Below: men drinking round a lamp-lit table. (See Ill. 287) Nógrád County (Palóc Museum, Balassagyarmat)

290 Above: hussar on horseback with drawn sword attacking an infantry-man armed with a bayonet, a fallen soldier between the two. Below: deer beneath a tree, and men conversing. (See Ill. 287) *26 cm*. Nógrád County (Palóc Museum, Balassagyarmat)

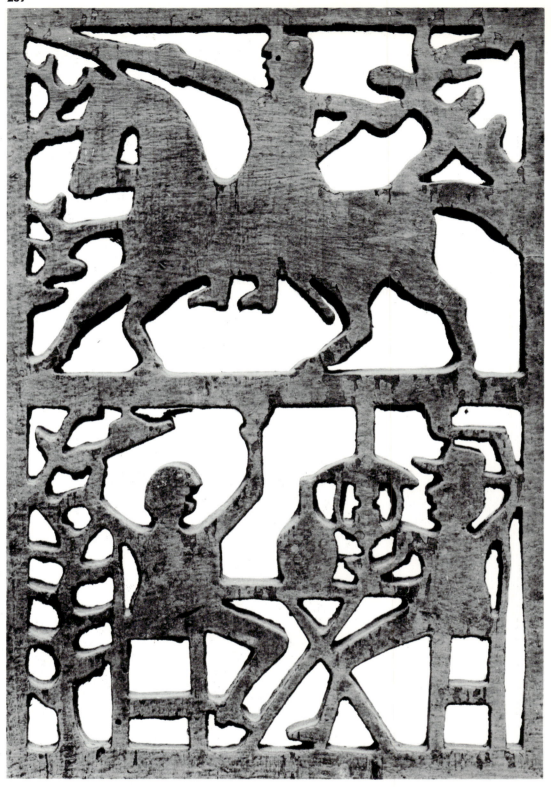

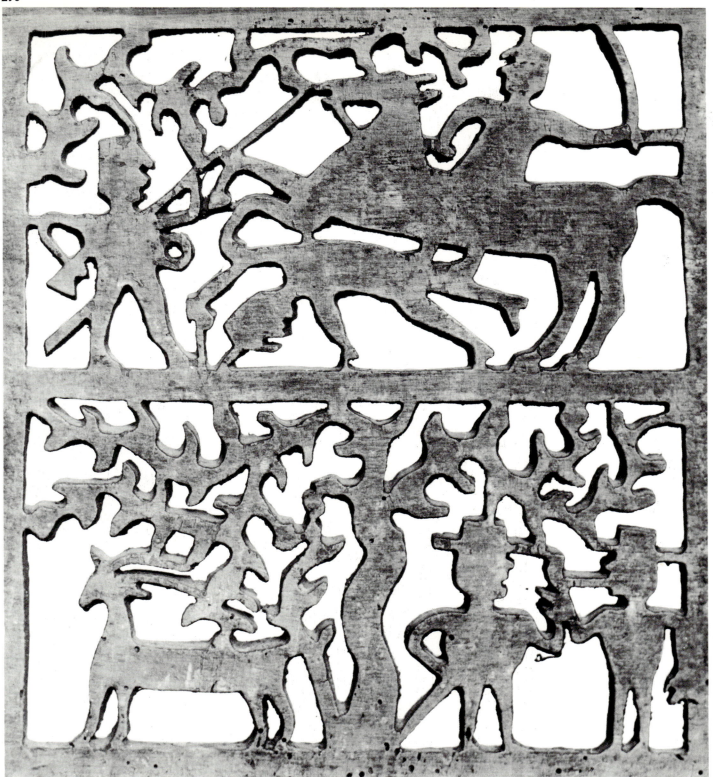

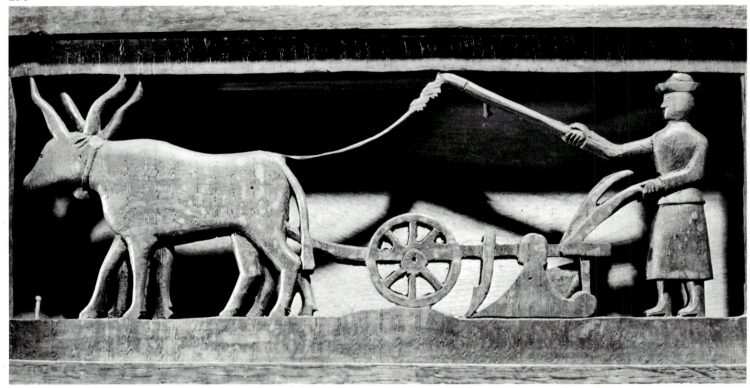

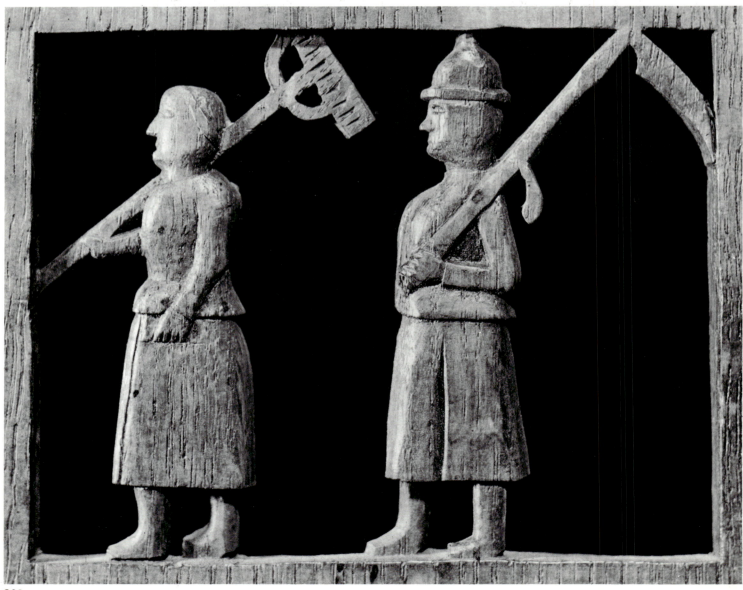

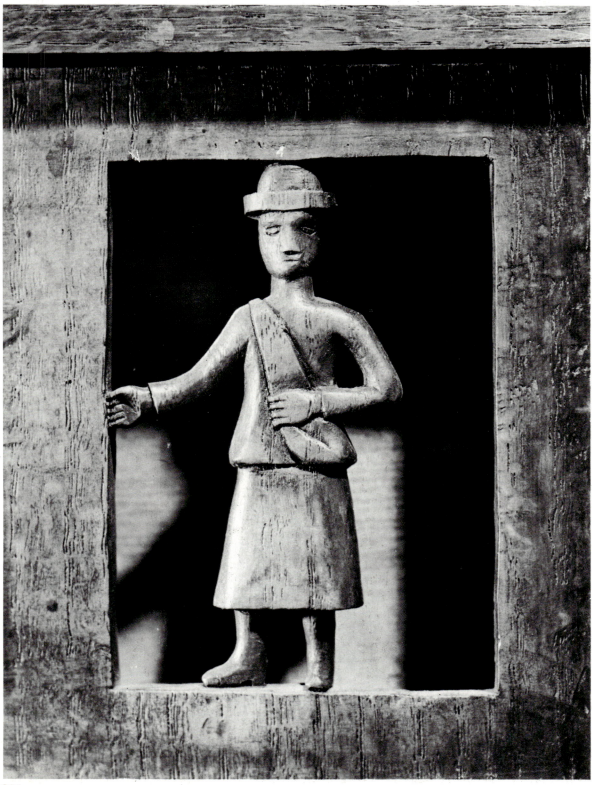

291 Man ploughing with oxen with bells. Open-work panel attached to the side of a hardwood table. Carved by János Bertók. *13.2 cm.* Piliny, Nógrád County (Ethnographical Museum)

292 Man and woman going to work in the fields, the woman carrying a rake on her shoulder, the man a scythe. Open-work panel attached to the side of a hardwood table. Carved by János Bertók. *13.2 cm.* Piliny, Nógrád County (Ethnographical Museum)

293 Man sowing. Open-work panel attached to the side of a hardwood table. Carved by János Bertók. *13.2 cm.* Piliny, Nógrád County (Ethnographical Museum)

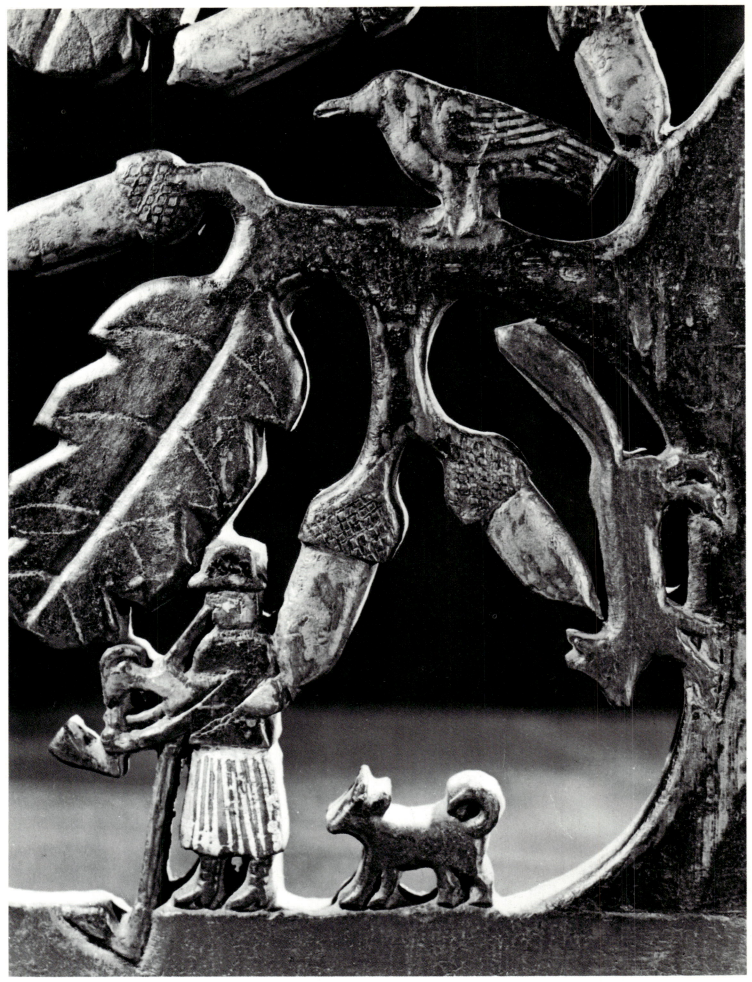

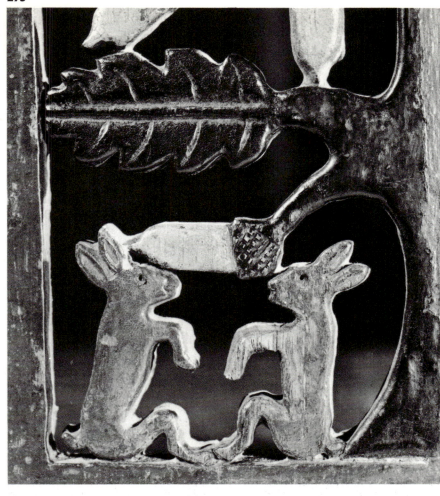

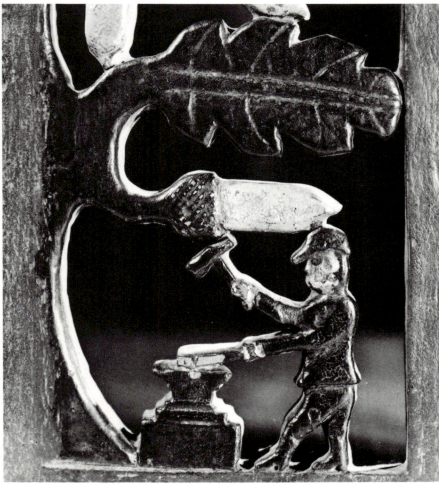

294 Shepherd with a dog and bagpipe under an oak-tree, with a bird and a squirrel in it. Detail of an open-work panel for a bench painted brown, green and buff. *18 cm*. Made by the shepherd Pál Lőrincz in 1902. Karancskeszi, Nógrád County (Ethnographical Museum)

295 Hares under a branch with acorn and leaf. According to the maker: "The two hares stand on their hind-feet, facing each other and discussing how to escape from the hunter." Detail of a panel for a bench. Open-work carving painted dark brown, dark green and buff. Oak. *15.5 cm*. Made by the shepherd Pál Lőrincz in 1902. Karancskeszi, Nógrád County (Ethnographical Museum)

296 Smith beating iron under an oak-tree. Carved open-work panel for a bench painted dark brown, dark green and buff. Oak. *15 cm*. Karancskeszi, Nógrád County (Ethnographical Museum)

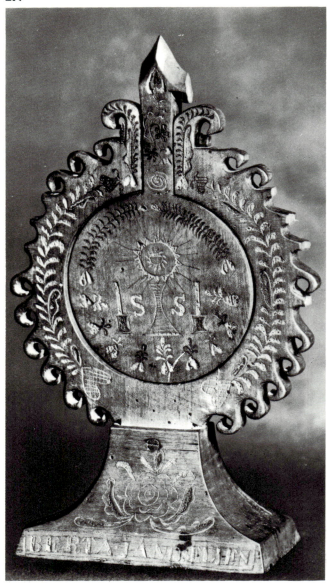

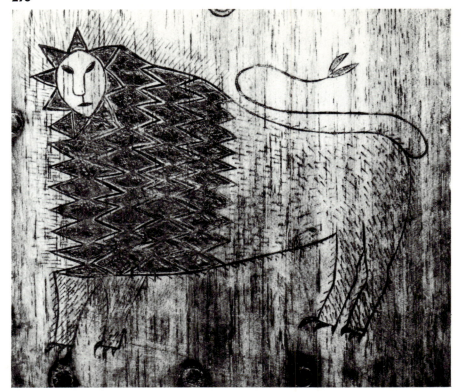

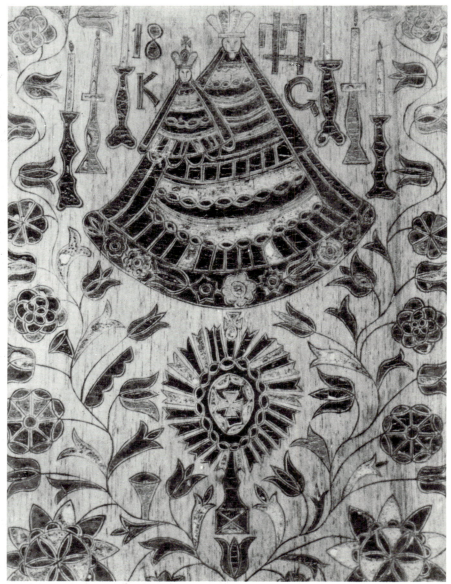

297 A standing mirror with an elaborate gable top, decorated with inlay of red and dark green sealing-wax. Wood from a fruit tree. Inscription: "LONG LIVE JÁNOS BERTA." *27 cm*. Taszár, Somogy County (Rippl-Rónai Museum, Kaposvár)

298 Lion. Detail from the top of the mirror-box in Ill. 299. Wood from a fruit tree, inlaid with sealing-wax in blue, red and yellow. *9 cm*. Vas County (Savaria Museum, Szombathely)

299 Virgin and Child, from the lid of a mirror-box. Inlaid in blue, red, yellow, pink and sky blue. Wood from a fruit tree. *24 cm*. Inscription: "1877 K G." Vas County (Savaria Museum, Szombathely)

300 Virgin and Child, decoration from the top of a standing mirror. Wood from a fruit tree with engraved decoration and sealing-wax inlay in red, green and black. Inscription on the bottom of the mirror frame: "A souvenir from János Nimet to Ana Bolter 1869. Made in Kismarton in 1869." *14 cm*. Kismarton (Eisenstadt, Austria) (Ethnographical Museum)

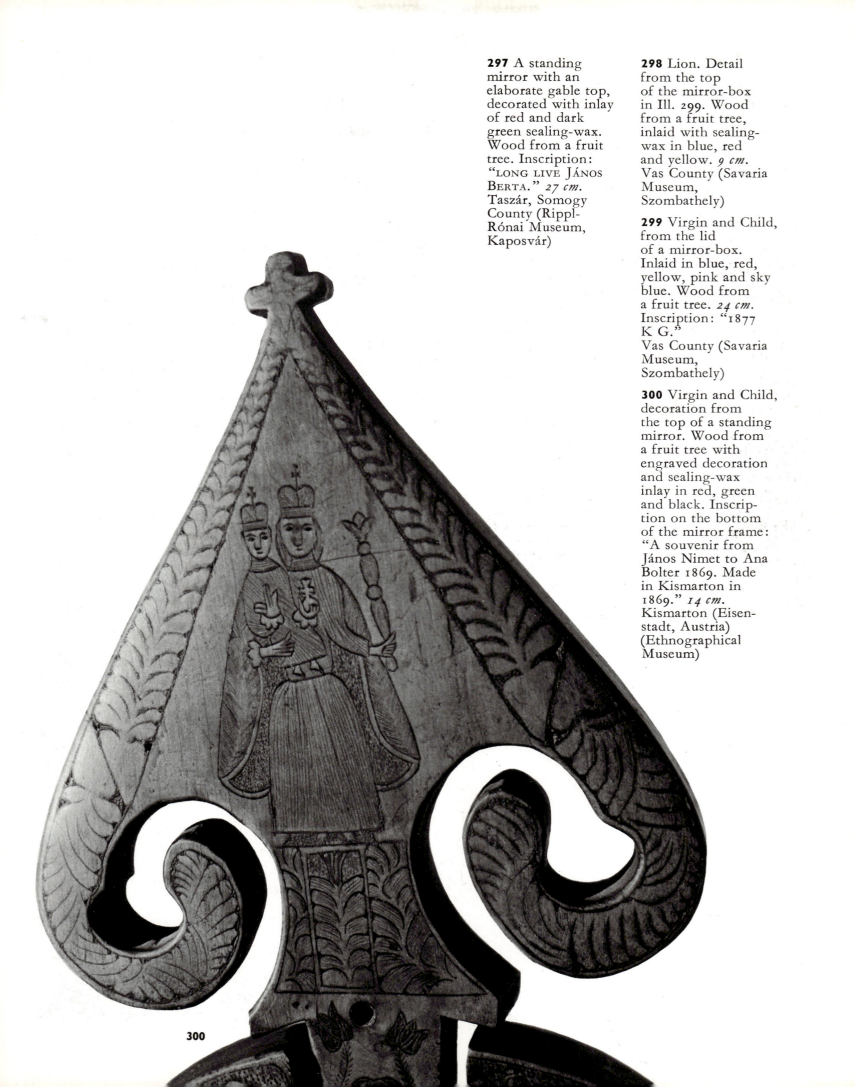

300

301 Young man
and girl holding
a spring of rosemary.
The top of a standing
mirror frame, inlaid
with sealing-wax
in dark and light
red and dark green.
Wood from a fruit
tree. Inscription on
the bottom of the
mirror frame: "1863
Made by István
Torma." *14 cm.*
Nagylózs, Győr-
Sopron County
(Ethnographical
Museum)

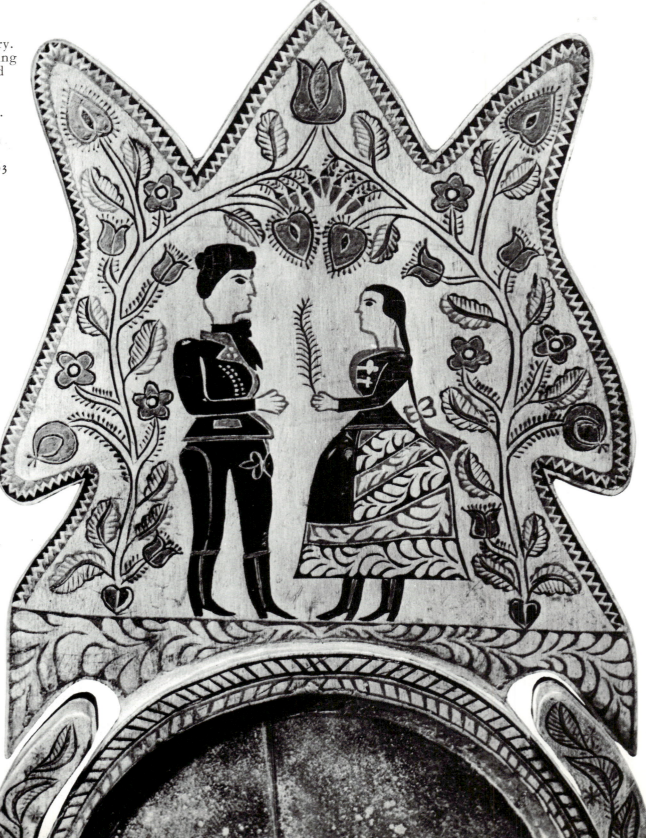

301

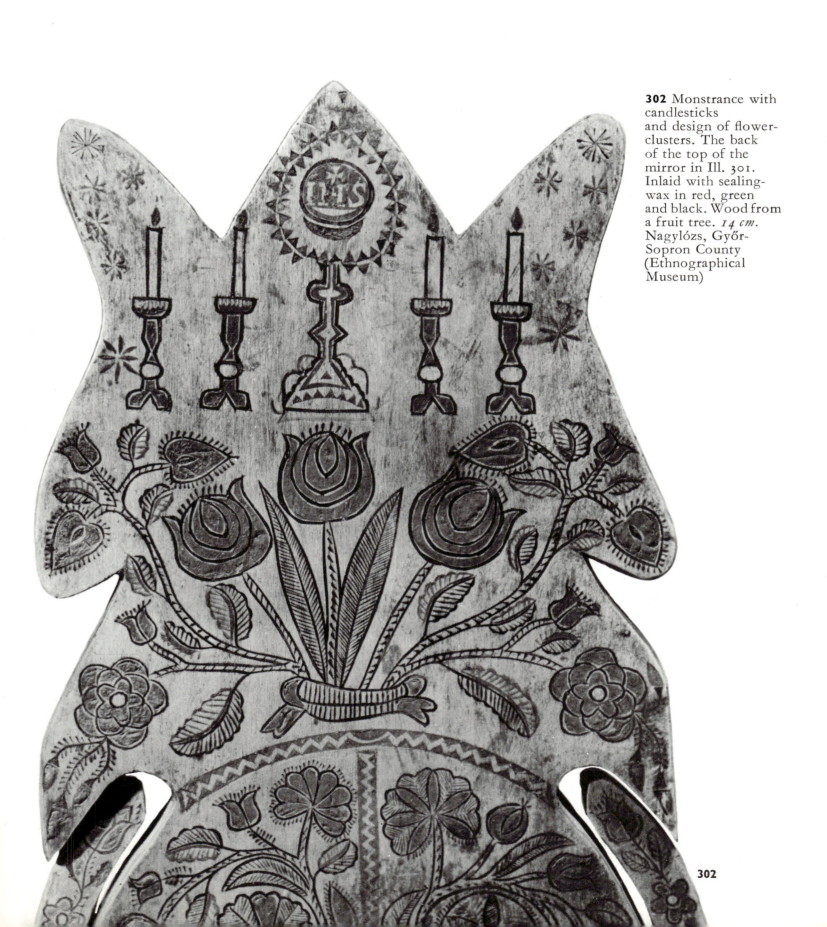

302 Monstrance with
candlesticks
and design of flower-
clusters. The back
of the top of the
mirror in Ill. 301.
Inlaid with sealing-
wax in red, green
and black. Wood from
a fruit tree. *14 cm.*
Nagylózs, Győr-
Sopron County
(Ethnographical
Museum)

302

303 Virgin and Child depicted with heart-shaped crowns between two angels. Detail from a mangling board, inlaid with sealing-wax in red and blue. Wood from a fruit tree. *11 cm*. Inscription: "1872." Western Hungary (Ethnographical Museum)

304 The Virgin with the Infant Christ in her arms, treading on a serpent. A round spice-box with four compartments, inlaid with green, black and red sealing-wax. Wood from a fruit tree. Diameter: *13.8 cm*. Inscription: "1874." Nick, Vas County (Savaria Museum, Szombathely)

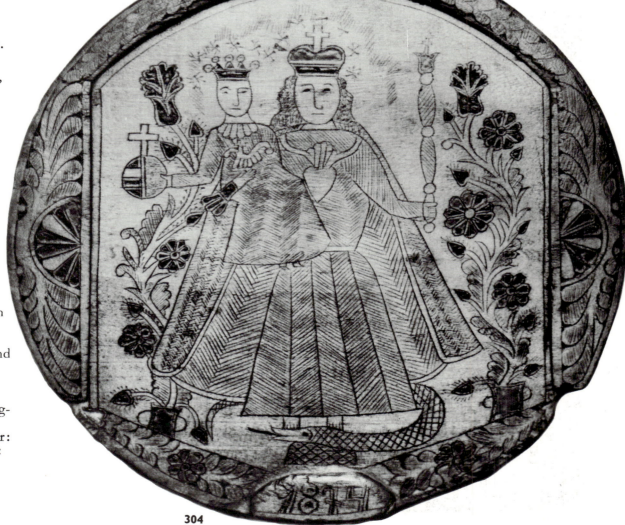

304

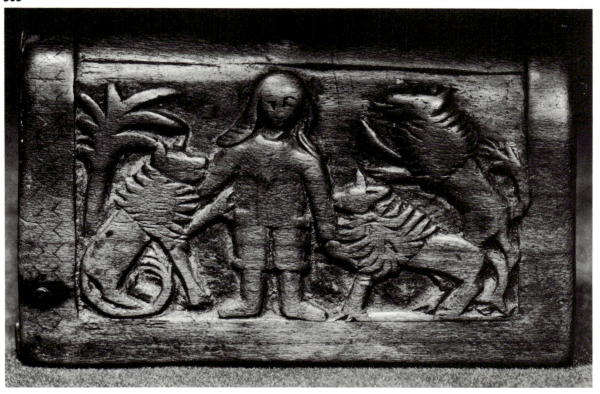

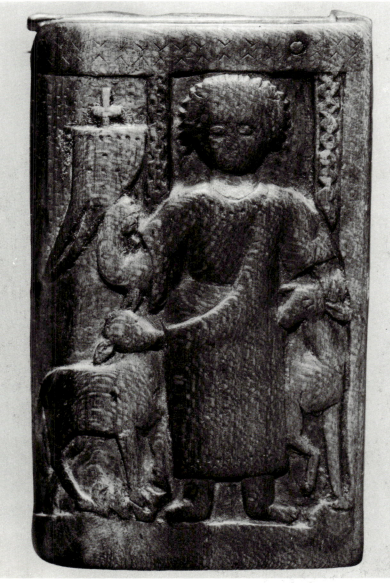

305 Daniel in the
lions' den. Matchbox
carved in relief.
Wood from
a fruit tree. *4.5 cm.*
Made by János
Barna.
Southern Nógrád
County
(Ethnographical
Museum)

306 Jesus the Good
Shepherd. Reverse
side of the matchbox
in Ill. 305. *7.2 cm.*
Southern Nógrád
County.
(Ethnographical
Museum)

307

308

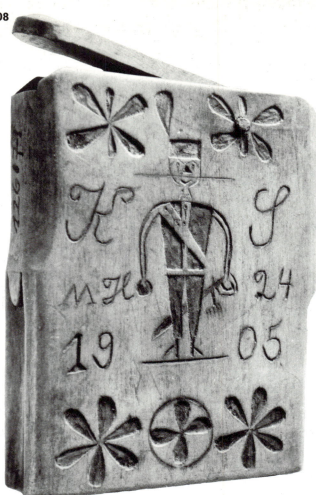

309

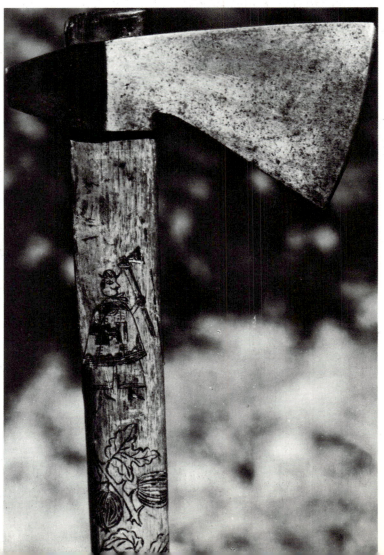

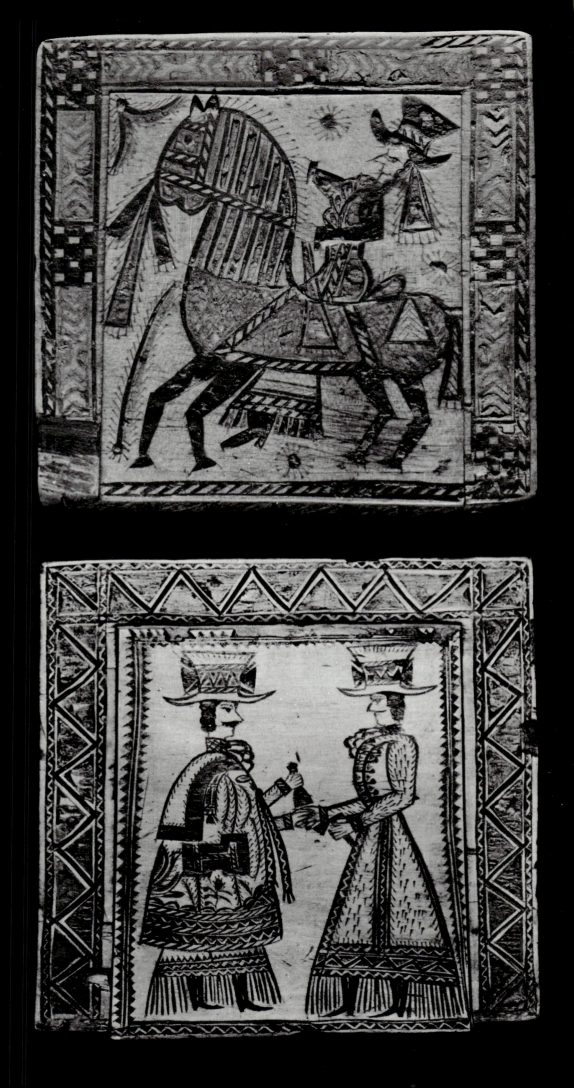

307 Highwayman on horseback pointing his pistol. Detail of a carved mangling board, inlaid with sealing-wax in red and black. Beech. Inscription: "MADE IN 1814 IN October FOR KATI NITRAI." *19 cm.* Zalakoppány, Zala County (Göcsej Museum, Zalaegerszeg)

308 Soldier, engraved, and painted black, on a matchbox. Wood from a fruit tree. *7.5 cm.* Inscription: "K S Month of March 24, 1905." Nagyszalonta (Salonta, Rumania) (Ethnographical Museum)

309 Swineherd in his *szűr* (frieze coat), carrying an axe. Detail from the sealing-wax inlay on the handle of a swineherd's axe. Inscription: "1868." *25 cm.* Zala County (Ethnographical Museum)

310 Highwayman on horseback. Mirror-case. Wood from a fruit tree, inlaid with sealing-wax in black and red. *9.7 cm.* Somogy County (Ethnographical Museum)

311 Herdsmen exchanging gifts. Mirror-case inlaid with sealing-wax in black and red. Wood from a fruit tree. *11 cm.* Vas County (Savaria Museum, Szombathely)

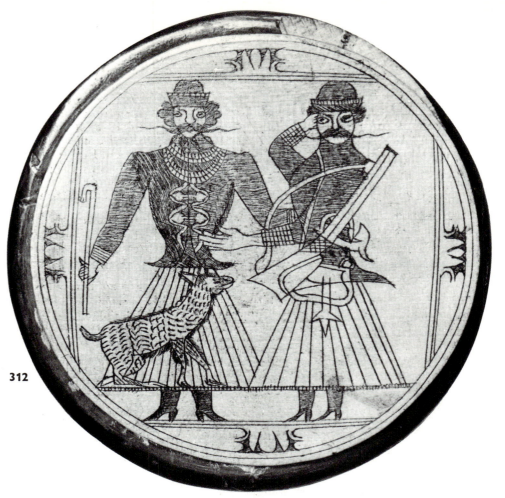

312

312 Shepherd with dog, and highwayman carrying a gun. Engraved decoration on a circular mirror-case. Wood from a fruit tree. *9.4 cm.* Mernye, Somogy County (Ethnographical Museum)

313 Highwaymen shaking hands. Mirror-case inlaid with sealing-wax in black and red. Wood from a fruit tree. *9.2 cm.* Pénzeskút, Veszprém County (Bakony Museum, Veszprém)

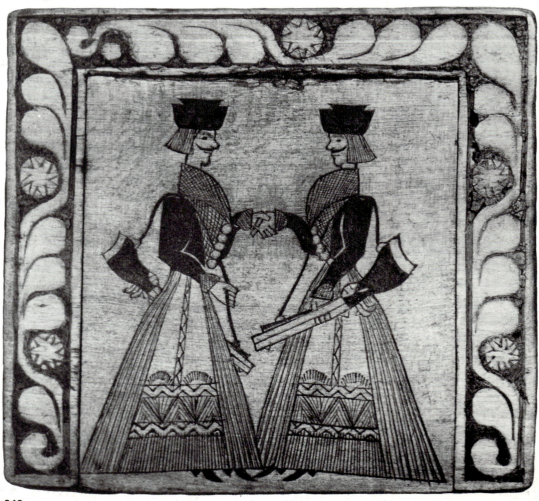

313

314 Circular mirror-
case with
a geometrical pattern.
Inlaid with red
sealing-wax. Wood
from a fruit tree.
Diameter: *10.2 cm*.
Rinyaszentkirály,
Somogy County
(Ethnographical
Museum)

315 Woman, hands
on hips, standing
between two tulips
in a vase.
Mirror-case. Wood
from fruit tree with
sealing-wax inlay.
6.1 cm. Inscription:
"I. J."
Mosdós,
Somogy County
(Rippl-Rónai
Museum, Kaposvár)

314

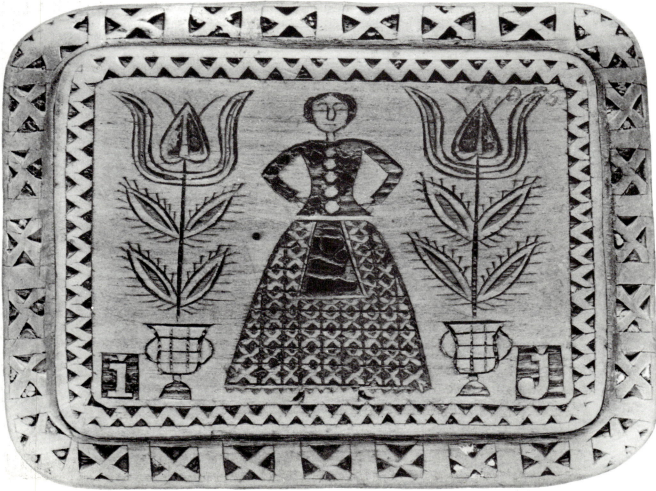

315

316 Woman raising
a bottle of wine
above her head.
Detail of an incised
shuttle with two
figures on each side.
Wood from
a fruit tree. Made
by the herdsman
Mihály Hodó. *8.5 cm*.
Zaláta,
Baranya County
Ethnographical
Museum)

317 Highwayman
raising his cup.
Detail of an incised
shuttle. (See Ill. 316)
8.5 cm.
Zaláta,
Baranya County
(Ethnographical
Museum)

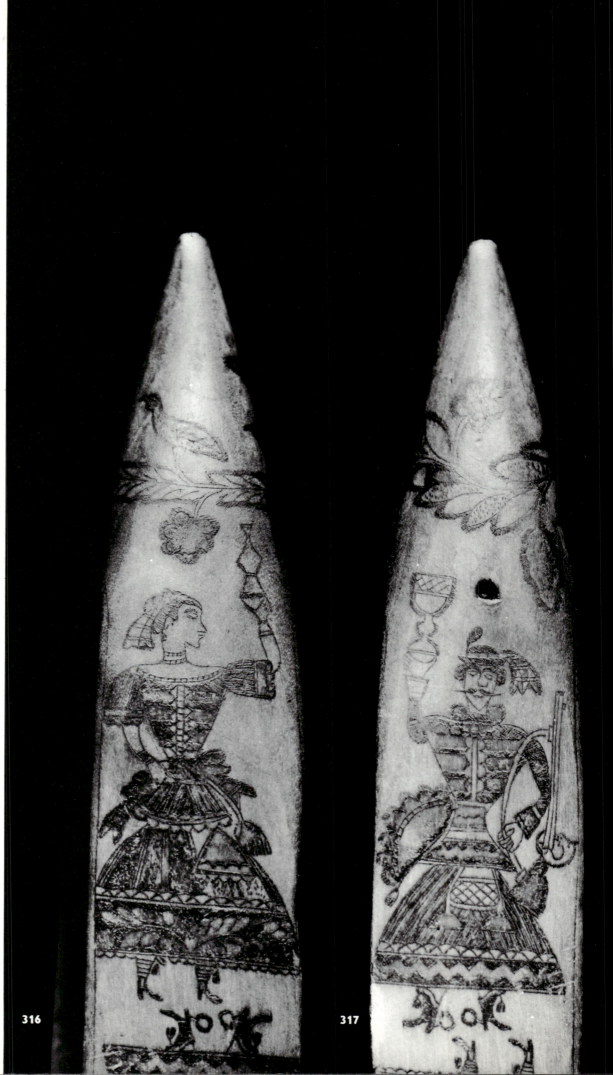

316

317

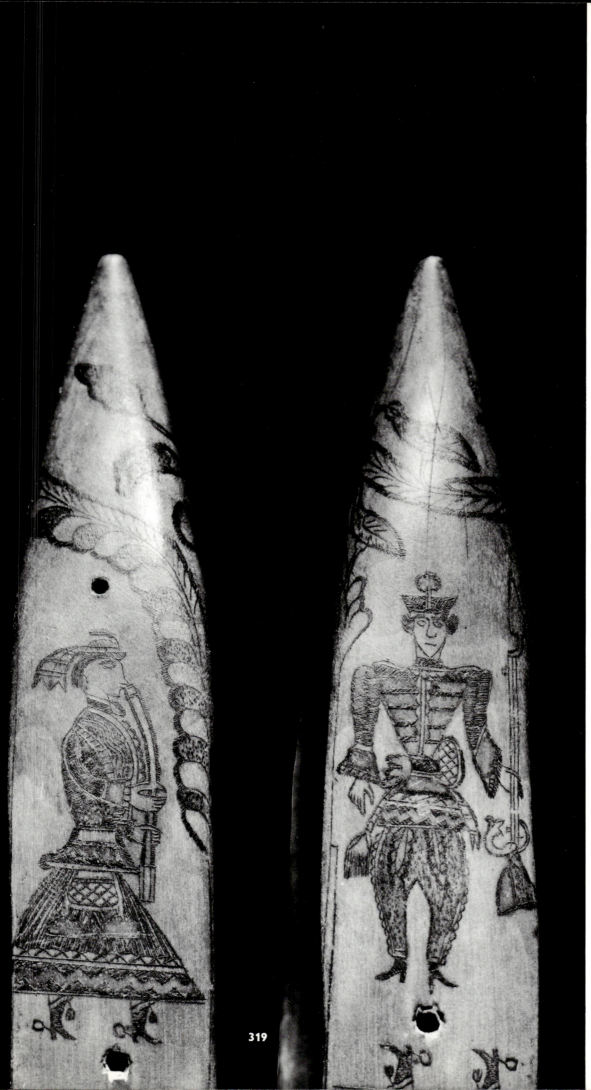

318 Herdsman
playing a long flute.
Detail of a shuttle.
Incised.
(See Ill. 316) *8.5 cm.*
Zaláta,
Baranya County
(Ethnographical
Museum)

319 Soldier at arms.
Detail of a shuttle.
Incised.
(See Ill. 316) *8.5 cm.*
Zaláta,
Baranya County
(Ethnographical
Museum)

318

319

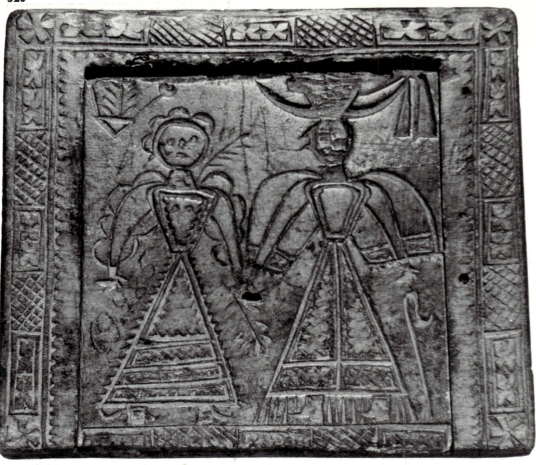

320 Shepherd and his
sweetheart. Mirror-
case. Incised and
originally inlaid with
black and red
sealing-wax which has
since fallen out. Wood
from a fruit tree.
10.5 cm.
Mihályfa,
Zala County
(Ethnographical
Museum)

321 Swineherd in a
cifraszűr (embroidered
frieze coat) shaking
hands with his
sweetheart who is
holding a flower.
The back of
the mirror-case in
Ill. 311. Inlaid with
sealing-wax in black
and red. Wood from
a fruit tree. *11 cm.*
Vas County
(Savaria Museum,
Szombathely)

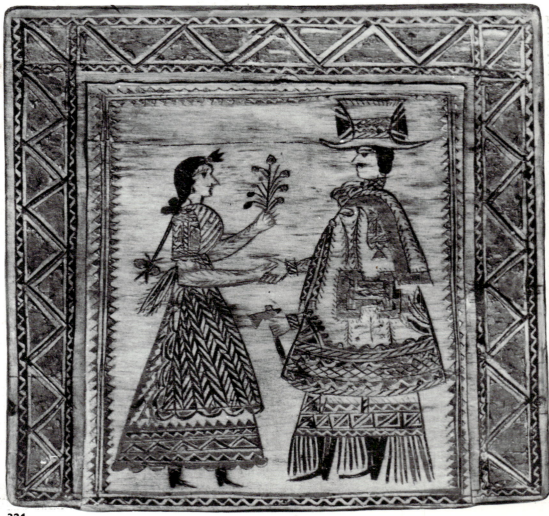

322 A couple drinking. The man is lifting a mug, his *szűr* (frieze coat) thrown over his shoulders, the woman is holding a flower in one hand and a bottle of wine in the other. Mirror-case inlaid with sealing-wax. *10 cm*. Felsőzsid, Zala County (Ethnographical Museum)

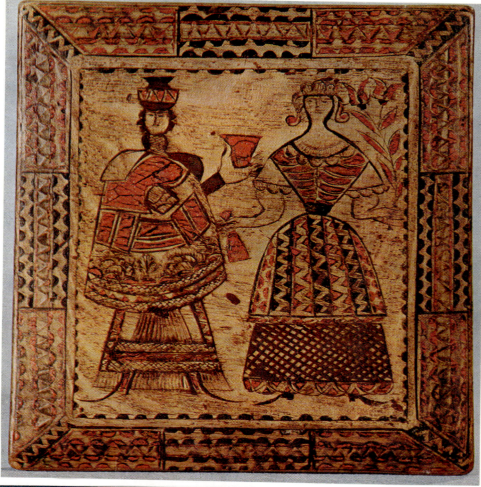

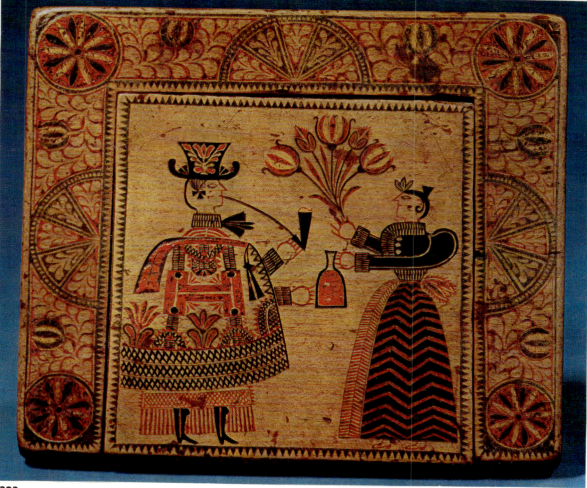

323 Herdsman and his sweetheart. The man is wearing a *cifraszűr* (embroidered frieze coat), a *Sobrikalap* ("Sobri hat"), named after the highwayman, and fringed linen pantaloons. The woman is offering wine with one hand and holding a bunch of flowers in the other. Mirror-case inlaid with sealing-wax. *10.5 cm*. Made by Zsiga Király. Győr-Sopron County (Ethnographical Museum)

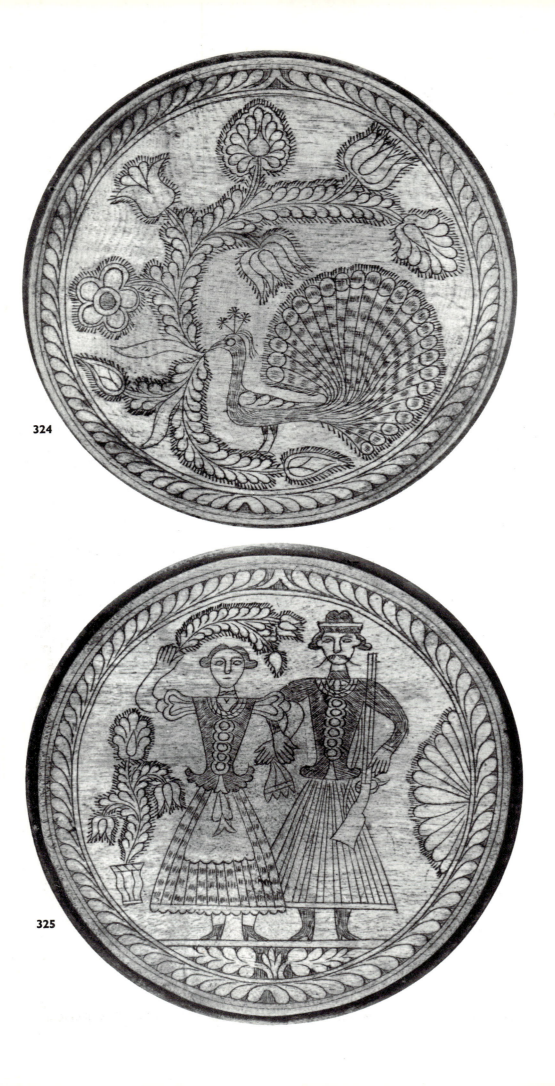

324

325

324 Peacock holding a flowering branch in his beak, incised on a circular mirror-case. Wood from a fruit tree. Diameter: *10.3 cm.* Mernye, Somogy County (Ethnographical Museum)

325 Highwayman and his sweetheart. Reverse side of the mirror-case in Ill. 324. Wood from a fruit tree with incised decoration. Diameter: *10.3 cm.* Mernye, Somogy County (Ethnographical Museum)

326 Drinking couple. The man holds a bottle of wine, the woman flowers and a kerchief. Mirror-case, incised. Wood from a fruit tree, inlaid with sealing-wax. *6.5 cm.* Gyömörő, Zala County (Ethnographical Museum)

327 A couple arm in arm among flowers and birds. Mirror-case, incised and inlaid with sealing-wax. Reverse side of mirror-case in Ill. 326. Wood from a fruit tree. *6.5 cm.* Gyömörő, Zala County (Ethnographical Museum)

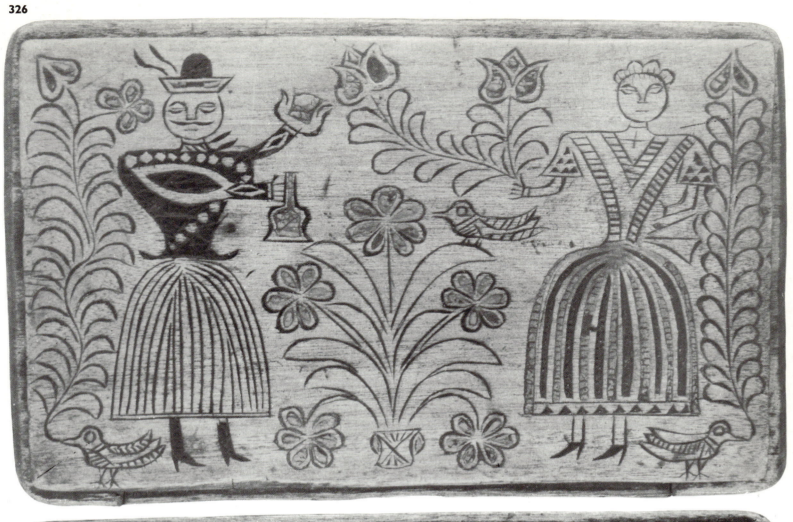

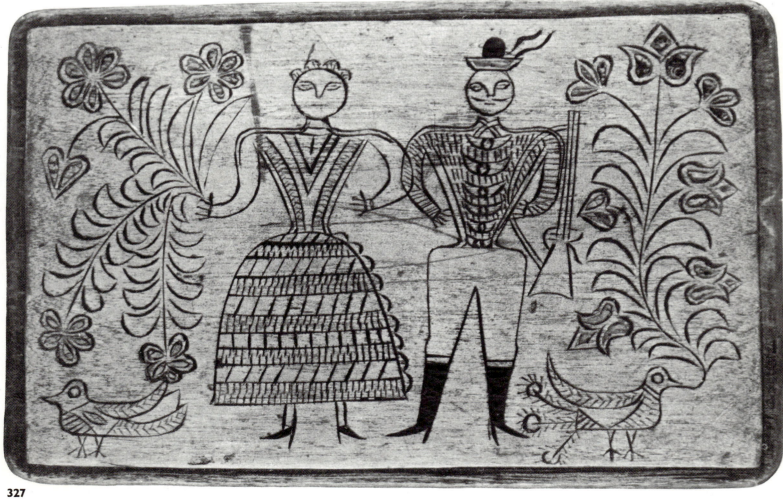

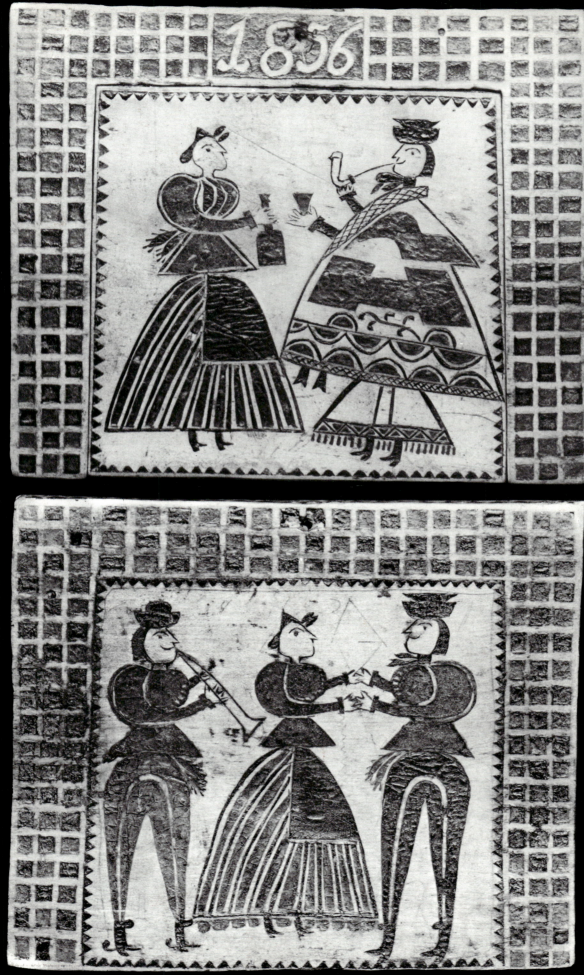

328 Herdsman in a *cifraszűr* (embroidered frieze coat) and his sweetheart. Mirror-case inlaid with sealing-wax in black, dark red and green. Wood from a fruit tree. *11.2 cm.* Inscription: "1856." Vas County (Savaria Museum, Szombathely)

329 Dancing couple with a musician playing the clarinet. Reverse side of the mirror-case in Ill. 328. Inlaid with sealing-wax in black, dark red and green. Wood from a fruit tree. *11.2 cm.* Vas County (Savaria Museum, Szombathely)

330 The shepherd Zsiga Király dancing to the music of a fiddler with his sweetheart, Nani Orbán. Detail of a mangling board inlaid with sealing-wax. *22 cm.* Inscription: "Made by Zsiga Király for Nani Orbán 1839." Ukk, Zala County (Ethnographical Museum)

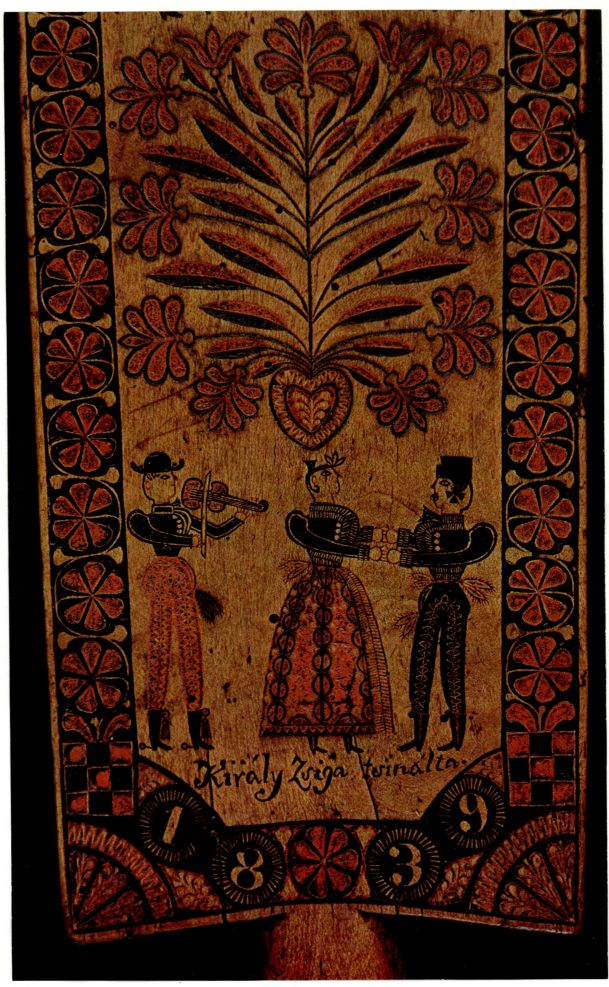

330

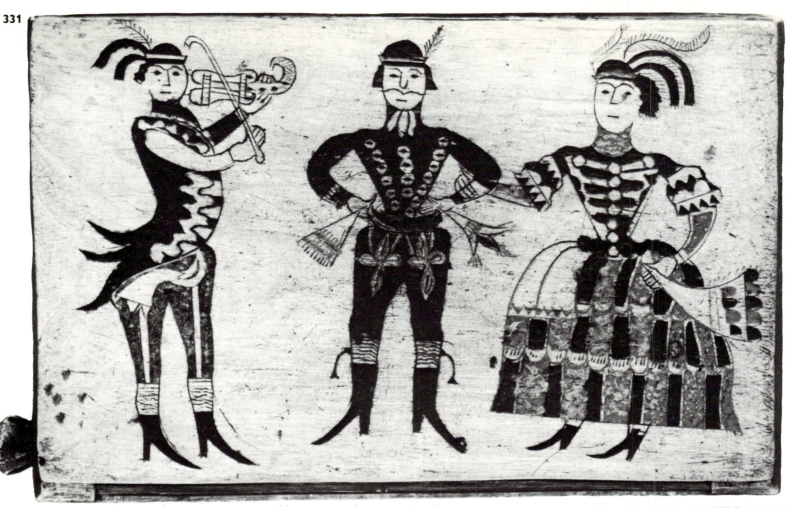

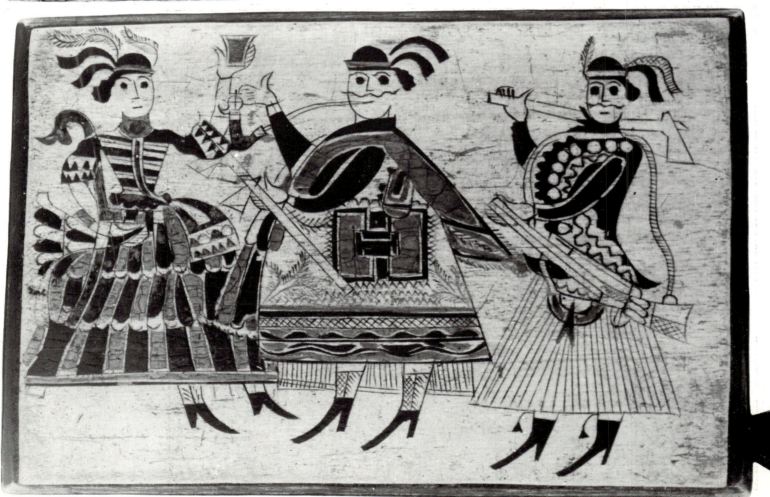

331 Mirror-case decorated with a dancing couple and fiddler. Inlaid with sealing-wax in red, green and black. Wood from a fruit tree. *6.5 cm.* Kisbajom, Somogy County (Ethnographical Museum)

332 Merrymakers: a woman raising her glass of wine, a herdsman with axe and *szűr* (frieze coat), and a highwayman with a gun. Reverse side of the mirror-case in Ill. 331. Inlaid with sealing-wax in red, green, and black. Wood from a fruit tree. *6.5 cm.* Kisbajom, Somogy County (Ethnographical Museum)

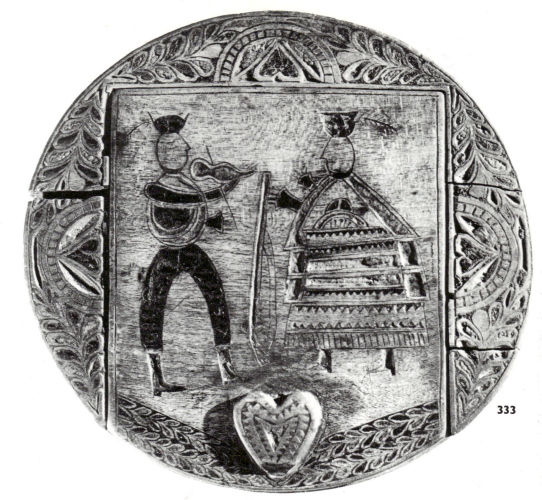

333

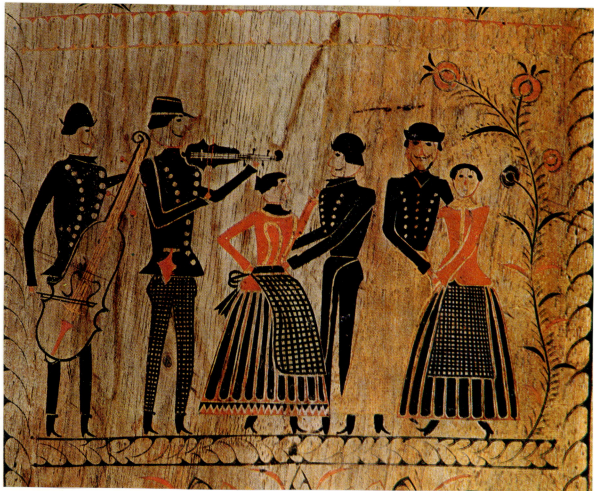

333 Fiddler and highwayman in a *szűr* (frieze coat). Spice-box inlaid with sealing-wax in red, green and black. *11.5 cm* Southern Transdanubia (Déri Museum, Debrecen)

334 Dancing couples and musicians. Detail of upper side of a mangling board inlaid with sealing-wax. *14 cm.* Inscription: "1868." Hövej, Győr-Sopron County (Ethnographical Museum)

334

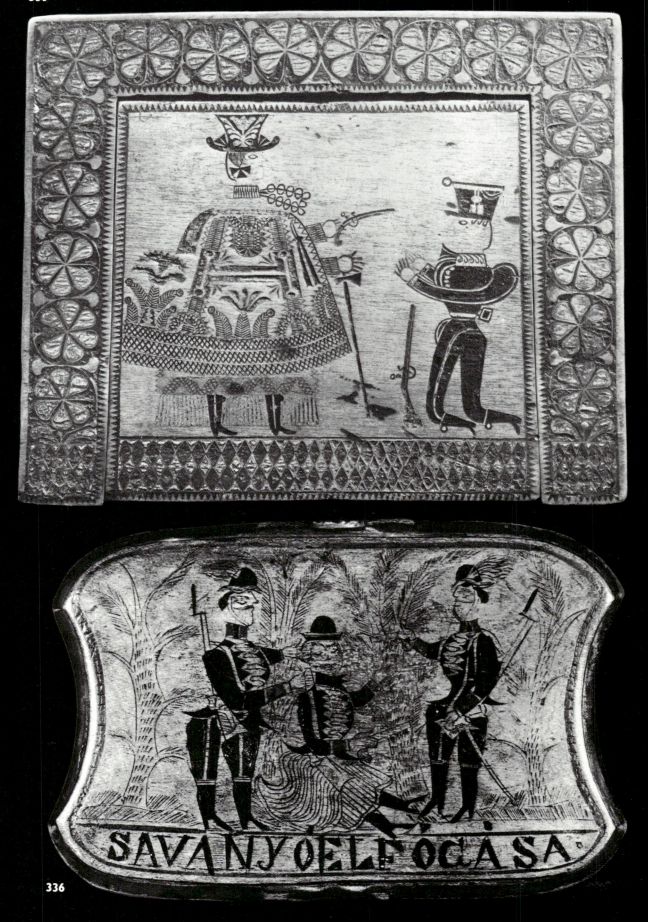

335

336

SAVANYÓ ELFOGÁSA

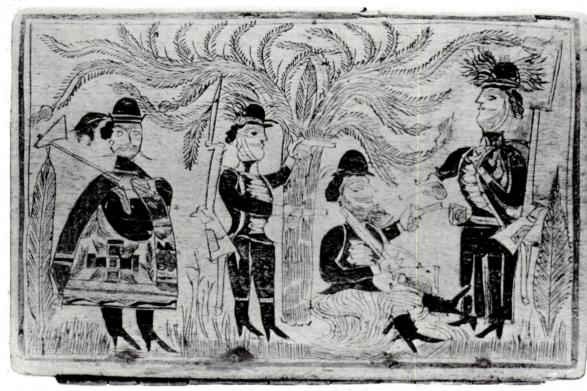

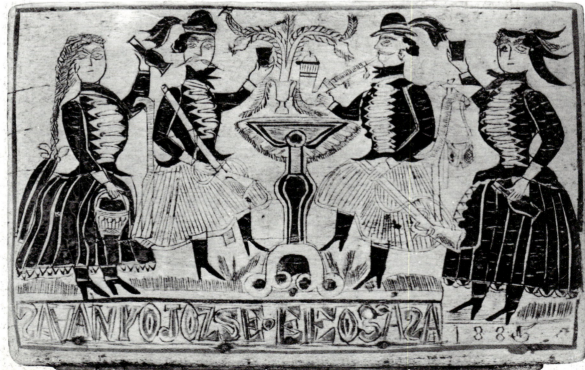

335 A highwayman forcing a gendarme to kneel before him. Mirror-case inlaid with sealing-wax in black, red and yellow. Wood from a fruit tree. Made by Zsiga Király. *11 cm.* Inscription: "1840." Magyargencs, Vas County (Ethnographical Museum)

336 Capture of the highwayman Jóska Savanyú. The highwayman is asleep under a tree, with a gendarme approaching from each side. Mirror-case inlaid with sealing-wax in red, green and black; and coloured incision. Wood from a fruit tree. *7.7 cm.* Inscription: "SAVANYÓ'S ARREST 1868." Nagyatád, Somogy County (Ethnographical Museum)

337 The capture of the highwayman Jóska Savanyú. The same subject as in Ill. 336, here with a man in a *szűr* (frieze coat) carrying an axe, presumably the man who betrayed him. Mirror-case inlaid with sealing-wax in red, green and black. The incision is coloured. Wood from a fruit tree. *8.5 cm.* Nagydobsza, István-major, Somogy County (Rippl-Rónai Museum, Kaposvár)

338 "CAPTURE OF JOZSE SAVANYO 1885." Above the inscription, two couples are drinking. Reverse side of the mirror-case in Ill. 337, inlaid with sealing-wax in red, green and black and with coloured incision. Wood from a fruit tree. *8.5 cm.* Somogy County (Rippl-Rónai Museum, Kaposvár)

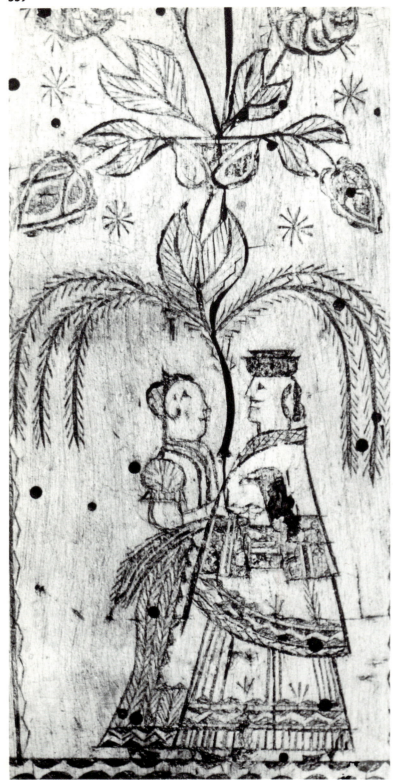

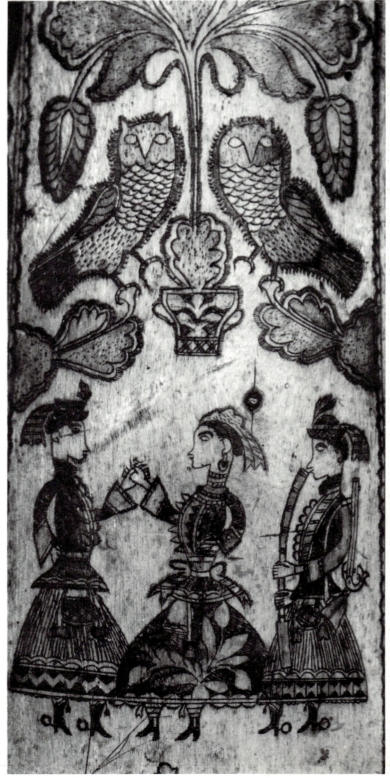

340 Dancing couple and an armed highwayman playing a long flute. Above: two owls on each side of flowers in a pot. Detail of a mangling board with incised and yellowed decoration. Made by Mihály Hodó. *20 cm.* Zaláta, Baranya County (Janus Pannonius Museum, Pécs)

339 Herdsman in a *szűr* (frieze coat) under a willow-tree with his sweetheart. Detail of a mangling board inlaid with sealing-wax. *16 cm.* Vas County (Savaria Museum, Szombathely)

341 Deer in a forest.
Mirror-case carved
in relief.
Varnished wood
from a fruit tree.
4.5 cm.
Veszprém County
(Bakony Museum,
Veszprém)

342 Mermaid and
flowers. Circular
mirror-case inlaid
with sealing-wax.
Diameter: *9.5 cm.*
Csokonya,
Somogy County
(Ethnographical
Museum)

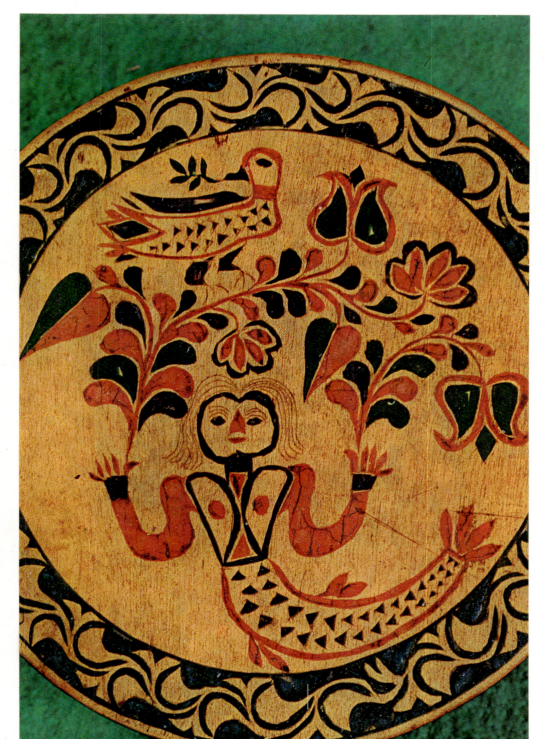

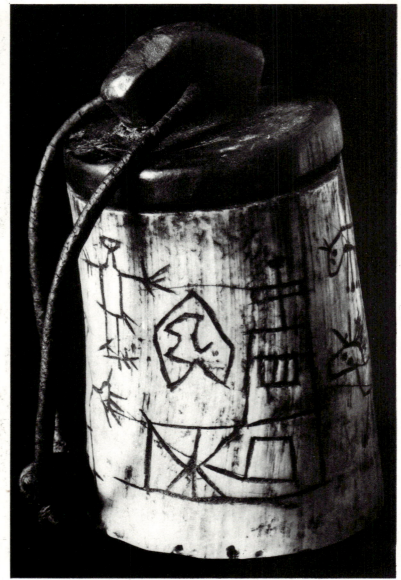
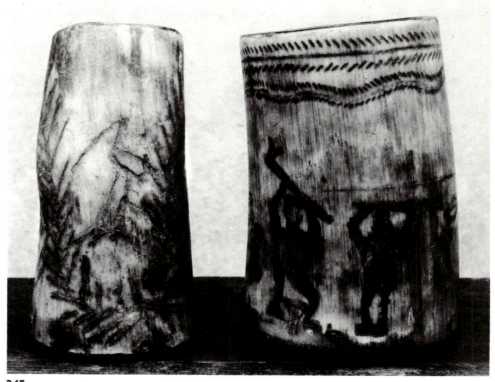

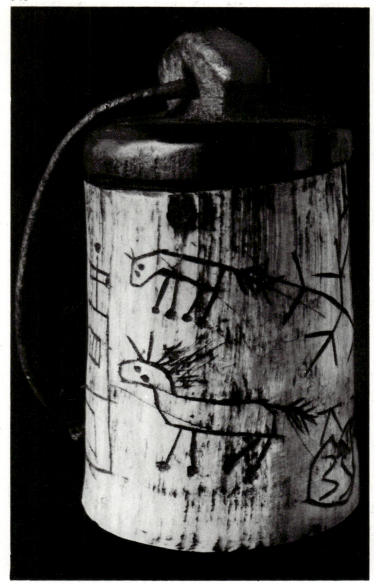

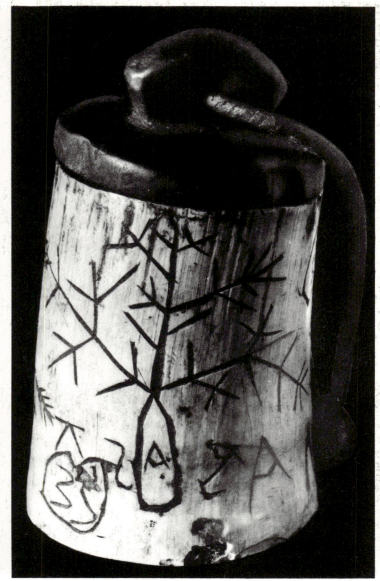

343 Ointment-case
with strap, engraved
with crude human
figures. Horn, with
wooden lid. *10.5 cm.*
Szeged,
Csongrád County
(Ethnographical
Museum)

344 Side of the
ointment-case in Ill.
343, crudely engraved
with a church
and a man. Horn.
10.5 cm.
Szeged,
Csongrád County
(Ethnographical
Museum)

345 Salt-cellar
and ointment-case.
Horn, with engraved
decoration. *9.5 cm*
and *9.5 cm.*
Okány, Békés
County,
and Mezőcsát,
Borsod-Abaúj-
Zemplén County
(Ethnographical
Museum)

346 Side
of the ointment-case
in Ill. 343, crudely
engraved with two
horses. Horn.
10.5 cm.
Szeged,
Csongrád County
(Ethnographical
Museum)

347 Side
of the ointment-case
in Ill. 343, crudely
engraved with
a stylized tree. Horn.
10.5 cm.
Szeged,
Csongrád County
(Ethnographical
Museum)

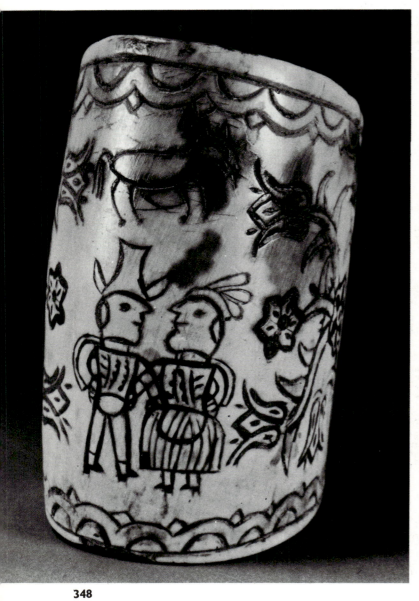

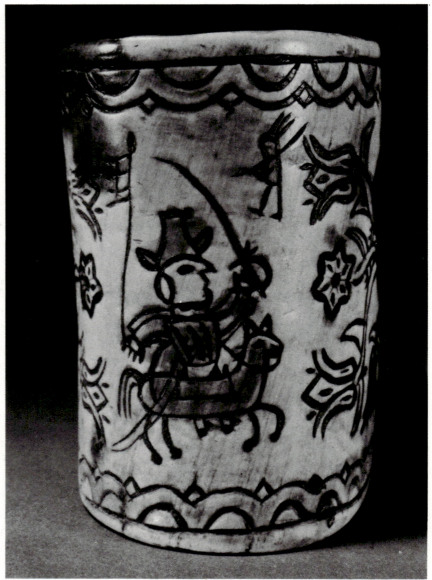

348

349

350 Front of a salt-cellar decorated with two birds facing each other. Horn, with incised decoration. *5.5 cm.* Nagyatád, Somogy County (Ethnographical Museum)

351 Swineherd, his sweetheart and a stork. Side of a salt-cellar inlaid with sealing-wax in red, green and black. Horn. *5.6 cm.* Inscription: "1872." Zaláta, Baranya County (Ethnographical Museum)

348 A man and a woman. Side of a salt-cellar inlaid with sealing-wax in red and green. *7.8 cm.* Vajszló, Baranya County (Ethnographical Museum)

349 Hussar on horseback. Other side of the salt-cellar in Ill. 348. Inlaid with sealing-wax in red and green. Horn. *7 cm.* Vajszló, Baranya County (Ethnographical Museum)

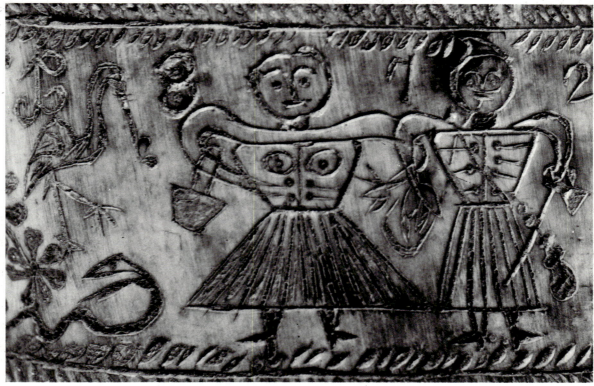

351

352

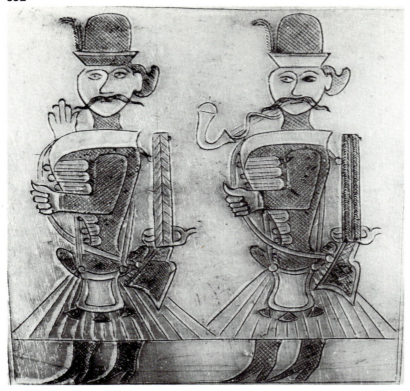

352 Two
highwaymen.
Salt-cellar.
Horn with incised
decoration. *7.4 cm.*
Somogy County
(Ethnographical
Museum)

353 Four armed
highwaymen. Side of
a salt-cellar. Horn
with incised
decoration.
6.9 cm.
Inscription: "1899."
Sellye,
Baranya County
(Ethnographical
Museum)

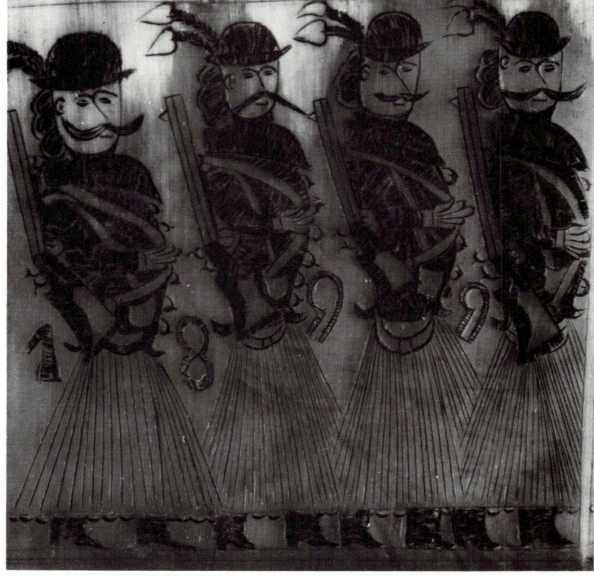

353

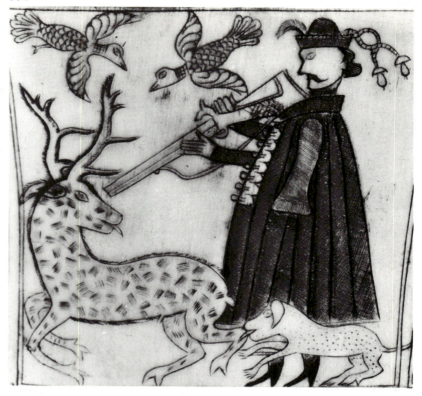

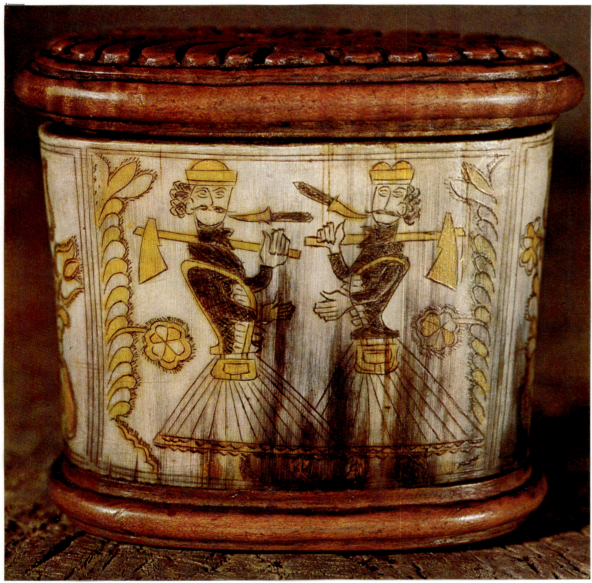

354 Hunter in cloak
aiming his gun
at a deer; above
the deer are birds.
Side of salt-cellar.
Horn with incised
decoration. Detail.
5.5 cm.
Henész,
Somogy County
(Rippl-Rónai
Museum, Kaposvár)

355 Two highwaymen
smoking. Salt-cellar
with incised and
yellowed decoration.
Horn.
5.6 cm.
Barcs,
Somogy County
(Ethnographical
Museum)

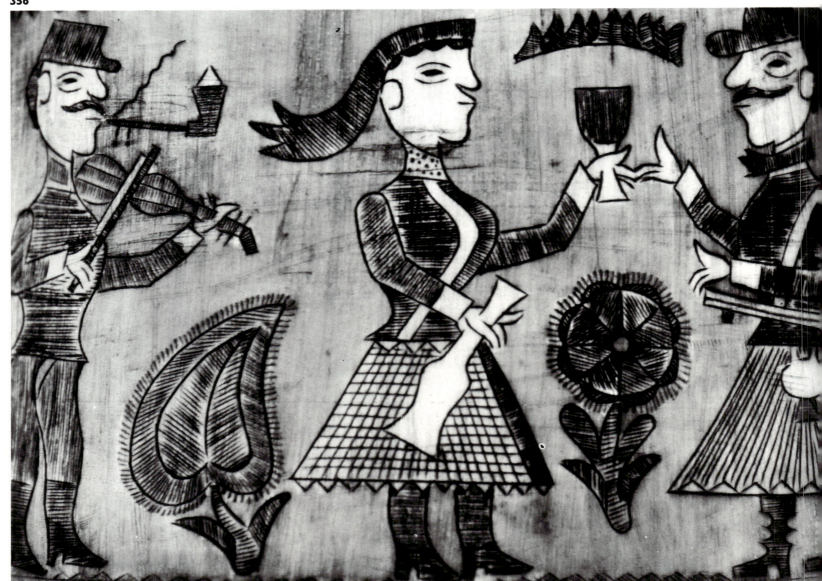

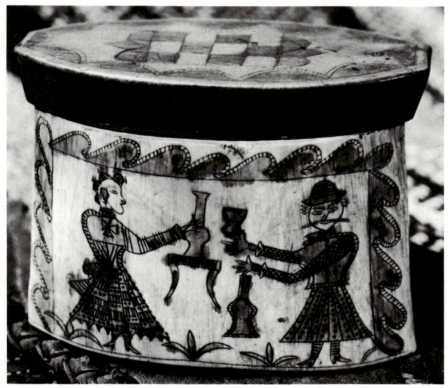

356 Drinking couple with musician. Salt-cellar with red and black incision on a yellow ground. Horn. *6.5 cm.* Inscription: "1893." South Transdanubia (Ethnographical Museum)

357 Merrymakers. Salt-cellar. Horn, with a wooden lid and incised, yellowed decoration. *6.5 cm.* Inscription: "1892." Kemse, Baranya County (Ethnographical Museum)

358 A highwayman and his sweetheart drinking wine, and a bird. Salt-cellar. Horn, inlaid with sealing-wax. Made by the shepherd István Kiss. *5 cm.* Nemespátró, Somogy County (Ethnographical Museum)

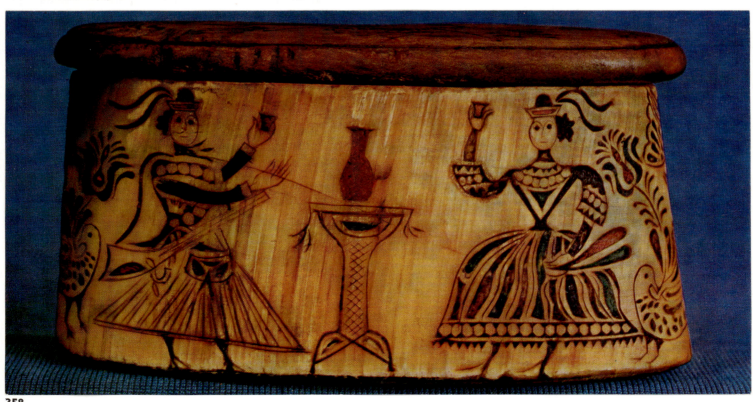

359 Highwayman with a gun and pistol, incised on the side of a salt-cellar. Horn with yellowed decoration. *9 cm.* Inscription: "1850." Somogy County (Ethnographical Museum)

360 Lady with earrings, incised on the side of the salt-cellar in Ill. 359. *9 cm.* Inscription: "1850." Somogy County (Ethnographical Museum)

360

361

359

361 Austrian soldier with gun and sword incised on the salt-cellar in Ill. 359. Horn. *9 cm.* Inscription: "1850." Somogy County (Ethnographical Museum)

362 Woman with a young gentleman and highwayman. Incised detail from a salt-cellar. Horn. *6 cm.* Erdőcsokonya, Somogy County (Ethnographical Museum)

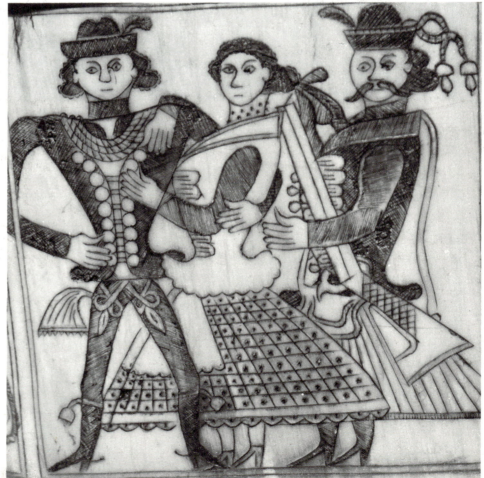

362

363 Herdsman riding
an ass.
Ointment-case
with belt strap, with
incised and yel-
lowed decoration.
9 cm.
Okány,
Békés County
(Ethnographical
Museum)

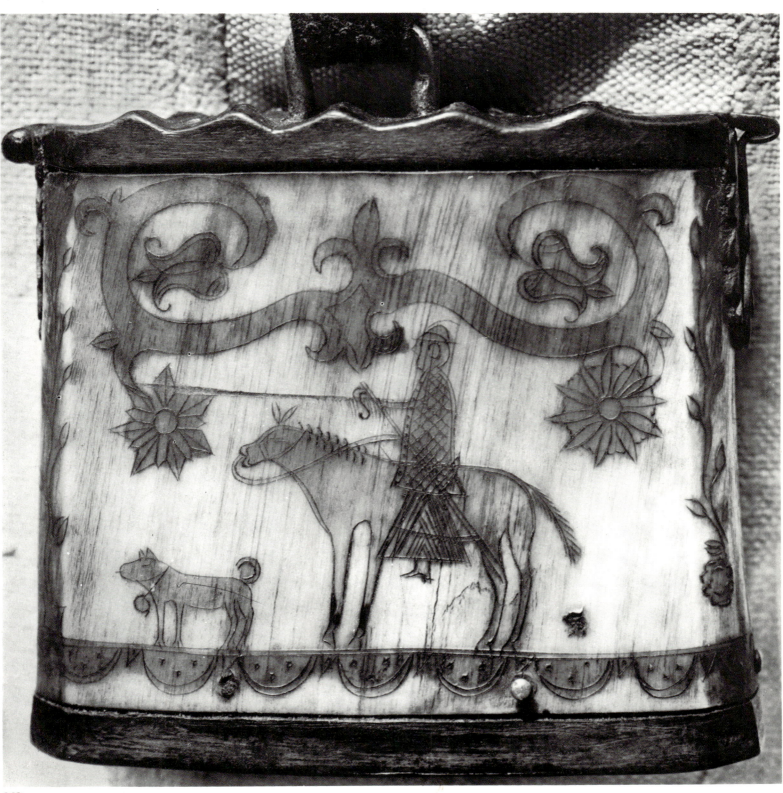

364 Deer under a tree, and birds above. Salt-cellar. Horn incised with yellowed decoration. *12 cm.* Made by the same man as the ointment-cases in Ills. 365 and 366. Hortobágy, Hajdú-Bihar County (Ethnographical Museum)

364

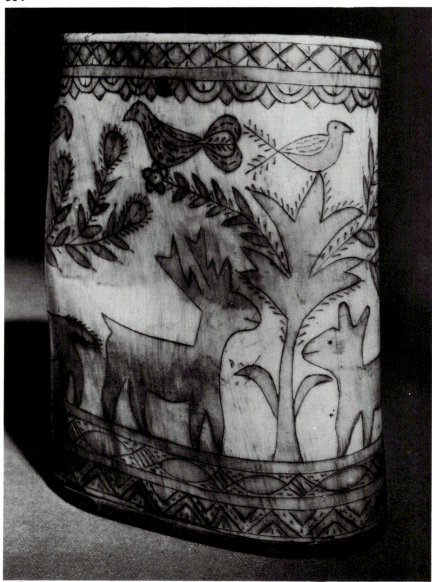

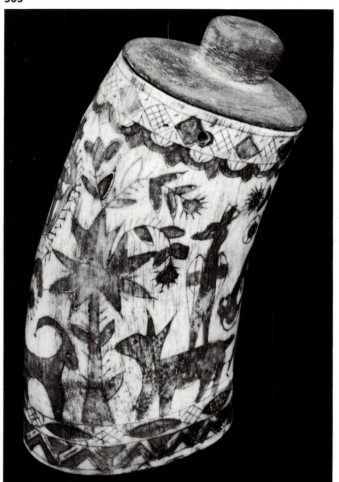

365

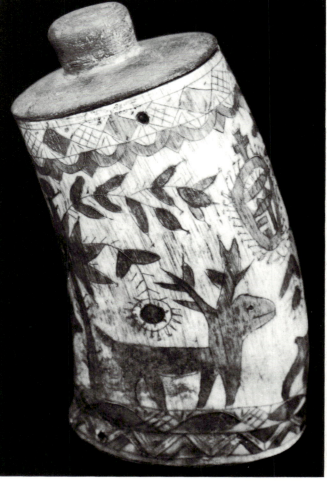

366

365 Fantastic beasts under a tree. Ointment-case with incised decoration. Horn. The decoration is yellowed with nitric acid. *9.5 cm.* Tiszavasvári, Szabolcs-Szatmár County (Local Museum, Tiszavasvári)

366 Other side of the ointment-case shown in Ill. 365. Incised with deer and the Hungarian coat of arms. The decoration is yellowed with nitric acid. Horn, with wooden stopper. *9.5 cm.* Büdszentmihály

(Tiszavasvári), Szabolcs-Szatmár County (Local Museum, Tiszavasvári)

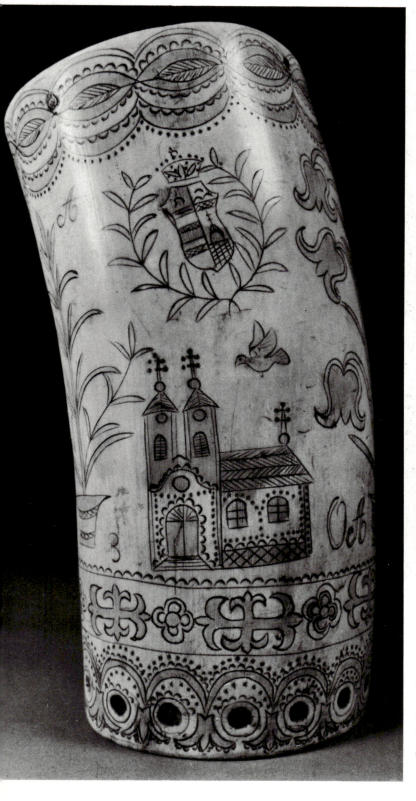

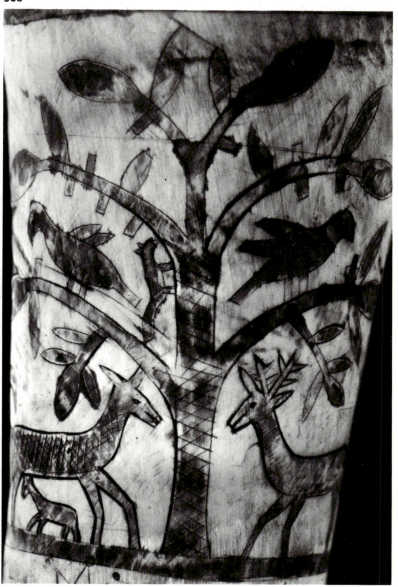

367 Ointment-case
incised with
a church with two
steeples and the
Hungarian
coat of arms
encircled by a garland.
Yellowed decoration.
Horn. *13.8 cm*.
Inscription: "1898."
Zemplén County
(Ethnographical
Museum)

368 Shepherd's horn
incised with deer,
squirrel and birds.
Detail. Yellowed
decoration. Made
by Pál Gyurkó.
Horn. *12 cm*.
Inscription: "1899
GY P."
Nógrád County
(Ethnographical
Museum)

369 Salt-cellars in the shape of rams. Horn, with wooden lids. Inlaid with red and black sealing-wax. *9.8 cm.* Mernye, Somogy County, *10.4 cm.* Somogy County (Ethnographical Museum)

370 Self-portrait of the shepherd Antal Kapoli, with his bride, incised on a salt-cellar. Horn, with yellowed decoration. *6 cm.* Inscription: "1897." Homokszentgyörgy, Somogy County (Ethnographical Museum)

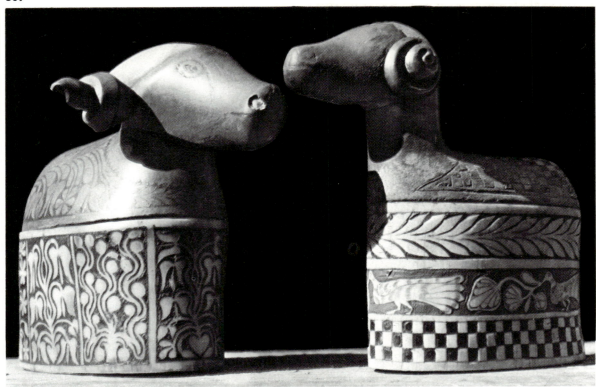

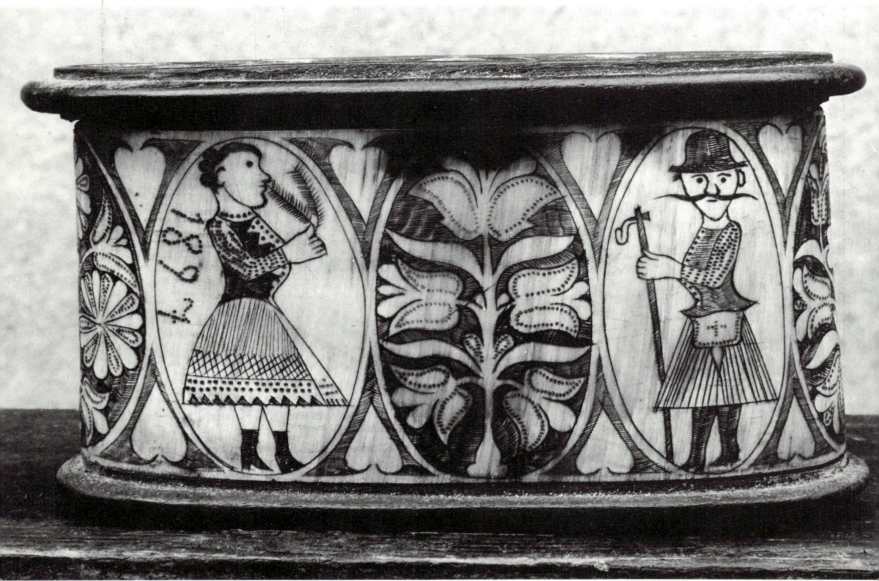

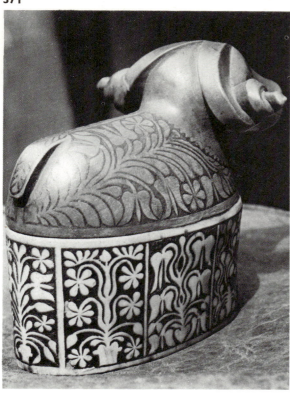

371 Salt-cellar
in the shape of a ram.
The back of the first
salt-cellar in Ill. 369.
9.8 cm.
Inscription: "1872."
Mernye,
Somogy County
(Ethnographical
Museum)

372 Salt-cellar
decorated with
flowering branches
in a pot. Horn, with
wooden lid, inlaid
with sealing-wax.
8.6 cm. Inscription:
"1870."
Somogy County
(Ethnographical
Museum)

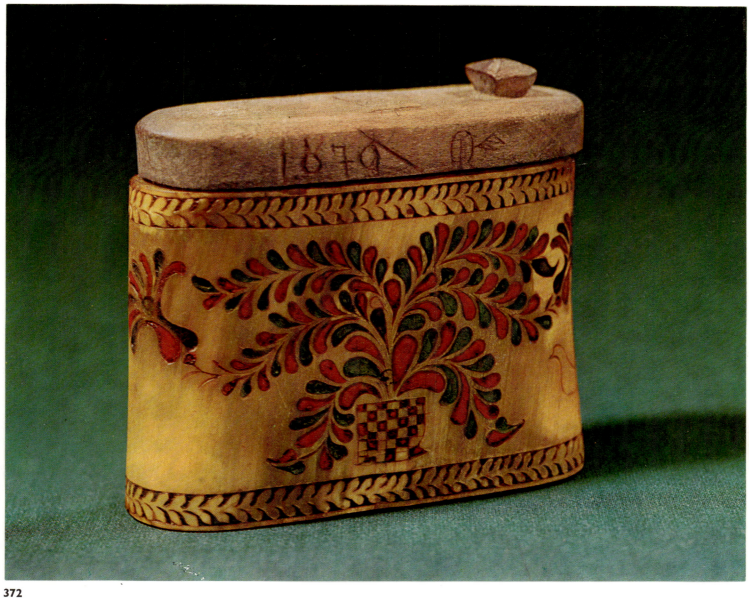

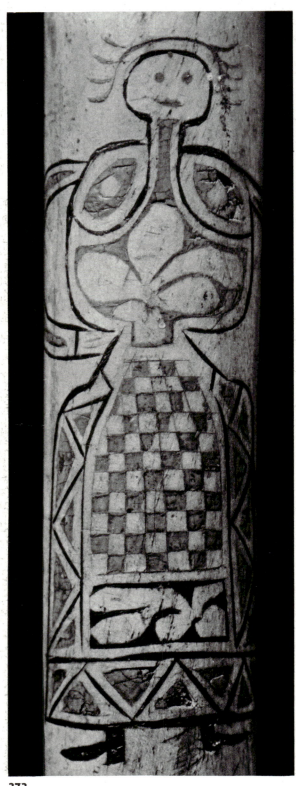

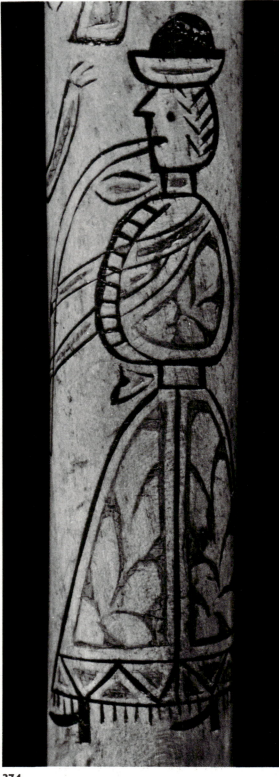

373 Woman carved
on the staff
of a shepherd's
crook. Detail. Wood
from a fruit tree
inlaid with red and
green sealing-wax.
7.5 cm.
Zala County
(Ethnographical
Museum)

374 Man playing
a long flute, carved
on the staff of the
shepherd's crook in
Ill. 373. Wood
from a fruit tree
inlaid with red
and green sealing-
wax. *7.5 cm.*
Zala County
(Ethnographical
Museum)

375 Highwayman
with a gun. Bottom
of a razor-case. Wood
from a fruit tree inlaid
with red sealing-
wax. *16.5 cm.*
Ormánság region,
Baranya County
(Ethnographical
Museum)

373 374

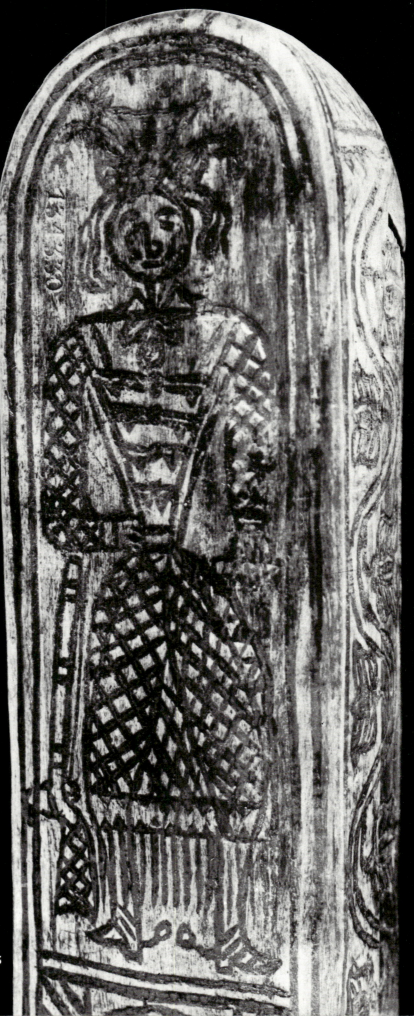

375

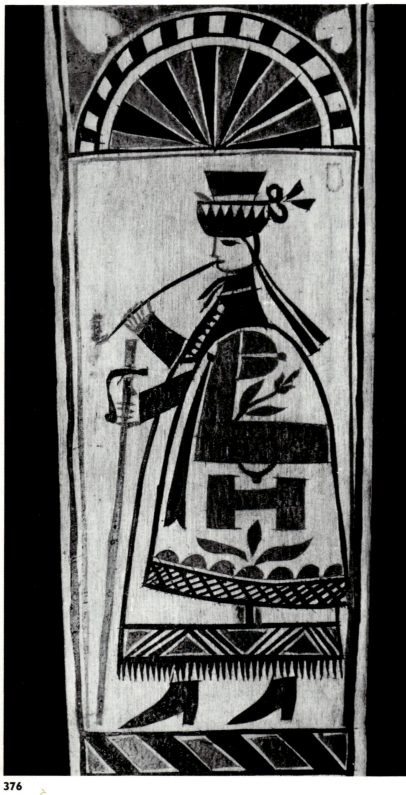

376

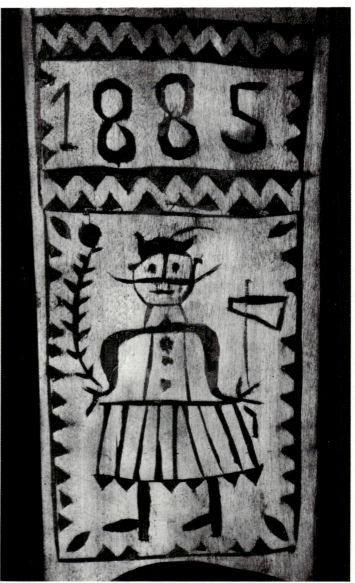

377

376 Shepherd smoking in his *cifraszűr* (embroidered frieze coat). Detail of a razor-case. Wood from a fruit tree inlaid with sealing-wax in red and black. *14.5 cm*. Inscription: "1842." Bakonybél, Veszprém County (Bakony Museum, Veszprém)

377 Swineherd with axe. Detail of a razor-case. Wood from a fruit tree inlaid with sealing-wax in red, blue and brown. *11.5 cm*. Inscription: "Souvenir 1885 Ferenc Kiss." Mike, Somogy County (Balaton Museum, Keszthely)

378 Highwayman and flowers. Hardwood razor-case inlaid with sealing-wax. *23 cm*. Inscription: "1843 F J." Sárosd, Zala County (Ethnographical Museum)

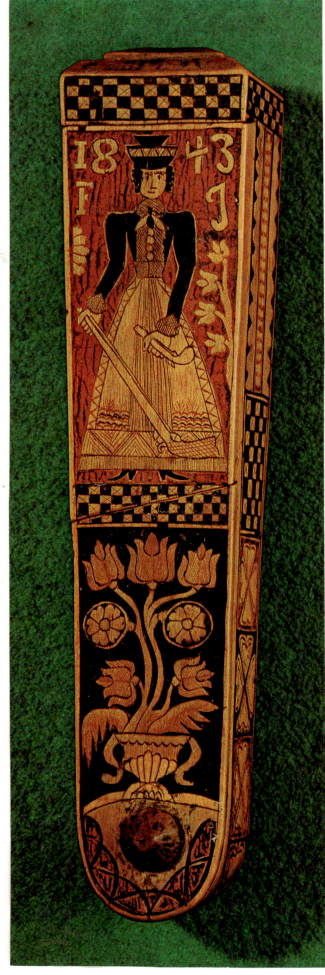

378

379

380

379 Young wild boar holding an acorn in its mouth. Detail from side of a razor-case. Wood from a fruit tree, with incised decoration. *1.7 cm*. Made by Mihály Hodó.
Baranya County (Ethnographical Museum)

380 A piglet with an acorn in its mouth. Detail. Side of the incised razor-case in Ill. 379. Wood from a fruit tree. *1.7 cm*. Made by Mihály Hodó.
Baranya County (Ethnographical Museum)

381 Stag. Detail. Back of the incised razor-case in Ills. 379–380. Wood from a fruit tree. *7 cm*. Made by Mihály Hodó.
Baranya County (Ethnographical Museum)

381

382

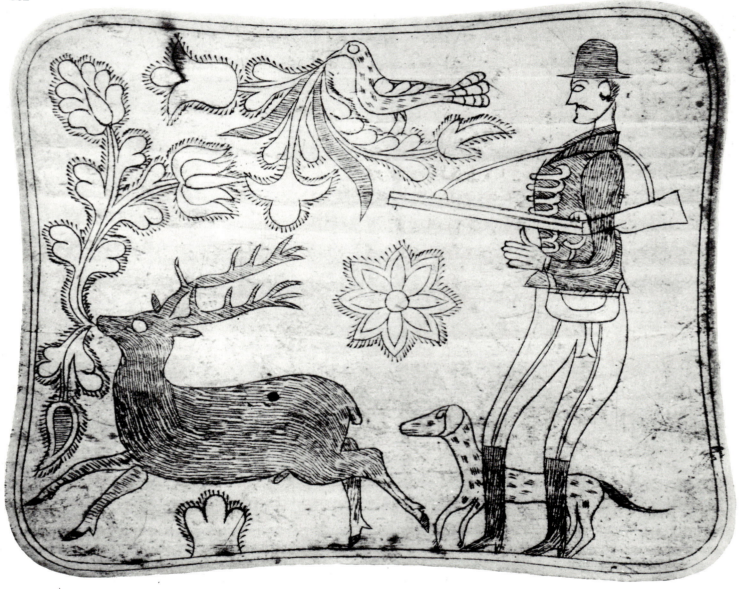

382 Mirror-case
engraved with
a hunter and a dog
chasing a stag; above
them, a bird carrying
a flowering branch
in its beak. The stag
also holds a flowering
branch in its mouth.
Wood from a fruit
tree. *8 cm.*
Transdanubia
(Ethnographical
Museum)

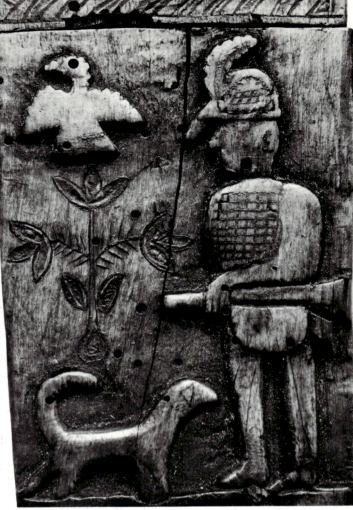

384

383 Matchbox carved in relief with a stag looking backwards. Wood from a fruit tree. *7.8 cm.* Mernye, Somogy County (Ethnographical Museum)

383

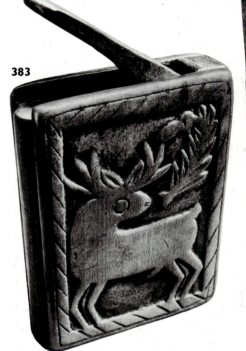

384 A hunter and a dog with bird. Detail. Lid of a razor-case carved in relief. Flowers inlaid with sealing-wax. *10.5 cm.* Inscription: "1856." Kisberzseny, Veszprém County (Ethnographical Museum)

385 Swineherd and spotted pig. Detail. Chair-back carved in relief. The swineherd's axe, the decoration on his *szűr* (frieze coat) and spots on the pig are inlaid with darker wood. *15 cm.* Inscription: "1822." Bakonybél, Veszprém County (Déri Museum, Debrecen)

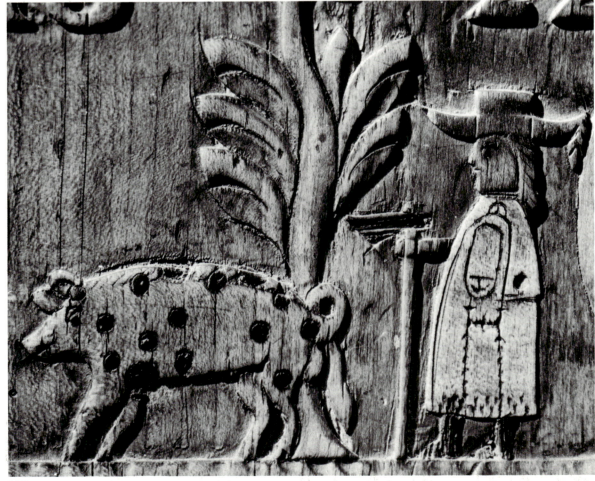

385

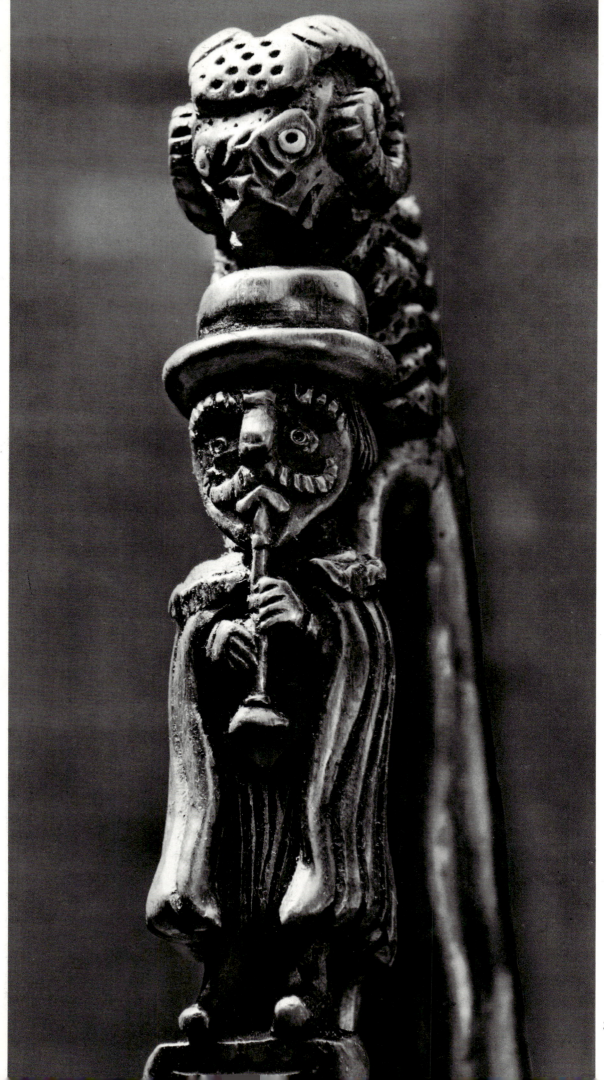

386 Herdsman playing a clarinet. Detail. Shepherd's crook carved in relief. The eyes of the herdsman and ram are made of blue and white glass beads, respectively. Wood from a fruit tree. *12 cm*. Inscription: "1889." Fejér County (Ethnographical Museum)

387 The Virgin and Child. Detail of the staff in Ill. 389, carved in relief. Wood from a fruit tree. *7 cm*. Made by János Barna. Drégelypalánk, Nógrád County (Ethnographical Museum)

388 A fox attacking his prey. Detail of the staff in Ill. 389, carved in relief. Wood from a fruit tree. *4.5 cm*. Made by János Barna. Drégelypalánk, Nógrád County (Ethnographical Museum)

389 Staff, carved in relief, with historical and religious subjects, animal figures and scenes from the lives of the animals. Wood from a fruit tree. Length of staff: *124.3 cm*. Made by János Barna. Drégelypalánk, Nógrád County (Ethnographical Museum)

390 Hungarian chieftain with sword. Detail of the staff in Ill. 389. Wood from a fruit tree carved in relief. *4.8 cm*. Made by János Barna. Drégelypalánk, Nógrád County (Ethnographical Museum)

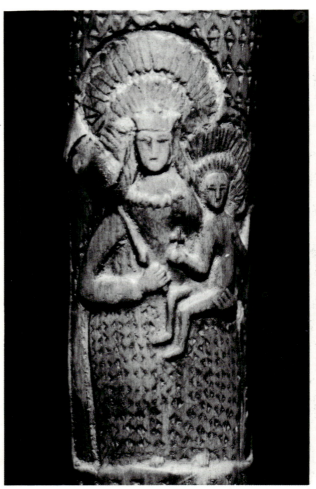

387

388

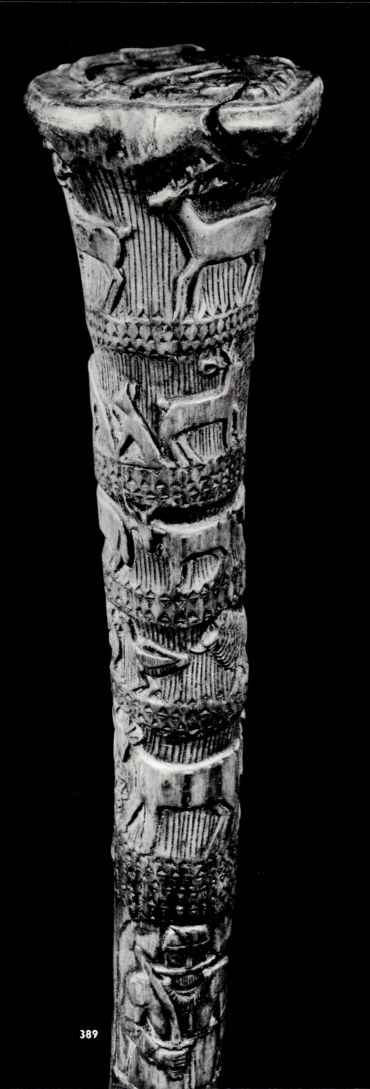

389

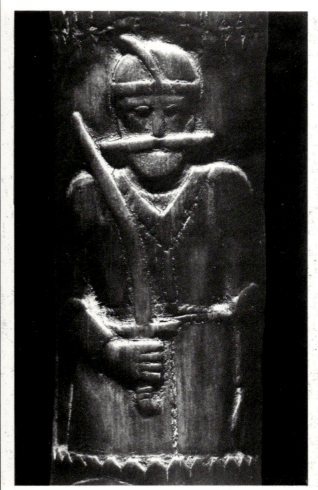

390

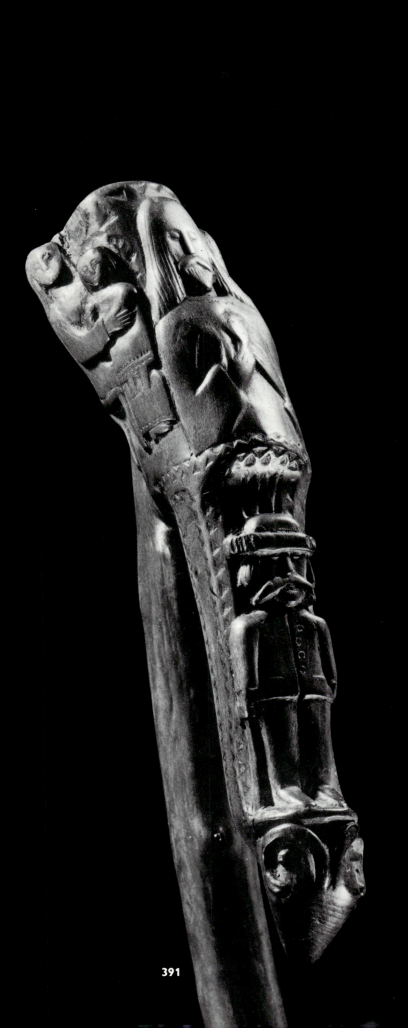

391

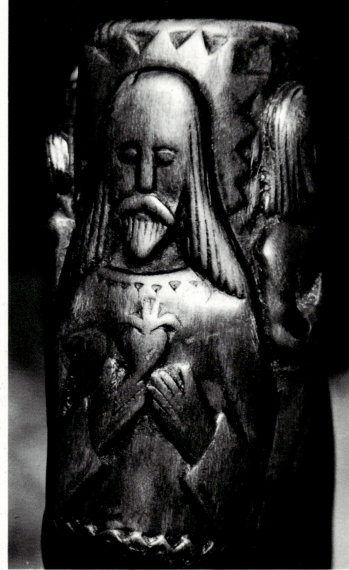

392

391 Shepherd's crook carved in relief with Jesus pointing to his heart and with self-portrait of the maker, János Barna. Wood from a fruit tree. Length of the head of the crook: *16.3 cm.* Drégelypalánk, Nógrád County (Ethnographical Museum)

392 Jesus pointing to his heart. Detail of the crook in Ill. 391, carved in relief. Wood from a fruit tree. *7 cm.* Made by János Barna. Drégelypalánk, Nógrád County (Ethnographical Museum)

393 Shepherds' crooks carved in the shape of a ram's head. Wood from a fruit tree. *20.5* and *16 cm.* Lengyeltóti, Somogy County (Ethnographical Museum)

393

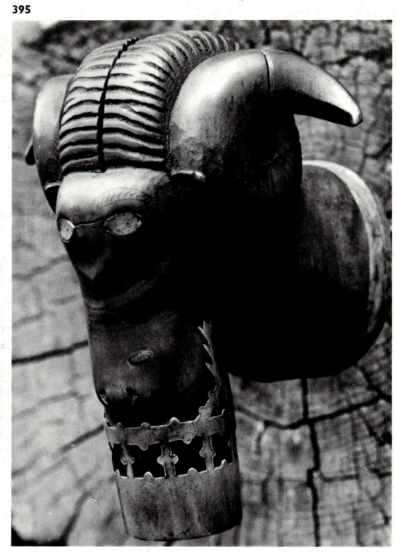

394 Head of
a shepherd's crook
carved in the shape
of a ram's head.
Wood from a fruit
tree with engraved
decoration. *8 cm*.
Homokszentgyörgy,
Somogy County
(Ethnographical
Museum)

395 Top of a bagpipe
carved in relief in
the shape of a ram's
head. The eyes are
made of beads, the
head is inlaid
with lead. *14 cm*.
Kishartyán,
Nógrád County
(Ethnographical
Museum)

396 Walking-stick
carved in relief in the
shape of a chamois's
head. Wood from
a fruit tree, originally
with leather ears.
30 cm. Alsócsernáton
(Cernatu, Rumania)
(Ethnographical
Museum)

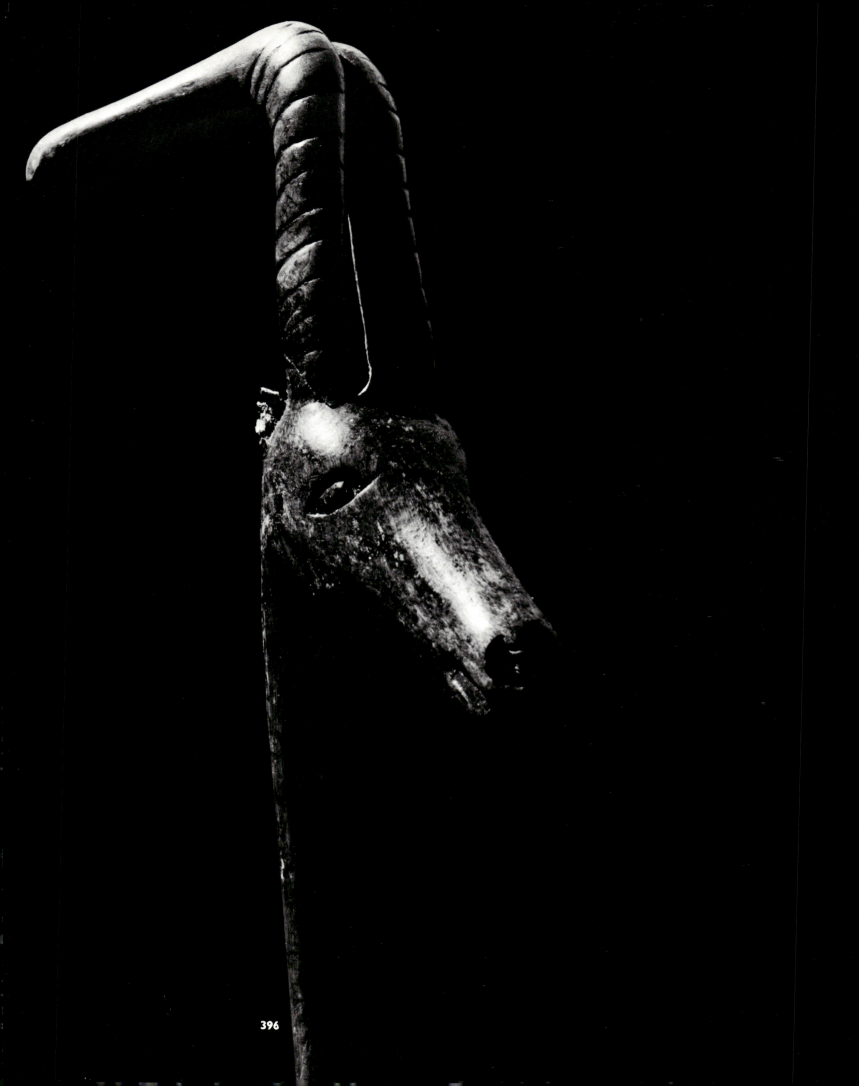

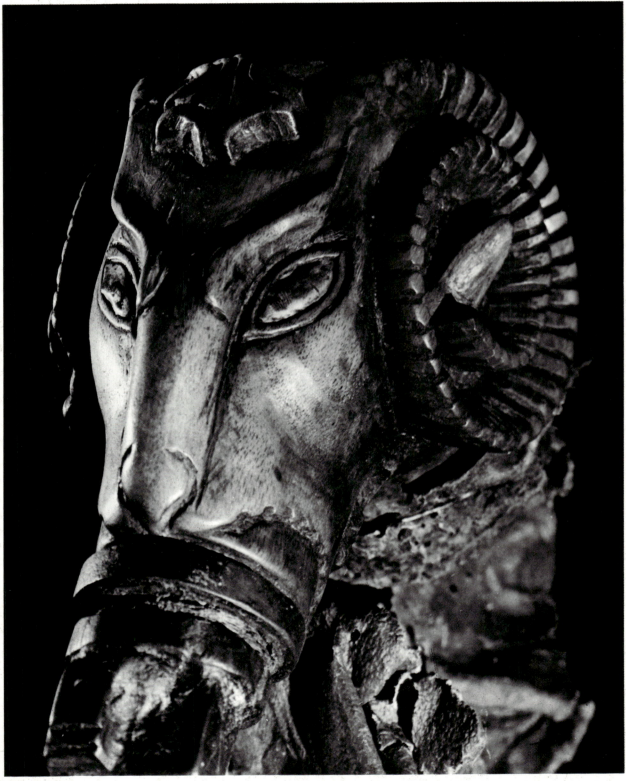

397 Top of a bagpipe carved in relief in the shape of a ram's head. Wood from a fruit tree. The eyes and ring on the mouth are made of copper, the ears are tinted red. *16 cm.* Southern Hungary (Ethnographical Museum)

398 Top of a bagpipe carved in the shape of a goat's head. Wood from a fruit tree studded with brass and copper nails. *18.5 cm.* Nógrád County (Ethnographical Museum)

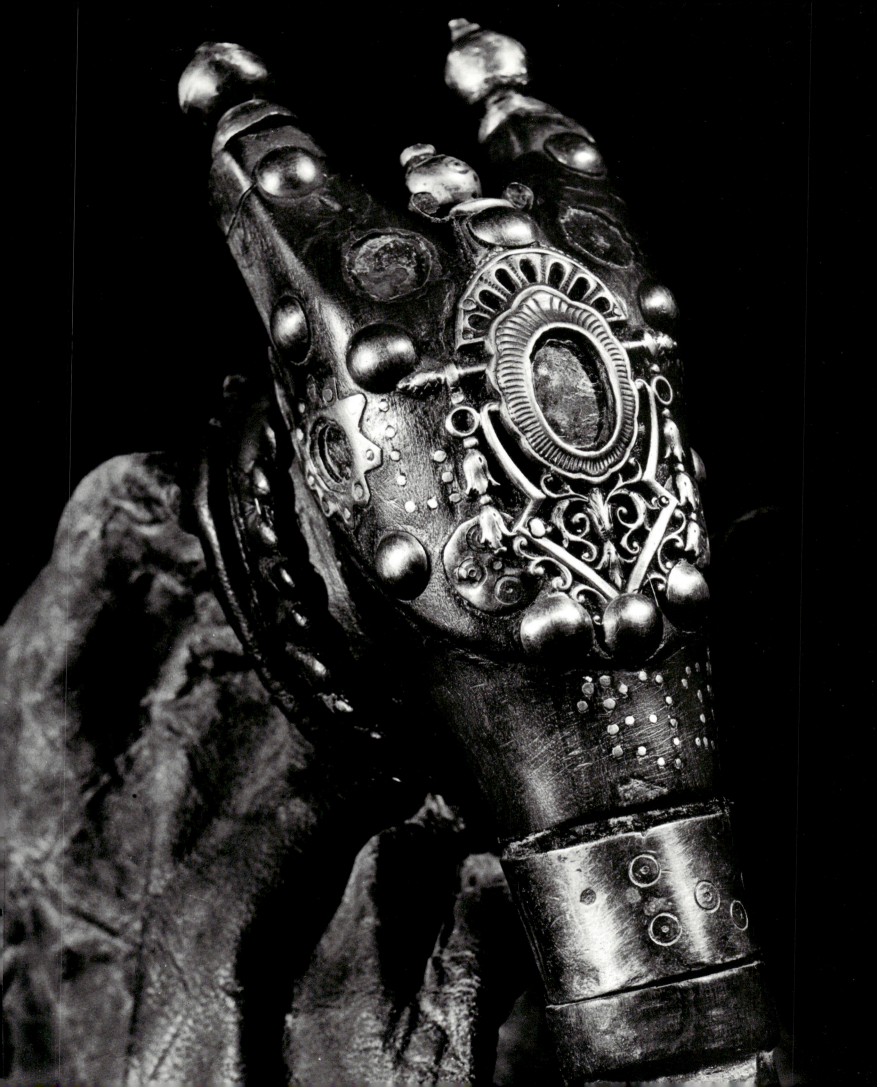

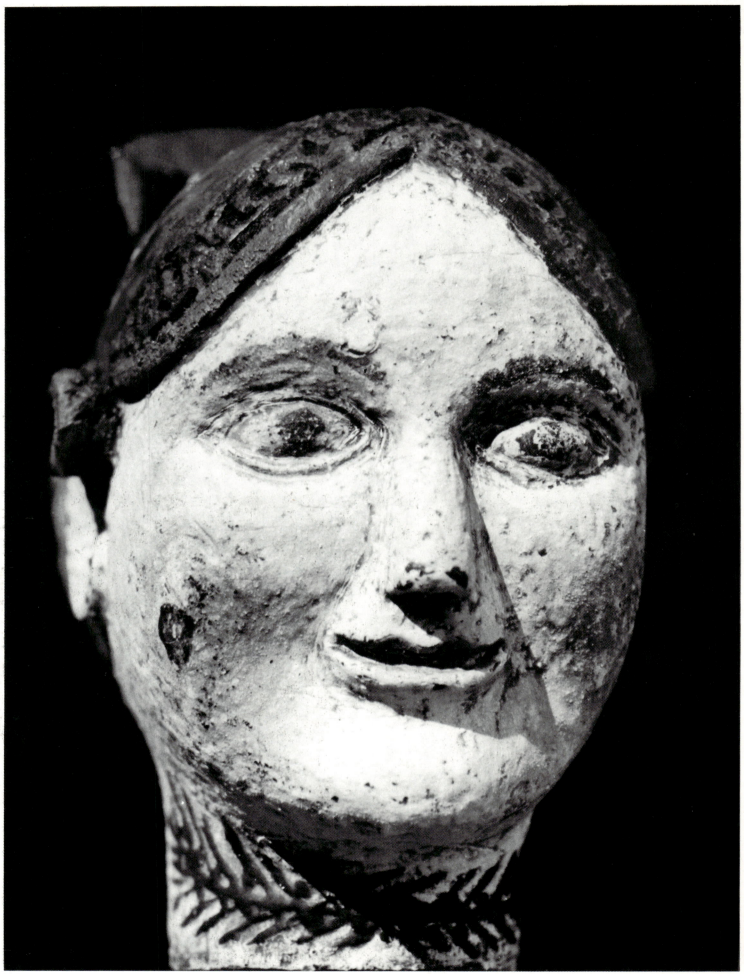

399 Woman's head on top bagpipe. Face painted pink, hair brown, rosemary on the neck, dark green with red spots. Wood. *11.5 cm*. Csongrád County (Ethnographical Museum)

400 Men's heads on bagpipes. Face painted off-white, hats, moustaches and eyebrows black, mouths red. Wood. *12 cm* and *13 cm*. Csongrád County (Móra Ferenc Museum, Szeged)

401 Women's heads on bagpipes. Painted. Left: face off-white, hair, eyes and eyebrows black, mouths red. *11 cm*. Centre: hair brown, lips red. *8.2 cm*. Right: face pink, eyes black, hair brown. *12 cm*. Csongrád County (Ethnographical Museum)

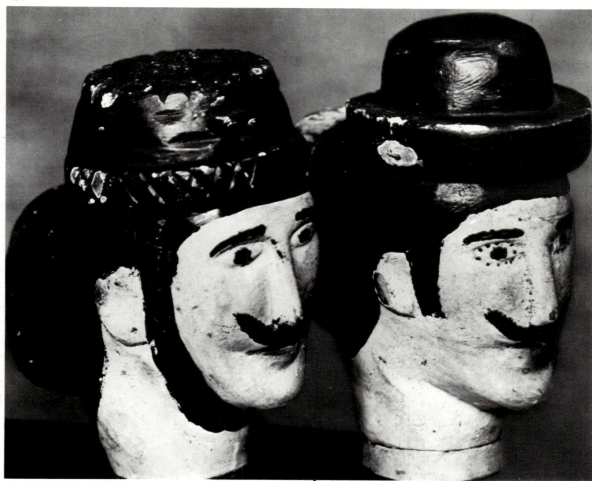

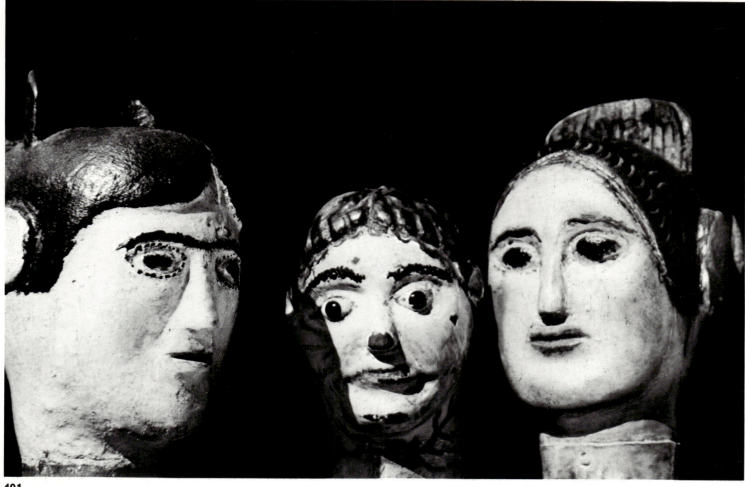

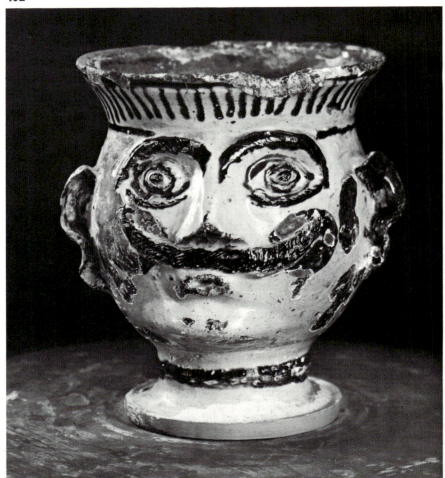

402 Tobacco-holder in the form of a human head. Lead-glazed pottery with applied decoration. Painted reddish-brown and brown on a white ground. *17.2 cm.* East of the Tisza region (Déri Museum, Debrecen)

403 Tobacco-holder in the form of a human head. Lead-glazed pottery with applied and painted decoration. Painted brown, ochre and green, on a yellowish-white ground. The eyes are blue. *19 cm.* Made in Tiszafüred, Heves County (Ethnographical Museum)

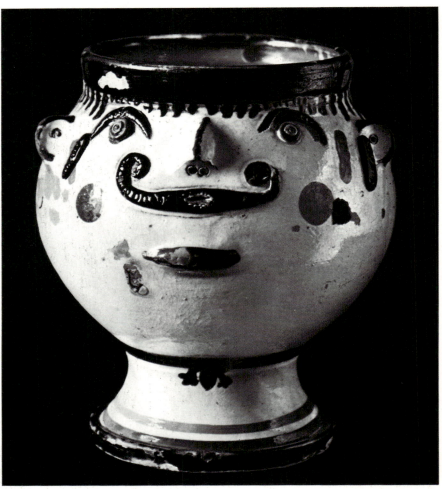

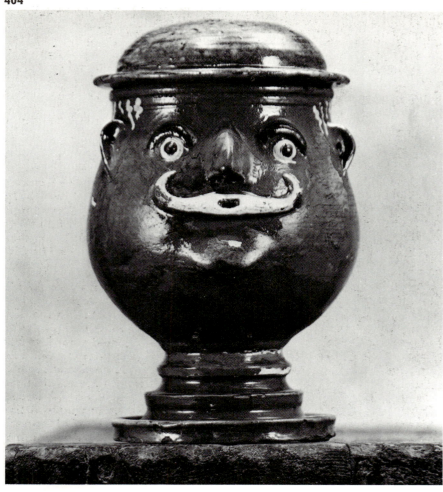

404 Tobacco-holder in the form of a human head, with the hat as a lid. Lead-glazed pottery. The hat is green, the face ochre, decorated in white and brown. *21 cm.* Inscription: "1905." Made and found in Tiszafüred, Heves County (Ethnographical Museum)

405 Tobacco-holder in the form of a human head, with hat. Lead-glazed pottery, 1888. Ochre ground, with hat, moustache and the eyebrows nut-brown and light-coloured whites of the eyes. *20 cm.* Known as "Gábor". Borosjenő (Inen, Rumania) (Mrs. Tibor Keresztes's collection)

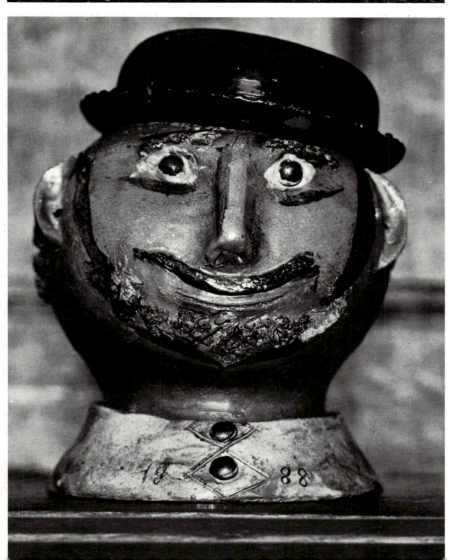

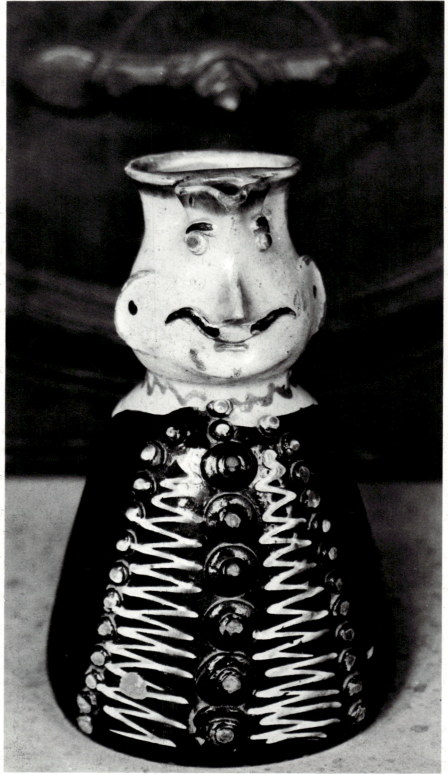

406 "Miska" wine jug. Lead-glazed pottery with applied and painted decoration. Head is light ochre, the body brown, white and blue, with green and red decoration round the neck. *23.8 cm*. Made in Mezőtúr, found in Karcag-Apavára, both in Szolnok County (Déri Museum, Debrecen)

407 Match-holder or salt-cellar in the shape of a human head. Lead-glazed pottery with yellowish-white ground painted in ochre, brown and green. *12 cm*. Made in Tiszafüred, Heves County (Ethnographical Museum)

408 Head of a "Miska" wine jug. Lead-glazed pottery with applied and painted decoration. The yellowish-white ground is decorated in red, ochre, green and yellow. *15 cm*. Inscription: "Anno 1847 This Pint Jug was made in the town of Mező Csáth Ordered by the Noble János Abonyi and made by me the Noble Márton Horvát." Made and found in Mezőcsát, Borsod-Abaúj-Zemplén County (Ethnographical Museum)

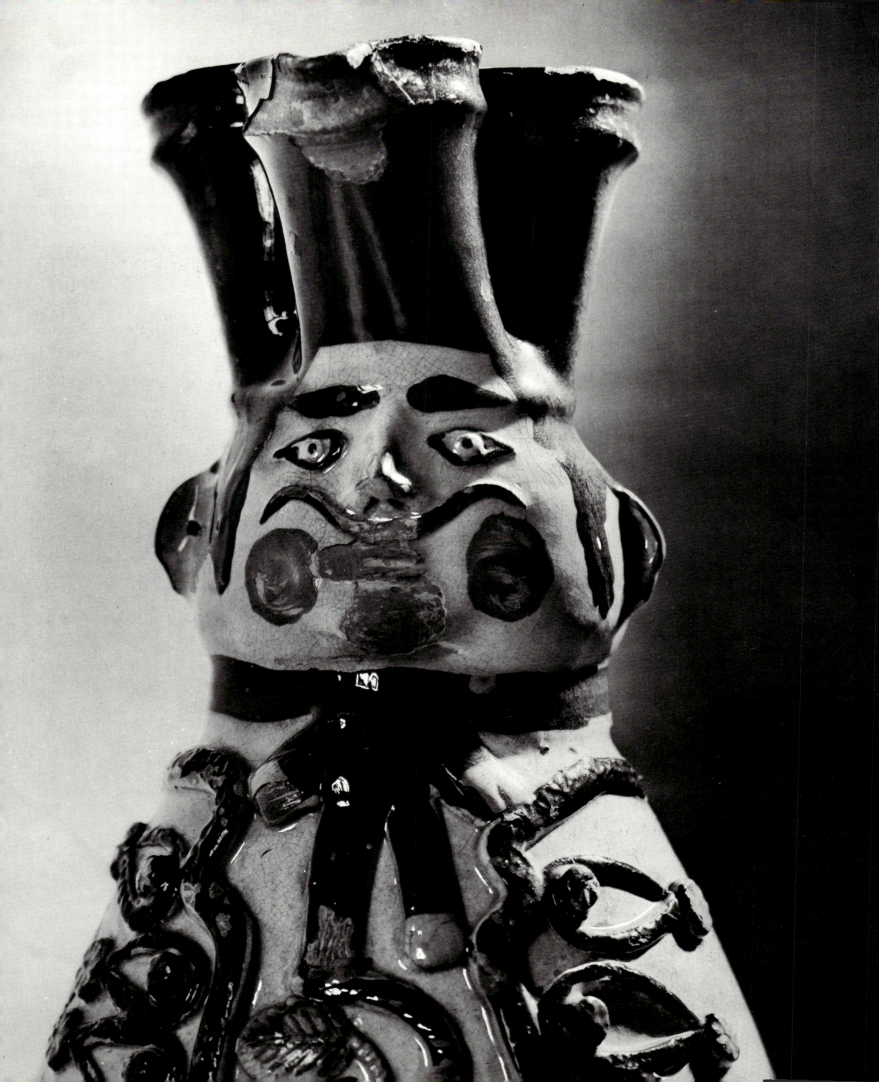

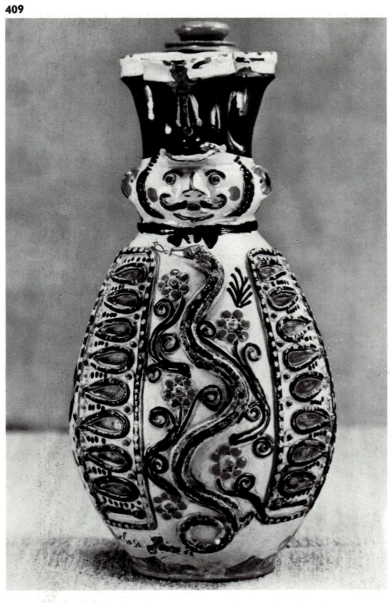

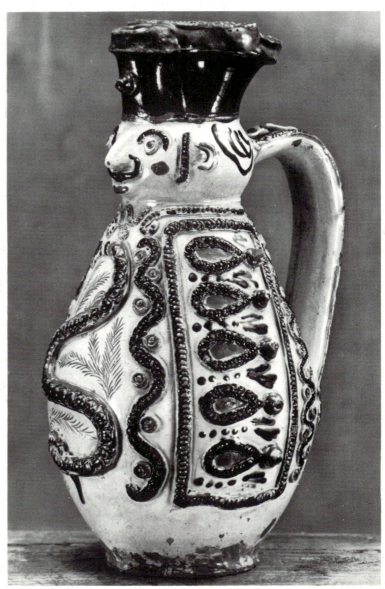

409 "Miska" wine jug. Lead-glazed pottery with applied and painted decoration. The yellowish-white ground is painted in brown, ochre, green and yellow. *37 cm.* Inscription: "This pint jug was made in the Year 1848 in the Town of Mező Csát for Ferenc Kürti..." Made and found in Mezőcsát, Borsod-Abaúj-Zemplén County (Ethnographical Museum)

410 "Miska" wine jug. Lead-glazed pottery with applied painted and incised decoration. The yellowish-white ground is decorated in red, ochre, green and brown. *32 cm.* Inscription: "1833." Made in Mezőcsát, Borsod-Abaúj-Zemplén County, and found in Tiszaszőlős, Heves County (Ethnographical Museum)

411 Tobacco-holder in the shape of a man. Lead-glazed pottery with applied and painted decoration. The head of the figure is yellowish-white, the clothing is blue with brown decoration. *20 cm.* Made and found in Debrecen, Hajdú-Bihar County (Déri Museum, Debrecen)

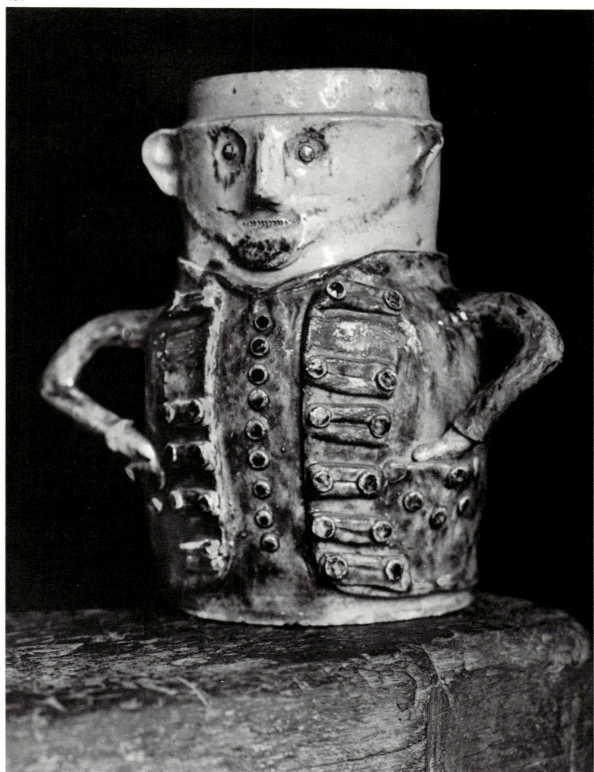

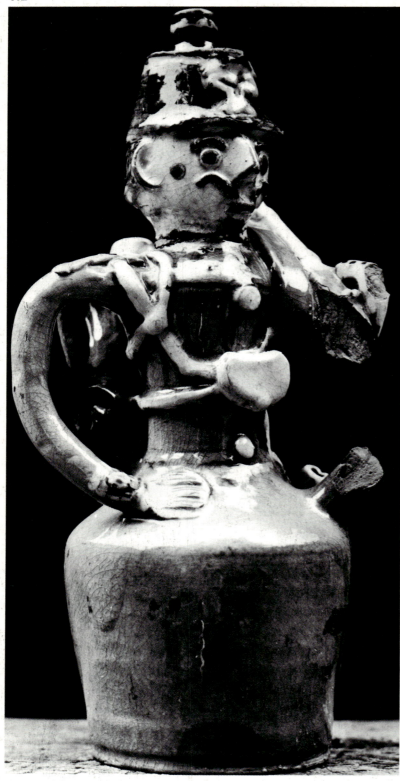

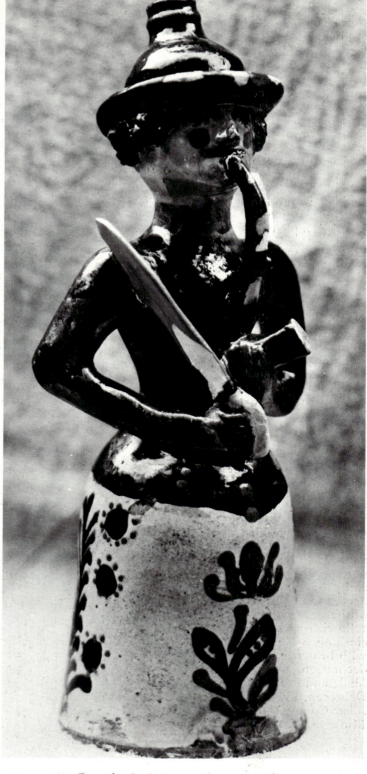

412 Brandy flask in the shape of a foot-soldier with full equipment. Lead-glazed pottery with grey, some buff brown, red, yellow and green decoration. The top of the shako forms the mouth of the vessel. One arm is missing. *26 cm.*

Made and found in Mezőcsát, Borsod-Abaúj-Zemplén County (Ethnographical Museum)

413 Brandy flask in the form of a county attendant with sword, smoking his pipe. Lead-glazed pottery. The hat and dolman are brown, the face and linen pantaloons are yellowish-white with brown and reddish-ochre decoration. *25.5 cm.*
Made and found in Hódmezővásárhely, Csongrád County (Ethnographical Museum)

414 Brandy flask in the shape of a man. Lead-glazed pottery. Yellow ground with green and brown decoration. *24 cm.* Inscription: "I myself Gábor K. Nagy made this flask in human shape for András Köteles in Túr, a Souvenir, 1890." Mezőtúr, Szolnok County (Ethnographical Museum)

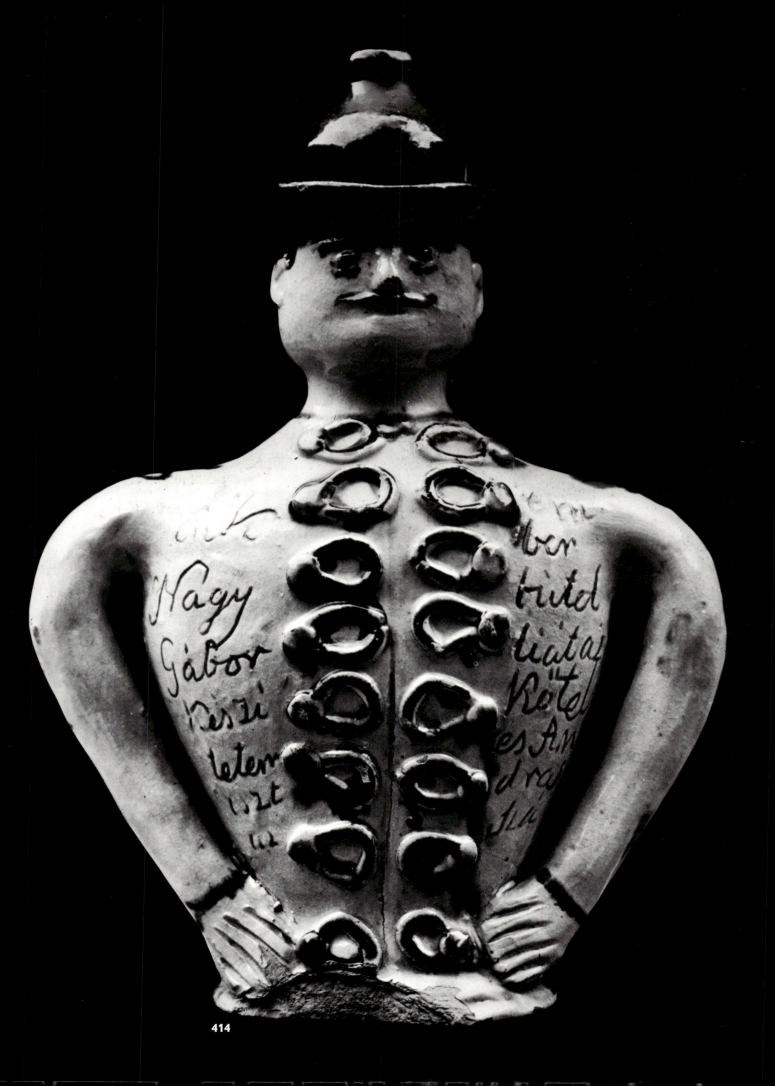

415 Brandy flask in the shape of a peasant wearing his sheepskin cloak inside out. Lead-glazed pottery with applied decoration. The glaze is yellowish-white, the sheepskin cloak light brown, the hat brown; the face is coloured in brown and reddish-ochre. The top of the hat forms the mouth of the vessel. *21 cm*. Made and found in Mezőcsát, Borsod-Abaúj-Zemplén County (Ethnographical Museum)

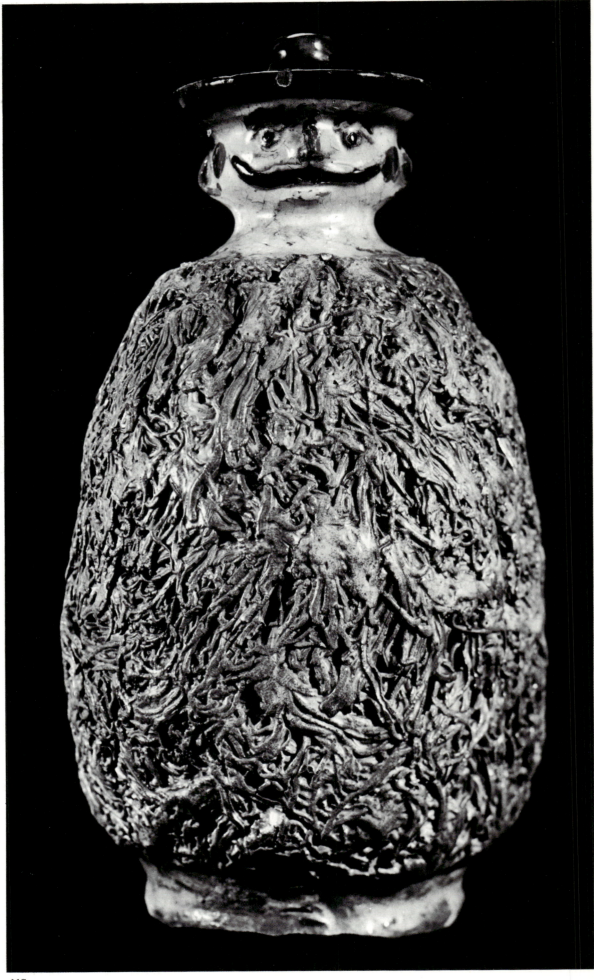

415

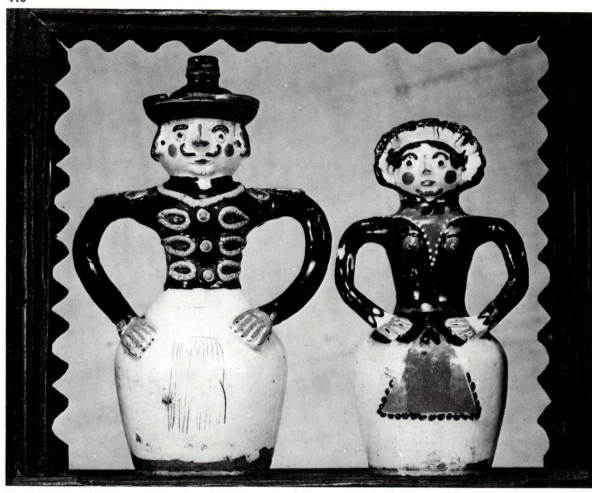

416 Brandy flasks
in the shape of
a peasant man and
woman. Lead-glazed
pottery with applied
and painted
decoration. The
man's face and linen
pantaloons are
yellowish-white,
the dolman is brown;
the braiding and
buttons are green
and yellow, and the
hat is brown, with
green decoration.
23.5 cm.
Made in Mezőcsát,
found in Ároktő,
both Borsod-Abaúj-
Zemplén County.
The woman's skirt
is yellowish-white,
the jacket brown,
the apron reddish-
ochre. The bonnet
with frills is
yellowish-white
with some brown.
19.5 cm.
Made in Mezőcsát,
Borsod-Abaúj-
Zemplén County
(Ethnographical
Museum)

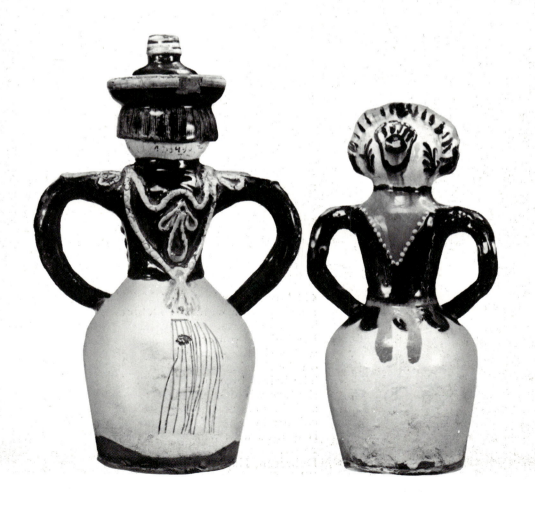

417 Brandy flasks
in Ill. 416, in the
shape of a peasant
man and woman,
seen from the back.
Lead-glazed pottery.

418 Woman in town clothes with baby in arms. Lead-glazed pottery.
The yellowish-white ground is decorated in green, brown and red. One of the arms is restored.
21.2 cm.
Made in Debrecen, Hajdú-Bihar County

(Déri Museum, Debrecen)

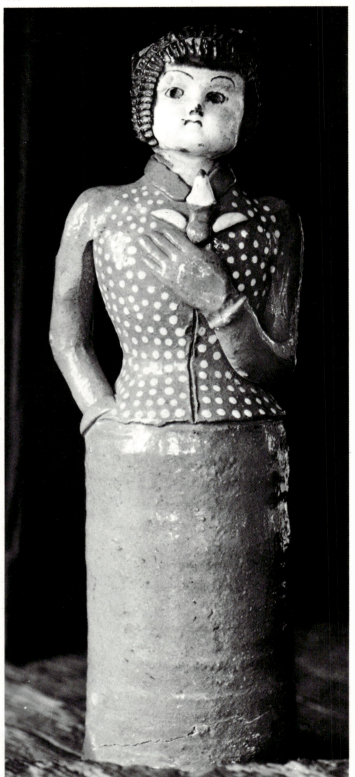

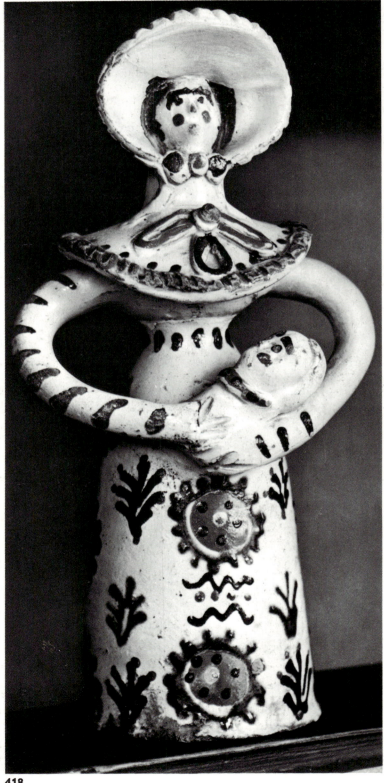

418

419 Money-box in the shape of a woman in town clothes. Lead-glazed pottery with a slit for money on the shoulder. The hair is brown, the face white and the ochre-coloured dress is spotted with white.
26 cm.
Debrecen, Hajdú-Bihar County

(Déri Museum, Debrecen)

420 Money-boxes
in the shape of girls.
Lead-glazed pottery.
Left: white,
decorated in blue
and green, the hair
and the book are
brown. *18.5 cm.*
Right: the figure is
wearing a maiden's
head-dress with
hanging ribbon.
It is decorated in dark
ochre, brown and
blue on a light ochre
ground. Used as
a money-box at
a wedding when the
money given for
the honour
of dancing with the
bride was dropped
through the slit.
20 cm.
Made at Csákvár,
Fejér County,
and Mezőtúr,
Szolnok County,
respectively
(Ethnographical
Museum)

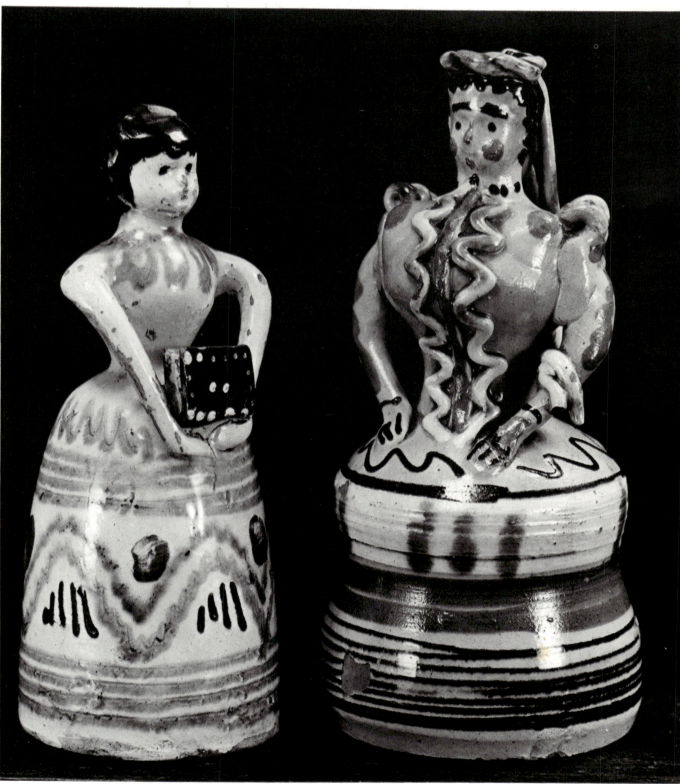

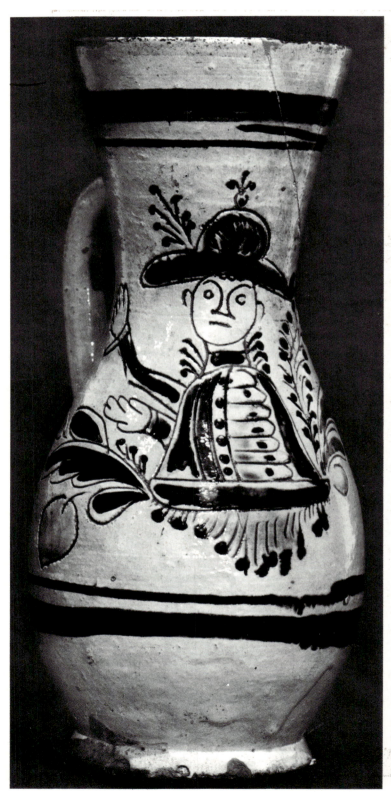

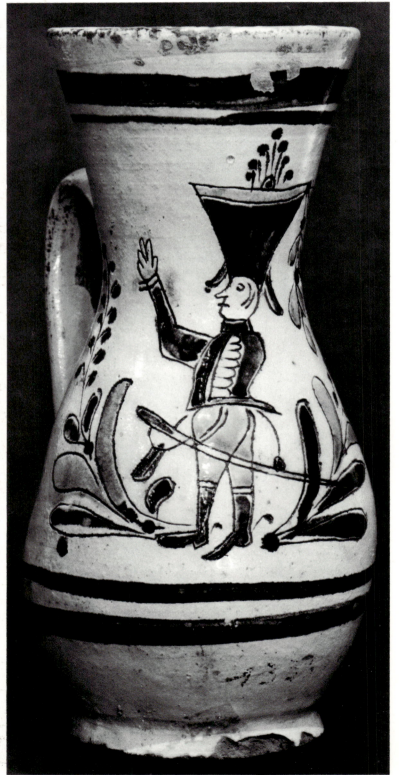

421

422

421 Wine jug
representing
Joseph II (the "king
with a hat"), who
never had himself
crowned.
Lead-glazed pottery
with scratched
and painted
decoration.
The white ground
is decorated in green
and brown. *22 cm.*
Inscription: "1798."
Székely region
(Eastern
Transylvania,
Rumania)
(Mrs. Tibor
Keresztes's
collection)

422 Wine jug
representing
a Székely frontier-
guard. Lead-glazed
pottery with
engraved and painted
decoration
in brown, yellow
and green on a
yellowish-white
ground. *20.5 cm.*
Found in
Kézdimartonos
(Mărtănus, Rumania)
(Ethnographical
Museum)

423 Wine jug
decorated with
a bird. Lead-glazed
pottery. *25 cm.*
Transylvania
(Rumania)
(Ethnographical
Museum)

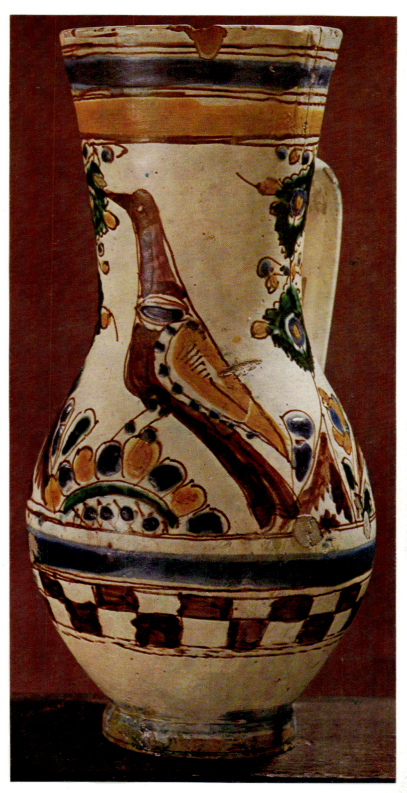

423

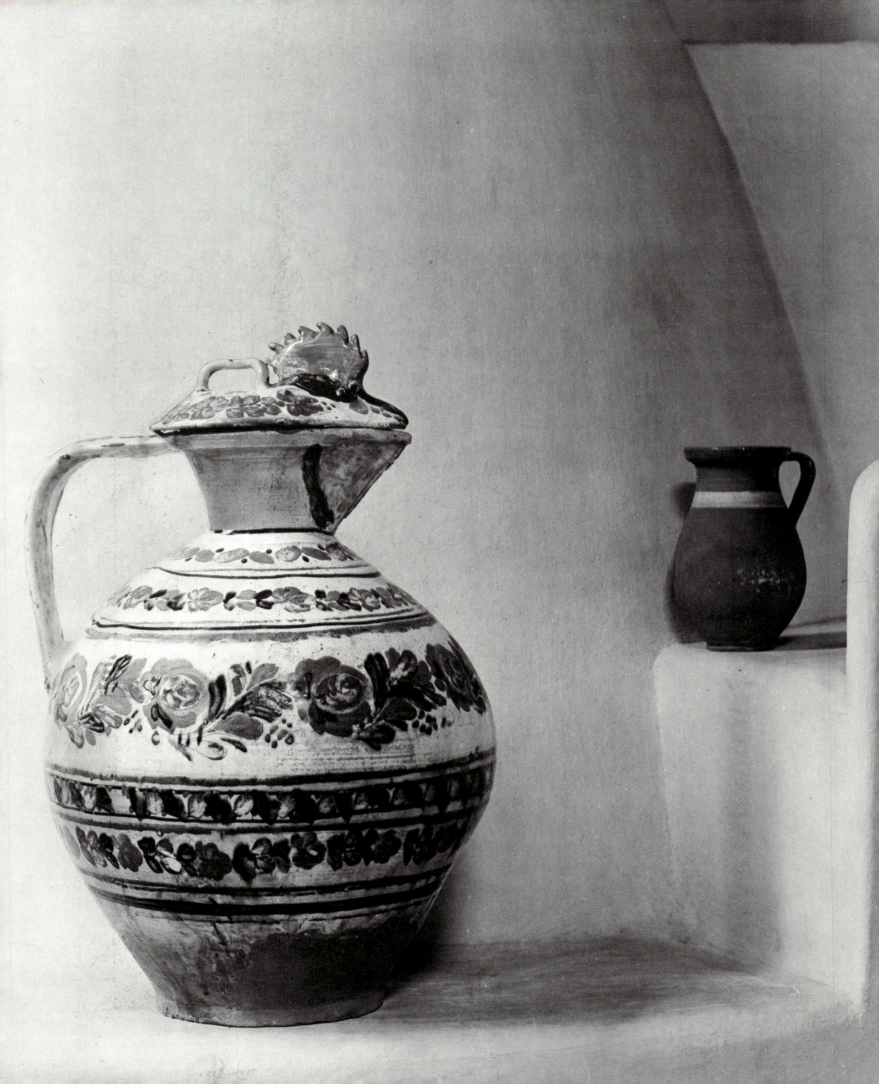

424 Wine jug with lid in the shape of a cock's comb. Lead-glazed pottery. The design is painted on a white ground in blue, red and green. *63 cm.* Made and found in Debrecen, Hajdú-Bihar County (Déri Museum, Debrecen)

425 Wine jug of the Potters' Guild in Debrecen. Lead-glazed pottery with scratched, painted and slip-trailed decoration. The originally white ground, now yellowish-brown, has red, green and brown decoration. *41.8 cm.* Inscription: "Long live the Grand Master of the Potters, Junior Master Bálint Katona, Master Josef Szebeny —1847—Senior Deacon István Hóles and Junior Deacon Mihály Katona—Made by Lajos Leányvári on the 26th day of March in Debrecen, 1847, in the Workshop of Master Bálint Katona. Long may he live, Vivat." Made and found in Debrecen, Hajdú-Bihar County (Déri Museum, Debrecen)

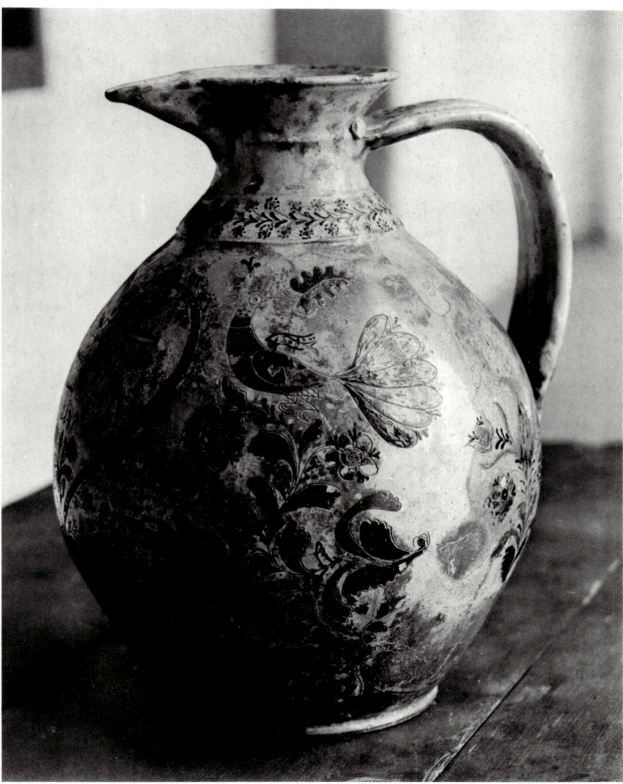

426 Wine bottle. Lead-glazed pottery with scratched, painted and slip-trailed decoration. The white ground is patterned in red, green, brown and yellow. *28.5 cm.* Inscription: "1832." Made and found in Debrecen, Hajdú-Bihar County (Déri Museum, Debrecen)

427 Wine jug for the Communion wine of the Calvinist church of Báránd. Lead-glazed pottery with yellowish-white ground slip-trailed in red, yellow and brown. *34.5 cm.* Inscription: "1793." Made in Debrecen, Hajdú-Bihar County

(Déri Museum, Debrecen)

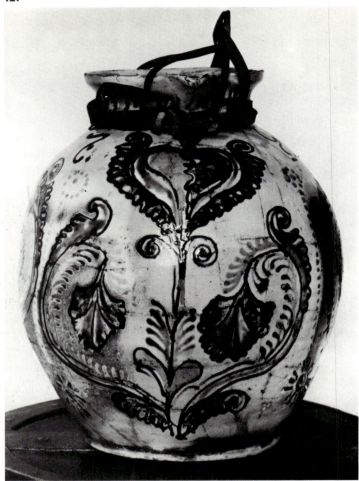

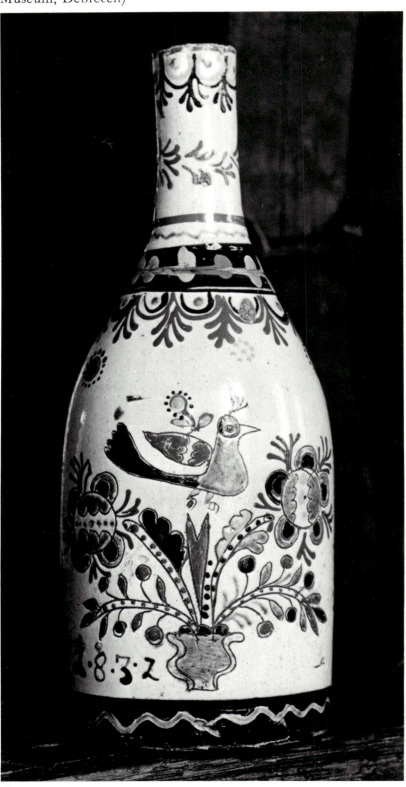

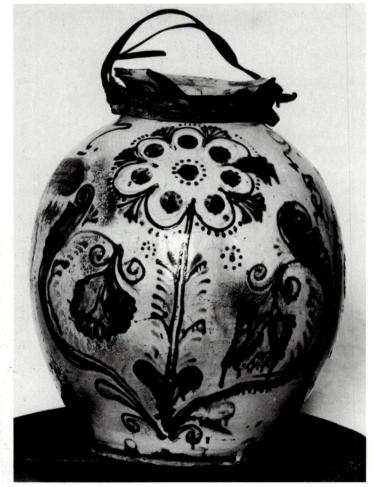

428 Wine jug
for the Communion
wine of the Calvinist
church of Báránd.
Lead-glazed pottery
with yellowish-
white ground
slip-trailed in red,
yellow and brown.
35.5 cm. Inscription:
"1793."
Made in Debrecen,
Hajdú-Bihar County
(Déri Museum,
Debrecen)

429 Wine jug
for the Bootmakers'
Guild of Peremarton.
Lead-glazed pottery
with applied and
painted decoration
and incised
inscription. The white
ground is coloured
in yellow, brown
and green. *38 cm*.
Inscription:
"The jug
of the Honourable
and Noble Guild
of bootmakers
in Peremartony
and its Outskirts
which was ordered
by my Lord
Mártony Pap—
Master of the Guild:
Pál Tóth; Tamás
Blaskovics; György
Gyöke; Istvány
Végbeli; Istvány
Pap and All
the others
in common: made
in Eöskü Die 8ª
Maii Anno
Domini m : dcc :
lxx by Mihály
Miller."
Öskü, Veszprém
County (Bakony
Museum, Veszprém)

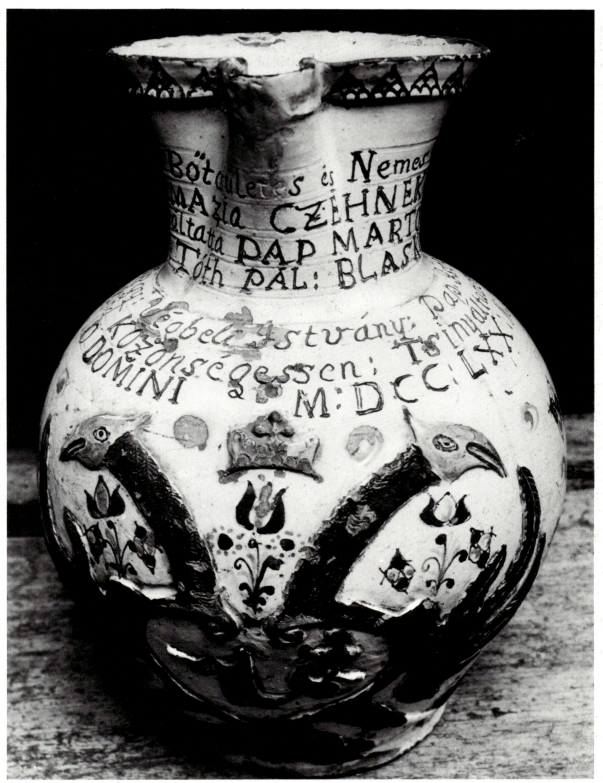

429

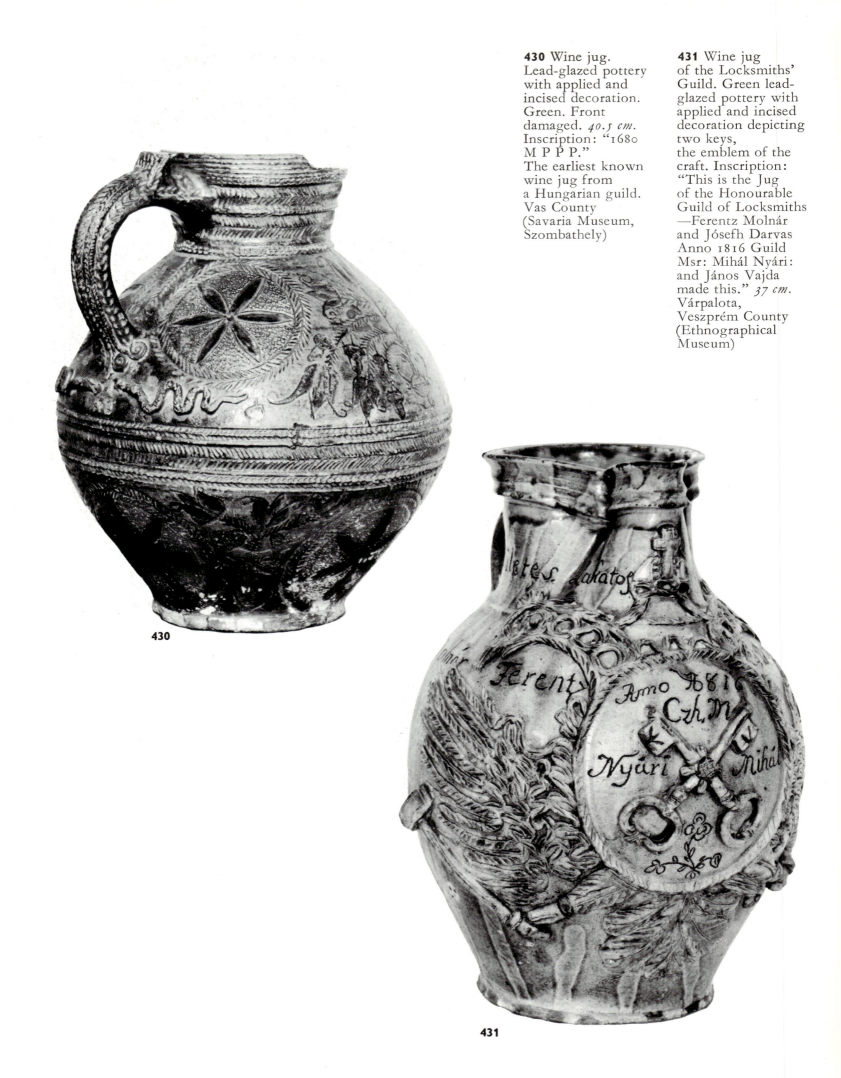

430 Wine jug. Lead-glazed pottery with applied and incised decoration. Green. Front damaged. *40.5 cm.* Inscription: "1680 M P P P." The earliest known wine jug from a Hungarian guild. Vas County (Savaria Museum, Szombathely)

431 Wine jug of the Locksmiths' Guild. Green lead-glazed pottery with applied and incised decoration depicting two keys, the emblem of the craft. Inscription: "This is the Jug of the Honourable Guild of Locksmiths —Ferentz Molnár and Jósefh Darvas Anno 1816 Guild Msr: Mihál Nyári: and János Vajda made this." *37 cm.* Várpalota, Veszprém County (Ethnographical Museum)

430

431

432 Wine jug of the Weavers' Guild. Green lead-glazed pottery with applied and stamped-in decoration. Three shuttles, the emblem of the guild, are depicted on the side of the jug; on the front is Christ's monogram with a crown above it. Inscription: "The jug of the Honourable Weavers' Guild in Szalabér, Sümegh, Die 26 junii." *37 cm*. Made in Sümeg, Zala County (Ethnographical Museum)

433 Wine jug of the Weavers' Guild. Lead-glazed pottery with applied decoration. The glaze is dark green with patches of lighter green. The two handles are missing. *37 cm*. Inscription: "Praise be to Jesus 1750 The little Jug of the Honourable Small Company. Grand Master Pál Takáts." Karád, Somogy County (Ethnographical Museum)

433

432

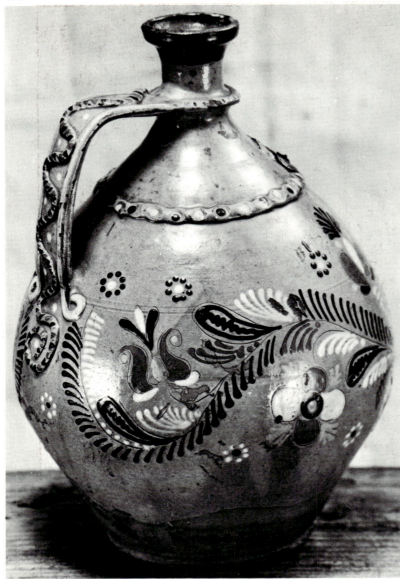

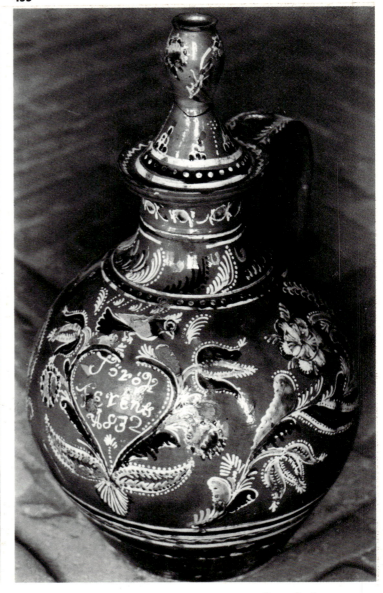

434 Brandy jug. Lead-glazed pottery with applied, incised and slip-trailed decoration. Light green ground with white, brown, red, ochre and yellow decoration. *38 cm.* Inscription: "This Brandy jug was made in the year 1889 for János Kerekes. May it be to the health of whoever takes a drink, Oh dear little vessel / container of my hopes / should my heart fill with sorrow, / let me drink from you. Made by József Horváth in Mező Csáth in my own workshop. This bottle must never be empty for when it is empty there is nothing in it." Made and found in Mezőcsát, Borsod-Abaúj-Zemplén County (Ethnographical Museum)

435 Brandy jug. Lead-glazed pottery with painted and slip-trailed decoration Red ground with green, brown, white and some yellow decoration. *57.5 cm.* Inscription: "Ferentz Török 1832." Made and found in Debrecen, Hajdú-Bihar County (Déri Museum, Debrecen)

436 Brandy jug. Lead-glazed pottery with slip-trailed and mottled decoration. *44 cm.* Hódmezővásárhely, Csongrád County (Ethnographical Museum)

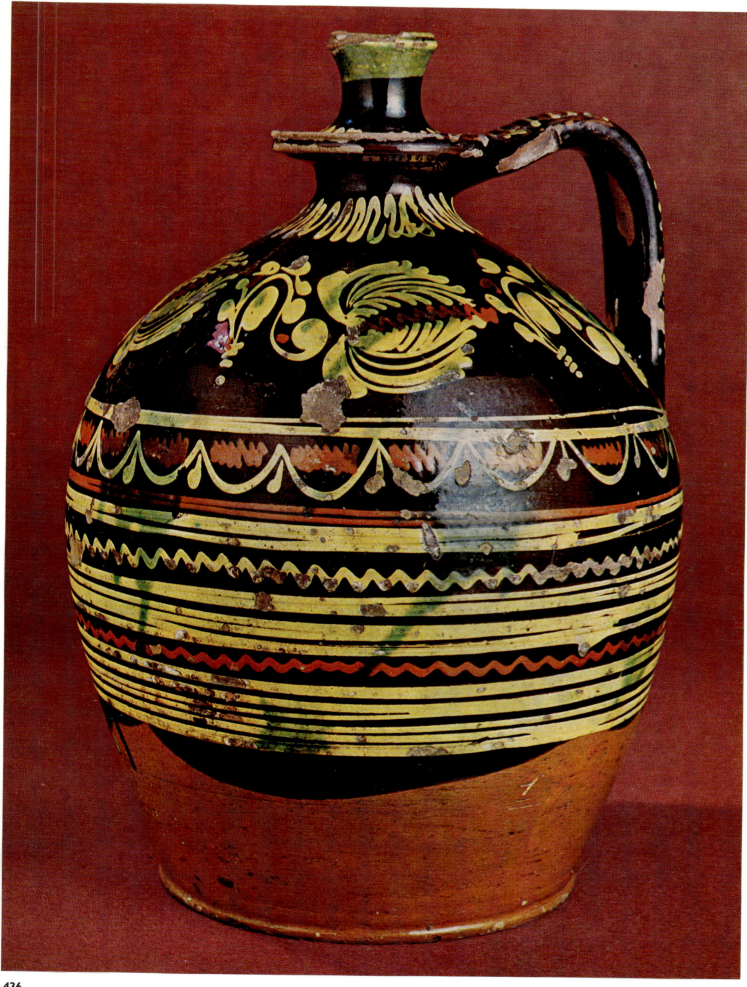

437

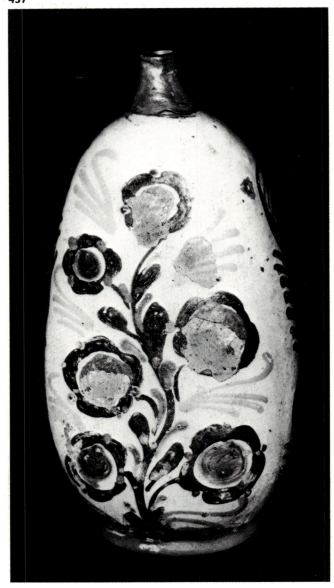

438

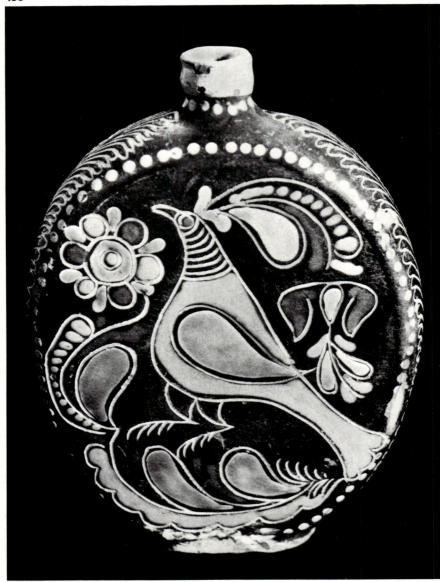

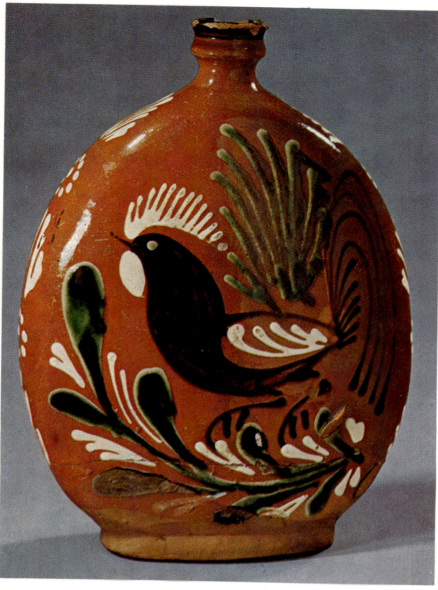

Brandy flask.
Lead-glazed pottery
with incised and
painted decoration
on a white ground in
brown, red
and green. Made by
Mihály Rajczy. *25 cm*.
Made and found
in Mezőcsát, Borsod-
Abaúj-Zemplén
County

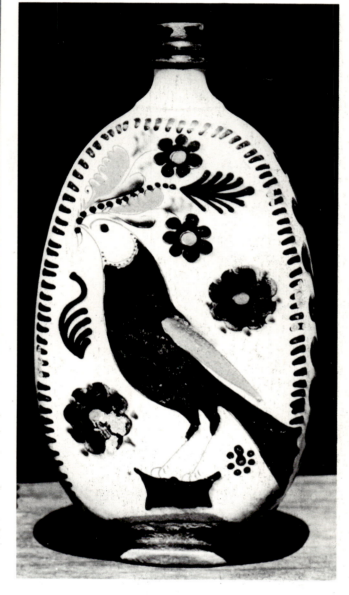

437 Flat pocket
brandy flask. Lead-
glazed pottery with
painted and slip-
trailed design of a
flower-cluster with
seven flowers. Light
ground with brown
and green decoration.
The mouth is dark
green. *18 cm*.
Made at Mezőcsát,
Borsod-Abaúj-
Zemplén County
(Ethnographical
Museum)

438 Brandy flask.
Lead-glazed pottery
with incised and
painted decoration.
Dark brown ground
with the bird
coloured green, red
and reddish-ochre.
The incised lines
reveal the white of
the slip. *16.5 cm*.
Inscription: "Made

in the Year 1880 for
István Erdey... if
there is Nothing in
it, Let Something
be in it, that was the
Lesson in Ároktü."
Made in Tiszafüred,
Heves County
(Ethnographical
Museum)

439 Brandy flask with
cock design. Lead-
glazed pottery with
slip-trailed decoration.
18 cm.
Made and found
in Tiszafüred,
Heves County
(Ethnographical
Museum)

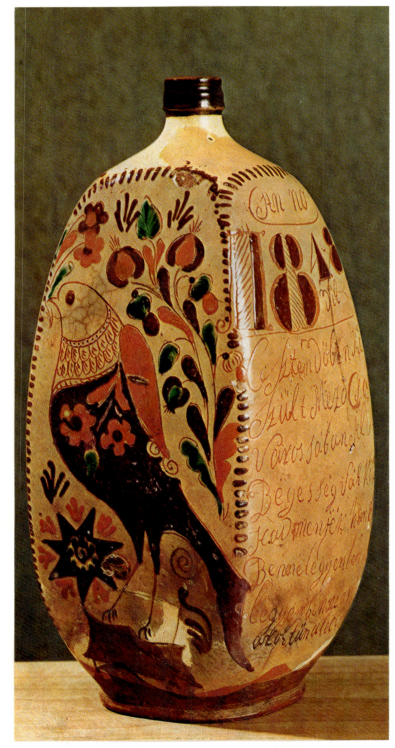

Brandy flask.
Lead-glazed pottery,
ochre-yellow with
incised decoration.
26 cm. Inscription:
"Belongs to Ferenc
Kováts Made in
Anno 1845 I wish
the man who Dares
to Steal this Bottle
the great honour of
pushing a barrow
in Pest and Buda and
to become the chief
captain of beggars."
Hódmezővásárhely,
Csongrád County
(Ethnographical
Museum)

441 Prism-shaped
brandy flask. Lead-
glazed pottery with
incised, slip-trailed
and painted
decoration. *30 cm.*
Inscription: "Anno
1848 Year Made in
the Town of Mező
Csát Health and
happiness Let's get
with it If it's empty
let us fill it
That's the custom
at Ároktü."
Mezőcsát, Borsod-
Abaúj-Zemplén
County
(Ethnographical
Museum)

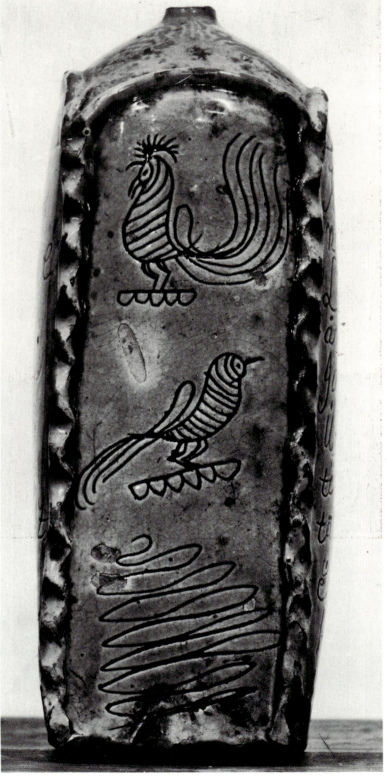

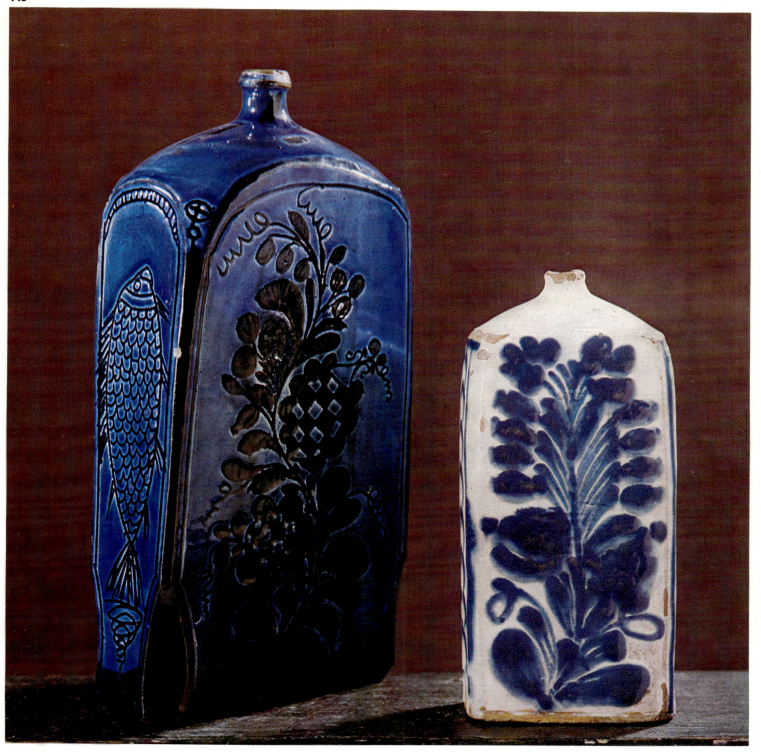

443 Brandy flasks. Lead-glazed pottery. Left: engraved with a flower-cluster design on the front, a fish on the side, and on the back, the inscription: "This bottle was made for Ferentz Szabó in H.M. Vásárhej 1884 Good Fortune should follow you Ferenc Szabó, wherever you happen to go, Never a Shadow, the wheather fine, the Summer sun should always shine Your Life should Flourish like Flowers in May Enjoy your life as long as you may, That is the wish of Sándor Tokodi." *26 cm.* Hódmezővásárhely, Csongrád County (Mrs. Tibor Keresztes's collection) Right: slip-trailed bottle. *17.5 cm.* Hódmezővásárhely, Csongrád County (Ethnographical Museum)

444 Small spice cupboard. Lead-glazed pottery with four small drawers and slip-trailed decoration in white, yellow, green and black on a reddishbrown ground. *28.3 cm.* Inscription: "1848."
Made in Mórágy, and found in Sárpilis, both Tolna County (Déri Museum, Debrecen)

445 Brandy flask decorated with a simplified version of the complete Hungarian coat of arms. Lead-glazed pottery painted dark blue on a white ground. The opening is on top. *26 cm.* Made and found in Hódmezővásárhely, Csongrád County (Mrs. Tibor Keresztes's collection)

446 Two brandy flasks in the shape of books. Leadglazed pottery. Left: *17 cm.* Inscription: "ANNA ÉGETTŐ's 1856."
Right: *17.5 cm.* Inscription: "1885." Both made and found in Hódmezővásárhely, Csongrád County (Ethnographical Museum)

444

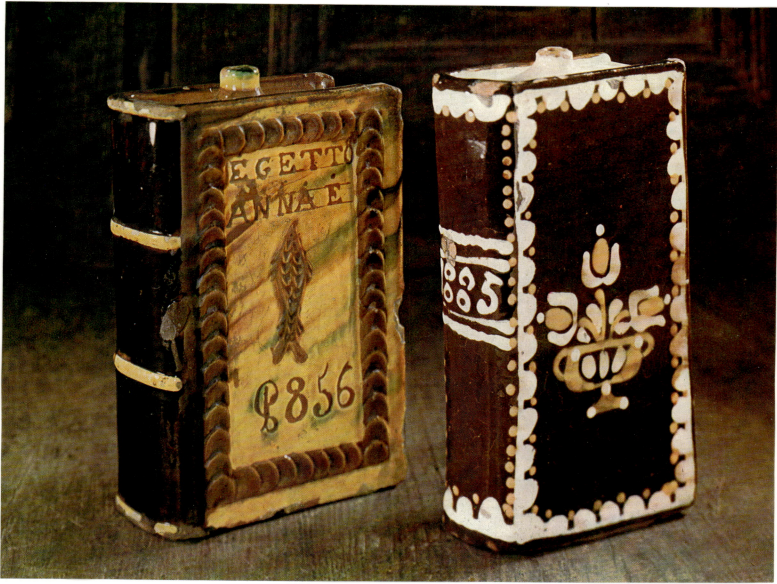

447 Large pot with handles for wedding cookery. Unglazed pottery decorated with bands applied by thumb. *74 cm.* Veszprém County (Bakony Museum, Veszprém)

448 Pot for wedding cookery. Lead-glazed pottery. Dark ochre, decorated with bands applied by thumb. *38 cm.* Inscription: "1900." Made in Sümeg, found in Vöröstó, both Veszprém County (Ethnographical Museum)

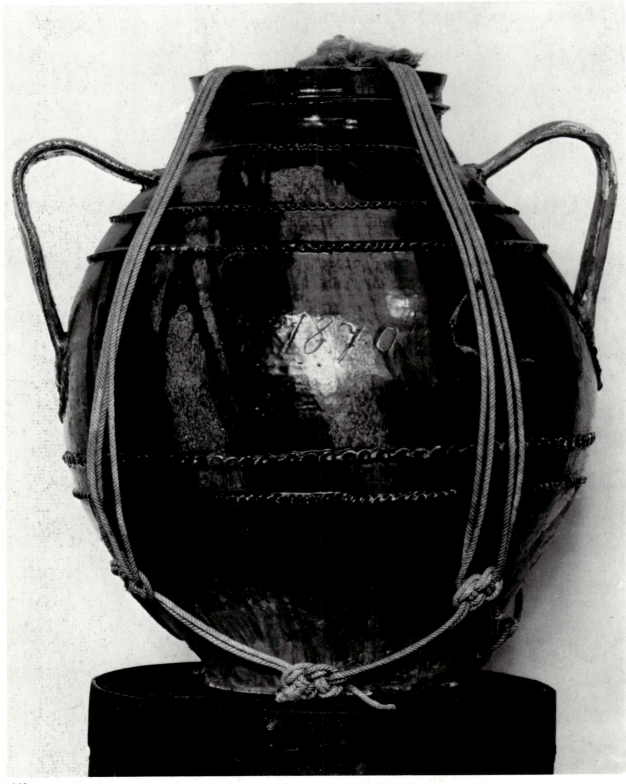

449 Vessel
for carrying food,
with rope for carry-
ing. Dark brown
lead-glazed pottery
with bands applied
by thumb. *46 cm*.
Inscription: "1870."
Great Plain (Déri
Museum, Debrecen)

450 Pitcher.
Unglazed pottery
with a design
of branches on the
side painted in red
pigment. The mouth
is green-glazed.
35 cm.
Made in Tata,
Komárom County,
found in Tahitótfalu,
Pest County
(Ethnographical
Museum)

451 Pitcher.
Unglazed pottery
with a design in
stripes and crosses
in red pigment.
20 cm.
Made in Tata,
Komárom County,
found in Tahitótfalu,
Pest County

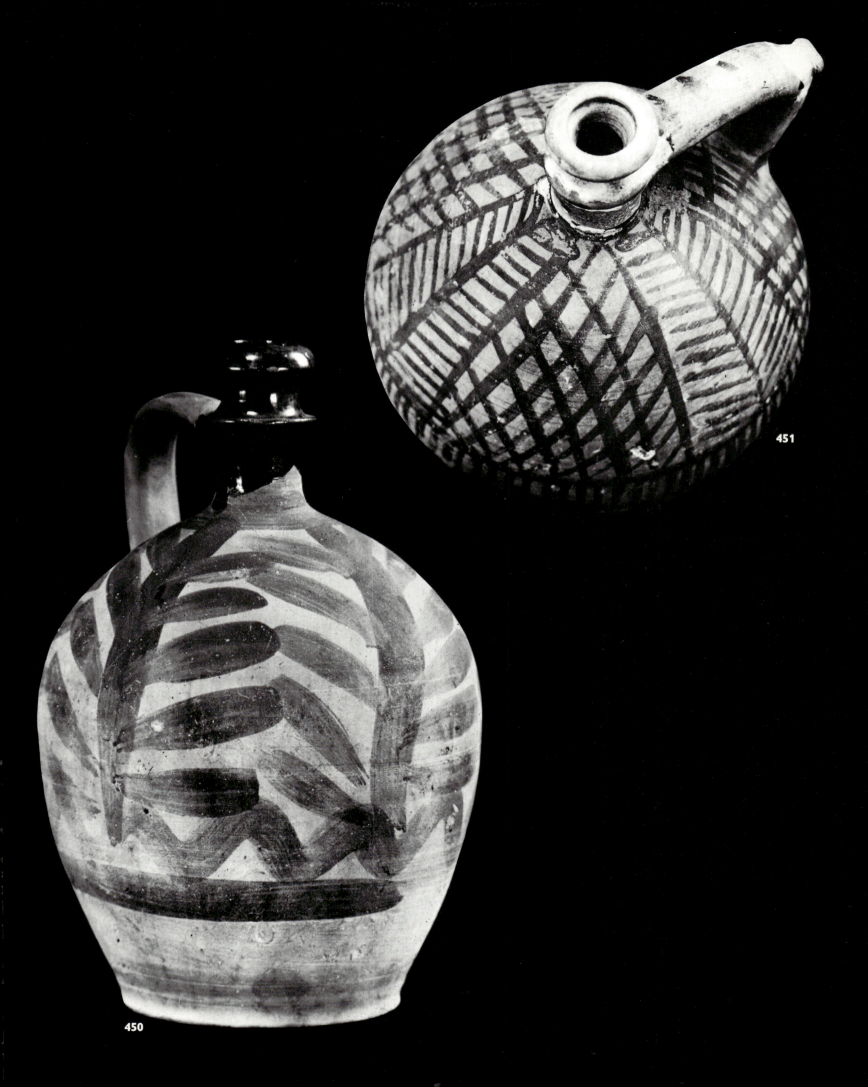

450

451

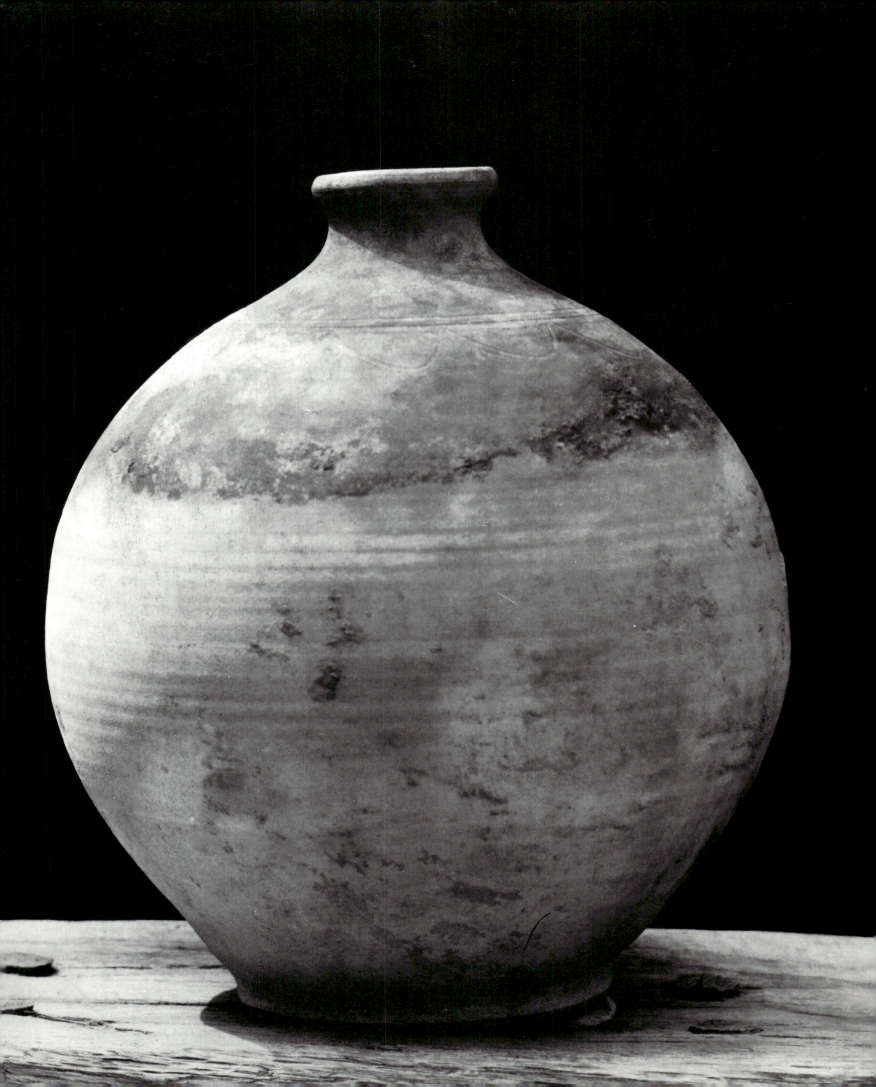

452 Vinegar container. Unglazed pottery with incised decoration under the mouth. *30 cm.* Átány, Heves County (Ethnographical Museum)

453 Milk pitchers with handles. Unglazed pottery. *26 cm* and *22 cm.* Sopron County (János Bozsó's collection, Kecskemét)

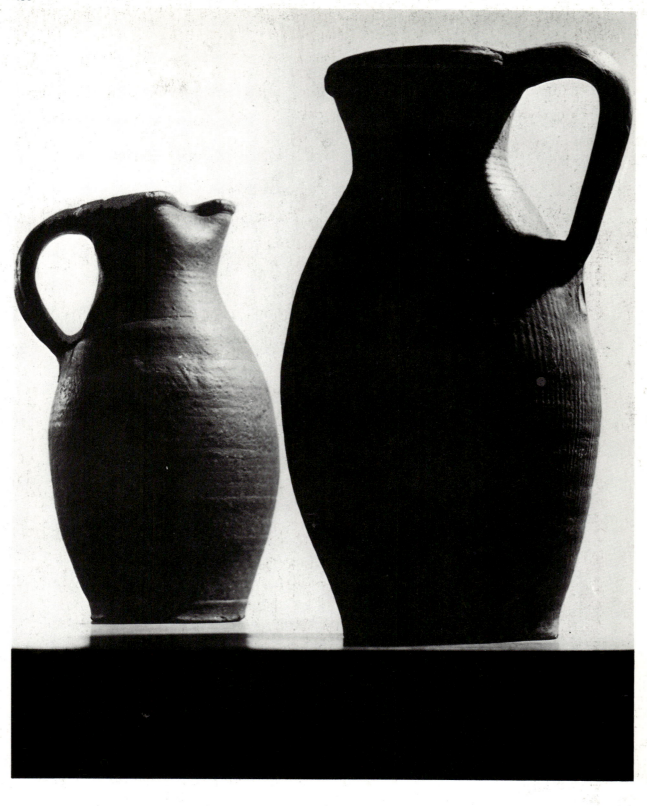

454 Dish decorated with a bird. Lead-glazed pottery with slip-trailed decoration in yellow, white, green and red on a dark brown ground. Diameter: *36 cm*. Made in Mórágy, found in Váralja, both Tolna County (Mrs. Tibor Keresztes's collection)

455 Dish decorated with a cock. Lead-glazed pottery with slip-trailed decoration. Diameter: *29 cm*. Made in Mórágy, found in the Sárköz region, both Tolna County (Ethnographical Museum)

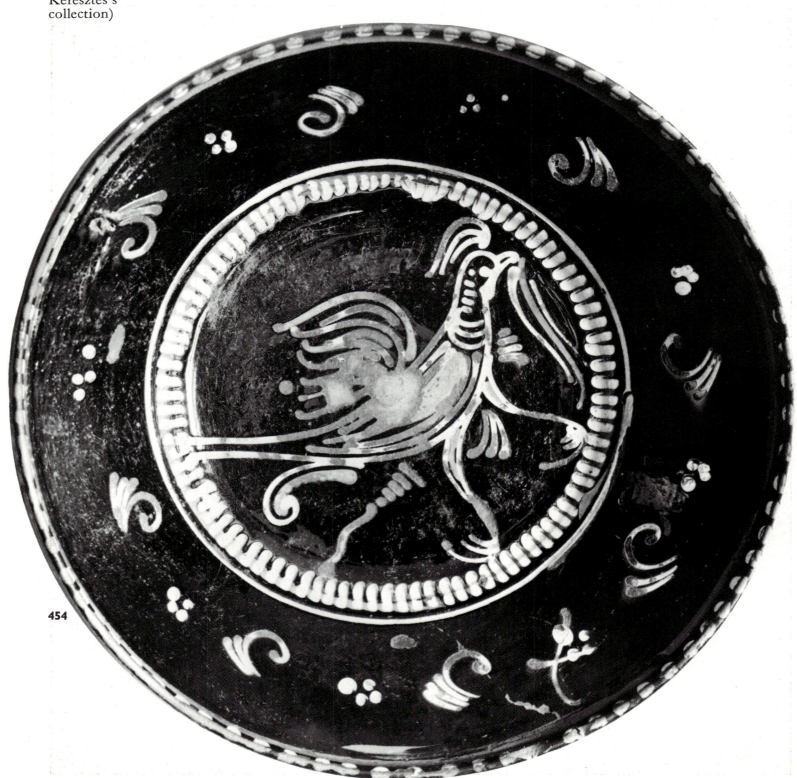

454

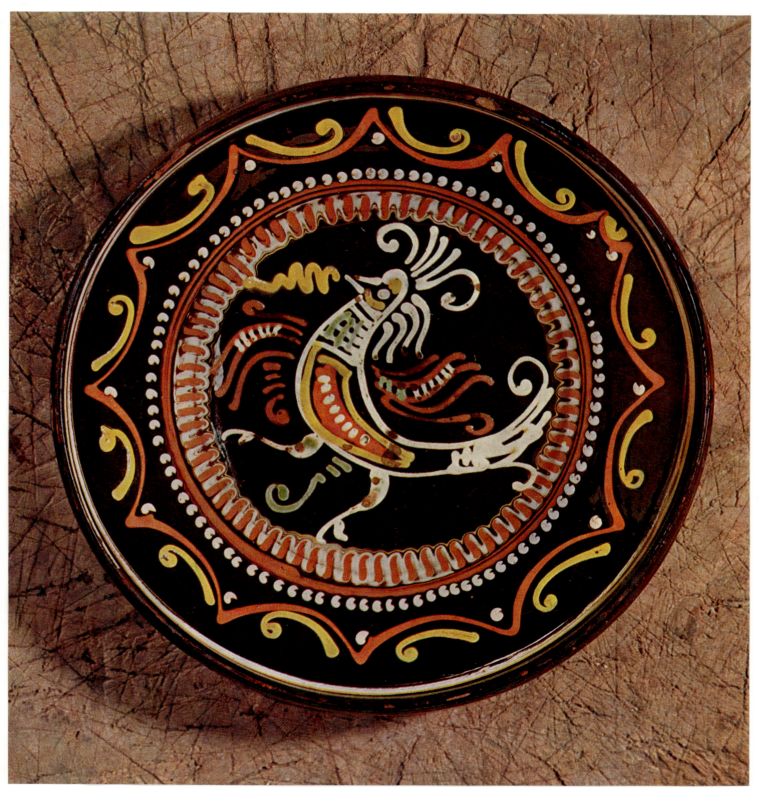

455

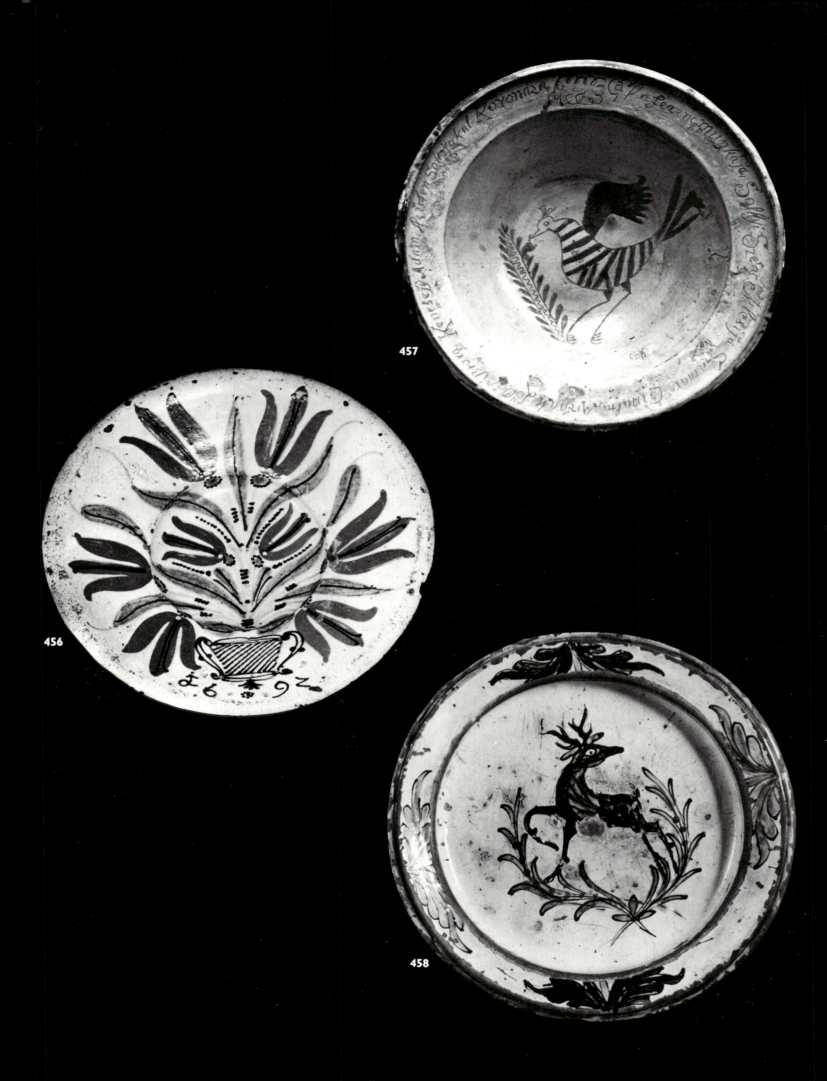

456 Dish decorated with a flower-cluster in a pot. Lead-glazed pottery. The design is slip-trailed and painted with a brush. The ground is white, the flowers are painted red, brown and green. Diameter: *27.5 cm.* Inscription: "1692." Miskolc, Borsod-Abaúj-Zemplén County (Herman Ottó Museum, Miskolc)

457 Plate for Communion bread. Lead-glazed pottery with incised decoration. Inscription: "The work of Ferenc Gál It was made for the Holy Church of Solly by the Minister Adam Kenesejy May God crown him with much good." Diameter: *26 cm.* Sóly, Veszprém County (Bakony Museum, Veszprém)

458 Dish decorated with a stag. Lead-glazed pottery. Painted in green, yellow, reddish-brown and blue on a white ground with dark brown outlines. Diameter: *25.5 cm.*

Székely land (Eastern Transylvania, Rumania) (János Lakos's collection)

459 Dish decorated with a bird looking backwards. Lead-glazed pottery with incised and painted decoration. Diameter: *28 cm.* Inscription: "anno 1843." Made by Mihály Rajczy.

Made and found in Mezőcsát, Borsod-Abaúj-Zemplén County (Ethnographical Museum)

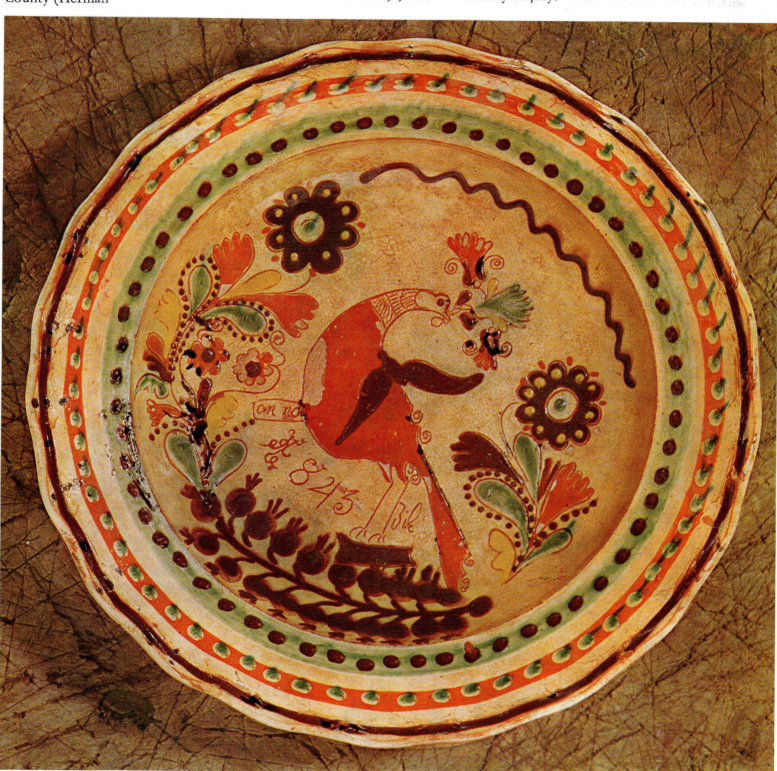

459

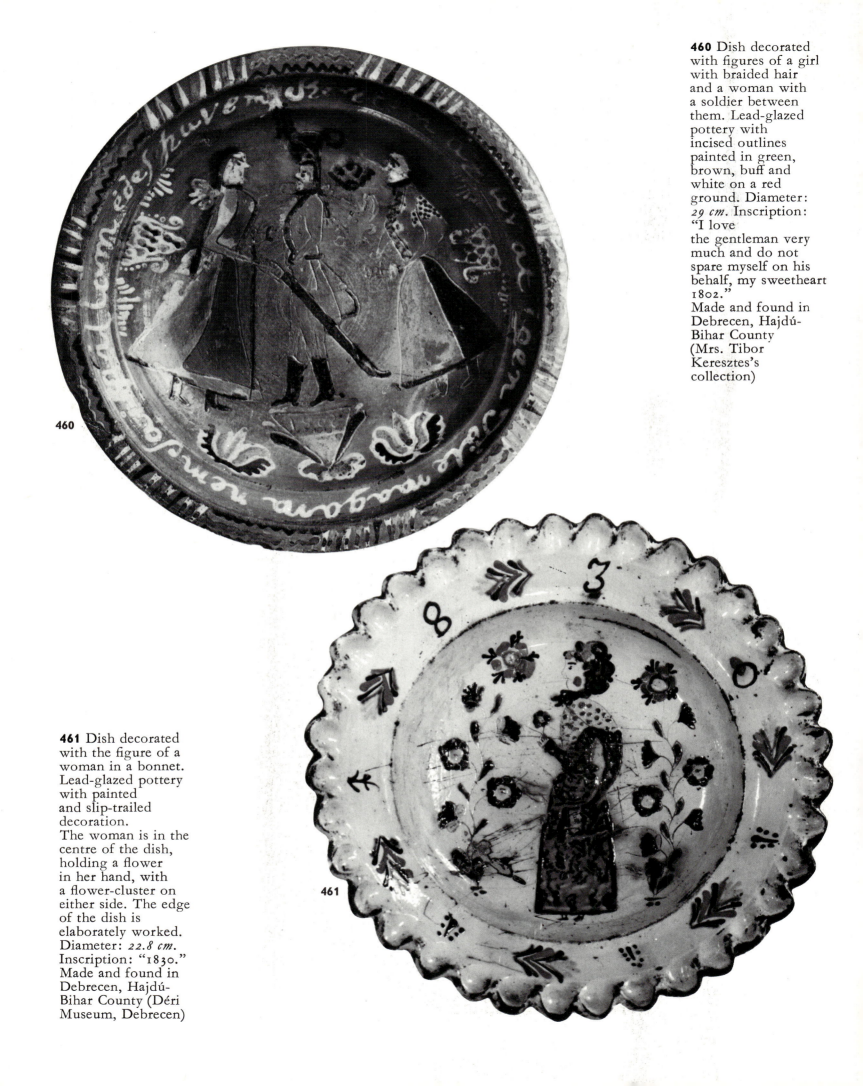

460 Dish decorated with figures of a girl with braided hair and a woman with a soldier between them. Lead-glazed pottery with incised outlines painted in green, brown, buff and white on a red ground. Diameter: *29 cm.* Inscription: "I love the gentleman very much and do not spare myself on his behalf, my sweetheart 1802." Made and found in Debrecen, Hajdú-Bihar County (Mrs. Tibor Keresztes's collection)

461 Dish decorated with the figure of a woman in a bonnet. Lead-glazed pottery with painted and slip-trailed decoration. The woman is in the centre of the dish, holding a flower in her hand, with a flower-cluster on either side. The edge of the dish is elaborately worked. Diameter: *22.8 cm.* Inscription: "1830." Made and found in Debrecen, Hajdú-Bihar County (Déri Museum, Debrecen)

462 Dish with a cock.
Lead-glazed pottery.
Slip-trailed in brown,
green, ochre and
blue on a white
ground and orna-
mented with
pinpricks and brush
strokes. Diameter:
52 cm.
Made and found in
Tiszafüred, Heves
County
(Ethnographical
Museum)

463 Plate decorated
with a bird. Lead-
glazed pottery.
The yellowish ground
has painted
and slip-trailed
decoration in two
shades of brown
and in green.
Diameter: *29 cm.*
Inscription: "1849."
Made by Mihály
Rajczy.
Mezőcsát, Borsod-
Abaúj-Zemplén
County (Herman
Ottó Museum,
Miskolc)

462

463

464 Sewing basket with lid. Lead-glazed pottery with open-work and applied decoration. Light ochre ground with blue, green and brown slip-trailed design. *16 cm.* Inscription: "1885." Mezőtúr, Szolnok County (Ethnographical Museum)

465 Open-work plate for doughnuts. Lead-glazed pottery, light sepia with greenish-yellow sides. Diameter: *31.5 cm.* Inscription: "1844 M S." Hódmezővásárhely, Csongrád County (Mrs. Tibor Keresztes's collection)

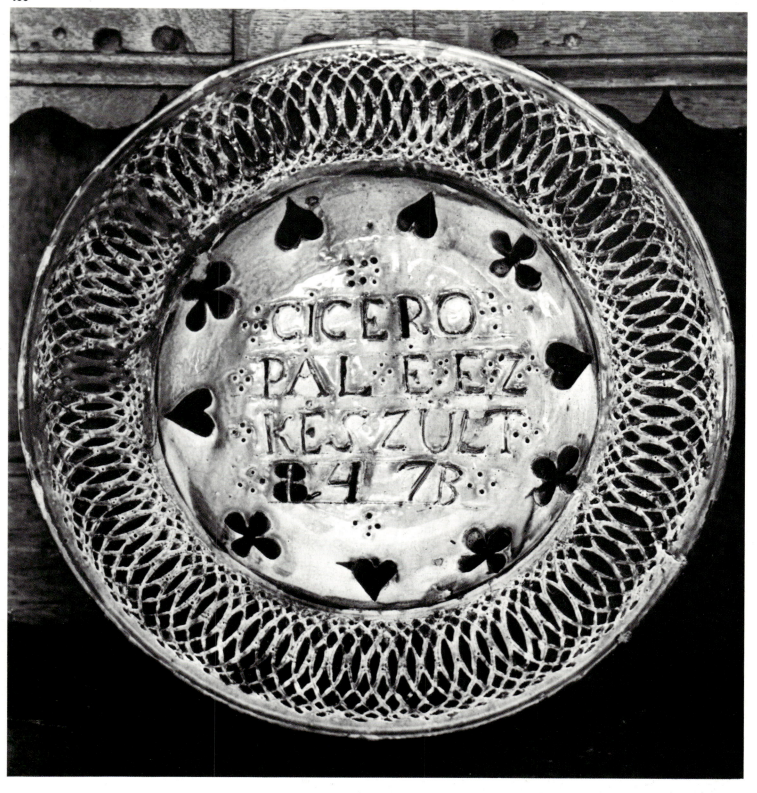

466 Open-work plate for doughnuts. Lead-glazed pottery with green rim and chrome-yellow centre. Diameter: *35.5 cm.* Inscription: "Pál Cicero's Made in '847."
Made and found in Hódmezővásárhely, Csongrád County (Mrs. Tibor Keresztes's collection)

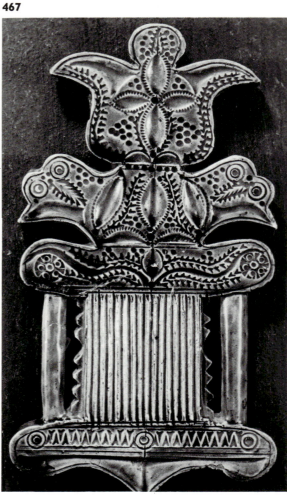

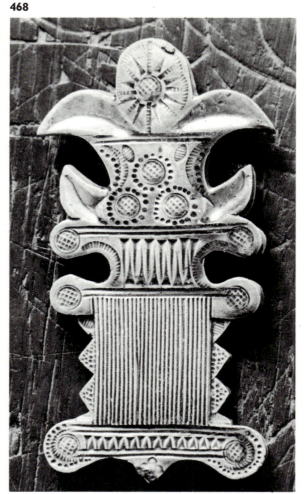

467 Board for making shell-shaped noodles. Lead-glazed pottery, green, with engraved decoration. *14.4 cm.* Inscription: "Made by József Toldi 1860." Made and found in Debrecen, Hajdú-Bihar County (Ethrographical Museum)

468 Board for making shell-shaped noodles. Lead-glazed pottery, green, with engraved and incised decoration. *15.1 cm.* Inscription: "Made by Pál Kis F L for Sára Bódi." Made and found in Debrecen, Hajdú-Bihar County (Déri Museum, Debrecen)

469 Board for making shell-shaped noodles. Lead-glazed pottery, green, with engraved and incised decoration. *15.2 cm.* Inscription: "Made by József Földi in 1896 Long live the noodle-maker." Made and found in Debrecen, Hajdú-Bihar County (Déri Museum, Debrecen)

470 Board for making shell-shaped noodles. Lead-glazed pottery with moulded decoration. White glaze, mottled green and blue. *15.2 cm.* Made and found in Debrecen, Hajdú-Bihar County (Déri Museum, Debrecen)

471 Oil-lamp. Lead-glazed pottery. Green. *13 cm.* Szentgál, Veszprém County (Bakony Museum, Veszprém)

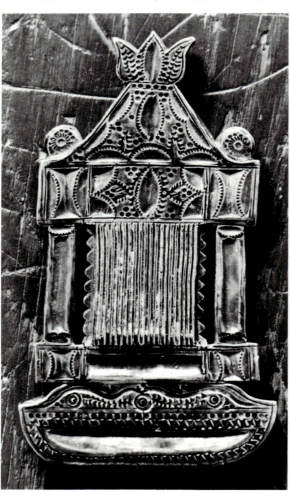

472

473

472 Vessel
for dipping candles.
Black-fired, unglazed
pottery with
decoration applied
in relief. *43.5 cm.*
Inscription:
"CZE SA AN 1833."
Mezőtúr,
Szolnok County
(Ethnographical
Museum)

473 Front
of a vessel
for dipping candles.
Terracotta, unglazed
pottery with decora-
tion applied in relief.
31 cm. Inscription:
"MADE IN 1829."
Found in Jászkisér,
Szolnok County
(Damjanich János
Museum, Szolnok)

474 Front
of a vessel
for dipping candles.
Black-fired, unglazed
pottery with
decoration applied
in relief. *32 cm.*
Inscription: "Anno
1820."
Túrkeve, Szolnok
County (Györffy
István Museum,
Karcag)

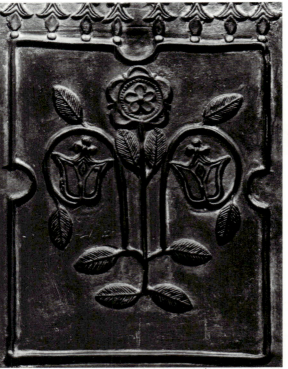

474

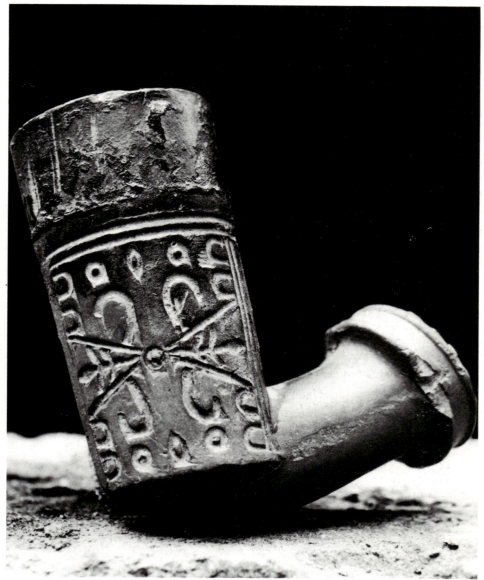

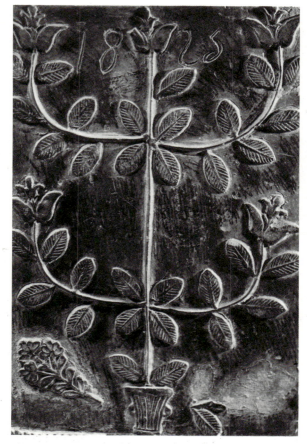

475

476

475 Front
of a vessel
for dipping candles.
Black-fired, unglazed
pottery with
decoration applied
in relief. *43 cm*.
Inscription: "1825."
Made at Mezőtúr,
Szolnok County
(Ethnographical
Museum)

476 Detail
of vessel for dipping
candles. Black-fired,
unglazed pottery
with decoration
applied in relief.
32 cm. Inscription:
"Belonging
to the Honourable
András Nagy."
Csongrád County
(Móra Ferenc
Museum, Szeged)

477 Clay pipe.
Terracotta, unglazed
pottery, with
engraved decoration.
6 cm.
Made and found in
Debrecen, Hajdú-
Bihar County
(Ethnographical
Museum)

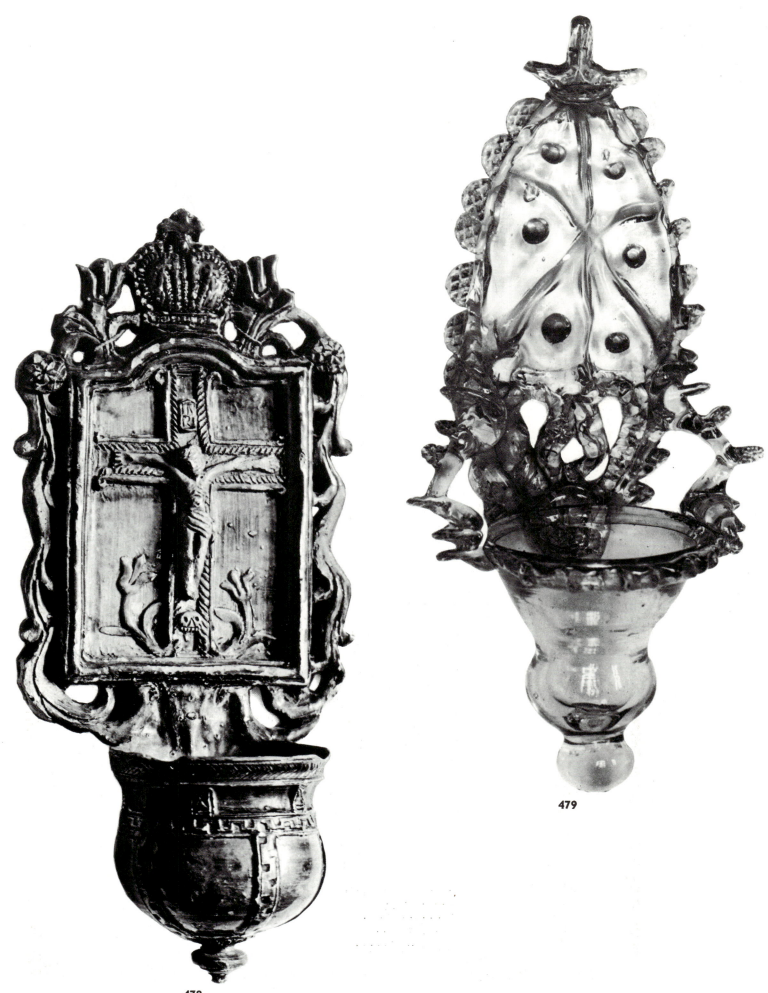

478

479

478 Stoup for holy water, with crucifix. Lead-glazed pottery with decoration in relief. The glaze is green and light yellow. *42 cm*. Made and found in Komárom, Komárom County (Mrs. Tibor Keresztes's collection)

479 Stoup for holy water. Blown glass. Made and found in Parádsasvár, Heves County (Sándor **Bökönyi**'s collection, Budapest)

480 Young girls in procession carrying the statue of the Virgin. Mezőkövesd, Borsod-Abaúj-Zemplén County

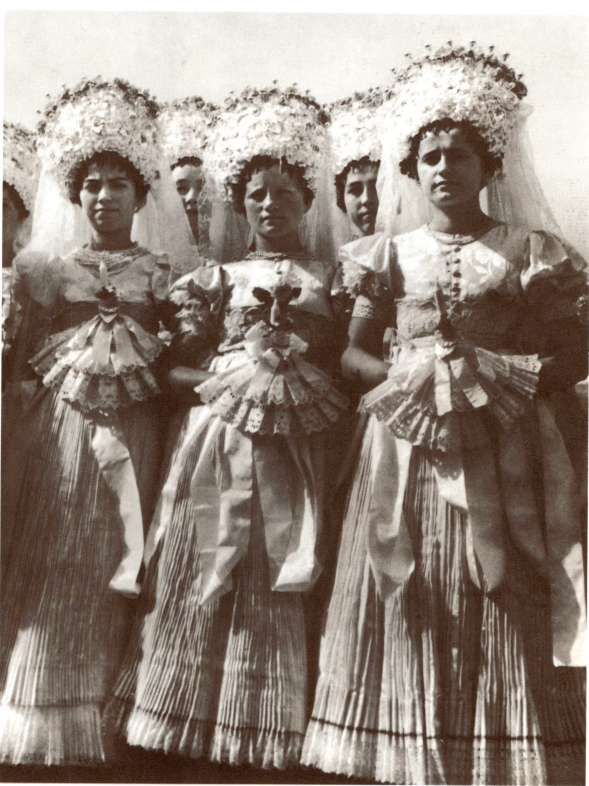

480

481

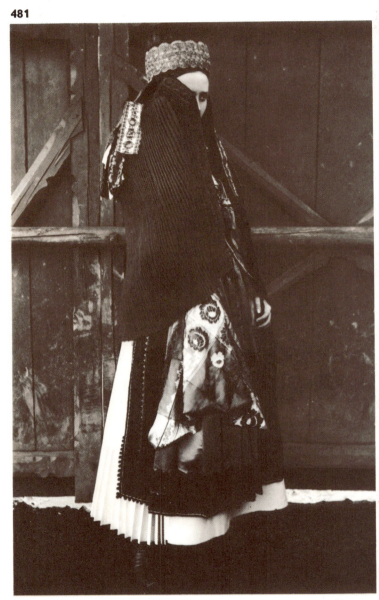

482

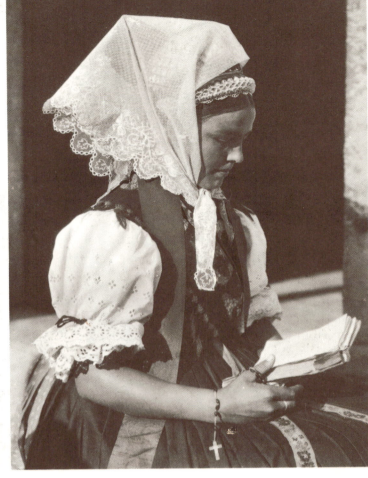

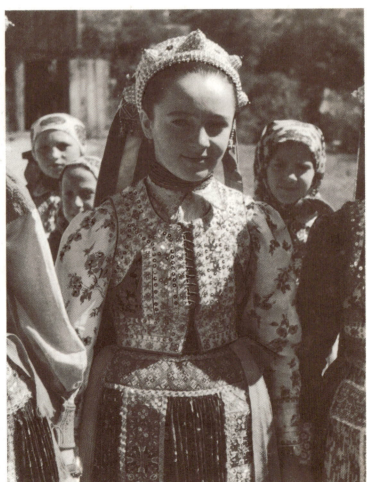

483

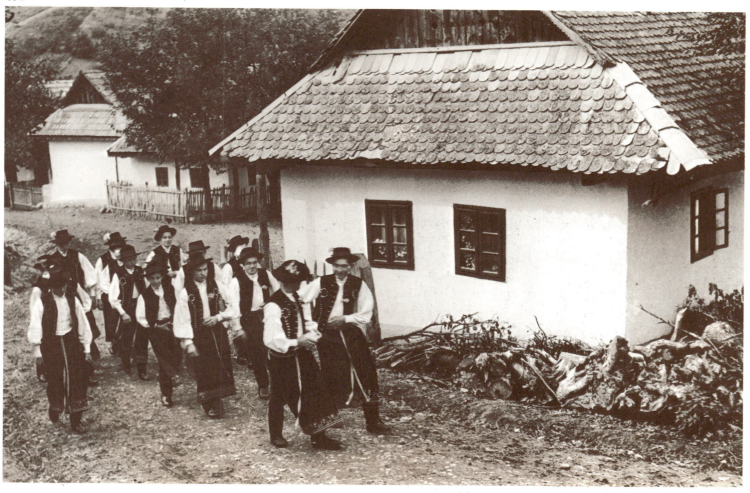

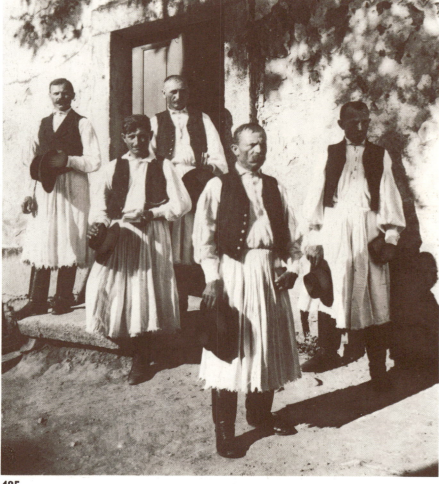

481 Young girl in the type of cloak worn for church, wearing a *párta*, the head-dress for maidens. Torockó (Rimetea, Rumania)

482 A young wife in her "big bonnet" with a tulle kerchief over it. Maconka, Heves County

483 Young girl wearing a *párta*, the head-dress for maidens. Méra (Mera, Rumania)

484 Group of young men in their holiday attire. Rimóc, Nógrád County

485 Men in summer attire made of home-spun linen and cloth waistcoats. Maconka, Nógrád County

486 Bridesmaid or *koszorúslány*, her dress adorned with the wreaths she has received when acting as a bridesmaid at previous weddings. Szeged, Csongrád County

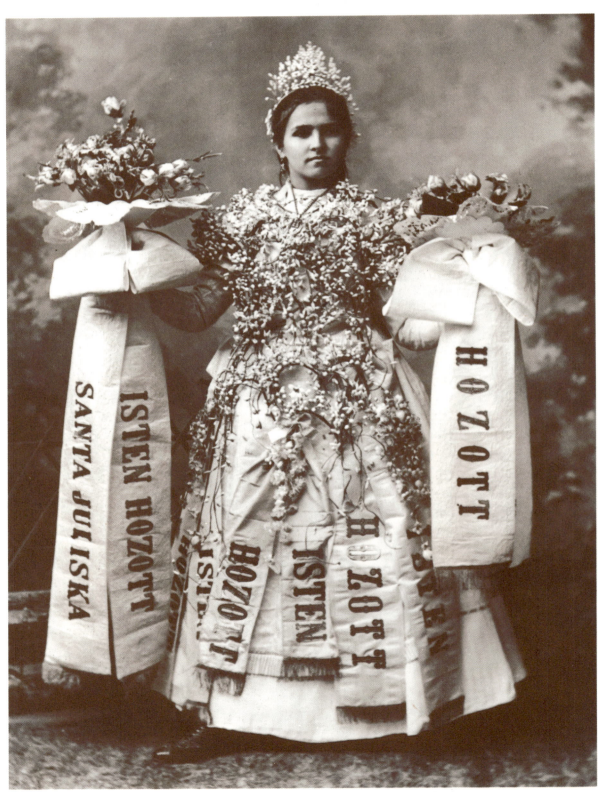

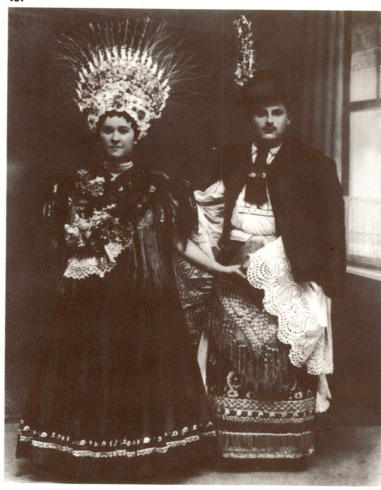

487 Bride
and bridegroom.
The bride is wearing
a tall wreath head-
dress adorned with
ears of corn.
The bridegroom,
with a nosegay in his
hat, is wearing
the "bridegroom's
shirt" with wide
embroidered sleeves
and, in front of his
apron, the "betrothal
kerchief."
Mezőkövesd,
Borsod-Abaúj-
Zemplén County

488 Young men
in tall hats, shirts
with wide
embroidered sleeves
and the apron worn
by unmarried
young men.
Mezőkövesd,
Borsod-Abaúj-
Zemplén County

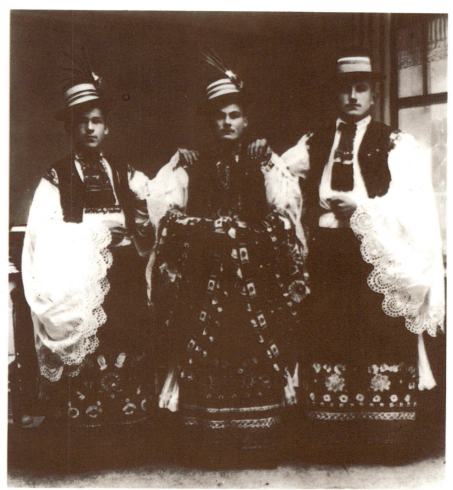

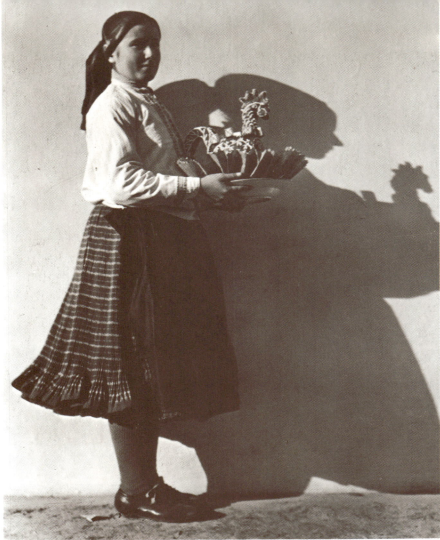

489 Young girl
with a present
of a wedding cake
in the shape
of a cock.
Boldog, Pest County

490 Milk-bread
baked for a wedding.
A present from
the godmother
of the bride.
Boldog, Pest County

491 Women
examining
the bride's
trousseau.
Vista
(Viştea, Rumania)

492 Wedding
procession.
In the centre is
the wagon with
the bride's bedding.
Balavásár
(Bălăvşeri, Rumania)

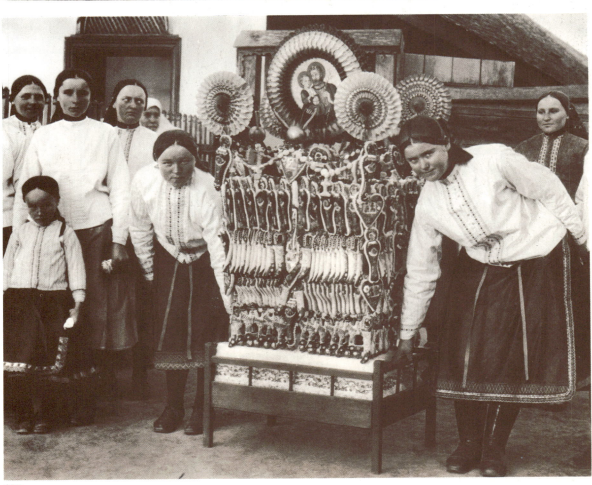

490

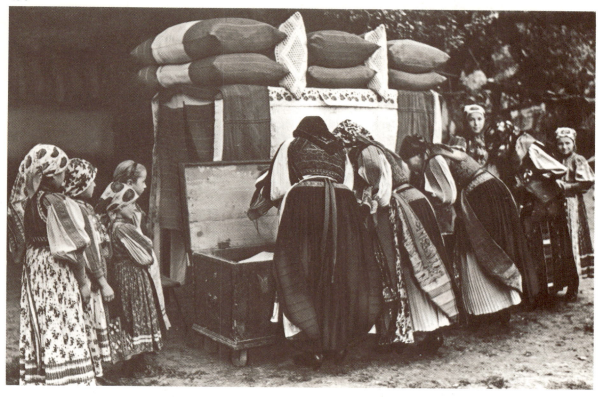

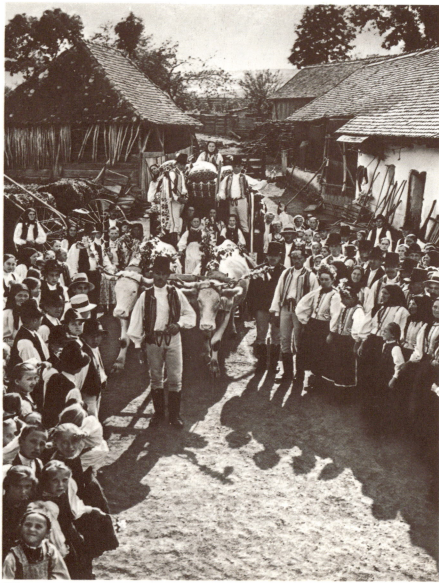

493

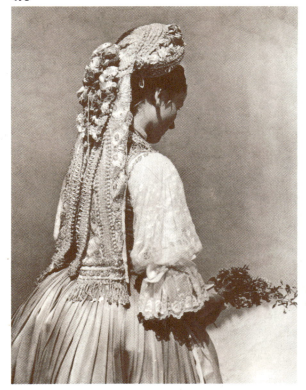

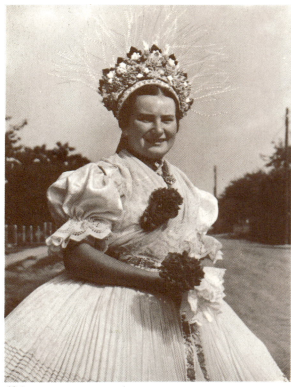

494

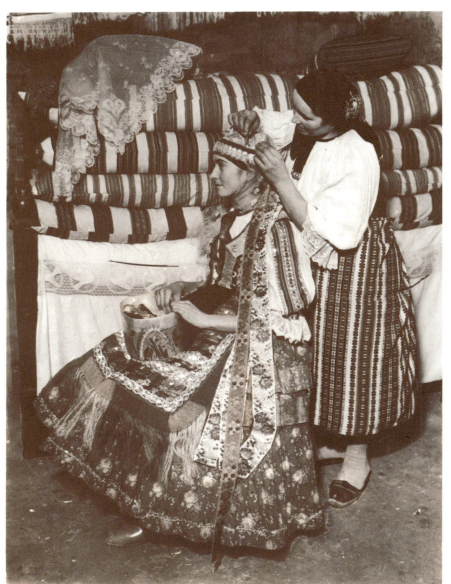

495

493 Young married woman in a "young wife's bonnet". Hugyag, Nógrád County

494 Bride. Rimóc, Nógrád County

495 Placing the new wife's head-dress on the head of a newly married young woman. Szeremle, Bács-Kiskun County

496 The new wife is conducted to church. The first Sunday after her marriage, she is escorted by the members of her husband's family to her new place in their pews. Magyargyerő-monostor (Manaștarul Unguresc, Rumania)

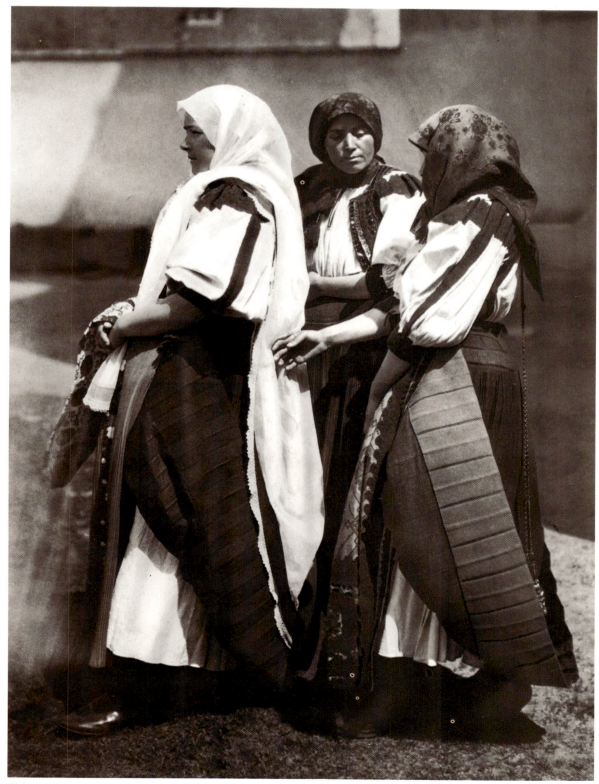

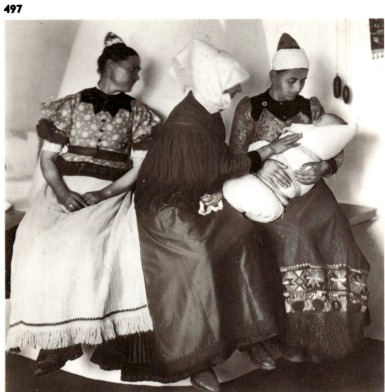

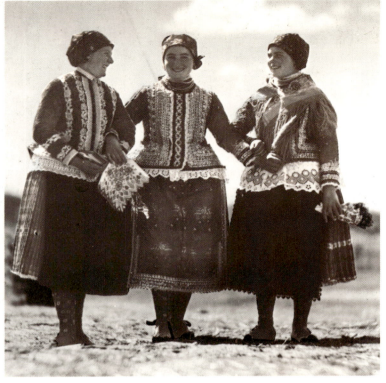

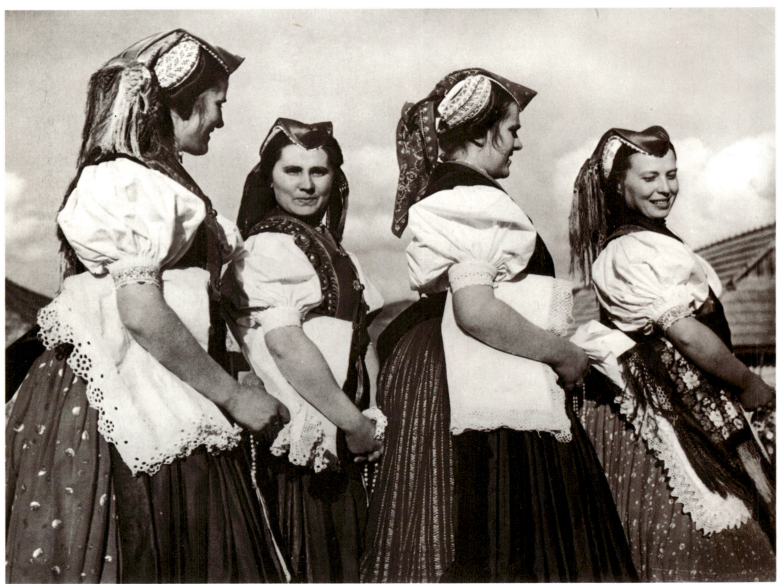

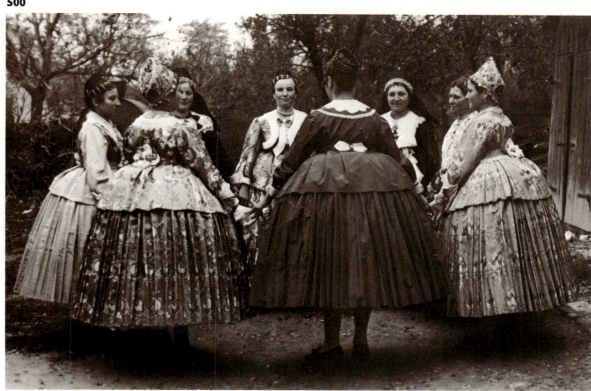

497 Women with baby. Mezőkövesd, Borsod-Abaúj-Zemplén County

498 Three young wives in their holiday attire. Sióagárd, Tolna County

499 Young wives on a holiday afternoon. Nagylóc, Nógrád County

500 A circle of young girls and wives in their holiday attire. Attala, Somogy County

501 Married couple. Pusztafalu, Borsod-Abaúj-Zemplén County

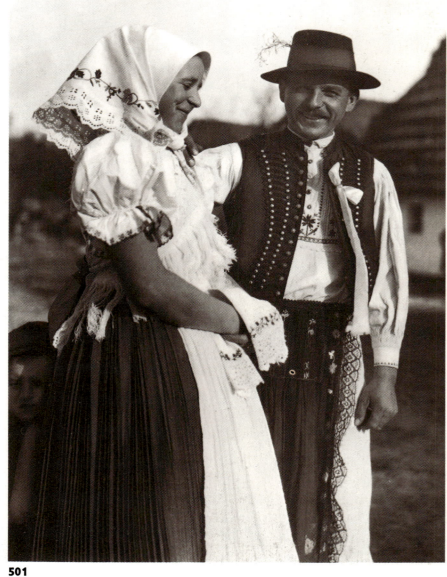

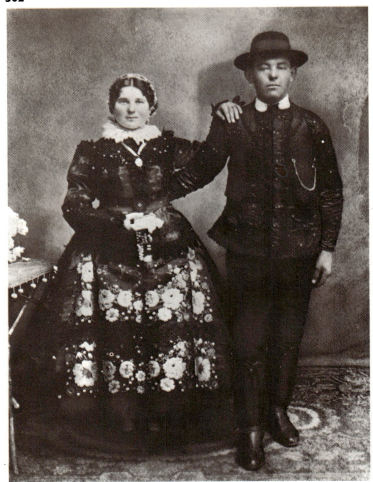

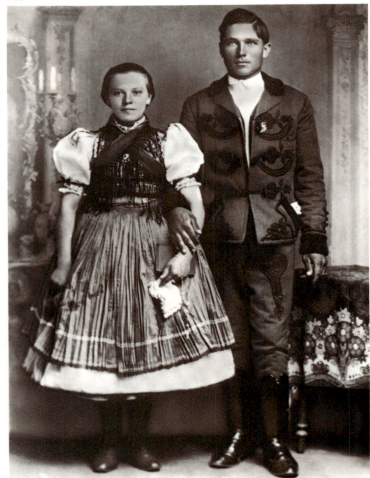

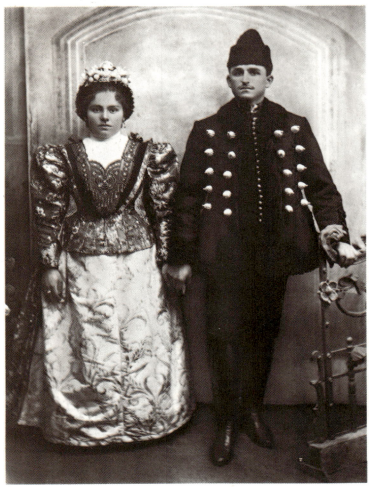

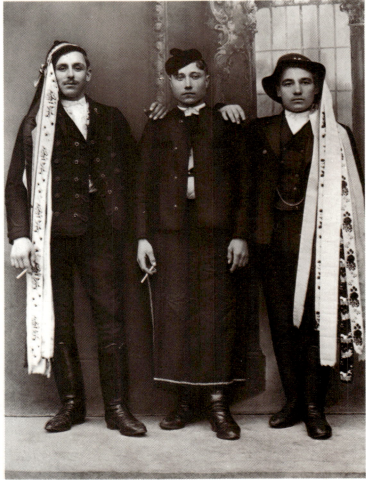

502 Young couple.
Kalocsa region,
Bács-Kiskun County.
The work of a local
photographer
commissioned
by villagers

503 Young couple.
Vajdácska, Borsod-
Abaúj-Zemplén
County.
The work of a local
photographer
commissioned
by villagers

504 Young couple,
the man wearing
a jacket decorated
with braid and silver
buttons.
Szolnok,
Szolnok County.
The work of a local
photographer
commissioned
by villagers

505 Young men.
The two standing
on each side have
been conscripted
for national service.
Their hats sport
ribbons.
Kapuvár, Győr-
Sopron County.
The work of a local
photographer
commissioned
by villagers

506 Old couple,
the woman in white
mourning.
Csököly,
Somogy County

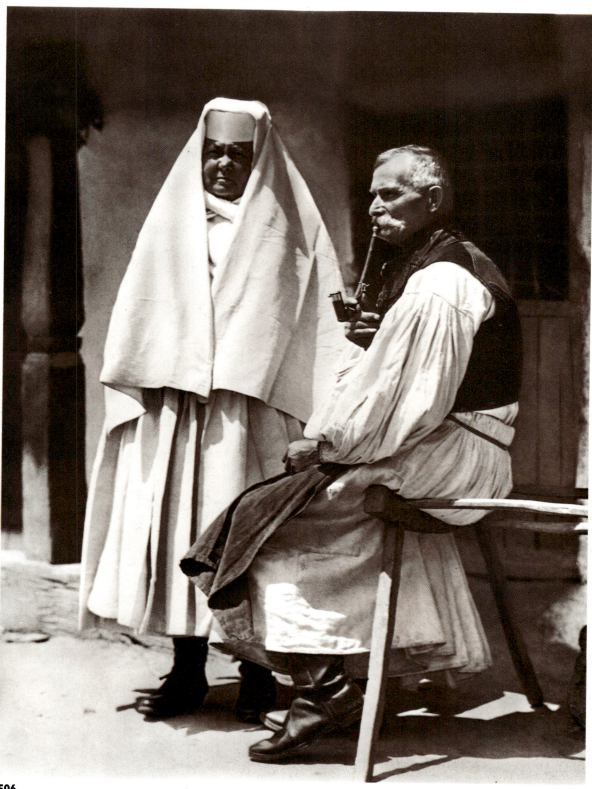

508

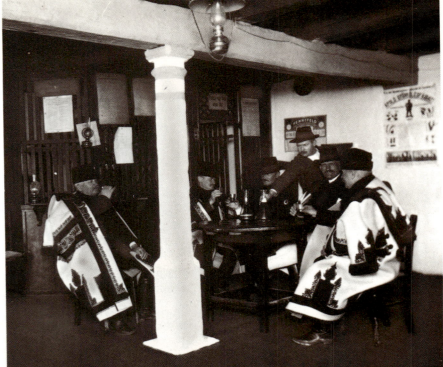

507

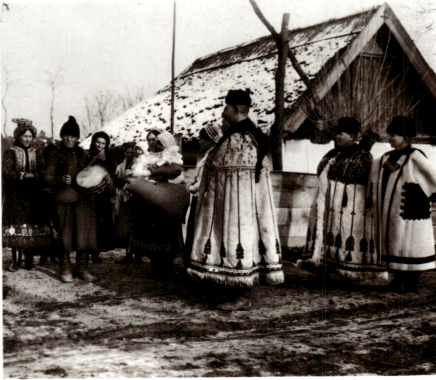

509

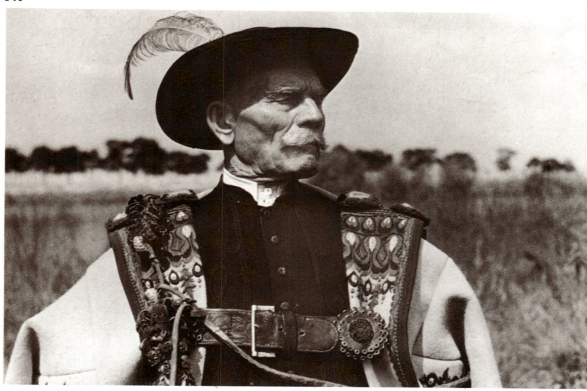

507 Man in a *suba* (embroidered sheepskin cloak) made for wearing in church. Decs, Tolna County

508 Men wearing *szűr* (frieze coats) in an inn. Cserépfalu, Borsod-Abaúj-Zemplén County

509 "Drumming the news." Szentistván, Borsod-Abaúj-Zemplén County

510 Herdsman in his *szűr* (frieze coat). Hortobágy, Hajdú-Bihar County

511 Women wearing sheepskin jackets. Cigánd, Borsod-Abaúj-Zemplén County

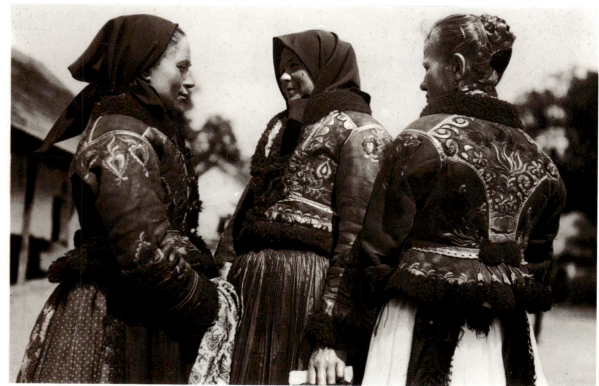

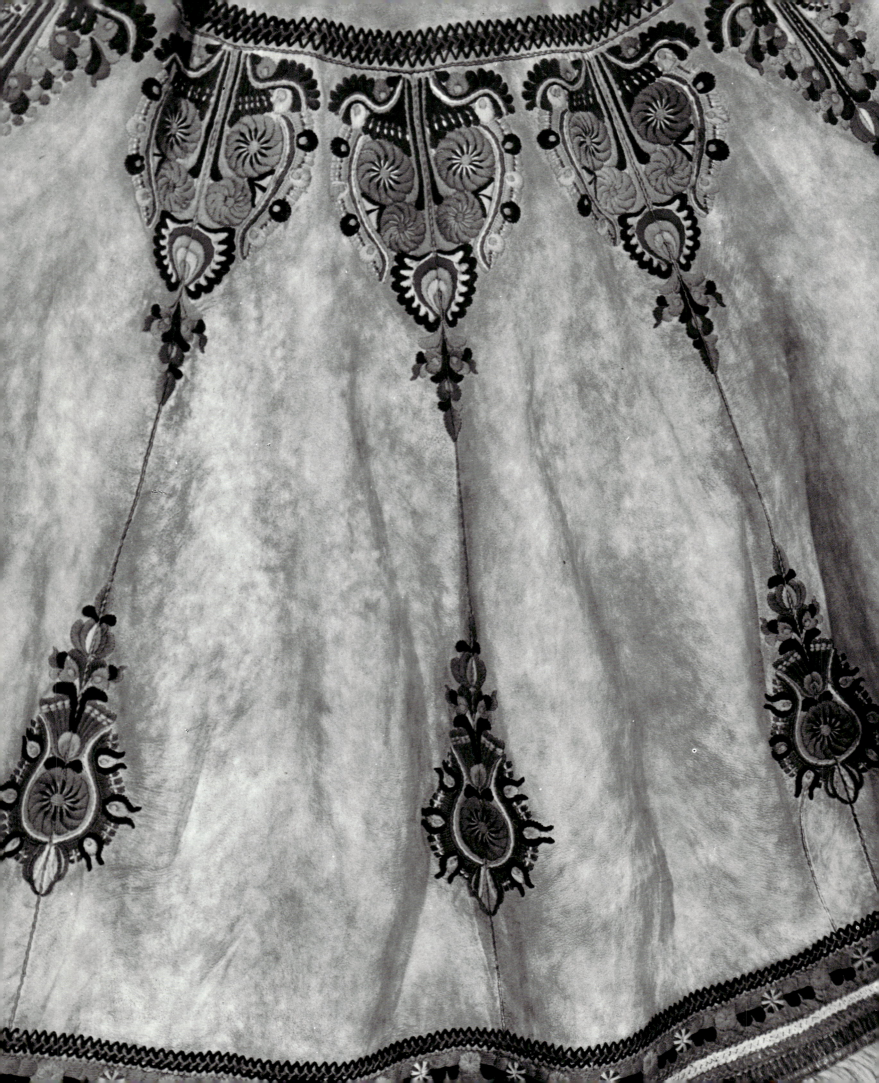

512 *Suba*
(embroidered
sheepskin cloak)
made from whole
skins joined together
lengthwise. On the
yellow-tanned leather
side of the sheepskin,
the embroidery is
worked with crewel
in dark and light
green, red, yellow,
blue, violet, black
and white. Detail.
The design known
as the "rose of the
suba" is sewn along
the vertical seams
of the cloak. *92 cm.*
Kiskunmajsa,
Bács-Kiskun County
(Ethnographical
Museum)

513 Embroidery
from the shoulder
of a *suba* (sheepskin
cloak). On the yellow-
tanned leather side
of the sheepskin,
the embroidery
is worked with
crewel in dark
and light green, red,
yellow, blue, violet,
black and white.
40 cm.
Kiskunmajsa,
Bács-Kiskun County
(Ethnographical
Museum)

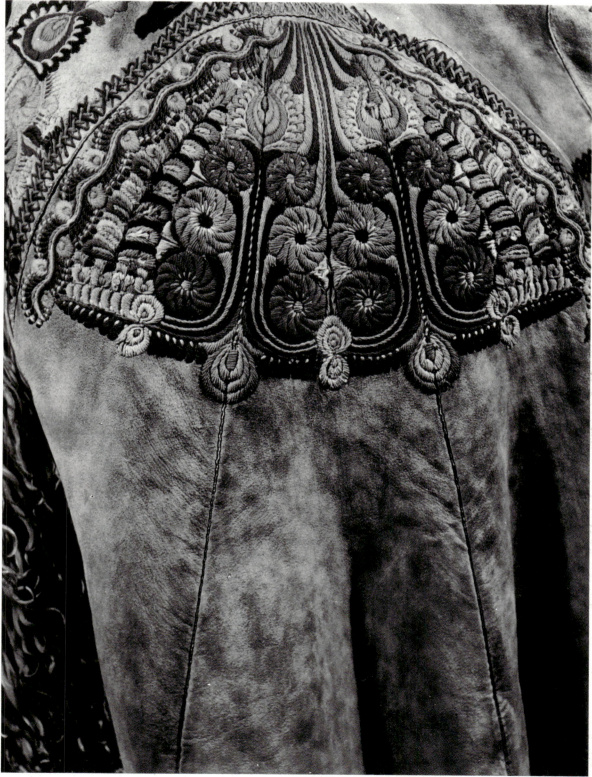

513

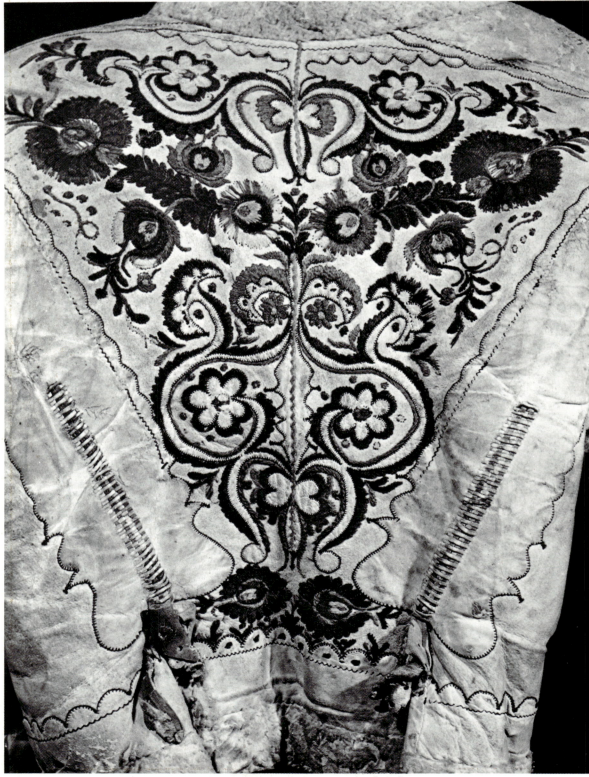

514 Back
of a woman's
sheepskin jacket.
Appliqué of bleached
white leather
and embroidery
with furrier's silk
yarn in two shades
of green, red, claret,
buff and blue on
white chamois.
Stitching and tassels
are of red chamois.
44 cm.
Békés County
(Ethnographical
Museum)

515 Woman's
sheepskin pelisse.
Embroidery worked
with furrier's silk
yarn. *84 cm.*
Debrecen,
Hajdú-Bihar County
(Ethnographical
Museum)

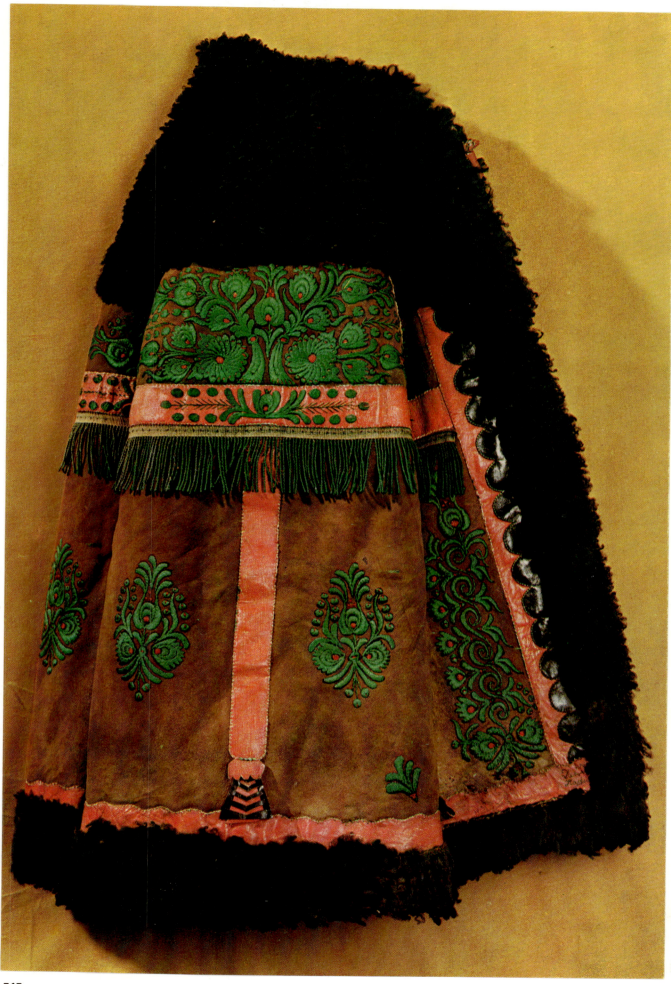

515

516 Back
of a woman's
sheepskin jacket.
Bleached leather
embroidered with
furrier's silk yarn
in violet, some
purple, two shades
of green, a little
black and yellow.
Along the seams,
white and red
chamois thongs.
57 cm.
Átány,
Heves County
(Ethnographical
Museum)

517 Shoulder piece
of a woman's
sheepskin pelisse.
Worked with bright
cotton thread in
green, buff, red,
yellow, blue
and violet on brown
leather trimmed
with red chamois
thongs. *25 cm.*
Hajdúböszörmény,
Hajdú-Bihar County
(Ethnographical
Museum)

518 Leather tobacco
pouch made of
a sheep's scrotum.
The wide flat edge
is embroidered with
coloured wool,
the edge is fringed
in leather. The pocket
is for tinder
and flint. *34 cm.*
Heves County
(Ethnographical
Museum)

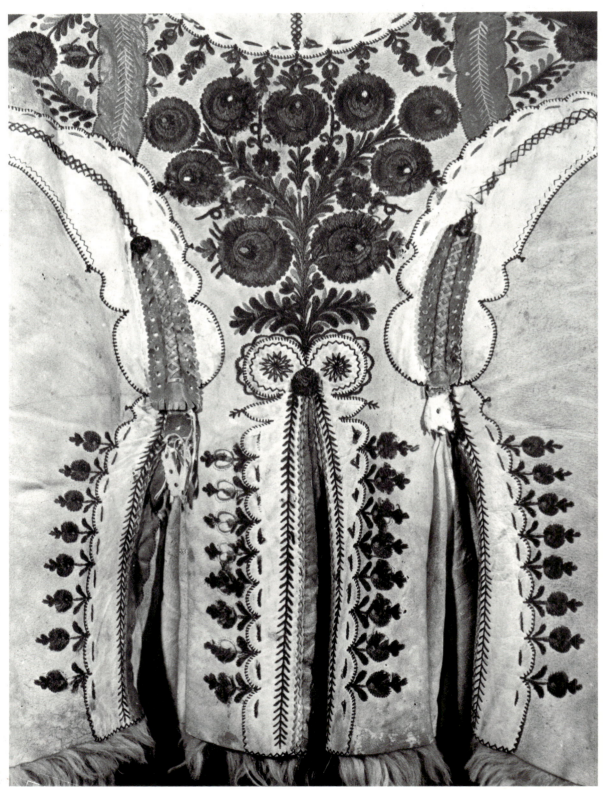

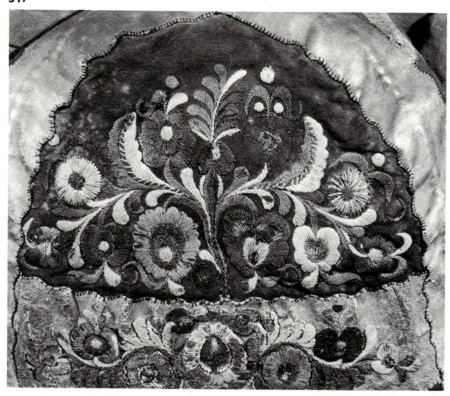

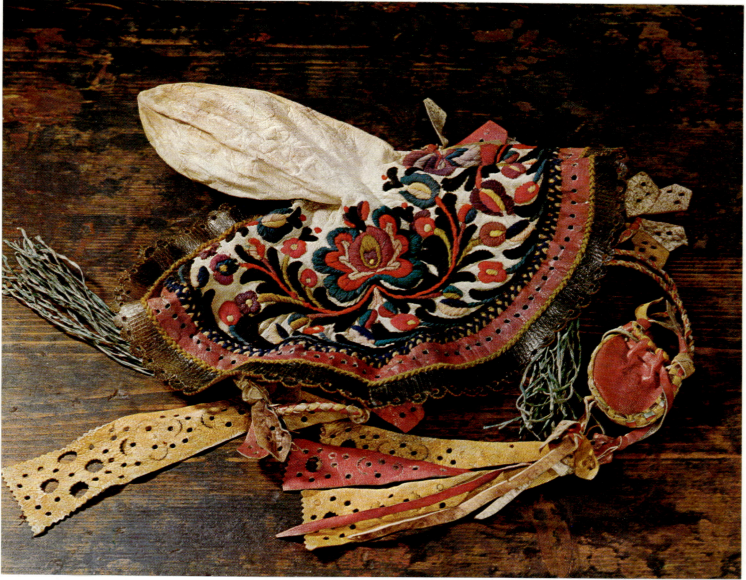

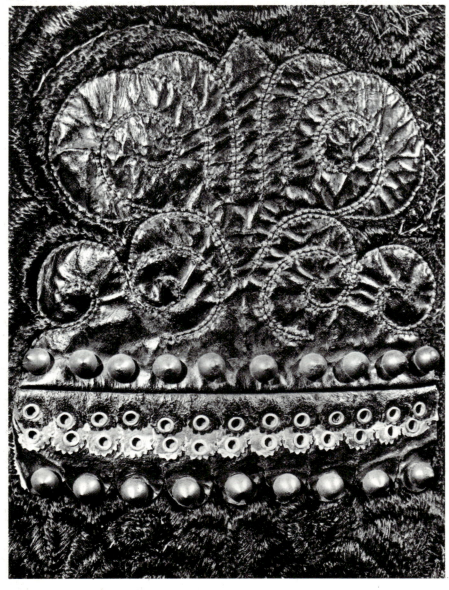

519 Appliqué
from the back
of a man's sheepskin
waistcoat. Black
chamois appliqué
worked on leather
and stitched with
green silk yarn,
surrounded
by embroidery
in claret, black
and dark green silk.
17 cm.
Kalotaszentkirály
(Sâncraiu, Rumania)
(Ethnographical
Museum)

520 Appliqué
from the back
of a woman's
sheepskin jacket,
decorated with
a large spiral of red
chamois thong.
Detail. *20 cm.*
Tolna County
(Ethnographical
Museum)

521 Back
of a woman's
sheepskin jacket.
Red and white
chamois appliqué
on bleached leather.
On and around
the appliqué,
the embroidery
is in black wool
and silk yarn in two
shades of green, red,
yellow, buff
and violet. Detail.
26 cm.
Tard, Borsod-Abaúj-
Zemplén County
(Ethnographical
Museum)

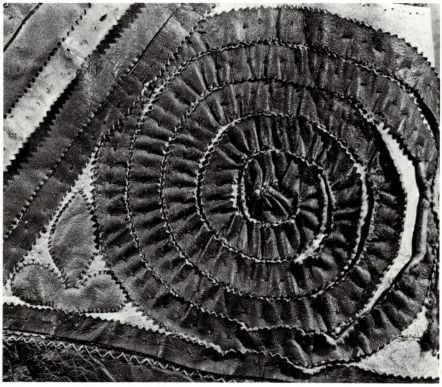

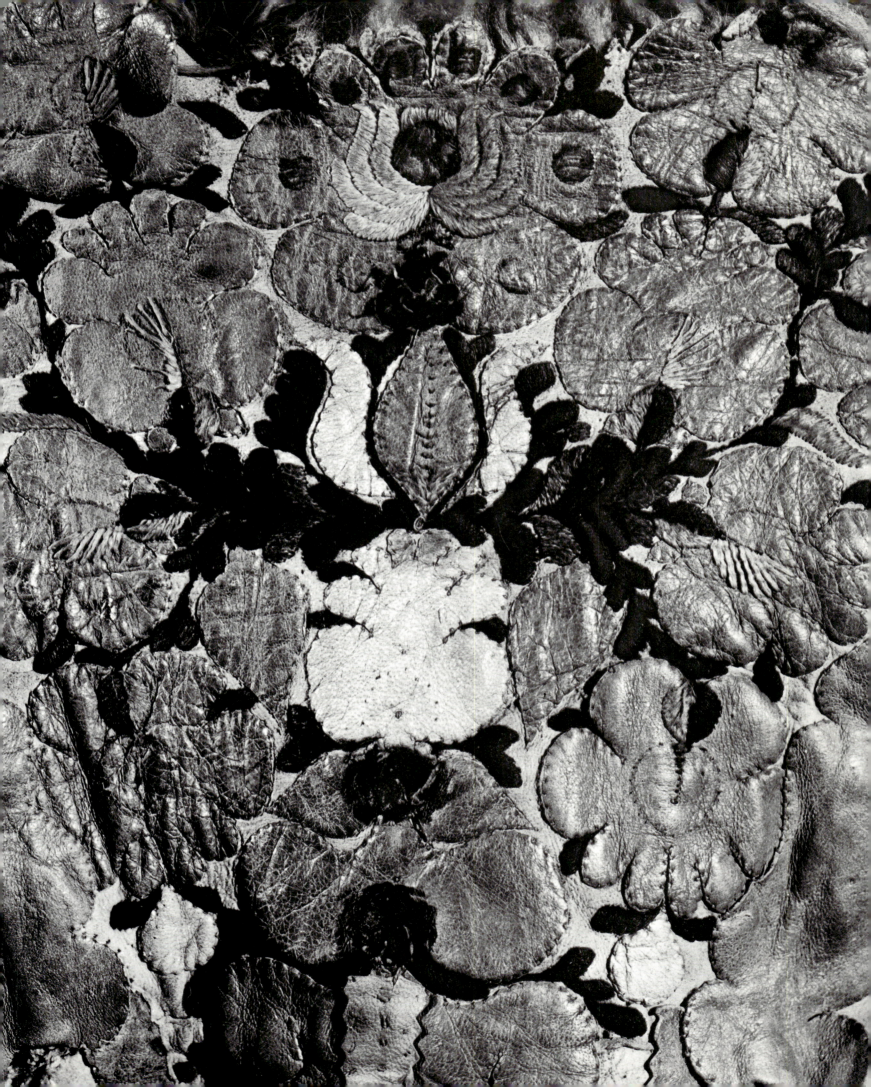

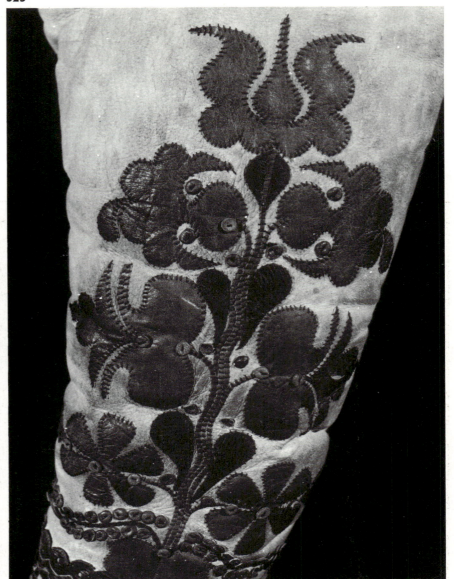

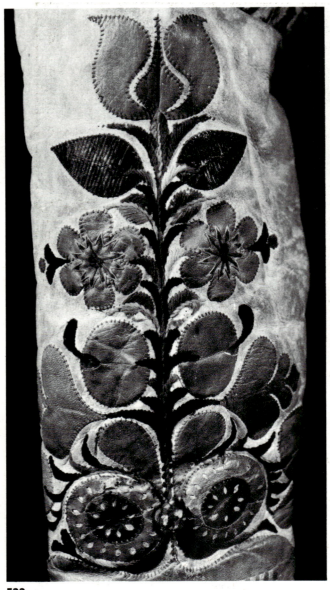

522 Sleeve
of a woman's
sheepskin jacket.
Red and green
chamois appliqué
with crewel
embroidery in green
and two shades
of red and buff.
Detail. *24 cm.*
Baranya County
(Ethnographical
Museum)

523 Sleeve
of a woman's
sheepskin jacket.
Bleached leather
with a flower-cluster
design of red and
green chamois,
and small scales
of red and yellow
chamois, sewn with
green yarn. *32 cm.*
Baranya County
(Ethnographical
Museum)

524 Back
of a woman's
sheepskin jacket.
Chamois appliqué
stitched with wool.
41 cm.
Baranya County
(Ethnographical
Museum)

522

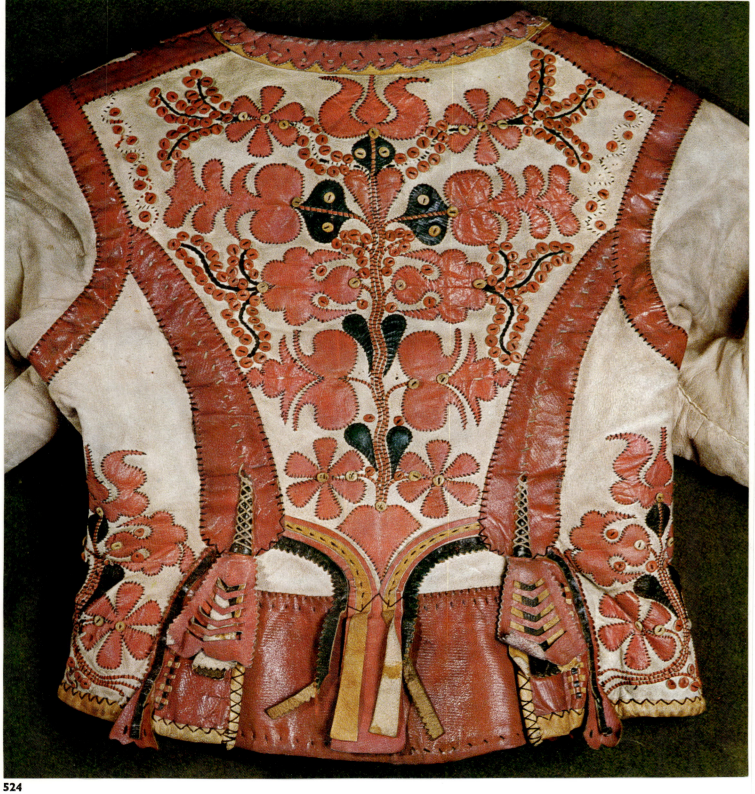

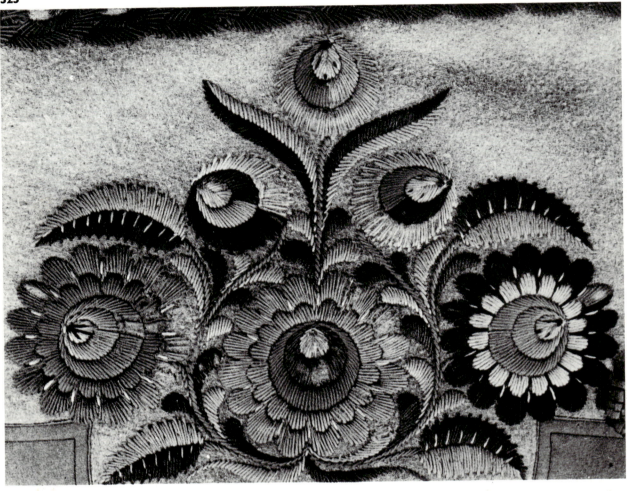

525 *"Szűr-*roses" decorating the side of a *szűr* (frieze coat). Embroidered on thick white frieze cloth with woollen yarn in two shades of green, violet, blue, red, yellow and pink. Trimmed below the "roses" with red cloth. *26 cm.* Somogy County (Ethnographical Museum)

526 Appliqué and embroidery from the bottom border of a *szűr* (frieze coat). Red cloth appliqué on white frieze cloth, covered with embroidery in red, pink, blue, green, violet and yellow wool. *27 cm.* Somogy County (Ethnographical Museum)

527 Back of a *cifraszűr* (embroidered frieze coat). Thick frieze with red cloth appliqué and coloured wool embroidery. Detail. *63 cm.* Szentgál, Veszprém County (Ethnographical Museum)

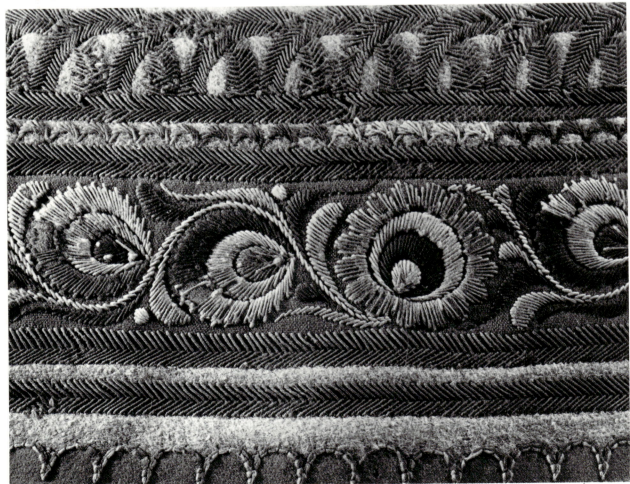

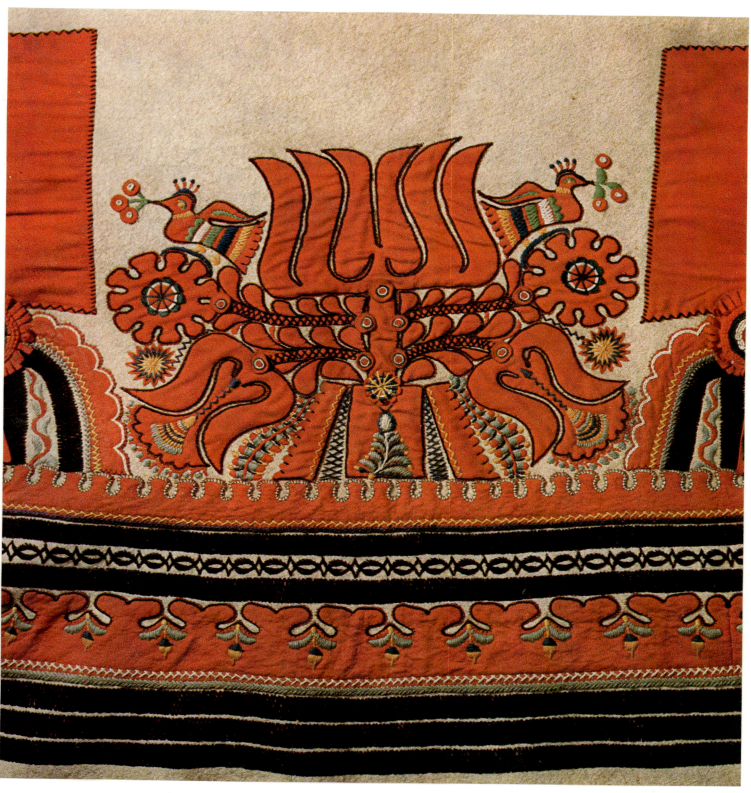

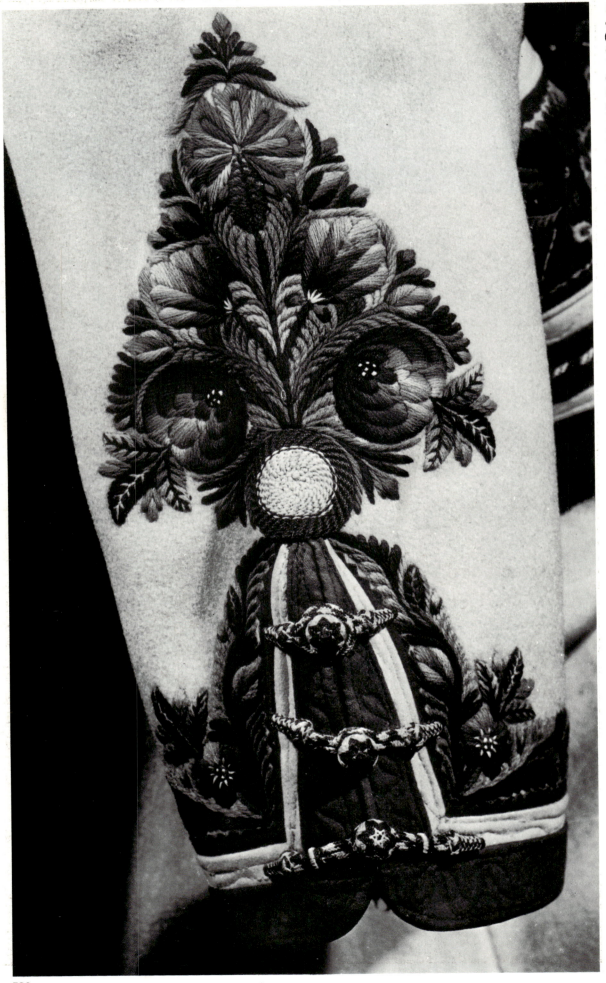

528 Sleeve
of a *cifraszűr*
(embroidered frieze
coat). Fine white
"aba" cloth
embroidered in
shades of green, red
and violet, also in
blue and pink wool
with a "dove-
basket" at the base
of the flower-cluster
design. On the cuff,
there is blue cloth
appliqué with three
double rows of long-
armed cross-stitch,
and embroidery.
34 cm.
Békés,
Békés County
(Ethnographical
Museum)

529 Back
of a *cifraszűr*
(embroidered frieze
coat) the sleeve
of which is shown
in Ill. 528. Shaded
woollen embroidery
on fine "aba" cloth.
120 cm.
Békés,
Békés County
(Ethnographical
Museum)

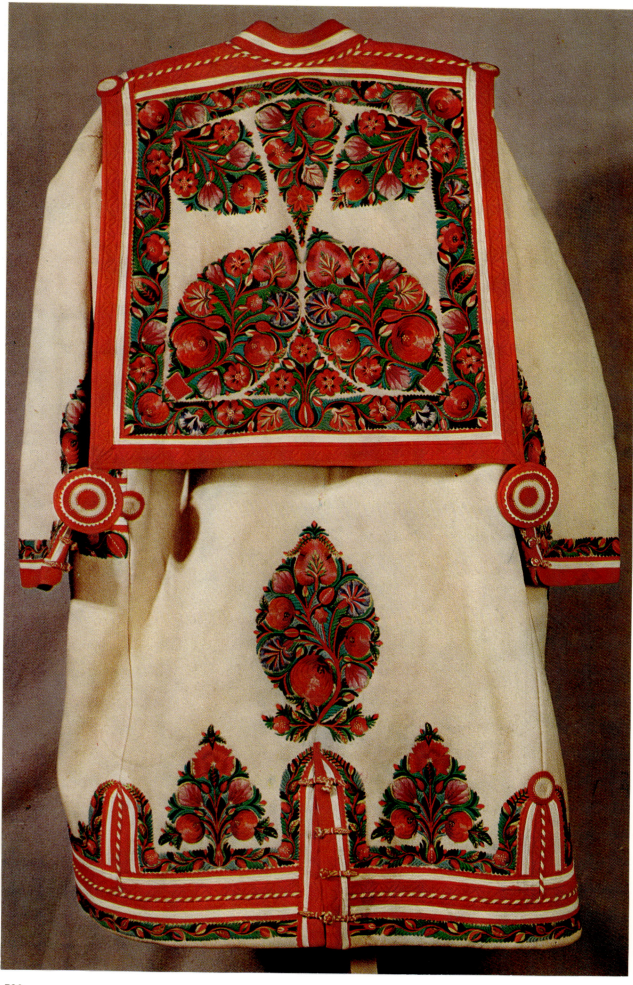

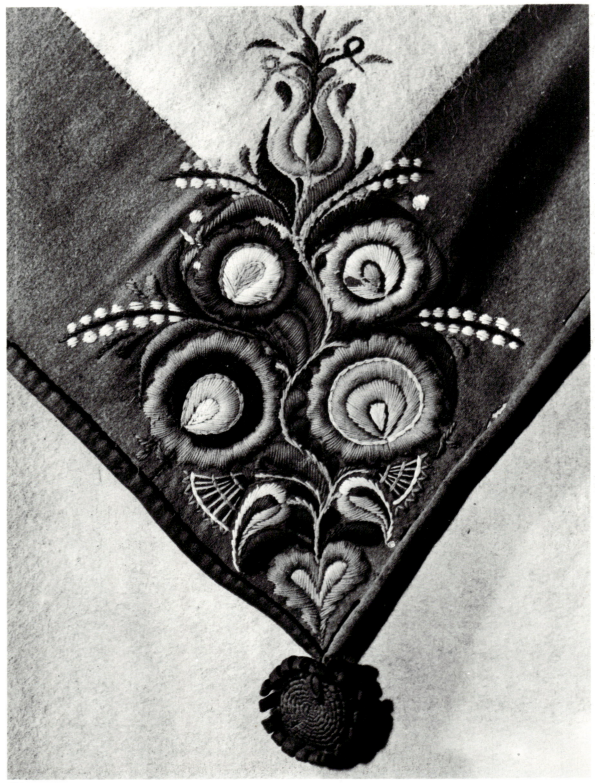

530 Embroidered corner of the collar of a *szűr* (frieze coat). Thick frieze with appliqué of red cloth and crewel embroidery in white, black, green, red, yellow and violet. *40 cm.* Veszprém County (Ethnographical Museum)

531 Detail from the bottom border of *cifraszűr* (embroidered frieze coat). Red, brown, green, blue and white crewel work on a white cloth ground. Crocheted "dove-basket" in red, white and green in the middle of one of the roses. The bottom edge of coat is bordered with rows of elaborately cut red and green cloth. Detail. *45 cm.* Mátra region, Heves County (Ethnographical Museum)

532 Embroidery on the side of a *cifraszűr* (embroidered frieze coat). Worked on thick white frieze in two shades of red, green, orange, brown, pink, violet and white crewel in rows, divided by elaborately cut stripes of red and green cloth. *27 cm.* Hortobágy, Hajdú-Bihar County (Ethnographical Museum)

531

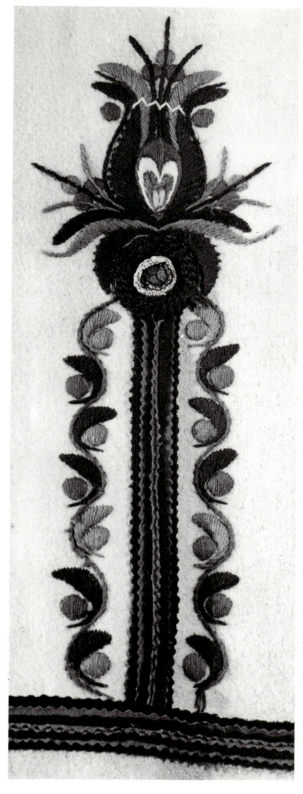

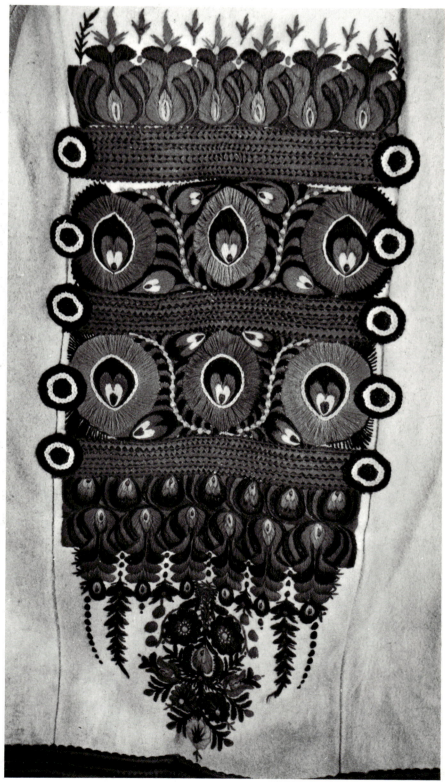

532

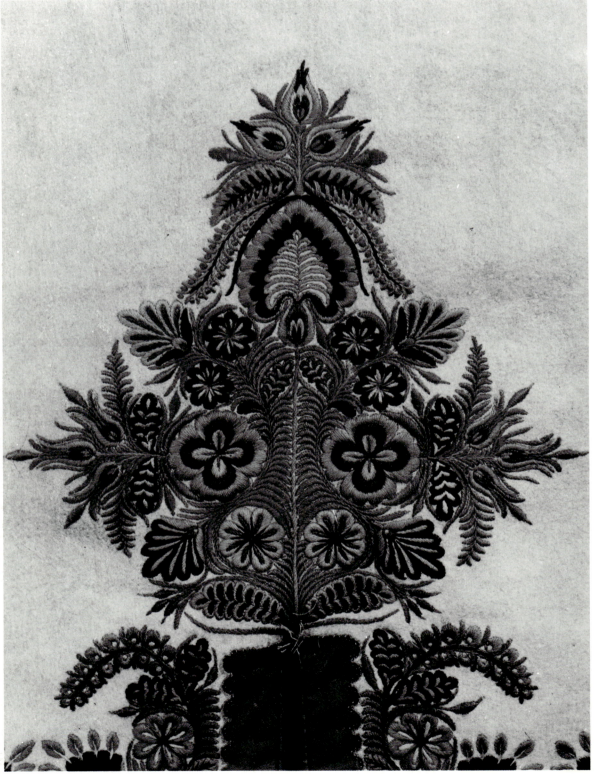

533 Embroidery
on the bottom
border of a *cifraszűr*
(embroidered frieze
coat). Thick white
cloth worked in
four shades of claret
and red, also pink
crewel in the design
of a bunch of flowers.
Red cloth appliqué
at the bottom
of the stem; the hem
is decorated with
sprays of flowers
and leaves in similar
colours. *50 cm.*
Bihar region
(Ethnographical
Museum)

534 Embroidery on the bottom border of a *cifraszűr* (embroidered frieze coat). A *"szűr*-rose" with the Hungarian coat of arms on white frieze, embroidered in brown, buff, blue, violet, green and pink woollen yarn. Near the hem, crocheted "dove-baskets", and below the hem, brown cloth stripes. *45 cm*. Bihar region (Ethnographical Museum)

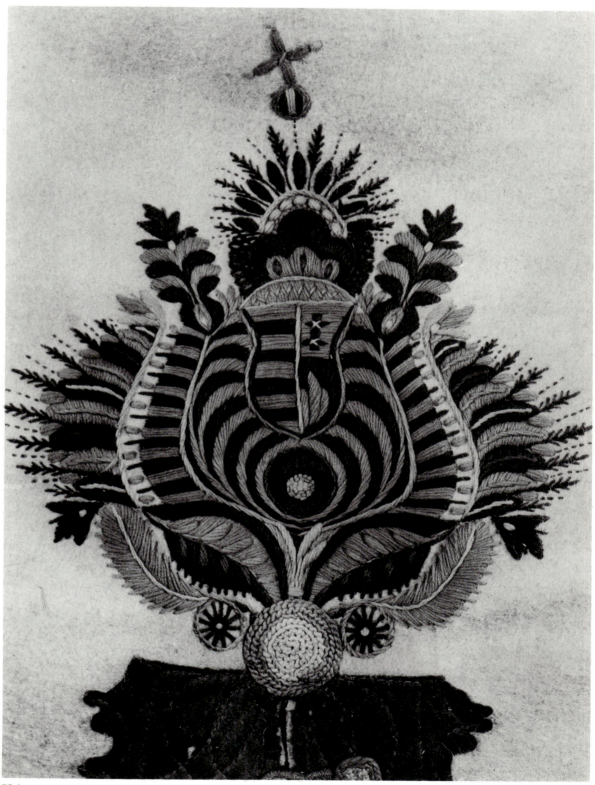

534

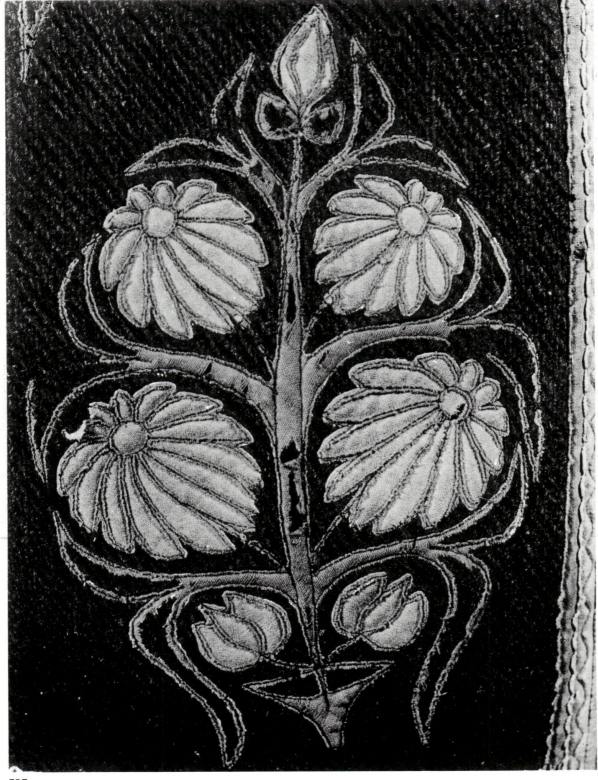

535 Appliqué
on the bottom border
of a *cifraszűr*
(embroidered frieze
coat). Thick black
frieze appliquéd with
a flower-cluster
in faded brown
machine-stitched
cloth. *34 cm*.
Tar, Heves County
(Ethnographical
Museum)

536 A "rose" with
appliqué from
the bottom border
of a *cifraszűr*
(embroidered frieze
coat). *48 cm*.
Derecske,
Hajdú-Bihar County
(Ethnographical
Museum)

535

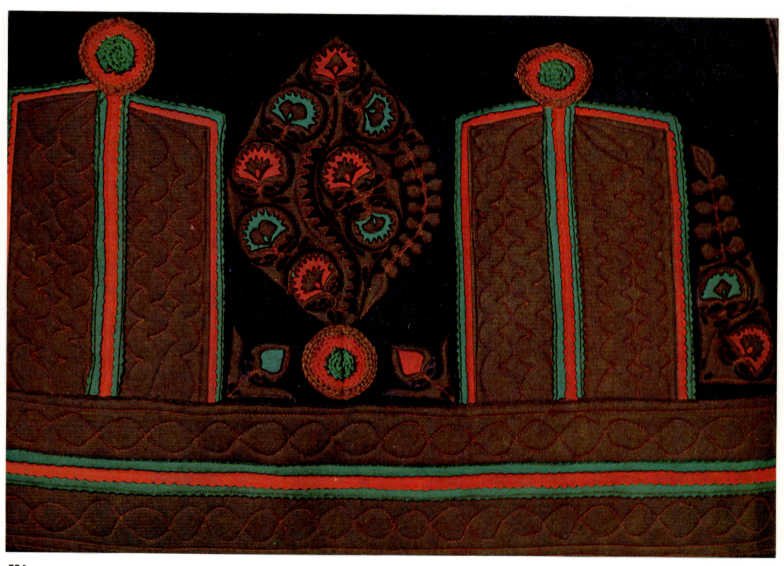

536

537 Buckle with engraved decoration for the *cifraszűr* (embroidered frieze coat) in Ills. 528 and 529. It is adorned with a leather rosette on the side and surrounded by embroidery. Silver. *15 cm.*

Békés County (Ethnographical Museum)

537

538 *Szűr* (frieze coat) button with engraved and hammered decoration. Brass. Diameter: *5.2 cm.* Great Plain (Ethnographical Museum)

539 *Szűr* (frieze coat) button with engraved and hammered star pattern. Brass. Diameter: *4 cm.* Great Plain (Ethnographical Museum)

540 *Szűr* (frieze coat) button with engraved and hammered decoration. Brass. Diameter: *5.2 cm.* Great Plain (Ethnographical Museum)

541 *Szűr* (frieze coat) button with engraved decoration and an elaborate edge. Brass. Diameter: *4 cm.* Great Plain (Ethnographical Museum)

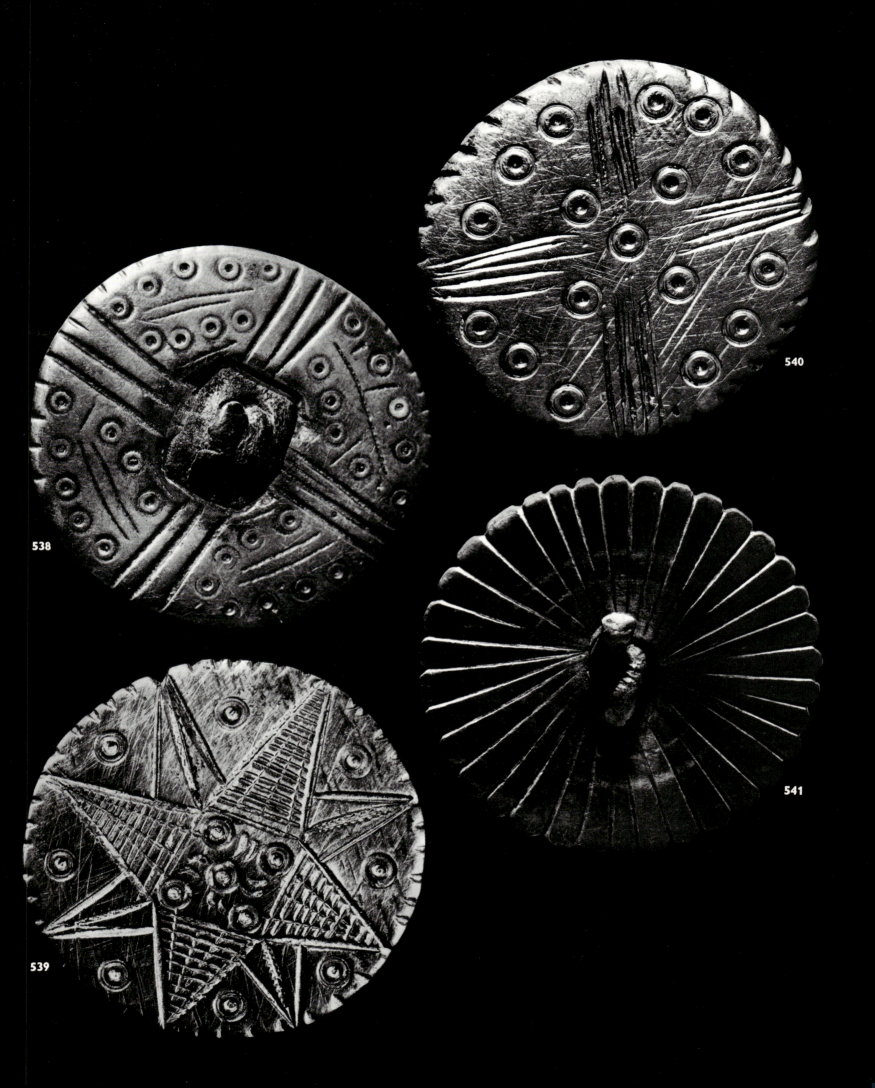

538

539

540

541

542 Chain
for a man's pelisse
or *mente*. Silver
filigree. Length
of half the chain:
26.5 cm. Diameter
of rosette: *6.5 cm*.
Made by Komárom
silversmiths.
Komárom,
Komárom County
(Ethnographical
Museum)

543 Buckle
of a chain for
a pelisse
in the shape of a sun.
Cast and silver-plated.
8 cm. Made
by Eger silversmiths.
Besenyőtelek,
Heves County
(Ethnographical
Museum)

544 Buckle
of a chain
for a pelisse with
a tulip design. Silver
filigree. *8 cm*. Made
by Komárom
silversmiths.
Csicsó (Čičov,
Czechoslovakia)
(Ethnographical
Museum)

545 Woman's
necklace known as
lázsiás, of silver
coins, framed in
silver and decorated
with coloured glass
beads. *48 cm*. Made
by silversmiths
of Baja.
Érsekcsanád,
Bács-Kiskun County
(Ethnographical
Museum)

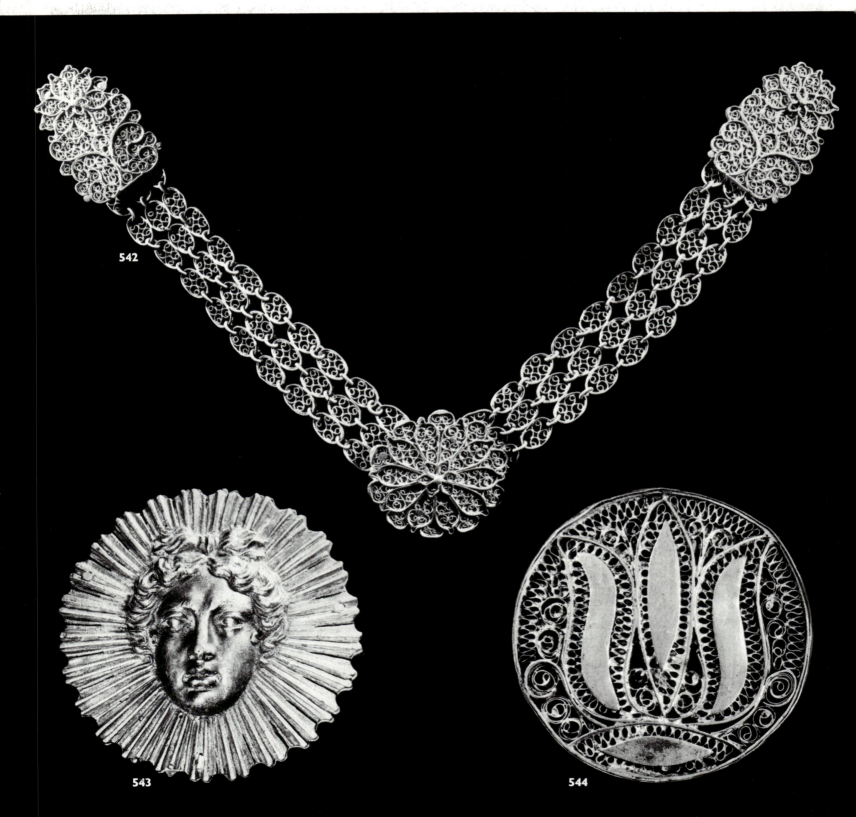

542

543

544

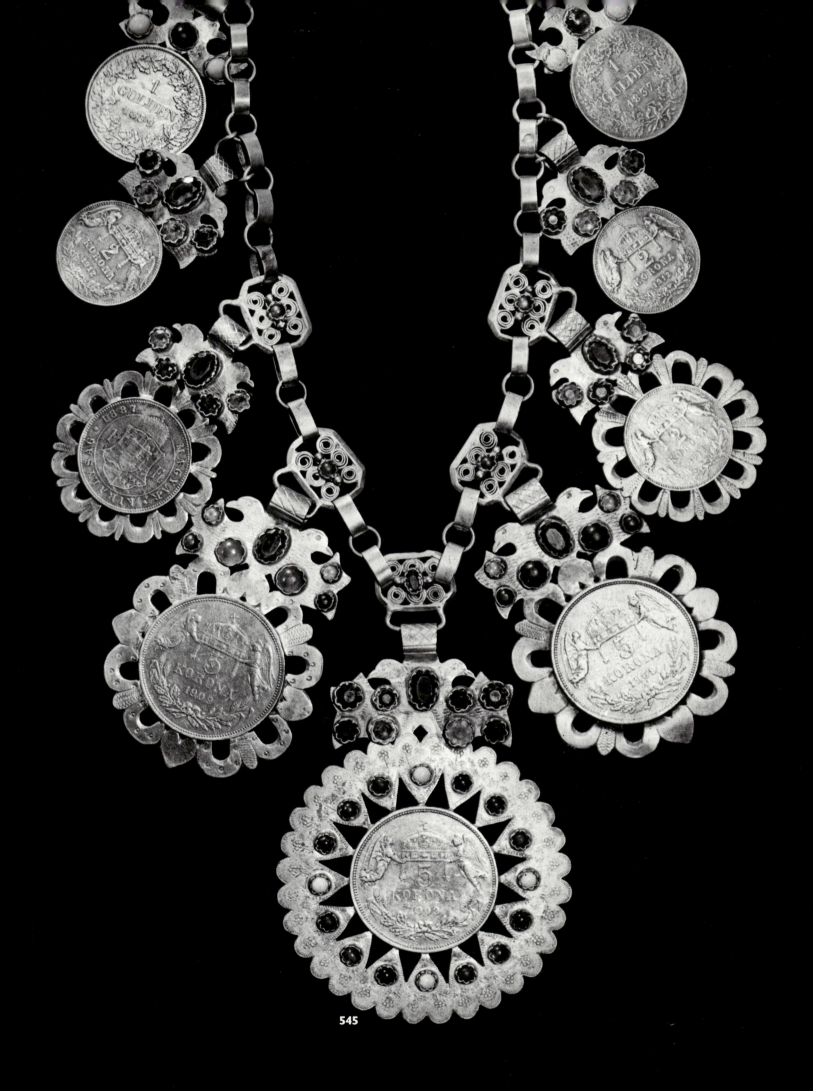

545

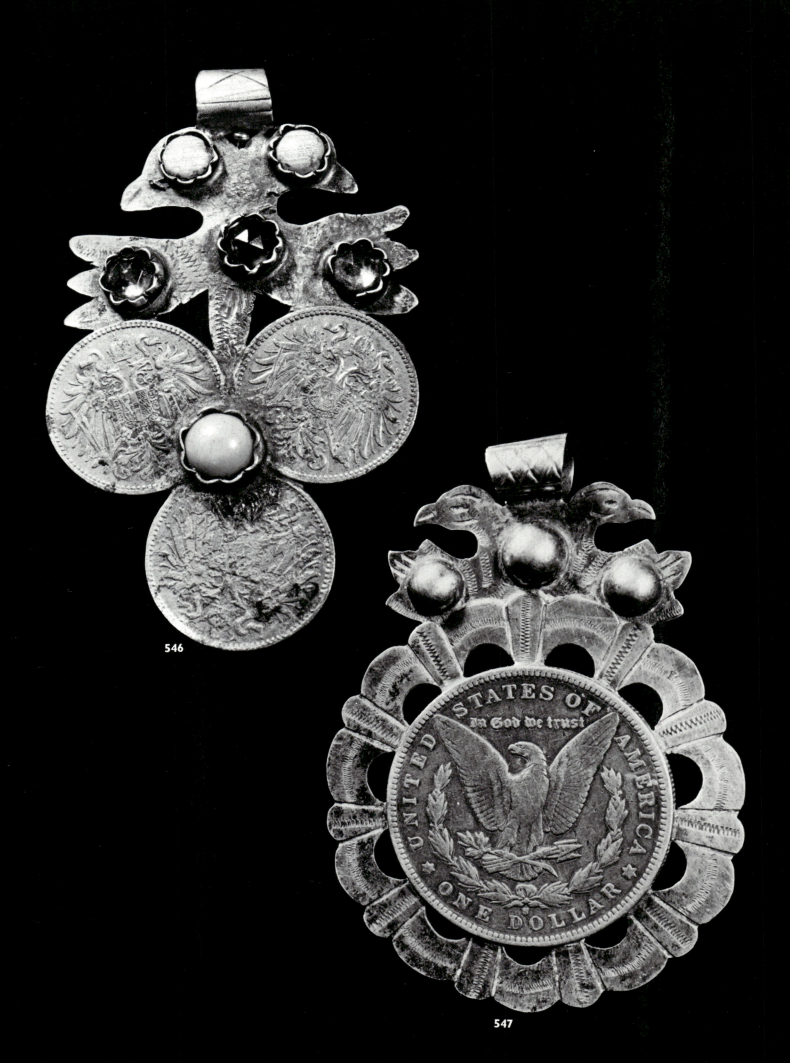

546

547

546 A three-coin medal from a *lázsiás* (woman's necklace). The silver coins are decorated with glass beads. *9.2 cm.* Érsekcsanád, Bács-Kiskun County (Ethnographical Museum)

547 *Lázsiás* (woman's necklace) made from a dollar, on order from a peasant who had returned home from America for a female member of his family. Made by silversmiths of Baja. (The coin dates from 1894.) Silver. *7.6 cm.* Érsekcsanád, Bács-Kiskun County (Ethnographical Museum)

548 Button from a man's waistcoat. Silver filigree. *5.5 cm.* Made by Komárom silversmiths. Komárom, Komárom County (Ethnographical Museum)

549 Seal ring of the Bootmakers' Guild, with engraved decoration. Brass. Bezel: *2 cm.* The initials "D C" are on either side of a spurred boot. Győr-Sopron County (Ethnographical Museum)

550 Woman's ring with a bezel in the shape of a heart. On the bezel, a flower, hammered and engraved. Silver. Bezel: *1.5 cm.* Made by Komárom silversmiths. Martos (Martovce, Czechoslovakia) (Ethnographical Museum)

551 Woman's ring with a bezel in the shape of a heart. On the bezel, a double flower, hammered and engraved. Silver. Bezel: *1.3 cm.* Made by Komárom silversmiths. Martos (Martovce, Czechoslovakia) (Ethnographical Museum)

552 Ring with hammered and engraved decoration. Silver-coated brass. *1.2 cm.* Szeged, Csongrád County (Ethnographical Museum)

548

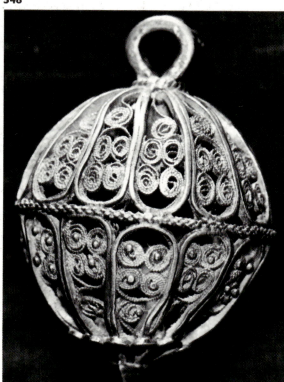

549

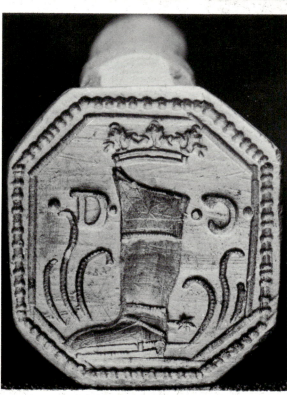

550

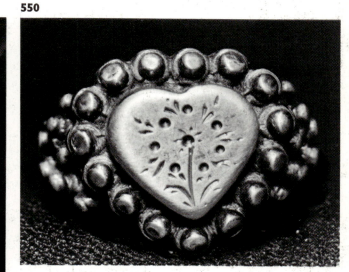

551

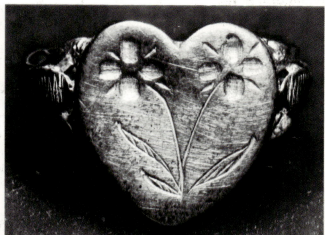

552

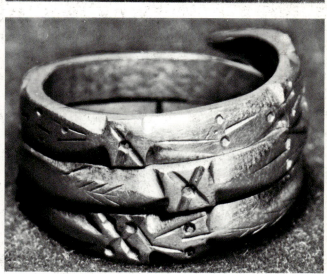

553

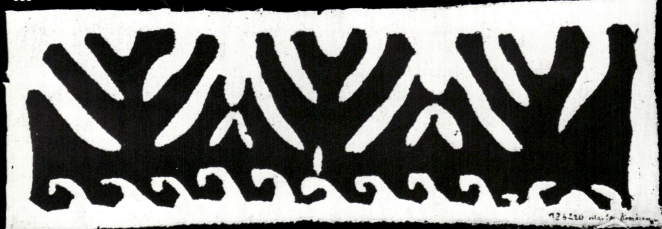

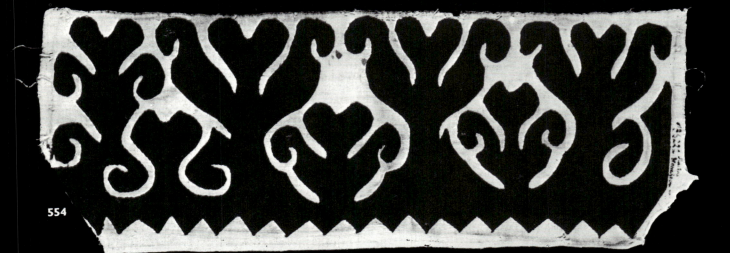

554

555

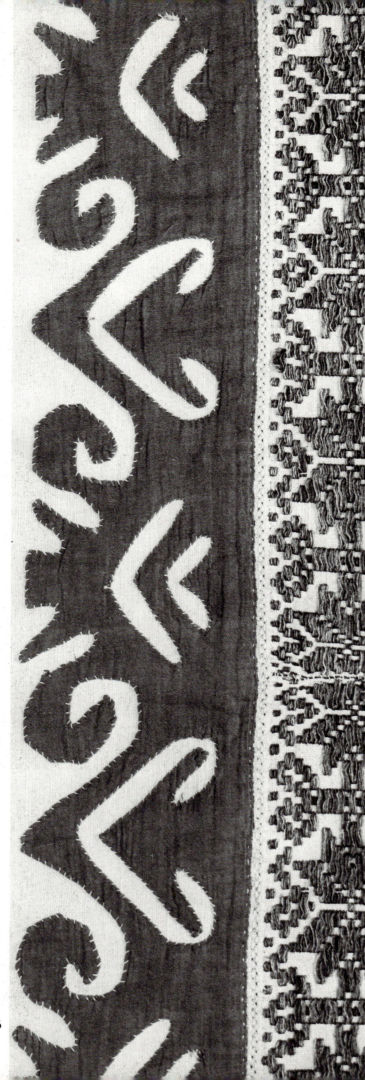
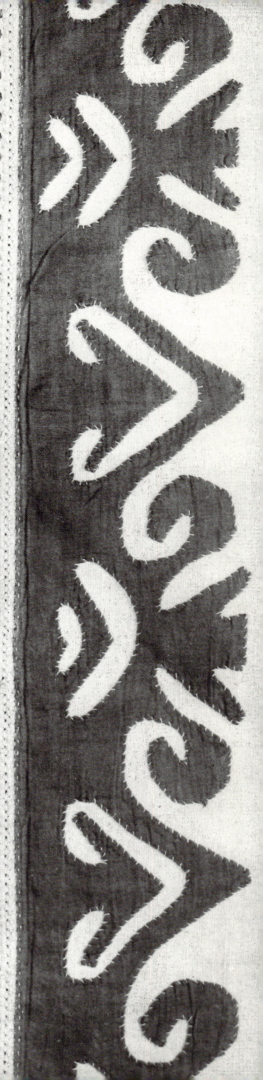

553 Cuff of woman's burial shift. White cambric with appliqué in black taffeta known as "four-fingered", as it was cut along four outspread fingers. *11 cm.* Martos (Martovce, Czechoslovakia) (Ethnographical Museum)

554 Cuff of woman's burial shift. White cambric with appliqué in black taffeta. *15 cm.* Martos (Martovce, Czechoslovakia) (Ethnographical Museum)

555 Cuff of a woman's burial shift. White cambric with appliqué in black taffeta. *15 cm.* Martos (Martovce, Czechoslovakia) (Ethnographical Museum)

556 Join between two edges of a coverlet. Red woven stripes join the edges and an appliqué of "red Viennese", e.g. red cotton, is mounted on them. *26 cm.* Táska, Somogy County (Ethnographical Museum)

556

557 Woven woollen
bedcover. White
ground, striped
in red and black.
Detail. *49 cm.*
Bács-Kiskun County
(Ethnographical
Museum)

558 Tablecloth
woven "in tables"
in a red and black
pattern. Detail. *58 cm.*
Sóvárad (Sărata,
Rumania)
(Ethnographical
Museum)

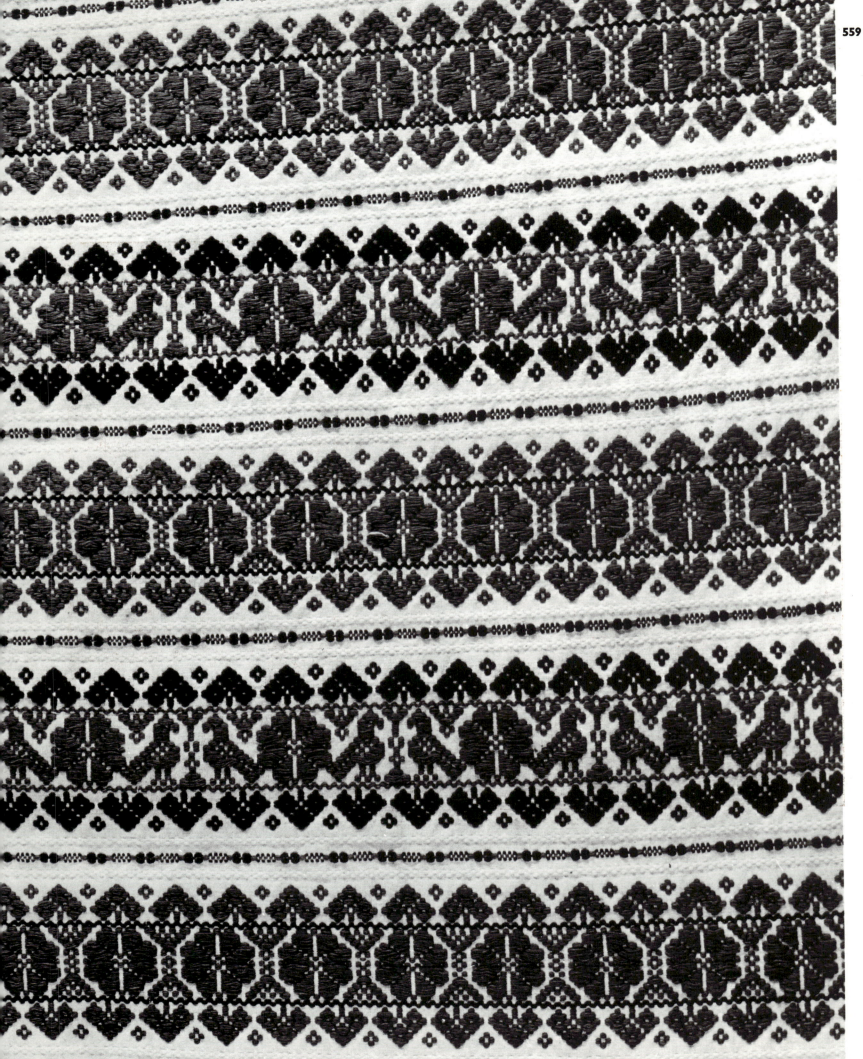

560

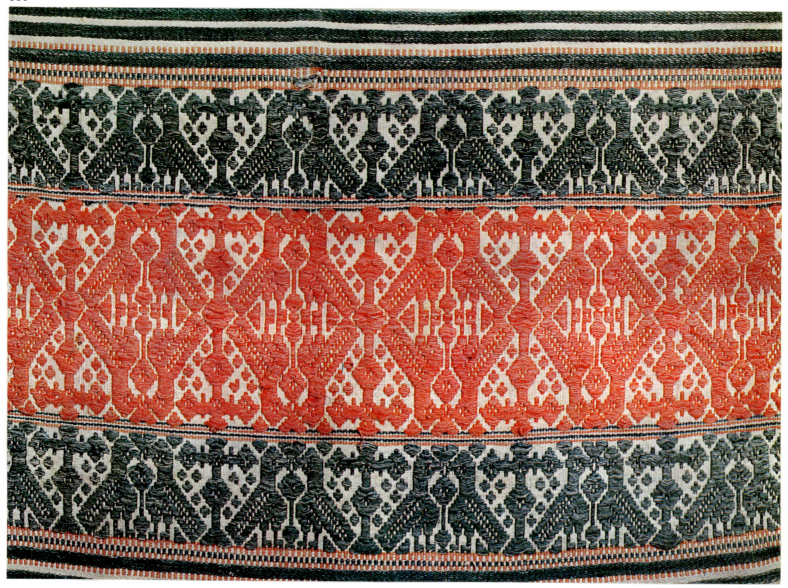

559 Ornamental
tablecloth. White
ground with pattern
of black and red
birds and stars.
Detail. Cotton yarn.
56 cm. Made by Sára
Kubránczky.
Decs, Tolna County
(Ethnographical
Museum)

560 Pillow-slip.
Work of former
master-weavers.
Detail. *38 cm.*
Upper Hungary
(Ethnographical
Museum)

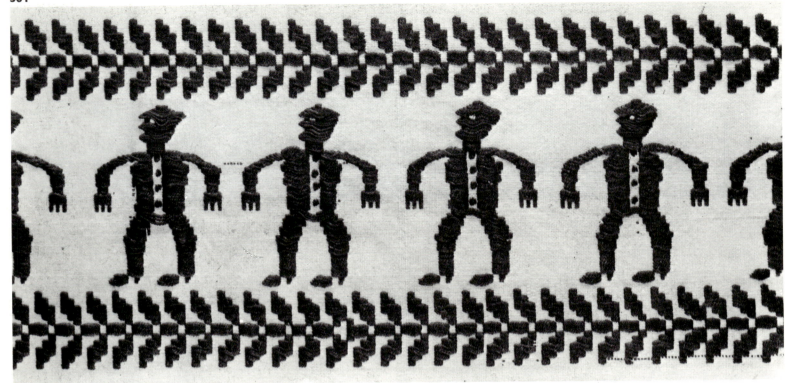

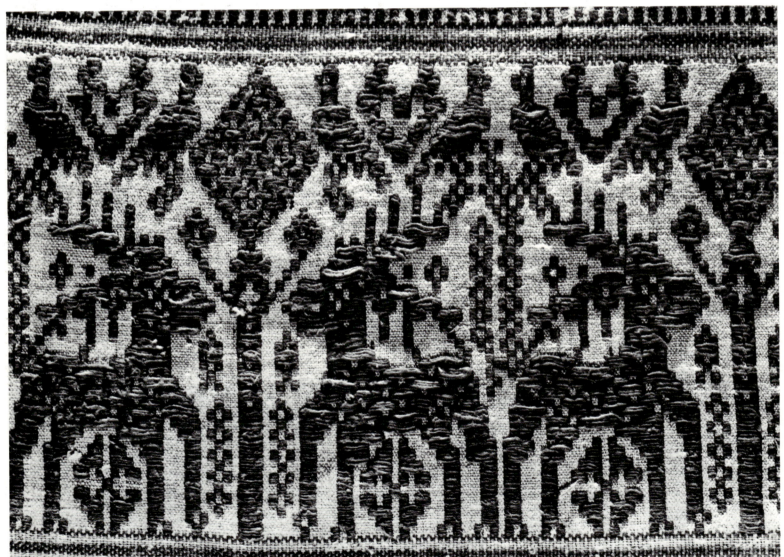

561 Pattern of human figures on the end border of an ornamental towel. White ground with red pattern. Cotton. *13 cm.* Ragyolc (Radovce, Czechoslovakia) (Ethnographical Museum)

562 Pattern of stags facing each other with stylized trees between them, on the end border of an ornamental towel. Woven on a natural hemp ground in red cotton yarn with facing birds above the stags. *23 cm.* Tolna County (Ethnographical Museum)

563 End border of a woven bedcover. Pattern of stars and birds facing each other on a natural coloured hemp ground woven with red, blue and white cotton yarn. Detail. *20 cm.* Mezőkövesd, Borsod-Abaúj-Zemplén County (Ethnographical Museum)

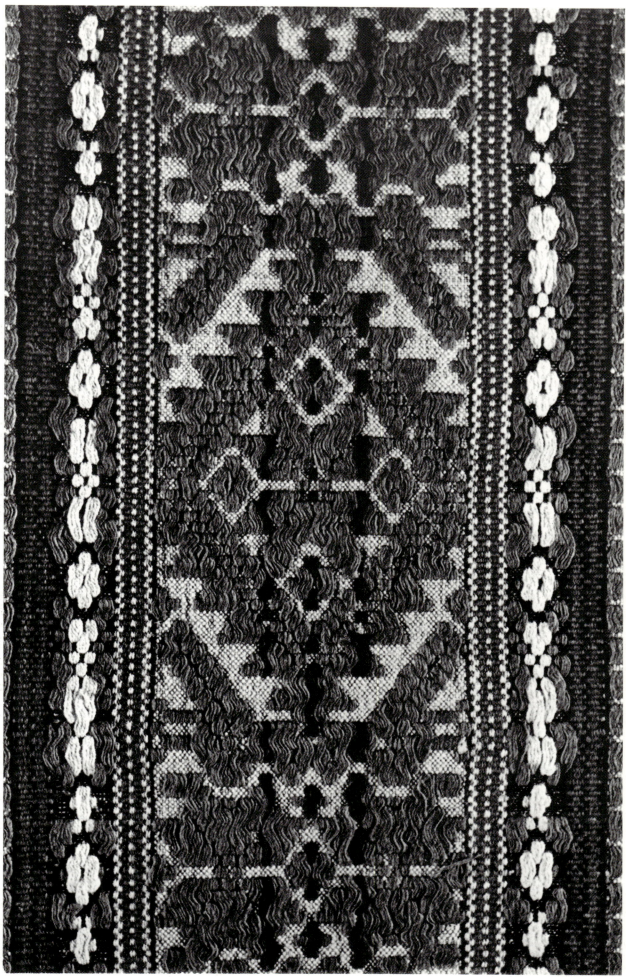

563

564

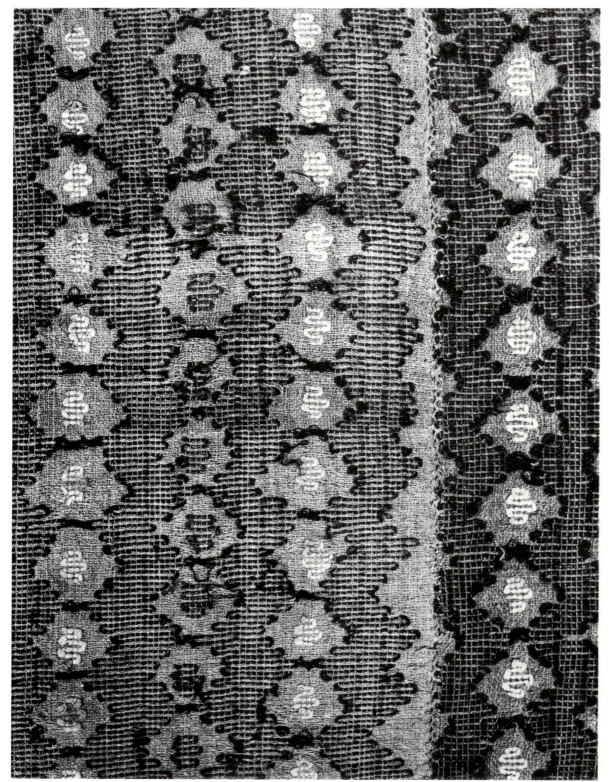

565

564 End border of a cloth. Woven in white cotton with four heddles and patterned with red velvet knotted technique. Detail. *16 cm.* Mezőség district (Rumania) (Ethnographical Museum)

565 Woollen bedcover. Red weave with green, white, violet and bright pink stripes threaded by hand. Detail. *70 cm.* Mezőkeszü (Chesau, Rumania) (Ethnographical Museum)

566 Apron. Natural coloured and red dyed wool. Detail. *14 cm.* Feketelak (Lacu, Rumania) (Ethnographical Museum)

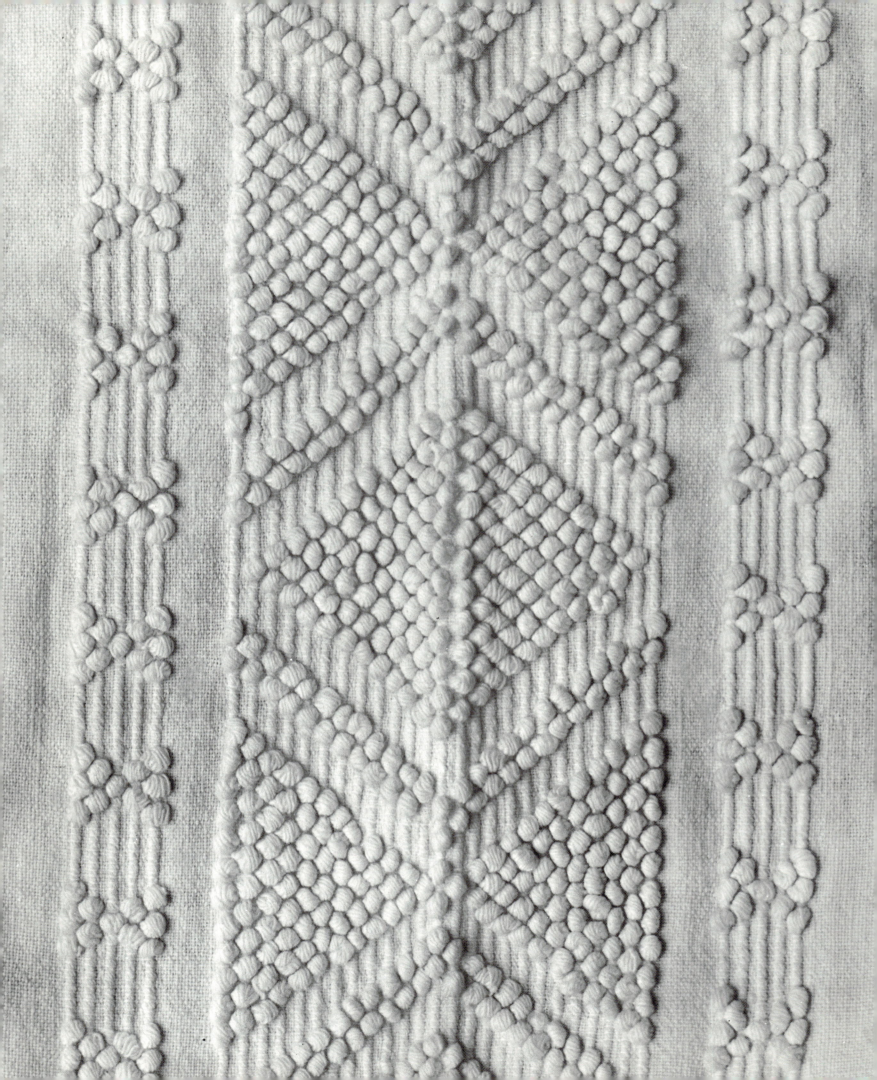

567 End border
of a pillow-slip.
White cotton weave
in velvet knotted
technique. Detail.
22 cm.
Mezőkeszü (Chesau,
Rumania)
(Ethnographical
Museum)

568 Border
of a woollen bed-
cover. Natural
coloured and red
wool with stripes.
Detail. *22 cm.*
Mezőség district
(Rumania)
(Ethnographical
Museum)

569 Bedcover.
Natural, raw wool
striped in light
and dark brown.
Detail. *50 cm.*
Mezőség district
(Rumania)
(Ethnographical
Museum)

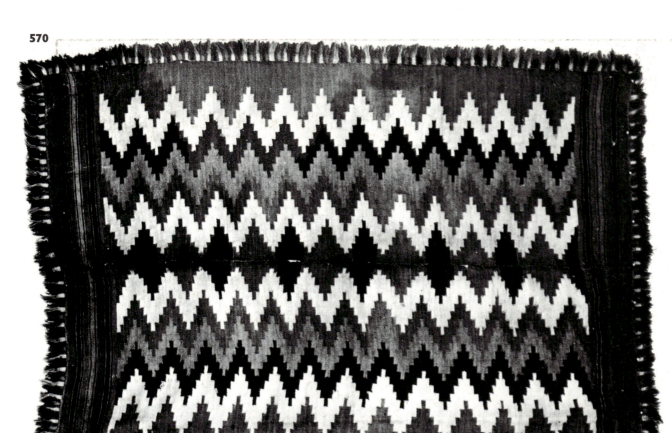

570 Székely woven rug. Originally red yarn, now faded to light brown, with blue, buff and white. Fringed with the same colours. Wool. *216 cm.* Csíkszereda (Miercurea Ciuc, Rumania) (Ethnographical Museum)

571 Székely woven rug. Originally red yarn, now faded to light brown, with blue, buff and white. Wool. *204 cm.* Csík Basin (Rumania) (Ethnographical Museum)

572 Székely woven rug with geometric pattern. Wool. *203 cm.* Székely land (Rumania) (Ethnographical Museum)

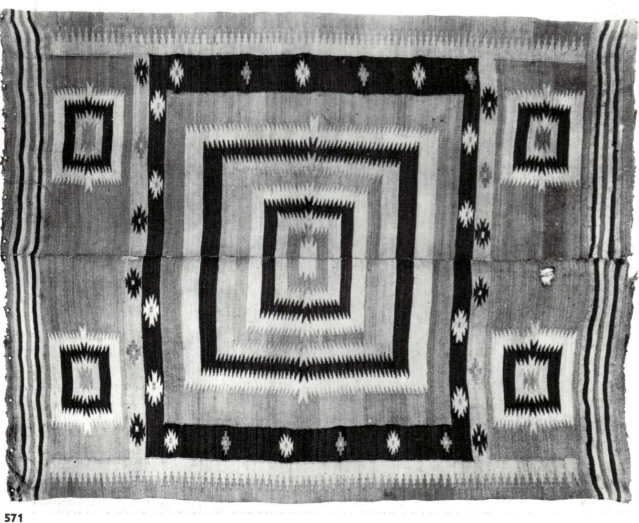

573

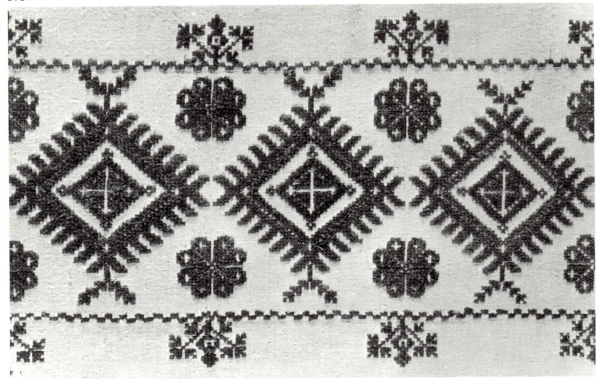

573 Border
of a coverlet,
embroidered
with blue cotton in
cross-stitch
and long-armed cross-
stitch. Cotton.
Detail. *24 cm.*
Transylvania
(Rumania)
(Ethnographical
Museum)

574 End border
of a pillow-slip.
Hemp ground with
pattern of pine-leaves
worked with blue
cotton in long-armed
cross-stitch. *23 cm.*
Kalotaszeg region
(Rumania)
(Ethnographical
Museum)

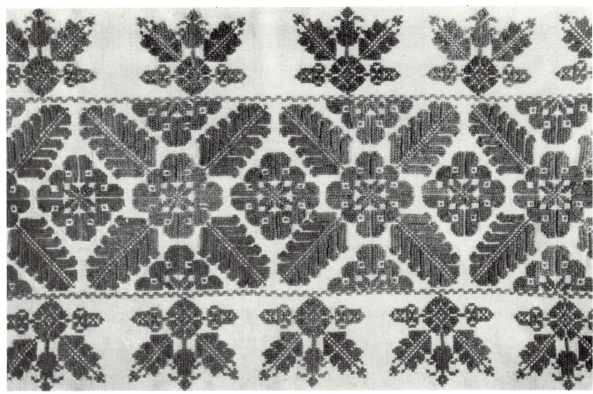

574

575 Border
of a coverlet.
Embroidered
with a continuous
geometric pattern
in blue and originally
red cotton, now
faded to pink. Cotton.
Detail. *24 cm*.
Osdola (Oşdula,
Rumania)
(Ethnographical
Museum)

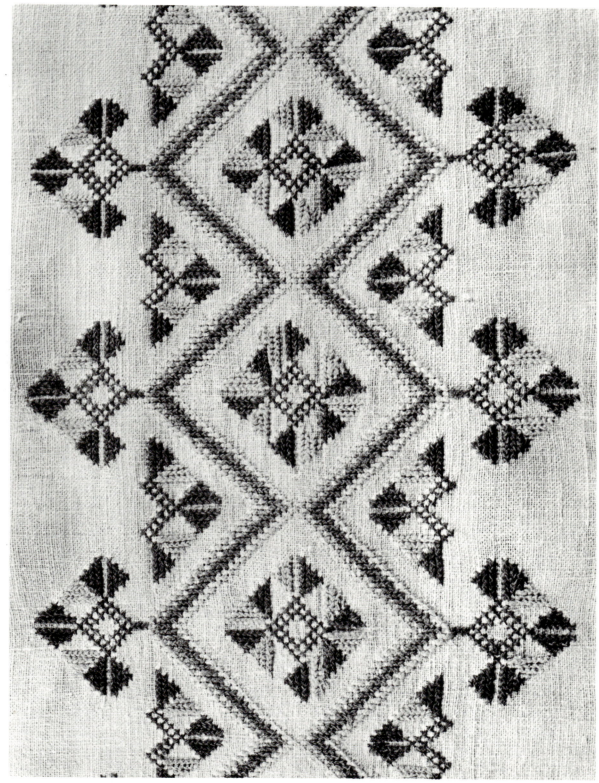

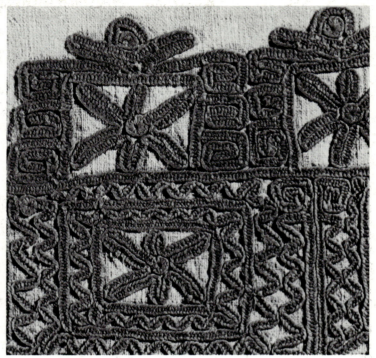

578

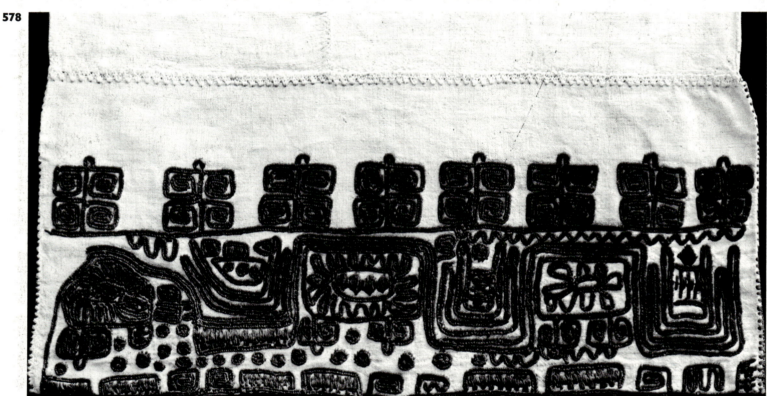

576 End border of a pillow-slip. Geometric motifs embroidered in square chain-stitch. Detail. *5 cm*. Kalotaszeg region (Rumania) (Ethnographical Museum)

577 End border of a pillow-slip. Geometric pattern embroidered on a hemp ground with red cotton in chain-stitch. Detail. *22 cm*. Kalotaszeg region (Rumania) (Ethnographical Museum)

578 End border of a pillow-slip. Geometric pattern embroidered on hemp ground with blue cotton yarn in square chain-stitch. *22 cm*. Kalotaszeg region (Rumania) (Ethnographical Museum)

579 End border of a pillow-slip. Worked on cambric with red crewel in square chain-stitch in a flower-cluster design on both sides of a horizontal axis. Detail. *44 cm*. Kalotaszeg region (Rumania) (Ethnographical Museum)

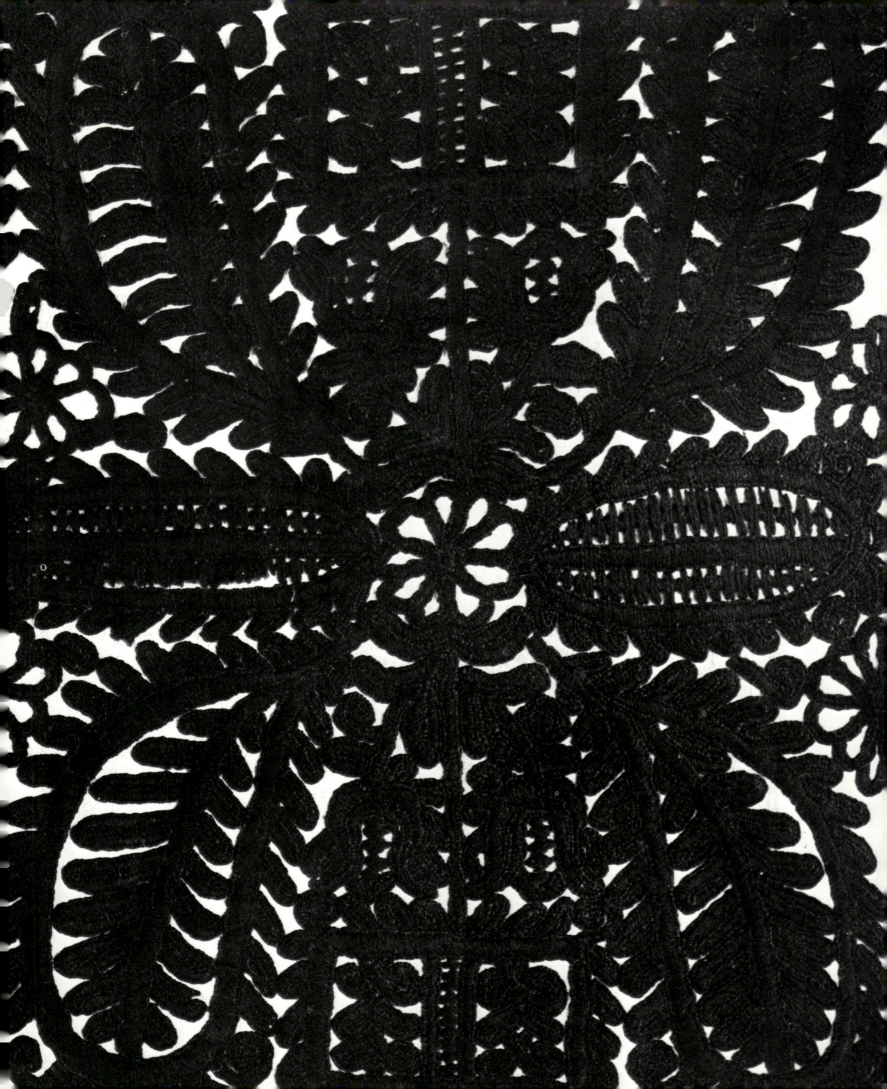

580

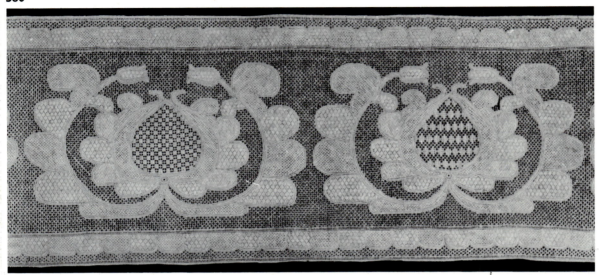

581

580 Two pomegranates from the border of a coverlet. Worked in bright white silk in reticella technique: cut and drawn thread-work with satin-stitch. *37 cm.* Aggtelek, Borsod-Abaúj-Zemplén County (Ethnographical Museum)

581 Pomegranates, from a pillow for the bier. Embroidery worked on hemp ground with black crewel. Detail. *24 cm.* Sárköz region, Tolna County (Ethnographical Museum)

582 Rosettes from the border of a bedcover. Design embroidered on white cambric ground with cotton yarn in a variety of stitches: satin-stitch, stem-stitch, loop-stitch, chain-stitch and oblique cross-stitch. *42 cm.* Buzsák, Somogy County (Ethnographical Museum)

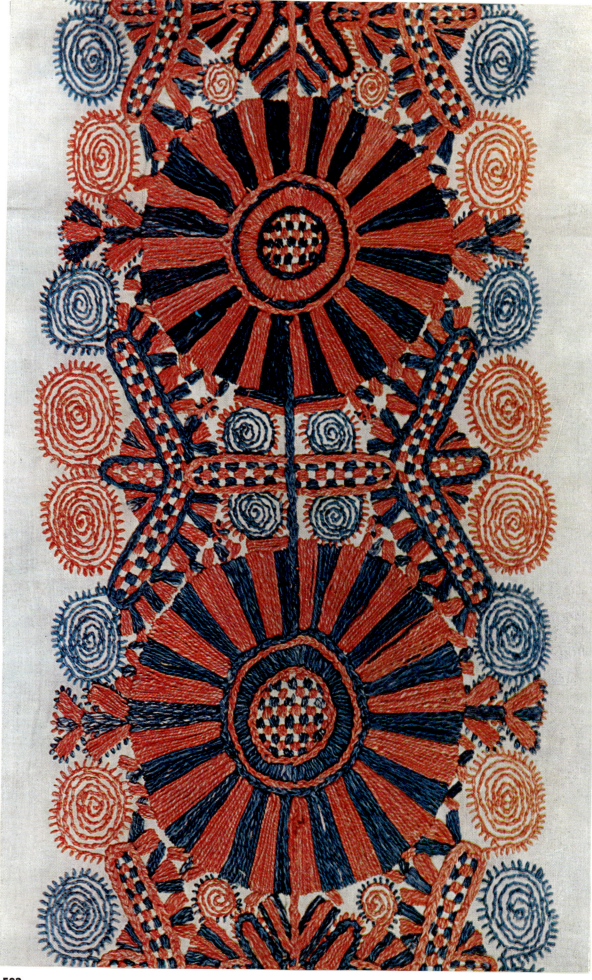

582

583 End border
of a funeral sheet.
Linen worked
in reticella technique:
cut and drawn-
thread work with
satin-stitch. Cocks
embroidered in red,
yellow, green
and blue silk. *28 cm.*
Upper Hungary
(Ethnographical
Museum)

584 Pelican feeding
her young with her
own blood. Detail
from the lace
of a funeral sheet.
Worked in plain-
stitch with red, blue
and white cotton
thread. *43 cm.*
Érsekvadkert,
Nógrád County
(Ethnographical
Museum)

585 Design of birds from the end border of a funeral sheet. Worked on a hemp ground with black crewel in satin-stitch and cross-stitch: some of the motifs are outlined with two rows of white yarn. Incomplete, now restored. *39 cm.* Upper Hungary (Ethnographical Museum)

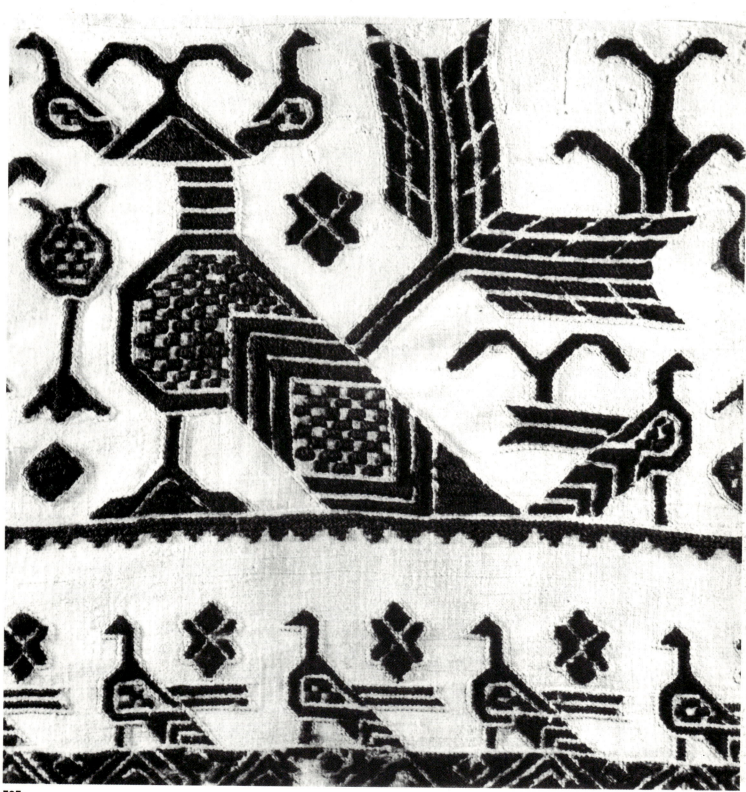

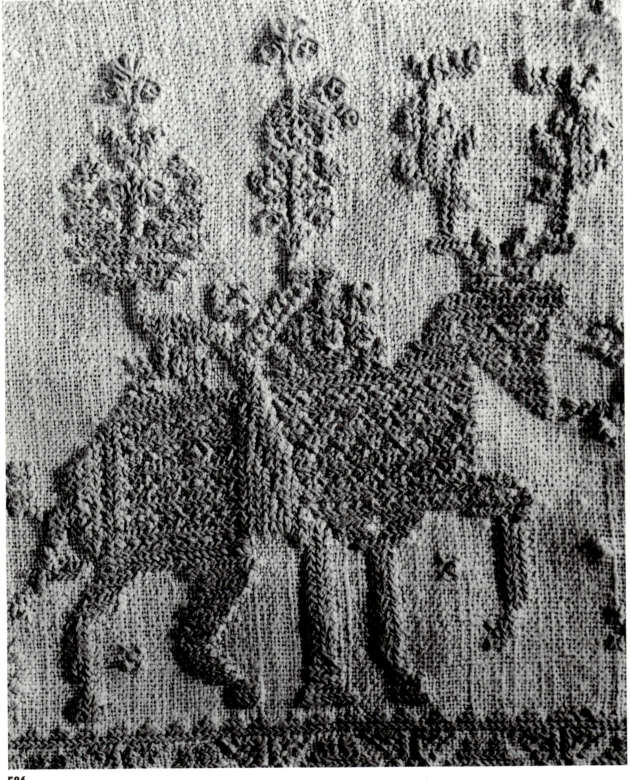

586 Stag from
a counterpane
border. Embroidered
on a hemp ground
with red cotton yarn
in cross-stitch
and stem-stitch.
36 cm.
Little Plain
in north-west
Hungary
(Ethnographical
Museum)

587 A row
of "Lamb of God"
motifs
from the border
of a counterpane.
Worked on a hemp
ground with red
yarn in long-armed
cross-stitch and out-
line-stitch. Detail.
31 cm.
Andrásfalva
(Bukovina region,
Rumania)
(Ethnographical
Museum)

588 Row of stags
looking backwards.
Detail from the end
border of a mattress
cover. Printed
pattern on hemp,
a rare technique
among Hungarians.
26 cm.
Region of Dés
(Dej, Rumania)
(Ethnographical
Museum)

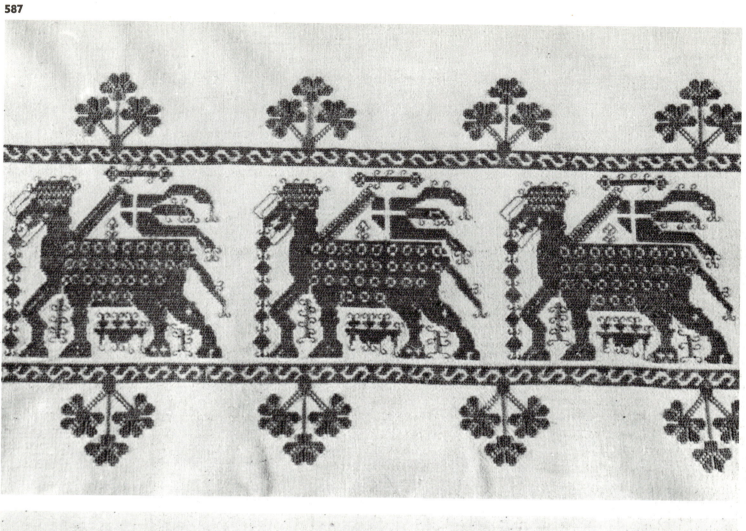

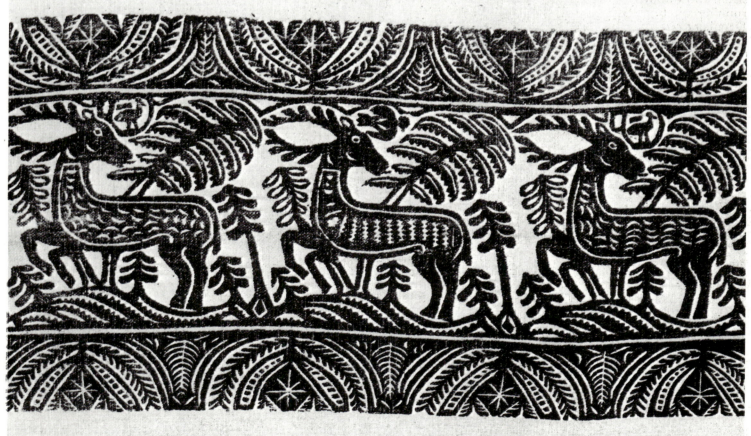

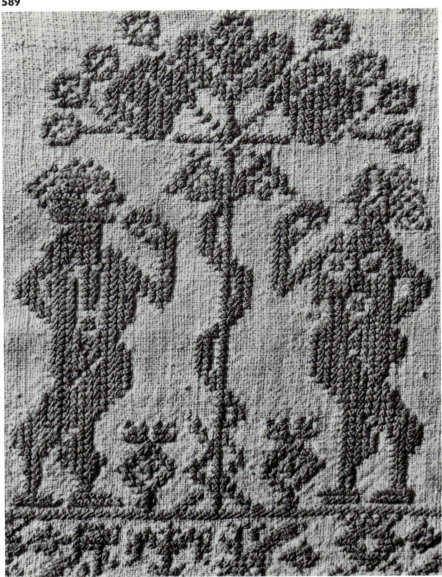

589 Adam and Eve under the Tree of Knowledge. Detail from the border of a funeral sheet. Worked on hemp with red cotton yarn in cross-stitch and long-armed cross-stitch. *20 cm.* Csicsó (Čičov, Czechoslovakia) (Ethnographical Museum)

590 Row of women, detail on the lowest stripe of a counterpane, below the principal design. Linen embroidered with red yarn in long-armed cross-stitch and outline-running-stitch. Detail. *11 cm.* Transdanubia (Ethnographical Museum)

591 Abraham sacrificing Isaac. Detail from the insertion net of a ceremonial counterpane. The net of hemp thread has been worked with bright white cotton yarn, using two kinds of running-stitch. *56 cm.* Upper Hungary (Ethnographical Museum)

592 Abraham sacrificing Isaac. From the end border of a pillow-slip embroidered in long-armed cross-stitch and cross-stitch. *42 cm.* Transylvania (Rumania) (Ethnographical Museum)

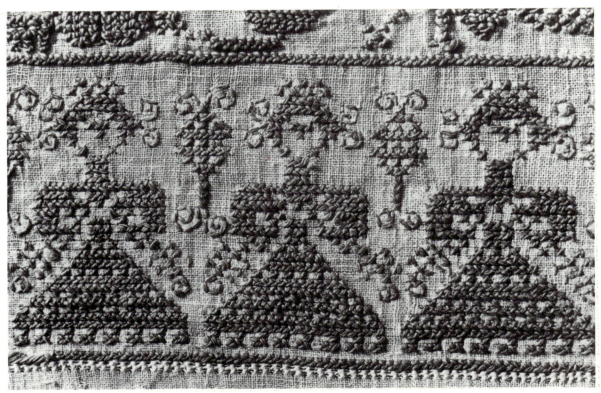

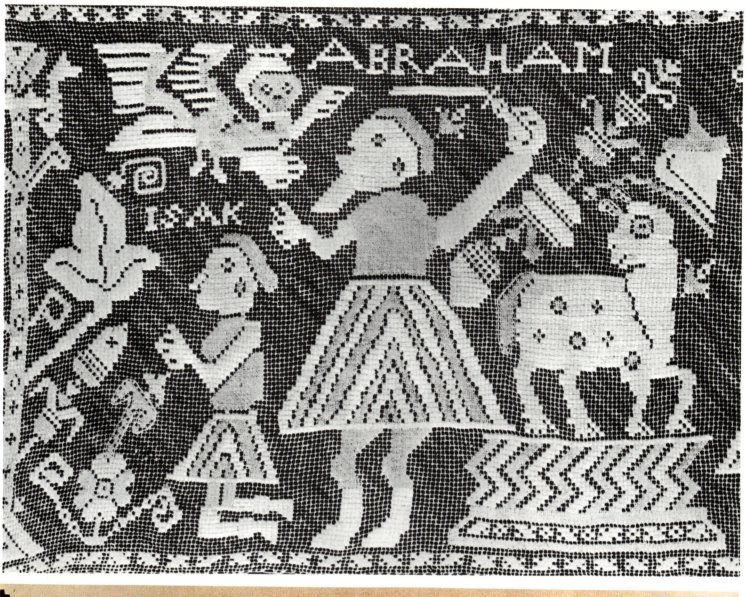

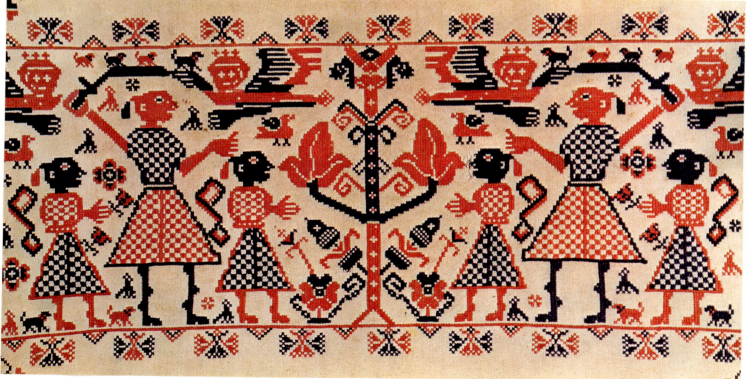

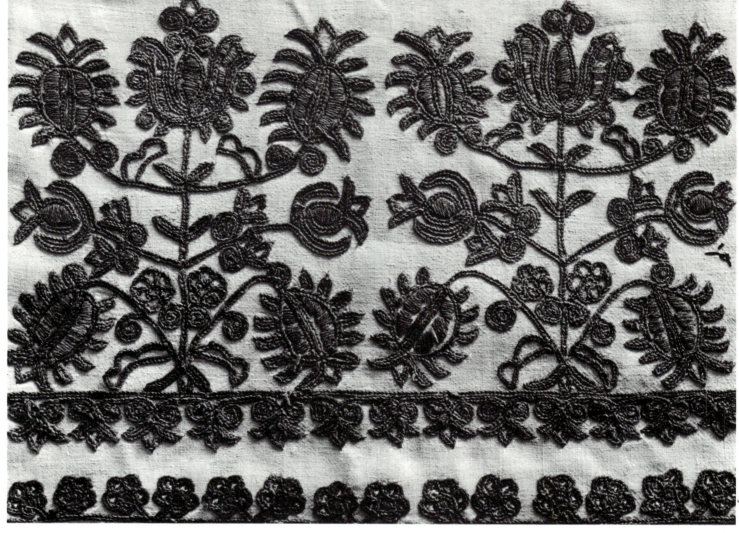

593 Two flower-clusters from the border of a kerchief. Embroidered on ripple-textured hemp in chain-stitch and satin-stitch with blue cotton yarn. *37 cm*. Kalotaszeg region (Rumania) (Ethnographical Museum)

594 Flower-clusters from the end border of a small sheet for the bottom of a bed. Embroidered on ripple-textured linen with blue cotton yarn in chain-stitch. *39 cm*. Kalotaszeg region (Rumania) (Ethnographical Museum)

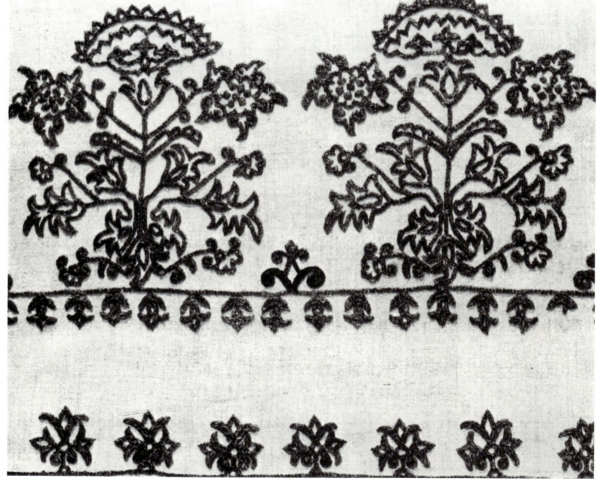

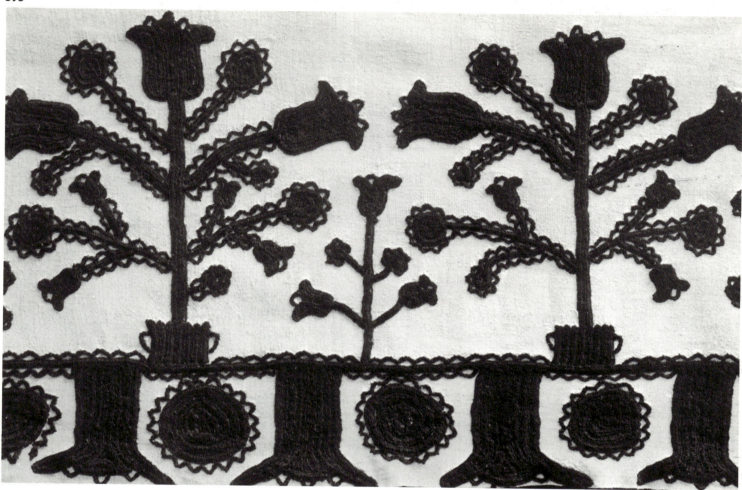

595 Flower-clusters
from the border
of a funeral sheet.
A row of flower-
clusters worked
on a hemp ground
with black crewel
in satin and chain-
stitch with a heavy
border design. *38 cm.*
Mezőség (Cîmpia
Ardealului) region,
Transylvania
(Rumania)
(Ethnographical
Museum)

596 A row of "lilies"
and tulips
from a wall-hanging.
Embroidered
on a heavy hemp
ground with thick
blue cotton yarn
in long-armed cross-
stitch. *32 cm.*
Torockó (Rimetea,
Rumania)
(Ethnographical
Museum)

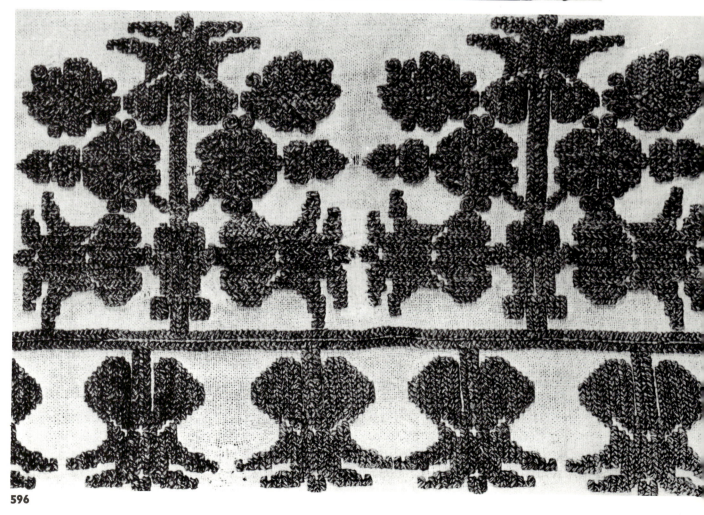

596

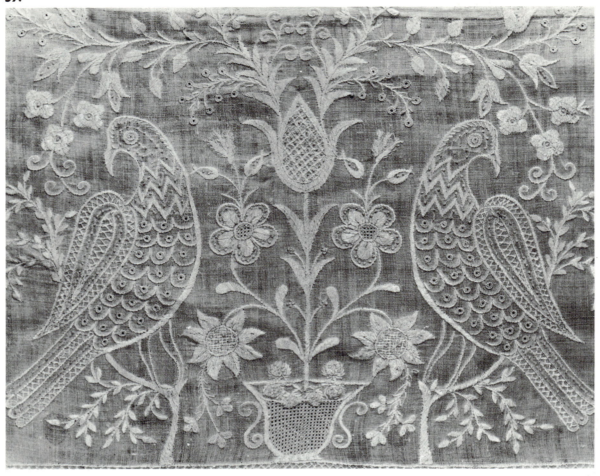

597 A pair of birds looking backwards, with a flower-cluster between them, from the border of a counterpane. Worked on white linen in bright white silk with a variety of stitches: satin, buttonhole and herringbone stitches and French knots. Detail. *31 cm.* Transdanubia (Ethnographical Museum)

598 A pair of leaping stags divided by a bunch of carnations and pomegranates, from the end border of a counterpane. Worked on linen with thick red cotton yarn in satin-stitch, whipped satin-stitch, stem-stitch and the stitch known as the "cross of Sopron". Detail. *33 cm.* Veszprém County (Ethnographical Museum)

599 Two birds facing each other divided by a simplified flower-cluster, from the end border of a pillow-slip. Embroidered on linen with red, green, yellow, blue and buff crewel in plain and whipped satin-stitch. Detail. *26 cm.* Trans-Tisza region (Ethnographical Museum)

600 Crested birds facing each other divided by a flower-cluster in a pot, on the end of a counterpane. Linen worked with red cotton yarn with satin-stitch, stem-stitch and cross-stitch. Detail. *34 cm.* Balf, Győr-Sopron County (Ethnographical Museum)

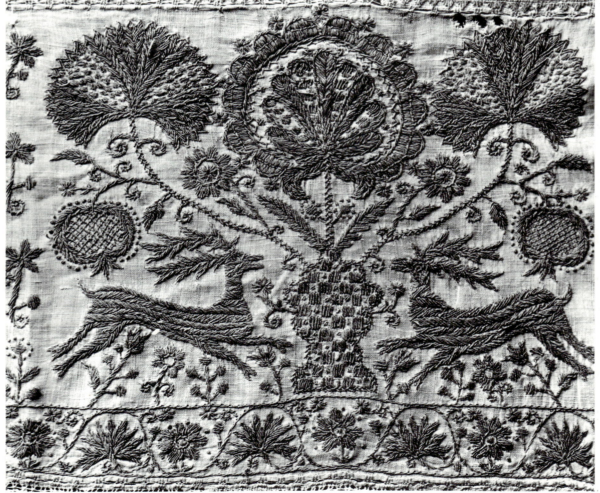

599

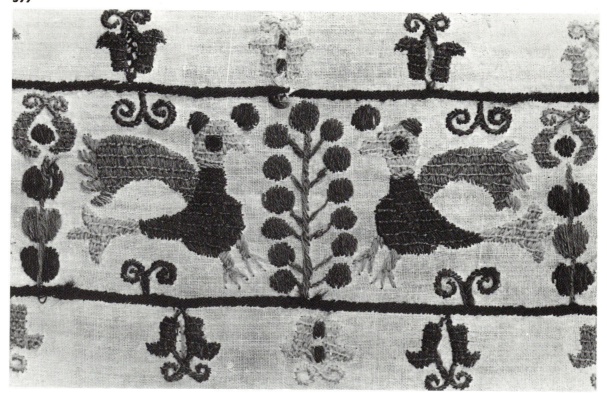

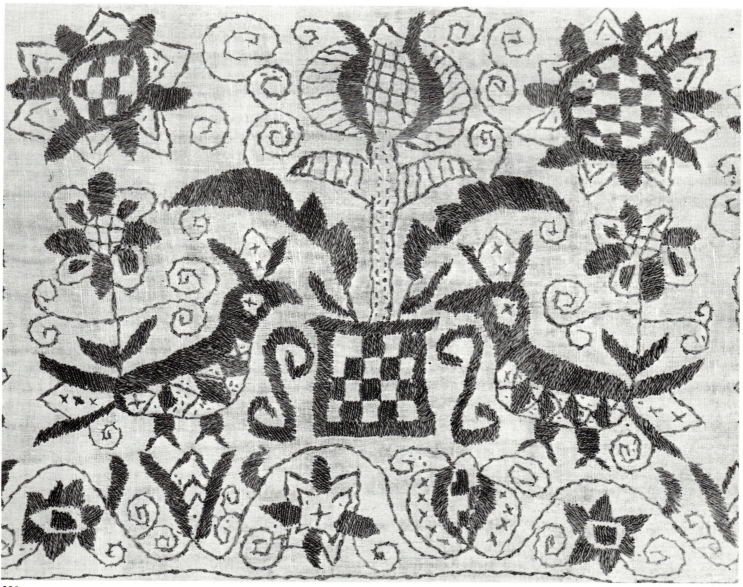

600

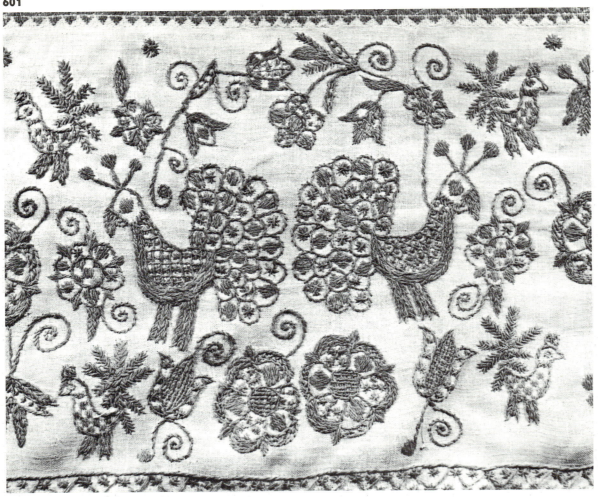

601 Pair of birds facing away from each other among foliage and rosettes from the border of a sheet. Worked with red cotton yarn in satin-stitch and stem-stitch with stars and the stitch known as the "cross of Sopron". *33 cm.* Sopron region (Ethnographical Museum)

602 Design of birds from the end border of a counterpane. Worked on hemp with red cotton yarn in plain and whipped satin-stitch and "Torockó" cross-stitch. *36 cm.* Homoródújfalu (Satul-Nou, Rumania) (Ethnographical Museum)

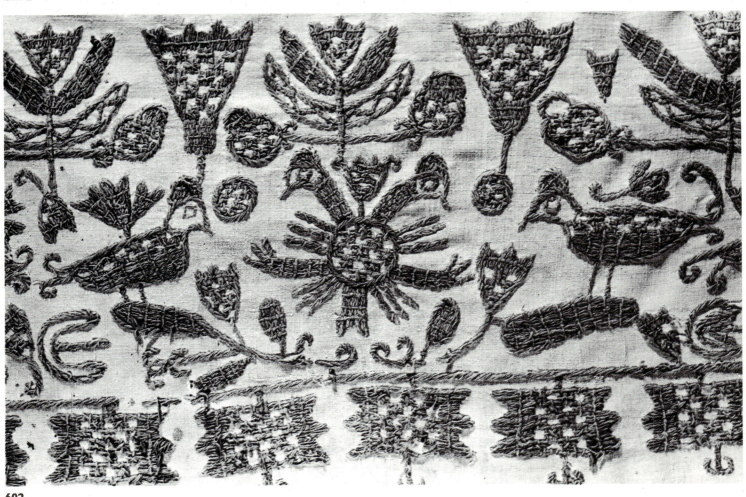

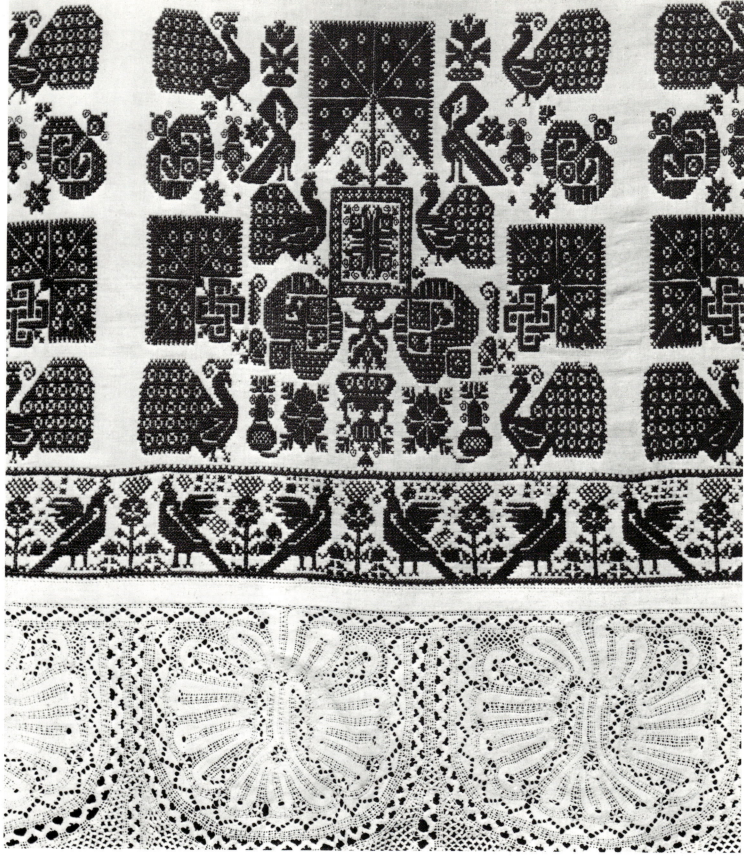

603 Detail
from the border
of a funeral sheet.
Linen worked with
crewel, faded brown,
with long-armed
cross-stitch
and cross-stitch.
58 cm. Inscription:
"1766."
Pécs, Baranya County
(Ethnographical
Museum)

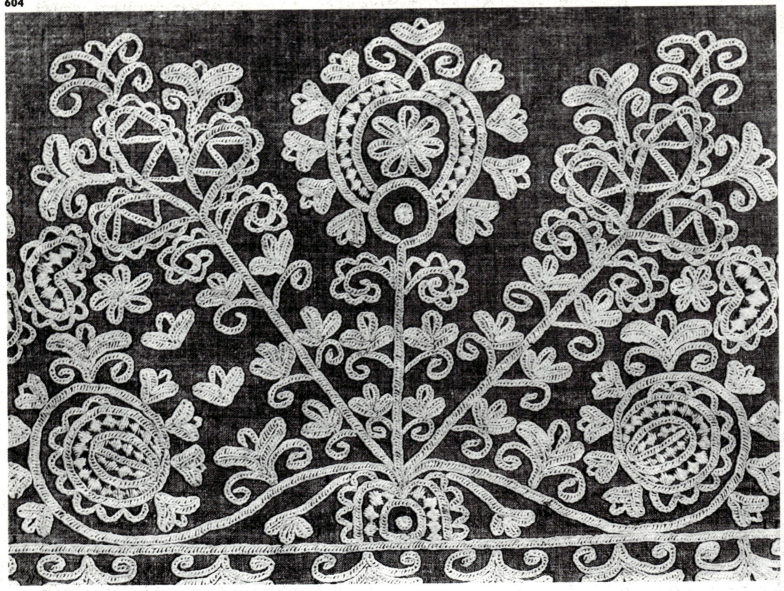

604 Five-stemmed
flower-cluster
design,
from the border
of a counterpane.
Embroidered
on a natural coloured
hemp ground with
a rippled texture
using white cotton
yarn in square
chain-stitch
and satin-stitch.
35 cm.
Kalotaszeg region
(Rumania)
(Ethnographical
Museum)

605 Embroidered
pomegranate
from the side
of the coif in Ill.
606. *13 cm.*
Mezőkövesd or
Szentistván,
Borsod-Abaúj-
Zemplén County
(Ethnographical
Museum)

606 Pomegranate
from the back
of a coif. Worked
on a faded brown
fine satin ground,
originally black,
with white cotton
yarn in satin-stitch,
chain-stitch
and French knots;
the centre
of the pomegranate
is filled in with
a so-called
"Mezőkövesd" cross.
22 cm.
Mezőkövesd or
Szentistván,
Borsod-Abaúj-
Zemplén County
(Ethnographical
Museum)

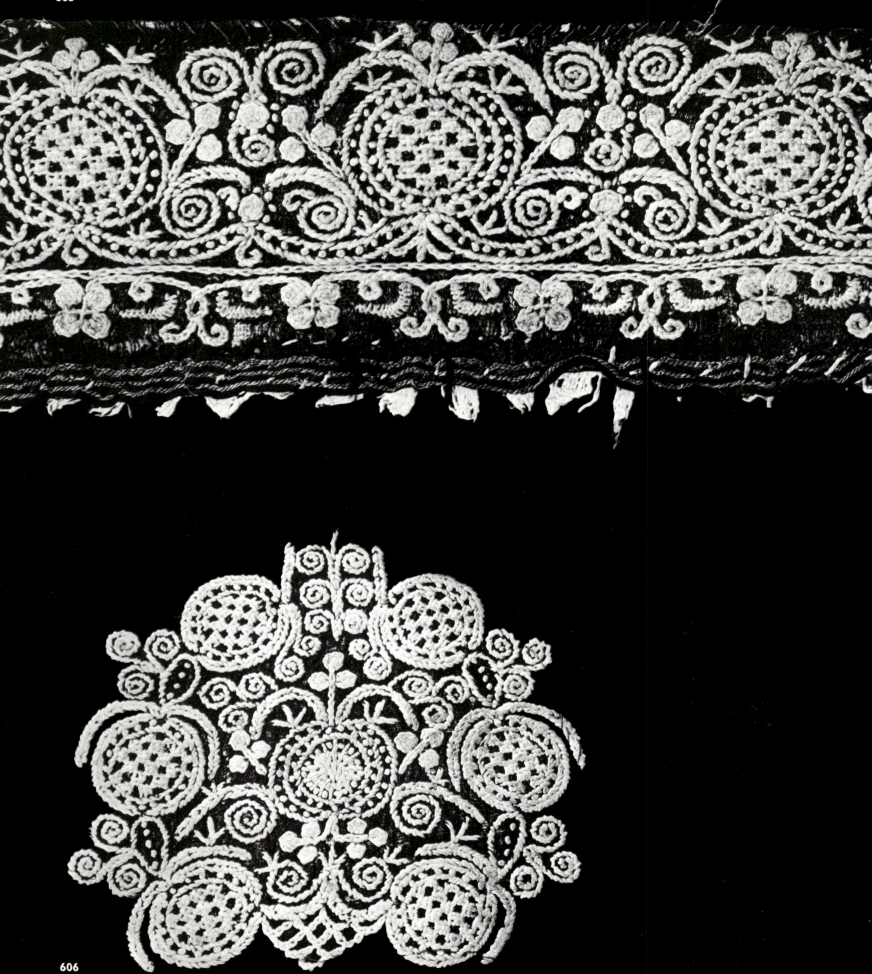

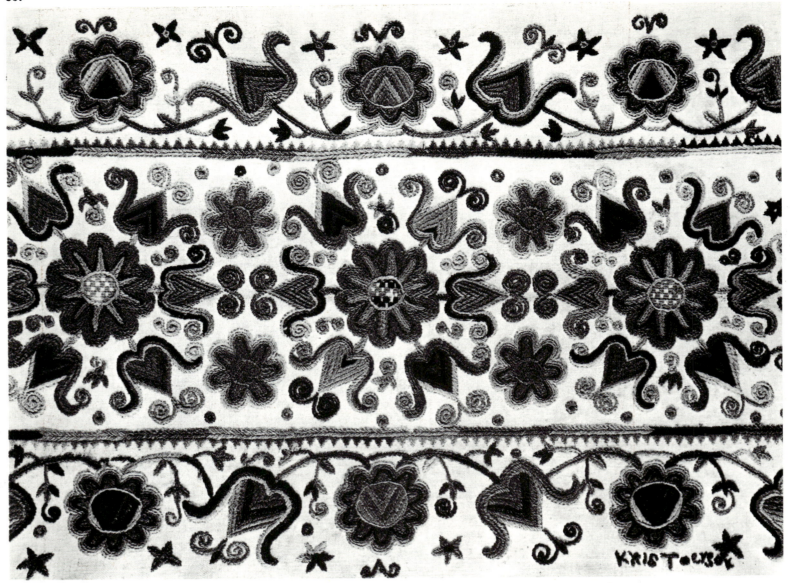

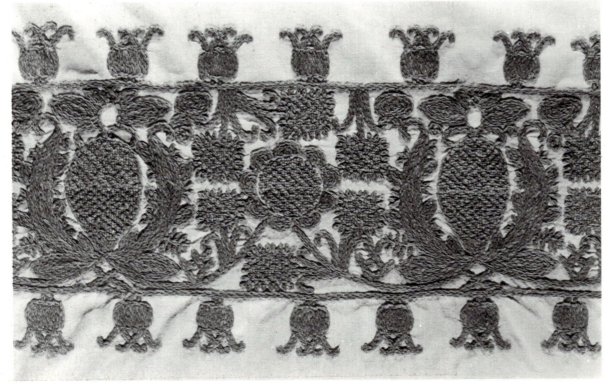

607 End border
of a pillow-slip.
Worked on linen
with crewel
in shades
of yellowish-brown,
blue and violet
with satin-stitch.
The pattern
is arranged
in compartments.
54.5 cm. Inscription:
"Kᴿɪsᴛᴏ Eʀsᴏᴋ",
Ersok being a form
of the name
Elizabeth.
Makó,
Csongrád County
(Móra Ferenc
Museum, Szeged)

608 Design
on the end border
of a pillow-slip.
Embroidered
on cotton with thick
red yarn, close rows
of stem-stitches,
and the so-called
"Torockó" cross-
stitch. *38 cm.*
Szék (Sic, Rumania)
(Ethnographical
Museum)

609 Embroidery
on a funeral sheet.
Cambric worked
in a close square
chain-stitch
and satin-stitch.
38 cm. Inscription:
"Dᴇsɪɢɴᴇᴅ ɪɴ 1818
ғᴏʀ Kᴀᴛᴀ Kᴏᴠᴀ́ᴄs."
Kalotaszeg region
(Rumania)
(Ethnographical
Museum)

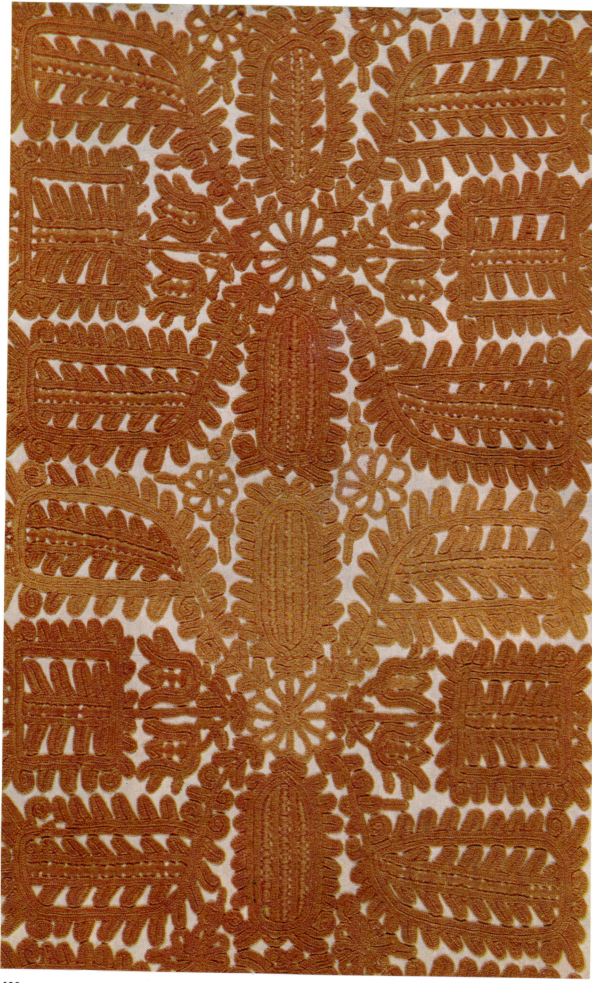

609

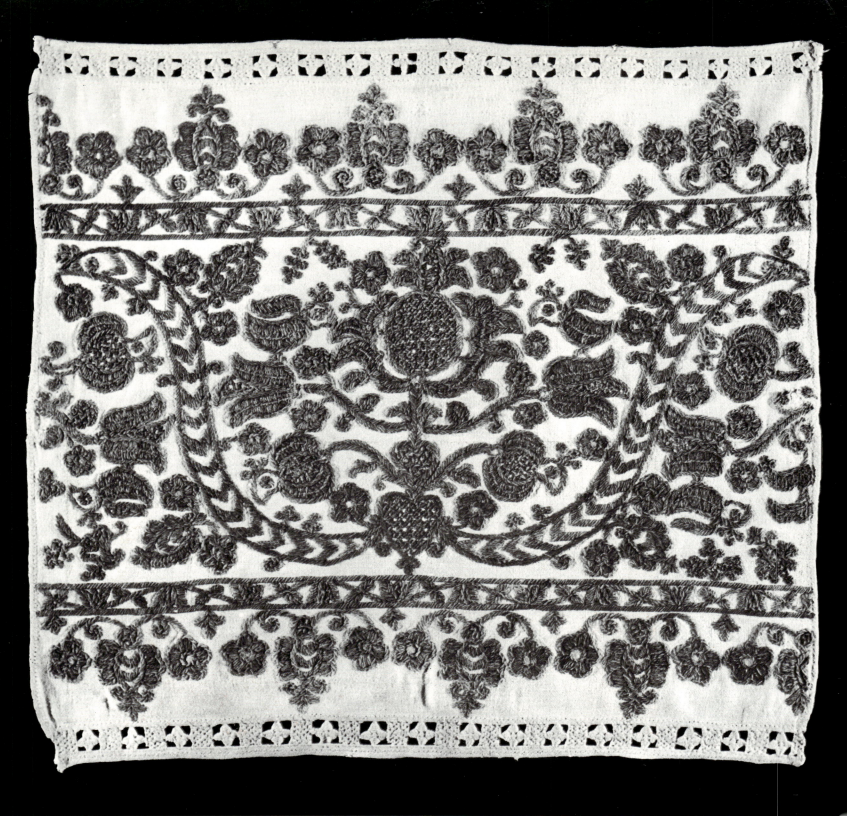

610

610 Flower-cluster with pomegranate framed by tendrils from a pillow-slip border. Heavy hemp ground embroidered with thick blue cotton yarn in satin and stem-stitch and the so-called "Torockó" cross-stitch. White needle-point lace on both sides. *55 cm.* Torockó (Rimetea, Rumania) (Ethnographical Museum)

611 Large stylized flower from the end border of a pillow-slip. Embroidered on linen with satin-stitch in shades of brown, buff and pink crewel. *22 cm.* Karcag, Szolnok County (Ethnographical Museum)

612 Pomegranates framed by tendrils from the end border of a pillow-slip. Damaged. *44 cm.* Region of Orosháza, Békés County (Ethnographical Museum)

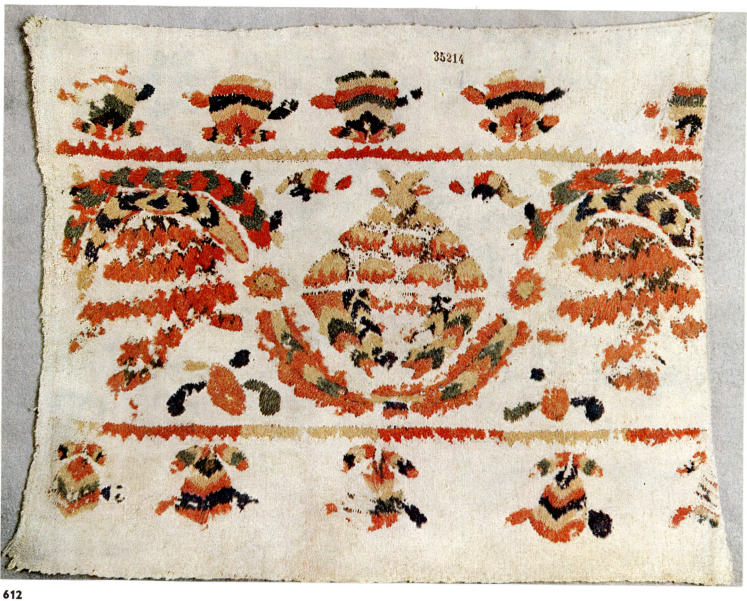

35214

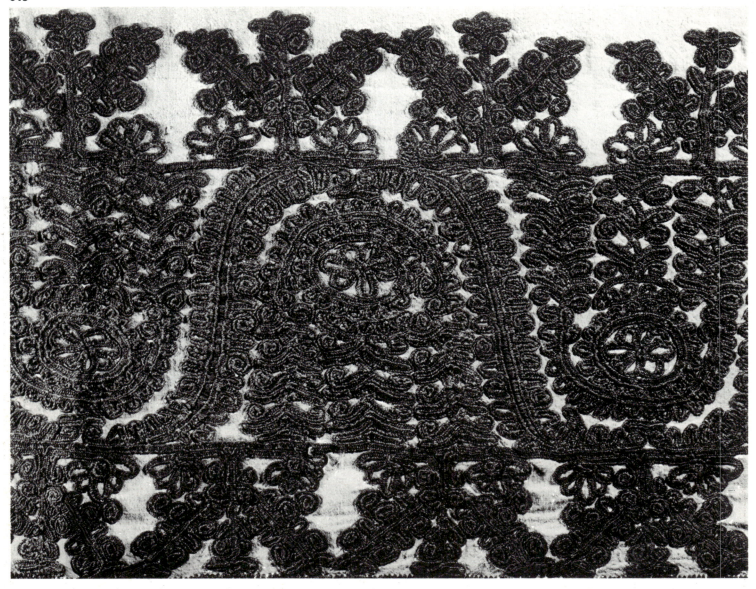

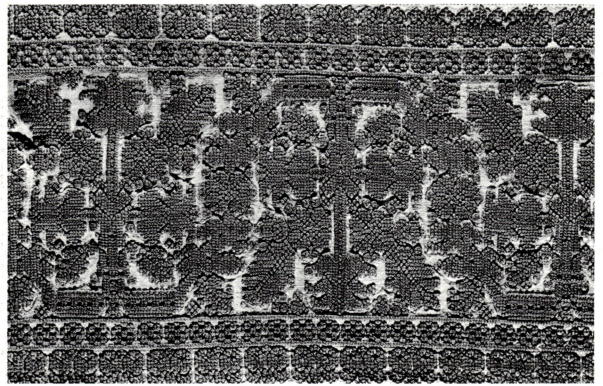

613 Curved stem
on the end border
of a counterpane.
Worked on linen
with a rippled
texture in blue
cotton in square
chain-stitch
and satin-stitch.
41 cm.
Inscription:
"in 1864."
Kalotaszeg region
(Rumania)
(Ethnographical
Museum)

614 End border
of a counterpane
with tendrils
and flower-clusters.
Worked on a heavy
hemp ground with
thick red cotton
yarn in long-armed
cross-stitch. Detail.
32 cm.

Torockó (Rimetea,
Rumania)
(Ethnographical
Museum)

615 Row of large
tulips. Embroidery
on the end border
of a pillow-slip.
Worked on a hemp
ground with crewel
in satin-stitch. *63 cm.*
Makó,
Csongrád County
(Móra Ferenc
Museum, Szeged)

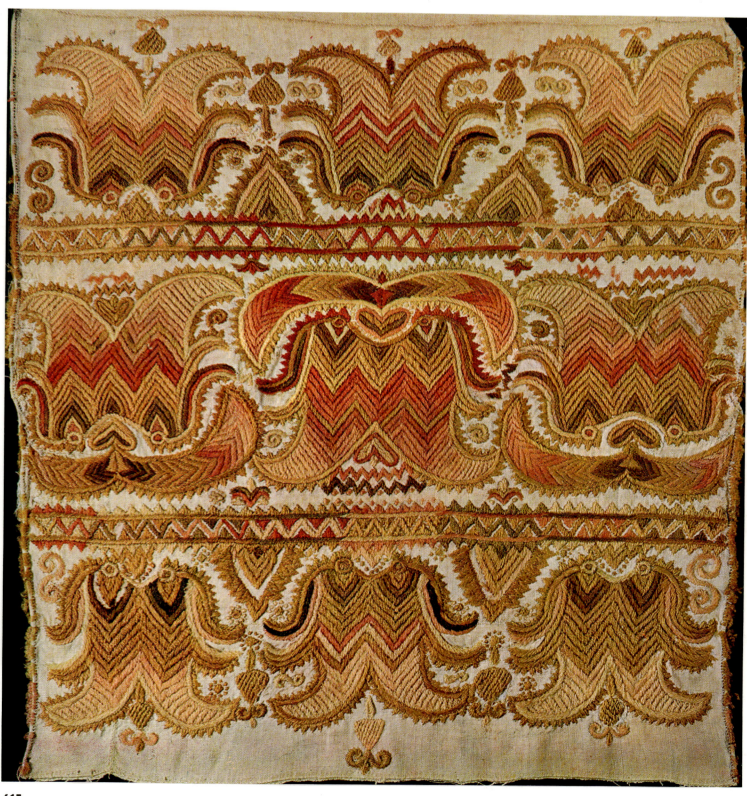

616 Simplified variation of the Transylvanian Báthori princes' coat of arms with dragon's teeth on the end border of a pillow-slip. Worked on a hemp ground with red cotton in long-armed cross-stitch and cross-stitch. *47 cm.* Transylvania (Rumania) (Ethnographical Museum)

617 Embroidered section from the end border of a counterpane. Embroidered on a linen ground with red, buff, brown and green crewel in satin-stitch. *35.3 cm.* Rábaköz region in Győr-Sopron County (Liszt Ferenc Museum, Sopron)

618 Tendrils with acorns from the embroidered border of a counterpane. Worked on a hemp ground in red and blue with long-armed cross-stitch and cross-stitch. *28 cm.* The Mezőség region, Transylvania (Rumania) (Ethnographical Museum)

619 Tendrils with tulips on the end border of a pillow-slip. Worked on a linen ground with crewel in plain satin-stitch and star-stitch. *41 cm.* Serke (Zirkovce, Czechoslovakia) (Ethnographical Museum)

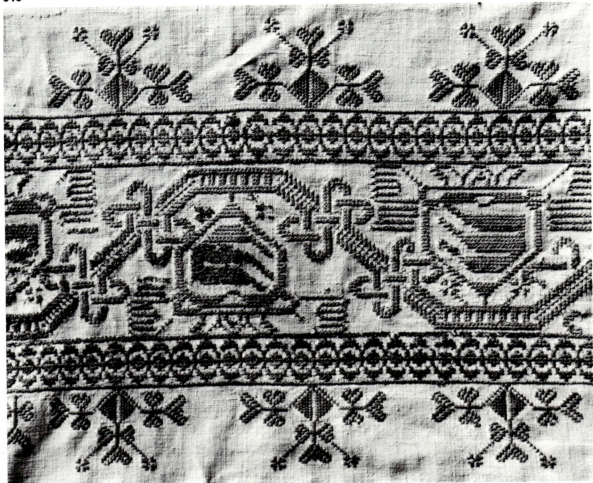

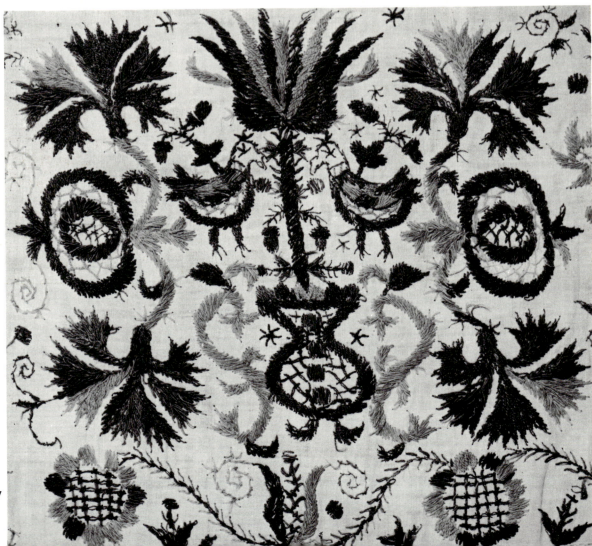

618

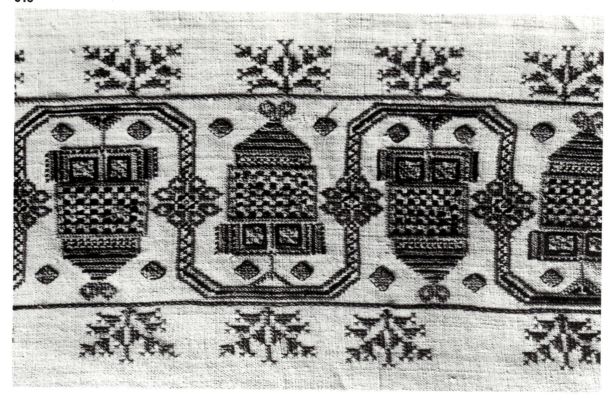

8846

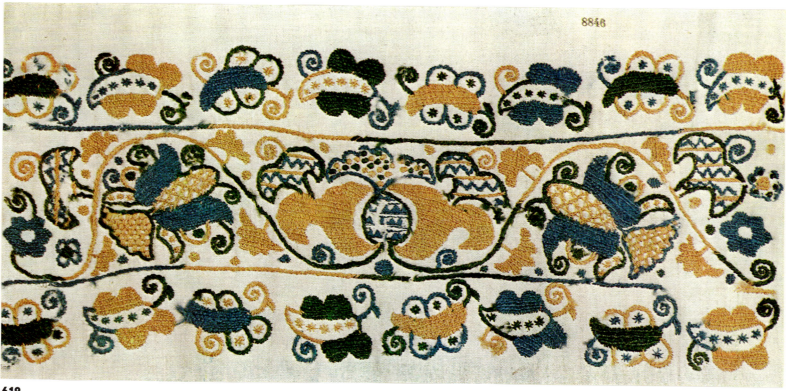

619

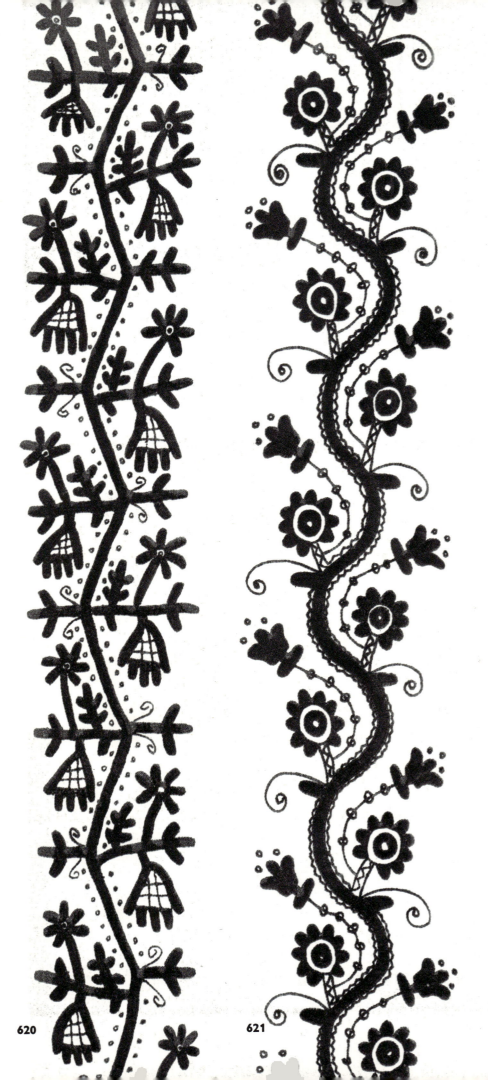

620 Design on a funeral sheet. White cambric worked with black cotton yarn partly outlined in "Mezőség" chain-stitch and embroidered in herringbone-stitch. Detail. *16 cm*. Mezőkeszü (Chesau, Rumania) (Ethnographical Museum)

621 "Serpent" design from a funeral sheet. White cambric worked with black cotton thread in "Mezőség" stitch. Detail. *28 cm*. Mezőkeszü (Chesau, Rumania) (Ethnographical Museum)

620

621

622 End border
of a pillow-slip.
Cambric embroidery
with red crewel
in herringbone-
stitch outlined
in chain-stitch.
Small rings
and tendrils are also
worked in chain-
stitch. Detail. *31 cm*.
Mezőkeszü (Chesau,
Rumania)
(Ethnographical
Museum)

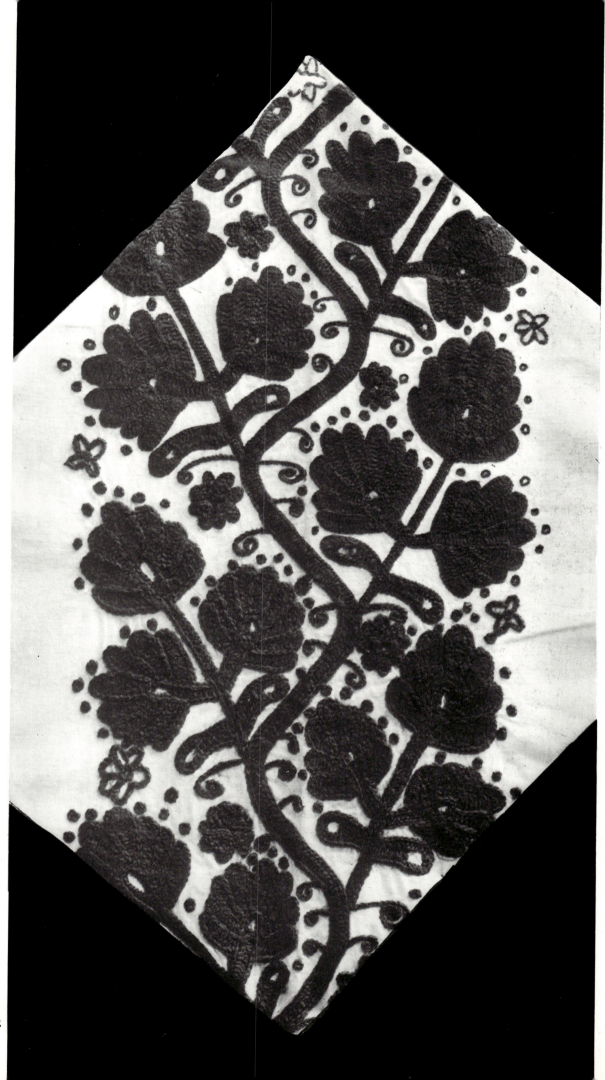

622

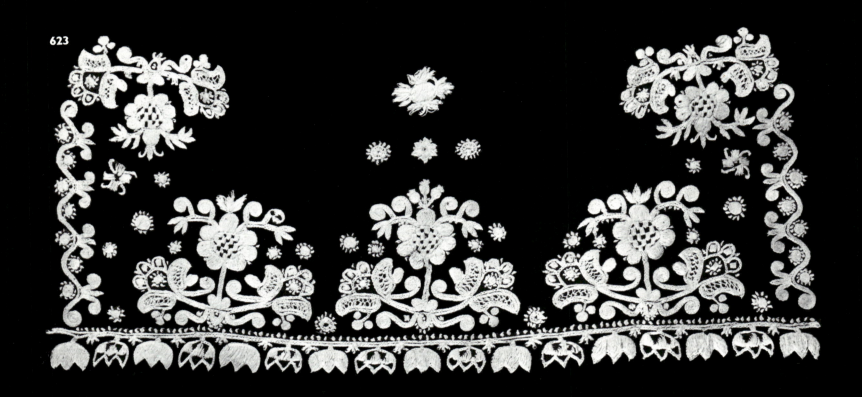

623

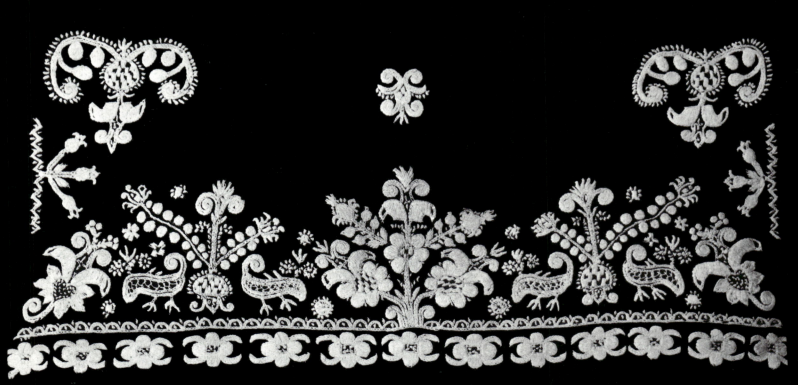

624

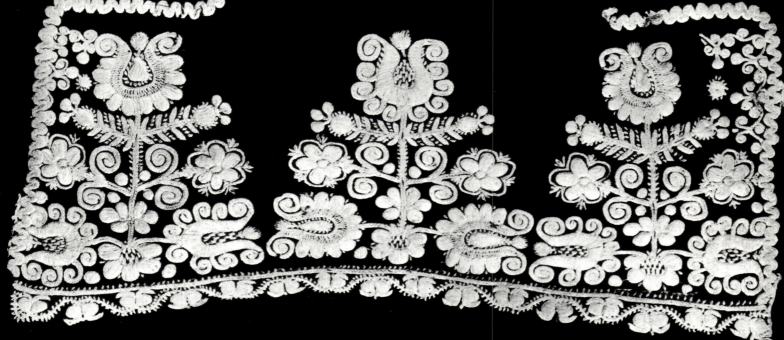

625

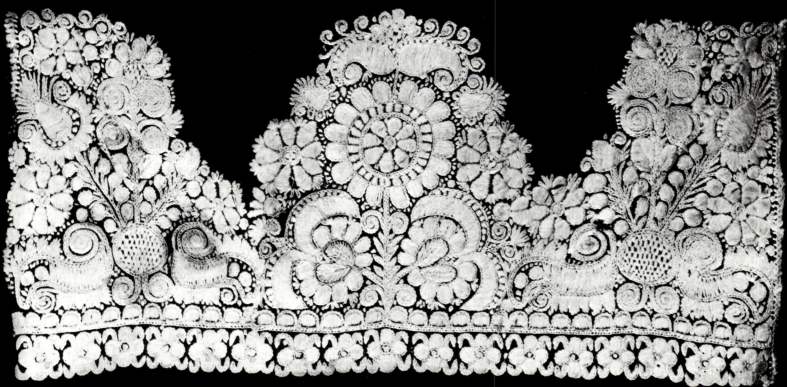

626

623 Coif taken apart and spread out. Black muslin embroidered with white yarn mainly in chain-stitch, satin-stitch and stem-stitch. *13.5 cm.* Sárköz region, Tolna County (Ethnographical Museum)

624 Coif taken apart and spread out. Black muslin embroidered in "little dog" motif, so-called after the animals standing beneath the flower-clusters, with white yarn mostly in chain-stitch, satin-stitch and herringbone-stitch. *14 cm.* Sárköz region, Tolna County (Ethnographical Museum)

625 A line of flower-clusters bearing seven flowers each, from a coif taken apart and spread out. Black muslin worked with white cotton yarn mainly in chain-stitch, satin-stitch and stem-stitch. Incomplete. *13 cm.* Sárköz region, Tolna County (Ethnographical Museum)

626 Flower-clusters from a coif. Black fine satin embroidered in "little dog" motif with white yarn mainly in chain-stitch, satin-stitch and stem-stitch. Detail. *14 cm.* Szeremle, Bács-Kiskun County (Ethnographical Museum)

627

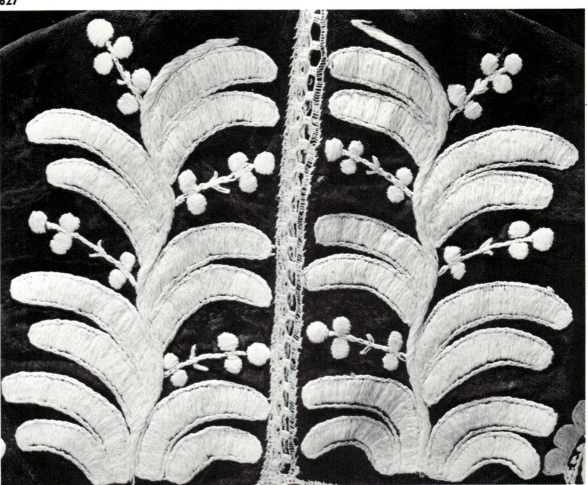

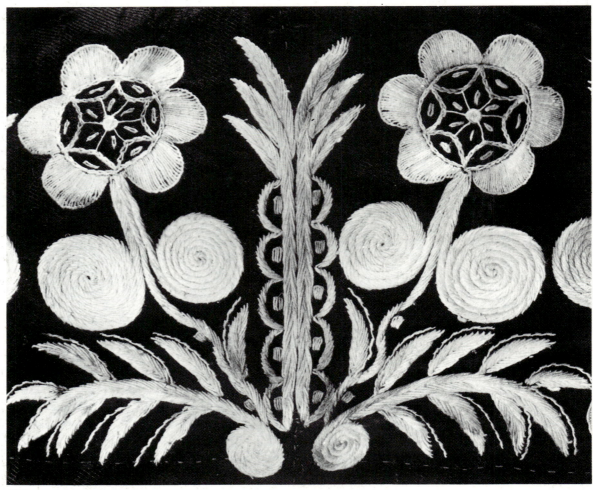

628

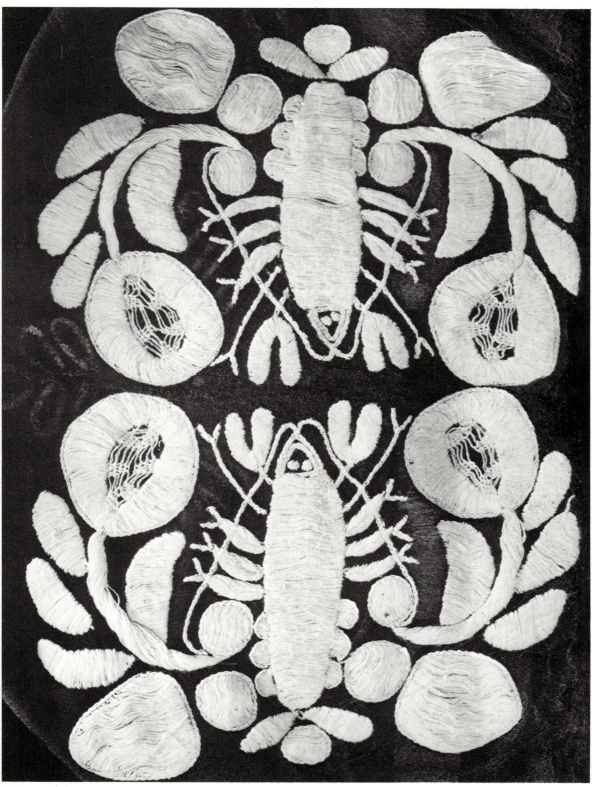

627 Embroidery from the back of a coif. Worked on a black muslin ground with white cotton yarn in satin-stitch and chain-stitch. The coif is sewn together lengthwise with an insert of manufactured lace. *12.5 cm*. Hercegszőlős (Kneževi Vinogradi, Yugoslavia) (Ethnographical Museum)

628 Embroidery from the back of a coif. Black muslin, worked in white yarn in satin-stitch and chain-stitch. *13 cm*. Nagyharsány, Baranya County (Ethnographical Museum)

629 Crab motif from the back of a coif. Worked on black muslin with white cotton in satin-stitch and chain-stitch, also net-work over the holes. *12.5 cm*. Karancs (Karanac, Yugoslavia) (Ethnographical Museum)

630 Border of a veil. Linen ground worked with gold thread and faded black silk in satin-stitch and French knots. Gold lace is sewn in between the embroidery. Detail. *8 cm.* Sárköz region, Tolna County

(Ethnographical Museum)

631 Border of a veil. Linen ground embroidered in red, green, blue and white silk, outlined with black. *10 cm.* Sárköz region, Tolna County (Ethnographical Museum)

632 Corner of a kerchief worn over the shoulder. White cambric appliquéd on the reverse side of white cambric. Bordered with manufactured lace. *55 cm.* Region of Kapuvár, Győr-Sopron County (Ethnographical Museum)

630

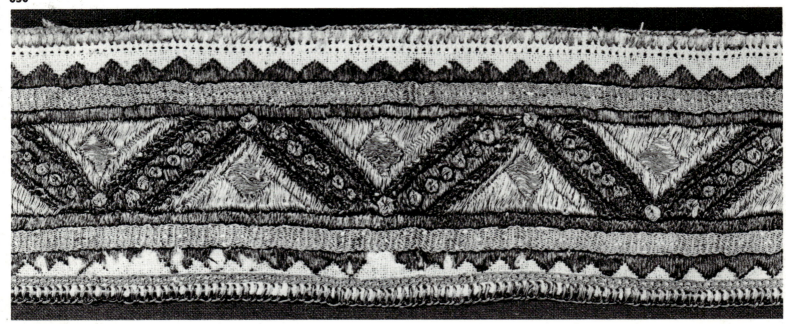

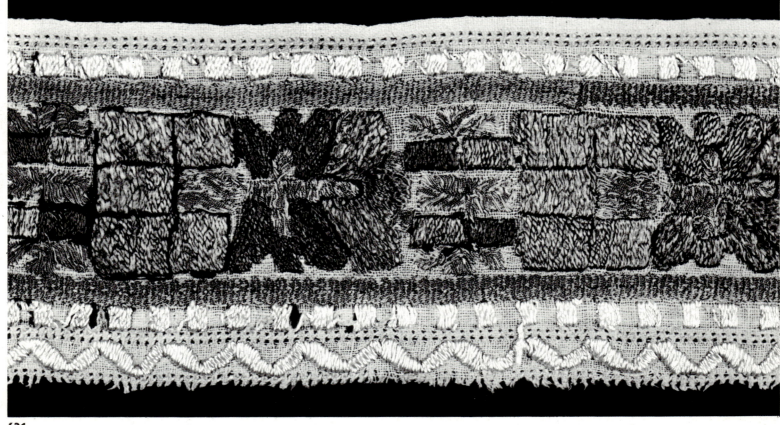

631

632

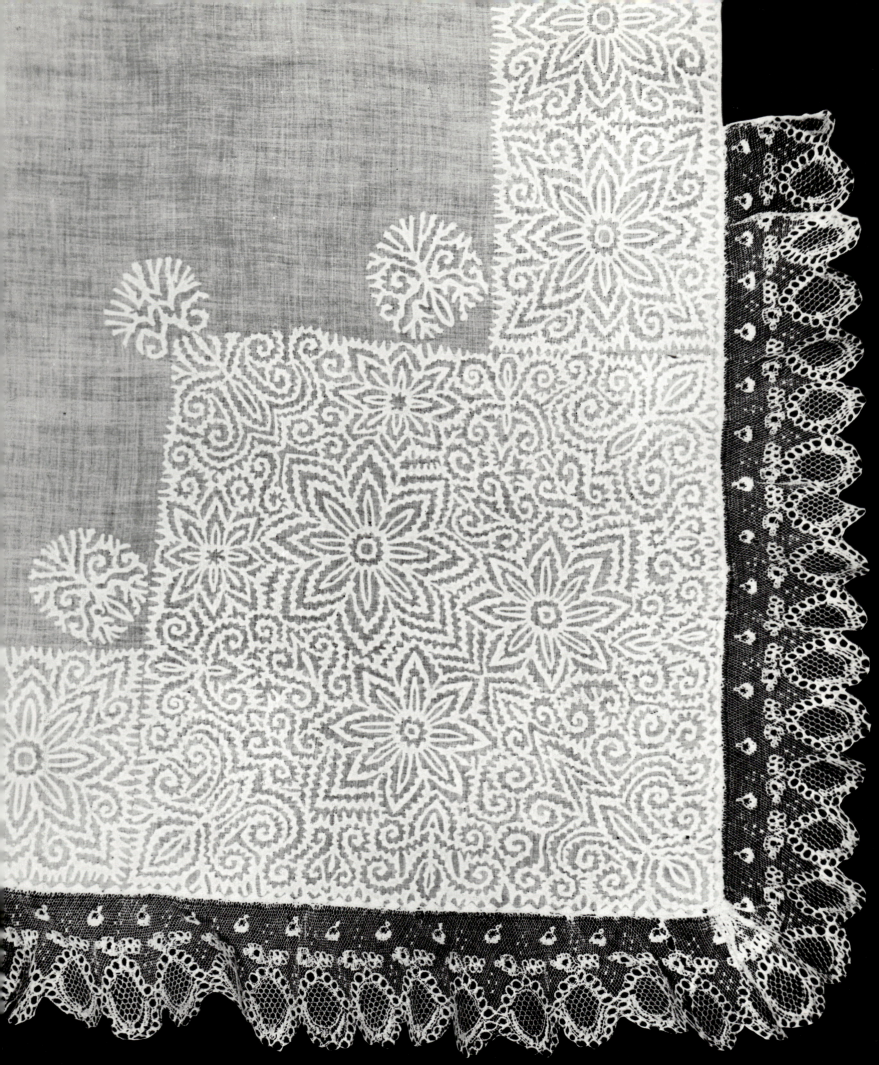

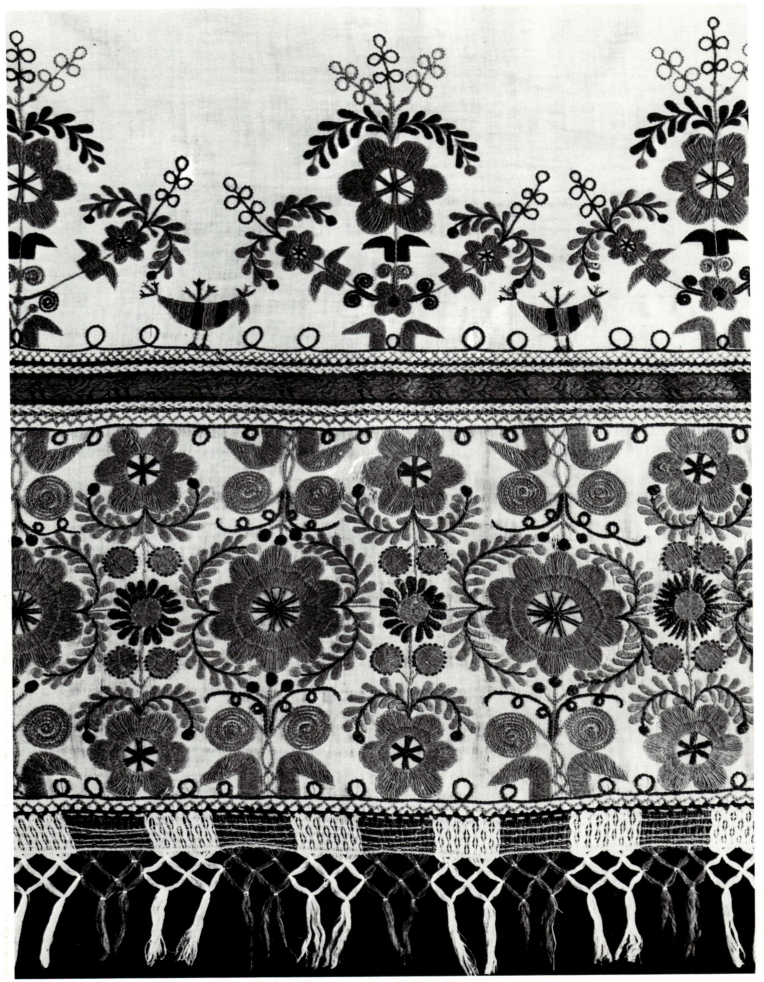

633 Embroidery from the border of a counterpane. White cambric ground worked in red and blue cotton with satin-stitch, figure-of-eight stitch and stem-stitch. The edges are joined with manufactured red and blue woven ribbons. Detail. *50 cm.* Mezőkövesd, Borsod-Abaúj-Zemplén County (Ethnographical Museum)

634 Design of birds and rosettes from the border of a counterpane. Hemp ground worked with red and blue cotton thread with mock satin-stitch, also herringbone- and stem-stitch. Along both lengths of the embroidery are manufactured strips. *34 cm.* Szentistván, Borsod-Abaúj-Zemplén County (Ethnographical Museum)

635 Half width of a counterpane. Yellowed cambric embroidered with woollen yarn, mainly in mock satin-stitch, satin-stitch, also chain- and stem-stitch. *41 cm.* Szentistván, Borsod-Abaúj-Zemplén County (Ethnographical Museum)

634

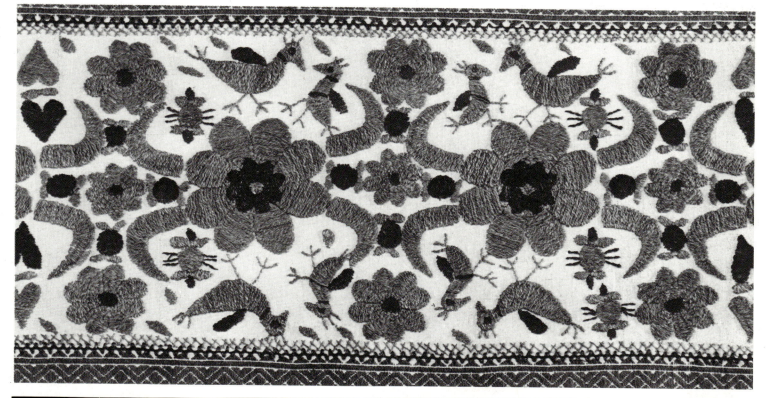

635

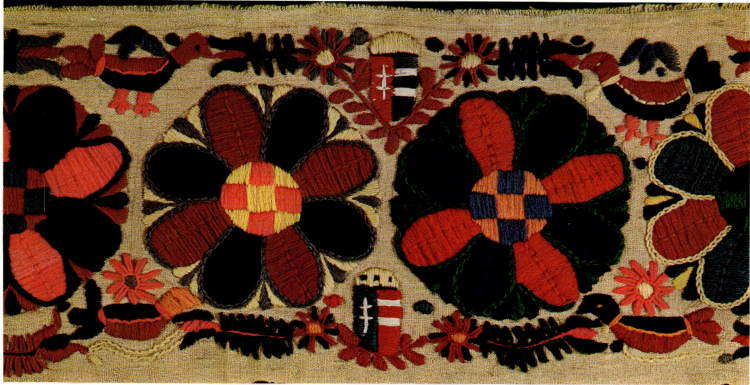

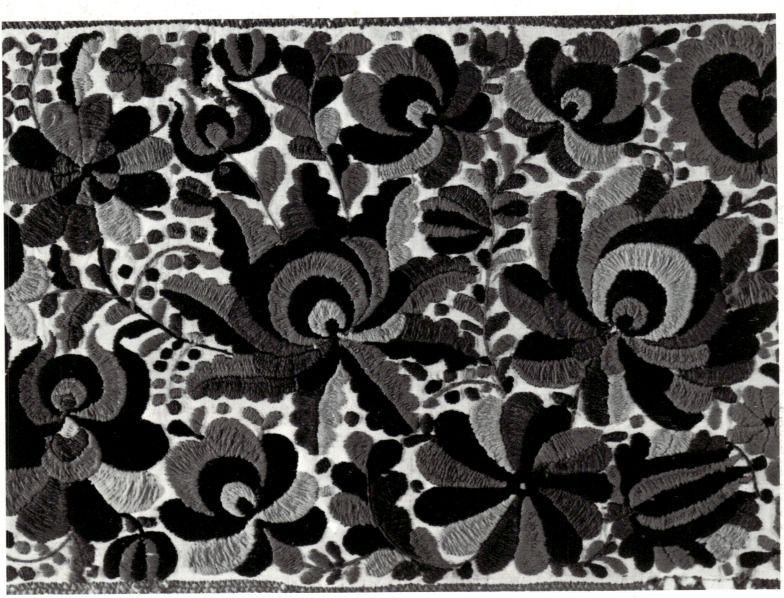

636

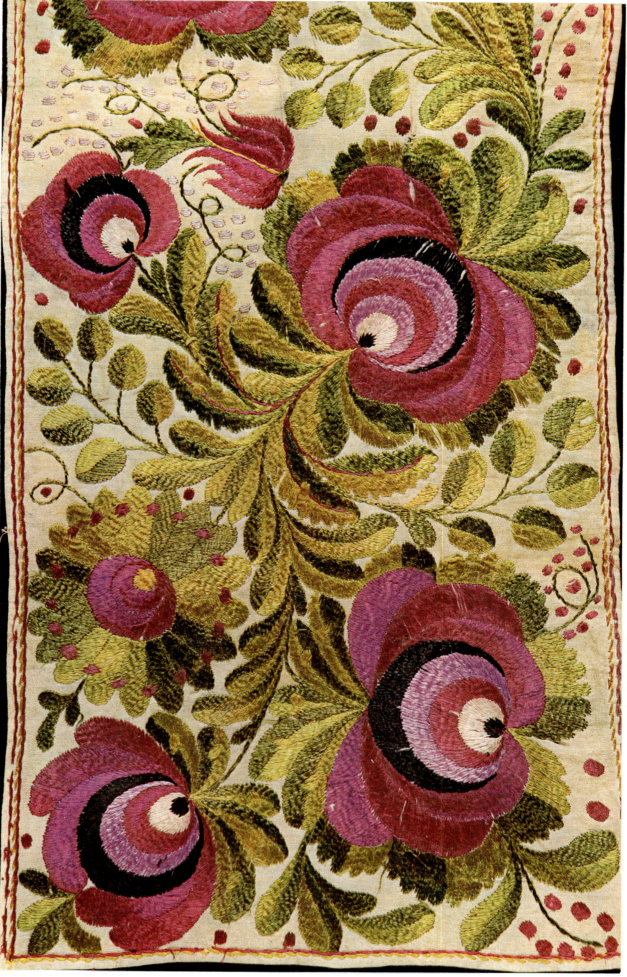

636 End border
of a counterpane
with large "Matyó"
roses. White cambric
embroidered
with crewel in red,
orange, two shades
of green, blue
and violet in mock
satin-stitch, figure-of-
eight stitch
and stem-stitch.
Detail. *33 cm*.
Mezőkövesd,
Borsod-Abaúj-
Zemplén County
(Ethnographical
Museum)

637 Embroidered
end border
of a counterpane.
White cambric
worked with furrier's
silk thread in satin-
stitch and stem-
stitch. Detail. *25 cm*.
Mezőkövesd,
Borsod-Abaúj-
Zemplén County
(Ethnographical
Museum)

638 Embroidery
on a small sheet
for the bottom
of a bed. Linen
with a rippled texture
embroidered
in square chain-
stitch and satin-
stitch. Detail. *62 cm*.
Kalotaszeg region
(Rumania)
(Ethnographical
Museum)

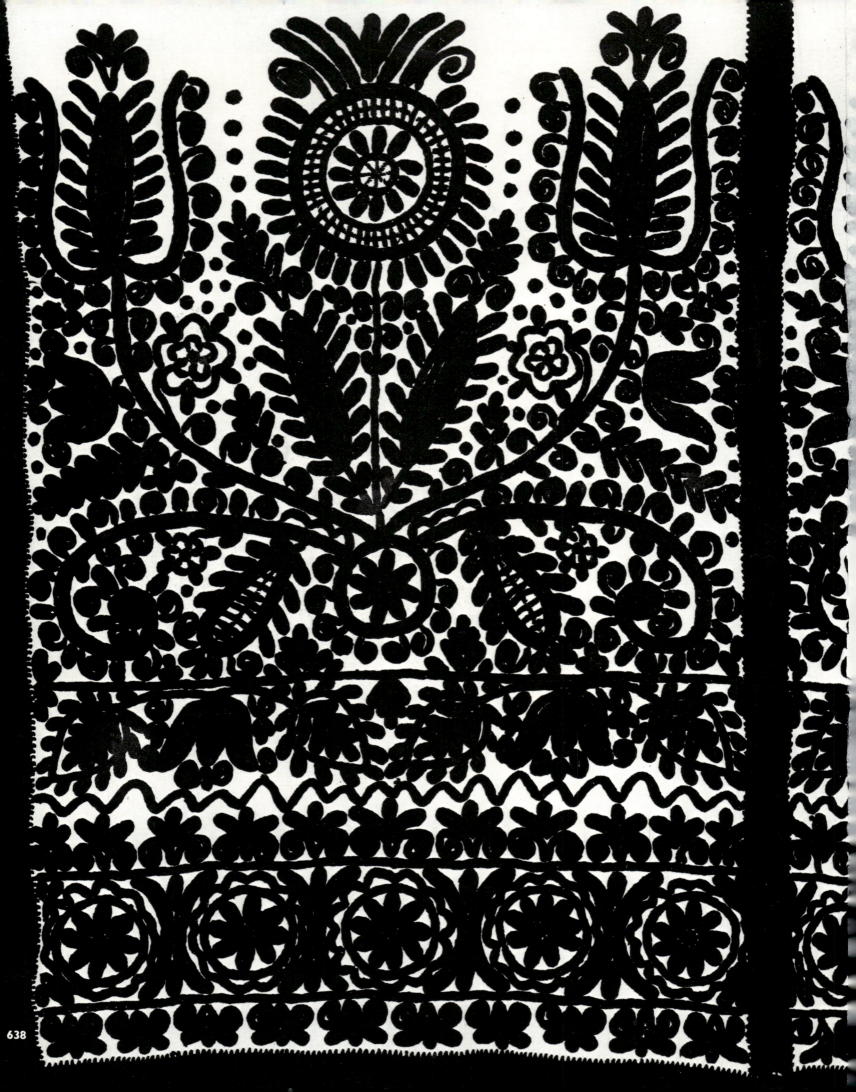

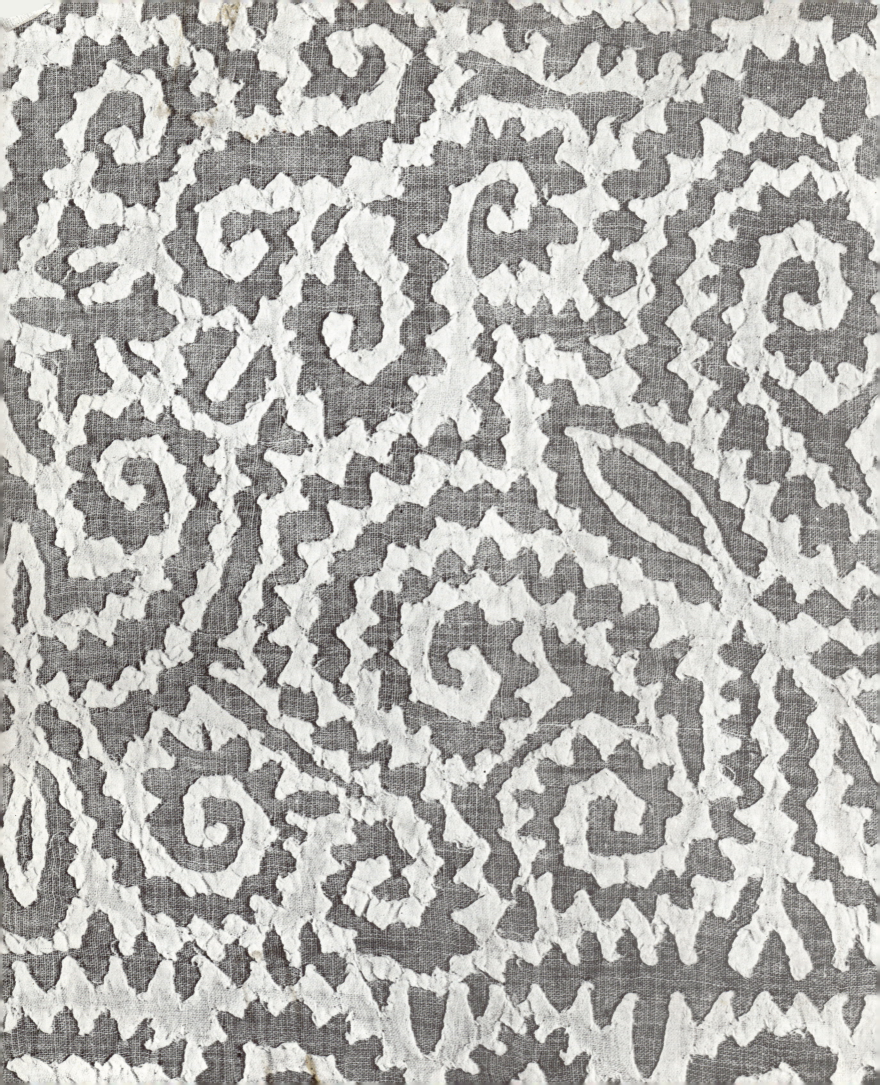